Postcolonial Approaches to Eastern European Cinema

Portraying Neighbours On-Screen

Ewa Mazierska, Lars Kristensen
and Eva Näripea

I.B. TAURIS

LONDON · NEW YORK

Acknowledgements

We wish to express our gratitude to the Estonian Film Institute for supporting this project with a grant.

Special thanks goes to all institutions and individuals, who provided us with the stills, used in the book and granted the permission to use them, such as Adam Wyżyński from the National Film Archive in Poland and the filmmakers Arvo Iho and Arsen Anton.

We are also indebted to Kamila Rymajdo for helping to proofread some of the chapters in this book.

Published in 2014 by I.B.Tauris & Co Ltd
6 Salem Road, London W2 4BU
175 Fifth Avenue, New York NY 10010
www.ibtauris.com

Distributed in the United States and Canada Exclusively by Palgrave Macmillan
175 Fifth Avenue, New York NY 10010

Copyright Editorial Selection © 2014 Ewa Mazierska, Lars Kristensen
and Eva Näripea
Copyright Individual Chapters © 2014 John Cunningham, Peter Hames, Petra Hanáková, Kristin Kopp, Lars Kristensen, Ewa Mazierska, Eva Näripea, Elżbieta Ostrowska, Vlastimir Sudar, Bruce Williams and Špela Zajec.

The International Library of the Moving Image 14

ISBN: 978 1 78076 301 9

A full CIP record for this book is available from the British Library
A full CIP record is available from the Library of Congress

Library of Congress Catalog Card Number: available

Designed and typeset by 4word Ltd, Bristol
Printed and bound in Great Britain by CPI Group (UK) Ltd, Croydon, CR0 4YY

Contents

List of Contributors

John Cunningham

John Cunningham lived in Hungary for nine years from 1991 where he taught Film and Media Studies at most of the major universities. He returned to the UK in 2000 where he has just recently retired from his post as Senior Lecturer in Film Studies at Sheffield Hallam University. He is the author of a number of studies on various aspects of Eastern European, particularly Hungarian, cinema. In November 2009 he was awarded the Pro Cultura Hungarica medal for his services to Hungarian art and culture.

Peter Hames

Peter Hames is Visiting Professor in Film Studies at Staffordshire University and a programme advisor to the London Film Festival. His books include *The Czechoslovak New Wave* (second edition, Wallflower Press, 2005, also translated into Czech and Polish), *Czech and Slovak Cinema: Theme and Tradition* (Edinburgh University Press, 2010), *Best of Slovak Cinema 1921-91* (Slovak Film Institute, 2013) and as editor, *The Cinema of Central Europe* (Wallflower Press, 2004), *The Cinema of Jan Švankmajer: Dark Alchemy* (Wallflower Press, 2008), and *Cinemas in Transition in Central and Eastern Europe after 1989* (with Catherine Portuges, Temple University Press, 2013). He also contributed to *Marketa Lazarová: Studie a dokumenty,* edited by Petr Gajdošík (Casablanca Publishers, 2009). His articles

have appeared in *Sight & Sound, Vertigo, Studies in Eastern European Cinema, KinoKultura* and *Kinoeye*.

Petra Hanáková

Petra Hanáková is Assistant Professor in the Film Studies department of the Charles University in Prague, the Czech Republic. Her research focuses on the theory of film and visual culture, gender analysis and the representation of national identity in film. She is the author of *Pandořina skřínka aneb Co feministky provedly filmu?/ Pandora's Box or What Have Feminists Done to Cinema?*, 2007, editor of *Výzva perspektivy. Obraz a jeho divák od malby quattrocenta k filmu a zpět/The Challenge of Perspective: Image and its Spectator from Quattrocento Painting to Film and Back*, 2008, and the co-editor of *Visegrad Cinema: Points of Contact from the New Waves to the Present* (2010, with Kevin Johnson). She is currently working on a book on national imagery in Czech visual culture.

Kristin Kopp

Kristin Kopp is Associate Professor of German Studies at the University of Missouri. Her research alternately addresses German-Polish relations, German colonialism, and German film. She is a recipient of the Alexander von Humboldt Foundation fellowship in support of research leading to her publication of *Germany's Wild East: Constructing Poland as Colonial Space* (University of Michigan Press, 2012), and is the co-editor of *Die Großstadt und das Primitive: Text, Politik, Repräsentation* (with Klaus Müller-Richter), *Peter Altenberg: Ashantee. Afrika und Wien um 1900* (with Werner Michael Schwarz), *Germany, Poland, and Postmemorial Relations: In Search of a Livable Past* (with Joanna Niżyńska), and *Berlin School Glossary: An ABC of the New Wave in German Cinema* (with Roger F. Cook, Lutz Koepnick, and Brad Prager).

Lars Kristensen

Lars Kristensen is a lecturer in Media, Aesthetics and Narration at the University of Skövde, Sweden, where he teaches film history and film theory in relation to games and digital cultures. He has taught Russian and Comparative Literature at the University of Glasgow and held the position of Research Associate at the University of Central Lancashire. He completed his PhD in Film Studies in 2009 at the University of St Andrews and has published predominantly on cross-cultural issues related to Russian, Chinese and Albanian cinema. He is the editor of the collection *Postcommunist Film – Russia, Eastern Europe and World Culture: Moving Images of Postcommunism* (Routledge, 2012).

Ewa Mazierska

Ewa Mazierska is Professor of Contemporary Cinema in the School of Journalism and Digital Communication at the University of Central Lancashire. Her publications include *European Cinema and Intertextuality: History, Memory, Politics* (Palgrave Macmillan, 2011), *Jerzy Skolimowski: The Cinema of a Nonconformist* (Berghahn, 2010), *Masculinities in Polish, Czech and Slovak Cinema* (Berghahn, 2008), *Roman Polanski: The Cinema of a Cultural Traveller* (I.B.Tauris, 2007), *Polish Postcommunist Cinema* (Peter Lang, 2007) and with Elżbieta Ostrowska, *Women in Polish Cinema* (Berghahn, 2006) and with Laura Rascaroli, *Crossing New Europe: The European Road Movie* (Wallflower Press, 2006). She is Principal Editor of the journal *Studies in Eastern European Cinema*.

Eva Näripea

Eva Näripea is affiliated with the Estonian Academy of Arts and with the research group of cultural and literary theory at the Estonian Literary Museum. She holds a doctorate from the Estonian Academy of Arts (*Estonian Cinescapes: Spaces, Places and*

Sites in Soviet Estonian Cinema (and Beyond), 2011). A number of her articles on representations of city- and landscapes in Soviet Estonian and Polish cinema have appeared in various Estonian and international publications (*KinoKultura, Studies on Eastern European Cinema, Studies on Art and Architecture* etc.). She has co-edited *Via Transversa: Lost Cinema of the Former Eastern Bloc* (2008, with Andreas Trossek) and a special issue on Estonian cinema for *KinoKultura: New Russian Cinema* (2010, with Ewa Mazierska and Mari Laaniste). Her current projects focus on representations of work in Eastern European science fiction films and in Estonian auteur cinema, on the relationship between tourism and European cinema and on recent Estonian coproductions.

Elżbieta Ostrowska

Elżbieta Ostrowska currently teaches film at the University of Alberta, Canada. Her publications include: *The Cinema of Andrzej Wajda: The Art of Irony and Defiance* (co-edited with John Orr, 2003), *The Cinema of Roman Polanski: Dark Spaces of the World* (co-edited with John Orr, 2006) and *Women in Polish Cinema* (with Ewa Mazierska, 2006)

Vlastimir Sudar

Vlastimir Sudar is an associate lecturer at the University of the Arts London, teaching film history and theory. He was also an associate lecturer at Goldsmiths College in London, in the History department, where he focused on film as a historical resource. He obtained his PhD at the University of St Andrews in Scotland and Balkan cinema is his main area of expertise. Vlastimir published on the subject in an anthology *The Cinema of The Balkans* (Wallflower Press, 2006), as well as in numerous journals and magazines, including *KinoKultura*. He has in the meantime also reworked his doctoral dissertation *A Portrait of the Artist as a Political Dissident: The Life and Work of Aleksandar Petrović*, which was published by Intellect, Bristol, in 2013. Vlastimir has an interest in cinema beyond his main

area of expertise and regularly contributes film reviews to *Sight &
Sound* magazine. Research for the essay published in this volume
was kindly supported by the University of the Arts London.

Bruce Williams

Bruce Williams is Professor and Graduate Director in the
Department of Languages and Cultures at the William Paterson
University of New Jersey. He has published extensively in the
areas of cinema history; film theory; Latin American and European
cinemas; and language and cinema. His current research interests
include Albanian cinema; cinema as a tool for nation-building in
North Korea and Albania; cinematic ties between Brazil and the
Soviet Union; and the sociolinguistics of the cinema. His articles
have appeared in such journals as *Quarterly Review of Film and Video*,
New Review of Film and Television, *Film History*, *Canadian Journal of
Film Studies*, *Cinémas*, and *Journal of Film and Video*.

Špela Zajec

Špela Zajec recently finished her Ph.D. on the subject of film
cultures in the territories of the former Yugoslavia at the University
of Copenhagen, Denmark, and she currently works as a research
assistant at the same university. She has a BA in Ethnology and
Cultural Anthropology from University of Ljubljana, Slovenia and
a European MA in Human Rights and Democratization.

Postcolonial Theory and the Postcommunist World

Ewa Mazierska, Lars Kristensen and Eva Näripea

This book is devoted to representations of neighbours in Eastern European cinema, using as its main methodological tool postcolonial theory. However, as practically every term used to describe our project has a contested meaning, we shall explain them first.

Eastern European cinemas, Eastern European neighbours

By 'Eastern European cinema' we mean cinemas of countries that were within the Warsaw Pact and the Federal People's Republic of Yugoslavia and today are labelled as postcommunist. They cover a geographical area that extends from East Germany in the West to Mongolia in the Far East, from Murmansk in the North to the southern tip of Albania. Although 'Eastern Europe' is by no means a homogeneous entity, it has in common a certain political and economic system, which was perceived as different from capitalism. We argue that the term 'Eastern Europe' is useful not only to describe the situation pertaining to the Cold War, but also after

the fall of communism, as this region preserved many peculiarities from the communist period.[1] Accordingly, we define this region as 'Eastern Europe' from the present perspective, yet also attempt to account for its communist and earlier past, in particular the times of the Tsarist and Habsburg Empires. Limited by space and our research specialisms, we decided to tackle only some national cinemas, leaving others untouched. However, we believe that our case studies are sufficient to test the effectiveness of postcolonial approaches to Eastern European cinema and allow other researchers to broaden or correct our analysis by discussing other national cinemas and other types of films.

By 'neighbours' we mean people living in a neighbouring country, ethnic minorities, namely those inhabiting the same country, but regarded as ethnically and culturally different, as well as those located further away, but exerting significant political, economic or cultural influence on the examined group. Of course, it would be impossible in a publication of this size to consider all neighbouring relations in Eastern Europe. Our choice was also dictated by our desire to show as many types of neighbouring relations as possible, a need to discuss different sub-regions of Eastern Europe and practicalities involved in preparing books of this kind. We decided to focus on people attached to a nation-state, leaving out Jews, Roma and stateless ethnic minorities as the main subjects of our investigation, as they would activate a different set of questions, especially the Holocaust, which have already attracted a large amount of scholarship. Nevertheless, we will refer to them as an important factor in mediating neighbouring relations between people possessing their own country. Our choice of neighbours is also informed by what Charles Taylor describes as the 'politics of recognition'. Such politics, as Taylor observes, is based on two assumptions; first on equal dignity of individuals and social groups and, secondly, on their distinctness and, hence, the right to preserve their language and traditions.[2] At the same time, an important motif of the chapters constituting this collection is precisely the lack of the 'politics of recognition' in Eastern Europe.

Their authors attempt to explain the reasons why the 'politics of recognition' was rejected during most of the history of this region, including during the communist period, and assess whether the shift towards the new economic and social order is conducive to applying it.

The concept of colonialism and its Western and Eastern versions

The term 'colonialism' denotes a specific form of domination and exploitation that has political, economic and cultural dimensions. Some commentators emphasize its cultural aspects,[3] while others stress the importance of economic and/or political aspects. For example, Ania Loomba argues that 'colonialism can be defined as the conquest and control of other people's land and goods'.[4] According to Estonian art historian Jaak Kangilaski, however, the most important characteristic of colonialism is the fact that the colonizer and the colonized come from different cultural and ethnic backgrounds, and that the colonizers have regarded their language and culture as higher than those of the colonized, and have seen their dissemination as progressive.[5] Kangilaski cites German historian Jürgen Osterhammel, who defines colonialism as a relationship between the local majority and the foreign intruders. Principal decisions about the colonized territories are made and implemented in the metropoles. The colonizers are convinced of their supremacy and right to rule.[6] Thus what defines colonialism is not a set of (legal) characteristics but the economic, political, cultural and socio-psychological nature of the colonialism in its entirety.[7]

However, these general definitions, while valid, certainly need to be further qualified. It has been argued that colonialism, defined in those broad terms, span at least four centuries and is affected by the onset of World War I, and covers nine-tenths of the land surface of the globe.[8] Thus it is difficult to imagine that what we are dealing with here is a monolithic and stable phenomenon. Scholars

of colonialism differentiate between pre-modern and modern colonialism. Robert J.C. Young compares early colonization to latter-day migration, arguing that in the original European use of the term 'colonization' referred to communities who settled elsewhere in search of 'a better life in economic, religious or political terms' without any ambition to rule over indigenous peoples, or to extract their wealth.[9] Yet

> [t]he European drive towards the establishment of a global trading network tended, in historical terms, to produce as a consequence exploitation colonies, the colonies of domination. Many such colonies were the not-always-intended product of the early trading companies, private enterprises that were given a monopoly to trade by the monarch from the fifteenth century onwards.[10]

According to Young, up to the nineteenth century, early colonization 'was rarely the deliberate policy of metropolitan governments'; rather it tended 'to be the haphazard product of commercial interests and group settlements'.[11] Modern colonization, however, according to Marxist thinking, was established alongside capitalism, and in addition to extracting wealth from the conquered countries, 'it restructured the economies of the latter, drawing them into a complex relationship with their own, so that there was a flow of human and natural resources between colonized and colonial countries'.[12]

In terms of geography, while the earlier forms of colonialism did not necessarily originate from Europe, modern colonialism has come to be thought of as a series of conquests by (Western) European (capitalist) countries, primarily Britain and France, in quest of territorial possessions on other continents. This kind of reasoning has resulted in two fundamental misconceptions: first, that everybody in (Western) Europe is a colonialist and all non-Europeans are victims of colonization; secondly, that 'proper' modern colonialism involves only the countries that rule over distant territories,[13] excluding those that have acquired their colonies by

conquering adjacent lands and peoples. This understanding of colonialism tends to ignore older European empires (Habsburg, Ottoman) that focused, either initially or entirely, on subjugating their neighbours (England colonized Scotland and Ireland, Spain colonized Catalonia), before moving further afield. Equally it leaves little room for the 'modern' case of Soviet colonialism. Thus, Europe has always been heterogeneous as a colonizing power, scarred by constantly shifting lines of fire and the changing dynamics of (neo)colonial relationships.

In addition, different types of colonialism have been detected. Anne McClintock differentiates between: 1) colonization that 'involves direct territorial appropriation of another geo-political entity, combined with forthright exploitation of its resources and labor, and systematic interference in the capacity of the appropriated culture (itself not necessarily a homogeneous entity) to organize its dispensations of power'; 2) internal colonization that 'occurs where the dominant part of a country treats a group or region as it might a foreign colony'; 3) '[i]mperial colonization, [which,] by extension, involves large-scale, territorial domination of the kind that gave late Victorian Britain and the European "lords of humankind" control over 85% of the earth, and the USSR totalitarian rule over Hungary, Poland and Czechoslovakia in the twentieth century'.[14] In the current situation, namely after the fall of the Berlin Wall, the position of an imperial colonizer is ascribed exclusively to the United States, although it has enjoyed this position practically since World War I. This view is held by, for example, David Harvey,[15] who also emphasizes the gap between the imperialistic actions of the USA and its anti-imperialistic rhetoric, suggesting that to function smoothly, the imperialistic power needs ideology in the Marxist/Althusserian sense – as a means to conceal the reality, in this case the reality of military conquest and economic domination. Harvey notes that in this respect the USA did not behave very differently from the Soviet Union.[16]

While for a long time a conspicuous gap in theorizations of (post)colonialism existed in terms of excluding the Soviet Union

as a major colonial power, McClintock's opinion, as well as a growing body of scholarship in Eastern Europe and in the West, acknowledges the need to include this area in the discussions on post-colonialism. In what follows we examine two interdependent issues: 1) the special case of Soviet/Eastern European post-colonialism; 2) the reasons why the discourse of post-colonialism was neglected in the Soviet case for so long and remains a matter of heated debate. We shall emphasize that for us the term 'Eastern Europe' derives its meaning from geo-politics, rather than geography. It denotes the part of Europe which after World War II adopted the system called (state, real) socialism and for a part or whole of its postwar history remained in an orbit of Soviet/Russian power, by becoming either part of the Soviet Union or one of its satellites, politically, militarily and economically connected by belonging to pan-Eastern European institutions such as the Warsaw Pact. Central Europe, on the other hand, in this book designates a geographic region, comprising, among others, countries such as Poland, Czechoslovakia, Yugoslavia, East and West Germany and their postcommunist incarnations.

Most commentators agree that the relationship between the Soviet metropole and the countries subordinated to its power was based on either a possibility of military takeover or an actual 'forcible takeover of land and economy'.[17] Even though the above-quoted Marxist definition related modern colonization with the establishment of capitalism in Western Europe, the important point here concerns the 'restructuring of economies' in the colonies, and this was indeed what happened in most cases in countries devoured or affected by the Soviet power during and after the Second World War. In addition, Miroslav Hroch, a Czech historian and political theorist, emphasizes that

> ... life under communist government entailed the lessening of civil rights and decreasing political sovereignty of Eastern and Central European nations, which was sometimes accompanied by restrictions on cultural and linguistic rights. People lived under the

uncontrollable political, cultural and economic power of the communist *nomenklatura* …[18]

which was an agent of colonial power relations.

The absorption of these previously independent nation states into the Eastern Bloc was represented not as enforced, but as their voluntarily joining the better political, economic and social system, welcomed by its leader, the Soviet Union, who ensured equal treatment of all countries and ethnic groups. In other cases, the Soviet Union developed a discourse of benign and anti-imperialist intervention in countries and regions suffering from various forms of backwardness, for example, the refrain from Central Asia that the Russians 'brought us electricity and education' or that the Soviet Union was forged of '15 sister [republics] of equal stature'.[19] In reality Soviet colonialism was strongly marked by promoting Russian ethnic interests; more so than by the needs of an international proletariat.[20] Soviet colonial rhetoric was thus similar to a traditional, Western–style colonial discourse, which also played up advantages of colonization to the colonized nations. Yet, while this discourse of 'voluntary merger' was first fiercely rejected at the grass roots level in the Eastern Bloc, especially by people who actively opposed the Soviet dominance, it gradually died out, together with hope of regaining independence. The colonized people started to 'sleep' (metaphorically and literally) with the enemy, collude with its colonial practices or subvert it in a more subtle way and, eventually, perceive it as 'one of us'.[21] The colonizers, on the other hand, were happy to project this image of voluntary submission into the socialist empire both within the sphere of their influence and to the outside world, in particular to the Western Left.

The situation was further complicated by the fact that the Soviet metropole exercised a varying degree of political, economic and cultural penetration in different parts of the Eastern Bloc and during different periods; similarly, its nationalities policies varied over time. What David Chioni Moore lists as 'classic measures'

of colonization – 'lack of sovereign power, restrictions on travel, military occupation, lack of convertible specie, a domestic economy ruled by the dominating state and forced education in the colonizer's tongue'[22] – did not affect the whole of the Eastern Bloc in the same way. In some countries in certain periods of postwar history the Soviet presence was hardly felt and, if it was, it was not an experience of being crushed by a colonial power, but rather of living with an 'inferior' partner and being in a position to exploit it. This pertains mainly to the Eastern European countries that did not form a part of the Soviet Union but were still dominated by it, and perhaps especially to Poland. Poland enjoyed, by and large, a privileged position within the Eastern Bloc, being able to retain many of its cultural and social privileges, such as a strong Catholic church and largely private agriculture and being rewarded rather than punished for the acts of rebellion against the political status quo.[23] The situation was rather different in the Baltic states, which during World War II were first invaded by Russia (in 1940), then Germany (in 1941) and then re-captured by Russia (in 1944), and afterwards were subjugated to ruthless Sovietization, which threatened the very existence of their indigenous language, culture and even the physical survival of their nations. Between 1940 and 1945, more than a million people in the Baltics died or were killed, escaped, or were sent to Siberia. During 1940–52 more than 203,000 people were deported from Lithuania, Latvia and Estonia.[24] In Latvia, where colonial policies were implemented perhaps with the greatest callousness, by the end of the Soviet Union ethnic Latvians constituted only 52 per cent of the total population of the country.[25]

In regard to the official trade it was sometimes difficult to say which party was at an advantage and which at a disadvantage. It is widely accepted that the economy in the whole of the region was remodelled according to the needs of Moscow. Hence, almost everywhere in the satellite countries the economic priority was extraction of raw materials (coal, metals) and heavy industry, such as production of steel, at the expense of producing consumer goods

and services and developing new technologies.[26] There was also a tendency towards excess, to acting on a 'Magnitogorsk mentality', which manifested itself, among other things, in large enterprises, often employing thousands of people.[27] Thanks to such policies, in due course, Eastern Europe became 'one large museum of the industrial revolution',[28] as well as experiencing many other negative effects of colonialism and postcolonialism. In the Baltic states, for example, this meant that the central Soviet government established industries for which the raw materials, as well as the majority of the workforce, were imported, or settled,[29] from other republics and the production of which was exported to other republics. These industries served the interests of the metropole and polluted local environs both literally and metaphorically. At the same time, such orientation had the advantage of ensuring full employment, high growth rate in some periods, especially in the 1950s exceeding those in the West[30] and a relatively high standard of living for those labouring in the privileged sector. Not surprisingly, some years after the fall of the Berlin Wall the paradox-loving leader of the (first) Solidarity, Lech Wałęsa, admitted that it was thanks to the huge Russian market, able to absorb ships and other products of Polish industry, that Polish workers eventually felt confident enough to organize themselves and rebel against the Soviet Union. Equally, following their victory, they found themselves diminished and practically redundant in the new, neo-liberal order.[31]

In the 1970s, when the restrictions of travelling were eased, thousands of entrepreneurial Poles travelled to the Soviet Union, nominally as tourists but in reality as black marketeers, exchanging such homemade products as plastic sunglasses or plastic jewellery, for gold and diamonds. Needless to say, the character of this exchange smelled of the colonial trade, in which the Soviets were rendered as the new, easily duped 'Indians', while the Poles saw themselves as superior, clever 'whites'. This has made a number of scholars regard Russo-Soviet colonization as 'reverse-cultural colonization': '*Mittel*-European capitals such as Budapest, Berlin, and Prague

were therefore seen in Russia, at least by some, as prizes rather than as burdens needing civilizing from their occupiers. In return, the Central Europeans often saw the colonizing Russo-Soviets as Asiatics',[32] as 'Orientals' unable to assume a position of a colonizer, especially in relation to apparently less Oriental people.[33]

Due to a higher standard of living and their geographical in-betweenness between East and West, Poland, Czechoslovakia and the Baltic countries perceived themselves as a natural part of the West. Yet Kangilaski correctly adds that even though Russian colonists might have felt inferior in relation to Baltic and (geographically) Central European people, 'those feelings were accompanied and often dominated by imperial pride and the belief in the special mission of the Russians'; and although Soviet colonizers were considered barbaric by many Eastern European nations, this did not make colonial oppression easier to bear; maybe even the opposite – it was experienced as something especially undeserved.[34] Moreover, Kangilaski observes that colonists were probably seen as barbarians by most colonized people.[35] Furthermore, as Ania Loomba argues, colonialism does not need to involve a white/Occidental power subjugating people who are non-white and Oriental, although this was the norm in nineteenth-century colonialism.[36] Equally, colonialism does not need to involve the metropole being superior in all respects over the colonized margins (besides, measuring superiority is not an easy task). It is sufficient that it is able to act as a colonizer by, for example, suppressing rebellions of the subjugated people, as was the case in Eastern Europe, for example in Hungary in 1956 and Czechoslovakia in 1968.

Hence, we subscribe to a view that military and economic colonization does not necessarily induce a cultural domination. A country which is occupied by a military power might successfully preserve and develop its culture and even influence its colonizer. A case in point was the fashion for Indian culture among young Brits in the 1960s and 1970s, as represented, for example, by the novels of Ruth Prawer Jhabvala, such as *Heat and Dust* (1975) and *Three Continents* (1987) and the films of James Ivory, based on Jhabvala's

scripts, such as *The Guru* (1969) and *Heat and Dust* (1983). Secondly, a specific country or ethnic group can be, at a given moment, colonized by different powers in different ways, confirming a wider rule that 'different and sometimes rival conceptions of empire can become internalized in the same space'.[37] For example, the minority ethnic groups living in the socialist countries, such as Silesians in Southern Poland and Mazurien in the North, experienced what is known as double occupation: by Poles and by Soviets. This position also pertained to Jews and Roma. Another example is Transylvanian Hungarians living in Romania, who were marginalized and even ostracized by a number of powers, including Romanian and Hungarian governments, as well as being victims of the changing relationships among the Soviet Union, Hungary and Romania. Additionally, enforced cultural colonization might be resisted by a voluntary self-colonization with a different culture. An often quoted example is the resistance of Soviet influence to the adoption of elements of Western culture by the inhabitants of the satellite countries or even Russians, for example by listening to British and American music or watching American films.[38] Furthermore, successful colonization brings a risk of losing cultural distinctiveness by the colonizer. Anthony Giddens claims that by colonizing the globe, America, in a sense, emptied its own culture, as McDonald's restaurants, Coca-Cola or Disney films are rarely associated with archetypal American culture, regarding it instead as global and nationally neutral.[39] To some extent, this was the case with Russia, whose culture was imbricated with 'Soviet culture'. Sovietization helped to spread Russian values across the whole of the Second World, but also deprived Russia of part of its cultural distinctiveness,[40] which resulted in the revival of aggressive Russian nationalism after the end of communism.

Finally, the Balkan region has its own history of colonization and empire building, fluctuating between the Ottomans and Habsburgs, which after 1945 strongly 'coloured' both the relationship between the people living in the Balkans and the Soviet Union, as well as that between themselves, for example the inhabitants of Yugoslavia and

Albania and among various ethnic groups constituting Yugoslavia.[41] In a nutshell, Balkanism can be seen as a culture of Orientalization, in which the Balkan nations construed each other as beneficiaries or victims of purported Orientalism. For example, some nations and regions making up Yugoslavia, such as Slovenians and Croats, were regarded as masters of the Orientalist gaze in relation to Bosnian Muslims (Bosniaks) and Albanians. Such a sense of superiority led at times to ethnic cleansing, for example to killing, imprisoning and forced expulsions of many thousands of the (mostly Muslim) Albanian population, in 1918–21.[42] Moreover, during the communist period, Serbia, being the largest of the republics making up Yugoslavia, with Belgrade hosting all institutions of power, was perceived by the other republics as a colonizer. This position was the more contested as Serbia was regarded as an 'inferior' colonizer, not unlike Russia in relation to Poland or the Baltic countries, due to having a large rural population, few natural resources and no access to the sea, unlike, for example, Croatia, which developed a significant tourist industry during the communist period.

Matters were further complicated by the relationship with Russia, who granted itself the status of a colonizer in relation to the whole of Yugoslavia, till the country broke its relationship with the Kremlin in 1948. The postwar history of Albania, the most rural and poorest of the Balkan countries, which gradually broke links with its allies till it became practically isolated, can be viewed as a history of de-colonization. That said, this history betrays a deep-seated colonial mindset, marked by the fear of its neighbours and a sense of inferiority.[43]

Postcolonialism and the scholarship on Eastern Europe

Having established why in our opinion the Soviet Union was a colonial power and how it affected the politics, economy and culture in its sphere of influence, we now turn to the question of how postcolonialism as a (set of) theoretical concept(s) is relevant in the postcommunist situation.

The field of postcolonial studies is an essentially heterogeneous, even contested territory, which includes a number of diverse, even contradictory, discourses that do not acknowledge the same ideas or methodologies, but are still interconnected and engaged in a dialogue.[44] However, according to a generally approved definition, postcolonialism deals with the effects of colonization on cultures and societies. As originally used by historians after World War II in terms such as 'the postcolonial state', 'postcolonial' had a clearly chronological meaning, designating the post-independence period. However, from the late 1970s the term has been used by literary critics to discuss the various cultural effects of colonization.[45] Some Eastern European scholars, such as Piret Peiker, have argued that postcolonial thought should be considered a general frame of reference for research in colonial power relations and their subsequent effects whenever and wherever they occur. Yet in reality the majority of studies concentrate on former British colonies. This approach shapes the theoretical foundations and the general worldview of postcolonialism, extending one 'experience of colonialism into a universal model of colonialism'.[46] This has far-reaching results: it overlooks colonization that originated from outside Europe, as well as various colonial regimes inside Europe.[47]

The term 'postcolonialism' is most commonly understood to have two dimensions: 'post' suggests 'after' the end of the colonial era, but a number of commentators have also stressed the idea that it actually includes the colonial, as well as the postcolonial, era. As Ania Loomba correctly observes, '[a] country may be both postcolonial (in the sense of being formally independent) and neo-colonial (in the sense of remaining economically and/or culturally dependent) at the same time'.[48] In today's world, while formal decolonization has produced apparently independent nation states in both the former Second and Third Worlds, the new global order that is characterized by a certain kind of economic and cultural domination, rather than direct political rule, still inscribes imbalances into relations between nations; thus '[c]olonialism

returns at the moment of its disappearance'.[49] This phenomenon is examined by David Harvey who observes that de-colonization, including in Eastern Europe, is accompanied by an invasion of 'vulture capital', typically American or multinational, which has a similar, if not worse effect than that of the old-style colonization, namely astonishingly large flows of tribute into the world's major financial centres and, reflecting it, amazing pauperization of the periphery.[50] Hence, while the collapse of the Soviet Union marked the end of a certain type of colonialism in Eastern Europe and reintroduced a much-desired political sovereignty to a number of countries, practically none of the nations of the former Eastern Bloc have remained untouched by the realities of this new global order that coordinates the circulation of cultural values, commodities and wealth, and which is not very different from the old-style colonialism.

Of the critics of the term 'postcolonialism' the observations made by Ella Shohat and Anne McClintock 30 years ago are still very much valid.[51] Their major doubts arise from the fact that this notion is imprecise, in a sense that it is not explicit either historically (when did it start?) or geographically (where does it occur?) and therefore entails all the risks of a 'universalizing category which neutralizes significant geopolitical differences',[52] as well as downplays the important aspects of cultural multiplicity and gender inequalities.[53] In Eastern Europe it is especially pertinent to ask when the postcolonial era started, because a number of Eastern European countries that had been independent during the interwar period were already postcolonial (in relation to German and Scandinavian colonizations and the Austro-Hungarian and Ottoman empires[54]) when (re)colonized by the Soviet Union. Some of them, like Poland, 'once played a role in history as colonizer and then found itself the victim of colonization'.[55] Yet this does not suggest that a postcolonial frame of reference is useless or unproductive, but rather that these multiple waves and modes of colonization should be taken into account when thinking about these cultures in a postcolonial frame of reference.

In contrast to Shohat and McClintock, Robert Stam, clearly embracing a postmodern discourse in his theorization of the postcolonial, argues that

> If the nationalist discourse of the 1960s drew sharp lines between First World and Third World, oppressor and oppressed, postcolonial discourse replaces such binaristic dualisms with a more nuanced spectrum of subtle differentiations, in a new global regime where First World and Third World are mutually imbricated. Notions of ontologically referential identity metamorphose into a conjunctural play of identifications. Purity gives way to contamination ... resulting in a proliferation of terms having to do with various forms of cultural mixing: religious (syncretism); biological (hybridity); linguistic (creolization); and human–genetic (*mestizaje*) ...[56]

The cases of Latvia, 'contaminated' with Russian identity, or Poland, with German identity, represent this trend very well. On the other hand, colonization might be regarded as a means to ensure pure culture of the colonized group. A case in point is East Germany. It was argued that thanks to belonging to the Soviet sphere, East Germans preserved the most precious elements of German culture, such as the language of Goethe, much more successfully than their Western neighbours, who were colonized more subtly yet more effectively by Americans.[57] This case points to the complexity of colonialism and, hence, postcolonialism.

While we agree that there are ahistoricizing, universalizing and potentially depoliticizing dangers inherent in the term 'postcolonial(ism)', we also argue that postcolonial theory can be productive in uncovering 'diverse strategies and methods of control and of representation'.[58] Providing a glimpse of this diversity is one of the objectives of this collection. We also believe that the heterogeneity of postcolonial thought is a virtue rather than a flaw, and that applying this frame of reference to analyses of Eastern European culture, and cinema in particular, provides new insights not only into Eastern Europe but also the broader postcolonial

discourse. Gayatri Chakravorty Spivak, addressing scholars in the field of Eastern European and Russian studies, reached a similar conclusion, arguing that 'when we look at these differences [of capitalist and socialist colonization] we realize that using the colonizer–colonized model creatively in your area will enhance existing colonial discourse and postcolonial studies as well as provide you with an interesting model'.[59] Most importantly, by utilizing this theoretical toolbox, the contributors to this collection have in common the desire to uncover relations of domination, which, after all, has been designated as one of the main tasks of investigations into postcolonialism in general.[60]

And yet, a strong resistance has existed against conceptualizing the position of subjects of Russo-Soviet colonization as that of colonized nations. One reason, as Moore observes, has been a sense of one's profound racial difference (and accompanying sense of superiority) from the colonized people of colour, such as Filipinos and Ghanaians.[61] The white colour of skin is important in this regard since, due to the same skin colour, the people of the Soviet Bloc felt close to the West, which is construed as white. That said, the number of studies devoted to Baltic (post) colonialism, especially in the light of the small size of the region, is high[62] in comparison with the countries of Central Europe, such as Poland, Hungary and the Czech Republic. The refusal of colonial discourse by Eastern European scholars also stems from the above-described fact that the Baltic states and Eastern European countries differed significantly from other 'classical' colonies in terms of far less admiration towards the colonizers and fewer attempts to mimic them, because for most people in these countries the West was the positive ideal.[63] The Western scholars, on the other hand, avoided using a postcolonial approach in relation to Eastern Europe due to, broadly speaking, sympathy toward the Soviet political project. As Moore, in agreement with others, writes,

> An enormous and honorable political commitment to the Third World has been central to much in three-worlds theorizing, the ancestor of

postcolonial critique. One aspect of that commitment has been the belief, not without reason, that the First World largely caused the Third World's ills, and an allied belief that the Second's socialism was the best alternative. When most of the Second World collapsed in 1989 and 1991, the collapse resulted in the deflected silence apparent in Shohat, and it still remains difficult, evidently, for three-worlds-raised postcolonial theorists to recognize within the Second World its postcolonial dynamic. In addition, many postcolonialist scholars, in the United States and elsewhere, have been Marxist or strongly left and therefore have been reluctant to make the Soviet Union a French- or British-style villain.[64]

For Marxist scholars the Cold War and the East–West divide were less important than the issues of the global spread of capitalism and the conflicts between the 'First' and the 'Third' World.[65] Moreover, they construed the socialist part of Eastern Europe as a monolith entity, a claim which we obviously disagree with and which, in our view, betrays a colonial mindset.

Colonialism and other types of domination

It has to be emphasized that there are no pure colonialisms; colonialism always overlaps with other types of domination/subjugation, most importantly those related to class and gender. According to Rosa Luxemburg, the condition of expansion of capitalism is the existence of the spaces of non-capitalist forms of production:

> Since the beginning of the nineteenth century, accumulated capital from Europe has been exported along these lines to non-capitalist countries in other parts of the world, where it finds new customers and thus new opportunities for accumulation on the ruins of the native forms of production. Thus capitalism expands because of its mutual relationship with non-capitalist social strata and countries, accumulating at their expense and at the same time pushing them aside to take their place. The more capitalist countries participate in this hunting for accumulation areas, the rarer the non-capitalist places still open to the

expansion of capital become and the tougher the competition; its raids turn into a chain of economic and political catastrophes: world crises, wars, revolution.[66]

For Luxemburg, imperialism/colonialism is thus a form of class domination. This fact explains why colonization brought few, if any, benefits for the working classes of traditional empires, such as Britain and France. In Victorian times, as the works of Marx and Engels[67] and the novels of Dickens testify, British workers lived in utter misery and squalor, despite Britain possessing a vast empire. Similarly, the class dimension of colonialism explains the fact that the upper echelons of subjugated powers tended to collude with the foreign empires because colonialism worked in their favour.

A similar pattern can be detected in the history of Tsarist and Soviet Russia. Russia's expansion under Tsars, resulting, for example, in annexing a large part of Poland in the second half of the eighteenth century, did not ease the situation of its own serfs (*narod*). It could even be argued that the situation of Russian serfs was harsher than their Polish counterparts. The particularly despicable attitude of the Russian gentry towards their own people encouraged Alexander Etkind, one of the most original cultural historians of Russia, to borrow from colonial discourse to depict the plight of the Russian indigenous population.[68] What Etkind describes as 'internal colonization' or 'internal Orientalism',[69] for us is the case of asymmetry of power resulting from differences between Russia's upper class (gentry) and lower class (serfs).[70] Similarly, during the Soviet era, the expansion of the Russian empire at the expense of its numerous republics and satellite countries did not bring prosperity to its ordinary citizens. Furthermore, the higher living standards in some republics and satellite countries, such as East Germany and Poland, rendered those who relocated there second-class citizens in relation to the indigenous population. This fact was often conveyed by Russians living in ghettos of poorly constructed housing estates.[71] It should be also mentioned that colonialism might be accepted by the local political and economic elites as a means to

enforce or legitimize existing class relations. Such a situation was not uncommon in the Eastern Bloc where the presence of 'Big Brother' guaranteed the existence of numerous privileges of local *nomenklatura*. However, the fact that the effects of class domination can be felt more strongly than those of colonial domination does not invalidate the claim that they might exist at the same time.

Equally, colonial intervention tends to have a gender bias. It is argued that the British presence in India had a civilizing influence on the relations between sexes in this country by helping to eradicate such practices as sati (the burning of widowed women). Similarly, many believed that the Soviet impact on its sphere of colonial influence was beneficial for women. This is because communism, thanks to being rooted in Marxist ideology, championed equality between the sexes. In reality, the situation was more complex, with the new system bringing some advantages and disadvantages to women. For example, the advent of communism facilitated women's employment, including those with children, thanks to very cheap or indeed free provision of childcare. On the other hand, the career opportunities for women were limited; few women in the socialist bloc gained positions of power. As Irene Dölling notes, '[a] form of state socialist patriarchy retained control over women's lives by "caring for" them in a paternal way which excluded any autonomous women's activities and any belief that women were capable of making gains for themselves'.[72] Russian/communist colonialism affected the relations between the sexes in a given country and was itself coloured by the existing traditions and power relations between men and women.

The colonial situation of men and women has affected their postcolonial circumstances in a major way. Typically postcolonial power relations between men and women reflect their colonial positions. Hence, women, who tended to be disadvantaged under colonial rule, are still disadvantaged. Anne McClintock claims that

> The term 'post-colonialism' is prematurely celebratory and obfuscatory in more ways than one. The term becomes especially unstable with

respect to women. In a world where women do 2/3 of the world's work, earn 10% of the world's income, and own less than 1% of the world's property, the promise of 'post-colonialism' has been a history of hopes postponed. It has generally gone unremarked that the national bourgeoisies and kleptocracies that stepped into the shoes of 'post-colonial' 'progress,' and industrial 'modernization' have been overwhelmingly and violently male. No 'post-colonial' state anywhere has granted women and men equal access to the rights and resources of the nation state. Not only have the needs of 'post-colonial nations' been largely identified with male conflicts, male aspirations and male interests, but the very representation of 'national' power rests on prior constructions of gender power.[73]

Robert J.C. Young goes even further by saying: 'The global militarization of masculinity, and the feminization of poverty have thus ensured that women and men do not live "post-coloniality" in the same way, or share the same singular "post-colonial condition."'[74] In many countries, where women were subjected to 'socialist' colonization, we still observe the same imbalance of power. Moreover, a large proportion of women from the old Soviet Bloc lost their old privileges, such as the right to abortion and free or cheap childcare.[75]

Eastern Europeans and their neighbours

There are compelling reasons to link colonialism/postcolonialism in Eastern Europe with the concept of neighbourhood. The most important of them is our observation that this region, unlike, for example, North America or Africa, was colonized predominantly by its neighbours, rather than by faraway empires and peoples. This colonization was, as we already indicated and as will be argued in subsequent chapters, multi-layered. Ethnic groups and countries living in this area in different times colonized each other, as well as being colonized from outside, for example by Germans or Turks. Consequently, Thomas Elsaesser's notion of Europe's vast

borderlands having a constant double occupancy[76] is particularly relevant to this region.

In Eastern Europe one was always at risk of losing one's identity or even one's physical existence due to being taken over by a neighbour. This risk increased during and after World War II, when the region was first an arena of bloody conflict with one's neighbours and then moved into the orbit of one of them, the 'Big Neighbour' – Soviet Russia. Such a history, on the one hand, led to a high degree of distrust and even contempt or hatred towards one's neighbour, and a desire to construct one's identity in opposition to the neighbour. On the other hand, however, it ensured a high degree of ethnic and cultural hybridization, so that at times the inhabitants of parts of Eastern Europe became almost indistinguishable from their neighbours. The signs of such hybridization were mixed marriages and the fact that most of the population living in the border areas were bilingual or spoke a hybrid language. Hybridization manifested itself also in forging an identity separate from the countries and nations constituting the opposition colonizer/colonized. We argue that the existence of neighbours, ethnic minorities and border territories undermined the modernist homogenizing projects of both nation states and the Soviet Bloc, characteristic of the respective interwar and communist periods[77] and explains, to some extent, the changes in their composition after the fall of Communism, including the rise in nationalisms, leading to military conflicts, most importantly in some parts of the former Soviet Union and in former Yugoslavia.

Our research on communist and postcommunist neighbours thus confirms and develops the work of authors such as Homi Bhabha[78] and Stuart Hall,[79] which questions assumptions and the validity of pan-national homogenizing projects or, indeed, any projects attempting to fix identities of individuals and groups. In particular, it shows that the proximity of the neighbour, who often penetrates deep into the nation's body, and the presence of minorities, 'give the lie to its self-containedness'.[80] In a wider sense, it shows that the neighbours resist both total absorption and

othering; they always represent, to use Bhabha's phrase, a 'culture's in-between'.

Another reason why we focus on neighbours is the construction of Eastern Europe as one entity, as Western Europe's Other, the European Orient or demi-Orient to its Occident. According to Larry Wolff, such conceptualization of Eastern Europe appeared during the Enlightenment, when Europe's centres of culture and finance had shifted from the treasures and treasuries of Rome, Florence and Venice to the now more dynamically important cities of Paris, London and Amsterdam. The philosophers of the Enlightenment articulated and elaborated their own perspective on the continent, gazing from West to East, rather than from South to North. Wolff argues that the current Westerners and, in a large measure, Easterners, passively inherited this division and that it survived the fall of the Berlin Wall.[81] Several historians have since critiqued Wolff's ideas. One accusation has been that he projects 'Eastern Europe' into the period when it did not exist and uses it as a shorthand for Russia.[82] Another criticism is that Wolff bypasses the Orientalization of Eastern Europeans by each other,[83] which should modify Western stereotyping of Eastern Europe as a European Other. However, these objections do not invalidate his main argument that the image of Eastern Europe is constructed out of a hierarchical syncretism, where the West holds the position of civilizers and the East a place that must learn from its more educated 'neighbour'. The fact that Eastern Europe appears as a term in connection with the institutionalization of Eastern European Studies in the late nineteenth century, as shown by Ezequiel Adamovsky,[84] only confirms this systematic compartmental thinking of civilization. We will attempt to unmask this institutionalization by offering a comparative analysis of the neighbour that extends beyond an easy construction of East and West or Orientalism and Occidentalism.

The collection begins, so to speak, in the West of the East, with a chapter by Kristin Kopp. As its title suggests, '"If Your Car is Stolen, It will Soon be in Poland": Criminal Representations of Poland and the Poles in German Fictional Film of the 1990s', the

prevailing image of a Pole in German films made after the fall of the Berlin Wall is that of a criminal, parasitic on Poland's more affluent neighbour by stealing from it and threatening to dissolve (in the case of German males) his identity. Yet, Kopp argues that such representation updates prewar German colonial literature set in the Polish east, which represents Poland as a wild and dangerous land, desperately in need of German intervention. She points to the frequent putting together of East Germans with Poles as representatives of the East against Western Germans and notes that in the 2000s, following Poland's accession to European structures such as the EU, German depictions of Poland and the Poles shifted from the abject to the equal, becoming, in a sense, postcolonial, as opposed to just or neo-colonial.

In the following essay, Ewa Mazierska examines representations of Germans in Polish postcommunist cinema, focusing on four examples: *The Pianist* (2002) by Roman Polanski, *Róża* (2011) by Wojtek Smarzowski and *Dogs* (*Psy*, 1992) and *Reich* (2001) by Władysław Pasikowski, in the context of earlier cinematic representation of Poles and Polish–German history. She argues that these films move away from the centuries-old stereotype of a German as Polish archenemy, offering a more ambiguous and positive image of Poland's Western neighbours. Among them there is a noble German who suffers on a par with or even more than Poles and characters who are German–Polish hybrids. She sees these postcolonial portrayals of Poland's Western neighbours as a reflection of very good relations between Poles and Germans following the fall of the Berlin Wall. Mazierska also observes the frequent presence of Jews as mediators between Poles and Germans, reflecting the war and postwar history of both countries.

Petra Hanáková continues the exploration of Germans as neighbours, albeit in Czech cinema: *Divided We Fall* (*Musíme si pomáhat*, Jan Hřebejk, 2000), *Habermann's Mill* (*Habermannův mlýn*, Juraj Herz, 2010) and *Champions* (*Mistři*, Marek Najbrt, 2004). Her focus is on Sudeten Germans, who since the Middle Ages have been a continuous presence in Bohemia, constituting an important

influence on and sometimes a colonial threat to Czechs, until they were finally expelled from this territory after World War II. Hanáková sees in their metaphorical return in Czech postcommunist cinema a means to deal with their disappearance from Czech soil as an absence affecting Czech self-identity. She notes that Sudeten Germans in the aforementioned films come across as essentially innocuous small people, as victims of Czech persecution or as possessors of a distinct and noble history and hence identity that contemporary Czechs lack. Together, they spread the message of forgiveness and close collaboration between Czech and German neighbours. In common with Mazierska, Hanáková also observes the frequent presence of Jews as mediators between Slavic and Germanic neighbours, demonstrating that colonial relations tend to be complex and layered, usually involving more than one set of oppressors and victims.

Close neighbourhood might lead to accentuating one's difference from or accepting one's similarity to one's neighbour. A clear sign of the second situation is sharing myths and heroes. This is the case of Juraj Jánošík, the bandit-hero, compared to Robin Hood and an object of adulation for numerous generations of Poles, Czechs and Slovaks. Peter Hames examines Jánošík's cinematic trajectory, from Jaroslav Siakeľ's Slovak *Jánošík* (1921) to the postcommunist international co-production, *Jánošík. The True Story* (*Janosik. Prawdziwa historia/Jánošík. Pravdivá história*, 2009), directed by Agnieszka Holland and Kasia Adamik. Both the historical background to Jánošík's legend and the cultural appropriation of Jánošík by different ethnic groups and political regimes, which Hames discusses in detail, referring also to literature and visual art, perfectly demonstrate the layered character of colonialism and postcolonialism. Hames also invokes the concept of borderland as a space where 'our land' and 'other land' lose their distinct contours, giving way to a different type of space.

John Cunningham discusses the representation of Romanians in Hungarian postcommunist cinema against a detailed discussion of the history of the relations between these two nations and countries.

In particular, he shows how the imperial politics of Ottoman Turks, Austrians, Nazis, the Soviet Union and the realities of the Cold War, including the split of Romania from the Soviet Union, as well as the shifts in domestic politics of the two countries, affected the relations between Romanians and Hungarians. The case bears similarities to a Czech–German neighbourhood, as discussed by Hanáková, due to over one million ethnic Hungarians living within the borders of Romania, in the northern region of Transylvania. Yet, while the Germans were expelled from the Sudetenland, Hungarians remained a constant, if often unwelcome presence in Romania. Cunningham argues that in Hungarian postcommunist cinema Romania functions as an unnamed setting for grinding poverty and crime, and its inhabitants, many of them Gypsies, rarely diverge from the binary categories of victims and oppressors. That said, Cunningham also lists signs of growing cooperation between Hungarian and Romanian film industries, which suggests the possibility of a change in the images of these neighbours.

The next part of the collection concerns neighbours from the South. Elżbieta Ostrowska begins by examining the portrayal of the Balkans in two films by Władysław Pasikowski about the Yugoslav wars, *Dogs 2* (*Psy 2. Ostatnia krew*, 1994) and *Demons of War According to Goya* (*Demony wojny według Goi*, 1998). She argues that they point to a metaphorical downgrading of the Balkans in the Polish hierarchy of (ex)communist countries and peoples, from being regarded as a kind of 'aristocracy of the socialist world', to being the darkest corner of ex-communist Europe. Ostrowska is as interested in the specificity of the new discourse of the Balkans as (post)colonial discourse and in its effect on Polish self-perception or, more specifically, on the construction of the Polish male subject. In order to answer the question of how Poles and the inhabitants of ex-Yugoslavia are constructed, she compares Pasikowski's films with a number of Western films discussing the Yugoslav wars. This also leads her to assess the role of the media in constructing the 'us' and 'others' and, especially, in preserving a sense of one's superiority over one's neighbours.

While Ostrowska's chapter concerns the perceptions of non-Balkan nationals of the peoples living in the Balkans, Špela Zajec and Vlastimir Sudar discuss inter-Balkan relations as represented in post-Yugoslav genre cinema. Zajec considers a large number of recent Serbian films, concerning both present-day Serbia and its distant past in a broad historical context. She is especially interested in how the history of this period was mobilized to redefine the identities of different ethnic groups and justify the (in)famous hostility of Serbians to their neighbours during the Yugoslav wars. She pays particular attention to Serbs' self-perception as the defenders of the gate to Europe against Muslim 'barbarians' and what she describes as a 'narcissism of minor differences', namely a post-Yugoslav desire to assert its difference, not only in relation to a different ethnic group, but even inhabitants of the neighbouring village, and the risks of such an attitude.

Unlike Zajec, Vlastimir Sudar, drawing on the concepts of Levinas and Derrida, examines in depth only one film, the thriller *No One's Son* (*Ničiji sin*, 2008), directed by Croatian director Arsen Anton Ostojić as a both literal and metaphorical rendition of Yugoslavs' distrust of their internal and external neighbours. He argues that this distrust, conveyed by the term BRIGAMA, which is both an anagram of the names of the countries surrounding Yugoslavia and Serbo-Croat for 'worries' or 'problems', resulted from Yugoslavia's isolation in Europe during the communist period and its earlier (colonial) history. Sudar presents *No One's Son* as a story of multiple displacements: of houses, countries, histories and identities and an attempt to ridicule and counter what Zajec describes as 'narcissism of minor differences'. He also draws attention to the role of European institutions on the shifts in identities and hierarchies of South Slavs and their neighbours.

This part of the book finishes with Bruce Williams' take on arguably the most inaccessible country in Europe – Albania and its neighbours, as represented on-screen. He focuses on one film, *Kolonel Bunker* (1998), made by the leading Albanian director Kujtim Çashku, which is a Polish–Albanian co-production. The

film concerns the plight of women from the Eastern Bloc who had married Albanian men prior to Albania's period of isolationism and who were subsequently persecuted by the regime. In order to explain how and why the neighbours were screened in this film and, metaphorically speaking, in Albanian reality, Williams takes upon himself the task of unearthing the layers of Albania's history, which he reads as colonial history. Importantly, one such layer of colonialism is Albania's own totalitarian past. Although during this period the country was not colonized by external forces, he views the paranoia about security pertaining to the Hoxha regime, as a consequence of feeling threatened by practically the whole world. Williams regards the making of *Kolonel Bunker* as a sign that Albania and its cinema are entering a new, distinctly postcolonial period.

The last part of the collection concerns the ex–Soviet Union and its neighbours. It begins with Lars Kristensen's exploration of the Russian neighbour as depicted in Nikita Mikhalkov's *Urga* (1991). The chapter argues that the film anticipates concern over the position of Russians abroad before the actual fall of the Soviet Union, thus illuminating a subversion of Soviet hierarchy where Russians abroad, once the symbol of Soviet/Russian imperial power, have become disempowered and even pitiful. The film presents an encounter of a Russian truck driver Sergei with a Mongolian man, Gombo and his family, who live in Northern China. Their meeting leads to a friendship, and hence to a relationship which overcomes the old sense of inequality. Discussing *Urga*'s textual features, as well as the circumstances of its production and reception, Kristensen argues that it attempts to project a hybridized identity, namely neither Chinese nor Mongolian, nor completely Russian.

Finally, Eva Näripea examines representations of Russians in Estonian cinema against the background of the cohabitation of Russians and Estonians on Estonian soil. She pays special attention to the films made in the last years of the existence of the Soviet Union: Leida Laius's *Stolen Meeting* (*Varastatud kohtumine*, 1988) and Arvo Iho's *The Birdwatcher* (*Vaatleja*, 1987) and *The Sister of Mercy* (*Halastajaõde – Ainult hulludele*, 1990). Although in Soviet Estonia

the Russians were given the role of the colonizers, Näripea argues that in these films their situation is more ambiguous as both sides come across as victims of colonialism. Moreover, she discusses how oppressions which are the effects of colonialism overlap with other types of marginalization, especially those pertaining to gender, by focusing on female characters. Equally, she draws attention to the bonds of solidarity between the underprivileged, which cut across colonial divisions, allowing for the creation of a new, metaphorical and real postcolonial space, where minority discourse is articulated and heard.

Although in this introduction and our description of specific chapters we use terms such as Polish, German, Czech or Albanian cinema, on many occasions it should be read as shorthand for describing international co-productions, typically between neighbours represented on-screen. Such films constitute more than half of the films discussed by the authors. Equally, as many of the authors of the chapters point out, these films often have a transnational life, being shown at international festivals and often gaining more recognition beyond their 'natural borders'. Some, like *The Pianist* and *Divided We Fall*, even became global hits, almost standing for the new, united, border-free Europe. However, the opposite phenomenon can be observed: films about us and our neighbours hang in a transnational no man's land, being neglected by both sets of its potential viewers. As we mentioned, colonialism overlaps with other types of submission, most importantly those pertaining to gender and class. Accordingly, the majority of authors pay special attention to the interstice between gender and colonialism. Equally, they draw attention to the fact that colonial relations are experienced differently by those at the bottom of the pile than by those who are rich.

While all the chapters are written within the framework of screening neighbours, the contributions exhibit various degrees of implementing postcolonial theory. Some authors were reluctant to use postcolonialism at the beginning, as if to confirm Moore's opinion that researchers of Eastern Europe tend to be hostile to

this concept, but all demonstrated flexibility to our suggestions. In the end we decided to embrace the different approaches, not least because we believe that using postcolonial theory is not so much about drawing on its vocabulary as seeing the connections between one's position in the world and one's history.

Notes

1 Eva Näripea and Andreas Trossek (eds.), *Via Transversa: Lost Cinema of the Former Eastern Bloc* (Tallinn: Eesti Kunstiakadeemia, 2008); Ewa Mazierska, 'Eastern European Cinema: Old and New Approaches', *Studies in Eastern European Cinema* 1:1 (2010), pp. 5–16; Lars Kristensen (ed.), *Postcommunist Film – Russia, Eastern Europe and World Culture* (London and New York: Routledge, 2012).

2 Charles Taylor, 'The Politics of Recognition', in Amy Gutman (ed.), *Multiculturalism: Examining the Politics of Recognition* (Princeton, NJ: Princeton University Press, 1994), pp. 25–73.

3 e.g. Bill Ashcroft, Gareth Griffiths and Helen Tiffin, *Post-Colonial Studies: The Key Concepts*, 2nd edn (London and New York: Routledge, 2007), p. 40.

4 Ania Loomba, *Colonialism/Postcolonialism* (London and New York: Routledge, 1998).

5 Jaak Kangilaski, 'Lisandusi postkolonialismi diskussioonile/Additions to the Discussion of Post-colonialism', *Kunstiteaduslikke Uurimusi / Studies on Art and Architecture* 20:1–2 (2011), pp. 7–25.

6 Jürgen Osterhammel, *Kolonialismus: Geschichte – Formen – Folgen* (Munich: Beck, 2009), pp. 19ff.

7 Kangilaski, 'Lisandusi postkolonialismi diskussioonile', p. 10.

8 Robert J.C. Young, *Postcolonialism: An Historical Introduction* (Malden, MA and Oxford: Blackwell, 2001), p. 2.

9 Young, *Postcolonialism*, p. 20.

10 Young, *Postcolonialism*, p. 23.

11 Young, *Postcolonialism*, p. 23.

12 Loomba, *Colonialism/Postcolonialism*, p. 3; see also Rosa Luxemburg and Nikolai Bukharin, *Imperialism and the Accumulation of Capital*, trans. Rudolf

Wichmann (London: Allen Lane, 1972); Karl Marx, *Capital: A Critical Analysis of Capitalist Production* [1887], vol. 1, trans. Samuel Moore and Edward Aveling (Moscow: Progress Publishers, 1965), pp. 713–74; David Harvey, *The New Imperialism* (Oxford: Oxford University Press, 2003).

13 e.g. Edward Said, *Culture and Imperialism* (London: Chatto & Windus, 1993).

14 Anne McClintock, 'The Angel of Progress: Pitfalls of the Term "Post-Colonialism"', *Social Text* 31–32 (1992), pp. 84–98.

15 David Harvey, *The New Imperialism* (Oxford: Oxford University Press, 2003).

16 Harvey, *The New Imperialism*, pp. 3–7.

17 Loomba, *Colonialism/Postcolonialism*, p. 20; see also Nancy Condee, *The Imperial Trace: Recent Russian Cinema* (Oxford and New York: Oxford University Press, 2009), p. 26.

18 Miroslav Hroch, '"Uus rahvuslus" ja selle ajalooline taust. Vanade ja uute rahvuslike liikumiste võrdlus', *Vikerkaar* 10–11 (2005), p. 88.

19 Stephen Collier et al., 'Empire, Union, Center, Satellite: A Questionnaire', *Ulbandus* 7 (2003), p. 7.

20 Yuri Slezkine, 'The USSR as a Communal Apartment, or How a Socialist State Promoted Ethnic Particularism', *Slavic Review* 53:2 (1994), pp. 414–52.

21 Epp Annus, 'The Problem of Soviet Colonialism in the Baltics', *Journal of Baltic Studies* (2011), DOI:10.1080/01629778.2011.628551. Online. Available at <http://dx.doi.org/10.1080/01629778.2011.628551> (accessed 5 February 2012), pp. 17–18.

22 David Chioni Moore, 'Is the Post- in Postcolonial the Post- in Post-Soviet? Toward a Global Postcolonial Critique', *PMLA* 116:1 (2001), p. 121.

23 Valerie Bunce, *Subversive Institutions: The Design and the Destruction of Socialism and the State* (Cambridge: Cambridge University Press, 1999), p. 32.

24 Sulev Vahtre (ed.), *Eesti ajalugu VI. Vabadussõjast iseseisvumiseni* (Tartu: Ilmamaa, 2005), p. 274.

25 See e.g. Andres Kasekamp, *A History of the Baltic States* (Basingstoke and New York: Palgrave Macmillan, 2010), p. 155.

26 Tony Judt, *Postwar: A History of Europe since 1945* (London: Pimlico, 2007), p. 328.

27 Stephen F. Cohen, *Rethinking the Soviet Experience: Politics and History since 1917* (Oxford: Oxford University Press, 1985); Bunce, *Subversive Institutions*, p. 24.

28 Bunce, *Subversive Institutions*, p. 21.

29 In fact, Andres Kasekamp argues that '[u]nlike the Russification implemented later by the Soviet regime, Tsarist policy [in the late-nineteenth century] did not entail colonization. Certainly, there was the presence in the Baltic region of Russians involved in the Imperial bureaucracy and military, as well as growing numbers of Russian industrial workers. However, this was not comparable to the massive influx during the Soviet period' (Kasekamp, *A History of the Baltic States*, p. 87).

30 Eric Hobsbawm, *Age of Extremes: The Short Twentieth Century 1914–1991* (London: Abacus, 1994), p. 259.

31 Lech Wałęsa says it in an anthology film, *Solidarity, Solidarity ... (Solidarność, Solidarność ...,* 2005), in the part directed by Andrzej Wajda.

32 Moore, 'Is the Post- in Postcolonial the Post- in Post-Soviet?', p. 121.

33 Nathaniel Knight, 'Was Russia Its Own Orient? Reflections on the Contributions of Etkind and Schimmelpenninck to the Debate on Orientalism', *Ab Imperio* 1 (2002), p. 300.

34 Kangilaski, 'Lisandusi postkolonialismi diskussioonile', pp. 23–4.

35 Kangilaski, 'Lisandusi postkolonialismi diskussioonile', pp. 23–4.

36 Loomba, *Colonialism/Postcolonialism*, p. 2.

37 Harvey, *The New Imperialism*, p. 5.

38 Petra Hanáková, '"The Films We are Ashamed of": Czech Crazy Comedy of the 1970s and 1980s', in Eva Näripea and Andreas Trossek (eds.), *Via Transversa: Lost Cinema of the Former Eastern Bloc* (Tallinn: Eesti Kunstiakadeemia, 2008), pp. 111–21; Ewa Mazierska, 'Postcommunist Estonian Cinema as Transnational Cinema', *Kinokultura*, Special Issue 10 (2010). Online. Available at <http://www.kinokultura.com/specials/10/mazierska.shtml> (accessed 5 February 2012).

39 Anthony Giddens, *The Consequences of Modernity* (Cambridge: Polity Press, 1990), pp. 51–3; John Tomlinson, 'Cultural Globalisation: Placing

and Displacing the West', in Hugh Mackay and Tim O'Sullivan (eds.), *The Media Reader: Continuity and Transformation* (London: Sage, 1999), pp. 165–77.

40 Condee, *The Imperial Trace*, p. 17.

41 John R. Lampe, *Yugoslavia as History: Twice there was a Country* (Cambridge: Cambridge University Press, 1996); John B. Allcock, *Explaining Yugoslavia* (London: Hurst & Company, 2000).

42 Miranda Vickers, *The Albanians: A Modern History* (London: I.B.Tauris, 1995), pp. 82–97.

43 Vickers, *The Albanians*, pp. 185–209; on anti-modernism see Stjepan Meštrović, *The Balkanization of the West* (London and New York: Routledge, 1994), p. 4.

44 Piret Peiker, 'Ida-Euroopa kirjandus postkoloniaalsest vaatenurgast', *Vikerkaar* 10–11 (2005), p. 143; Tiina Kirss, 'Gayatri Chakravorty Spivak: feminism ja postkolonialismi looklev rada', *Vikerkaar* 4–5 (2003), p. 142.

45 Ashcroft, Griffiths and Tiffin: *Post-Colonial Studies*, p. 168.

46 Kangilaski, 'Lisandusi postkolonialismi diskussioonile', p. 23.

47 Peiker, 'Ida-Euroopa kirjandus postkoloniaalsest vaatenurgast', pp. 143–44.

48 Loomba, *Colonialism/Postcolonialism*, p. 12.

49 McClintock, 'The Angel of Progress', p. 86.

50 Harvey, *The New Imperialism*, especially pp. 118–19.

51 See Ella Shohat, 'Notes on the "Post-Colonial"', *Social Text* 31–32 (1992), pp. 99–113; McClintock, 'The Angel of Progress'.

52 Shohat, 'Notes on the "Post-Colonial"', p. 103; see also Stuart Hall, 'When Was "the Post-Colonial"? Thinking at the Limit', in Iain Chambers and Lidia Curti (eds.), *The Post-Colonial Question: Common Skies, Divided Horizons* (London: Routledge, 1996), pp. 242–60.

53 McClintock, 'The Angel of Progress', pp. 86, 92.

54 See e.g. Aleksander Fiut, 'In the Shadow of Empires. Postcolonialism in Central and Eastern Europe – Why Not?', *Postcolonial Europe* (n.d.). Online. Available at <http://www.postcolonial-europe.eu/index.php/en/essays/58--in-the-shadow-of-empires-> (accessed 1 November 2011); Paul Cooke, *Representing East Germany since Unification: From Colonization to Nostalgia* (Oxford: Berg, 2005).

55 Janusz Korek, 'Central and Eastern Europe from a Postcolonial Per-
 spective', *Postcolonial Europe* (n.d.). Online. Available at <http://www.
 postcolonial-europe.eu/index.php/en/essays/60--central-and-eastern-
 europe-from-a-postcolonial-perspective> (accessed 1 November 2011).

56 Robert Stam, *Film Theory: An Introduction* (Oxford: Blackwell, 2000),
 p. 295.

57 Gerd Gemünden, 'Nostalgia for the Nation: Intellectuals and National
 Identity in Unified Germany', in Mieke Bal, Jonathan Crewe and Leo
 Spitzer (eds.), *Acts of Memory: Cultural Recall in the Present* (Hanover,
 NH: University Press of New England, 1999), pp. 121–33, p. 124;
 Cooke: *Representing East Germany since Unification.*

58 Loomba, *Colonialism/Postcolonialism*, p. 16.

59 Collier et al., 'Empire, Union, Centre, Satellite', pp. 15–16.

60 E.g. Loomba, *Colonialism/Postcolonialism*, p. 19.

61 Moore, 'Is the Post- in Postcolonial the Post- in Post-Soviet?', p. 117;
 see also Violeta Kelertas (ed.), *Baltic Postcolonialism* (Amsterdam and
 New York: Rodopi, 2006), p. 4.

62 E.g. Kelertas, *Baltic Postcolonialism*; Tiina Kirss, 'Rändavad piirid:
 postkolonialismi võimalused', *Keel ja Kirjandus* 10 (2001), pp. 673–82
 and 'Gayatri Chakravorty Spivak'; Epp Annus, 'Postkolonialismist
 sotskolonialismini', *Vikerkaar* 3 (2007), pp. 64–7 and 'The Problem of
 Soviet Colonialism in the Baltics'; Kangilaski, 'Lisandusi postkolonialismi
 diskussioonile'; Peiker, 'Ida-Euroopa kirjandus postkoloniaalsest
 vaatenurgast'.

63 Kangilaski, 'Lisandusi postkolonialismi diskussioonile', p. 16.

64 Moore, 'Is the Post- in Postcolonial the Post- in Post-Soviet?', p.
 117; see also Korek, 'Central and Eastern Europe from a Postcolonial
 Perspective'.

65 Kirss, 'Rändavad piirid: postkolonialismi võimalused', p. 679.

66 Luxemburg and Bukharin: *Imperialism and the Accumulation of Capital*,
 pp. 59–60.

67 Marx, *Capital*; Friedrich Engels, *The Condition of the Working Class in
 England* [1845] (London: Penguin, 2009).

68 Alexander Etkind, *Internal Colonization: Russia's Imperial Experience*
 (Cambridge: Polity Press, 2011), p. 2.

69 Collier et al., 'Empire, Union, Centre, Satellite', p. 18.

70 Such relation can be compared to the relationship between, for example, British masters and colonial people in places like India. It was suggested, however, that the Russian self-image of being victims of internal colonization is a strategy of glossing over actual and brutal colonization and oppression (Kelertas, *Baltic Postcolonialism*, p. 7) of other ethnic groups. Our position is that what Etkind calls 'internal colonization' of Russia, however brutal it was, should not undermine the claim that the Tsarist Russia and its successor, Soviet Russia, embarked also on the colonization in a more traditional sense of the word, seeking to subjugate other nations.

71 This phenomenon is shown in a recent Polish film *Mała Moskwa* (*Little Moscow*, Jerzy Krzystek, 2008).

72 Dölling, quoted in Chris Corrin, 'Introduction', in Chris Corrin (ed.), *Superwoman and the Double Burden: Women's Experience of Change in Central and Eastern Europe and the Former Soviet Union* (London: Scarlett Press, 1992), p. 19.

73 McClintock, 'The Angel of Progress', p. 92; on postcolonialism and the oppression of women from the Third World see also Barbara Ehrenreich and Arlie Russell Hochschield (eds.), *Global Woman: Nannies, Maids and Sex Workers in the New Economy* (London: Granta, 2003).

74 Young, *Postcolonialism*, pp. 9–10.

75 See, for example, Małgorzata Fuszara, 'Abortion and the Formation of the Public Sphere in Poland', in Nanette Funk and Magda Mueller (eds.), *Gender Politics and Post-Communism* (London: Routledge, 1993), pp. 241–52; Susan Gal and Gail Kligman (eds.), *Reproducing Gender: Politics, Publics, and Everyday Life after Socialism* (Princeton, NJ: Princeton University Press, 2000).

76 Thomas Elsaesser, 'Space, Place and Identity in European Cinema of the 1990s', *Third Text* 20:6 (2006), pp. 647–58.

77 Alan Dingsdale, *Mapping Modernities: Geographies of Central and Eastern Europe, 1920–2000* (London: Routledge, 2002).

78 Homi K. Bhabha, 'Culture's In-Between', in Stuart Hall and Paul du Gay (eds.), *Questions of Cultural Identity* (London: Sage, 1996), pp. 53–60.

79 Stuart Hall, 'The Question of Cultural Identity', in Stuart Hall, Tony McGrew and David Held (eds.), *Modernity and Its Futures* (Cambridge: Polity Press, 1992), pp. 273–325.

80 Bhabha, 'Culture's In-Between', p. 57.

81 Larry Wolff, *Inventing Eastern Europe: The Map of Civilization on the Mind of the Enlightenment* (Stanford, CA: Stanford University Press, 1996), pp. 1–7; on Western perceptions of Eastern Europe see also Dingsdale: *Mapping Modernities*, pp. 123–4.

82 Michael Confino, 'Re-inventing Enlightenment: Western Images of Eastern Realities in the Eighteenth Century', *Canadian Slavonic Papers* 36:3–4 (1994), pp. 510–11.

83 Csaba Dupcsik, 'Postcolonial Studies and the Inventing of Eastern Europe', *East Central Europe* 26:1 (1999), pp. 1–14; Alex Drace-Francis, 'A Provincial Imperialist and a Curious Account of Wallachia: Ignaz von Born', *European History Quarterly* 36:1 (2006), pp. 61–89.

84 Ezequiel Adamovsky, 'Euro-Orientalism and the Making of the Concept Eastern Europe in France, 1810–1880', *Journal of Modern History* 77:3 (2005), pp. 591–628.

References

Adamovsky, Ezequiel, 'Euro-Orientalism and the Making of the Concept Eastern Europe in France, 1810–1880', *Journal of Modern History* 77:3 (2005), pp. 591–628.

Allcock, John B., *Explaining Yugoslavia* (London: Hurst & Company, 2000).

Annus, Epp, 'Postkolonialismist sotskolonialismini', *Vikerkaar* 3 (2007), pp. 64–76.

Annus, Epp, 'The Problem of Soviet Colonialism in the Baltics', *Journal of Baltic Studies* (2011), DOI:10.1080/01629778.2011.628551. Online. Available at <http://dx.doi.org/10.1080/01629778.2011.628551> (accessed 5 February 2012).

Ashcroft, Bill, Griffiths, Gareth and Tiffin, Helen, *Post-Colonial Studies: The Key Concepts*, 2nd edn (London and New York: Routledge, 2007).

Bhabha, Homi K., 'Culture's In-Between', in Stuart Hall and Paul du Gay (eds.), *Questions of Cultural Identity* (London: Sage, 1996), pp. 53–60.

Bunce, Valerie, *Subversive Institutions: The Design and the Destruction of Socialism and the State* (Cambridge: Cambridge University Press, 1999).

Cohen, Stephen F., *Rethinking the Soviet Experience: Politics and History since 1917* (Oxford: Oxford University Press, 1985).

Collier, Stephen et al., 'Empire, Union, Center, Satellite: A Questionnaire', *Ulbandus* 7 (2003), pp. 5–25.

Condee, Nancy, *The Imperial Trace: Recent Russian Cinema* (Oxford and New York: Oxford University Press, 2009).

Confino, Michael, 'Re-inventing Enlightenment: Western Images of Eastern Realities in the Eighteenth Century', *Canadian Slavonic Papers* 36:3–4 (1994), pp. 505–22.

Cooke, Paul, *Representing East Germany since Unification: From Colonization to Nostalgia* (Oxford: Berg, 2005).

Corrin, Chris, 'Introduction', in Chris Corrin (ed.), *Superwoman and the Double Burden: Women's Experience of Change in Central and Eastern Europe and the Former Soviet Union* (London: Scarlett Press, 1992), pp. 1–26.

Dingsdale, Alan, *Mapping Modernities: Geographies of Central and Eastern Europe, 1920–2000* (London: Routledge, 2002).

Drace-Francis, Alex, 'A Provincial Imperialist and a Curious Account of Wallachia: Ignaz von Born', *European History Quarterly* 36:1 (2006), pp. 61–89.

Dupcsik, Csaba, 'Postcolonial Studies and the Inventing of Eastern Europe', *East Central Europe* 26:1 (1999), pp. 1–14.

Ehrenreich, Barbara and Hochschield, Arlie Russell (eds.), *Global Woman: Nannies, Maids and Sex Workers in the New Economy* (London: Granta, 2003).

Elsaesser, Thomas, 'Space, Place and Identity in European Cinema of the 1990s', *Third Text* 20:6 (2006), pp. 647–58.

Engels, Friedrich, *The Condition of the Working Class in England* [1845] (London: Penguin, 2009).

Etkind, Alexander, *Internal Colonization: Russia's Imperial Experience* (Cambridge: Polity Press, 2011).

Fiut, Aleksander, 'In the Shadow of Empires. Postcolonialism in Central and Eastern Europe – Why Not?', *Postcolonial Europe* (n.d.). Online.

Available at <http://www.postcolonial-europe.eu/index.php/en/essays/58--in-the-shadow-of-empires-> (accessed 1 November 2011).

Fuszara, Małgorzata, 'Abortion and the Formation of the Public Sphere in Poland', in Nanette Funk and Magda Mueller (eds.), *Gender Politics and Post-Communism* (London: Routledge, 1993), pp. 241–52.

Gal, Susan and Kligman, Gail (eds.), *Reproducing Gender: Politics, Publics, and Everyday Life after Socialism* (Princeton, NJ: Princeton University Press, 2000).

Gemünden, Gerd, 'Nostalgia for the Nation: Intellectuals and National Identity in Unified Germany', in Mieke Bal, Jonathan Crewe and Leo Spitzer (eds.), *Acts of Memory: Cultural Recall in the Present* (Hanover, NH: University Press of New England, 1999), pp. 121–33.

Giddens, Anthony, *The Consequences of Modernity* (Cambridge: Polity Press, 1990).

Hall, Stuart, 'The Question of Cultural Identity', in Stuart Hall, Tony McGrew and David Held (eds.), *Modernity and Its Futures* (Cambridge: Polity Press, 1992), pp. 273–325.

Hall, Stuart, 'When Was "the Post-Colonial"? Thinking at the Limit', in Iain Chambers and Lidia Curti (eds.), *The Post-Colonial Question: Common Skies, Divided Horizons* (London: Routledge, 1996), pp. 242–60.

Hanáková, Petra, '"The Films We are Ashamed of": Czech Crazy Comedy of the 1970s and 1980s', in Eva Näripea and Andreas Trossek (eds.), *Via Transversa: Lost Cinema of the Former Eastern Bloc* (Tallinn: Eesti Kunstiakadeemia, 2008), pp. 111–21.

Harvey, David, *The New Imperialism* (Oxford: Oxford University Press, 2003).

Harvey, David, *A Brief History of Neoliberalism* (Oxford: Oxford University Press, 2005).

Hobsbawm, Eric, *Age of Extremes: The Short Twentieth Century 1914–1991* (London: Abacus, 1994).

Hroch, Miroslav, '"Uus rahvuslus" ja selle ajalooline taust. Vanade ja uute rahvuslike liikumiste võrdlus', *Vikerkaar* 10–11 (2005), pp. 85–96.

Judt, Tony, *Postwar: A History of Europe since 1945* (London: Pimlico, 2007).

Kangilaski, Jaak, 'Lisandusi postkolonialismi diskussioonile/Additions to the Discussion of Post-Colonialism', *Kunstiteaduslikke Uurimusi / Studies on Art and Architecture* 20:1–2 (2011), pp. 7–25.

Kasekamp, Andres, *A History of the Baltic States* (Basingstoke and New York: Palgrave Macmillan, 2010).

Kelertas, Violeta (ed.), *Baltic Postcolonialism* (Amsterdam and New York: Rodopi, 2006).

Kirss, Tiina, 'Rändavad piirid: postkolonialismi võimalused', *Keel ja Kirjandus* 10 (2001), pp. 673–82.

Kirss, Tiina, 'Gayatri Chakravorty Spivak: feminism ja postkolonialismi looklev rada', *Vikerkaar* 4–5 (2003), pp. 142–51.

Knight, Nathaniel, 'Was Russia Its Own Orient? Reflections on the Contributions of Etkind and Schimmelpenninck to the Debate on Orientalism', *Ab Imperio* 1 (2002), pp. 299–310.

Korek, Janusz, 'Central and Eastern Europe from a Postcolonial Perspective', *Postcolonial Europe* (n.d.). Online. Available at <http://www.postcolonial-europe.eu/index.php/en/essays/60--central-and-eastern-europe-from-a-postcolonial-perspective > (accessed 1 November 2011).

Kristensen, Lars (ed.), *Postcommunist Film – Russia, Eastern Europe and World Culture* (London and New York: Routledge, 2012).

Lampe, John R., *Yugoslavia as History: Twice there was a Country* (Cambridge: Cambridge University Press, 1996).

Loomba, Ania, *Colonialism/Postcolonialism* (London and New York: Routledge, 1998).

Luxemburg, Rosa and Bukharin, Nikolai, *Imperialism and the Accumulation of Capital*, trans. Rudolf Wichmann (London: Allen Lane, 1972).

Marx, Karl, *Capital: A Critical Analysis of Capitalist Production* [1887], vol. 1, trans. Samuel Moore and Edward Aveling (Moscow: Progress Publishers, 1965).

Mazierska, Ewa, 'Eastern European Cinema: Old and New Approaches', *Studies in Eastern European Cinema* 1:1 (2010), pp. 5–16.

Mazierska, Ewa, 'Postcommunist Estonian Cinema as Transnational Cinema', *Kinokultura*, Special Issue 10 (2010). Online. Available at <http://www.kinokultura.com/specials/10/mazierska.shtml> (accessed 5 February 2012).

McClintock, Anne, 'The Angel of Progress: Pitfalls of the Term "Post-Colonialism"', *Social Text* 31–32 (1992), pp. 84–98.

Meštrović, Stjepan, *The Balkanization of the West* (London and New York: Routledge, 1994).

Moore, David Chioni, 'Is the Post- in Postcolonial the Post- in Post-Soviet? Toward a Global Postcolonial Critique', *PMLA* 116:1 (2001), pp. 111–28.

Näripea, Eva and Trossek, Andreas (eds.), *Via Transversa: Lost Cinema of the Former Eastern Bloc* (Tallinn: Eesti Kunstiakadeemia, 2008).

Osterhammel, Jürgen, *Kolonialismus: Geschichte – Formen – Folgen* (Munich: Beck, 2009).

Peiker, Piret, 'Ida-Euroopa kirjandus postkoloniaalsest vaatenurgast', *Vikerkaar* 10–11 (2005), pp. 142–51.

Said, Edward, *Culture and Imperialism* (London: Chatto & Windus, 1993).

Shohat, Ella, 'Notes on the "Post-Colonial"', *Social Text* 31–32 (1992), pp. 99–113.

Slezkine, Yuri, 'The USSR as a Communal Apartment, or How a Socialist State Promoted Ethnic Particularism', *Slavic Review* 53:2 (1994), pp. 414–52.

Stam, Robert, *Film Theory: An Introduction* (Oxford: Blackwell, 2000).

Taylor, Charles, 'The Politics of Recognition', in Amy Gutman (ed.), *Multiculturalism: Examining the Politics of Recognition* (Princeton, NJ: Princeton University Press, 1994), pp. 25–73.

Tomlinson, John, 'Cultural Globalisation: Placing and Displacing the West', in Hugh Mackay and Tim O'Sullivan (eds.), *The Media Reader: Continuity and Transformation* (London: Sage, 1999), pp. 165–77.

Vahtre, Sulev (ed.), *Eesti ajalugu VI. Vabadussõjast iseseisvumiseni* (Tartu: Ilmamaa, 2005).

Vickers, Miranda, *The Albanians: A Modern History* (London: I.B.Tauris, 1995).

Wolff, Larry, *Inventing Eastern Europe: The Map of Civilization on the Mind of the Enlightenment* (Stanford, CA: Stanford University Press, 1996).

Young, Robert J.C., *Postcolonialism: An Historical Introduction* (Malden, MA and Oxford: Blackwell, 2001).

1

'If Your Car Is Stolen, It Will Soon Be in Poland': Criminal Representations of Poland and the Poles in German Fictional Film of the 1990s

Kristin Kopp

At the end of the first decade of German unification, two popular films were released that both employed the trope of criminally abject Polish borderlands to frame their narratives; the male protagonists in both films become involved with Polish car-theft rings, and their ensuing blunders provide the film's structuring conflicts. In Tom Tykwer's frenetically paced *Run Lola Run* (*Lola rennt*, 1998), Manni calls his girlfriend, Lola, to tell her that he has lost the bag of money he earned after smuggling a car into Poland and that he only has 20 minutes to recover the cash before his meeting with the local mafia lord. Fuelled by a techno soundtrack, Lola runs through the streets of a newly unified Berlin trying to figure out a way to get her hands on 100,000 marks to save Manni.

It has been noted that Lola's path through Berlin does not trace a linear route, but instead splices together segments filmed in

various locations in both East and West Berlin; Lola's zigzag run stitches the two halves of the city together into one conceptual whole,[1] a unification that reinforces the image with which the film cuts from its philosophical prologue to its narrative sequence: as if seen from high above, the eastern and western halves of a satellite picture of Berlin slam together into a topographic whole; Berlin united. Not to be overlooked are the ways in which this spatial construction serves as an allegory for the unification of the nation as well as that of the city – the map could just as easily have shown two halves of the nation being instantaneously joined, the whole set of social, political and economic ramifications reduced to the temporary aftershocks of the collision that briefly shakes the image. The city/nation that emerges is thoroughly homogenized and conceptually framed by the border to Poland. The former East and West of Berlin are now visually indistinguishable, and even the largely immigrant neighbourhood of Kreuzberg is presented devoid of Turkish pedestrians. The streets through which Lola runs thus all appear equally 'German', and East and West Berlin appear as a successfully unified whole positioned in opposition to the criminal Polish space with which Manni has come into contact.

Released two years later, Vanessa Joop's *Forget America* (*Vergiß Amerika*, 2000) suggests a much less confident mental map of the unified nation. Benno and David live in the East German town of Aschleben, and struggle to make their way into adulthood in a region blighted by unemployment and a disintegrated civil society. The film locates this post-Wall East German landscape in the middle of a conceptual East–West trajectory: one end is marked by the 'American Dream' alluded to in the film's title – the dream that hard work in the pursuit of a visionary goal can lead to economic success and perhaps even an exciting life spent conquering new frontiers. Benno strives to realize this dream by setting up a used car dealership specializing in old American cars. In scenes of him working long hours fixing up cars, or driving old convertibles across vast, open plains, the viewer gains the sense that, if Benno had been located in the right time and place, he might have been successful

with his venture. But no one in Aschleben is able to buy his cars, and Benno thus falls into debt – and into a dangerous relationship with the Polish mafia that offers him help.

If the 'American Dream' represents a utopian fantasy linked to the West, its opposite is a dystopian nightmare that threatens from the East, and that is much closer and more palpable in Aschleben than the distant dreams of Western economic success. The Polish mafia, not the Western market, is on the scene in Aschleben, and its agents make ever-greater demands. Benno becomes increasingly desperate, violent and erratic in his behaviour, but by the time he admits to himself that he has become involved in a situation that he cannot control, it is already too late. Benno attempts to extricate himself from his underworld connections, but there is no escape from this devil's pact: when he drives what he believes to be his last car shipment to Poland, he discovers that the mafia has cut the brake cables on his American car, and he drives over a cliff to his death. Striving for the American dream, the East German instead meets with demise in Polish hands.

In both Tykwer's optimistic cartography and Joop's pessimistic vision of German unification, Poland plays a necessary role as the site of the other against which the German nation's unification is enacted and its success measured. In German filmic narratives of the 1990s, the German–Polish border is the source of impending threat that is either successfully staved off by a successfully united and internally homogenized Germany (in *Run Lola Run*), or that seeps into East German space, exploiting its economically and socially weakened condition (in *Forget America*). In both cases, the trope of Polish criminality dominates representations of Poland and the Poles in the German cinema of the 1990s. Both Michael Klier's *Eastern Crossing* (*Ostkreuz*, 1991) and Helke Misselwitz's *Little Angel* (*Engelchen*, 1996) feature Polish swindlers in Berlin who seduce economically vulnerable East German woman into their criminal underworlds, while in Kaspar Heidelbach's 1993 thriller, *Polski Crash*, and Oskar Roehler's 1997 *In with the New* (*Silvester Countdown*), Germans travelling into Polish space become

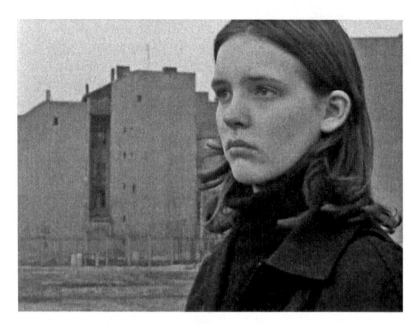

Figure 1.1
Elfie (Laura Tonke) lives trapped in a no man's land of abandoned
buildings, weeds, and rubble on the outskirts of East Berlin.
Ostkreuz (*Eastern Crossing*, 1991, dir. Michael Klier)

the victims of violent crime, usually involving powerful mafia
organizations.

One might argue that the depiction of Polish criminality in the
1990s was merely a reflection of real concerns at a time when news
of Polish border smuggling and car theft was ubiquitous in the
German press media. Yet such an argument misses the way in which
narratives of Polish crime served to construct the German national
victim of this crime wave as well as the relationship between this
German subject and an abject Polish other. In order to recognize
the conceptual structure underlying these constructions, one must
understand the discursive legacy out of which it arose.

'Postcolonialism' in the German–Polish context

In the German–Polish context, 'postcolonialism' has a specific logic not necessarily shared by other neighbouring relationships in Central and Eastern Europe – a logic derived from the development of a German construction of Poland as colonial space in the second half of the nineteenth century.[2] Over the course of the following several decades and into World War II, German political interventions in ethnically Polish space were fuelled and informed by this colonial discourse.

Germans had migrated eastward since the medieval period and Prussia had extended its border deep into ethnic Polish space during the Polish Partitions of the late eighteenth century. It was, however, only in the context of German nation-building in the nineteenth century that this history of migration and expansion came to be reassessed and rearticulated through a colonial idiom. This discursive shift can already be seen during the 1848 revolution, when Germans saw a window of opportunity in which to establish their long-envisioned unified nation state, but needed to determine exactly where the borders of this new country would lie. During the famous 'Poland Debate', the question of whether to include the predominantly Polish ethnic regions of Prussia was hotly contested.[3] Assertions that the Poles had a right to establish their own independent state gradually gave way to arguments claiming that their inherent inferiority negated such a right. The Poles, according to their detractors, were comparable to overseas colonial subjects: unable to manage their own affairs due to their essentially backward, childlike and morally degenerate nature. The German desire to maintain control over this space was thus justified through an appeal to that later referenced as the 'white man's burden' – a logic provided in narrative form in 1855, with Gustav Freytag's bestselling novel, *Debit and Credit* (*Soll und Haben*), whose protagonist set out to colonize Polish space with colourful fantasies of 'cowboys and Indians' informing his understanding of his venture.[4]

After uniting in 1871, Germany entered into the colonial race in the 1880s as a newcomer alongside the long-established colonial powers of France, England, etc. Sensing a need to claim a colonial pedigree to justify their membership on the global stage, German colonialists increasingly reframed German historical experience in Poland in colonial terms – in which Germans had brought civilization to the primitive east over centuries of 'colonial labour', and continued to do so into the present. Simultaneously, the German state launched an 'inner colonial' campaign in its ethnically Polish territories, which was designed to increase the agricultural population there, and which attempted to mobilize potential German recruits with triumphant colonial fantasies derived from the overseas colonial context. In these literary and political texts, the Poles were racialized as Slavic others and often portrayed as 'black' in narrative depictions.[5] Like colonized populations overseas, Slavs were constructed as a *Naturvolk* – a people that fell on the 'nature' side of the nature/culture divide, and who therefore had little or no ability to progress towards higher states of civilization independently. While the Poles were perceived to be more advanced than, for example, the Africans in Germany's colonies, this difference was readily explained by the Poles' proximity to – and contact with – Germans and the technological innovations, political structures and social customs they had been introducing into Polish space for centuries. According to the logic of this colonialist discourse, the Slavs were no more able to develop themselves than the Africans in the German colonies. They were more civilized (or at least more European) than the Africans, but this was only due to the long-term diffusion of German innovation into adjacent Polish space.[6]

Accordingly, narratives of German–Polish contact often featured episodes of cultural diffusion: the introduction of the iron plough (and the German use of it to render virgin territory fertile), the building of structures made of stone instead of wood (and the resulting permanence of German architecture in comparison to the 'wooden huts' or 'earthen hovels' of the Poles), the establishment of German

schools and churches (and the effects of their enlightenment on the Polish population) and the struggle to assert the German virtues of efficiency, industriousness, responsibility and moral rectitude in the face of Polish chaos, laziness, filth and criminal shiftiness.

If German diffusion brought innovation and culture into a space that would have been otherwise devoid of any sign of civilizational progress, any flows in the opposite direction were to be avoided at all cost, because, according to diffusionist logic, all elements arising out of the colonized space were necessarily atavistic in nature and thus dangerous and destructive; irrational forces opposed to civilization and progress, contagious disease, contaminating ideas etc. During the period of high imperialism, for example, the Poles were frequently equated with destructive natural elements that needed to be staved off, most frequently as floodwater threatening to spill over into German space, where it would wash away German structure, order and identity.

After World War I, Germany lost both its overseas colonies and large stretches of territory in the east, which were ceded to the newly reinstated Polish state. Forcefully decolonized, Germany technically entered into a 'postcolonial' period. However, German rhetoric *vis-à-vis* both Poland and the former overseas colonies actually accelerated and intensified during the interwar period as ever larger numbers of Germans demanded the return of the lost territories.[7] In the case of the lands ceded to Poland, a series of revisionist tropes came to be firmly entrenched: Germans had been 'colonizing' the Polish lands for hundreds of years, and all signs of civilization, spatial organization and social structure that could be found there only existed due to their colonial labour and the diffusion of their innovations. The Poles, as a *Naturvolk*, had not been able to lift these lands out of their primitive state on their own: since the Germans had brought this space into civilized existence, it was therefore rightfully theirs.

This 'postcolonial' narrative of spatial entitlement was widely championed, appearing in narrative form in literature and documentary film, in political publications and the press. As an

issue that achieved broad social consensus, Hitler could even appeal to it to frame his declaration of war on 1 September 1939:

> Danzig was and is a German city! The Corridor was and is German! All of these territories owe their cultural development exclusively to the German people, without whom the deepest barbarism [*die tiefste Barbarei*] would prevail in these eastern territories.[8]

Germany's 'postcolonial' discourse was entrenched in a colonial mindset of diffusion, and led not to a normalization of relations with Poland, but instead to further acts of territorial aggression.

Tropes of colonial diffusion

Significantly, the fictional Poland films of the post-1989 period do not stake any land claims whatsoever, either in direct or in symbolic form. While this specific 'postcolonial' narrative has receded from circulation, the 1990s did witness the reappearance of tropes derived from colonial-diffusionist discourse. Positioning Poland as an external, atavistic and threatening Other served a new set of rhetorical-discursive functions in the post-Wall period, most notably the negotiation of East German identity in the wake of German unification.

The first decade following the fall of the Berlin Wall was a period of significant tension between East and West Germans. As Paul Cooke argues, East Germans were greatly disappointed by unification's failure to bring about economic and social equality between both halves of the country.[9] Cooke turns to an argument perhaps most notably petitioned by Wolfgang Dümcke and Fritz Vilmar in their co-edited volume, provocatively titled *Kolonialisierung der DDR* (1996),[10] which addressed the changes imposed upon the GDR in conventionally colonial terms: the destruction of the native economic system, the establishment of a new social hierarchy with leadership imported from 'abroad' and the systematic degradation of local cultural practices and collective

morals. West Germany, the argument summarizes, colonized East Germany in a manner comparable to past episodes of European colonization overseas.

Whether one accepts the truth of this explanatory model is not critical to Cooke's larger observation that a 'language of colonization pervaded discussions of German unification and the place of east Germans within this new society in the 1990s'.[11] Colonialization, Cooke argues, is more about the perception (and representation) of the East–West relationship in colonial terms than about 'facts on the ground'. His research shows how texts of the 1990s reveal the prevalence of such a colonial discourse.

In negotiating the identity of the former East Germans within united Germany – whether as equal citizens or colonized victims – the construction of the Poles inherited from the prewar period came to play a central role. To support either argument, it was necessary to anchor the Poles as a placeholder representing the dystopic reverse of the 'Western dream'. Where this other is present as the socially, economically and morally degenerate 'criminal', then one can either argue that 1) in comparison to their former Warsaw Pact brethren, the East Germans are faring quite well, despite any setbacks they may be facing in the unification process, or 2) the opposite, that the East Germans are paying a high human cost within a unified Germany: their plight is so dire that they can be brought into conceptual alignment with the Poles. For either argument to hold, there is no rhetorical possibility of representing Poles as doing *well* in their new state. Indeed, the 'fact' that they are doing very poorly must be taken for granted and remain unexamined. Therefore, while the German news media certainly took note of the economic miracle taking place in Warsaw in the 1990s, this world was held at great conceptual distance from the Poles and the Polish spaces depicted in German narrative media – be it feuilleton headlines announcing 'The Jump Back in Time over the Oder River'[12] or the feature films set in the contemporary period depicting Poles as unable to achieve progress without external intervention, thus falling into atavistic, criminal

behaviours when left to their own devices.[13] The Polish criminal
thus became a staple element of all depictions of Poland.

Polski Crash

Kaspar Heidelbach's *Polski Crash* (the title an associative amalgam
of Polish and English words) had its debut at the Hof International
Film Festival in 1993, and tells the story of a German man's attempt
to rescue his brother from the mafia in Poland. Although a low-
budget production easily categorizable as a made-for-TV thriller,
Polski Crash is useful for its presentation of a series of colonial tropes
that are characteristic of the German narrative discourse on Poland
in the early 1990s.

The film opens with surveillance camera images of Piet Nickel
(in an early performance by Jürgen Vogel) stealing a red Ferrari
from a parking garage. We follow his route as he has the car's plates
exchanged and new papers forged, and as he then drives over the
border into Poland – a game at which he is obviously quite adept.
He is working with a stolen car ring, but he now seems to want to
go it alone: once in Poland, Piet pretends to sell the car, but instead
kills the mafia's buyer, leaving with both car and cash. Some time
later, he sends word to his brother, Tom Konnitz (played by TV
veteran Klaus Behrend), who initially refuses to become involved
with whatever his troubled brother might be up to, but reluctantly
heads for Warsaw once he hears that Piet has specifically mentioned
a pivotal moment from their childhood past. With the exception
of a series of flashbacks depicting this memory, the rest of the film
takes place in Poland.

De-individuated Polish space

In the films of the 1990s, Polish space is represented through a
trope of illegibility. The setting may move from Germany to
Poland, but this space is never present as a specific place with a
specific local identity, local culture or local history. It is instead de-

individuated, homogenized and cast as a matrix onto which various signs of Otherness can be projected. Neither the traditional centres of Polish culture and identity – Warsaw, Krakow or the Carpathian mountains – nor the cities so marked by contested German–Polish history – Breslau/Wrocław, Danzig/Gdańsk, Lodsch/Łódź or Posen/Poznań – are explored as such in any of these films.

Polski Crash announces a Varsovian location through a titled location shot featuring the city skyline, and the first scene in the city features its famed Palace of Culture and Science in the background. But aside from this brief introduction, the city appears as a series of deserted parking lots, empty warehouses and dark alleyways. Warsaw asserts no identity independent of the criminal matrix projected upon it, and thus does not present any resistance to the reading of Polish space as uniformly abject. Polish urban space becomes marked by an almost Kafkaesque illegibility of power structures and of the identities of individuals within the system: in this nightmare vision of Warsaw, lines conventionally drawn to distinguish social and institutional categories are systematically blurred. It becomes apparent that the police and the mafia are working together, and it is often not clear who works for whom or who can be counted on for help. Tom falls into the web of violence and control spun over the city (and beyond), and cannot navigate his way out. Particularly ambiguous is the woman claiming to be Piet's girlfriend, Alina, but whose cheap fur, stiletto heels and garish makeup render her indistinguishable from the prostitutes that frequent Tom's hotel. Alina claims to be a student, and seems to offer Tom help, but who is she really? The dubbed performance by the French actress Clotilde Courau only exacerbates the illegibility of Alina's character.

The camera reflects Tom's sense of his environment, and does not provide access to information beyond what happens immediately to Tom – the image never leaves his immediate environment. Without privileged access to information beyond what Tom experiences directly, the viewer cannot 'read' the convoluted environment any better than he can.

Oskar Roehler's 1997 *In with the New* (*Silvester Countdown*) depicts Warsaw as similarly de-individuated. A young Berlin couple – ironically named Romeo and Julia – are on a train headed into Poland, but it is unclear where exactly they are headed. They are in a sleeping compartment, indicating that they are venturing further into the country than a mere jaunt over the border. But their destination is never directly revealed and is even camouflaged by the first scene in Poland. We do not see the couple's train arrive at a station; instead, the scene cuts to an unmarked space – where the couple struggles to climb up an unused ski slope covered in snow. It is a natural rather than an urban environment, its relationship to the urban centre never clarified. In *In with the New*, none of the city's iconic buildings or monuments are presented – neither the towering, Stalinesque Palace of Culture and Science nor the historic old town with the Sigismund column, Royal Castle and Barbican. Warsaw becomes a non-place.

Dissolution of the male subject

Tom is arrested by the police and captured and brutally tortured by the mafia in rapid succession – both groups use violence and manipulation in order to force Tom into divulging his knowledge of Piet's whereabouts. Without clear lines of law, authority and control, and with violence threatening to be unleashed at any moment, Tom becomes distrustful of all around him, including Alina (whose role in Piet's former plots and relationship to the mafia indeed remains unclear throughout the entire film). He reacts by himself becoming violent, striking and sexually assaulting Alina before breaking down in despair: 'I don't know what's happening to me – I feel like I'm in a jungle here!' Tom's voyage into the centre of Poland is rendered analogous to Marlow's journey into the 'heart of darkness' in Joseph Conrad's novel.

As a space devoid of rational order, Poland becomes the site of dissolution of the male German subject. As the structuring force of civilization is left behind, the German traveller into Poland either

gives in to his dark side (as does Piet Nickel), or loses his self-possession (as does Tom Konnitz). This trope of male dissolution derives from prewar German colonial literature set in the Polish East. In the many narratives set in the 1890s–1940s, Poland never appeared as a 'charismatic realm of adventure' as was often the case in English colonial literature.[14] Men did not set out for Poland in order to prove themselves, returning with the fortunes and tales to show for it. Instead, time and again, German colonists and travellers met with defeat, leaving the pages of these novels littered with their corpses, bankruptcies, failed relationships and broken dreams. Despite the failure encountered by these protagonists, however, these novels were not arguing against German intervention, but instead, that Germany needed to increase the resources and settlers it sent to the Polish East in order to change the civilizational status of the space. Without a solid German hold on the land, there would never be any structure to the space, nor to the social relations staged therein; it would instead remain a vast Slavic wasteland in which the isolated German subject would dissipate.

When Tom Konnitz finally finds Piet, holed up in a bunker in an abandoned train station near the Ukrainian border, he finds a madman he no longer recognizes as his brother – Piet has become a psychopathic killer, and suffers from the omnipotent delusion that he can outsmart the Polish mafia. He intends to capture the load of stolen cars they are exporting eastward under the protection of the Russian army, which is withdrawing its troops and hardware using this railway line. Tom tries to save his brother from what must certainly end in his demise against so great a foe, but Piet has lost himself, if not on the 'dark continent', then in the darkness that exists right next door in Poland.

In *In with the New*, this dissolution of the male subject takes place in the psychosexual realm of late adolescence. In Berlin, Romeo and Julia inhabit an enormous, labyrinthine apartment that is only minimally furnished with prop-like objects: a tricycle in one room, a TV in the hallway, an enormous poster of Romeo. The camera never rationally surveys the apartment, its endlessness

thus feels more like a psychic metaphor than a physical location, as if, with their mattress tossed on the floor, the couple were symbolically squatting in the adult space that they hope one day to inhabit legitimately. When the scene shifts to Warsaw, the couple crash in an apartment that is the mirror image of their own, similarly unfathomable in its expanse, and decorated in the same provisional style. The couple have left Berlin to spend New Year's Eve – perhaps the first significant threshold-crossing of their relationship – here, in this space that mirrors their own, but which will exist under a different sign: Warsaw will thus become Berlin's dystopic *doppelgänger*.

Warsaw is a space that Romeo can neither understand nor purposefully interact with. His lack of agency is conveyed to the viewer through a series of motifs decidedly Freudian in nature. Romeo has forgotten his glasses at home, and thus cannot see properly. He has also forgotten sturdy winter shoes and is thus unable to walk on the winter streets (or up the ski slope in the scene mentioned above). Forced to ride home in a taxi due to Romeo's wet feet, he and Julia are first driven into the distant outskirts of the city, and then robbed at gunpoint by a seemingly psychotic taxi driver.

In Berlin, the success of Romeo and Julia's relationship had been clearly defined in purely sexual terms. In Warsaw, Romeo's impotence in the face of the Polish environment leads first to his own psychic disintegration, then to the hollowing out of his relationship with Julia. The problem becomes apparent on the train ride into Poland, where the discovery of Romeo's missing glasses is closely associated with his inability to satisfy Julia sexually. She later tells Romeo that she feels like an evil force joined them that night on the train, a force intent on separating them from each other. As if the atavistic force projected onto Polish space could also infect those Germans who came into contact with it, the German male subject is threatened with dissolution in Poland.

Need for external intervention

Travelling into Poland on the train, Tom Konnitz meets his former high school girlfriend, who claims to be heading to Warsaw for a convention, but who is instead trailing Tom in the hopes that he will lead her to Piet, for she is a member of the German secret service and is on to Piet's car theft. She and her partner track each of Tom's successive moves. She initially attempts to protect him from the forces at play, but once Tom has made contact with Piet, she has him arrested. In the interview that follows, she tells him that she can no longer assume his innocence: 'I know that the prospect of making quick money changes a person – every one.' In the lawlessness of this Polish 'wild east', no subject can remain intact – except for the true agents of the law.

Knowing that the German agents and the Polish mafia are both on to Piet's plot, and that the latter are intent on killing him, Tom tries to rescue his brother from certain death. He sees that the only possibility of saving Piet's life is in his brother's surrender to the German forces, but Piet reacts by attempting to kill Tom and carry on with his plan. A lengthy struggle on the train ensues (they run over the top of the train in a clichéd reference to *The Great Train Robbery*). As the train screeches to a halt, Piet is about to deliver the death blow to Tom when, out of nowhere, he is shot dead. As the camera pans back to the train, we see the German agents. In postcommunist Poland, the film suggests, the mafia, the police and the military have become inextricably linked, and the government's inability to manage the country has brought threat to Germany in the form of a crime wave. Only the German agents are able to bring any degree of order to this situation, and they arrive – from Germany – just in the nick of time.

The colonial-diffusionist discourse is thus mobilized in an unadulterated form in Heidelbach's film. Poland, now on its own, has instantly sunk into a backward state of chaos, crime and violence. The Poles are not able to run a state without external intervention, and their helplessness serves as an invitation for outsiders to come

in and arrange their affairs. The Russian train with the stolen cars pulls away, headed for the Ukrainian border, and the film seems to suggest that only a larger German military force would have been able to stop it. The Poles are not equipped to defend their own territory nor to create the social structures in which modern civilization and order might flourish.

Locating East Germany

East Germany remains a silent/silenced element in *Polski Crash*. The German characters all grew up in the western city of Dortmund, and the only German space we see is in the west of the country. Given the overall structuring dichotomy of (West) German order versus Polish chaos, where does the film conceptually locate the new German states? Although *Polski Crash* is admittedly an action thriller not necessarily aspiring to larger considerations of German identity, the absence of East Germans in a film that works so hard to structure a strong German–Polish divide invites an examination of the text's (un)conscious elision.

Piet Nickel and Tom Konnitz are identified as brothers at several moments during the film, but their differing last names are not explained. In his conversations, Tom reveals that, as young men, the brothers had been involved in a certain degree of mischief, perhaps even petty crime, but that this is a phase of his life he has left behind, losing track of his brother and his increasing criminality. In the flashback that accompanies Tom throughout the film, a dichotomy of good brother/bad brother is clearly established: the boys are still children, and Piet is destroying the windows in an abandoned building as Tom warns that they need to return home. They race to the doorbell, Tom presses it and, in slow motion, the house explodes. Although Piet will admit that he had purposefully opened the gas valve of the oven before leaving the house, his reasons for doing so are neither explored nor explained. As the doorbell clearly read 'Konnitz', we can perhaps assume that Piet Nickel's membership in the family was rather that of the 'bad step-child'.

With the house, as the symbol of the unified household, destroyed, the boys seemingly followed separate paths. Tom remains in Dortmund and is clearly aligned with the West through his relationship with the German agent. Piet, meanwhile, took up a position in the East, in a liminal space traversing the German–Polish border. Piet had shown signs of criminally atavistic behaviour as a child, and now he has melded his personal space in (East?) Germany with the criminal world through which he moves in Poland. Piet thus represents a third space located between the Poland of violent crime and chaos, and the Germany of law and social order. With his death, this third space is eliminated, and the conceptual divide separating Germany from Poland is deepened and strengthened. Read in this way, 'East Germany' must be erased/silenced to keep the German–Polish distinction clear.

Atavistic Polish elements in German space

The Polish actor Mirosław Baka has been well known to arthouse audiences since his debut performance in Krzysztof Kieślowski's *A Short Film about Killing* (*Krótki film o zabijaniu*, 1988). He appeared in several German films of the 1990s and 2000s, and, in the early post-Wall years, he played the role of Polish criminals in both *Polski Crash* (as the mafia warlord Józef Malik) and in *Eastern Crossing* (as the smuggler and con man Darius [sic!]). The latter film is interesting for an interrogation of colonial-diffusionist tropes, because it takes place in Berlin, and Darius thus represents a reverse-diffusion of Polish elements into German space. In this regard, his character is similar to that of Andrzej in *Little Angel*, also a Polish petty criminal in the newly unified city. Films criticizing the human cost of reunification often introduce such Polish characters – border criminals, cigarette smugglers and car thieves – with whom East Germans become aligned, in order to show that East Germans are more defined by a shared postcommunist social malaise than by the promise of a West German standard of living. In *Forget America*, these Polish criminals remained unnamed and unexplored figures

lurking on the periphery of the film; in Klier's *Eastern Crossing*, Darius is a central character.

Eastern Crossing is a film about those left behind by German unification. Fifteen-year-old Elfie lives with her mother in the shipping containers that were converted into housing to accommodate the large number of blue-collar workers migrating to Berlin. While the labourers, many of them from Poland, are there to participate in what was, for a time, the largest building site in the world, Elfie and her mother live in the containers because they are destitute, and unable to make the deposit on even the lowliest of apartments. Elfie thus lives in the no man's land of upturned

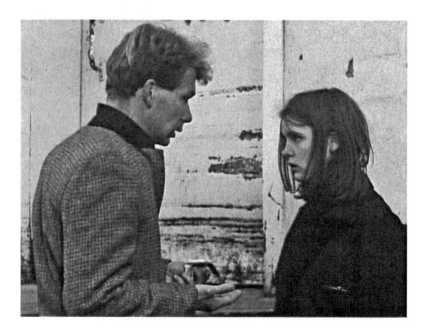

Figure 1.2
While the economic stability of the 'West' remains an unattainable dream, Elfie discovers that she is located in an 'East' characterized by desperation and criminality. En route with Darius (Mirosław Baka) to sell a stolen car, Elfie's travel into Polish space is not interrupted by any noticeable borders – her world is thus rendered conceptually co-extensive with this 'East'.

dirt, weeds and rubble that fill the space where the Berlin Wall once divided the city. Elfie's mother had fled with her to West Germany just before the fall of the Wall, but now finds herself back in Berlin, unable to find employment, and entering into ever greater dependency on a shady middleman who organizes day labourers for the construction sites.

Shot in grainy, washed-out shades of bluish-gray, the landscape is dismal and oppressive as a dejected Elfie skulks around the abandoned buildings and alleyways of her surroundings. Her Berlin is a world away from the high-paced urban metropolis that exists adjacent to her marginalized location, but there is no sense that this border into the Western world can be traversed, and Elfie appears trapped. When a chance encounter brings her together with Darius, Elfie pressures him to let her work with him, and to take on ever more dangerous tasks for a cut of the earnings.

In order to stress the desperation of her plight, the socially peripheral space that Elfie inhabits is portrayed as co-extensive with Poland which, in the film's depicted world, is singularly presented as a space of crime. In one scene, Darius and an adult accomplice need to deliver a stolen car to potential Russian buyers, and they bring Elfie along because she has learned enough Russian to translate the deal. They drive at length through a barren, wintry landscape, and end their trip at an abandoned train station. Upon closer investigation, Elfie finds that all of the signs in the train station are in Polish. Although we have not seen them cross a border (and have no expectation that Elfie is travelling with a passport), they are now inexplicably in Czelin, on the Polish side of the Oder. When the Russians arrive and realize that Darius intends to swindle them, weapons are drawn, the Russians grab Elfie, and Darius and his accomplice escape in the car, leaving their young accomplice behind. Abandoned in the snow, Elfie must find her way home alone: it will take her more than a day of tracking the train lines to the West, but she makes it back to Berlin – again without crossing any marked border. In *Eastern Crossing*, the shared plight of marginalized Germans and Poles is rendered through a linking of

Figure 1.3
Eastern Crossing depicts the world of post-unification West Berlin as an
unreachable, distant mirage. Even the television tower, located near the border
formerly dividing the city, seems distant, crushed by the weight of surrounding
poverty and despair.

the spaces they inhabit. Elfie never sees West Berlin, but she moves
– if with great effort – through a continuous German–Polish space.

The 2010s and the comic return to Polish crime

A decade after German unification, depictions of Polish criminals
rather abruptly ceased, at the same time as the number of films
depicting Poland and the Poles increased significantly. Poland
joined the EU in 2004 and, in 2007, joined the European Schengen
Area, inside which it is no longer necessary to undergo border
checks when moving between countries. The discussions regarding

Poland's ascension into these two international organizations began around the turn of the century and contributed to a discursive shift in the construction of Polish space. Between 2000 and 2007 we see numerous films in which the German–Polish borderlands gain a distinct, independent identity. This is most notably the case in Hans-Christian Schmid's *Distant Lights* (*Lichter*, 2003), in which the border region linking Frankfurt Oder and Słubice is shown to be woven together by a series of economic, social and political flows;[15] but also in Michael Schorr's 2006 comedy of the tri-border area of the Czech Republic, Poland and Germany *Schroeder's Wonderful World* (*Schröders wunderbare Welt*); or Till Endemann's Baltic borderland in *The Grin of the Deep Sea Fish* (*Das Lächeln der Tiefseefische*, 2005).

Films of the early 2000s also frequently featured neighbouring Polish space as an enchanted forest, as in Christoph Hochhäusler's 2003 retelling of the Hänsel and Gretl fairy tale as one woman's abandonment of her step-children over the border in Poland (*This Very Moment/Milchwald*, 2003); Sabine Michel's magical realist tale of a German village that remains under a curse until a Polish woman emerges from the nearby enchanted forest (*Take Your Own Life/Nimm dir dein Leben*, 2005); or the encouragement of young Jule to believe she is the princess in a fairy tale forest in Jan Krüger's *En Route* (*Unterwegs*, 2004).

Although border smuggling is not entirely absent from these films, it is reduced to adolescent smuggling of cigarettes, and no longer features instances of car theft or appearances by mafia lords. Acts of violence are shifted away from the public spaces of organized crime and into the domestic spaces of familial dysfunction and private shortcomings.

From these dramas of the first half of the 2000s, we are now witnessing a new turn to the comedy genre, specifically the culture-clash comedy and its reliance on ethnic stereotypes. The stolen cars and auto mafia absent from the post-2000 dramas now reappear, but in ironically altered form. In *Polska Love Serenade* (Monika Anna Wojtyllo, 2007), a young, free-spirited student from Berlin

crosses the border with her old car, 'Herbie', in the hopes of having it stolen in order to cash in on her auto insurance. She is ultimately successful, but only after handing over her keys to the local priest. In Lars Jessen and Przemysław Nowakowski's co-directed German–Polish co-production, *Wedding Polka* (*Hochzeitspolka*, 2010), members of a former German rock band steal a Polish Fiat in order to escape a mob they have provoked. (This provocation, staged as a culture clash between the worst elements of the German–Polish cliché canon, and on intensified nationalist terms, leaves one band member exclaiming '*We* can't steal cars from the Poles!') And, in the most recent German–Polish co-production *Polish Easter* (*Polnische Ostern*, 2011), a grandfather travels to Poland with his own wheel clamp to prevent his car from being stolen. As he gradually comes to trust his environment, he ceases locking the car in this manner, only to have his car stolen – as he returns from the gas station bathroom, his car has disappeared, but, in its place hangs the confirmation dress he was bringing to his granddaughter, which the car thief had thoughtfully removed.

Catholicism thus comes to play a large role in these films, all staged around Catholic events – Christmas (*Polska Love Serenade* takes place over the Christmas holiday), Easter (in *Polish Easter*) and a Polish Catholic wedding (in *Wedding Polka*). Along with the Polish language (the unpronounceability of Polish words and names being a favourite trope), the Polish Catholic religion offers the largest source of difference, but, as these comedies show, they are differences that can be overcome: Germans can learn to speak Polish (we see the main protagonist of *Wedding Polka* practising his Polish marriage vows to a cassette tape in his car), and elements of Polish Catholicism can play a role in the spiritual life of otherwise rather secular individuals (as in *Polish Easter*, a film whose narrative is framed with the act of an adamantly agnostic, yet spiritually longing German telling his story to a Polish priest in a confessional booth).

These comedies also differ from their filmic predecessors by directly critiquing German 'postcolonial' and neo-colonial practices.

In *Polska Love Serenade*, the young jurist *in spe* Max is sent by his father to Lubomierz/Liebenthal to meet with the current Polish inhabitants of his grandfather's former estate and investigate the possibility of suing them for the value or return of the home. The film firmly situates this agenda as a further manifestation of Max's overall narrow-minded (*spießig*) character, from which he will be freed through his liberating experiences in Poland. He finds happiness in abandoning his closely scripted life, relinquishes his juridical intentions and makes plans to return to Poland with Anna to celebrate New Year's Eve, thereby removing himself from the social structures in Germany – his family and fiancée – that are boxing him in.

Similarly, in *Wedding Polka*, Frieder finds that he has become narrow-minded through his job of managing a German factory in eastern Poland. This venture is clearly identified in its neo-colonial character – the factory workers are compared to Chinese labourers who will work for far less than their German counterparts and who will lose their jobs once cheaper labour becomes available in Ukraine. In this 'highly alcoholic comedy from the wild east'[16] Frieder comes to criticize the business practice of his German employer, and quits his job.

Conclusion

Wedding Polka begins with a fast sequence in which Frieder announces to his parents his plan to move to Poland. They strongly disapprove on the grounds that Frieder would be heading into territory that is 'much too dangerous. You want to risk your life for this? Running water, paved roads, medical care, safety. All of these things cannot be taken for granted. It will take decades before they are that far … In essence, it is a wild country!' The scene then cuts to the image of a Native American in camouflage teaching two Polish soldiers how to track enemies on the Polish–Ukrainian border – he has been brought in by the Polish government in order to train their men in preparation for the opening of the Schengen border. 'Rich', as he is called, is much loved by the local Polish community. 'Why',

Frieder asks him, 'do the Polish people accept you when it is so hard to become one of them?' In a truly postcolonial moment, Rich answers: 'I think it's because they know I'm going to leave again.'

In the films of the second decade of the twenty-first century, Germans have moved decisively away from the Poland-discourse of the 1990s, which appealed to colonial constructions of Poland in the process of negotiating German identity after unification. It is useful to address the categories of colonial and 'postcolonial' thought when appraising post-Wall German films depicting Germany's Polish neighbours. Yet it is equally important to recognize that these categories are not static, and that German depictions of Poland and the Poles have shifted greatly over the 20 years in question, from the abject to the equal.

Notes

1 Karin Hamm-Ehsani, 'Screening Modern Berlin: Lola Runs to the Beat of a New Urban Symphony', *Seminar* 41:1 (2004), pp. 50–65.

2 Kristin Kopp, *Germany's Wild East: Constructing Poland as Colonial Space* (Ann Arbor, MI: University of Michigan Press, 2012).

3 Michael G. Müller, Bernd Schönemann and Maria Wawrykowa, *Die "Polen-Debatte" in der Frankfurter Paulskirche: Darstellung, Lernziele, Materialien* (Frankfurt am Main: Georg-Eckert-Institut für Internationale Schulbuchforschung, 1995).

4 Kristin Kopp, 'Reinventing Poland as German Colonial Territory in the Nineteenth Century: Gustav Freytag's *Soll und Haben* as a Colonial Novel', in Robert L. Nelson (ed.), *Germans, Poland, and Colonial Expansion to the East: 1850 through to the Present* (New York: Palgrave Macmillan, 2009), pp. 11–37.

5 Kristin Kopp, 'Constructing Racial Difference in Colonial Poland', in Eric Ames, Marcia Klotz and Lora Wildenthal (eds), *Germany's Colonial Pasts* (Lincoln, NE: University of Nebraska Press, 2005), pp. 76–96.

6 For information on the diffusionist model attending colonial thought see J.M. Blaut, *The Colonizer's Model of the World: Geographic Diffusionism and Eurocentric History* (New York: Guilford, 1993).

7 Sara Friedrichsmeyer, Sara Lennox and Susanne Zantop, 'Introduction,'
 in Sara Friedrichsmeyer, Sara Lennox and Susanne Zantop (eds), *The
 Imperialist Imagination: German Colonialism and Its Legacy* (Ann Arbor,
 MI: University of Michigan Press, 1999), pp. 1–29, p. 24.

8 Adolf Hitler, *Reden des Führers. Politik und Propaganda Adolf Hitlers,
 1922–1945,* ed. Erhard Klöss (München: Deutscher Taschenbuch
 Verlag, 1967).

9 Paul Cooke, *Representing East Germany since Unification: From
 Colonization to Nostalgia* (New York: Berg, 2005).

10 Wolfgang Dümcke and Fritz Vilmar, *Kolonialisierung der DDR. Kritische
 Analysen und Alternativen des Einigungsprozesses* (Münster: Agenda, 1996).

11 Cooke, *Representing East Germany since Unification*, p. 2.

12 Kuno Kruse, 'Zeitsprung über die Oder', *Die Zeit*, 11 March 1995.

13 Kuno Kruse features the following lead-in: 'It is only a few steps over
 an iron bridge, high over the river, and yet it is a passage into another
 time. Border crossings can be tunnels through time. The German side,
 Frankfurt Oder: bright shopping malls, ATM machines. The people are
 forging their new lives, those in the time after the Wall, behind which
 so many desires had been held back. The Polish side, Slubice on the
 Oder, gray-black facades, the asphalt rutted. Dealers, smugglers, money
 changers' (Kruse: 'Zeitsprung über die Oder').

14 Ella Shohat and Robert Stam, *Unthinking Eurocentrism: Multiculturalism
 and the Media* (New York: Routledge, 1994).

15 Kristin Kopp, 'Reconfiguring the Border of Fortress Europe in Hans-
 Christian Schmid's Lichter', *Germanic Review* 82:1 (2007), pp. 31–53.

16 This is the film's 'subtitle' as printed on the DVD package.

References

Blaut, J.M., *The Colonizer's Model of the World: Geographic Diffusionism and
 Eurocentric History* (New York: Guilford, 1993).

Cooke, Paul, *Representing East Germany since Unification: From Colonization to
 Nostalgia* (New York: Berg, 2005).

Dümcke, Wolfgang and Vilmar, Fritz, *Kolonialisierung der DDR. Kritische
 Analysen und Alternativen des Einigungsprozesses* (Münster: Agenda, 1996).

Friedrichsmeyer, Sara, Lennox, Sara and Zantop, Susanne, 'Introduction', in Sara Friedrichsmeyer, Sara Lennox and Susanne Zantop (eds), *The Imperialist Imagination: German Colonialism and Its Legacy* (Ann Arbor, MI: University of Michigan Press, 1999), pp. 1–29.

Hamm-Ehsani, Karin, 'Screening Modern Berlin: Lola Runs to the Beat of a New Urban Symphony', *Seminar* 41:1 (2004), pp. 50–65.

Hitler, Adolf, *Reden des Führers. Politik und Propaganda Adolf Hitlers, 1922–1945*, ed. Erhard Klöss (München: Deutscher Taschenbuch Verlag, 1967).

Kopp, Kristin, 'Constructing Racial Difference in Colonial Poland', in Eric Ames, Marcia Klotz and Lora Wildenthal (eds), *Germany's Colonial Pasts* (Lincoln, NE: University of Nebraska Press, 2005), pp. 76–96.

Kopp, Kristin, 'Reconfiguring the Border of Fortress Europe in Hans-Christian Schmid's *Lichter*', *Germanic Review* 82:1 (2007), pp. 31–53.

Kopp, Kristin, 'Reinventing Poland as German Colonial Territory in the Nineteenth Century: Gustav Freytag's *Soll und Haben* as Colonial Novel', in Robert L. Nelson (ed.), *Germans, Poland, and Colonial Expansion to the East: 1850 through the Present* (New York: Palgrave Macmillan, 2009), pp. 11–37.

Kopp, Kristin, *Germany's Wild East: Constructing Poland as Colonial Space* (Ann Arbor, MI: University of Michigan Press, 2012).

Kruse, Kuno, 'Zeitsprung über die Oder', *Die Zeit*, 11 March 1995.

Müller, Michael G., Schönemann, Bernd and Wawrykowa, Maria, *Die 'Polen-Debatte' in der Frankfurter Paulskirche: Darstellung, Lernziele, Materialien* (Frankfurt am Main: Georg-Eckert-Institut für Internationale Schulbuchforschung, 1995).

Shohat, Ella and Stam, Robert, *Unthinking Eurocentrism: Multiculturalism and the Media* (New York: Routledge, 1994).

2

Neighbours (Almost) Like Us: Representation of Germans, Germanness and Germany in Polish communist and Postcommunist Cinema

Ewa Mazierska

In a dominant version of Polish history and popular tradition its Western neighbours, the Germans, function as the Poles' arch-enemies. It is difficult to grow up in Poland and not to hear about Princess Wanda, the daughter of legendary King Krak, who preferred to commit suicide by throwing herself into the Vistula river rather than marry a German prince, and about Polish suffering under German occupation during times of partition (from the end of the eighteenth century until 1918) and World War II. The history of Polish–German relations is construed as that of German aggression and Polish victimhood. Even the greatest victory of Poles (supported by Lithuanians) over Germans in the guise of the the Teutonic knights at the Battle of Grunwald/Tannenberg in 1410 is represented as a miraculous yet just victory of a weak colonized nation over a powerful colonizer. A Pole thus looks at his or her

German neighbour with a mixture of scorn and envy. The German represents what the Pole is not but perhaps what they would like to be if they had enough strength. This attitude can be viewed as conforming to a larger pattern, which Maria Janion describes as a sense of Polish inferiority towards the West and superiority towards the East.[1] This is also a reason why in Poland Germanness is associated with masculinity, while Poland in relation to Germany is represented as female, as in the legend of Wanda.

Yet the discourse of Polish high moral ground, weakness and suffering, and German viciousness, aggression and strength, although prevailing in Polish culture, is not the only one. Poland also played the role of an aggressor and colonizer in relation to Germany. A recent chapter of such history was the period following the end of World War II, when Poland received or regained, as was officially claimed (thus pointing to numerous waves of colonizations), a large chunk of the eastern territory of prewar Germany, leading to the expulsion of up to 6 million ethnic Germans from their homes. Of course, the question of whether colonization took place on this occasion is a thorny one because colonization normally involves political power on the part of the colonizer. By contrast, in 1945, Poland was practically powerless, as it acted in accordance with the Yalta Agreement, which decided to move the Polish borders westward. Nevertheless, the fact that Poland (re)gained what was previously part of the Reich (and many centuries before that, had belonged to Poland) was played down in Polish postwar history, not only to obscure the harsh treatment of Germans by Poles and Russians during the period of expulsions, but also to not disrupt the larger narrative of Polish victimhood caused by German aggression.

Anda Rottenberg argues that this narrative is also undermined by the fact that Poles emulated Germans in their *Drang nach Osten*, colonizing the territories of its eastern neighbours in a similar way to how they were themselves colonized. She even claims that Poles, or more exactly Polish elites, allowed the Germanic nations to populate Polish cities, because they were themselves interested

more in the eastern territories: Lithuania or Ruthenia, from where their wealth subsequently came.[2] Such a claim supports an idea that a particular nation at a particular time can be both a colonizer and an object of colonization and that colonization can affect different social strata in a different way.

German invasions on Polish territories and, more rarely, Polish on German territories, led to the hybridization of Polish and German societies and cultures. A sign of that is the Polish language being full of Germanisms, many Polish people having German surnames and some people and whole regions which changed allegiance between Poland and Germany and enjoyed periods of autonomy having a hybrid cultural identity, neither Polish nor German, but their own. A clear example is Silesia; the experience of Silesians is akin to what Thomas Elsaesser terms 'double occupancy'[3] and which consists of regarding both Poland and Germany as occupying powers.

These counter-memories and counter-discourses about Germans and Poles frequently infiltrated the dominant vision of Polish–German history, as reflected in Polish cinema during the communist period. Therefore, before moving to the representations of Germans in some Polish films of the postcommunist period, I will consider the history of Polish–German relationships as represented in Polish films of the communist period, focusing on images which challenged the dominant victor/victim discourse.

Germans in Polish cinema of the communist period

By and large, Polish postwar cinema reproduced the discourse of German aggression and Polish victimization. This is reflected in the prevailing theme of the films representing Germans: 80 per cent of them are about World War II and the majority of those are battle films.[4] For Poles brought up on these films and television series a German was almost synonymous with a member of the SS, Gestapo or Wehrmacht. In addition, one of the most popular films in Polish postwar history, *Teutonic Knights* (*Krzyżacy*, Aleksander Ford, 1960), was also about the subjugation of Poland by German

ancestors and Polish retaliation. And yet, even the most populist films about World War II avoided images of German vulgarity as conveyed in Western accounts, for example by George Steiner, who wrote: 'One comes to understand how the sheer grossness of German pleasures – the bursting sausages and flowered chamber pots, the beer-warmers and the fat men in tight leather shorts – was the ideal terrain for the sadistic-sentimental brew of Nazism.'[5] In Polish postwar cinema we observe a certain moderation in piling vices onto the Germans. If they were sadistic, they were not stupid or vice versa. Moreover, the simple dichotomy 'bad German – good Pole' was complicated by the politics of the Cold War and the realities of the postwar Polish–German relationship. The partition of Germany between Western and Eastern powers led to the creation of the GDR, the 'country of good Germans' and the officially less good, yet more attractive to ordinary Poles, West Germany. They emigrated there in large numbers or relocated temporarily for work, to return to Poland with the highly desired West German marks.

The existence of 'good Germans', who can be construed as potential inhabitants of the GDR, was reflected in Polish cinema by including in war films German communists engaged in anti-Nazi conspiracy. The most celebrated example is *The Last Stage* (*Ostatni etap*, 1948), directed by ex-Auschwitz prisoner Wanda Jakubowska. The co-author of the script was Gerda Schneider, a German, who, during the war, like Jakubowska was incarcerated in Auschwitz and, like her, wanted to make a film about her experience. The finished film has no single main character, but three leading heroines: Marta, a Polish Jew who works as a translator; Anna, a German nurse and communist; and the Russian doctor, Eugenia. These three women serve as symbols of the main enemies of fascism: Jewry, communism and Russia, conveying the opinion that it was thanks to their co-operation that the Nazis were eventually defeated. In Jakubowska's film the 'good Germans' are as instrumental in conquering Nazism as are Russians and are, of course, more important than the Western armies, which are practically excluded from the narrative. The

tacit assumption of *The Last Stage* is that after the war the 'good Germans', who were persecuted by Hitler's henchmen, would settle in socialist Germany and become Poland's good neighbours. This film can be regarded as postcolonial because of its intent of overcoming and obliterating the colonial past.

We also find Germans from the East in a Polish–German romance, *Two People from Big River* (*Dwoje z wielkiej rzeki*, Konrad Nałęcki, 1958). The film avoids celebrating socialist Germany and instead focuses on the difficulties of the Polish–German relationship resulting from centuries-long animosity between Poland and Germany. It also goes against the grain of the weak Poland/strong Germany stereotype by casting as the main characters a German woman from Silesia who stands for a weak, feminized Germany and a male Polish character who encapsulates a victorious Poland. In one episode we even see the Polish protagonist forcing himself onto his future German girlfriend. This is not a straightforward rape, because the woman is as interested in the handsome Pole as he is in her. Nevertheless, this quasi-rape can be seen as a symbol of colonial violence permeating Polish–German relations (rape being a colonial motif) and a reference to the history of numerous rapes committed against German women during the last phase of World War II by the Eastern 'liberators', especially on the part that was amputated from the Reich to constitute Polish 'regained territories' (*Ziemie Odzyskane*).

Polish cinema returned to the 'regained territories' in *Law and Fist* (*Prawo i pięść*, Jerzy Hoffman and Edward Skórzewski, 1964). The film is set immediately after World War II. Its protagonist, Andrzej Kenig, arrives in this part of Poland following his release from a concentration camp. He joins a group of men to whom the new authorities give the task of ensuring that the goods left behind by the Germans are passed in a good state to Polish repatriates from the East. It turns out, however, that Kenig's comrades, some of them brutalized by war misery, regard this assignment as an opportunity for looting and enjoying themselves. Kenig has to stand up to them in an unequal battle, reminiscent of *High Noon* (1952) by

Fred Zinnemann.[6] Although the film's main concern is the welfare of the new inhabitants of this territory, it also tackles the moral acceptability of Poles taking over what Germans were forced to leave. This happens when Kenig and Anna, a woman who was also imprisoned in the concentration camp, visit a house that previously belonged to a wealthy German family. Here Anna playfully tries on various clothes left by its previous owner, which Andrzej asks her if she does not feel uncomfortable to do. This question provokes Anna to an outburst of anger. She smashes the porcelain and lists all the harms inflicted on her by the Germans, including the murder of her husband, the loss of her house and the years of incarceration and fear from which she would never recover. The implication of Anna's outburst is that the war losses of Germans and Poles are incomparable; the former would never be able to make up for the suffering of the latter. However, the very fact of making such a statement suggests that some Poles had doubts about the morality of their behaviour, which consisted of repeating, albeit on a smaller scale, what the Germans did to them.

The German name of the film's noble protagonist, never discussed throughout the film, suggests that some Poles with German roots were great Polish patriots and suffered immensely during the war. Kenig might also be seen as a 'cultured German' disguised as a Pole (his intellectualism is underscored by casting in this role Gustaw Holoubek, who became the chief intellectual among Polish postwar actors), who returns to his old homeland, to save German treasures from the barbaric Poles in order to return them one day to their rightful owners. Such a reading is encouraged by showing Kenig's special care of cultural treasures (old books, religious art) found in the houses abandoned by Germans and his insistence that they will be displayed in museums, rather than sold to private owners. We also see Kenig for the first time when he prevents a group of Poles raping a woman. Although her nationality is not disclosed, I am tempted to see her as German, and Kenig's act as German intervention to curb the excesses of Polish colonization of the old Prussia. Yet it should be emphasized that such an interpretation

requires 'reading between the lines' and deriving more from the character's German name than might be intended.

The main character in the television series *More than Life at Stake* (*Stawka większa niż życie*, Andrzej Konic and Janusz Morgenstern, 1967–8), set during World War II in occupied Poland, was conceived as a Soviet agent who poses as an officer in Abwehr. However, during the process of an adaptation of the script to screen, his Russianness was eliminated, most probably to prevent alienating Polish viewers, who, despite pro-Soviet indoctrination, were hostile towards the Soviet army. In the end, the secret agent, Stanisław Kolicki, is nominally Polish, but his identity is hybrid: Polish–German. He is seen 'at work' as a German officer practically all the time and rarely does he interact with people who know his true identity. For everybody around him he is Hans Kloss and he was also Kloss for the Polish audiences. In his uniform Kolicki-Kloss encapsulates a virility which Polish soldiers after the war were lacking because of being subjected to Soviet rule. This is perfectly visible when Kloss appears in the proximity of 'ordinary' Poles: they are thwarted by his elegance, intelligence and charisma. These features are also associated with belonging to the upper class, a position not looked upon favourably by the communist authorities, yet bearing positive associations among ordinary Poles. Kloss can be regarded as a safe repository of what was banned from the official discourses on Polishness, yet did not disappear from Polish cultural memory.

Kloss not only stands above 'pure' Poles, but also above 'pure' Germans. He overshadows all the Nazis with whom he works, because they are fanatical or stupid and, of course, do not know who he really is, while he knows practically everything about them. Thanks to working in Abwehr, an espionage organization, he is also safely removed from the 'dirty' side of war, such as exterminating Jews and Poles. This adds mystery and elegance, imparted to him by his being driven by a chauffeur and visiting many attractive places, such as Paris.[7] Furthermore, he is the most handsome man in the neighbourhood, thanks to being played by

one of the most attractive Polish actors of his generation, Stanisław Mikulski. As Kloss, Mikulski became the most popular male pin-up in communist Poland in the late 1960s and early 1970s, as well as gaining popularity in countries such as Czechoslovakia, Albania and even East Germany. From this popularity we can infer that Kloss projected an idealized image of a German for Eastern Europeans in general: a German who is their friend, as well as representing the old military charisma, banned from the socialist armies.

Finally, *The Magnate* (*Magnat*, Filip Bajon, 1986) questions the stereotypical image of the Polish–German relationship as German conquest and Polish subjugation. Based on a true story of the aristocratic family von Teuss, who lived in Silesian Pszczyna/Pless, on the Polish–German–Czech border, it shows how the upheavals of the twentieth century and especially the rise of fascism in Germany, World War II and its aftermath destroyed a family with rich traditions and the whole culture to which it belonged. The patriarch in the film, Hans Heinrich von Teuss, an industrialist and a virile man who was married twice and fathered four children, is represented as a hybrid character who successfully inhabited the geographical and cultural boundaries spanning Poland and Germany. Nationality was never a problem for him; he happily served the Kaiser but also employed a Polish engineer to manage his coalmines. He could also be described as a quintessential Central European, for whom locality (in his case Pszczyna district) mattered more than national identity and who felt at ease in the whole of Europe. By contrast, his sons prove unable either to emulate his potency or to balance his multicultural heritage. Franzel, the eldest, who comes across as domineering, cold and asexual, becomes a Nazi follower, and is involved in the abduction of his youngest brother Bolko by the Nazis, which leads to Bolko's torture and death. Bolko, a compulsive gambler and womanizer, spends most of his life in the casinos of Nice and Monte Carlo and marries his stepmother while his father is still alive. He comes across as a caricature of a decadent cosmopolitan European. He is so preoccupied with seeking pleasure that he overlooks the political

realities of the 1930s, paying for his recklessness with his own life. Finally, the middle son Conrad is a homosexual and a Polish patriot who survives the war, but becomes utterly marginalized and then dispossessed by the new communist authorities. Bajon shows that historical circumstances combined with personal weaknesses lead to the demise of the younger von Teusses, who proved unable to live happily as pure Germans, pure Poles or 'travelling Europeans'. In this way his film promotes the existence of Polish–German or even multinational borderland, understood both as a geographical location and a symbolic space, whose inhabitants are allowed to possess hybrid identities, yet are anchored to a particular locality. *The Magnate*, because it was made in the period following martial law of 1981, when tens of thousands of Polish citizens, a large proportion of them from Silesia, emigrated to Germany, can also be seen as a voice of discussion about the morality of such a decision. It suggests that rather than chastising the emigrants as traitors to Poland (an accusation voiced most often in relation to footballers from Silesia, who chose German clubs over Polish ones) or, perhaps, as second-class Germans (the fate some of them encountered in Germany), they should be allowed to enjoy and cultivate their hybrid identity, as much for their own sake as for that of Poland and Germany.

In the following parts of this chapter I will argue that Polish postcommunist films developed the ambiguous or subversive representations of Germans and Germany present in *Law and Fist*, *More than Life at Stake* and *The Magnate*. I will support my claim by focusing on *The Pianist* (2002) by Roman Polanski, *Róża* (2011) by Wojtek Smarzowski and *Dogs* (*Psy*, 1992) and *Reich* (2001) by Władysław Pasikowski. There are many more films with German characters, made in Poland after 1989 and some films such as *Departure* (*Odjazd*, Magdalena and Piotr Łazarkiewicz, 1991) and *The Call of the Toad* (*Wróżby kumaka*, Robert Gliński, 2005) could be regarded as more obvious choices because of their situating Polish–German relations in a more prominent place. However, I settled on those films where Polish–German links are less obvious because, as Michel Foucault noted, looking at the fuzzy edges of

the phenomenon at hand allows us to understand better what we are placing at its heart.[8]

Two downfalls of *The Pianist*

The Pianist (2002) is a Polish film because of the Polishness of its director, its funding, its literary source and the nationality of the film's protagonist. However, for the same reasons its Polishness is problematic. Roman Polanski, its director, is in part a Russian Jew, born in Paris. He lived in the USA, uses a French passport and is regarded as the epitome of a cosmopolitan artist and man. The film's main character, Władysław Szpilman, on whose memoirs it is based, is a Polish Jew. Finally, the film is an international co-production, with more than ten companies listed on the IMDb website as its financial backers, including Canal Plus, the Polish state and a number of German film companies. Although one cannot and should not infer the film's ideology solely from the nationalities and political positions of its financial backers, it can be assumed that German engagement in Polanski's project encouraged the director to treat its German characters kindly. Polanski himself, in a documentary accompanying the DVD version of the film, admits that this was the case: he wanted to show some sympathy to the Germans. This task was facilitated by Szpilman's memoirs. As a story of the survival of a Jewish man during various circles of the Holocaust inferno, it includes a number of good Poles and a good German – Wilm Hosenfeld. Hosenfeld, who in civilian life worked as a teacher and was a captain in the Wehrmacht, discovered Szpilman in hiding in Warsaw after the Polish defeat in the Warsaw Uprising of 1944. Upon hearing Szpilman playing the piano, he not only allowed him to walk free, but also helped the man to survive his last winter in Warsaw by bringing him food and warm clothing. Yet, Hosenfeld's noble act was not rewarded. He was taken prisoner by the Soviet army in the final days of the war, and died in a war camp at Stalingrad seven years later, a year before Stalin's death.

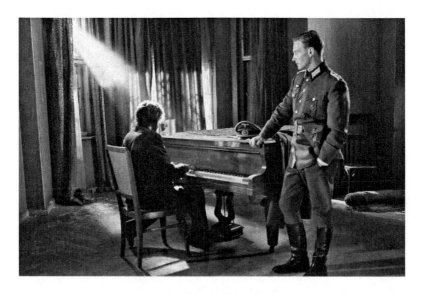

Figure 2.1
Adrien Brody as Szpilman and Thomas Kretschmann
as Wilm Hosenfeld in *The Pianist*

The importance of Hosenfeld for Szpilman's story is underscored by adding to the English and German versions of Szpilman's memoirs, as well as their new Polish version, two parts – 'Extracts from the Diary of Captain Wilm Hosenfeld' and 'Epilogue: A Bridge between Władysław Szpilman and Wilm Hosenfeld', written by German-Jewish poet and essayist, Wolf Biermann. Hosenfeld's memoirs project him as a man who deeply disagreed with Nazi policies.[9] From Biermann's epilogue we learn that Hosenfeld 'had been tortured in captivity because the Soviet officers thought his claim to have saved a Jew a particularly outrageous lie'.[10] In the book Hosenfeld thus comes across as a martyr, who is punished twice, first for being a German, second for helping a Jew.

Polanski does not base his film on Hosenfeld's memoirs, but his film underscores the similarities between Hosenfeld and Szpilman and the connection between the tragic fates of the two men. More than in the book, the film shows both men as music lovers, who do

not lose faith in its power even in the most adverse circumstances. This is visible when Hosenfeld asks Szpilman to play the piano and upon hearing it we see his face radiate with joy, as if transported to a better place. During their last meeting, Hosenfeld brings Szpilman his Wehrmacht overcoat so he does not freeze to death. In a Nazi uniform, Szpilman can be taken for a Nazi although he is a victim of the Nazi ideology. Indeed this happens when he is almost killed by Warsaw's liberators who mistake him for a German soldier. By analogy, because of his uniform, Hosenfeld can be regarded as a follower of Hitler, although in reality his views are distinctly anti-Nazi. Uniforms and labels, we can infer, do mislead – what matters is the soul hidden behind them.

We see Hosenfeld for the last time herded with other German soldiers in a Soviet POW camp, brutally mistreated by the Russians and separated from the civilian population by barbed wire. The Soviet camp looks like the German concentration camps. There Hosenfeld approaches a Polish man, who is Szpilman's friend, telling him that he saved the pianist. After passing this information to Szpilman, the two men visit the place where there was a camp, but find only bare land. We learn from Biermann's epilogue that in the meantime the camp has been moved, but the image offered by Polanski suggests that it was liquidated, not unlike many places where the Germans kept their victims before killing them. Polanski presents the fate of Hosenfeld as more tragic than that of Szpilman because Szpilman survived the war and had a successful career as a pianist and a composer, as demonstrated by him playing Chopin in a concert hall packed with people, while Hosenfeld perished in an inhospitable land, lonely and forgotten.

Both the book and the film primarily concern individuals with atypical histories, not least because a Polish Jew had a very small chance of surviving the war and German soldiers were known for killing Jews, not saving them. However, the viewer also inevitably regards Szpilman and Hosenfeld as representative of groups to which they belonged because of their ethnicity and profession. Szpilman thus stands for the community of Polonized Jewish intelligentsia

and the victims of Nazi policies. Equally, Hosenfeld represents middle-class Germans and Wehrmacht officers. His belonging to Hitler's army is underscored by his Wehrmacht uniform (till the scene in the POW camp we do not see him in different attire) and the casting choice of Thomas Kretschmann, who has played a Nazi officer in nine different films, including *Stalingrad* (Joseph Vilsmaier, 1993), *Downfall* (*Der Untergang*, Oliver Hirschbiegel, 2004) and *Valkyrie* (Bryan Singer, 2008). For the current viewer Kretschmann epitomizes an upper-class Nazi: handsome, virile and fearless, even if good at heart.

By showing Hosenfeld as a good German soldier who helped Jews and perished at the hands of the Soviets, Polanski's film encourages the viewer to distance the Wehrmacht from Hitler's other organizations, such as the Gestapo and SS, which were directly involved in the annihilation of Jews. Secondly, it links the tragedy of the Holocaust with the situation of Germans in Eastern Europe, which led to Poland's 'regaining' German territories. Polanski's discourse on Germany during and after the war is thus not different from that offered by many German conservative historians, especially those engaged in the 'Historians' Dispute', such as Martin Broszat, Ernst Nolte and, especially, Andreas Hillgruber, who in his widely discussed book, *Two Kinds of Ruin: The Fall of the German Reich and the End of European Jewry* (*Zweierlei Untergang. Die Zerschlagung des Deutschen Reiches und das Ende des europäischen Judentums*, 1986), presented Judeocide and Germany's loss of its eastern territory as tragedies of a similar weight.[11]

Of course, Polanski and his collaborators cannot be and were not criticized in the same way Hillgruber was, because, to repeat, his film concerns primarily individuals, not nations, and was made not by a German nationalist, but by a Polish Jew and a cosmopolitan artist. If anything, the director was praised for his magnanimity: the ability to see some good in the nation responsible for his mother's death in a Nazi gas chamber. Yet my purpose in comparing Polanski's *The Pianist* with Hillgruber's work is not to equate Polanski's moral position with that of Hillgruber, but to underscore

a larger shift in the assessment of Germans and World War II, which Polanski's film indicates, concerning Western Europe and, increasingly, Poland. In this discourse 'ordinary' Germans (which also includes German soldiers) still function as Polish enemies, but equally, they are put together with Jews and Poles as victims of the Russians/Soviets, who come across as the arch-perpetrators and ruthless colonizers, responsible for World War II dragging on, in the form of the Cold War, practically until the end of Communism. Similarly, the good German, unlike in the films made during communist times, most famously in Jakubowska's *The Last Stage*, is no longer good because he is a communist. His goodness is linked to his religious faith and rejecting any grand-scale ideologies. He is pitted not only against Nazism, but also against a godless, barbaric communism, against which, as an individual, he has little chance of winning.

In his perceptive review of *The Pianist* Michael Oren argues that the film promotes what can be described as a 'European ideal', marked by, among other things, cosmopolitanism, aversion to power and atheism.[12] In my view, adhering to this ideal requires also treating with sympathy and understanding all those who belong to Europe and their ancestors, defined currently largely by membership of the main European political organizations such as the European Union. This leads to playing down the old (colonial) animosities or displacing them outside Europe, as defined above, in this case towards Russia, as we observe in Polanski's film.

The suffering of a Masurian woman in *Róża*

Some of the ideas that are only suggested in *The Pianist* are presented openly in *Róża* (2011), directed by Wojtek Smarzowski. In comparison with postcommunist cinema, this film offers a new structuring of the community of the victors and victims of World War II, with Poles and Germans represented as victims and Russians as victors and perpetrators. The film focuses on Tadeusz, a Polish ex-Home Army soldier. It begins by showing Tadeusz's

wife being raped and killed by some German soldiers during the Warsaw Uprising of 1944. The widowed Tadeusz then moves to 'regained territories', where he meets Róża, a widowed peasant woman. During the course of the film Masuria is represented as a borderline territory, whose inhabitants have a distinct identity, neither German nor Polish. However, they are seen from outside as one or the other and the political situation forces them to take sides, and it is suggested that during the war they leaned more towards Germany. Róża's husband fought on the German side, but she is described as somebody who was sympathetic towards Poland. Tadeusz moves in with her to protect her from Russian 'liberators' and their Polish sidekicks, who are in reality invaders, stealing from her farm and raping her repeatedly. In due course Tadeusz falls in love with her. Hence, the old animosities are buried and the Polish man and a woman who, from a Polish perspective, is German, forge a new alliance, this time against the communists, most importantly Russian. The similarity of the Polish and Masurian fate is strengthened when Róża develops cancer as a result of the multiple rapes and dies and Tadeusz is sent to a Stalinist prison, where he survives physically, but becomes a physical wreck, unable to resume his life when he is eventually released.

Another specificity of *Róża* is its emphasis on the primacy of gender identity over the national one. The female heroine of the film suffers not so much as a member of a specific nation, but as a woman: being sexually and physically abused. In this respect the film draws a parallel between her fate and that of Polish women raped and killed by German soldiers during the war. This parallel did not elude the critics. Agnieszka Morstin discusses Smarzowski's film together with *Jak być kochaną* (*How to be Loved*, 1962) by Wojciech Jerzy Has, which tells the story of a Polish woman, Felicja, who was raped during the war by German soldiers. She also compares it to the recent women-focused films about war crimes, such as *Grbavica* (*Esma's Secret*, 2006) by Jasmila Zbanic[13] and mentions two million German women living in the East who were raped by Soviet soldiers during the final phase of the war.[14] The thrust of her

argument is that all these women are in an equal measure victims of the war: the German women are no less innocent than the Polish or Bosnian ones, not least because they suffered similar injuries. Ultimately, such an argument renders national differences if not entirely unimportant, then secondary.

Metamorphoses of Franz Maurer in Władysław Pasikowski's films

Franz Maurer appeared for the first time in Władysław Pasikowski's *Dogs* aka *Pigs* (*Psy*, 1992). Played by the popular Polish actor, Bogusław Linda, he is a member of the communist political police, the SB (known as *ubek*), during the country's transformation from Communism to postcommunism. Although nobody questions Franz's nationality, and he does not allude to having any German ancestors, his surname sounds distinctly German and there is no custom to name Polish Franciszek 'Franz'. 'Maurer' not only sounds German, but also rhymes with Mauser, a type of German pistol. Franz drives a German BMW car and sports a bomber jacket, which has a dual German and American association. Franz's Germanness at times is part of his overall Western outlook, marked also by smoking Camels, drinking whisky, living in a spacious house fitted with an open fireplace and being divorced from an affluent woman, who conveniently emigrated to the West, leaving her wealth to Franz (or at least it looks this way initially). Franz provides a contrast to his boss who prefers Polish cigarette brand Radomskie, and his old pals who drink Polish vodka and live in ordinary apartments in unattractive communist blocks.

The question arises as to why Pasikowski 'Germanized' the Polish *ubek*. In my view, not to render this organization a Polish Gestapo but, on the contrary, to make it look more sympathetic and, especially, to edify Franz over other characters in the film. Showing Linda's character as a normal Polish *ubek* would make this aim more difficult to achieve. Pasikowski's effort to render Franz as attractive is laid bare in the early scene of the film, presenting Franz subjected to

'verification', a procedure meant to establish who from the old secret service is suitable to make the transition to the civil police. During its course we learn that he was a marksman of the highest standard (one would like to say of German quality): he was able to shoot a man from over 200 metres. He also proved able to act independently and thanks to that saved the lives of innocent people, including women and children.

These attributes which Maurer reveals during his interrogation lead the viewer to believe that Franz joined the secret services not for material advantage or to serve the communist cause, but for adventure: to prove himself as a male at a time when men had little opportunity to fight in wars, not unlike young men in the West joining the FBI, CIA or MI5. This association is later augmented by people frequently calling Franz 'the Saint', which refers both to Franz's selfless behaviour and to the popular British 1960s spy series, starring Roger Moore. Not surprisingly, Jane Perlez of the *New York Times* saw in Linda a local incarnation of an eternal macho type and compared him to Mickey Rourke.[15] Yet, Polish viewers might also regard him as a descendant of Kloss, the most famous Polish secret agent on-screen prior to Franz Maurer. The connection with *More than Life at Stake* is strengthened by its being shot in a limited range of colours, with a prevalence of sepia, which denaturalizes postcommunist reality, making it look like a re-presentation (of old films). Pasikowski thus constructs Franz as a hybrid of the best features of (stereotyped) Poles and Germans, Westerners and Easterners, gleaned from different periods of political and film histories of these countries and regions. In order to align Franz with the best features of the East and the West, Pasikowski distances him from those who were regarded as the worst. This happens through the introduction of the motif of ex-Stasi's who post-1989 transformed into the mafia, dealing in drugs and stolen cars, and joining forces with Polish gangsters. Franz not only refuses to be a part of this new postcommunist 'bloc', but fights against it. Rendering Franz as both sympathetic and believable is facilitated by casting Bogusław Linda in this role. Linda was one of the main

actors of the cinema of Moral Concern of the late 1970s, thanks to roles in films by Krzysztof Kieslowski and Agnieszka Holland. From my perspective, his role as the cosmopolitan Bolko, one of three sons of Hans Heinrich von Teuss in *The Magnate*, is also significant. As Franz, Linda in some measure revisits this role, although the discourse on nation is, in comparison with Bajon's film, subdued.

After *Dogs* Pasikowski made four more films with Linda: *Dogs 2. Last Blood* (*Psy 2. Ostatnia krew*, 1994), *Demons of War According to Goya* (*Demony wojny według Goi*, 1998), *Samum Operation* (*Operacja Samum*, 1999) and *Reich* (2001). The German subtext of Linda's characters in *Dogs 2* and *Demons of War According to Goya* is still present, but it is displayed largely in a non-Polish, Balkan context; therefore I will leave these films out of my analysis, moving to *Reich*, where Polish–German relationships are more prominent, as its title indicates. The film is set among Polish and German gangsters, dealing in drugs and stolen cars. Linda's character, a contract killer is, not unlike in *Dogs*, furnished with the rather non-Polish name of Alex. We meet him for the first time in Berlin, conversing in German with other gangsters. Soon, with his new friend Andre, a man of similar, mixed identity, he goes to Poland. He claims that he wants to retire from his life as a gangster, but in reality he participates there in more action, involving stolen cars and beautiful women. Alex also comes across as a hybrid figure. In Berlin, he is frequently contemptuously described as a 'softie', whose proper place is in Poland, because the tough German reality does not suit him. Alex himself agrees with this assessment, as demonstrated by his story of sparing the life of the child of a man whom he assassinated, which seriously undermined his credentials as a contract killer. Of course, this story shows his difference from more brutal members of the German mafia, who lack similar prejudices, and attests to Franz's Polishness. Yet in Poland, Franz functions as 'the man from Reich'. This is confirmed by his frequent telephone conversations with his German superiors, his musing on his time in Germany, and driving a convertible Mercedes, which is also a sign of his position as a high-ranking gangster. For members of the Polish mafia operating

Figure 2.2
Bogusław Linda as Franz Maurer in *Dogs*

in Gdańsk, Alex is not a softie, but a hardened criminal. His very name awakens respect in them. As the mafia boss says: 'If Alex wants to get rid of us, we are already dead.' Yet even for Poles, German gangsters do not constitute the peak of viciousness and brutality; this place is occupied by Russian gangsters. The boss of the Gdańsk mafia, upon learning about the brutal murder of several of his men, immediately assumes that the gory job was done by the Russians. His assumption proves false, but making it suggests that in postcommunist Poland the Russians took over from the Germans as the chief 'baddies'. In this respect, *Reich* bears resemblance with *The Pianist* and *Róża*.

In Pasikowski's film Germany is presented as a multicultural country, full of immigrants from different parts of the world. Alex's comrades from the gang all speak German, but their names and appearance do not strike one as particularly German; some probably came from ex-Yugoslavia or Turkey. Alex's friend, Andre, like Alex,

was born in Poland but lived in Germany for many years and turns out to be a secret agent working for the German anti-drug police unit. Gdańsk and Łódź, where the bulk of the film is set, come across as 'more Western than the West', with all the stereotypical features of Western decadence: night clubs, drugs, prostitution, expensive cars, multinational hotels and fake Italian mansions where large sums of money are exchanged. Poland and Germany are thus projected as sisters and rivals. This position is reflected in a well-known joke told in Berlin by a German gangster: 'Go for a holiday to Poland; your car is already there.' But the response to this joke by another member of the German mafia – Poles steal so much in Germany that soon there will be nothing left for Germans to steal – undermines its sarcasm. The two countries, as presented by Pasikowski, are so similar because they both belong to a ruthless world of neo-liberal capitalism, where people can succeed only by eliminating their opponents. This diagnosis is confirmed by the film's ending in which Andre, whom Alex regarded as his best friend, discloses to him that he got an assignment to kill Alex. Linda's character has to die because as an 'honest gangster' he does not suit this ruthless world, in which neither nationality nor friendship count and the only colour that matters is the colour of money.

Conclusion

I argue that after the fall of communism Polish cinema has offered more positive images of Germans and Germanness than ever before. We find in it splendid men, who attract Poles with their nobility and virility. A touch of Germanness is used to add charm and charisma to Polish characters, as shown in *Dogs*. We even observe a gradual obliteration of the difference between Germans and Poles. In *Reich* it is difficult to establish who is a German and who is a Pole, where Germany finishes and Poland begins, a clear sign that they belong to a postcolonial order. There is also an attempt to see Germans as victims, while recognizing Poland's own war and postwar crimes,

as in *The Pianist* and *Róża*. We can also see that the neighbouring relations between Poles and Germans are somewhat mediated or coloured by their relationship to Jews. The shift towards more positive representations of Germans and Germany is at the expense of the Russians who, in postcommunist cinema, took over from the Germans as Polish arch-enemies and are made responsible for the suffering of Poles and Jews.

These changes can be seen in the context of the good relationship between Poland and Germany after the collapse of Communism. In the Polish popular press, after 1989, we often encounter the phrase 'Germany, Poland's main ally in the European Union'. By contrast, the Polish relationship with Russia has not been so good in a comparable period. Another factor showing Poland and Germany as similar is their belonging to the late capitalist world, where national divisions matter less than they used to. This can be seen as the reverse of the postwar political trend of 'rationalizing' the territories of Europe and making the countries mono-national. The films discussed in this chapter advocate and justify the trend of bringing the old enemies back together.

Notes

1 Maria Janion, *Niesamowita Słowiańszczyzna: Fantazmaty literatury* (Kraków: Wydawnictwo Literackie, 2007), p. 10.

2 Anda Rottenberg, 'The Mythological Foundations of History', *Herito* 1:1 (2010), p. 23.

3 Thomas Elsaesser, 'Space, Place and Identity in European Cinema of the 1990s', *Third Text* 20:6 (2006), pp. 647–58.

4 Andrzej Gwóźdź, 'Teutonic Knights, Hakatists, Fascists: The Picture of the German in the Polish Post-War Cinema', *Canadian Review of Comparative Literature* 3 (2007), p. 352; Eugeniusz Cezary Król, 'Czy w polskim filmie fabularnym lat 1946–1995 istnieje wizerunek "dobrego Niemca"? Przyczynek do dyskusji nad heterostereotypem narodowym w relacjach polsko-niemieckich', *Rocznik Polsko-Niemiecki* 15 (2007), p. 68.

5 George Steiner, *Language and Silence: Essays 1958–1966* (London: Faber and Faber, 1967), p. 137.

6 Sławomir Bobowski, 'Wielka mistyfikacja: Ziemie Odzyskane w kinematografii PRL-u', *Pamięć i przyszłość* 1 (2008), p. 46.

7 Krzysztof Teodor Toeplitz, *Mieszkańcy masowej wyobraźni* (Warszawa: Państwowy Instytut Wydawniczy, 1972), p. 163.

8 Michel Foucault, 'Questions of Geography', in *Power/Knowledge* (New York: Harvester Wheatsheaf, 1980), pp. 67–8.

9 Wilm Hosenfeld, 'Extracts from the Diary of Captain Wilm Hosenfeld', in Władysław Szpilman, *The Pianist* (London: Phoenix, 2002), p. 203.

10 Wolf Biermann, 'Epilogue: A Bridge between Władysław Szpilman and Wilm Hosenfeld', in Władysław Szpilman, *The Pianist* (London: Phoenix, 2002), p. 215.

11 On the discussion of their position see Robert G. Moeller, *War Stories: The Search for a Usable Past in the Federal Republic of Germany* (Berkeley, CA: University of California Press, 2001), pp. 51–87, 171–98; Perry Anderson, *A Zone of Engagement* (London: Verso, 1992), p. 173.

12 Michael B. Oren, 'Schindler's Liszt: Roman Polanski's Mistake about the Holocaust', *The New Republic*, 17 March 2003, p. 28.

13 Agnieszka Morstin, 'Mocne filmy i głębokie kompleksy: *Róża* Wojtka Smarzowskiego wobec *Jak być kochaną* Wojciecha J. Hasa', *Kwartalnik Filmowy* 77–78 (2012), pp. 201–10.

14 Morstin: 'Mocne filmy i głębokie kompleksy', p. 205.

15 Jane Perlez, '*Psy 2: Ostatnia krew* (1994): Pole Makes Hollywood Formula His Own', The *New York Times*, 30 April 1994. Online. Available at <http://movies.nytimes.com/movie/review?res=9C05E5 DD1230F933A05757C0A962958260> (accessed 3 May 2010).

References

Anderson, Perry, *A Zone of Engagement* (London: Verso, 1992).

Biermann, Wolf, 'Epilogue: A Bridge between Władysław Szpilman and Wilm Hosenfeld', in Władysław Szpilman, *The Pianist* (London: Phoenix, 2002), pp. 209–22.

Bobowski, Sławomir, 'Wielka mistyfikacja: Ziemie Odzyskane w kinematografii PRL-u', *Pamięć i przyszłość* 1 (2008), pp. 41–9.

Elsaesser, Thomas, 'Space, Place and Identity in European Cinema of the 1990s', *Third Text* 20:6 (2006), pp. 647–58.

Foucault, Michel, 'Questions of Geography', in *Power/Knowledge* (New York: Harvester Wheatsheaf, 1980), pp. 63–77.

Gwóźdź, Andrzej, 'Teutonic Knights, Hakatists, Fascists: The Picture of the German in the Polish Post-War Cinema', *Canadian Review of Comparative Literature* 3 (2007), pp. 352–60.

Hosenfeld, Wilm, 'Extracts from the Diary of Captain Wilm Hosenfeld', in Władysław Szpilman, *The Pianist* (London: Phoenix, 2002), pp. 191–208.

Janion, Maria, *Niesamowita Słowiańszczyzna: Fantazmaty literatury* (Kraków: Wydawnictwo Literackie, 2007).

Król, Eugeniusz Cezary, 'Czy w polskim filmie fabularnym lat 1946–1995 istnieje wizerunek "dobrego Niemca"? Przyczynek do dyskusji nad heterostereotypem narodowym w relacjach polsko-niemieckich', *Rocznik Polsko-Niemiecki* 15 (2007), pp. 31–78.

Moeller, Robert G., *War Stories: The Search for a Usable Past in the Federal Republic of Germany* (Berkeley, CA: University of California Press, 2001).

Morstin, Agnieszka, 'Mocne filmy i głębokie kompleksy: *Róża* Wojtka Smarzowskiego wobec *Jak być kochaną* Wojciecha J. Hasa', *Kwartalnik Filmowy* 77–78 (2012), pp. 201–10.

Oren, Michael B., 'Schindler's Liszt: Roman Polanski's Mistake about the Holocaust', *The New Republic*, 17 March 2003, pp. 25–8.

Perlez, Jane, '*Psy 2: Ostatnia krew* (1994): Pole Makes Hollywood Formula His Own', The *New York Times*, 30 April 1994. Online. Available at <http://movies.nytimes.com/movie/review?res=9C05E5DD1230F93 3A05757C0A962958260> (accessed 3 May 2010).

Rottenberg, Anda, 'The Mythological Foundations of History', *Herito* 1:1 (2010), pp. 14–27.

Steiner, George, *Language and Silence: Essays 1958–1966* (London: Faber and Faber, 1967).

Toeplitz, Krzysztof Teodor, *Mieszkańcy masowej wyobraźni* (Warszawa: Państwowy Instytut Wydawniczy, 1972).

3

'I'm at Home Here': Sudeten Germans in Czech Postcommunist Cinema

Petra Hanáková

A memorable series of Czech commercials made in 2007 presents the 'national treasure', Pilsner Urquell beer, as a source of inspiration for great national achievements throughout Czech history. One of the ads features Josef Jungmann, a prominent nineteenth-century Revivalist and the author of the first Czech–German dictionary, distributing leaflets and promoting the beauty of the Czech language to the uninterested crowds on the streets of Prague. Dispirited after a day of failures, he meets other Revivalists typically in a pub, confessing he does not know how to continue his mission. Yet suddenly a glimpse through the beautifully coloured beer in a glass mug inspires in them all a eulogy on the beer and the language, which both, as they say, delight the mouth and cheer the national spirit. In the final shot, the whole room rises to an elated toast, which ends abruptly when Jungmann thanks the waiter for the next beer – in German.

This little joke, the punch line provided by the German word *danke* that automatically slips from the mouth of the famous Revivalist, sums up tellingly the paradoxical character of the relations

between Czech and German culture that for centuries coexisted in Central Europe and fought for cultural hegemony in the area of the historical Czech lands. Since the Middle Ages, the area known as Bohemia has been home to people of both Germanic and Slavic origin, which generated both productive cultural contacts and ethnic frictions. Celebrated Czech nineteenth-century historians like František Palacký saw the contact between the Czech and German populations as formative, and believed the struggle of the Czech nation against attempts at Germanization was vital to the formation of the 'imagined' memory of the modern national community.

When Janusz Korek ponders the question of the relevance and usefulness of postcolonial theory for the situation of Central and Eastern Europe – a location that diverges vastly from the traditional idea of colonies situated far beyond the seas and controlled from a distance – he points out that the scholarship has so far focused mostly on the Soviet imperial treatment of the satellite socialist states, and emphasizes the necessity of *historicizing* the colonial past of regions squeezed between the borders of the so-called East and West:

> The postcolonial perspective on Central and Eastern Europe ... should not concentrate exclusively on the issue of the Soviet period versus the post-Soviet one. Such a view is insufficient for an understanding of many cultural, social and political processes taking place both before and after de-Sovietization. It would be desirable to take a postcolonial look at the whole region, its literature and culture, and to describe the imperial experiences of all the pretenders to hegemony, not only Tsarist Russia, as Said suggested. He also observed, by the way that Ukraine and Poland, just like the other countries and nations of Central and Eastern Europe, had found themselves in the spheres of influence of not one but two imperialisms: Russian and German. This partly explains, incidentally, why the problems connected with this region of Europe were either ignored or falsified in the cultures and academic scholarship of both these empires.[1]

There is no doubt that certain historical co-ordinates of the Central European experience have overtones of encounter with, or resistance to, colonial demands. Looking at the interaction between nations and cultures in this area (in the case of this chapter, German and Czech cultures in the area of the Czech lands) can on one hand shed some light on the intricacies of colonial situations within the confines of Europe with its historical mixing, overlapping and intercultural struggle. But at the same time, the basic terms of postcolonial thinking – the elemental concepts like home and world, native and foreign, settlers and colonizers, closeness and distance, compliance and revenge are here blurred, disclosed as indefinite, and revealed as ethically problematic. In what follows, I want to look at three films from the period of postcommunist cinema and see how they visualize these terms and conflicts, with the main focus on the representation of Czech and German relations.

The Germans since (at the latest) the Middle Ages have been far more than just the Western neighbour of Bohemia or the Czech lands – they have been a continuous presence in the area, a constant influence and sometimes a (colonial) threat to the Czechs – especially during the aggressive Germanization and re-Catholicization of Central Europe spanning three centuries following the Battle on the White Mountain in 1620. At the same time, Czech history does not equal the history of the Czech lands. The definition of nationality in this area has been historically less connected to ethnicity than to the allegiance to land, so that still in the nineteenth century some commentators talked about the inhabitants of Bohemia as one nation speaking two languages and used the denomination *böhmisch* (the German expression for 'Bohemian') for both the Czech and German population. The tensions between Germans and Czechs escalated and the ethnicity principle of course prevailed during the Czech National Revival in the nineteenth century and was sealed by the establishment of the independent Czechoslovakia in 1918, in which the German minority (about three million people) formed almost a quarter of the country's population. The last and most tragic chapter in

this history was written during the Protectorate, as the *böhmisch* Germans' support of Hitler eased the secession of the Sudetenland to the Reich in 1938, which in turn caused the Czech backlash after the liberation, including the acts of frantic aggression towards the German minority in the first months after the war – the so called 'wild expulsion' preceding the organized *odsun* ('full deportation') of Germans from the Czechoslovak Republic during the first two years after liberation, which corresponded with the massive expulsions of Germans from other parts of Eastern Europe.[2]

The representation of Germans in Czech culture mirrors this complex historical experience and the situation in which the German is never just the neighbour most of the time securely separated by borders, or even the ruthless invader and colonizer. The Germans also represent the uncanny Other, the *inner* enemy threatening the integrity of the nation and questioning the very definition of the national self from within, by living too close, sometimes in the same place (sharing the same 'home') and often negating the disparity in lifestyles and behaviours expected from distinct nationality and ethnicity. The Germans, in many ways, have always been too close and too like the Czechs. (While I do not have exact data at hand, from the historical accounts it is obvious that intermarriages between the German and Czech communities were far from rare, and also that most of the populace in areas with high level of ethnic mingling had to be in principle bilingual.)[3]

The image of Germans in Czech culture and specifically in literature has already been researched in several projects,[4] with the conclusion that strong anti-German sentiments appear as early as the early fourteenth-century *Chronicle of Dalimil* and culminate in the nineteenth and twentieth centuries first with the Revival and then with the brutal experience of the war.[5] Within the iconography of Germans in Czech literature and cinema in the twentieth century, and specifically in its second half, one particular figure stands out most as the epitome of the national strife – the ominous figure of the Sudeten German. The denomination Sudeten or Sudetenland is now commonly used for all the borderline areas of Czechoslovakia

where the German population had clear majority – although the title is historically imprecise, as Sudeten was the name for only one of the four regional Czechoslovak governmental units with German demographic predominance that were established in 1918. The term Sudeten German also underwent a specific generalization – it goes beyond an ethnic and local label, and embodies ambivalently both the perfidy (the shocking betrayal of the closest neighbours who joined the enemy before and during the war), and the guilt at least latently felt by parts of the Czech population in respect to the expulsion, although it was rationalized as a necessary cleansing, a final reckoning with the German 'Fifth Column' that helped Hitler to bring down Czechoslovakia and plotted to expropriate the Czech areas and hand them over to the Reich.

While tensions and nationalistic conflicts can be found in the representations of the Czech and German community in the Sudetenland already in the 1930s, the figure of the Sudeten German became a major troubling presence in Czech cinema after the war. Jan Sedmidubský, in his substantial but still unpublished thesis *The Image of the Sudeten Germans and the 'Sudeten German Question' in Czech Cinema 1945–1969* (*Obraz sudetských Němců a sudetoněmecká otázka v českém hraném filmu 1945–1969*), reiterates the basic coordinates of the problem. First, the image of the Sudeten German was conflated in the postwar years with the image of German Nazism, as the Czech border areas witnessed relatively rapid politicization and change in the behaviour of the local Germans towards the Czechs during the period of Nazi indoctrination. Secondly, during the war, a significant percentage of Sudeten Germans actively accepted Nazi ideology and put it into everyday practice in the Protectorate, and thirdly, the Czechs retroactively believed that the Sudeten German irredenta significantly contributed to the initial unleashing of the war.[6]

Sedmidubský shows how the representation of German characters in film tends towards the stereotype of an ungrateful, untrustworthy and unwanted neighbour, always ready to stab the Czechs in the back, and at all times driven by the inborn urge to

dominate and harm. The few films that contradicted this stereotype and blurred the typical national attributes of the German/Czech (or even Soviet) characters, most notably the cause célèbre of *Carriage to Vienna* (*Kočár do Vídně*, Karel Kachyňa, 1966), were criticized as revisionist and, most of all, antinational. The iconology of Germans as the enemy was of course gradually complicated by the growing political need to present the 'Eastern Germans' from the GDR as 'the good Germans' and to distinguish them from the Western Germans who had to be pictured as the epitome of evil. This tendency was already present in Czech cinema in the 1950s, notably in the musical *Tomorrow Everyone will be Dancing* (*Zítra se bude tančit všude*, Vladimír Vlček, 1952), which takes place in Berlin at the Festival of Communist Youth. The trend of course reaches more prominence in the 1970s in TV productions and co-productions. Typically, the Eastern German is never pictured as a Sudeten German by origin, as this would blur too strongly the dichotomy of good/bad neighbour. Nevertheless, picturing the (Western and/or Sudeten) German as the enemy can be read throughout the socialist period as an act of patriotism, a confirmation of the right to the land and the proof of rightfulness of the expulsion. As Sedmidubský concludes:

> In any case, the films picturing Sudeten Germans contributed at the time to the consolidation of the Czech 'revivalist nationalism' and its dream to unify and dominate the Czech lands on the basis of Revivalist ideals as the home of the one and only nation that henceforth will no longer have to deal with the 'foreigners', and will not need to beg any other nation for its own sovereignty. After the experience of the Munich agreement, it is implicitly assumed that minorities can – and inevitably always will! – cause only problems.[7]

This longer historical exposé is necessary for understanding the intriguing variety and complexity that the postcommunist cinema brought to the contested area. The diversification of German iconography in the last decade was triggered by the change in

awareness and availability of information about Czech crimes against Germans committed after the end of the war that were brought to light by historical research and reflected in the mainstream media. The so-called 'Brno death march', in which 20,000 to 35,000 Germans from the city of Brno were forced to march to the Austrian borders in inhuman conditions, became especially well known[8] as did the highly publicized case of Dobrotín, where the massacre of ethnic Germans in the first days after the war was only recently confirmed by archaeological excavations and forensic analysis.[9]

While there are other cinematic projects with marginal characters of German or Sudeten German origin, I will consider here three films made in the last decade that show different uses and modification of the stereotype of the German as the hostile Fifth Column of the Czech lands. Two of these films are big-budget productions set during the war, which both did rather well at the box office and thus had the potential to communicate widely the new readings of the iconography – *Divided We Fall* (*Musíme si pomáhat*, Jan Hřebejk, 2000) and *Habermann's Mill* (*Habermannův mlýn*, Juraj Herz, 2010). The third example, *Champions* (*Mistři*, Marek Najbrt, 2004), is an art-house film set vaguely in the present, which was well received by critics but ignored by mainstream audiences. While catering to different types of spectators, all of the films struggle with clichés that plague the contested area of national representation.

Prohaska, the good unbearable man

Jan Hřebejk and his co-author, the writer Petr Jarchovský, dedicated the three films of their 'historical trilogy' to traumatic events and periods in twentieth-century Czech history – the first movie, *Cosy Dens* (*Pelíšky*, 1999) is set during the Prague Spring, *Divided We Fall* takes place during the German occupation and *Pupendo* (2003) in the normalization years. *Divided We Fall* follows the story of the Čížeks (literally 'little Czechs'), a middle-aged childless couple who are trying to do the right thing during the war – first by keeping

as low a profile as possible, then, after hiding David, an escaped Jew, by a series of camouflage actions that help them survive and sidetrack the German officials that administer their little town. But the main threat for most of the film comes not from the Germans that arrived with the war, but from one who has been there before – Horst Prohaska, the Sudeten German acquaintance of the Čížeks. Prohaska is a prototype (and stereotype) of the Sudeten German as presented by the Czech derogatory expression *Sudeťák*. He is loud, pushy, nosy and unpredictable; it is often hard to tell if he is 'just' joking or openly menacing the Čížeks. Sporting a Bavarian-style jacket, breeches and Hitler-like moustache, he is the caricature of all things German; by speaking perfect Czech and identifying with the region, he is at the same time too close to the community of the Czechs (even his name, Prohaska, is a Germanized version of the traditional Czech name Procházka). He is played by well-known Czech comedian Jaroslav Dušek, who mostly speaks Czech in the role (switching to German only in exchanges with his children and Nazi officials, and his German has a strong Czech accent), which strengthens the local, familiar and 'native' feel of the character.

The story of Prohaska's friendship with Mr Čížek dates back to their childhood and is a familiar tale of mockery, where the Czech children called Prohaska *Wurst* ('sausage' in German) instead of Horst and Čížek defended him, and Prohaska now feels he has to repay the Čížeks by helping them survive during the occupation. His gratitude doesn't stop him from lusting after Mrs Čížek. His wooing often crosses the line, in one case nearing attempted rape, which the film, in its efforts of reconciliation, turns into a comic scene. This is an important motif from the postcolonial perspective. On one side, Prohaska here openly connects rape to eugenics – he is praising Mrs Čížek not directly for her beauty, but for her Aryan, or 'Nordic', features (*nordische Rasse*, as he says) and claims that their union would produce perfect children for the new society. On the other side, rape has been exposed in postcolonial theory since the classical texts by Edward Said both as a metaphor for

the functioning of colonialism and the actual power mechanism of colonial exploitation and oppression, a reference which is also valid here. Yet, in the context of the Czech lands, another important allusion comes to mind – the constant and troubling fascination of German writers with the Slavic woman as the ultimate (sexual) muse. Immortalized in Pavel Eisner's book *Lovers: The German Poet and the Czech Woman* (*Milenky: Německý básník a česká žena*, 1930), where Eisner (a Prague literary scholar and translator fluent in German, Czech and French) explains how only through the physical encounter with the Czech, Slavic woman, can the German writer embrace his intellectual genius. This intercultural instinctual attraction and animalization of the 'native' woman that stimulates intellectual creativity can be traced in many literary works of the period, and again shows more complex psycho–sexual dynamism in the contact of cultures than can be simply subsumed under a rubric of colonial exploitation of one group by another.

Yet Horst is not an intellectual, but more than anything else a pragmatist – a personal trait that appears convenient and even advantageous during the war. He is a typical collaborator, but not because of his political convictions – fascist attitudes and decisions are here displaced, presented only as an influence of his wife (he refers to her as 'that fanatic of mine', in a *cherchez-la-femme* type of sexist guilt displacement), whom we never see and who escapes to the Reich before the war and the film are over. Where the Čížeks are naive or downright cowards, Prohaska is savvy and persistent. He specifically teaches the Čížeks the art of mimicry (as he says: 'loyal expression' is vital so 'that Germans, who are excellent typologists, cannot read what you think'). He repeatedly distances himself from 'the Germans', refuses to move to the Reich ('This is my home!', he claims) and reveals his support for the Nazis only as a strategy for survival.

Horst as a type is unmistakably a stereotypical character; he has all the bad traits attributed commonly to the (Sudeten) Germans. But what changes in the film is the treatment of this in many ways negative character. The main motto of the film – which literally

translates as 'we have to help each other' (or 'divided we fall' in the English version and 'we have to stick together' in the German version) predicates a certain moral relativism, a higher tolerance for dubious acts once they have good reasons and can be read as survival strategies. Although the atrocities of the war are always at least latently felt as the background of the story, it also presents the belief that beyond any national or political façade, there is a good man inside, capable of the right feelings and of helping others. Even the Nazi town official who at the beginning insists on the superiority of the Germanic race and sends his sons proudly off to death at the Eastern front, is at the end pictured as a broken old man who apologizes to the Czechs. We may see here a similarity to the recent tendency to humanize the Nazis in European cinema (Oliver Hirschbiegel's *Downfall* (*Der Untergang*, 2004) might be the best example of this trend). Yet, here the Nazi official is only a background figure, and the main conflict is played out between Horst and the Čížeks, as 'little people' unsuccessfully trying to avoid politics and continue living their uncomplicated lives.

In this context, *Divided We Fall* not only uses the stereotype of Germans – it builds all the characters on stereotypical models: Čížek is the dove-like-natured Czech, likeable but feeble and cowardly, his wife Marie is the Marian figure who longs for a child, Horst is the typical intrusive *Sudeťák*, David is the cultured, refined and educated Jew, one of the Soviet soldiers is a yokel who has never seen a water tap before, the resistance fighters are inhumanly uncompromising and have no tolerance for any suspicious behaviour. There is significantly always only one representative of each of the stereotyped groups, and all the clichés involved provide the characters with certain equality – all of them are shown as inherently 'decent people' (*slušní lidé*) with excusable little flaws, but also as people who happen to live in 'abnormal times' and thus are forced by circumstances to behave abnormally. Helping others here means also forgiving and forgetting, and sharing the belief that evil does not reside in people's individual acts, but comes from the outside.[10]

The symbolic final scene of the film presents a dreamy vision in which Čížek shows his newborn son (born on the day of liberation and virtually a product of 'collaboration', brought to this world by mutual efforts of Čížek, Prohaska and David) to a group of German and Jewish ghosts sitting together at the table. The final reconciliation – both of the living and the dead – is achieved through the valorization of the stereotype as a mask, a strategy, or a façade that only hides the generally good nature of the 'normal people'. Ethnicity and even politics in this configuration virtually lose all importance, and although the film valorizes the (typically negative) stereotypes, they are replaced by another schema that results in the absolution of any guilt and also the eradication of historical memory itself. Symbolically, the film ends with a vision of the continuation of the Czech nation as a product of ethnic mixing, but at the same time, at the end of the film all the German children who appear throughout the story are already back in Germany or dead. Germans thus become ghosts, and even though Horst is allowed to stay, the film is conspicuously silent about what place he will have in the new society.

Although the film promotes forgiveness and forgetting, from another perspective it also presents a deeply problematic vision of the specific plight of the Czechs in the history of the region. The film was criticized by a leading 1990s critic, Andrej Stankovič, as not only ahistorical and profoundly ideological (i.e. expressing the ideology of Czech survival as the imperative that excuses all morally dubious acts), but also anti-Semitic (suggesting that if it weren't for the Jews, the Czechs could survive the war without getting discredited by the collaboration[11]). In reaction to this review, the director of the film both published a hostile reply in the same newspaper and sent an extremely rude denunciatory letter of protest to the Ministry of Culture in which he asked for the reviewer to be fired. This gesture of intolerance for different readings, typical more of the communist times, reveals the investment in the 'right' interpretation of the film that on the surface promotes hybridity and reconciliation between cultures but remains blind to the possible

ideological bias implicated in the story. This position is in many ways symptomatic of the postcommunist Czech culture in which re-readings of the past are welcomed in mainstream works only if they at the same time support the stereotypical image of the Czechs as blameless victims of history.

Ziege, the return of the repressed

Marek Najbrt's *Champions* (*Mistři*, 2004) brought to the cinema screens a different type of Sudeten German – the one that returned to the Czech Republic after the fall of the Iron Curtain. He significantly differs from previous portrayals of the German returnees: in films and TV dramas made during the socialist times, Sudeten German characters typically come back as spies and wrongdoers plotting against the communist regime – these characters appear in

Figure 3.1
In *Champions*, the returnee Ziege (Will Spoor) takes care of the local cemetery, the reminder of the expelled German community.

Czech cinema during the whole socialist period (a typical example is Otakar Vávra's *Night Guest/Noční host*, 1961) and also play an important role in the popular propagandistic TV series *Thirty Cases for Major Zeman (Třicet případů majora Zemana*, 1974).[12]

Although *Champions* is obviously set in the present, the film has a strangely timeless feel as the action takes place in a run-down village in the middle of nowhere, where a community of Czech misfits laze around in an improvised local pub. Another inhabitant of the village is an old German called Ziege, who is allowed to stay in his former house when the residents from the city (who use it as a weekend cottage) are not around. This does not particularly please the current owner of the cottage Pavel (he reproaches his ex-wife for letting Ziege return to the house, calling her in a fit of anger 'a merciful cow').

Ziege differs from the rest of the group – he represents history, rootedness, sacrality and memory – while the Czech community is totally alienated, defunct and downright hostile, he is calm, connected to the land and rooted in the memory of his forefathers. While the Czechs bond over modern rituals, specifically while watching the hockey championship on a semi-functional TV, he represents religiosity, superficially by switching the TV to a religious channel, but also on a deeper level by taking care of the church and cemetery. Half deaf, about two generations older and speaking only German (he is portrayed by a Dutch actor Will Spoor), he is the spectre from the past, but not a menacing presence, more a reminder that the village was deprived of its historical memory. Ziege cannot represent the powerful fears that originated immediately after the expulsion – the dread that the Germans will return even stronger and claim what was theirs, fulfilling the aggressive vision of a new invasion and revenge. He is more of a ghost – and he spends most of his time in the cemetery, where the gravestones significantly have mostly German names on them. He might have been forced to leave, 'expulsed', deprived of his property, but he evidently did not lose the bond to the place of his youth – he is, uncannily, more at home here than the Czechs.

The Czech community, on the other hand, is evidently a displaced one, and although we can only guess at what brought these outcasts and outsiders to the godforsaken borderline area and what made them give up any hope of a better life, we get a clear sense that they did not manage to create any connection to the place they live in. They form only very aggressive relations – knowing the other's weaknesses, they exploit each other and share only the illusory and dubious rituals of national bonding as manifested in the rooting for the Czech team in the hockey championships. The ironic title of the film of course plays on the absurdity of the announcement 'we are the champions' which the characters keep yelling, and which is obviously both true (as the Czech hockey team win the championship), and totally wrong when related to the desperate quality of their lives.

The Czechs are also in many ways the new settlers – we see it most explicitly in Pavel, who presents himself as the 'worldly' guy only visiting from Prague, but who actually comes to live in the village permanently when he loses his job and his wife divorces him, supposedly stealing all his money. The alienated new settler – as someone who comes to the border area only after the original population is expulsed, often escaping to anonymity from their past lives – is of course a sociological fact that plagues the borderline regions up to the present. But here the situation works on a more abstract level as a symbol for the state of a nation that has just surfaced from a period of totalitarian culture, deprived of its generic roots, forced to forget and give up its historical memory and also fruitful contacts with other cultures. Isolation and failure of public communication are the main axes of this microcosm, as they were during the communist times – and as this film shows, this situation survives well into the postcommunist period.

At the end of the film, the repressed historical memory is coming back – first in the acts of violence against Ziege, in which the Czech men paint swastikas on the church doors and break the gravestone of Ziege's family. Ziege calls them all idiots who cannot imagine what war actually was – unlike him, who experienced

Figure 3.2
Two of the Czech misfits (Jiří Ornest, Leoš Noha) threaten Ziege by
damaging the gravestones of his family.

it firsthand. And it is also Ziege who, in a way 'ob-scenely' (we do not see it, only hear the blast) finishes off the agony of the community by firing a hand grenade that had been hidden in the cemetery since the war . The moment of illusory national victory (the triumph in the Championship) for the Czech characters is thus narratively aborted by this act, which is strangely irrational and illogical – Ziege so far had been the quiet, sensible and solid character who represented culture and values. This, in many ways arbitrary, move finishes off the life of the whole community, and the fact that the final blow comes unexpectedly from the Sudeten German is of course rather surprising (we do not know either the reasons or the results of the act – was it suicide, murder or a fit of insanity? Did only Ziege die, or did he really kill the whole group?). This semantic openness doesn't lead to significant rereading of the postcolonial memory, but it serves as a final statement about the futility of the Czech community. The film reflects the uncertainties

of Czech identity and shows how much hostility this insecurity and precariousness can bring – thus one would expect the end to come from inside the Czech group. Ziege in this context appears as the narrative vehicle – the last just man who is given the right to decide the fate of the whole group, it is as if he is the 'conscience of place' taking its revenge – or just finishing the agony of an uprooted, lost (Czech) community.

Habermann, the clichéd victim

Juraj Herz's *Habermann's Mill* (*Habermannův mlýn*, 2010) is the first film in the whole history of Czech(oslovak) cinema to deal openly with Czech brutality towards Germans and to picture the so-called 'wild expulsion'. It also tries to fully reverse the above described stereotypes of Sudeten German characters by switching the polarity

Figure 3.3
In *Habermann's Mill*, Habermann (Mark Waschke) and Březina (Karel Roden) are presented as the token representatives of the 'good German' and the 'good Czech'.

and contrasting evil Czechs with one token good German. The story of a rich mill-owner August Habermann is loosely inspired by a true case from North Moravia where a German industrialist was most probably beaten to death in the first days of the liberation by the revolutionary guards and the Czechs from the same village who wanted to steal his valuables. The film contrasts the petty and spiteful Czechs with Habermann as the schematically good guy – he is handsome, athletic, intelligent, a fair employer and a romantic, reliable husband. He is in fact so perfect that he appears not only unrealistic and lifeless, but also paradoxically brings to mind the connotations of the image of the Aryan *Übermensch*. He is unbelievably apolitical,[13] 'neutral', almost naively principled and idealistic – for example, he jokes that 'electricity does not have nationality' when confronted with an accusation from a Nazi official that he employs too many Czechs in his power plant.

Habermann is played by the popular German film and TV actor Mark Waschke and is dubbed into Czech without any accent; his Czech wife is played by Hannah Herzsprung, a German actress, and also dubbed into Czech. While *Divided We Fall* and *Champions* try to be more realistic in the representation of the (troubled) communication between two ethnic groups with different languages, *Habermann's Mill*, with its plentiful dubbing, creates an unconvincing and historically false image of the Sudetenland dominated by the Czech language, with German only as a marginal presence.

The Czech characters are on the contrary presented as grifters, profiteers and conformists, who learned their ways in the historical situation of a country where 'occupiers come and go, while we Czechs stay'. There are only two exceptions: Habermann's wife Hana, who is revealed as Jewish during the film, and his friend, the wise forester Březina. The division of roles is purely schematic in the film – from the very beginning the figures are fully black-and-white, like in a fairy tale, and the distribution of nationalities in marriages between central characters is even (the good German has a Czech/Jewish wife, the good Czech has a German wife). As

the film is a typical EU co-production of the Czech Republic, Germany and Austria, some reviewers consider this fact a reason for the symmetry and evenness.[14] The film deliberately tries to avoid any ambivalent or unexpected turn of events. We could claim that in the microcosm of the film Habermann is more at home in his town than his Czech employees are – but none of the characters are convincing enough to support such a claim. The protagonists could appear in any schematic story that depicts hatred towards the rich and successful, without necessarily being connected to any national confrontation.

The film came out seven years after the eponymous documentary *Habermannův mlýn* (Milan Maryška and Petr Jančárek, 2003) which collected available evidence about the death of the real Habermann

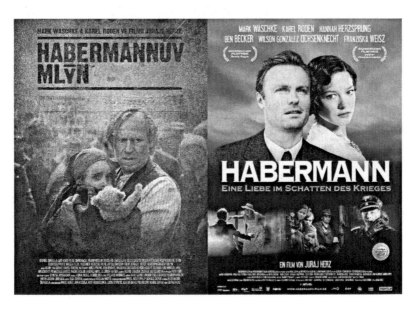

Figure 3.4
The Czech version of the poster for *Habermann's Mill* surprisingly doesn't feature the main character, but his best Czech friend Březina (Karel Roden) protecting Habermann's daughter. The German poster, on the other hand, features the Habermanns, both played by popular German actors (Mark Waschke and Hannah Herzsprung).

in Eglau/Bludov. Both this fact and the unconvincing nature of the simple reversal of roles – the German presented as the perfect good guy, Czechs as the repulsive villains – make the film unconvincing. While it did rather well at the box office, it failed to provoke further political discussion or any stronger emotional reaction from the public. While the film could have served as an antidote to the black-and-white portrayals of the Germans as wrongdoers during the communist period, when the resentment towards Germans as 'traitors' was still high, its platitudinous tone turns it into a boring moralizing story which fails to critically reflect the representation of both national identity and its corollary – the definition of otherness.

<p style="text-align:center">★</p>

As we have seen, the representation of German and especially the Sudeten German characters in postcommunist cinema tries to twist the stereotypes of German as the enemy formed during centuries and fortified in the socialist times. The German 'spirit' (presented as untrustworthy, intrusive, aggressive) served throughout the history of Czech culture as the antipode of the Czech dove-like, democratic, hospitable character; and this basic dichotomy often functioned as a reference for the definition of the Czech national character. The negative image of Germans was often also conceived as a retribution for the defamation and defeat; the trauma of the war was combined with the trauma of the expulsion and rapid homogenization of the formerly multinational populace. The idea of the multiethnic national state – a state that would be home for both (or several) nations – was logically presented only as a historical aberration and liability.

The change in historical consciousness that happened in the 20 years after the fall of Communism brought to cinema screens attempts to open up the stereotypical portrayals and to question the categorical attribution of guilt and revenge. As we have seen, the three films which we can consider most daring in this respect use different strategies – *Divided We Fall* keeps the stereotypes but valorizes their

potential and shows possible collaboration between the ethnicities; *Champions* uses an aged German character and provides him with qualities that are missing in the Czech protagonists to avoid the clichéd image of the Sudeten villain; and while *Habermann's Mill* daringly brings the theme of the wild expulsion for the first time to Czech cinema screens, it only reverses the stereotypes of Czechs and Germans and presents a morality story with unrealistically monochromatic characters. None of these films manages to fully expose the complexity of representations and images of the German neighbours that are inherited and turned into stereotypes through history, none of them really explores the vicissitudes of national proximity as a product of colonial encounter. Although the theme remains somewhat controversial and deserves further attention, we are still waiting not only for a film that will be a provocative, novel and unbiased study of Czech–German relations (or of the ethnic stereotypes that plague them) – the way for example Karel Kachyňa's *Carriage to Vienna* reversed the typical images of invaders and victims in traditional war films. But we are also waiting for a film that will portray everyday life in the Sudetenland before the arrival of the Nazi ideology that disrupted many natural bonds and mutual exchanges between the communities in the mostly mountainous areas of the Sudetenland, where life has been hard for Czechs and Germans alike.

Notes

1 Janusz Korek, 'Central and Eastern Europe from a Post-colonial Perspective', *Postcolonial Europe* (n.d.). Online. Available at <http://www. postcolonial-europe.eu/index.php/en/essays/60--central-and-eastern-europe-from-a-postcolonial-perspective> (accessed 2 February 2012).

2 By the 'wild expulsion' we understand the impulsive, often very aggressive acts of eviction against the German population (starting immediately after the war, even before the Potsdam Conference in the summer of 1945 sanctified and set the rules for the systematic deportation of Germans from Eastern Europe). Generally seen as an act of justified

retaliation and never questioned during socialist times, the expulsion and its vindication have been openly discussed by historians only in recent years; see, for example, Tomáš Staněk, *Poválečné 'excesy' v českých zemích v roce 1945 a jejich vyšetřování* (Praha: Ústav pro soudobé dějiny, Akademie věd České republiky, 2005) and for a broader historical context, Václav Houžvička, *Návraty sudetské otázky* (Praha: Karolinum, 2005).

3 Although I did not find usable statistics to support this claim, I grew up in the area of the former Sudetenland and can share the 'data' I gathered from my family. My grandfather's family line lived for several generations in the city of Krumlov/Krumau, a town with about 8,000 inhabitants before the war, out of which only about 15 per cent were ethnically Czech. My grandfather's family was Czech, lower middle class, but everyone had some education in both Czech and German schools, so they were all practically bilingual. Out of his five siblings, one sister worked for a couple of years in Vienna (as a cook), which was typical for many young people from the area, two siblings entered into ethnically mixed marriages (with Austrian and German spouses), and one of my grandfather's sisters adopted and raised two German children. Although the family was very closely connected with the German community, my grandfather left the town directly after the establishment of the Protectorate, as he found the ethnic tensions unbearable and wanted to protect his children and my grandmother, who only shortly before the war came to Krumlov from Prague and was not fluent in German. The family returned to the city directly after the war.

4 For example, Jan Křen and Eva Broklová (eds), *Obraz Němců, Rakouska a Německa v české společnosti 19. a 20. století* (Praha: Karolinum, 1998).

5 As Václav Maidl claims in his study of the representation of German characters in Czech literature of the nineteenth and twentieth century, 'if we look briefly at the two hundred years of modern Czech literature, we find that the German and German-speaking characters and environments – with rare exceptions – are pictured negatively'. (See Křen and Broklová: *Obraz Němců, Rakouska a Německa v české společnosti 19. a 20. století*, p. 299.)

6 Sedmidubský elaborates on the second point: Sedmidubský, *Obraz sudetských Němců a sudetoněmecká otázka v českém hraném filmu 1945– 1969*, p. 188).

7 Sedmidubský: *Obraz sudetských Němců a sudetoněmecká otázka v českém hraném filmu 1945–1969*, pp. 188–9).

8 See Hanns Hertl (ed.), *Němci ven! Die Deutschen raus!* (Praha–Podlesí: Dauphin, 2001). The number of people killed in the march differs significantly in Czech and German historical accounts – while some German sources claim that up to 10,000 people died, Czech historians confirm 1,691 victims. Similarly, some sources estimate the full number of expulsion victims as up to 220,000 people, yet the authoritative committee of Czech historians that researched the issue for the Czech Ministry of Education in 1996 recommends a much more moderate estimate of 22,000 victims of expulsion crimes (Zdeněk Beneš et al., *Odsun – Vertreibung (Transfer Němců z Československa 1945–1947)* (Praha: Ministerstvo mládeže a tělovýchovy ČR, 2002), pp. 49–50).

9 Rob Cameron, 'Czech Archaeologists Find Bodies of Germans Massacred in 1945', *Deutsche Welle*, 19 August 2010. Online. Available at <http://www.dw-world.de/dw/article/0,,5926842,00.html> (accessed 2 February 2012). The Dobrotín case revealed 'only' 15 victims, yet the place became symbolic for the process of gradual consensus that acts of anti-German rage after the liberation are not excusable. While the claim that the expulsions and murders of Germans should be considered acts of revenge and retaliation and thus judged differently than the German war atrocities still circulates, the current historical view admits that many of the massacres of Germans were actually acts of violence and greed against a population that had no direct political participation in the occupation.

10 We can see here also the reference to an influential New Wave film, *The Shop on the Main Street (Obchod na korze*, János Kádár and Elmar Klos, 1965), where the central character is also a decent little man who works for the Nazis as an Aryanizator (administrator of the confiscated Jewish property) but believes he can actually save the old Jewish lady whose little store becomes his first assignment. In *Divided We Fall*, Mr Čížek also works for the Aryanization office, thus eventually partaking in the Holocaust machine.

11 For more on this case, see Andrej Stankovič, *Co dělat, když Kolja vítězí* (Praha: Triada, 2008), pp. 201–6 and 498–505.

12 See Kamil Činátl, 'Obraz Němce v Třiceti případech majora Zemana', *Cinepur* 10 (2009), pp. 27–30.

13 Several historians commented on the fact that this kind of impartiality from a Sudeten industrialist would be highly improbable and unattainable during the political pressures of the Protectorate (see Petr Žídek et al., 'Habermannův mlýn: divoký odsun nově', *Lidové noviny*, 16 October 2010. Online. Available at <http://www.lidovky.cz/tiskni.asp?r=ln_noviny&c=A101016_000088_ln_noviny_sko&klic=241782&mes=> (accessed 2 February 2012)).

14 Some reviewers also compared the film to Andrzej Wajda's *Katyń*, as a historical film made by a famous director and a work that leaves a lot to be desired, but is a good educational tool for schools (Kamil Fila, 'Habermannův mlýn se ohlíží příliš pozdě a mdle', *Aktualne.cz*, 10 October 2010. Online. Available at <http://aktualne.centrum.cz/kultura/film/recenze/clanek.phtml?id=679460> (accessed 2 February 2012); Oto Horák, 'Medvědí služba', *Cinepur blog*, 13 October 2010. Online. Available at <http://cinepur.cz/blog.php?article=151> (accessed 2 February 2012)).

References

Beneš, Zdeněk, Kuklík, J. ml., Kural, V. and Pešek, J., *Odsun – Vertreibung (Transfer Němců z Československa 1945–1947)* (Praha: Ministerstvo mládeže a tělovýchovy ČR, 2002).

Cameron, Rob, 'Czech Archaeologists Find Bodies of Germans Massacred in 1945', *Deutsche Welle*, 19 August 2010. Online. Available at <http://www.dw-world.de/dw/article/0,,5926842,00.html> (accessed 2 February 2012).

Činátl, Kamil, 'Obraz Němce v Třiceti případech majora Zemana', *Cinepur* 10 (2009), pp. 27–30.

Fila, Kamil, 'Habermannův mlýn se ohlíží příliš pozdě a mdle', *Aktualne.cz*, 10 October. Online 2010. Available at <http://aktualne.centrum.cz/kultura/film/recenze/clanek.phtml?id=679460> (accessed 2 February 2012).

Hertl, Hanns (ed.), *Němci ven! Die Deutschen raus!* (Praha–Podlesí: Dauphin, 2001).

Horák, Oto, 'Medvědí služba', *Cinepur blog*, 13 October 2010. Online. Available at <http://cinepur.cz/blog.php?article=151> (accessed 2 February 2012).

Houžvička, Václav, *Návraty sudetské otázky* (Praha: Karolinum, 2005).

Korek, Janusz, 'Central and Eastern Europe from a Postcolonial Perspective', *Postcolonial Europe* (n.d.). Online. Available at <http://www.postcolonial-europe.eu/index.php/en/essays/60--central-and-eastern-europe-from-a-postcolonial-perspective> (accessed 2 February 2012).

Křen, Jan and Broklová, Eva (eds), *Obraz Němců, Rakouska a Německa v české společnosti 19. a 20. století* (Praha: Karolinum, 1998).

Sedmidubský, Jan, *Obraz sudetských Němců a sudetoněmecká otázka v českém hraném filmu 1945–1969* (unpublished MA thesis, Charles University in Prague, 2006).

Staněk, Tomáš, *Poválečné 'excesy' v českých zemích v roce 1945 a jejich vyšetřování* (Praha: Ústav pro soudobé dějiny, Akademie věd České republiky, 2005).

Stankovič, Andrej, *Co dělat, když Kolja vítězí* (Praha: Triada, 2008).

Žídek, Petr et al., 'Habermannův mlýn: divoký odsun nově', *Lidové noviny*, 16 October 2010. Online. Available at <http://www.lidovky.cz/tiskni.asp?r=ln_noviny&c=A101016_000088_ln_noviny_sko&klic=241782&mes=> (accessed 2 February 2012).

4

Jánošík: The Cross-Border Hero

Peter Hames

In his important essay on the application of the term 'postcolonial' to the post-Soviet sphere, David Chioni Moore refers to countries being dominated from anything from 50 to 200 years by Russian and subsequently Soviet power.[1] Referring to the Central European aspect of this domination, he recognizes the importance of 'reverse colonization'. By this, he implies that the dominant power asserts control over centres (e.g. Berlin, Prague, Budapest) that the conqueror perceives as more rather than less 'civilized' than itself. On the other hand, he also suggests more controversially that those who now advocate a Central European identity are mainly demonstrating a postcolonial reaction to years of Soviet domination. However, it would also seem possible to argue that many elements of that identity were sustained (if partially suppressed) during the 40 years of Soviet hegemony.

In considering representations of the bandit-hero, Juraj Jánošík[2] in Czechoslovak, Polish and Slovak cinema, it should be recognized that the stories and legends on which both 'Soviet' and 'post-Soviet' representations are based developed during the eighteenth and nineteenth centuries and first attained wider significance in areas of present-day Slovakia, Poland and the Czech Republic under the

Habsburg Empire. This interest also occurred in the context of the development of nationalism and nation-building in the nineteenth century. Here it is worth recalling that Italian unification took place in 1861, German unification in 1871 and that Hungary achieved internal autonomy within the Habsburg Empire in 1867. Czechoslovakia was formed as a new state in 1918 and Poland re-emerged as a nation state in 1918.

The 'dynastic' empire of the Habsburgs differed, of course, from that of the Soviets and was to a large extent the source of that 'Central European' culture to which many of the post-Soviet states felt themselves integrally related. It was also within that empire that the desire for independent nationhood developed together with the ideologies, histories and cultures that supported it. Since the Habsburg Empire (or Austria–Hungary in 1867–1918) meets the accepted criteria for an empire, it is also reasonable to argue that the assertion of national cultures during the nineteenth century (especially the reassertion of the Czech language and the development of a separate Slovak language, and even the first Polish modern language dictionary) match the criteria for the development of 'postcolonial' cultures. Much of the resultant literature would also meet Elleke Boehmer's definition of postcolonial literature as that 'which critically or subversively scrutinizes the colonial relationship'.[3]

The model for future 'national' developments was clearly the Austro-Hungarian 'compromise' of 1867, which established the Austro-Hungarian Dual Monarchy in which the Emperor Franz Josef became Emperor of Austria and King of Hungary. This achievement of Hungarian internal autonomy was, of course, a longer-term consequence of the Hungarian Revolution of 1848, which had been suppressed by the Austrian Habsburgs with the aid of Russian troops.

The Slovaks had been part of the Hungarian kingdom since the tenth century after the demise of the Greater Moravian Empire. Most of Hungary had, in turn, formed part of the Ottoman Empire in 1541–1699 after which it became part of the Habsburg Empire.

After the Battle of the White Mountain in 1620, the Czech lands of Bohemia (Czechia) and Moravia had been subject to Austrian domination, the Czech aristocracy had been destroyed and Czech was ended as a language of state. In 1867, when it achieved internal autonomy, Hungary had been under Austrian Habsburg control for 168 years. In 1918 the Czech lands had been under Austrian Habsburg domination for nearly 300 years, and Slovakia had been under Hungarian rule for over 1,000 years. Poland–Lithuania disappeared from the map of Europe in 1795 for 123 years when it was partitioned between Austria, Prussia and Russia, with Russia absorbing the larger proportion. The Polish legends of Jánošík, however, developed within the Austrian part of the partition, the province of Galicia. This was essentially an artificial construct[4] bordering on present-day Slovakia, and comprised part of present-day Poland and Ukraine.

While the above account is somewhat schematic, it is sufficient to indicate that the three areas of the Carpathian Mountains where the Jánošík stories circulated – Slovakia, Poland and Moravia – were all within the Habsburg Empire under either Austrian or Hungarian rule. In the nineteenth century no one seriously envisaged the end of the empire, and national movements were directed towards internal autonomy on the Hungarian model. Hungary, in fact, recognized Croatian autonomy in 1868. Given the multi-ethnic character of the areas prior to the First World War, the notion of dual loyalties was not considered impossible. Galicia, with its Polish, Ruthenian and Jewish populations, enjoyed relative autonomy under Austria. The dominant administrative power resided with the Polish gentry, hence its role as a focus for Polish national culture and political exchange. On the other hand, much of the day-to-day administration was carried out by Czech immigrants, a presence not entirely welcomed by the aristocracy.[5]

The search for autonomy was not, however, without its problems. The Czech quest for autonomy, a movement sometimes known as 'Austroslavism', and the Czech National Revival of the nineteenth century met German resistance. Since German speakers controlled

most of the political and economic life in the major cities and made up around 37 per cent of the population of Bohemia,[6] this was somewhat inevitable. In response, in the final years of the monarchy, plans were explored for a federal system that would have been based on the monarchy's nations rather than territorial demarcation.

In the case of Hungary, Magyarization was an attempt to unify a territory in which Magyars made up only 41.6 per cent of the population. The cause of Slovak nationality within Hungary was promoted by Ľudovit Štúr, with his project for creating a Slovak literary language in 1843. He was also involved with presenting the *Claims of the Slovak Nation* (*Žiadosti slovenskieho národu*) to Hungary in the aftermath of the Hungarian Revolution of 1848.[7] However, Hungarian opposition to Slovak autonomy and ultimately, the creation of Czechoslovakia, remained consistent under governments of all political persuasions until the end of World War II.

If Slovak nineteenth-century nationalism inevitably demonized Hungarians and Czech nationalism Germans, it is well to remember that Upper Hungary (present-day Slovakia) was not merely a colony of Hungary. As already indicated, Hungary was itself a multi-ethnic state and, during the period of Ottoman rule, the Slovak capital of Bratislava (Pressburg) had been the capital of Hungary, under the name of Poszony. At that time, Upper Hungary in fact constituted the kingdom (under Habsburg domination). Before the nineteenth century, borders and allegiances did not correspond to the more essentialist ethnic and national perspectives of the present. In the time of Jánošík, the authorities could have been of various ethnicities. As Martin Votruba points out, the folk songs about outlaws rarely referred to ethnicity, and where they do, refer to Habsburg Germans (i.e. administrators and military brought in to integrate the kingdom into the Empire in the seventeenth and eighteenth centuries).[8] There were no references to Hungarian oppression, and the policies of Magyarization did not fully develop until the nineteenth century.

It is against this complex background that we have to consider the figure of Jánošík and its cinematic representation. His story

has provided the basis for six feature films (one in two parts). Two were produced in Czechoslovakia before World War II, three during the communist period in Czechoslovakia, one in Poland; a Polish–Slovak–Czech–Hungarian production was completed in 2009. In addition, it was the subject of the first animation features in both Poland and Slovakia. Popularly (or loosely) described as the Slovak Robin Hood, Jánošík's popularity within Polish and Czech culture has also rendered him a Slav hero in a more general sense.[9] Also, like the Greek mythological heroes, he is halfway between gods and mortals. As Peter Burke suggests, the mythogenic nature of outlaws 'suggests that they satisfy repressed wishes, enabling ordinary people to take imaginative revenge on the authorities to whom they were usually obedient in real life'.[10] The purpose of this chapter is to discuss the ways in which the film representation of Jánošík has (or has not) evolved in the period since the production of the first film in 1921, and also the ways in which it has embodied the representation of 'neighbours'.

Before doing this, however, it is necessary to say something about the literary image of Jánošík as it evolved in the nineteenth century and the roots of the Jánošík story in historical fact. Juraj Jánošík was executed for highway robbery in 1713 at the age of 25, with his birth date variously given as February or May 1688. The trial proceedings provide the main source of historical evidence and list him as having been born in the northwest Slovak village of Terchová, in the Malá Fatra mountains, where the family name of Jánošík is still common. According to the proceedings, Jánošík joined the uprising of Ferenc Rákóczi in 1708–11. Rákóczi's rebellion was the fifth in a sequence of rebellions by the Kingdom of Hungary against Habsburg German domination during the seventeenth and early eighteenth centuries. The kingdom, which had been overwhelmingly Protestant, was subject to forced re-Catholicization. Although Rákóczi was a Catholic, he favoured Hungarian independence and religious toleration. It is also worth noting that the rebellion originated as a popular uprising of the *kuruc* ('the hidden'), which included peasant opposition to feudalism as

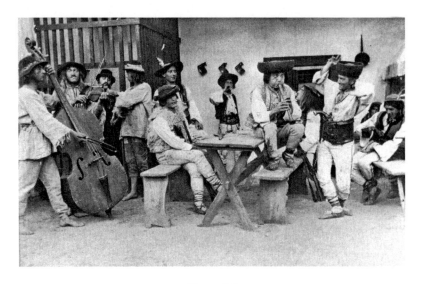

Figure 4.1
Tavern scene from *Jánošík* (Jaroslav Siakeľ, 1921),
copyright Slovak Film Institute – Photoarchive

one of its objectives. At one stage, Rákóczi had promised freedom to those serfs bearing arms and their descendants, forcing through a law in 1708.[11] This provides support for the notion that Jánošík may have been a fighter against social oppression.

The rebels were defeated at the Battle of Trenčín (present-day Slovakia) in 1708. At some stage, Jánošík then became a member of the Habsburg Imperial Army, serving as a prison guard at Bytča Castle in 1710, 25 miles from where he was born. According to the records, he provided services to the imprisoned outlaw leader, Tomáš Uhorčík, who escaped in the autumn of 1710. Jánošík was bought out of the army by his father a month later. This gave rise to speculation that he had helped Uhorčík to escape and that his father had been given funds by the outlaw (a theme developed in the 2009 film).

Jánošík confessed to having joined Uhorčík's group of outlaws in 1711 and becoming their leader shortly thereafter. Uhorčík gave up his trade as outlaw and returned to Klenovec in south-

central Slovakia, where he lived under the name of Martin Mravec. Interestingly, Uhorčík's operations had extended over eight robbing 'seasons' and Jánošík's little more than a year. Jánošík's group operated in north-central Slovakia in the counties of Orava, Liptov and Spiš, but also in parts of Silesia and Moravia. Although several members of the band were Polish, there is no documentary evidence of him operating in the Kingdom of Poland. At the same time, he was specifically asked about possible links with Poland at the time of his trial, suggesting that outlaws crossed the frontier in both directions, and a concern about possible contacts with leaders of the Rákóczi revolt who had fled there in 1711.[12]

While Jánošík admitted his robberies, he always maintained that he had never killed anyone and remained faithful to his fellow outlaws. Nonetheless, he was still held responsible for the death of a priest, who had died after being shot by two of his men.

He was also accused of sacrilege (using Eucharistic bread for target practice). He was tried on 16–17 March 1713, tortured and executed. Jánošík (unusually) survived the experience of torture but was executed by the method whereby a hook was threaded through his left side and he was left to hang. Uhorčík was sentenced a month later and his body broken on the wheel. Both were common forms of execution at the time.

Folk songs, legends and stories about outlaws and brigands, of course, existed prior to the development of the Jánošík mythology. While eighteenth-century market songs developed its generic elements, ethnic tensions were generally absent. However, Slovak romantic poetry of the nineteenth century provided 'the first clear-cut images of the brigand as a benevolent, rebellious, tragic, quasi-folkloric freedom-fighter'[13] and imitated folk traditions. Jan Botto wrote that in his *The Death of Jánošík* (*Smrť Jánošíkova*, 1858) his aim was 'to portray the life of the freedom fighter who lives in the hearts of the people and who had been growing there for the entire five hundred years of serfdom. This freedom fighter got perhaps only his name from Jánošík, and even that only partly'.[14] He only learned the 'true history' of Jánošík in 1866.

In the case of Poland, interest seems to have developed somewhat later, in the late nineteenth and early twentieth centuries. Drawing on oral traditions and legends, Kazimierz Przerwa-Tetmajer wrote an extended cycle of stories between 1903–10, which featured Jánošík and the rebel leader Kostka-Napierski. Here 'shepherds, poachers, and bandits reach the stature of Homeric heroes and local yarns are transformed into chronicles of some fantastic history'.[15] Thus Jánošík's legendary fight became a feature on both sides of the boundary between the two countries, marked by the Tatra Mountains (the highest part of the Carpathians), a fact that is hardly surprising. In the Czech lands of Bohemia and Moravia, Jánošík's story was included in Alois Jirásek's compilation of *Old Czech Legends* (*Staré pověsti české*, 1894), while the play *Jánošík* (1910), by the (Moravian) Czech writer Jiří Mahen was to be a basis for both of the two feature films produced between the wars.

The 'highlander' culture on which Tetmajer drew consisted of various groups, notably the Gorals (Górale), whose descendants live in all three countries and have adopted different nationalities since the finalization of borders in 1924. It is often argued that the border between Slovakia and Poland actually cuts through an originally unified highlander culture – one can at any rate argue that it is a continuum. While the Goral speakers in northern Slovakia have kept a mainly Polish dialect, they have asserted Slovak ethnicity.[16] The area has also constituted a region of border dispute and armed confrontation, with Poland initially laying claim to the whole Górale area.[17] The matter of borders was finally settled by the League of Nations – although there were further changes after World War II before a further agreement in 1958 reasserting their original status.

There are some significant differences between the Polish and Slovak legends. For Poles, the mountainous region of the Tatras constitutes only a small part of the country whereas, for Slovaks, the mountains in general, and the Tatras in particular, have become almost synonymous with national identity. Hence, the regularity of Jánošík's appearance in all areas of Slovak culture and the

monumental statue of him erected in the hills above Terchová in 1988 to mark the 300th anniversary of his birth.

If we turn to the two films made between the wars, it is evident that neither can be regarded as purely Slovak. The first, Jaroslav Siakeľ's *Jánošík* (1921), produced within the new state of Czechoslovakia, was the only Slovak fiction feature of the interwar period. It was a project of the Slovak-American Siakeľ brothers, based in Chicago, and produced by the Tatra Film Corporation.

The film was originally to have been based on a novel about Jánošík published in the USA in Slovak in 1894 – *Jánošík, Captain of the Mountain Lads – His Tumultuous Life and Horrific Death* (*Jánošík, kapitán horských chlapkov – jeho búrlivý život a desná smrt*) by Gustav Maršall-Petrovský. However, only half the screenplay was completed before shooting and the film also drew on Mahen's play and other sources. While a Slovak film, it could also be said to have

Figure 4.2
Theodor Pištěk as Jánošík and Mária Fábryová as Anička in *Jánošík*
(Jaroslav Siakeľ, 1921), copyright Slovak Film Institute – Photoarchive

Slovak-American and Czech (Moravian) bases. It is an indication of the resonance of the legend within the Slovak diaspora. The main role was played by the leading Czech actor, Theodor Pištěk, although not conforming to the athletic stereotypes that were later developed.

The film presents its story quite explicitly as legend, beginning in the present day as an old peasant recounts the story to contemporary figures. Jánošík returns home after studying for the priesthood to find his mother dead. His father, who has failed to turn up for work on the estates of the Hungarian, Count Šándor, is beaten to death. After meeting the bandit Hrajnoha, Jánošík joins the outlaws and becomes their leader – but, he insists, there will be no killing, since 'death does not change anybody'. After his trial, a hook is threaded through his side and he is left to hang, with the instruction that his body be quartered after his death. The film's final credit refers to him as 'the first fighter for the freedom of the Slovak people'.

There is no surviving evidence of his studying for the church (or indeed, studying at all), or for the death of his parents motivating his actions. Nonetheless, both factors are regular constituents of the legend. Similarly, Count Šándor has no historical counterpart. At the real trial of Jánošík, the fact that he had participated in the Rákóczi (i.e. Hungarian) revolt was held against him, and his defence sought to present him as a loyal servant of the Habsburg Emperor through his service in the Imperial army. Siakel's film does not refer to either and is influenced rather by the enforced Magyarization of the nineteenth century, which had been one of the reasons for Slovak emigration to the USA. The theme of feudal suppression is linked to these more recent experiences.[18]

There is little space to consider here the issues of Czech/Slovak identity other than to state that there were elements of both identity and separation. The state of Czechoslovakia (1918–39, 1945–93) recognized two official languages – Czech and Slovak – and there were separate literary developments. According to Jan Rychlík, most Czechs saw Czechoslovakia as a reconstitution of the Bohemian independence that had been lost in 1620, with Slovakia

as an additional province. The majority of Slovaks, he suggests, saw it as the union of two nation states – as Czecho–Slovakia.[19] As was the case with Galicia, there was some resentment at the dominant (and inevitable) role played by Czechs as administrators and modernizers within Slovakia.

Since Jánošík had also operated in Moravia, and was one of the heroes discussed in *Old Czech Legends*, it was not surprising that the Czech Company, Lloyd Film, should have turned to the subject of Jánošík in Martin Frič's adaptation of 1935. It was screened at the 1936 Venice Festival in the face of Hungarian objections and went on to achieve international success, gaining release in France, Germany and the United Kingdom among other countries.

Frič's film, shot in Terchová and Liptov, is ideologically simple but is also a mixture of apparently incompatible genres. Lively and fast moving, Frič's principal model seems to be Hollywood, with a number of scenes recalling classic Douglas Fairbanks swashbucklers such as *The Mark of Zorro* (1920) or *Robin Hood* (1922). The long-legged and athletic Pal'o Bielik (as Jánošík) recalls Fairbanks as he leaps from rock to rock, making sudden interventions and escapes, and even swinging on a rope.[20] Rapid montage and graphic images recall the work of Eisenstein and Pudovkin.

With Jánošík's capture, the film cuts directly to the execution scene with a close-up of the waiting hook. Surprisingly, Jánošík casts off his chains, sings and dances, rejects an offer of pardon if he raises a group to fight the Turks and throws himself on the hook. While Graham Greene understandably noted that romance, robber tunes and a Fairbanks-style hero didn't go with the spike,[21] it is an ending that corresponds to the legend. Jánošík was reputed to have danced three times around the scaffold before impaling himself.

In some ways, the film is a more explicit 'call to arms' than that of Siakel'. The stylized credit sequence offers the name 'Jánošík' penetrated by the image of his axe, which, more than in any other adaptation, remains a constant motif throughout. Jánošík assumes statuesque poses against the mountains in key sequences, so that he and the mountains become indivisible. In the final scenes, a close

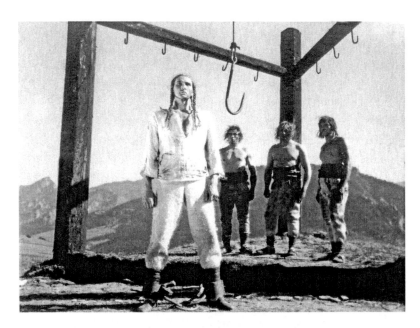

Figure 4.3
Pal'o Bielik as Jánošík in *Jánošík* (Martin Frič, 1935),
courtesy of National Film Archive, Prague

up of his dying face is superimposed/juxtaposed with the eternal images of the mountains, the streams and their music, with the cross of Slovakia superimposed. He (and, by extension, the Slovaks) is literally at one with the land. As in Siakel's film, he is betrayed by a gypsy woman in the first instance and captured when the old woman throws peas on the floor. Similarly, his return and capture are linked to his attempt to see his fiancée, Anka.

The film presents the life of the outlaw as an inevitable response to tyranny – they are fighting the 'overlords' with truth on their side. Others will continue the struggle and the name of Jánošík, which literally echoes throughout the film, will never die and be forever associated and combined with country and nation, acting as a rallying cry for the poor and oppressed. While the film undoubtedly presents a degree of Slovak self-image, it could also

be said to indulge freely in exoticism and hence, from a Czech perspective, elements of Orientalism.[22]

Paľo Bielik went on to become the first significant Slovak film director and filmed the Slovak National Uprising in 1944 for his film *For Freedom* (*Za slobodu*, 1945). In the 1960s, he turned to historical epics, one of which was his two-part version of *Jánošík* (1962–3), the only 'straight' version to appear in the communist period in Czechoslovakia, made to celebrate the 250th anniversary of Jánošík's death. In 1997, it was quoted as one of the most successful Slovak films of all time, with both parts in the top ten and part one in second place.

It is scarcely surprising that this postwar *Jánošík* does not differ in essence from the earlier versions, save in its epic ambition and the use of colour and widescreen. It also mirrors the post-Cinemascope Hollywood epics of the late 1950s/early 1960s in its audience appeal and narrative form. While following a similar development to the earlier versions, this time written by Bielik, the two-part expansion gives more attention to chronology and characterization. Pavel Branko described it as more down to earth than the earlier films and closer to a contemporary social drama.[23]

The motivation for Jánošík becoming a bandit is different from the previous films but the basic situation – the exploitation of the peasants as little more than slaves – remains the same. The landowner, Count Žuray, despite his objection to the education of peasants, allows the priest to persuade him to sanction Jánošík's education. His son Aurel, however, is a sadist. This more complicated scenario emphasizes class rather than nationality as the defining factor. As in Frič's film, the mountains are visually linked to Jánošík – in his youth, as the path he must follow to the seminary and as the location for his union with the outlaws.

One need hardly point to the archetypal nature of the story – Jánošík's initiation, education, trauma, battle with the Count and joining with the bandits – the growth to manhood and the birth of the hero. The similarities to the legend of Robin Hood (and

its Hollywood variants) are notable. The Count can be compared to the Sheriff of Nottingham, with his designs on the principal female and exploitation of the people. The outlaw/bandit is his principal enemy, representing the people versus the aristocracy, the native versus the foreigner (interestingly Aurel is a pupil of French 'manners'). It is not surprising that the outlaw figure should become the predecessor of both liberal democracy and communism, 'the land of the free' as well as the land with 'no more masters'. The mountains, like the forest of Sherwood, represent a place of danger, where men are free and contemporary dissidents can survive, but where they must also live on their merits.

The emphasis on landscape and horses brings the film close to the western, with a number of scenes exploiting the conventions of the genre. The bandits' acrobatics – here they descend a 'firemen's pole' and use an extended wooden slide to descend from their mountain eyrie – recall Martin Frič's film, as does the use of whistles, cries and choral accompaniment. Parallels with the western may also be linked to the then vogue for German westerns based on the novels of Karl May.

At the end of the film, a crowd of thousands weep, Jánošík refuses his pardon and fires rise from the surrounding peaks. The parallel with scenes of the crucifixion in Hollywood films is inescapable. But here, the peasants also walk in numbers into the mountains and join the bandits, symbolically joining an army of rebels. This (if it were true) could be the beginnings of a Zapatista-style revolt. Indeed, the scenes recall episodes of Elia Kazan's *Viva Zapata!* (1954), which were themselves modelled on Eisenstein's *The Battleship Potemkin* (*Bronenosets Potëmkin*, 1926).

Like Jan Hus, Jánošík was naturally adopted as a communist icon and the statue erected in Terchová dates from the last years of this period. There is little here to challenge communist (or even Stalinist) ideology, and the story is one that could also be appropriated and assimilated by Hollywood with minor ideological change. Apart from the collective peasant ending and the lack of attack on Hungarian neighbours (since they were now 'brothers'

within the Soviet Bloc), there is little to distinguish it ideologically from its interwar predecessors.

It was the mid-1970s before Slovak cinema revisited the Jánošík story more or less simultaneously with two very different approaches, in Viktor Kubal's animated feature *Jurko the Outlaw* (*Zbojník Jurko*, 1976), which was also the first Slovak animated feature, and Martin Ťapák's pastiche *Pacho, the Bandit of Hybe* (*Pacho, hybský zbojník*, 1975). Kubal, who went to school in Terchová and had imbibed stories about Jánošík from an early age, took the legend directly to the world of the fairy story.

In his film depiction, the baby Jurko's mother is arrested and he is suckled by a fairy spirit, who revisits him at key points in the story. She provides him with the magic belt that endows him with virtually superhuman powers and ensures his final escape to an apparently eternal life in the mountains. Kubal uses a pure graphic style that reflects the simplicity of his tale, deliberately avoiding the fights and conflicts of the previous films. His Jánošík nonetheless adheres to the long-legged archetype. The film's images range from portraits of the mountains recalling Japanese watercolours to abstraction and crayon drawings. The score deliberately draws on folk tradition.

Pacho, the Bandit of Hybe, directed by Martin Ťapák, who had played Uhorčík in Bielik's 1960s *Jánošík*, literally plays with the conventions of the story, treating the Slovaks' own perspectives with a sense of irony. Much is made of the diminutive stature and 'ordinary' appearance of Pacho (Jozef Kroner), which is in complete contrast to the romantic image. He falls in with the bandits and becomes their leader as a joke. It proved the most popular Slovak film from 1970–82, and owed much to the witty dialogue written by Milan Lasica and Július Satinský (uncredited as they were under an official ban).

Like Jánošík, Pacho returns home after a long absence and becomes involved with the local Count Erdödy, whipping him in defence of a peasant. Apart from robbing the Count, the bandits also set fire to the castles of the lords, provoking an alliance against

them. A never-ending list of aristocrats (including the Eszterhazys and the Báthorys) join common cause against him as his abilities and attributes become exaggerated and inflated. Aristocratic ladies swoon at stories of the bandits' uncouth ways and hairy chests, and the Empress finally sends a mission to capture Pacho and bring him back as a husband. When the army finally capture him, they refuse to believe it is Pacho, since he does not correspond to the Jánošík-style painting they are using to identify him.

If we turn to the Polish *Janosik* by Jerzy Passendorfer, again enormously successful, we are looking at a film that reasserts the conventions of escapist historical drama. A feature was released in 1973, but the main impact was achieved through his 13-part television serial of 1974. Each episode lasted 45 minutes and is, in effect, a separate adventure. The main difference is that Jerzy (not Juraj or Juro) Jánošík is now situated on the Polish side of the Tatras and has become 'the Polish Robin Hood'. In one episode, the bandits escape to Slovakia, mirroring a scene in Bielik's film where he suggests that his followers escape to Poland.

The television series, written by Tadeusz Kwiatkowski, coincided with a popular comic book series written by Kwiatkowski and drawn by Jerzy Skarzynski. As in the Slovak films, Jánošík defends the poor and ends up a bandit by default. In the first episode, he saves a boy from being tortured by the Count's guards and is thrown into jail. In subsequent episodes, the Count captures Jánošík's girlfriend (here named Maryna) and Jánošík rescues her. As in the first *Jánošík*, the bandits attend the Count's ball dressed in clothes they have stolen from the aristocratic guests. At the end of the film, the wedding of Jánošík and Maryna is the occasion for his arrest when the church is surrounded. He and his men are executed and a young boy inherits his role.

Generally, it could be said that the film applies a Polish equivalent of the Slovak iconography. Like Bielik in Martin Frič's film, Jánošík is tall but perhaps more conventionally handsome and dressed in the white costume of the highlander. As played by Marek Perepeczko, his straight long hair and open-necked shirt

Figure 4.4
Illustration by Jerzy Skarżyński from the *Janosik* comic series, written by Tadeusz Kwiatkowski, courtesy of Wydawnictwo POST

has a more contemporary relevance and, as he takes on multiple opponents in sword fights, he recalls Gérard Philipe in *Fanfan la Tulipe* (Christian-Jaque, 1952) or Burt Lancaster in *The Crimson Pirate* (Robert Siodmak, 1952). Like Hollywood action heroes of the 1950s and 1960s, his shirt is removed on a regular basis and women are regularly impressed by his physical strength and moral courage. The use of nineteenth-century costume gives the films a specific Polish resonance while the star persona and charisma provide a strong antidote to the flawed heroes of 'the cinema of moral concern'. Both nonetheless maintain an anti-authoritarian stance.

The film's stereotypical approach based on standard historical romance seems to be deliberate and the music theme echoes that of Ennio Morricone's for *A Fistful of Dollars* (*Per un puono di dollari*, 1964). The comic book illustrations drawn by Skarżyński are not far removed from similar visualizations of heroes like *Conan the Barbarian*, and, of course, cross-reference the films. In these respects, and also in its use of highlander dialect, the Polish Jánošík is portrayed as someone apart.

The postcommunist version of the Jánošík story, *Jánošík: The True Story* (*Janosik. Prawdziwa historia* (Polish)/*Jánošík. Pravdivá história* (Slovak), 2009) is, perhaps appropriately, a Polish–Slovak–Czech–Hungarian co-production. Since it was completed in Poland with Polish money, it is frequently considered a Polish production, yet began as a Slovak project. The writer-director, Eva Borušovičová, originally wrote the screenplay as her graduation project and a production was launched by the Slovak producer Rudolf Biermann in 2002. The directors were Kasia Adamik, daughter of Polish director Agnieszka Holland and stage and television director Laco Adamik, and Holland herself. The part of Jánošík is played by the Czech actor Václav Jiráček. The US co-producers failed to come up with the money and the film was abandoned with only 40 per cent of the shooting completed. In 2009, the Polish producer Dariusz Jabłoński, who had already made a number of co-productions with Slovakia and the Czech Republic, rescued the project.

Figure 4.5
Ivan Martinka as Uhorčík and Václav Jiráček as Jánošík in *Jánošík: the True Story*
(*Janosik, Prawdziwa historia/Jánošík, Pravdivá história*, Agnieszka Holland and
Kasia Adamik, 2009), production: Apple Film Production,
copyright Marcin Makowski/Apple Film Production

Here it is also worth noting the links of Holland and Adamik with Czechoslovakia. Laco Adamik, who has been part of the Polish cultural scene for many years, was born in Slovakia, studied architecture in Bratislava and graduated from FAMU (the Prague Film School), where Holland had also graduated. Perhaps, one could argue that we are looking at a 'Slav' interpretation of the Jánošík legend. Like Juraj Jakubisko's *Báthory* (2008), a Slovak–Czech–British–Hungarian co-production – the most successful Slovak film in distribution since 1989 – it is best seen as a collective attempt to revisit a local legend. In fact, Holland perceived the mountain culture as constituting a world of its own where Polish, Slovak and Czech (Moravian) cultures intersected. The fact that it attempts to tell the 'true story' is no doubt the product of Borušovičová's student ambition rather than a postcommunist confrontation with

history, while the interest of the producers – Biermann (initially) and Jabłoński (subsequently) – was obviously based on the recognition of a custom-made local audience and an epic subject that might transcend local boundaries and reach a world market.

One might expect the emergence of 'the true story' of Jánošík to be a specifically postcommunist development – the replacement of ideology and myth by critical analysis. But, according to Votruba, the collected notes to the trial proceedings were first published in 1952 at the height of Stalinism.[24] Borušovičová spent some time working with them. However, while the communist authorities undoubtedly preferred myth to reality, there is no reason to suppose that, had there been a democratic government in the early 1960s, it would have favoured a 'less ideological' Jánošík – and Kubal's fairy tale and Ťapák's pastiche suggest that a less than reverent attitude was possible in Slovakia even at the height of normalization.

In telling us 'the true story', Adamik and Holland's film undoubtedly sets out to distance itself from both Polish and Slovak myths. Thus, Jánošík serves under Rákóczi and in the Imperial army, assists Uhorčík in his escape from the castle of Bitča and is bought out of the army by his father (with money supplied by Uhorčík). The undercover life of Uhorčík as Mravec is developed and the killing of the priest and the desecration of the host both form part of the narrative. Holland and Adamik also added what Holland referred to as some 'youthful eroticism' – if rather mannered and eccentric in context. But while the film avoids the comic strip elements of the Passendorfer/Kwiatkowski version and the 'monumental' aspirations of the Terchová statue, it can hardly be said to demolish the myth.

Like Passendorfer's version, it was also filmed as a television serial (in four parts), which apparently incorporates most of the original script. The film version is therefore somewhat inevitably episodic. Its large budget (one of the highest since the fall of Communism) is certainly evident, Martin Štrba's cinematography is striking, and the images have a range and quality that reach beyond the earlier films. It was nominated for best costume design and sound awards

(Poland), and best costume design and art direction (Slovakia). In 2010, it was listed as the third most successful Slovak film to be released in Slovakia between 1993 and 2009, although it was unsuccessful in Poland.

The story of a young man who becomes a bandit despite himself is treated without the 'nationalism' and 'super-heroism' of the earlier films. Nonetheless, Jánošík's athleticism and bravery are not in doubt and we are shown how legends and stories about him gradually develop. The title of the original screenplay, *The True Story of Juraj Jánošík and Tomáš Uhorčík* (*Pravdivá história o Jurajovi Jánošíkovi a Tomášovi Uhorčíkovi*), reflects its wider focus. In avoiding the 'national' and 'class' bases of the previous films, Adamik and Holland establish new connections. The notion that Jánošík can be compared to any contemporary combatant returning from war (for example, Iraq) is deliberate. Jiráček also possesses an undoubted charisma and modern appeal (Holland suggests that of a young Tom Cruise, although his appearance is nearer to that of Daniel Day-Lewis). The targets for his robberies are not demonized or ridiculed to the same degree as in previous films. Nor is he avenging the death of his parents or defending the peasantry, and his political sympathies remain unclear.

Despite the film's specific reference to the historical context, Jánošík's role as a national hero is downplayed. The sole information is provided by the titles telling us that the opening action is set on the borderland of Poland and present-day Slovakia and that Habsburg troops are hunting down rebels following the defeat of the Rákóczi rebellion. Jánošík's claim that he was forced into service could be a ruse, but he must nonetheless repay the Emperor for his mistakes with 'loyal service'. However, the fact that he later allows Rákózci rebels to escape, even giving them directions, suggests that his sympathies may lie with them. The observation by one of them that 'the struggle for freedom and justice never ends' seems to be addressed to someone who could be more than an onlooker. Yet there is no sense of him representing the ideals of either Slovak or Polish nationalism or the cause of Hungary. He is often cast in the

role of bystander, someone who is equally sceptical of all dogmas and certainties.

The portrayal of women is both more developed and quite different from that in the earlier films and is overwhelmingly linked to notions of superstition and betrayal. Jánošík's grandmother talks of how his mother ate earth when she was pregnant, which is why he is made of clay, accounting for his strength and a somewhat ambiguous suggestion that he can choose his own destiny. The pagan witch, Marketa, who lives with the outlaw, Huncaga, foretells Uhorčík's future death. When Huncaga later murders the priest, it is because he has refused to baptize their baby son, who has subsequently died. Marketa then uses the baby's penis for one of her spells. This particular conflict between Christianity and paganism is hardly resolved, since neither alternative is presented in a positive light.

When Jánošík first returns to his village at the beginning of the film, he discovers that his sweetheart, Anusia, is betrothed to another. He is later seduced by the barmaid Zuzanna with the help of a magic potion. But, as the film progresses, he is increasingly aware of the presence of a third woman who seems to be watching him from a distance at key points in the action. Initially, this enigmatic symbol seems like a refugee from 1960s art cinema. She is eventually revealed as Barbora, daughter of a local priest, and appears to represent Jánošík's potential salvation through marriage and domesticity. In the final scene of the film she gives birth to his son. While these images might not seem particularly 'progressive', they do reflect a popular tradition appropriate to the period.

Jánošík is portrayed as a young man drawn into a sequence of historical events rather than the designated representative of national destiny or fighter against serfdom. This is closer to the historical circumstance in which service to both Hungarian and Habsburg causes were possibilities. Similarly, the close interaction between peasant and outlaw life was a social reality and Terchová seems to have had a history in this respect. This more 'realistic' portrait, therefore, is that of a young man drawn into the conflicts and social realities of his time.

The film's lack of success in Poland was probably due to this characterization as a 'weaker' and more indecisive hero. The portrayal of Jánošík as a lithe young man also contradicts the iconic images of the Frič, Bielík and Passendorfer versions. His characterization as a superficially weaker but more complex character and his portrayal as a 'neighbour' rather than an exceptional portrait of Polish heroism would not have been easy to accept. In this respect, the film undermines the Polish tradition more fundamentally than the Slovak one. Also, given the popularity of Passendorfer's version and the more overt links to popular culture via the graphic novels, this shift was probably even more of a culture shock. Furthermore, the film's most positive character, Uhorčík, lively and uncomplicated, is played by the Slovak actor, Ivan Martinka, and the duplicitous Huncaga by the Polish actor Michał Żebrowski.

Yet if the film's romanticism is not that of Bielik or Frič, its hero remains central, albeit as the focus of a narrative that becomes progressively more sombre. While Jánošík is seen against some impressive mountain backdrops and, as in the other films, identified with them, a triumphant mood is explicitly avoided. At the end of the film, when he is due to be married, the bandit Huncaga (referred to as a Judas) betrays him a second time. As he is executed in relative isolation, he is secretly watched by a child (not by the thousands that accompanied Bielik's film). A year later, his son is born. So his life remains an example and his spirit, it could be argued, is reborn – but shorn of its nationalist and explicit class identity. The pain of his death is emphasized and, before dying, he kisses the cross. This emphasis on family and religion might be seen as a 'Polish' addition. Although the legend of his religious training is not repeated, the Christ parallel continues (even extending to dream sequences). But, although the heroic myths disappear, the romantic tragedy of Jánošík remains and his martyrdom is even more explicit and existential.

If one considers the overall representation of neighbours in the films, then it is surprising, given the border disputes, that Slovaks and Poles are scarcely differentiated and are clearly presented as

'brothers'. This could be because the films are set within what might be termed a linked community for whom the 'territorial' issue does not arise. On the other hand, during the trial scene in Adamik and Holland's film, Jánošík explicitly refers to his band as containing two Poles and one Moravian. Of course, this follows the transcript of the trial, but the fact that ethnic origins are generally downplayed in the film is clearly significant.

Certainly, in the two interwar films, the portrayal of Hungarians is predictably negative and reflects the nineteenth-century Slovak notion of Hungarians as 'barbarians'. Similarly, the betrayal by the gypsy woman in both of them conforms to the stereotype of the nomadic and untrustworthy 'other' familiar from nineteenth-century fiction. In Adamik and Holland's film, the national identities of the rich are also less obviously stereotyped. If one considers the film by Bielik – the one 'straight' film from the communist period – it is arguably more nuanced than the prewar versions although, like them, based on the story as it developed in the nineteenth century. Stereotypes of 'the Other' are derived from pre-communist tradition. The film by Adamik and Holland, apart from using the documentary sources, is distinguished primarily by a desire to avoid the overt messages of the earlier versions, to show a hero without a clear national identity adapting to situations that he does not control.

In its radical subversion of national stereotypes, Adamik and Holland's film arguably seeks to universalize the hero's dilemmas while introducing an aspect of Slovak and Polish history to a new audience (US actress Sarah Zoe Canner appears in the role of Barbora). It seeks to be 'transnational', although it has been subject to 'national' responses. In terms of both production and execution, the film fits the concept of the transnational. In an interesting article on transnationalism in the work of Agnieszka Holland, Elżbieta Ostrowska refers to Holland's aversion to heroic themes and the fact that 'national, ethnic, class, religious, gender and sexual aspects of identity are constantly in question'[25] – a description that could well apply to *Jánošík: The True Story*. It is clearly of interest that both

the first and last films should have been directed by filmmakers who had chosen to live abroad, either within the Slovak-American diaspora (Siakel') or, to use Ostrowska's term for Holland, as 'a cultural nomad'. On the other hand, the same criterion could not be applied to the origins of the screenplays.

While the pre-1989 films were harnessed to the process of nation-building and the assertion of national community, with Hungarians, Germans and Gypsies represented as Other, the class division of peasant versus landowner was always present. Social injustice was linked to foreign or 'colonial' domination. Thus there are parallels with more recent 'Third World' or 'postcolonial' films, where peasants are the victims of colonialism or fight individually or collectively against the dominant power. Here, for instance, one might cite Glauber Rocha's *António das Mortes* (1969), where the killer of bandits turns against the local landowner, or Med Hondo's *Sarraounia* (1987), where the legendary African princess becomes a rallying point for the defeat of colonialism.

If the Frič and Bielik films could also be linked to revolutionary romanticism and socialist realism respectively, they also share in the escapism of commercial genres – as do the swashbuckling heroics of Passendorfer's version and the doomed romantic hero of Adamik and Holland. But the most recent Jánošík seems sceptical about power, revolution and national causes and suspects and discovers that the free life of the outlaw promoted by national mythologies is itself an illusion. In this respect, the film differs from other Polish epics as well as from other 'heritage' films produced in the region.

A consideration of the Jánošík legend on film suggests that it contributed in various degrees to the post-Habsburg and postcolonial development of Slovakia, Poland and the Czech Republic but more particularly of Slovakia. Here, Jánošík has attained the level of national hero, a function performed by a variety of historical figures in the cases of Poland and the Czech Republic. The fact that the stories were appropriated by the communist regimes under Soviet domination hardly changed their essential content or meaning. One would have to argue that the

'postcolonial' culture of the interwar years became the 'colonial' culture of the communist years. If one accepts the notion that 'postcolonial' culture precedes 'postcolonial' reality, it could be argued that the films maintained the patriotic and nation-building function that applied in the interwar years (and also, of course, to their literary origins under the Habsburg Empire).[26] Does 40 years of domination by a Soviet-directed Communist Party – aided by military occupation where necessary and the international strategic assumptions proceeding from the Yalta and Potsdam agreements of 1945 – really constitute an empire? It is probably not too heretical to suggest that autonomy within an existing power structure might constitute a logical national objective until the wider balance of power revealed signs of movement.

Both Czechoslovakia and Poland had highly developed national cultures and these were not entirely suppressed. In some ways, the role of culture was privileged, with intellectuals continuing in their nineteenth-century role of (intermittently) speaking for the nation and the limitations of socialist realism were frequently transcended. Similarly, the role of history remained ambiguous. Czech and Slovak cinema made films about Hus, Comenius, Smetana, Dvořák and Jánošík, and Polish cinema made films about Chopin or based on the works of Sienkiewicz and Wyspiański. The existing mythologies of national culture were quite naturally appropriated by the new communist authorities – but simultaneously perpetuated oppositional models (e.g. heroism, martyrdom and persecution could be linked to contemporary examples). Although they may often have been presented in fake or simplified form, it would be mistaken to deny their continuing force.

It is not entirely surprising for films based on recognized subjects of nineteenth-century nationalism to show some continuity after the fall of the Austro-Hungarian Empire, during the communist interregnum and subsequently. As Paul Coates suggests with respect to the Polish 'national' example under Communism, nationalism was not a unitary discourse, 'but comprises various, possibly detachable components, some of which can go underground while

others remain visible, abbreviated into metonymies or mere markers of the place of the buried, the repressed that will always return'.[27]

The Jánošík legend can be said to comprise a number of basic elements: revolt against social injustice and poverty, assertion of the rights of peasants against those of landlords and a defence against ethnic discrimination. These objectives were held in common (at least in theory) in all three of the periods under discussion. To this one can add poetry, music, romance, lyricism, adventure and the folk traditions so important to culture (particularly in Slovakia). The difference in Slovakia, in contrast to Poland and the Czech lands is, as Votruba suggests, the extent to which the 'intellectualised and academic' myth incorporated not only folk mythology but combined it with elements of a 'real historical character'.[28] *Jánošík: The True Story* does differ, as indicated above, in its emphasis on the overall tragedy of its story, but is steeped in romanticism for all that, and is ultimately a contemporary application dependent on the force of underlying tradition. If the films in general confront the realities of foreign and class domination, the latest suggests that reality cannot be reduced to a nationalist agenda.

Notes

1 David Chioni Moore, 'Is the Post- in Postcolonial the Post- in Post-Soviet? Toward a Global Postcolonial Critique', *PMLA* 116:1 (2001), pp. 111–28.

2 I have used the Slovak 'Jánošík' throughout as opposed to the Polish 'Janosik' except in the case of Polish film titles.

3 Elleke Boehmer, *Colonial and Postcolonial Literature: Migrant Metaphors*, 2nd edn (Oxford: Oxford University Press, 2005), p. 3.

4 Larry Wolff, *The Idea of Galicia: History and Fantasy in Habsburg Political Culture* (Stanford, CA: Stanford University Press, 2010).

5 Antoni Kroh, *O Szwejku i o nas* (Nowy Sącz: Sądecka Oficyna Wydawnicza, 1992); Ewa Mazierska, *Masculinities in Polish, Czech and Slovak Cinema: Black Peters and Men of Marble* (New York and Oxford: Berghahn Books, 2008).

6 Paul A. Hanebrink, 'Sicknesses of the Empire', in Zsuzsa Gáspár (ed.), *The Austro-Hungarian Dual Monarchy (1867–1918)* (London: New Holland Publishers, 2008).

7 Robert Evans, 'Kossuth and Štúr: Two National Heroes', in László Péter, Martyn Rady and Peter Sherwood (eds.), *Lajos Kossuth Sent Word … * (London: Hungarian Cultural Centre; School of Slavonic and East European Studies, University College, 2003).

8 Martin Votruba, 'Hang Him High: The Elevation of Jánošík to an Ethnic Icon', *Slavic Review* 65:1 (2006), pp. 24–44. Revised version: online. Available at <http://www.pitt.edu/~votruba/sstopics/assets/Martin_Votruba_Hang_Him_High_The_Elevation_of_Janosik.pdf> (accessed 30 December 2011).

9 Robert Pynsent points out that in the early nineteenth century, the word *slovenský* could mean either Slav or Slovak (see Robert B. Pynsent, *Questions of Identity: Czech and Slovak Ideas of Nationality and Personality* (London: Central European University Press, 1994), p. 60).

10 Peter Burke, *Popular Culture in Early Modern Europe*, 3rd edn (Farnham: Ashgate, 2009), p. 221.

11 Katalin Péter, 'The Later Ottoman Period and Royal Hungary', in Peter F. Sugar (ed.), *A History of Hungary 1606–1711* (Bloomington, IN: Indiana University Press, 1990).

12 Martin Votruba, 'Highwayman's Life: Extant Documents about Jánošík', *Slovakia* 39:72–73 (2007), pp. 61–86. Revised version: online. Available at <http://www.pitt.edu/~votruba/sstopics/assets/Martin_Votruba_Highwayman%27s_Life_Extant_Documents_about_Janosik.pdf> (accessed 30 December 2011).

13 Votruba: 'Hang Him High', p. 21.

14 Quoted in Peter Petro, *A History of Slovak Literature* (Montreal and Kingston: McGill-Queen's University Press, 1995), p. 82.

15 Czesław Miłosz, *The History of Polish Literature*, 2nd edn (Berkeley and Los Angeles, CA: University of California Press, 1983), p. 338.

16 Martin Votruba, 'Linguistic Minorities in Slovakia', in Christina Bratt Paulston and Donald Peckham (eds.), *Linguistic Minorities in Central and Eastern Europe* (London: Multilingual Matters, 1998), pp. 255–79.

17 Tetmajer was a key figure in the National Committee set up in defence of the Goróle region, which sent a delegation to the Paris Peace Conference requesting that the whole area be awarded to Poland.

18 The feudal conditions depicted in the film were not restricted to Slovak peasants and continued well into the twentieth century. Gyula Illyes's memoir *People of the Puszta* (1936) revealed a lifestyle that had changed little.

19 Jan Rychlík, 'Czech-Slovak Relations in Czechoslovakia', in Mark Cornwall and R.J.W. Evans (eds.), *Czechoslovakia in a Nationalist and Fascist Europe, 1918–1948* (Oxford: Oxford University Press, 2007).

20 A *New York Times* review (25 December 1936) described Bielik's appearance as 'a compelling composite of Douglas Fairbanks, Eddie Polo, Gary Cooper and King Kong'.

21 David Parkinson (ed.), *The Graham Greene Film Reader* (London: Penguin Books, 1995), p. 119.

22 The mid-1930s seemed to reveal an increased interest in using the natural scenery of Slovakia and Ruthenia. The best-known example is Gustav Machatý's erotic melodrama *Ecstasy* (*Extase*, 1932). The Czech writer Ivan Olbracht also published his novel *Nikolaj Šuhaj the Bandit* (*Nikolaj Šuhaj, loupežník*, 1933), the story of a twentieth-century Ruthenian highway robber. He is described in Arne Novák's *Czech Literature* as 'a strong and just hero of the people' (Arne Novák, *Czech Literature*, trans. Peter Kussi (Ann Arbor, MI: Michigan Slavic Publications, 1986), p. 285).

23 Pavel Branko, 'Jánošík po tretie', *Práca*, 16 August 1963 (reprinted in DVD notes for Jánošík (Bratislava: Slovak Film Institute/Slovenský filmový ústav, 2003)).

24 Votruba, 'Highwayman's Life'.

25 Elżbieta Ostrowska, 'Agnieszka Holland's Transnational Nomadism', in Ewa Mazierska and Michael Goddard (eds.), *Beyond the Border: Polish Cinema in a Transnational Context* (Rochester, NY: University of Rochester Press, forthcoming).

26 One wonders how the new 'colonial' culture might be defined. Positive representations of the dominant power can be assumed, but one would have to limit it to films serving the Soviet 'empire' via the relatively

short-lived dogma of extreme socialist realism or films overtly or implicitly supporting the Soviet invasion of Czechoslovakia in 1968 or the suppression of Solidarity in Poland. Many films could be considered 'postcolonial' in the sense that they explicitly or implicitly challenged a 'colonial' or dependent relationship with the Soviet Union.

27 Paul Coates, *The Red and the White: The Cinema of People's Poland* (London: Wallflower Press, 2005), p. 8.
28 Votruba, 'Highwayman's Life', p. 14.

References

Boehmer, Elleke, *Colonial and Postcolonial Literature: Migrant Metaphors*, 2nd edn (Oxford: Oxford University Press, 2005).

Branko, Pavel, 'Jánošík po tretie', *Práca*, 16 August 1963 (reprinted in DVD notes for *Jánošík* (Bratislava: Slovak Film Institute/Slovenský filmový ústav, 2003)).

Burke, Peter, *Popular Culture in Early Modern Europe*, 3rd edn (Farnham: Ashgate, 2009).

Coates, Paul, *The Red and the White: The Cinema of People's Poland* (London: Wallflower Press, 2005).

Evans, Robert, 'Kossuth and Štúr: Two National Heroes', in László Péter, Martyn Rady and Peter Sherwood (eds.), *Lajos Kossuth Sent Word …* (London: Hungarian Cultural Centre; School of Slavonic and East European Studies, University College, 2003).

Hanebrink, Paul A., 'Sicknesses of the Empire', in Zsuzsa Gáspár (ed.), *The Austro-Hungarian Dual Monarchy (1867–1918)* (London: New Holland Publishers, 2008).

Kroh, Antoni, *O Szwejku i o nas* (Nowy Sącz: Sądecka Oficyna Wydawnicza, 1992).

Mazierska, Ewa, *Masculinities in Polish, Czech and Slovak Cinema: Black Peters and Men of Marble* (New York and Oxford: Berghahn Books, 2008).

Miłosz, Czesław, *The History of Polish Literature*, 2nd edn (Berkeley and Los Angeles, CA: University of California Press, 1983).

Moore, David Chioni, 'Is the Post- in Postcolonial the Post- in Post-Soviet? Toward a Global Postcolonial Critique', *PMLA* 116:1 (2001), pp. 111–28.

Novák, Arne, *Czech Literature*, trans. Peter Kussi (Ann Arbor, MI: Michigan Slavic Publications, 1986).

Ostrowska, Elżbieta, 'Agnieszka Holland's Transnational Nomadism', in Ewa Mazierska and Michael Goddard (eds.), *Beyond the Border: Polish Cinema in a Transnational Context* (Rochester, NY: University of Rochester Press, forthcoming).

Parkinson, David (ed.), *The Graham Greene Film Reader* (London: Penguin Books, 1995).

Péter, Katalin, 'The Later Ottoman Period and Royal Hungary', in Peter F. Sugar (ed.), *A History of Hungary 1606–1711* (Bloomington, IN: Indiana University Press, 1990).

Petro, Peter, *A History of Slovak Literature* (Montreal and Kingston: McGill-Queen's University Press, 1995).

Pynsent, Robert B., *Questions of Identity: Czech and Slovak Ideas of Nationality and Personality* (London: Central European University Press, 1994).

Rychlík, Jan, 'Czech-Slovak Relations in Czechoslovakia', in Mark Cornwall and R.J.W. Evans (eds.), *Czechoslovakia in a Nationalist and Fascist Europe 1918–1948* (Oxford: Oxford University Press, 2007).

Votruba, Martin, 'Linguistic Minorities in Slovakia', in Christina Bratt Paulston and Donald Peckham (eds.), *Linguistic Minorities in Central and Eastern Europe* (London: Multilingual Matters, 1998), pp. 255–79.

Votruba, Martin, 'Hang Him High: The Elevation of Jánošík to an Ethnic Icon', *Slavic Review* 65:1 (2006), pp. 24–44. Revised version: online. Available at <http://www.pitt.edu/~votruba/sstopics/assets/Martin_Votruba_Hang_Him_High_The_Elevation_of_Janosik.pdf> (accessed 30 December 2011).

Votruba, Martin, 'Highwayman's Life: Extant Documents about Jánošík', *Slovakia* 39:72–73 (2007), pp. 61–86. Revised version: online. Available at <http://www.pitt.edu/~votruba/sstopics/assets/Martin_Votruba_Highwayman%27s_Life_Extant_Documents_about_Janosik.pdf> (accessed 30 December 2011).

Wolff, Larry, *The Idea of Galicia: History and Fantasy in Habsburg Political Culture* (Stanford, CA: Stanford University Press, 2010).

5

From Nationalism to Rapprochement? Hungary and Romania On-Screen

John Cunningham

In terms of the inter-state relations within Eastern Europe, those between Hungary and Romania are among the most complex and fractious. With over one million ethnic Hungarians living within the borders of Romania,[1] in the northern region of Transylvania (Erdély in Hungarian), with the troubled and complex history that goes along with this, it was probably never going to be easy for Hungary and Romania to work out a modus vivendi about this disputed, ethnically mixed region which has been the focus of tensions between the two countries for such a long time.

It is necessary to discuss some of the theoretical framework within which the analysis is located, particularly as some of the analysis on offer may question, if not run counter to, the main thrust of this volume. Applying the ideas of postcolonialism to the states of the Eastern Bloc has gained major currency in recent years with the publication of essays, for example, by David Chioni Moore,[2] Anikó Imre,[3] the development and extension of the writings of Ella Shohat and Robert Stam[4] and Edward Said, particularly his seminal text *Orientalism*.[5] However, whether or not postcolonial

theory can be applied to the current topic of discussion is not so easily settled and it is one of the intentions of this chapter to raise these issues, not so much to 'prove' or 'disprove' (whatever that might mean) postcolonial theory but to develop a discussion. The first point that needs to be made, and it is a very general one, is that the history of Hungarian–Romanian relations, on-screen or off, is dauntingly complex.

The 'who got there first' argument – what Pål Kolstø calls the 'myth of antiquitas'[6] – is probably of no major weight in these kinds of discussion but it can provide a useful starting point. It is therefore worth noting that the Transylvanian Hungarians have been in this region since around 900 (Christian era) and as such they are a settled, indigenous people. Not that this guaranteed them any stable existence; within that approximately 1,100 year history invaders, armies, rulers and political systems have come and gone in a scenario which is repeated in almost all parts of Eastern Europe. There are the usual suspects: Ottoman Turks, Austrians, Nazis, the Soviet Union, the home-bred quasi-Stalinists and of more recent vintage the foreign and home-bred disciples of free-market capitalism. For large parts of this history Transylvania maintained some form of semi- or full autonomy along with an idea of its distinctiveness and/or separateness from the rest of the region – from what became known as the Regat,[7] the Banat[8] and from the Hungary of the Western Carpathian Basin (i.e. basically the Hungary of today). During the several hundred years of Ottoman dominance in the region, the Transylvanian aristocracy often made deals, usually involving some kind of tax or duty, which guaranteed their autonomy. When the region came under Austrian dominance it was Hungarians who led the resistance to their rule, culminating in the revolution of 1848, but of equal importance was the Hungarians' acceptance of the Compromise of 1867[9] and the establishment of the Dual Monarchy. And from 1868 to the end of World War I Transylvania was ruled from Budapest, supposedly, as an equal partner in the Austro-Hungarian or Habsburg Empire. This ended with the Treaty of Trianon (see below) but it seems

questionable whether this agreement can be meaningfully fitted into any idea of either colonialism or postcolonialism, owing as it did everything to vague Wilsonian ideas of 'self-determination' (which were largely ignored by Britain and France) and much more pressing strategic concerns about the postwar balance of power and 'spheres of influence', particularly in response to the perceived threat coming from newly emergent Bolshevik Russia. In a troubled history Transylvanians (whether of Hungarian, German, Jewish and even Romanian origin) had, and still have, a strong sense of their distinctness and identity.[10]

Nor is there any strong sense amongst Transylvanians of their inferiority to those around them or ruling them. Edward Said has remarked that, '[t]o be colonized is potentially to be a great many different but inferior things, in many different places, at many different times'[11] but reading the history of Transylvania (and, just as important – talking to people who live there) it is difficult to find any sense of this. Inferiority is rarely on display in the streets of Cluj or Timişoara, in cultural productions, political rhetoric or day-to-day conversations, and the region has always been cherished and revered by Hungarians. It has supplied many artists, writers and other figures who have become part and parcel of the intellectual, cultural, artistic and scientific landscape of Hungary: the internationally renowned composer György Ligeti, national poet Endre Ady, filmmaker István Szőts are just three examples. Nor did the Romanian authorities, after 1920, treat the region as some kind of internal colony; in fact many of the measures that were put in place by the Romanian government were designed, at least partly, to enable backward Romania to 'catch up' with its much more developed northern region – the reverse of a colonial situation. Transylvanians have rarely functioned in popular or dominant discourse as the 'noble savage' or 'colonial primitives'.[12] As anywhere in Europe, the usual regional stereotypes can be found – for example, the Hungarian-descended people of the Székely region in Transylvania are regarded by many Hungarians as stoic, laconic and grumpy, and there are also xenophobic epithets,[13] none

of which necessarily point to colonial attitudes. These considerations make for a complicated analysis and one which is open, no doubt, to serious contestation from a range of perspectives. Edna Longley may have been overstating her argument when commenting on 'the post-colonial pastry-cutter'[14] as applied to Irish literature,[15] nevertheless as a warning, if nothing else, it carries a powerful resonance.

This chapter will suggest that for most of the period under consideration both countries have remained fixed in a nationalist framework which has contributed to an atmosphere in which cross-border cultural and artistic gestures, representations and practices have been restricted. This is true for both the right-wing regimes of the interwar years and the Stalinist and quasi-Stalinist regimes of the postwar years, associated with Mátyás Rákosi and János Kádár in Hungary and Gheorghe Gheorghiu-Dej and Nicolae Ceauşescu in Romania. The fact that the postwar regimes of Eastern Europe were often nationalistic in both word and deed, that nationalism was often the flip side of the Stalinist coin, should come as no surprise. In 1940, Leon Trotsky in his, at the time, unpublished work on Stalin, writes at some length on the latter's nationalistic attitudes to amongst others the Georgians, tragically ironic given Stalin's own national origins.[16] Stalin also manipulated nationalism during World War II, for example labelling it the 'The Great Patriotic War', rehabilitating the Orthodox Church, dissolving the Third International (Comintern) in 1943, dropping the *Internationale* and replacing it with a much more conventional and bombastic anthem and so on.

Successive regimes following in Stalin's footsteps have exploited national sentiments or crushed them depending on the political and economic exigencies of the time. That national considerations often dominated post-World War II Eastern European politics is hardly surprising given the patchwork nature of the ethnic make-up of many areas within the region, and most of the East European communist leaderships were quite willing to play the national card when they saw fit. In Hungary, the Communist Party frequently

engaged in rhetoric more redolent of national-populism than anything even vaguely Marxist, including the peculiar notion that the Hungarian Communist Party was the inheritor of the ideals of Lajos Kossuth, the leader of the 1848 rebellion against Austria. There were similar sentiments on the other side of the border,

> The traditional characteristics of the 'bourgeois-landlord' nationalism became incorporated into the Communist version. Chauvinism, anti-Semitism, anti-Russian and anti-Hungarian attitudes, and excessive patriotism were integral parts of the new nationalism; perhaps as important as socio-economic reform.[17]

Whether the election of a government in Hungary committed to a nationalist agenda will exacerbate or even re-ignite the problems of the past remains to be seen, while the accession of both countries to the European Union adds yet another factor to this complex brew.

The first aspect of the troubled Hungary–Romania relationship that strikes the observer is that, for much of the period since the introduction of the moving image, representations of their respective neighbours have been few and far between and the same can be said for other aspects of cinema, such as the interchange of personnel and film distribution. A necessary but brief overview of the history of the relations between the two countries, centring mainly on Transylvania is therefore necessary and will give some suggestions as to why this is the case.

The Versailles Treaty at the end of World War I will, of necessity, be our starting point. As part of the treaty process, the fate of the territories of the Hungarian part of the Austro-Hungarian Empire were concluded in the Trianon Pavillion in Versailles. The agreement, signed on 4 June 1920, defined the fate and shape of postwar Hungary and its borders with its neighbours and was a major component in the dismantling of the empire. As part and parcel of this process, the fate of Transylvania was also decided. 'Greater Hungary' (i.e. prewar Hungary, part of the so-called Dual

Monarchy) lost around two thirds (71.5 per cent) of its territory to its neighbours, such as the newly formed state of Czechoslovakia. Of the total population 13.28 million people (63.56 per cent) of 'Greater Hungary' were lost, although the majority of these people were not Hungarian.[18] Overnight, Hungarian power and authority in the region had been reduced to almost nothing. Flags in Hungary were flown at half mast and the provisions of the treaty were regarded by many – not just politicians – as a gross injustice and a national disaster.[19] The ceding of Transylvania to Romania was perceived as a particularly grievous loss, for this was considered one of the heartlands of the Hungarian nation and has a special place in Hungarian history, the construction of a national identity and national mythology.[20] It is worth noting that prior to the Trianon settlement no Romanian state had ever existed in the region; however, from 1920 to the present day, except for 1940–44, Transylvania has been part of Romania.

After Trianon, Hungarians in Transylvania became Romanian citizens but there were few who embraced this with enthusiasm and many left.[21] The new constitution of 1923 bestowed Romanian citizenship on everyone and the idea of a specific Hungarian identity was marginalized and in many areas of civil life discriminated against in various ways, including through legislation. This was particularly apparent in the area of education, where Hungarian-language schools and institutions of higher education were closed down, forced to teach in Romanian or had other restrictions placed on them. The Hungarian National Theatre in Kolosvár (Cluj-Napoca in Romanian) was closed down and forced to move to inferior premises while the increasingly harsh social and cultural climate also contributed to the decline and eventual disappearance of the Hungarian-owned and -run film industry that had thrived in Kolosvár from around 1913 to 1920.[22] Throughout the interwar years the position, security and well-being of the Hungarian minority fluctuated but the general trend was one of national and regional marginalization resisted by the Hungarians, who set up their own political party, the National Hungarian Party (Országos

Magyar Párt) which won 15 seats in the Romanian Parliament in 1926. However, successive Romanian governments remained suspicious of Hungarians, both within and without Transylvania, feelings that were fuelled by the irredentist noises emanating from Budapest at regular intervals during the interwar years about the necessity to reclaim the 'lost territories'. However, Hungary was powerless to actually do anything and Hungarian irredentism was reduced to the oft-repeated but vacuous slogan, *Nem, nem, soha!* ('No, no, never!'). If Hungary was to reclaim the 'lost territories' it would need a strong ally. The situation began to change in the early 1930s.

After 1933 Nazi Germany became the major power-broker in the region, manipulating the various national aspirations of the countries of Central and Eastern Europe while at the same time maintaining a balance that favoured its own strategic, political and economic goals. It was, for example, keen to exploit Hungarian agricultural potential and particularly Romanian oil reserves (the largest in Europe) at Ploesti. On 30 August 1940 the worst fears of the Romanians materialized when, under the auspices of the Axis powers, Hungary was able to reclaim much of Transylvania (and southern Slovakia) after the agreement reached at the Nazi-brokered Second Vienna Accords. Shortly thereafter, in early September, Hungarian troops led by Regent Horthy marched into Kolosvár to great acclaim from the local (Hungarian) population and, in total, Hungary 'liberated' about half of Transylvania. It is indicative of the loyalties, passions and emotions involved that many Hungarians from southern Transylvania, which remained under Romanian control, moved northwards and thousands of Romanians in the Hungarian area moved south.[23] It was not to last however and the decision by the Hungarian government to join the Nazi offensive against the Soviet Union was a disaster. When the fortunes of war turned against the Nazis in the wake of Stalingrad, its ill-equipped ally saw its hold on Transylvania disappear as the Red Army advanced further and further westward. The Romanians signed an agreement on 12 September 1944 with the Soviet Union and

joined them in the war effort (like the Hungarians they, initially, sided with the Nazis) and the region returned to Romanian rule. This situation was cemented when the pre–World War II borders were reaffirmed (with some extremely minor adjustments) by the Allies in Paris in February 1947.

It was during this short period of Hungarian rule that a film was made that remains not only one of the most revered of Hungarian films but one which is set entirely in Transylvania. István Szőts' *People of the Mountains* (*Emberek a havason*), which premiered at the Venice Film Festival in 1942, is a tale of a Hungarian woodcutter and his family in the Székely area of the Carpathian Mountains. As I have already written in some depth about this film it is not my intention to go into detail about it here. Suffice to note that the film contains not a single Romanian character, nor a single word of the Romanian language.[24] Despite the beautiful cinematography and the moving story that unfolds, the Transylvania portrayed in this film is totally Hungarian. The 'Other' doesn't exist, it is not even hinted at.[25] Nor can it be the case that the director or the screenwriter, József Nyirő, were ignorant of the situation in Transylvania – in fact both of them were born in the region (and as such it is highly likely that they were both bilingual). Whether this imbalance in the film is due to fear, or the kind of prejudice where the 'other' is simply off limits, is hard to say. Likewise, whether or not government censorship or studio intervention was involved is unanswerable without further research. Certainly from a propaganda viewpoint the government had a distinct interest in representations of Transylvania that showed it to be totally Hungarian. With the end of the war the situation between the two countries was to change dramatically.

By the late 1940s both Romania and Hungary were completely under the domination of the Soviet Union and their respective puppet regimes, although it may be argued that the Romanians, because of their U-turn late in the war, were looked on more favourably than the Hungarians.[26] Developments in both countries followed a pattern which can be seen across the Eastern Bloc. The respective governments of Hungary and Romania now found

Figure 5.1
Kornél Mundruczó's *Delta* set in an anonymous Romania

themselves in something of a dilemma. On the surface they had to play the charade of Stalinist 'international brotherhood' while at the same time pretending that old animosities had been laid aside, which was far from the case. In Transylvania, the Romanian government pursued policies, some of which would not have looked out of place in the worst periods of the 1920s or 1930s. Up to 1953 the Romanian government took a number of decidedly Stalinist measures against the Hungarian minority, which included closing down Hungarian-language newspapers, persecuting or harassing any potentially dissident voices, abolishing religious publications or severely restricting them and, in 1952, dissolving the Hungarian People's Union, an organization established in 1944 to, supposedly, represent the interests of the minority. By 1953, Romanian party-leader Gheorghe Gheorghiu-Dej could announce confidently that the 'problem of the nationalities' had been solved. What followed, however, was a policy which often looked like forced assimilation. Despite fluctuations, as leaderships local and regional changed or were deposed and political factions fought out their customary internal dogfights, this policy of restriction and repression was to continue until the collapse of the Ceaușescu regime in 1989.[27] There

was a period of relative relaxation after the death of Stalin in 1953 when, for example, the literary figure Gábor Gaál, who had been arrested in 1952, was rehabilitated, and in the summer of 1956 the Romanian authorities allowed a small group of Hungarian writers, which included the well-known Gyula Illyés, to visit Romania.

In Hungary, the dictatorship of Mátyás Rákosi had established itself in 1948 but was challenged by the reformer Imre Nagy in the early 1950s. A chain of developments then ensued which led to the Hungarian Uprising of 1956, an event that had important implications over the border. In Cluj, Timişoara and other Romanian cities there were demonstrations by students and others, not all of whom were ethnic Hungarians.[28] The Romanian authorities became alarmed that there could be a 'knock-on' effect and believed that if the insurrectionists were successful it might lead to renewed calls for Transylvania to be returned to Hungary. The Romanian government was also deeply implicated in the diplomatic ruse whereby Imre Nagy and his family and supporters were coaxed out of the Yugoslav Embassy in Budapest, where they had been granted a limited form of asylum by Tito.[29] Nagy, his family and entourage were to become 'guests' of the Romanian government but the reality was that they were prisoners who would be handed over to the Hungarians when the time was right, as indeed happened in the following year.[30] This rare example of Hungarian–Romanian cooperation was carried out solely for repressive purposes and closely scrutinized by the Soviet authorities. Some of the more visible aspects of this wretched double-cross are portrayed in Márta Mészárosz's 2004 film *The Unburied Dead* (*A temetetlen halott*), including scenes where Imre Nagy's Romanian 'hosts' are seen eavesdropping on their 'guests' and compiling reports for the Secret Police.[31]

After the collapse of the uprising, the Romanian government responded with a series of measures that were riddled with ambiguity. Concessions were enacted in the sphere of literary publications for example, but persecution of those perceived as being oppositionists continued unabated. János Kádár, the Hungarian Party secretary

who had replaced Rákosi, paid a high-level visit to Romania in February 1958 and while both sides went through the necessary rituals of Warsaw Pact 'camaraderie', little was resolved and Transylvanian Hungarians were alarmed when stories leaked out suggesting that Kádár declared himself satisfied with Romanian policy regarding the minorities.

The Romanian government had never been happy with the presence of Soviet troops on its soil and in 1953 raised the issue of their withdrawal, which eventually transpired in July 1958. By contrast, Soviet troops were to remain stationed in Hungary until the late 1980s. For the Hungarian minority the next ten years or so consisted mainly of increased marginalization. Given such a background it seems unsurprising that filmmakers from either side of the Hungarian–Romanian border played safe and simply ignored the existence of their 'fraternal neighbour'. The political rhetoric of the time insisted on the notion of Eastern Bloc solidarity, and Hungarian or Romanian filmmakers for their part probably could not, even had they wanted to, have made films which featured any aspect of life or history about the other, and unsurprisingly the topic of Transylvania appears to be simply off limits. The few examples where Hungarian filmmakers touch on the topic of Romania or Transylvania do nothing to challenge this general perception. The historical epic *The Sea has Risen* (*Föltamadott a tenger*, László Ranódy and László Nádassy, 1953), a rather tortured account of the 1848 Hungarian insurrection against Austrian rule, depicts a band of Romanian volunteers joining the Hungarians.[32] In 1958, the highly respected Félix Mariássy made a film, *Smugglers* (*Csempészek*), which is set on the Hungarian–Romanian border and is centred on the romance between two smugglers, a Romanian woman and a Hungarian man, and in the following year Frigyes Bán directed *Fatia Negra* (*Szegénygazdagok*), a tale of Transylvanian highway robbers. All three films are set in a relatively safe past whereas a film set in the contemporary period had the potential to raise questions and would, no doubt, be scrutinized closely by the governmental cultural guardians of both countries. To what extent self-censorship

played a role here is difficult to say; most of the personnel involved are now dead and self-censorship practices were rarely recorded.

In 1965 Romania acquired a new Secretary-General. Gheorghiu-Dej died in March 1965 and was replaced by the man whose name was to become synonymous with Romania and the darkest period in its entire history. Nicolae Ceauşescu continued the policies of his predecessor towards the Hungarian minority – on the one hand concessions were made, for example the establishment of the Kriterion Publishing house,[33] which specialized in minority-language publications but, at the same time, Ceauşescu initiated aggressive attempts to homogenize Romanian society and, in effect, remove the last traces of 'Hungarianness' from Transylvania. This included his notorious plan to eradicate country villages and replace them with centralized housing concentrations, a scheme which attracted worldwide condemnation and one which would have included both Hungarians and Romanians. By 1985 broadcasting Hungarian-language TV programmes was terminated and two years later plans were announced to outlaw the use of the Hungarian language in public places.

By the time of Ceauşescu's accession Hungarian cinema had entered into what turned out to be a 'golden period'. A host of new directors emerged, influenced by the French New Wave and other trends in world cinema, and directors such as Miklós Jancsó and István Szabó put Hungarian filmmaking on the world map in a way which had never been achieved before. For the purposes of our discussion one aspect of this development was that Hungarian filmmakers tended to look westward and in some cases also to other Eastern European cinemas such as Poland.[34] They did not look directly eastwards and Romanian cinema, although not without merit in the 1960s, was of relatively marginal interest among the Eastern Bloc filmmakers. Likewise, there appears to have been a relatively lukewarm attitude to showing Romanian films in Hungary; for example in 1961 five Romanian films were distributed, compared to 14 from one of Hungary's other close neighbours, Czechoslovakia.[35] Like most generalizations this needs qualifying.

In the 1960s Romanian cinema too had its equivalent New Wave and for the first time in its history a number of outstanding films were made. International co-productions followed but these were mainly with Romania's old European 'friend' France; no doubt the French were pursuing their own agenda here and it is possible that this policy, on the Romanian side, was part of Ceauşescu's drive to assert and maintain independence from the USSR and the rest of the Warsaw Pact countries.[36] Liviu Ciulei's *Forest of the Hanged* (*Pădurea spînzuraţilor*, 1964), the best-known Romanian film of the period, made a major international impact, winning the Best Director award at Cannes in 1965; it is one of the few films of this time, from either side of the border, to engage with the complexities of Hungarian–Romanian relationships. Set in Transylvania in 1916, Apostol Bolga, a lieutenant in the Romanian army, has to negotiate a conflicting set of allegiances and friendships including his love for the ethnic Hungarian peasant woman, Ilona. At a time when Romanian and Hungarian forces (the latter as part of the armies of the Dual Monarchy) were at war with each other in Transylvania, the sensitive and intelligent Bolga is, almost inevitably, torn apart by the contradictions and conflicts surrounding him. His final undoing comes when he refuses to participate in a trial of a group of Hungarian and Romanian peasants who defied the authorities and ploughed their land, which is situated near to the combat zone. Bolga deserts, is captured and the film ends as he awaits his fate in prison.[37]

It is worth asking why/how this film, which works against the grain in so many ways, was made. It is possible that this was one of those historical moments, not unusual in the narratives of Eastern Europe, when state watchdogs allowed a certain relaxation, when a film 'movement' begins to attract international attention and is granted more leeway than the other arts or when artists are able to exploit a gap in the 'system'. Perhaps the authorities saw it as an affirmation of Romanian nationhood rather than as the deeply humanistic plea for understanding and co-existence that it undoubtedly was. The cinema of Eastern Europe is not short of

these examples of 'maverick' films which point up, amongst other considerations, that censorship and other forms of state control were rarely as totalitarian or oppressively effective as Western Cold War propaganda frequently alleged.

Despite some successes, in the 1970s Romania cinema laboured under the increasingly autocratic rule of Ceauşescu, whose Stalinist inclinations were exemplified in the construction of his monstrous 'Palace' in Bucharest and, at the other end of the scale, his decision, worthy of Orwell's *Nineteen Eighty-Four*, to licence the use of typewriters. In the 1980s the only Romanian film that bucks the trends noted here appears to be *Angela Goes Further* (*Angela merge mai departe*, Lucian Bratu, 1981), a story about Angela, a female taxi driver who falls in love with Gyuri from the Hungarian minority.[38] In 1993, Hungarian maverick filmmaker András Jeles, made *Why Wasn't HE There?* (*Senkiföldje – Dieu n'existe pas*), a Holocaust film about Éva, a 13-year-old Jewish girl sometimes referred to as the 'Hungarian Anne Frank', who lives in a small town in Transylvania but, again (as with *People of the Mountains*), there is no Romanian presence in this film.[39]

As an indication of what might have happened if a filmmaker had made a film about the 'Other', it might be instructive to look at the controversy surrounding the publication of a book on the history of Transylvania by a group of Hungarian academics. In 1986, with the participation of the Hungarian Academy of Sciences' Institute of History, *A History of Transylvania* (*Erdély története*), a history of the region from prehistoric times up to the present was published in three volumes. An abridged English version was published in 1994. The book was roundly denounced in Romania, including by none other than Ceauşescu himself who thought the book was a 'Horthyist, fascist, chauvinist, revenge-seeking compilation'.[40] It is also indicative of the times that even representatives of the Hungarian minority condemned the book, so fearful must they have been of reprisals against them. Actually, only a few people could have read the offending tome as it was banned in Romania and, although generalizing from this state of affairs to the world of

cinema requires some caution, it nevertheless gives an indication of growing state intimidation and the paranoid cultural-political climate of the times.

With the demise of Ceauşescu, the collapse of the Eastern Bloc and the eager embrace of free-market capitalism it was inevitable that the situation within both the Hungarian and Romanian film industry would change, but what is noteworthy is how slowly and unevenly this change has taken place. In the 1990s Romanian cinema steadily began to recover but over the border Hungarian cinema went into a state of crisis. Production slumped, cinemas closed down and in 1991 the Hungarian Film Week was cancelled because the organizers thought the films on offer were sub-standard. Despite the cataclysmic events in both countries (although Romania's revolution was altogether more dramatic) it is, again, difficult to find a film from either side of the border that represents the significant events of 1989–90. For their part Hungarian filmmakers made a small number of films which depicted the effects of the changes within Hungary, with films such as *Moscow Square* (*Moskva Tér*, Ferenc Török, 2001), *Dear Emma, Sweet Böbe* (*Édes Emma, drága Böbe*, István Szabó, 1992) and *Bolshe Vita* (Ibolya Fekete, 1996), while the Romanian industry only began to make major narrative films about their revolution and its consequences when a newer generation of directors emerged, kick-starting the Romanian New Wave.

A film which did depict the events of 1989 with a cross-ethnic perspective is Marius Barna's *War in the Kitchen* (*Război în bucătărie*, 2000). Set significantly in the birthplace of the revolution, Timişoara/Temesvár, this film involves a Romanian soldier falling in love with a woman from the town's Hungarian minority. The director is probably from the Hungarian minority and/or a product of a mixed marriage as the family name, Barna, is Hungarian. A Hungarian–German co-production, *Europe is Far Away* (*Europa messze van*, Barna Kabay, 1994) featured a Romanian scientist pursued by the Securitate who escapes to Hungary with his family. He is forcibly returned to Romania, but his son Petru absconds and

finally reaches Germany. Later the family are allowed to leave for Germany and they begin to search for their son. Intriguingly, this potentially interesting film has never been released.

One of the few films that confronted issues of the relationship between Hungary and Romania, was a short experimental film of just over five minutes' duration. *Anthem* (*Rever*, Szabolcs KissPál, 2001) features a group of five young women singing the words of the Hungarian national anthem to the tune of the Romanian national anthem. This mixing of nationalisms and deliberate flouting of borders echoes the origins of the director, who hails from Tírgu Mureş in Romania, but now lives and works in Budapest. Whether or not the director could have 'got away with this' if the film had been anything other than an experimental short seems unlikely.

Since 2000 the situation seems to be changing slightly. Four major Hungarian films have been made in or partly in Romania: Robert Pejo's *Dallas Pashamende* (2004), Csaba Bollók's Transylvania-situated *Iska's Journey* (*Iszka utazása*, 2007), Kornél Mundruczó's much-acclaimed *Delta* (2008) and *Katalin Varga* (2009) which, although directed by Englishman Peter Strickland, is very much a Hungarian film albeit with a sizable Romanian participation, most notably producers Tudor and Oana Giurgiu. However, the makers of *Dallas Pashamende*, a film centred on a Gypsy community in Romania (and initially shot in Romania), had to relocate after pressure from the Romanian authorities who thought that it would project a negative view of the country.[41] None of the films actually portray Romania in a favourable light. Most ambiguous is Mundruczó's *Delta*. Romania is never named, yet the presence of an Eastern Orthodox church in one scene is a clear indication that the film is not shot in Hungary but in an eastern neighbour. The story concerns a young man, a 'black sheep' of the family, who returns home and finds that he has a stepfather. His sister, born after he left home, begins to help him build a house out in the delta and soon their relationship becomes intimate. At the end of the film, after providing a feast for local villagers where the locals' behaviour becomes increasingly drunken and boorish, they are both killed in a barbaric fashion.[42]

Figure 5.2
Poster for *Delta* (2008) by Kornél Mundruczó

In *Iska's Journey* the location moves from the beautiful Danube Delta to the former coal-mining area of the Jiu/Zsil Valley. Here the 12–13-year-old Iszka (Maria Varga – a non-professional essentially playing herself), an ethnic Hungarian, ekes out a miserable existence picking scrap metal from the rusting coal yards and abandoned colliery machinery. In a style not dissimilar to that of Ken Loach, the film follows the fortunes and mishaps of Iszka until she is kidnapped after accepting a lift and the film ends with her imprisoned on a ship awaiting an uncertain future as part of the sex-trafficking 'industry'. Finally, *Dallas Pashamende* is set on a huge rubbish heap where a Hungarian-speaking Gypsy community lives and works salvaging items from the rubbish. A former inhabitant of this community, now a doctor, returns and eventually rejects his life outside.

In two of these four films, Romania exists as a 'realm of the imagination', but it is an imagination that is decidedly grim and significantly in neither film is Romania named. In *Dallas Pashamende* the film hardly ever moves out of its massive amphitheatre-like rubbish dump and although the inhabitants have improvised bars and discos, the fact remains that life here is on the margins of civilization. Although *Delta* astonishes with the beauty of its cinematography and the magnificence of the Danube Delta scenery, it contains a sinister and almost primeval core where a father rapes his stepdaughter and where the local people operate a savage law of reprisal on those who dare to flout social conventions. *Iska's Journey*, with its unrelenting realism, is a very different kind of film with its portrayal of grinding poverty and hopelessness. The few miners who remain in the Jiu Valley are Romanian and they treat Iszka with some kindness, giving her food when she goes to their canteen, but it is an isolated example of human decency. The Romania portrayed here is a grim place and definitely not of the imagination; with the closure of the mines, the Jiu Valley must be one of the most depressed areas in the whole of Europe. Iszka and her sister are forced to give their hard-earned pittance from their labours to their alcoholic parents and there are few respites from a

life of toil and penury. Her one chance to get away – she wants to go to the sea which she has never visited – disappears when she is abducted.

Despite the beauty of its setting (in the Székely area), the Transylvania of *Katalin Varga*, one of the few films to include Romanian and Hungarian characters, is a place of rape, vengeance, suicide and murder. Katalin Varga has a child, Orbán, after being raped by two men, one a Romanian and the other a Hungarian, a fact she hides from her husband for 11 years. Eventually he finds out and she leaves her village with her son. She finds one of the rapists (the Romanian) and kills him. She then finds the Hungarian, who is now married, and a curious relationship develops between them. His wife eventually figures out what has happened and hangs herself. Katalin is hunted down by the dead man's brother-in-law and two others who pose as Romanian police. Towards the end of the film they find Katalin and kill her, demonstrating a vicious, Old Testament, eye-for-an-eye, system of values.

It is noteworthy that these films use Romania as a named or unnamed setting for grinding poverty and/or the most primeval abuses of human beings. It is too early to state whether or not this is a trend, but the representation of Otherness as brutishness and its linking with Romania cannot be ignored. While the element of Hungarian nationalism is absent in these films – no one has made a 'reclaim Transylvania' film – they suggest that although some aspects of the Hungarian–Romanian relationship have changed for the better, on the screen there is still a state of flux.

There have been some other Hungarian–Romanian co-productions. For example, *Retrace* (*Visszaterre*, Judit Elek, 2010, also with Swedish funding) is a story of a Holocaust survivor returning during the Ceaușescu period to the Transylvanian town where she was born.[43] Shifting the focus of the discussion a little, in October 2009 there was a Romanian Film Week in Budapest organized with support from the Hungarian Ministry of Art and Culture, a recognition by Hungary of the importance of the Romanian New Wave, featuring such films as *Police, Adjective* (*Polițist, adjectiv,*

Corneliu Porumboiu, 2009) and *Boogie* (Radu Muntean, 2008). The now well-established Transylvanian Film Festival in Cluj-Napoca, which has a significant ethnic-Hungarian participation, is another landmark and welcome sign. 'Behind the scenes' as it were, other developments are also encouraging. Highly respected Romanian cinematographer Vivi Drăgan Vasile has worked on a number of Hungarian films including *Ábel in the Forest* (*Ábel a rengetegben*, 1993) set in 1920s Transylvania, *The Outpost* (*A részleg*, 1994) and *Dallas Pashamende*. He was given the Pro Cultura Hungarica award in 2002 and was a member of the Jury for the 42nd Hungarian Film Week in 2011.

Perhaps, this 'quiet border crossing' which could also be called 'creeping normalization', which can be seen elsewhere in Europe in, for example, the relationship between the Irish Republic and the UK, will be the way the situation will evolve; and with the two neighbours now both members of the EU new possibilities open up all the time. However, with the 2010 electoral victory in Hungary of the so-called 'Liberals' (FIDESZ), actually a right-wing party with strong nationalistic tendencies, inter-governmental relations between Hungary and Romania do not look set to improve much. Hungarian Prime Minister Viktor Orbán has already made noises about wanting to give the Hungarian minorities living outside Hungary's borders the vote in Hungarian elections, a proposal hardly designed to develop warm feelings in Bucharest. The Orbán government has also attacked the arts, drastically reducing funding for film production. However, although the Hungarian government's policies on the film industry are little short of disastrous, they may, ironically, encourage more cross-border cooperation as cash-strapped Hungarian production companies seek new partners abroad. As the Hungarian film industry, now under the helmsmanship of government-appointed Andy Vajna (the one-time Hollywood-based producer of *Rambo* and *The Terminator*), sees its funding reduced to probably eight features a year it seems unlikely that favoured directors will be risking what state funding is available to make any cutting-edge or controversial

films. Commercial viability is now the order of the day and to what extent Hungarian filmmakers will turn to their neighbours in any major way remains to be seen. As one door closes perhaps another opens.

Notes

1 Census figures for Transylvania were often an exercise in political manipulation rather than an attempt at precise demographics by either Hungarian or Romanian authorities. In 1977, official Romanian figures showed 1.75 million Hungarians (defined by mother tongue) living in Romania. However, people belonging to the Csangó minority (a people who are of Hungarian descent and speak Hungarian) and children of mixed marriages were automatically registered as Romanian.

2 David Chioni Moore, 'Is the Post- in Postcolonial the Post- in Post-Soviet? Towards a Global Postcolonial Critique', *PMLA* 116:1 (2001), pp. 111–28.

3 Anikó Imre, *Identity Games: Globalization and the Transformation of Media Cultures in the New Europe* (Cambridge, MA, and London: MIT Press, 2009).

4 For example, Ella Shohat and Robert Stam, *Unthinking Eurocentrism: Multiculturalism and the Media* (New York: Routledge, 1994).

5 Edward Said, *Orientalism* [1978] (London: Penguin Books, 1985).

6 Pål Kolstø (ed.), *Myths and Boundaries in South-Eastern Europe* (London: Hurst and Co., 2005).

7 The Regat – the area of Romania to the south of Transylvania populated primarily by Romanians and centred on Bucharest. Originally applied to the Kingdom of Romania – Vechiul Regat (literally 'Old Kingdom'), includes Wallachia, Moldavia and Dobrugea.

8 The Banat—the area south-west of Transylvania and extending into northern Serbia.

9 After quelling the 1848 Revolution the Austrian monarchy held out the possibility that Hungary could join Austria in a so-called Dual Monarchy where both countries recognized the Emperor. This was eventually solidified in the Compromise of 1867.

10 During my nine-year stay in Hungary I met many Transylvanian
 Hungarians living in Hungary and I visited Transylvania at least five
 times, including one spell teaching in Cluj. All the Transylvanians I
 met, of whatever background, spoke with immense pride about their
 homeland and there was never any hint that they were somehow
 'second class' either to Hungarians over the border or to their
 Romanian neighbours. Significantly, none of the Hungarians I spoke
 with favoured returning Transylvania to Hungary. The most common
 opinion was that it should become some kind of autonomous region
 within a broader federation—what was sometimes referred to as the
 'Swiss option'.

11 Said, quoted in Robert Shannon Peckham, 'Internal Colonialism:
 Nation and Region in Nineteenth Century Greece', in Maria Todorova
 (ed.), *Balkan Identities: Nation and Memory* (London: Hurst, 2004), pp.
 41–59.

12 It is difficult to think of, for example, a 'Transylvanian Rudyard Kipling'
 from any community. It might be possible to argue that the Dracula
 legend is an exception here but Dracula, invented by the Anglo-Irish
 Bram Stoker, who never visited the region, has not served any major
 cultural function in either Hungary or Romania—except for tourism.
 In Hungary, Stoker's novel was extremely popular when it was serialized
 in the newspaper *Magyar Hirlap* in 1898, but filmic representations,
 either side of the border, have been few and far between. There was a
 Hungarian–Austrian film, *The Death of Dracula* (*Drakula halála*, Károly
 Lajthay, 1921) which appears to bear some affinity with *The Cabinet of
 Doctor Caligari*, but this is now lost. The main fascination with this tale
 has been in Britain, Germany and the USA.

13 The more right-wing, nationalistic elements in Hungarian Transylvania
 sometimes refer to Romanians as *Cigányok* (Gypsies), while similar
 elements in the Romanian community may refer to Hungarians as
 Bozgors ('people without land').

14 Edna Longley, *The Living Stream: Literature and Revisionism in Ireland*
 (Newcastle upon Tyne: Bloodaxe Books, 1994).

15 Longley is specifically referring to David Lloyd's *Anomalous States: Irish
 Writing and the Post-Colonial Movement* (1993), but she also has some

important disagreements with Fredric Jameson, Edward Said and Terry Eagleton. Unfortunately space does not allow for any elaboration (see Longley: *The Living Stream*, pp. 22–44).

16 See for example Leon Trotsky, *Stalin*, vol. II: *The Revolutionary in Power* [1947] (London: Panther, 1969), pp. 168–76.

17 Stephen Fischer-Galati, 'Romanian Nationalism' in Peter F. Sugar and Ivo John Lederer (eds), *Nationalism in Eastern Europe* (Seattle, WA: University of Washington Press, 1994), pp. 373–95.

18 Ildikó Lipcsey, *Romania and Transylvania in the Twentieth Century* (Buffalo, NY, and Toronto: Corvinus Publishing, 2006), p. 27. For a detailed consideration of the position of minorities in post-World War I Central and Eastern Europe see József Galántai, *Trianon and the Protection of Minorities* (Highland Lakes, NJ: Atlantic Research and Publications, 1992).

19 For a detailed rundown of the discussions at Trianon see Bryan Cartledge, *Makers of the Modern World: Mihály Károlyi and István Bethlen* (London: Haus Publishing, 2009).

20 Lajos Kossuth, the leader of the 1848 revolt against Austrian rule, once famously described Transylvania as 'the right hand of our fatherland'.

21 One of those who left the new Romania was a young would-be writer, Emeric Pressburger, who began the first of a number of migrations which for him ended up in England and his famous partnership with the director Michael Powell.

22 I attempt to discuss the Hungarian cinema of Kolosvár/Cluj in John Cunningham, 'Jenő Janovics and Transylvanian Silent Cinema', *Kinokultura*, Special Issue 7 (2008). Online. Available at <http://www.kinolkultura.com/specials/7/hungarian.shtml> (accessed 30 December 2011).

23 About 140,000 Transylvanian Romanians fled to the south in the immediate aftermath of the Hungarian occupation, some of them tempted by the prospect of land being offered by the Bucharest government in Bukovina and Bessarabia (Vladimir Solonari, *Purifying the Nation: Popular Exchange and Ethnic Cleansing in Nazi-Allied Romania* (Washington DC: Woodrow Wilson Center Press; Baltimore, MD: Johns Hopkins University Press, 2010), p. 260). This was part of a colonization

process and referred to as such by central government (it even had a 'Department of Colonization', the SSSRCI, State Sub-Secretariat of Romanization, Colonization and Inventory, created in May 1941), but interestingly, the Transylvanian Romanians were considered outside the terms of reference of this scheme. Indeed, 'over the entire World War II period, the Romanian government actively *discouraged* emigration of ethnic Romanians from northern Transylvania, the possibility of which was provided for in the Vienna Accord with Hungary' (Solonari: *Purifying the Nation*, p. 97, emphasis original). The main task of the SSSRCI was to supervise the confiscation of Jewish property in Romania.

24 See John Cunningham, 'Emberek a havason/People of the Mountains', in Peter Hames (ed.), *The Cinema of Central Europe* (London: Wallflower Press, 2004a), pp. 35–44.

25 Much the same can be said for the Hungarian silent cinema from Kolosvár/Cluj in the early part of the century. Although many films have been lost, from the evidence available there appears to be no Romanian presence in these films at all.

26 King Michael of Romania abdicated his throne on 30 December 1947, after which the Romanian Communists quickly took full control of the country, having earlier disposed of or neutralized their political rivals. In Hungary, the communists held many influential positions in the immediate prewar government and in the fraudulent elections of 1947 were able, with their 'fellow travellers', to secure a majority. For more details see Peter Kenez, *Hungary: From the Nazis to the Soviets: The Establishment of the Communist Regime in Hungary, 1944–1948* (Cambridge: Cambridge University Press, 2006), particularly ch. 13.

27 It should be noted that the Romanian minority in Hungary, almost entirely scattered along the border, is very small, numbering only a few thousand and was therefore rarely a component of the debates and conflicts around the issue of the 'minorities'.

28 One of the main student leaders in Timişoara was the Romanian Aurel Baghui. In Romania in the post-1956 period approximately 600 people were imprisoned and at least ten people were executed, while a number died from maltreatment while in prison (see Lipcsey: *Romania and Transylvania in the Twentieth Century*, pp. 136–8).

29 There have also been stories that Romanian agents were operating in Budapest during the 1956 uprising spreading 'black propaganda' that the Nagy government included the 'liberation' of Transylvania as part of its political agenda.

30 For more details see Roger Gough, *A Good Comrade: János Kádár, Communism and Hungary* (London: I.B.Tauris, 2006), pp. 103–18.

31 The Romanian scenes in this film—the brief 'interlude' when Nagy and his cohort are detained in Romania—were shot in Slovakia. Whether or not this was for any diplomatic reasons or simply because of filming or budgetary considerations I do not know.

32 These volunteers are, supposedly, under the command of the Romanian military leader Avram Iancu. There is, from the point of view of historical accuracy, a question mark over this aspect of the film.

33 Kriterion, based in Bucharest, published some important material including Lajos Jordáky's *The History of the Transylvanian Silent Film Studios (1903–1930)* (*Az erdélyi némafilmgyártás története (1903–1930)*).

34 I discuss this topic in more depth in John Cunningham, *Hungarian Cinema: From Coffeehouse to Multiplex* (London: Wallflower Press, 2004b) and in my forthcoming work on István Szabó (Wallflower Press).

35 Ferenc Kovács (ed.), *Filmévkönyv 1961* (Budapest: Gondolat Kiadó, 1962). By 1983, the situation had changed little; just five Romanian feature films were distributed in Hungary. Four films crossed the border in 1984 and in 1996 there were no Romanian films distributed in Hungary (none of these figures includes films shown on TV).

36 Romanian independence, particularly from the Soviet Union, had already been asserted by Gheorghiu-Dej and was continued by Ceauşescu. He opposed the invasion of Czechoslovakia in 1968 and refused to condemn Israel in the 1967 Six Day War. Not that this independence benefited the Romanian population, who continued to labour under an increasingly corrupt and megalomaniac police state.

37 For further discussion of this remarkable film see Marian Ţuţui's excellent essay in Dina Iordanova (ed.), *The Cinema of the Balkans* (London: Wallflower Press, 2006), pp. 24–41.

38 My thanks to Romanian film scholar Lucian Georgescu for mentioning this to me. I haven't seen this film.

39 The curious mixed Hungarian/French of the original title (*Senkiföldje*) means 'No man's land' in English and is possibly due to the film's origin as a Hungarian–French co-production. Although the main character Éva (who is based on a real person) has been referred to as the 'Hungarian Anne Frank', there appears to be some doubt as to the authenticity of her diary.

40 Lipcsey, *Romania and Transylvania in the Twentieth Century*, p. 178.

41 As told to me by László Kántor, the film's producer.

42 This is rather ironic, as local people from the Delta helped out in the film and are thanked in the end credits for their friendship and assistance. I have not come across any reference as to how the locals received the film.

43 Unfortunately, I haven't seen this film so I cannot make any further comment on it.

References

Cartledge, Bryan, *Makers of the Modern World: Mihály Károlyi and István Bethlen* (London: Haus Publishing, 2009).

Cunningham, John, 'Emberek a havason/People of the Mountains', in Peter Hames (ed.), *The Cinema of Central Europe* (London: Wallflower Press, 2004a), pp. 35–44.

Cunningham, John, *Hungarian Cinema: From Coffeehouse to Multiplex* (London: Wallflower Press, 2004b).

Cunningham, John, 'Jenő Janovics and Transylvanian Silent Cinema', *Kinokultura*, Special Issue 7 (2008). Online. Available at <http://www.kinolkultura.com/specials/7/hungarian.shtml> (accessed 30 December 2011).

Fischer-Galati, Stephen, 'Romanian Nationalism', in Peter F. Sugar and Ivo John Lederer (eds), *Nationalism in Eastern Europe* (Seattle, WA: University of Washington Press, 1994), pp. 373–95.

Galántai, József, *Trianon and the Protection of Minorities* (Highland Lakes, NJ: Atlantic Research and Publications, 1992).

Gough, Roger, *A Good Comrade: János Kádár, Communism and Hungary* (London: I.B.Tauris, 2006).

Imre, Anikó, *Identity Games: Globalization and the Transformation of Media Cultures in the New Europe* (Cambridge, MA, and London: MIT Press, 2009).

Iordanova, Dina (ed.), *The Cinema of the Balkans* (London: Wallflower Press, 2006).

Kenez, Peter, *Hungary: From the Nazis to the Soviets: The Establishment of the Communist Regime in Hungary, 1944–1948* (Cambridge: Cambridge University Press, 2006).

Kolstø, Pål (ed.), *Myths and Boundaries in South-Eastern Europe* (London: Hurst and Co., 2005).

Kovács, Ferenc (ed.), *Filmévkönyv 1961* (Budapest: Gondolat Kiadó, 1962).

Lipcsey, Ildikó, *Romania and Transylvania in the Twentieth Century* (Buffalo, NY, and Toronto: Corvinus Publishing, 2006).

Longley, Edna, *The Living Stream: Literature and Revisionism in Ireland* (Newcastle upon Tyne: Bloodaxe Books, 1994).

Moore, David Chioni, 'Is the Post- in Postcolonial the Post- in Post-Soviet? Towards a Global Postcolonial Critique', *PMLA* 116:1 (2001), pp. 111–28.

Peckham, Robert Shannon, 'Internal Colonialism: Nation and Region in Nineteenth Century Greece', in Maria Todorova (ed.), *Balkan Identities: Nation and Memory* (London: Hurst, 2004), pp. 41–59.

Said, Edward, *Orientalism* [1978] (London: Penguin Books, 1985).

Shohat, Ella and Stam, Robert, *Unthinking Eurocentrism: Multiculturalism and the Media* (New York: Routledge, 1994).

Solonari, Vladimir, *Purifying the Nation: Popular Exchange and Ethnic Cleansing in Nazi-Allied Romania* (Washington DC: Woodrow Wilson Center Press; Baltimore, MD: Johns Hopkins University Press, 2010).

Trotsky, Leon, *Stalin*, vol. II: *The Revolutionary in Power* [1947] (London: Panther, 1969).

6

Postcolonial Fantasies. Imagining the Balkans: The Polish Popular Cinema of Władysław Pasikowski

Elżbieta Ostrowska[1]

In her seminal book *Imagining the Balkans*, Maria Todorova writes that the 'Yugoslavs throughout the Cold-War period proudly refused to identify with Eastern Europe and looked down on it'.[2] She quotes Dubravka Ugrešić who, upon being confronted with questions about life behind the Iron Curtain, would explain 'that we are not "like them"', like Romania, Bulgaria, or Czechoslovakia. We are something else'.[3]

Indeed, the Poles thought of the Yugoslavs (at that time differences between ethnic groups of Serbs, Croats or Bosnians were not addressed or even admitted by most Polish people) as 'something else'. Although the Federal People's Republic of Yugoslavia was established in 1946 as a part of the Eastern Bloc, creating a large communist 'neighbourhood' in Eastern Europe, its affiliation with the Non-Aligned Movement since 1961 provided relative independence from the Soviets. Thus, the inhabitants of Yugoslavia were for the Poles distant neighbours, not only in a

geographical but also a political sense. They envied them for the consumer goods that they lacked and admired Marshall Tito's refusal to accept Soviet hegemony. In the 1970s, Polish youth listened to Goran Bregović's band Bijelo Dugme, venerating its similarity to Western rock music, which enabled it to function as a symbol of an opening to a better Western world. Yet, 20 years later, the same Goran Bregović, with his appropriation of folk music, became an epitome of Balkan exoticism, opposing any notion of Western values. Even so, he became even more popular in Poland. His commercial success was partly a result of his collaboration with Emir Kusturica, for whom he composed the soundtrack for *Underground* (1995). Polish audiences indulged in the pleasures of consuming Balkan Otherness, embodied in cinematic images of wild, hairy-chested and sexually hyperactive Serbs whose primary bodily instincts expressed themselves in the rhythms of Balkan music. Bregović's collaboration with the Polish singer Kayah can be seen as a cultural attempt to propagate Balkan exoticism or, perhaps, to manifest a kinship between the Balkans and the Slavs in opposition to the West. Apparently, Ivaylo Ditchev is sceptical about these demonstrations of cultural and geopolitical identity and he calls Bregović and Kusturica 'exclusive resellers of local color'.[4] He sees their artistic activity as marking a break with the Balkan modernist tradition represented earlier by Eugene Ionesco, Julia Kristeva or Theo Angelopoulos. This cultural change can be interpreted to be the result of more profound geopolitical changes in Europe after 1989 that repositioned both former Yugoslavia and Poland.

The Balkans' (dis)placement in post-Cold War Europe

Much research on the Balkans emphasizes their long-lasting cultural and political borderline position in Europe. As Dušan Bjelić states in his introduction to the collection of essays entitled *Balkan as Metaphor*, 'the Balkans formed the "bridge" between the East and the West, a metaphor naturalized by Ivo Andrić in his Nobel Prize-winning

novel, *The Bridge on the Drina* (*Na Drini ćuprija*).[5] Interestingly, the Poles ascribed a similar position to themselves. Although the historical status of Poland as 'the bulwark of Christendom' locates it within the realm of the political and cultural West, it is also conflated, simultaneously, with its periphery identified as Eastern Europe. As Larry Wolff argues in *Inventing Eastern Europe*,[6] the idea of Eastern Europe was invented during the Enlightenment. According to Wolff, Western intellectuals, travellers and writers created a discourse about Eastern Europe in a manner similar to that of the Orient, as proposed by Edward Said.[7] Anna Klobucka comments:

> Faced with the paradox of their simultaneous inclusion and exclusion from 'Europe', or, in other words, finding themselves marooned in the indeterminate space between Europe and what lies beyond Europe, nationalist and ethnic formulations originating on the periphery of the subcontinent have typically negotiated their subject positions as borderline in a tripartite topographic division. This spatial construct has allowed peripheral European cultures to account both for their relation to the hypercivilized Other of the ultra-European continental core and the uncivilized, 'barbarous' Others of the extra-European margin.[8]

Likewise, the Balkan peninsula region, a part of the Ottoman Empire in the past, has been located within European liminal space marking a transition between East and West, yet more often associated with the former than the latter. Milica Bakić-Hayden offers a seminal analysis of the relationship between Orientalism and Balkanism. She writes:

> While it is important to recognize the specific rhetoric of Balkanism, however, it would be difficult to understand it outside the overall Orientalist context since it shares an underlying logic and rhetoric with Orientalism. Balkanism can indeed be viewed as a 'variation on the Orientalist theme'[9] that distinguishes the Balkans as a part of Europe that used to be under Ottoman, hence Oriental, rule, and, as such, different from Europe 'proper'.[10]

With the realignments of Eastern Europe after 1989 and the breaking up of Yugoslavia, the geopolitical borders between the West and East of Europe radically changed. In joining NATO in 1999 and the EU in 2004, Poland, along with Hungary, the Czech Republic and Slovakia, shifted from Eastern to Central Europe. Clearly, the West now became ideologically closer and it is precisely this position from which, as Maria Todorova claims, Central Europe 'looks with aversion and a feigned incomprehension at the Yugoslav quandary as if it belongs to an entirely different species'.[11] It can be said that, with this aversive look, Central Europe joins Western Europe in a symbolic act of pushing the Balkans from their traditional position of in-betweenness into a space cohabited by the 'Other'. As Dina Iordanova writes, '[t]he Balkans gravitated … toward a gloomy orientalist fringe of the new Europe. Within a short time, they became more "Other" than they used to be'.[12] In a similar vein, Andrew Hammond defines the Balkans' position in post-1989 Europe: 'After the loss of Cold War paradigms, and the consequent shifts in the Western imaginary, the Balkans were chosen as a little piece of Cold War Eastern Europe to be retained as the model of otherness.'[13]

In this chapter, I will examine two films by Władysław Pasikowski, *Dogs 2* (*Psy 2. Ostatnia krew*, 1994), and *Demons of War According to Goya* (*Demony wojny według Goi*, 1998) that address the new geopolitical order of post-Cold War Europe. Both of them include the theme of conflict in former Yugoslavia and feature both Balkan and Polish characters. These two ethnic groups of characters are related to each other and thus it can be claimed they also define each other. I am interested here in the way in which Balkan characters function as the 'Other' for the Poles and as such facilitate the process of defining both individual and collective identity. Whenever useful or necessary I will make reference to a number of other films dealing with the subject of the Bosnian war (ranging from Western films, European co-productions and those made by Balkan filmmakers) in order to shed additional light on the fluctuating geopolitical position of Poland in post-communist Europe. Whilst focusing on these

Figure 6.1
Demons of War According to Goya, Władysław Pasikowski, 1998

issues, I will be following Hammond's claim that, '[i]n Foucauldian terms, the Balkans have been, like madness, criminality, disease, a spectacle from the social margins against which people at the centre gain definition and become individualized'.[14] I will look at these representations of the Balkans as revealing the dynamic and often contradictory process of renegotiating contemporary Polish identity, especially its fluctuation between West and East. To examine this issue, I will use the concept of 'nesting Orientalism' as elaborated by Bakić-Hayden. She claims that within the Eastern Europe that has been constructed by the West as its Other (paralleling the Orientalism of Edward Said), the Balkans are conceived as the most 'Eastern'.[15] The two films by Pasikowski use, and work through, these gradations between East and West. In their depiction of the Balkans, Polish characters seem to be located in proximity to the Western pole of an ideological mental map of Europe. Yet, under closer scrutiny, the geopolitics of these films reveals numerous gaps and fissures that problematize the position of Polishness within a simple division between West and East.

Polish popular cinema goes West

Numerous film critics perceive Pasikowski's popular genre films as a symptom of the intrusion of the West into a Polish national cinema that had been traditionally identified as part of Eastern European cinema. When deciding to make a war movie about the conflict in the former Yugoslavia, Pasikowski indeed symbolically enters the realm of the West. Firstly, he introduces the generic formula of a war movie which, so far, had not been used in Polish cinema. Although there is an abundance of Polish films about war, World War II in particular, none of them fits the Hollywood formula of the war film genre in which 'the warrior myth relies on a construction of a form of masculinity in which men behave with discipline, capability and bravery according to strict codes of duty, honour and heroism'.[16] Conversely, heroism was either critically interrogated (by Andrzej Wajda, Andrzej Munk or Kazimierz Kutz) or openly appropriated for the needs of communist propaganda (by Jerzy Passendorfer, Ewa and Czesław Petelscy, among many others). In using the Hollywood mode of war movies, Pasikowski symbolically leaves the realm of the national and enters the supranational territory of mass entertainment. Interestingly enough, Pasikowski's *Demons of War* is one of the very few movies dealing with the issue of the military conflict in former Yugoslavia produced within the former Eastern Bloc (except for the countries of former Yugoslavia of course). Whilst the Western European and American film industries displayed a significant interest in this subject matter, in films such as *The Peacemaker* (Mimi Leder, 1997, USA), *Welcome to Sarajevo* (Michael Winterbottom, 1997, UK/USA), *Saviour* (Predrag Antonijevic, 1998, USA), *Warriors* (TV drama, Peter Kosminsky, 1999, BBC), *Behind Enemy Lines* (John Moore, 2001, USA), *The Hunting Party* (Richard Shepard, 2007, USA), the cinemas of Central Eastern Europe have not substantially addressed this issue. Thus, I would argue that the mere fact that Poland produced a war film about the conflict in former Yugoslavia signifies a cultural and political accommodation to the West. Yet, as

I will demonstrate, the geopolitical transformation of the position of Poland is obstructed by various social and cultural factors that are implicitly addressed within the fictional realities of the examined films.

Both Pasikowski's films employ narrative patterns used by Western war films when representing 'exotic conflicts'. Effective in such films as *The Year of Living Dangerously* (Peter Weir, 1982, USA) or *The Killing Fields* (Roland Joffé, 1984, USA), the figure of a journalist functioning as the viewer's guide within the fictional reality is also frequently used in the 'Balkan war movies', e.g. *Welcome to Sarajevo*, *Harrison's Flowers* (Elie Chouraqui, 2000), *The Hunting Party*. The character of a single soldier performing a military mission in a far-distant and often exotic country is also widely used in Western war films in order to either criticize or support Western hegemony, Captain Willard from *Apocalypse Now* (Francis Ford Coppola, 1979) being the most iconic example. Most of the Western 'Balkan war' films exploit these narrative patterns, perpetuating Western ideological hegemony. As Dina Iordanova points out, in most of these films there is a Westerner 'who ventures into the Balkan realm of barbarity'.[17] While discussing the cinematic representations of villains and victims, she emphasizes their schematization. The villains conform to the following types: the ridiculed and diminished politician; the intriguing thug; the flamboyant warlord; and the mindless killing machine. In turn, victims are depicted as martyrs, witnesses or ordinary people. They are invariably portrayed, as Iordanova claims, as one-dimensional and less compelling characters than the villains. These stock characters, with all the necessary modifications and adjustments, belong to the generic conventions of war films. Pasikowski's own adjustments and modifications of these conventions, present in his 'Balkan war' films, may reveal the process of ideological negotiation between Polishness and the West.

Suffice it to say, Pasikowski's films offer almost all of the stereotypes itemized and described by Iordanova and thus they can be seen as an act of adjustment to the narrative and iconographic

patterns of the Western system of cinematic representation. The Polish films also make use of an image inventory for the representation of death, violence and cruelty in the Balkan conflict. Therefore, through this act of appropriation of and adjustment to the Western system of representation a symbolic abandonment of the cultural realm of Eastern Europe occurs. The more barbarian the Balkan characters are, the more civilized the Poles appear in their UN-badged uniforms. Interestingly, the first scene of *Demons of War*, in which Polish soldiers drive their military vehicle into a small Balkan town, is almost identical to an analogous scene from Kosminsky's *Warriors* presenting British soldiers entering a Bosnian town for the first time. In contrast to the natives, the Polish and British soldiers in their uniforms and vehicles appear almost like 'aliens' from a different planet. Everyone looks on them with a mixture of astonishment and distrust, as one might look upon an unwelcome stranger. These radically contrasting characters clearly stand for a general opposition between East and West. The change, or indeed reversal, of geopolitical order that has taken place since the period of the Cold War is clearly signified by the use of this bipolar representational regime. If, then, it was Yugoslavia that was associated with the West, now it is Poland, whereas the Balkan countries have been conceptually shifted towards the East, if not a deep Oriental South.

Such politics of representation confirms Iordanova's observation that '[d]uring the decade, while Central Eastern Europe was being reconceptualized and "re-admitted" to the European realm, the Balkans became a chunk of the former Eastern Bloc that would be left outside the cultural boundaries of Europe'.[18] Simultaneously, one can observe the aforementioned phenomenon of 'nesting Orientalism' at work. As Bakić-Hayden claims, 'Eastern' becomes a relational category within which there is a certain gradation enabling the construction of an ideological hegemony. 'Nesting Orientalism' is part of a discourse in which '"East" like "West" is much more of a project than a place'.[19] If conceived of as ideological projects, the realms of 'East' and 'West' are constantly renegotiated

and thus they are historically changeable. Eventually, they are not clearly defined and the boundaries between them are often blurred. Pasikowski's films reveal the complexity of this binary opposition and the numerous gaps and fissures in this seemingly self-explanatory ideological model.

Dogs 2 begins with constructed documentary footage of the Bosnian war which will appear familiar to anyone exposed to its worldwide media coverage. Using documentary, or semi-documentary footage in feature films depicting the Bosnian war, or any contemporary military conflict for that matter, is a frequent cinematic device, most often aimed at intensifying the effect of realism. Often, the footage is tightly incorporated into narratives that feature the characters of journalists who serve as a litmus test of the Western attitude to a given conflict, in this case the Bosnian war. In *Welcome to Sarajevo*, a British journalist, Michael Henderson, initially tries to maintain his position as a neutral 'observer'; as he says: 'We're not here to help, we're here to report.' However, with the passage of time and his failure to receive adequate interest from his network's superiors regarding the plight of an orphanage, he decides to take up a more active stance. He undertakes to smuggle a Bosnian Muslim girl to London. However modest and perhaps insignificant his deed is – when one thinks about thousands of orphaned children in the former Yugoslavia who did not get any help – he is given a chance to go beyond the limits of 'journalistic neutrality' and redeem his conscience.

In *No Man's Land* (*Ničija zemlja*, 2001), a European co-production directed by a Bosnian filmmaker Danis Tanović, a Western female journalist Jane Livingstone is denied a similar chance to actively participate in events. Rather the opposite occurs. Regardless of her efforts, she is unable to go beyond her assigned position as a passive observer of events. As William Van Watson notices, 'Tanović ... pursues his goal of indicating ... the incompetence of Western media in its attempts at mediation'.[20] The film voices the Balkans' opinion of Western media. One of the film's protagonists, a Bosnian soldier, addresses the British journalist as a 'vulture' who exploits the

Figure 6.2
Dogs 2: The Last Blood, Władysław Pasikowski, 1994

conflict for financial profit. Moreover, the process of transforming the reality of war into a palatable and consumable image/product is revealed when Jane's supervisor asks her from a studio in England whether her cameraman managed to capture a scene of death she just witnessed.[21] Examining this scene, Van Watson argues that '*No Man's Land* ... suggests that the reporters are the true predatory animals in their hunger for images of "primordial cruelty", or what was termed "war porn"'.[22] By and large, films made from 'within' the region depict distrust, if not open dismissal of mediated images of the conflict, whereas Western films search for possible ways of redeeming a media passivity that often signifies the political and public indifference of the West.

If documentary or semi-documentary footage is employed in Bosnian war films in order to develop various types of ideological discourses, it is significant that Pasikowski organizes the opening sequence of *Dogs 2* in a somewhat self-reflexive fashion. Initially, he focuses on a cameraman's interaction with a local man who worries whether there is sufficient light for shooting. He then instructs the cameraman to take a classic shot with a centred composition with him as its focus. Clearly, he prepares things to be 'properly' shot,

acting as a *metteur-en-scène* staging a 'theatre of war' scene to be broadcast to a worldwide audience. He is mockingly aware that the televisual image produces a spectacle rather than delivering raw reality. Simultaneously, through his concern for the *mise-en-scène* of the shots, the man tries to transgress his predetermined position as a passive object of the camera gaze. The cameraman, who presumably represents the democratic media, follows instructions, allowing him to 'co-produce' the image. Nevertheless, we still see the cameraman in the foreground as he tries to hold the wonderfully balanced frame composition. Although the local man occupies the centre of the frame, he is relegated to its background and as such is not visible at all. I would argue that the opening sequence of the film reveals the representational dilemma of the media coverage of the post-Yugoslavian conflict, or any military conflict for that matter. Notwithstanding all of the efforts undertaken by various media to position this war in the centre of the image, its foreground is inevitably occupied by its producers, either literally, as in television coverage by journalists speaking to the camera,[23] or figuratively as in feature films through the effect of narrative character focus (i.e. through the figure of a Westerner from whose perspective the viewer looks at the Balkans). As Van Watson notes in his article analysing cinematic representations of the Bosnian war: 'The Western media is the West's self-image, its illusions and even its delusions … the relentless drive of its internationally broadcast ego.'[24] The self-reflexive devices used by Pasikowski in the opening sequence disclose this ideological process at work and allude to some of its ambiguities. With his mocking approach towards media coverage of the Bosnian war, the Polish filmmaker reveals a similar distrust towards mediated images of it, as do many Balkan directors. More importantly, the film does not offer any possibility of redemption for the morally questionable process of transforming the post-Yugoslavian conflicts into a commodified image to be consumed by a worldwide audience.

Further, the opening sequence of *Dogs 2* shifts its focus. The local man vanishes somewhere into off-screen space and the viewer

is then presented with two atrocious images of war reality. The first of these is an impaled man, a perfect icon of the stereotypical Balkan savagery that the now off-screen narrator attempted to question earlier in his short conversation with the cameraman. The absence of a speaking subject renders it easy to locate the image of the impaled man within the representational framework established by Western explorations of Balkan violence in which, as Dina Iordanova argues, 'the Balkans emerge as inhabited by violence-crazed and violence-craving people, who are explicitly shown to enjoy the violence they perpetrate'.[25] Yet eventually the scene undermines this Western perspective on Balkan violence. The image of an impaled man is followed by a shot of a man holding a human head. The Polish audience can easily identify the man as the secondary character of a weapons trader from an earlier film by Pasikowski, *Dogs* (*Psy*, 1992). It is clear that whilst he is evidently not the perpetrator of this atrocity, his smile reveals that he experiences a perverse pleasure arising from this visceral contact with violent death. He proudly displays the decapitated head to the camera as if it were some kind of war trophy. Moreover, he looks directly into the camera and consequently at the viewer, who therefore cannot occupy a safe position of voyeuristic distance any longer. Our status as viewers is revealed and *ipso facto* the war reality is inevitably transformed into an object to look at. Thus, it is presented to us as a spectacle providing the viewer with a visual (dis)pleasure. As disconcerting as the image is, it serves to highlight that it is not only the Balkans which are to be associated with cruelty and violence. Another group, here, the Poles, are also culpable, even if they do not perpetrate it. Therefore, the image cannot play the ideological function identified by Van Watson in representations of the Bosnian war atrocities:

> War porn serves the image consumer of the West, taking comfort in the media projection of atavistic violence from the Balkans as it allows the psychological projection of such uncivilized behavior onto the Balkans, constructing a demonized Other and allowing a purged self(-image).[26]

The sight of a Polish man proudly presenting a human head does not allow a Polish audience to construct a 'purged self(-image)'. The opposite occurs. They are required (even if only briefly) to recognize 'a demoniacal Other' within themselves.

Positioning a Pole not only behind the camera as a supposedly objective observer of the war, but also in front of it diminishes the secure distance between the actors of war and its observers. In Western films this position of objective viewer is also occasionally transgressed (e.g. *Saviour*, *Welcome to Sarajevo*), however it is invariably and perhaps inevitably linked to the victims not the victimizers. The Polish character in the opening sequence of *Dogs 2* disconcertingly oscillates between these two positions, erasing the distance between them and causing them to merge.

In *Demons of War* there is a Polish mercenary who serves as an antagonist to the Polish hero, Major Keller,[27] played by Bogusław Linda. *Saviour* also features a mercenary, played by Dennis Quaid, who ruthlessly kills a young Balkan boy. However, his morally ambiguous military service is exonerated by the personal trauma he has experienced earlier in the film and, finally, he redeems himself

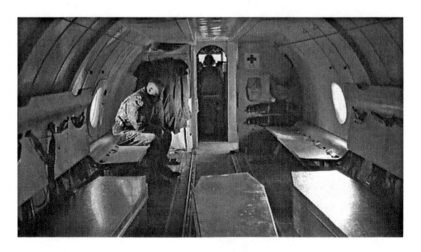

Figure 6.3
Demons of War According to Goya, Władysław Pasikowski, 1998

from his various atrocities by saving a newborn baby, the progeny of a war rape. Pasikowski's mercenary is merely presented as a cynic who makes profit from the war. There is no redemption for him, but only severe punishment delivered by his compatriot. By and large, in Western films the Balkan conflict is typically represented from the perspective of a Westerner who frequently plays the role of a neutral observer. If he or she abandons this position, it is in order to take a more active stance towards the war in order to criticize the indifferent attitude to it prevalent in the Western media. In Pasikowski's films these representational patterns seem to become blurred. The Polish characters easily find their way 'behind enemy lines'; however this is not only to fight against perpetrators of violence, but also to fight with their own local opposition.

The doctrine of neutrality officially adopted by the West can be seen to reveal a significant aspect of Western geopolitics. Although officially non-interventionist, the doctrine of neutrality inevitably favoured one of the sides in the conflict. As Van Watson explains:

> The ostensible neutrality of the West, codified in the arms embargo, favored the JNA, or Yugoslav National Army, as they possessed the far greater amount of weapons and comprised one of the largest standing forces in the world. When Congress passed a bill in 1995 to lift the arms embargo that had been crippling Bosnia's ability to defend itself, Clinton vetoed it. Since declared neutrality effectively appeased the more heavily armed aggressor, the envoys of the agencies of Western hegemony and the West's ostensible neutrality, namely, NATO and the UN, earned the much deserved contempt of the locals. The presence of the UN forces, under the acronym UNPROFOR, provided its own form of 'fake participation', the appearance of intervention, which Western officials desired, while being denied the authority of actual intervention, which Western officials did not desire.[28]

For the UNPROFOR soldiers sent to Bosnia the neutrality doctrine meant passivity even while facing the most atrocious

acts of ethnic cleansing. This kind of experience is the main theme of Kosminsky's *Warriors*. Each of the four main characters suffers because of the politically imposed passivity that prevents intervention that would save a human life, even when possible. Western neutrality contradicts the Western ethical system and inevitably causes trauma to the film characters. Consequently, after returning from Bosnia the protagonists are unable to reintegrate themselves into society. Tanović's *No Man's Land* also addresses the issue of Western neutrality. In one line of dialogue, Captain DuBois says: 'You can't be neutral facing murder. Doing nothing to stop it is taking sides.' The protagonist of *Demons of War* does not discuss the issue of political neutrality in order to discover its genuine meaning. He simply instructs one of his soldiers: 'This is a war! And we are one side in it.' However puzzling this dialogue is, it stands as a bold denial of the concept of neutrality. But the side on which Keller positions himself and his troop is rather ambiguous. Do they stand on the Bosnians' side against the Serbs? Even if they act, it does not seem to be a politically motivated gesture. Unlike other films about the Bosnian war, in Pasikowski's film there is no explanation of its origins, the participating sides, the Western contribution to it and so on. The whole issue is presented in Keller's one laconic line of dialogue: 'In this war everyone fights with everyone.' Expressing an opinion as to the necessity to 'take a side', Keller also openly rejects the Western doctrine of neutrality, and perhaps this can be understood as a symbolic detachment from the West despite the military collaboration under the auspices of NATO. Or perhaps Keller sees the war as a struggle between the civilized (Western) world and the 'barbarian' world of the Balkans? Yet, as I have already argued, the Poles are to be found on both sides.

Polish masculinity: Oriental fantasies

The in-betweenism of Polishness bounded by East and West seems to be effectively revealed through gender and sexual politics as

represented in both films. *Dogs 2* features a Bosnian girl brought to Poland who is ironically introduced to the protagonist Franz as *jasyr*, which is a Polish word for a Turkish or Tatar, usually a female, captive. As we later learn, she has been bought for a crate of Johnnie Walker. With its blatant misogyny, this story elaborates a model of Polish masculinity. This mini-narrative, familiar in its generic convention of oral war stories told by men, links the motif of the trading of women, commonly seen as a sign of backwardness and often associated with the Orient, with a brand of alcoholic beverage which functions as a symbol of 'real' Western masculinity. It is Johnnie Walker not Polish vodka that is used as a currency to participate in and take advantage of the Oriental model of patriarchy. Thus, it is a material good produced by the West that enables the sexual objectification of a woman and her simultaneous positioning within the Oriental discourse. Franz Maurer participates in this symbolic exchange in order to annihilate it and finally replace it at the end of the film, with a fantasy of a family life lived in a far-away country, most likely in South America, thus neither in the West nor East. The ironic stylization of the last scene, offering a pastoral image of a secluded small cottage, a woman and a horse invokes a nostalgic longing for a lost world based on a clear-cut gender division. I would argue that this last image can be seen as analogous to the often quoted idea of Rebecca West from her travel memoir of 1941, *Black Lamb and Grey Falcon*, which chronicles her journey through the Balkans. She writes: 'It is strange, it is heartrending, to stray into a world where men are still men and women still women.'[29]

In *Demons of War* there is a similar nostalgic fantasy constructed around another Balkan woman. Keller meets her when she is on her way back home with her relatives. When he tries to persuade her not to travel there as it might be dangerous, she boldly says, 'This is my home'. This blatant conflation of femininity and the idea of home is developed later on, when Franz arrives at her cottage with his platoon to get some rest. Following the generic convention of a war film, at some point she comes to him offering

him warm food as well as her body. Keller will reward this later on, when he rescues her from a gang of war renegades. Although the motif of rescuing a woman from oppressive enemy forces is a common generic convention of war films, it can also be seen as general component of Western imagery, revealing its ideological underpinning. As Ella Shohat argues, the motif 'helps produce the narrative and ideological role of the Western liberator as integral to the colonial rescue fantasy'.[30] It needs to be stressed here that the role of liberator was not previously available for male characters either in Polish cinema or wider Polish culture. Indeed, the opposite is more often than not the case. Polish films are populated with men who are often shown as passive witnesses of women, often 'their' women, being abused by an enemy. Suffice to mention *Hurricane* (*Huragan*, Józef Lejtes, 1928), *How to be Loved* (*Jak być kochaną*, Wojciech Jerzy Has, 1962) or *The Ring with the Crowned Eagle* (*Pierścionek z orłem w koronie*, Andrzej Wajda, 1992) among many others. Admittedly, these thematic motifs and their attendant imagery speak of the emasculation of Polish men. Thus, I would argue that in Pasikowski's films the motif of rescue (in *Dogs 2* Franz also rescues Tania, taking her to an exotic land), a founding image of the Western fantasy of masculinist supremacy is appropriated to remasculinize the Polish hero,[31] who traditionally celebrated disasters rather than victories. This masculinist supremacy is conveyed not only through the movement of the narrative but is also signalled at the level of the linguistic. In *Demons of War* Keller displays astonishing, even if utterly implausible, linguistic capabilities. He can speak any language as needed, whether it is Serbo-Croat or French. Thus, figuratively he proves his access to the Lacanian realm of the Symbolic, another domain of masculine supremacy. To sum up, it can be argued that by utilizing a rescue motif, Pasikowski's films reposition Polish masculinity into the Western model of hegemonic masculinity. His films fit well with Susan Jeffords's claim that 'patriarchy underwrites war and war underwrites patriarchy'.[32]

Yet this hegemonic model of masculinity is ultimately destabilized in *Demons of War* as a result of another symbolic exchange that

occurs later on in the film. There are two significant props established in the narrative as peculiar objects of desire, namely two VHS tapes. The first is a pornographic movie that has been smuggled from Poland for Keller's platoon; in fact, it is a bad porn movie and nobody wants to watch it. The second is a recording of a Serbian massacre of Bosnians. A French female journalist wants the second tape in order to distribute it to the world, whereas a Serbian politician representing the forces that are responsible for the massacre wants to prevent such a politically damaging exposé. The thematic motif of the photographic or filmic record of war atrocities present in Pasikowski's film is frequently used in Western films about the conflict in former Yugoslavia, for example in *Welcome to Sarajevo* and most prominently in *Behind Enemy Lines*. In the latter, the protagonist succeeds in a twofold manner; firstly he saves his own life, after being left 'behind enemy lines', and secondly he secures the photographic evidence of the Serbian massacre, bringing it to the civilized world of the West where the truth will be finally revealed. Van Watson describes the film as a 'self-congratulatory Hollywood product that tends to simplify the Bosnian conflict by creating an easily demonized Other, against which Americans and Western Europeans can lionize themselves'.[33] In short, in *Behind Enemy Lines*, as in many other films depicting the Balkan conflicts, Western masculine hegemony wins.

Pasikowski's *Demons of War* seems to occupy an in-between position within cinematic discourse on masculinity. Its traditional model is neither solidified nor is it radically dismantled. The circulation of the recording of the massacre committed by the Serbs reveals an uncertain Polish masculinity. The tape gives access to knowledge that could be translated into political power. When the Polish soldiers acquire the recording, they have such a possibility. Yet they decide to give it back to the Serbs in bargaining to save the life of one of their comrades. Ethical empathy wins over political pragmatism, again undermining the traditional pattern of masculinity. Yet, political opportunity is not altogether destroyed.

As we learn later, Houdini, a member of Keller's squad, has replaced the political recording with the porn movie. One of the last scenes of the film shows an enraged Serbian politician realizing as he watches bad porn that the compromising recording will be publicized sooner or later. It can be assumed that Houdini's trick was to save Polish masculinity. Yet, surprisingly, Keller, a Polish hero who has the tape that signifies knowledge, does not keep it. He decides to give it to the French female journalist who will take it home where its political value will be activated.

The exchange of the two tapes lends itself to a symptomatic reading. Keller hands over recorded images of pornography and violence, both of which must be seen in connection with a traditional notion of masculine hegemony. Therefore, passing these images to somebody else can be interpreted as an act undermining this hegemony. In turn, Houdini's trick with the porn tape is a partial sabotaging of Serbian military power. Keller and Houdini can be seen as specific variants of the Lacanian figures of the fool and the knave as described by Slavoj Žižek:

> Today, after the fall of Socialism, the knave is a neoconservative advocate of the free market who cruelly rejects all forms of social solidarity as counterproductive sentimentalism, while the fool is a deconstructionist cultural critic who, by means of his ludic procedures destined to 'subvert' the existing order, actually serves as its supplement.[34]

Keller, with his excessive individualism and bitter distrust of any kind of institutionalized cooperation, can be seen as a variation on the knave figure; he is sceptical about the idea of a 'war observer' and 'neutral military forces'. He is completely disillusioned that his platoon will be mere observers in the conflict and demands that they play traditional soldierly roles. He seems to follow a simple logic: a soldier is either to be killed or to kill. War demands and justifies it. Keller's disillusionment with military neutrality produces an understanding that his surrogate and subordinate form of power cannot match real political power. In turn, Houdini's tricky

exchange of the tape is a jester-like joke that ridicules the war and Serbian power based on cruelty and violence. Therefore, despite being critical or even subversive towards the existing ideological order, both of these figures are eventually complicit with it. What makes this complicity bearable, or, as Žižek puts it, what 'sustains each of the two positions' is 'the libidinal profit, the "surplus-enjoyment"'.[35] As he further explains:

> Each of the two positions, that of fool and that of knave, is … sustained by its own kind of jouissance: the enjoyment of snatching back from the Master part of the jouissance he stole from us (in the case of the fool); the enjoyment which directly pertains to the subject's pain (in the case of the knave).[36]

Žižek attributes this rather paradoxical pleasure to a figure of the exploited, the servant who compensates for powerlessness with a surrogate form of phantasmic power. Keller's bitter self-consciousness represents genuine wisdom, whereas Houdini's trick stands for his everyday smartness. Yet one needs to remember that this 'wisdom' and 'smartness' is only a manifestation of a 'surplus of enjoyment' that is a phantasmic cover for actual powerlessness.

Thus the narrative as well as the visual imagery employed in *Demons of War* can be seen in relation to the discourse of postcolonialism. More specifically, the film reveals the ambiguous and contradictory positioning of the Polish national subject within this discursive order. On the one hand, the motif of the 'rescue fantasy', as elaborated by Shohat,[37] symbolically signifies an allegiance to colonial power. On the other hand, the characters playing the symbolic roles of a knave and a fool, as discussed by Žižek,[38] reveal this power as mere fantasy. In this way the film sharply exposes the clash between Eastern and Western positions on the discourse of colonialism.

Conclusion

A psychoanalytical reading of the film *Demons of War* can be extrapolated onto the geopolitical map of 1990s Europe. The film's resolution attributes male (and perverse) sexuality to the Balkans, reinforcing their image as the European Other, whereas recorded political knowledge is passed to the West, embodying once again a European rationality. The Polish subject embodied in the film by its protagonist, Keller, is detached from either pole of this geopolitical dichotomy. He separates himself from the former that represents his own backwardness, yet is simultaneously aware of the inaccessibility of the Western paradigm. In the film's final image, Keller returns home alone. He sits in the hold of the plane surrounded by the coffins of his comrades. Once again, he occupies a liminal space between East and West. Thus, a Polish subject's initial attitude of superiority towards the Balkans is later undermined by a submissive acceptance of Western superiority. Here the film's narrative develops a metaphorical trajectory. The Polish subject attempts to take on board all aspects of Western postcolonial power. Yet, this ideological movement turns out to be futile. The traditional model of Polish masculinity, based on the acceptance of both collective and individual failure, continues to confine the Polish subject as he moves uncertainly between the Western and Eastern poles of the postcommunist ideological order in Europe.

Notes

1 My thanks to Michael Stevenson who gave me generous assistance in writing this essay. I am also grateful to the editors of the volume for their comments and suggestions.

2 Maria Todorova, *Imagining the Balkans* (Oxford: Oxford University Press, 1997), p. 52.

3 Todorova, *Imagining the Balkans*, p. 52.

4 Ivaylo Ditchev, 'The Eros of Identity', in Dušan I. Bjelić and Obrad Savić (eds), *Balkan as Metaphor: Between Globalization and Fragmentation* (London and Cambridge, MA: MIT Press, 2005), pp. 235–50, p. 246.

5 Dušan I. Bjelić, 'Introduction: Blowing up the "Bridge"', in Dušan I.
 Bjelić and Obrad Savić (eds), *Balkan as Metaphor: Between Globalization
 and Fragmentation* (London and Cambridge, MA: MIT Press, 2005), pp.
 1–22, p. 15.

6 Larry Wolff, *Inventing Eastern Europe: The Map of Civilization on the
 Mind of the Enlightenment* (Stanford, CA: Stanford University Press,
 1994).

7 Edward Said, *Orientalism* [1978] (New York: Vintage Books, 1997).

8 Anna Klobucka, '*Desert and Wilderness* Revisited: Sienkiewicz's
 Africa', *The Slavic and East European Journal* 2 (2001), pp. 243–59,
 p. 245.

9 Milica Bakić-Hayden and Robert M. Hayden, 'Orientalist Variations
 on the Theme "Balkans": Symbolic Geography in Recent Yugoslav
 Cultural Politics', *Slavic Review* 51:1 (1992), pp. 1–15.

10 Milica Bakić-Hayden, 'Nesting Orientalism: The Case of Former
 Yugoslavia', *Slavic Review* 54:4 (1995), pp. 917–31, pp. 920–1.

11 Todorova, *Imagining the Balkans*, p. 52.

12 Dina Iordanova, *Cinema of Flames: Balkan Film, Culture and the Media*
 (London: British Film Institute, 2001), p. 9.

13 Andrew Hammond, 'The Danger Zone of Europe: Balkanism between
 the Cold War and 9/11', *European Journal of Cultural Studies* 8 (2005),
 pp. 135–54, p. 135.

14 Hammond, 'The Danger Zone of Europe', p. 150.

15 Bakić-Hayden, 'Nesting Orientalism'.

16 Guy Westwell, *War Cinema: Hollywood on the Front Line* (London:
 Wallflower Press, 2006), p. 112.

17 Iordanova, *Cinema of Flames*, p. 61.

18 Iordanova, *Cinema of Flames*, p. 31.

19 Bakić-Hayden, 'Nesting Orientalism', p. 917.

20 William Van Watson, '(Dis)solving Bosnia: John Moore's *Behind Enemy
 Lines* and Danis Tanovic's *No Man's Land*', *New Review of Film and
 Television Studies* 6:1 (2008), pp. 51–65, p. 60.

21 Susan Sontag claims that photography is an aestheticizing medium per
 se: 'Cameras miniaturize experience, transform history into spectacle.
 As much as they create sympathy, photographs cut sympathy, distance

the emotions' (Susan Sontag, *On Photography* (New York: Anchor Books, 1990), pp. 109–10).

22 Van Watson, '(Dis)solving Bosnia', p. 57.

23 In *No Man's Land* the British journalist addresses her audience in one of her TV reports: 'You can probably just make out behind me, as I'm speaking to you, the Serbian soldier, limping, closely followed by the Bosnian soldier'

24 Van Watson, '(Dis)solving Bosnia', p. 65.

25 Iordanova, *Cinema of Flames*, p. 163.

26 Van Watson, '(Dis)solving Bosnia', p. 58.

27 It is symptomatic that Pasikowski's protagonists are invariably provided with 'Western' names, e.g. Franz Maurer, Keller, Angela, etc., which might be interpreted as another symbolic attempt to enter a Western paradigm.

28 Van Watson, '(Dis)solving Bosnia', p. 53.

29 Rebecca West, *Black Lamb and Grey Falcon: A Journey through Yugoslavia* (London: Penguin Books, 2007), p. 208.

30 Ella Shohat, 'Gender and Culture of Empire: Toward a Feminist Ethnography of the Cinema', in Matthew Bernstein and Gaylyn Studlar (eds), *Visions of the East: Orientalism in Film* (New Brunswick, NJ: Rutgers University Press, 1997), pp. 19–66, p. 39.

31 In his review of *Demons of War*, Andrew Horton accuses the film of being openly pro-war and glorifying traditional patterns of masculinity. He writes: 'the blazing flames of the torched village exist not so much as to demonstrate the terror inflicted on the villagers but more as a dramatic, blazing backdrop, against which Linda can have his final confrontation with his arch-enemy. A brief glimpse of a girl being raped is worryingly shown, not in order for us to identify with her terrible fate but to justify Linda's violent retribution against the perpetrators' (Andrew J. Horton, 'The Horrors of Heroism: Wladyslaw Pasikowski's *Demony wojny wedlug Goi*', *Central Europe Review* 6, 2 August 1999. Online. Available at <http://www.ce-review.org/99/6/kinoeye6_horton1.html> (accessed 15 January 2012)).

32 Quoted in Westwell, *War Cinema*, p. 113.

33 Van Watson, '(Dis)solving Bosnia', p. 56.

34 Slavoj Žižek, *The Plague of Fantasies* (London and New York: Verso, 2008), p. 56.
35 Žižek, *The Plague of Fantasies*, p. 56.
36 Žižek, *The Plague of Fantasies*, p. 59.
37 Shohat, 'Gender and Culture of Empire', p. 39.
38 Žižek, *The Plague of Fantasies*, p. 59.

References

Bakić-Hayden, Milica, 'Nesting Orientalism: The Case of Former Yugoslavia', *Slavic Review* 54:4 (1995), pp. 917–31.

Bakić-Hayden, Milica and Hayden, Robert M., 'Orientalist Variations on the Theme "Balkans": Symbolic Geography in Recent Yugoslav Cultural Politics', *Slavic Review* 51:1 (1992), pp. 1–15.

Bjelić, Dušan I., 'Introduction: Blowing up the "Bridge"', in Dušan I. Bjelić and Obrad Savić (eds), *Balkan as Metaphor: Between Globalization and Fragmentation* (London and Cambridge, MA: MIT Press, 2005), pp. 1–22.

Ditchev, Ivaylo, 'The Eros of Identity', in Dušan I. Bjelić and Obrad Savić (eds), *Balkan as Metaphor: Between Globalization and Fragmentation* (London and Cambridge, MA: MIT Press, 2005), pp. 235–50.

Hammond, Andrew, 'The Danger Zone of Europe: Balkanism between the Cold War and 9/11', *European Journal of Cultural Studies* 8 (2005), pp. 135–54.

Horton, Andrew J., 'The Horrors of Heroism: Wladyslaw Pasikowski's *Demony wojny wedlug Goi*', *Central Europe Review* 6, 2 August 1999. Online. Available at <http://www.ce-review.org/99/6/kinoeye6_horton1.html> (accessed 15 January 2012).

Iordanova, Dina, *Cinema of Flames: Balkan Film, Culture and the Media* (London: British Film Institute, 2001).

Klobucka, Anna, '*Desert and Wilderness* Revisited: Sienkiewicz's Africa', *The Slavic and East European Journal* 2 (2001), pp. 243–59.

Said, Edward, *Orientalism* [1978] (New York: Vintage Books, 1997).

Shohat, Ella, 'Gender and Culture of Empire: Toward a Feminist Ethnography of the Cinema', in Matthew Bernstein and Gaylyn Studlar (eds), *Visions*

of the East: Orientalism in Film (New Brunswick, NJ: Rutgers University Press, 1997), pp. 19–66.

Sontag, Susan, *On Photography* (New York: Anchor Books, 1990).

Todorova, Maria, *Imagining the Balkans* (Oxford: Oxford University Press, 1997).

Van Watson, William, '(Dis)solving Bosnia: John Moore's *Behind Enemy Lines* and Danis Tanovic's *No Man's Land*', *New Review of Film and Television Studies* 6:1 (2008), pp. 51–65.

West, Rebecca, *Black Lamb and Grey Falcon: A Journey through Yugoslavia* (London: Penguin Books, 2007).

Westwell, Guy, *War Cinema: Hollywood on the Front Line* (London: Wallflower Press, 2006).

Wolff, Larry, *Inventing Eastern Europe: The Map of Civilization on the Mind of the Enlightenment* (Stanford, CA: Stanford University Press, 1994).

Žižek, Slavoj, *The Plague of Fantasies* (London and New York: Verso, 2008).

7

'Narcissism of Minor Differences'? Problems of 'Mapping' the Neighbour in Post-Yugoslav Serbian Cinema

Špela Zajec

Contemporary Serbia. A man is slowly returning to consciousness in a hospital. A total amnesia. He is visited by a colonel from the State Security. He was a major of the Military Security Agency, he's being told. He had a wife and a son; both of them have been killed. They were best friends, the colonel says. He gives him a small toy – a wooden horse. A secret video recording exists, the major learns. Another character shows up, an inspector from the police; he has information on the people responsible for the massacre of his family. However, he must follow the inspector's orders first; so, he starts to eliminate key figures in Serbian 'public' life and proves himself as an effective killing machine. The clues are guiding him to a Muslim family.

He finally finds the tape, made with a hand-held camera ('BINGO!' is written on it). A hanged body appears; in a close-up,

the camera focuses on the dead bodies lying on the floor. The colonel appears in the video and in front of him are people on their knees with their hands bound behind their backs – the camera is now more distant. The colonel is shouting, inquiring about the dead bodies, who killed them. 'Some army', a man on his knees quietly replies. 'Your army!', the colonel rages. Our protagonist, the major,[1] walks into the frame wearing sunglasses and army uniform. He approaches the kneeling people and starts shooting them one by one matter-of-factly. A little boy is the only one left alive, looking around in confusion. The major turns away and lights a cigarette. The boy approaches the major, handing him a small wooden horse. Later the colonel is raging again, firing more bullets into the bodies lying on the ground. The camera zooms in on the toy horse, now standing on the hood of a military vehicle.

The film, a political thriller titled *The Fourth Man* (*Četvrti čovek*) directed by a genre filmmaker, Dejan Zečević, was produced in Serbia in 2007, and with the content of the featured VHS tape (the scene refers to actual footage taken during the war in the neighbouring Bosnia and Herzegovina [BiH] in the 1990s) it introduces some initial elements regarding the treatment of 'neighbours' in the cinema of this conflict-ridden country. Starting from this film, I will draw attention to the 'neighbourhood regimes' represented in contemporary Serbian cinema.

First, I will present some basic concepts that underline my writing. In the second part, I will say a few words about the 'neighbourhood regimes' practised in Yugoslav (Socialist Federal Republic of Yugoslavia, SFRY) cinema and elaborate on the complex and changing conceptualization of the neighbour figure in the territories that throughout most of the twentieth century were known as 'Yugoslav' (with various political formations founded on the domination of the 'South Slavs') – of which Serbia was a part. In the third section, I will try to show how 'neighbour' groups and identities are depicted in contemporary Serbian cinema (after the dissolution of the SFRY).

The chapter is based on a number of assumptions; firstly, depictions of neighbours in film interact and reflect ideas about 'in-

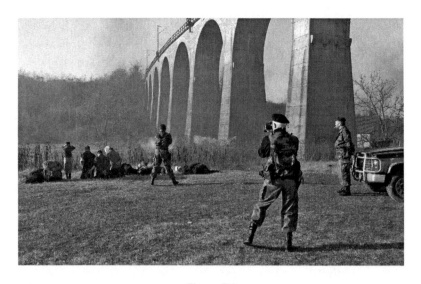

Figure 7.1
The Fourth Man, a massacre of Bosnians by Serbian troops

groups' and 'out-groups',[2] about nationhood and neighbourhood. The perception of neighbours forms a part of a wider management of group identities, group membership and belonging, and it is hence always based on formations of inclusion and exclusion. This process is managed through *formal* mechanisms (including policies regarding citizenship etc.) as well as *informal* ones, and films provide what might be called an informal perspective.[3] The process of 'mapping' neighbours might be more complex, if the group membership is radically changing, and if the groups in the process are, as are many in the case of the former Yugoslavia, characterized by close cultural proximity.

Secondly, the concept of the 'neighbour' can be very elusive: who is the 'neighbour' in Serbia, for the people recognized as the 'Serbs' (the question is closely connected to the question of 'who are the Serbs')? Someone from the other side of the state/territorial border?[4] Ethnic 'Other'? What about the Roma and Jewish people, are they – even if living in Serbia – also 'neighbours', since they are

not perceived as belonging to the Serbian ethnic 'in-group' by the majority of the population?

I have decided to focus on the neighbourhood issues that are related to recent Serbian military history – on the former 'brothers', non-Serbian groups in the 'sister republics' that turned into the new 'Other', the 'enemies' when the armed conflicts erupted. Hence, in this chapter, the neighbour issue and figure in Serbian cinema is read in relation to what was labelled as the 'Yugoslav wars of secession' or 'civil wars' in the new Serbian neighbouring states (Croatia and BiH), and the – previously – Serbian province of Kosovo in the 1990s.

The space known as 'Yugoslav' territories reveals a variety of pathologies of power relations and forms of socio-political and cultural domination. Before the twentieth century, the territories were subject to various regimes that claimed the right to 'rule' the region, with various demands for submissiveness and various responses from the local population – and various 'perceptions' of the very systems of authority. Parts of the region were subject to Ottoman Empire and/or Austro-Hungarian dominations. While Austro-Hungarian domination was primarily understood in terms of 'bringing progress' (material culture), the Ottoman presence was later interpreted as more ambiguous. In the territories of the later BiH, many people converted to Islam, while the Serbian authorities found Ottoman rule in the past a useful tool for group mobilization, as we shall see later.

In 1918, the first Yugoslav state was set up, and it lasted until 1941 when it was invaded and occupied by the Axis powers. Most of Serbia was occupied by Germany, while parts of its territory were annexed by Hungary, Bulgaria and Italian-dominated Albania. Part of Serbia, neighbouring Croatia and BiH became the Independent State of Croatia (NDH), created by the Croatian radical right political movement, Ustaša,[5] which had fully adopted the Nazi-Fascist ideology and established a dictatorship with racial laws and a system of concentration camps. Hundreds of thousands of ethnic Serbs, as well as Roma and Jews, suffered in the NDH. However,

a strong resistance movement was formed, the communist-led Partisan movement (its composition was multiethnic, comprising Serbs as well as Croats and other ethnic groups from the Yugoslav territory). In 1943, the resistance movement proclaimed a new political formation (Democratic Federal Yugoslavia), and in 1946, with the establishment of a socialist government, the state was renamed the Federal People's Republic of Yugoslavia.[6] In the aftermath of the war, the victorious Partisans revenged themselves horribly on (alleged) Ustaša collaborators,[7] but those crimes were subsequently whitewashed. The government established a system that 'owed everything to the successful struggle against foreign occupiers and their domestic collaborators, and thus the narrative of World War II became the cornerstone of the newly reunited Yugoslav state'.[8]

Cinema played a salient role in the post-war Yugoslav political project as a whole. Yugoslav film, as Daniel Goulding observes, embodied the 'strengths as well as fragility inherent in multiple and diverse nations and nationalities attempting to forge a supranational site of cultural identity and inter-dependence while at the same time retaining and celebrating diversity and difference'.[9] The creation of community, building a nation on the basis of citizenship and an all-encompassing Yugoslav identity (and promotion of the state socialist project) was supported by creating external (as well as internal) enemies, especially in the state-supported and hugely popular genre of 'Partisan films'. Partisan films were an appropriation of war and action genres, set in World War II (presenting a period when the 'new' Yugoslavia was created) with recurring themes and motifs of a particular mission and sacrifice. These films basically divided their characters into 'good guys' (the Partisans) and their enemies (Nazis and Fascists) and their local collaborators. The 'Other' was considered on ideological terms much more than on ethnic ones. Partisan epics such as *The Battle of Neretva* (*Bitka na Neretvi*, 1969, produced in FR BiH) and *Sutjeska* (*The Battle of Sutjeska*, 1973, produced in SR BiH and SR Montenegro), *67 Days: The Republic of Užice* aka *Guns of War* (*Užička republika*,

1974, produced in SR Serbia), attracted large audiences across the SFRY republics; a significant part of the audiences was formed of pupils and people in military services who paid compulsory visits.[10] However, a fashionable discourse in 'post-Yugoslav' film studies concerning the treatment of SFRY authorities as 'oppressors' is critically addressed, among others, by Nebojša Jovanović.[11] He aptly warns *against* perceiving Yugoslav cinema as an 'instrument with which the totalitarian regime manipulated the masses'[12] and reducing Partisan films to a pure propaganda tool. He strongly argues for the necessity to consider Yugoslav cinema in the context of 'all the antagonisms inherent in the Yugoslav socialist system'.[13]

In the 'post-Titoist period' (the period between the death of Yugoslav President-for-life Josip Broz Tito in 1980 and the dissolution of the Yugoslav socialist state in 1991), the conceptual differences regarding the treatment of the 'neighbour' were transformed in all Yugoslav sister republics. While in SFRY the idea of domination was more or less non-existent (many sources affirm that in SFRY de facto lived the idea of equality among the 'national' communities), Serbian politician Slobodan Milošević and the Serbian Academy of Sciences and Arts (SANU) refused the idea of equality, attempting to point to the 'endangered' Serbian nation, in order to establish Serbian domination in SFRY. This attempt frightened non-Serbian political elites in other republics and consequently they – using ethno-national primordial arguments[14] – exploited this Serbian attempt at domination in order to gain power themselves. The 'reactionary populist and organicist mechanisms of social control' were activated and organized in domains of ethnicity and culture.[15] We can talk about the creation of communicative spaces of particular ethnic/religious regimes (understood monolithically in terms of 'primordial ties'). Each of them – while defined by close 'cultural proximity' – offered highly exclusivist identities and ideologies. In 1991 the Yugoslav republics of Slovenia, Croatia and Macedonia proclaimed independence, followed by BiH in 1992. The remaining republics of Serbia and

Montenegro, being left alone, consequently proclaimed a new Federal Republic of Yugoslavia (FRY) in April 1992. The latter formation changed its name to Serbia and Montenegro, and was subject to further disintegration, with Montenegro's proclamation of independence in 2006; in 2008, the Serbian province of Kosovo, inhabited mainly by Kosovar Albanians, also declared its independence. Since internal, republican borders became external, attempts have been made to fit the international and 'republican-territorial' borders with the 'nations'.[16]

The Battle of Kosovo: 'The Turks' and ethno-nationalist 'revival'

At the beginning of the 1990s, the region came into the international spotlight due to ferocious armed conflicts occurring along ethnic and religious lines. Military and paramilitary Serbian forces participated in all of these wars. The conflicts were often explained by primordial arguments, based on the 'biologically' determined nature of inter-ethnic hatred.[17] However, considerable evidence points towards the fact that the war was carefully planned, and that the interpretations based on the primordial arguments ignore both political manipulations and selective interventions leading to the escalating violence, and the enormous role of the media in the process. In initial interethnic armed conflict, a major role was attributed to the interpretation of history; a traumatic past was actually invoked and manipulated in Serbia to mobilize the population. Primarily, events from World War II were used,[18] but even events from the fourteenth century surfaced.

The latter issue is embodied by the highly significant 'historical epic' *The Battle of Kosovo* (*Boj na Kosovu*, 1989) which shows a shift in the management of group membership and belonging in the late 1980s in the Yugoslav republic of Serbia. Made by impressively productive director Zdravko Šotra, the film introduced a new treatment of the neighbourhood, or rather a 'new' neighbour figure. Belonging to the body of films concerned with historical

figures and important political events, it perfectly characterizes the process of cultural transformation pretending to carry out the 'cultural evolution, or the resurrection of the repressed, traditional national forms' that, as put by Pavle Levi,[19] in fact represents 'a smooth succession between the two cultural doctrines (state-socialist and ethno-nationalist)'. The key event in the film – the Battle of Kosovo – concerns the confrontation between the army of the Serbian Tsar Lazar and the advancing Ottoman forces of Sultan Murat, referring to a historical event from the fourteenth century, considered fatal by the Serbs. As the story goes, the Serbian defeat in the battle resulted in five centuries of Ottoman rule during which many Turks and Albanians settled in Kosovo, a Serbian province until 2008. Although the Kosovo myth fits more than well in Eric Hobsbawm's argument set out in *The Invention of Tradition*,[20] the myth played an enormous role in the recent history of the group recognized as Serbs. Along with Sabrina Ramet's notions of myths as 'historically and politically situated discursive tools',[21] the consolidation of the Kosovo battle myth proved to be an extremely effective instrument for group mobilization.[22] Popular support was mobilized 'around the theme of national injustice'.[23]

Produced for the 600th anniversary of the Battle of Kosovo, the 1989 film is a TV drama that clearly 'overgrows its original TV framework', as Serbian film critic Dimitrije Vojnov[24] writes. Focusing on those in power,[25] on the pursuits and dilemmas of great men (mythologized or even mythical characters of Knight Miloš Obilić and Tsar Lazar who die as heroes), the film invokes traditional notions of 'Serbianness' and is part of a unifying effort towards defining the Serbian community.[26] It makes the Serbs nationally aware as the defenders of 'Europe'. European civilization represents a positive binary pole in the sense of the Saidian Orientalism, as the Ottomans' intention is to conquer Europe via Serbia. The film implies Huntington's 'clash of civilizations',[27] for instance, in the warning to Tsar Lazar: 'Not only two states are going to fight in Kosovo, Turkey and Serbia, neither only two nations, nor only two rulers, but two continents, two religions, two gods. See, this is the battle you are

entering, Lazar.' *The Battle of Kosovo* 'institutes' the actual strength of the enemy and its evilness. The Ottoman army is 'so big it can be heard two hours before it can be seen' and, as the spectator soon learns, 'there is no more ferocious army than the Ottoman one'. The institution of the immeasurably powerful and brutal adversary plays alongside the discourse that 'our' tiny fatherland is jeopardized, which is used alongside numerous other 'Balkan' countries. It turns the local resistance to 'the Ottoman advance in Europe', here Serbian resistance, into 'full explanatory and justifying myths' for the 'Balkan' backwardness compared to Western Europe, as 'the Balkan' nobles 'defended Western Europe with the price of their own history'.[28] In the light of the upcoming dissolution of Yugoslavia, this unsubtle 'historical spectacle' embodies the political and military perspective of Milošević's government, where the treatment and actual creation of the 'new' neighbours as the new 'Other' and as an (ancient but new) enemy were of crucial importance. For example, the Bosniak population in the newly-established BiH – mainly Muslims – were labelled with the derogatory term 'Turks' by the Serbs. However, the primary 'Others' were the Albanians, whose numerical supremacy in Kosovo and Kosovo's political autonomy (special status given by the 1974 Yugoslav federal constitution was abolished in 1989/1990) was perceived as a consequence of Ottoman imperialism. While the armed conflict in Kosovo started only in the late 1990s, the territory is characterized by long-term ethnic tensions between Albanian and Serbian populations; and the late 1980s were strongly marked by the Serbian authorities' suppression of the Albanian population who had the status of a national minority, not a constituent nation of Yugoslavia.

The film certainly assists in defining and creating a 'Serbian interpretative framework', which at that time was primarily linked to pro-war mobilization of the population along ethnic and religious lines. While set in the medieval Serbian state, it is obvious that the film can be read monolithically in terms of a) ethnic polarization in the 1980s, and b) mobilizing audiences for the coming armed conflicts in the Serbian neighbouring states of Croatia, BiH and its

province of Kosovo. It helps in establishing Serbs as victims and, hence, the 'Others', and the Ottomans as perpetrators.

The 1990s: Serbian neighbours in the period of the Serbian (para)military 'involvement' in the war in the neighbouring states

While *The Battle of Kosovo* did not reach far outside the Serbian interpretative framework, other films made in Serbia in the 1990s dealt with the neighbour figures or the issues of the (territorial, ethnic) neighbourhoods only occasionally. As Jurica Pavičić[29] notes, the majority of the films produced in the 1990s (around 100 or so) focused on 'external' rather than 'internal' affairs. This is significant in terms of Serbia's role in its neighbouring territories – Serbian military and paramilitary troops (both those from the Federal Republic of Yugoslavia as well as the Bosnian Serbs) were systematically and repeatedly committing the most extreme abuses of human rights, war crimes, crimes against humanity, genocide and rape, and causing enormous mass suffering of the population belonging to the other ethnic groups (Bosniaks, Croats and Kosovar Albanians). The 1990s saw some open propaganda films (directly or more subtly) demonizing the previous 'brothers', new 'neighbours' and enemies, but such films did not dominate, perhaps simply because, unlike neighbouring Croatia, as Jurica Pavičić[30] writes, the Serbian state was neither the main financial backer of films nor their 'client'. Milošević's government was basically uninterested in supporting film culture; so, with the cut in state subsidies, the government censorship of the previous regime was replaced by auto-censorship, driven by the presumed audience and potential market.[31] I would point out that it takes a special effort to please an audience influenced, on the one hand, by harsh war propaganda and pro-war mobilization discourse, and on the other hand, by high-octane 'escapist' popular culture, never politically 'off duty',[32] that completely dominated the Serbian media and popular culture in the turbulent 1990s.

Among the films that 'map' the neighbour figure in Serbia the most well-known and internationally acclaimed film is perhaps *Pretty Village, Pretty Flame* (*Lepa sela lepo gore*, Srđan Dragojević, 1995). Produced in the last days or immediately after the ferocious armed conflict in BiH with its horrifying Serbian involvement, the film's story revolves around the fate of the 'Tunnel of Brotherhood and Unity' in BiH, and presents two friends from different, later adversarial, ethnic backgrounds. Set up in a ceremonial manner at the beginning of the 1970s, the 'Tunnel' embodies basic Yugoslav values. A few years later, two young boys, Halil, a Muslim and Milan, a Serb, live and play in the surroundings of the now-abandoned Tunnel, inventing tales about an ogre who lives inside. In the early 1990s, with the armed conflict erupting, Halil and Milan find themselves on opposite sides. When his troop is trapped, Milan and his surviving co-fighters flee into the Tunnel for refuge. Outside, Halil's troop is waiting for them, knowing the Serbs will finally run out of water and come to the surface, meeting their deaths. The film generated ferocious response in both the Serbian and non-Serbian public spheres, with the Serbs accusing it of being unpatriotic. Even more than Emir Kusturica's *Underground* (1995), the film became a media event in all states that experienced action by the Serbian military and paramilitary forces, especially in BiH and Croatia, but also in Slovenia, although its warfare experience cannot be compared with the other countries.[33] It was the film's 'speaking position' that made it highly debatable. *Pretty Village, Pretty Flame* was largely discussed in terms of the level of violence allocated to one particular side (Bosniaks and Serbs) in the conflicts, an unequal treatment of warring sides – while Serbian crimes were shown with ironic flair, the Bosniak atrocities were depicted with utter seriousness (sadistic waiting and murdering). The film was highly controversial in relation to what actually happened in BiH, even though Serbs were not the only ones committing atrocities. As Igor Krstić[34] summarizes, alongside other internationally well-known and critically acclaimed films from the region (like *Underground*), *Pretty Village, Pretty Flame* provided a Serbian

perspective, a particular point of view on highly controversial issues. As Krstić[35] explains, it positions 'the viewer unconsciously to identify with the perspective of those who raped women, burned villages and mass-executed Muslims and Croats in Bosnia and in Kosovo. [It] promote[s] viewer identification with the libidinal economy of the "aggressors": an identification with "Balkanian drives"; excesses, addiction to violence and abuse of women, perversities and criminal behaviour'.

Among the more important films of the 1990s that 'mapped' the (new) neighbourhood issues, even though in very different ways, are *Vukovar Poste Restante* (*Vukovar, jedna priča*, Boro Drašković, 1994), *Premeditated Murder* (*Ubistvo s predumišljajem*, 1995/1996) and *The Hornet* (*Stršljen*, 1998, both directed by Gorčin Stojanović), and *Deserter* (*Dezerter*, 1992) and *The State of the Dead* (*Država mrtvih*, 2002, both made by Živojin Pavlović, a legendary director from the Yugoslav era). *Vukovar Poste Restante* follows the fate of a couple, a Croatian woman and a Serbian man, who have been friends from childhood, in the war-torn town of Vukovar in Croatia, used in the film as a metaphor for the fierce dissolution of the former Yugoslavia. Also significant for their representations of neighbours are *Premeditated Murder* and *The Hornet*. The first, following two love stories from the early 1990s and World War II, explicitly refers to the war in 'Srpska Krajina'. The latter, set in the present, depicts forbidden love between a Serbian girl and a Kosovar Albanian, who, while pretending to be a refined Italian businessman, actually works as an assassin for the Albanian mafia. The film uses the (negative) stereotypes of the Albanians, institutionalized in the Serbian interpretative framework, even – perhaps in order not to be accused of playing along with such stereotypes introduces the 'Good Albanian Guy'.

The Knife: neighbourhood issues in the late 1990s

After the armed conflicts, the perception of 'neighbours' in Serbian cinema has to a large extent been shaped by the 'revised'

politico-military perspective, the interpretative framework of what happened in those 'wars of secession' in the Serbian neighbouring states. One of the enormously popular films from the late 1990s that significantly outlines neighbourhood issues and the neighbour figure was the 'historical' film *The Knife* (*Nož*, Miroslav Lekić, 1999), made with the highest budget at that time.[36] Taking place in the countryside and in the capital of BiH, it was produced three years after the signing of the Dayton Agreement, which brought the armed conflict in BiH to a close.

The film is an adaptation of a controversial literary source, a populist novel-pamphlet that first emerged in the late 1970s, and was soon banned for eliciting interethnic hatred. *The Knife* characterizes the 'film policy' of a particular political party, the Serbian Renewal Movement (Srpski pokret obnove[37]), with the author of the novel, Vuk Drašković, being the president of the party. This ambitious 'melodramatic epic about identity'[38] starts during World War II and ends in the recent wars of secession. The fictional story is 'constructed in such a way that the personal relations, problems and stories clearly illustrate broader social and historical problems', as Ib Bondebjerg[39] writes about historical transition drama. It follows the life of Ilija, kidnapped as a baby from a Serbian-Christian-Orthodox family during World War II and brought up in the Muslim tradition. He eventually faces a moral crisis when confronted with the truth about his ethnic origins. Filled with anger, he joins the Serbian army as a doctor in the war in Bosnia, where he meets his 'brother' who has been raised in a virulent anti-Muslim environment.

At first sight the film operates as a place for moral concerns, questioning the 'usefulness' of war. It ends with the two 'brothers' with 'switched' ethnic identities sitting in the middle of war, wondering about their true identities and potential targets of their hate. But the film provides more room for interpretation. Through the main protagonist's search for identity, the main adversaries in the BiH conflict; the Bosnian Muslims, are reminded to discover and accept their true identity as Serbs, as was noted by non-Serbian

film critics[40] as well as the Serbian 'opposition' (i.e. *Republika*)[41]. As expressed by Radovan Kupreš, the film reminds us that 'Serbs and Muslims do not need to hate and kill each other, not because inter-ethnic hatred is wrong and fatal, but because they are two nations in one'.[42] What is even more significant, and quite in contradiction to the mentioned 'reminder', is that an alternative reading perceives ethnic identity monolithically in terms of primordial ties. The protagonist Ilija (aka Alija) recognizes a Muslim, his 'brother' (as 'an objectified Other') only by his sadistic actions, sadistic nature: 'Who are you, Miloš? You are killing, slaughtering … the Ustaša do that!'[43] In assuring Serb supremacy by glorifying Christian Orthodox religious affiliation (Orthodox iconography plays an important part, in particular the idyllic scene of a pre-Christmas dinner of Ilija's family before their ferocious Muslim neighbours come and kill them), Islamism is portrayed as a kind of 'treacherous deviancy'; the Muslims are depicted as desiring a Turkish invasion of Serbia to re-build an empire in Europe.[44]

In addition to narrative cinema, the theme of neighbourhood was also 'mapped' in documentary films. Among the most awarded were those made by Mihailo P. Ilić (*Judgement/Presuda*, 1998; *Markale*, 1999).[45] Both documentaries try to 'reveal' the 'truth' about the war in neighbouring Bosnia and mass atrocities committed by Serbs – about the Trnopolje concentration camp[46] and the massacre at Markale – as a simple 'montage fraud', 'fabrication' of atrocities that would bring the Serbs (again) undeserved punishment.[47]

I will conclude that, while films dealing with neighbourhood issues were not numerous, they did generate much more media attention than all the other films combined. Moreover, with some exceptions in Serbian cinema of the 1990s, the neighbour figure primarily exists as a negative counterpart – in more or less subtle versions – in relation to Serbian 'wholeness', in order to put Serbian nationhood into such a framework that would please the Serbian 'in-group', and justify its actions in their neighbouring states. Its neighbour character greatly helps in creating, as Krstić puts it, 'pathological identity politics', switching 'fantasies of ethnic

nationalism so effectively onto unconscious structures of antagonism and hatred, that the people passionately took up these ethnic identities and reconstructions of previous neighbours as blood enemies'.[48] As the author continues, 'the paranoid spiral of violence led Serbia's people to believe in always new "demonic enemies" – the Croats, the Albanians in Kosovo, the Muslims in Bosnia'.

Mapping the neighbourhood issues in the 2000s

Post-2000 Serbia faces changes, or at least partial changes, in the overall political climate.[49] In 2000, Milošević's outspoken nationalistic and aggressive military policy was brought to a close and, consequently, so was the period of international isolation and bombardments of the Serbian capital by the international community. However, 'liberal nationalists' with the President of Serbia Koštunica and his Democratic Party prevented discontinuity with legal and institutional steps of the previous regime,[50] and the assassination of Prime Minister Đinđić endangered the transformation processes further. Despite being based on the same dilemmas, the rhetoric of Europeanization,[51] primarily understood as meeting EU accession criteria, was introduced, bringing with it more diverse narratives regarding neighbourhood issues and recent military history.

Among the films that were outlining the neighbourhood issues regarding the armed conflict, I will pinpoint a black comedy from 2008, made by Goran Marković, one of the most established film directors belonging to the cherished 'Prague group' in Yugoslav cinema. *The Tour* (*Turneja*) is set in the 1990s; a local theatre group from the Serbian capital embarks – with the objective of earning some quick money, and completely unaware of what is going on – on a tour to entertain (Serbian) villagers and troops in the neighbouring BiH, next door to the heart of the ferocious warfare. A tired surgeon working on the front line in the Serbian camp explains to the ignorant, more or less disaffected actors why 'this war' is 'irrational': 'Here are warring the same people, speaking

the same language, having the same mentality, same emotions. They do not differ, in anything. Serbs, Croats, Muslims, they are all identical people. One nation.' Later the group accidentally visits all the warring sides – Serbian, Croat and Muslim camps; and all of the war participants are highly unpleasant. For instance, when entering the Croatian camp, the actors work hard to find out which ethnic group they have stumbled upon, so they can 'fit in' appropriately. Unfortunately, the Croats discover that the actors are 'not their kind' – their identity is unmasked when they use the incorrect word for 'theatre', which differs in Serbian and Croatian – and send them into a minefield. The group also meets a truck full of naked captives. Both the captives and their torturers are Muslims, from different towns, a local tells the actors. 'Narcissism of small differences', one of the group members from Serbia, alcoholic Žak, philosophically comments. 'Freud',[52] he adds, to the surprise of others. While the film actually presents one of the less biased views of the relations between Serbs and their 'neighbours' in Serbian cinema – and it was perceived and discredited as anti-Serbian in Serbia – the film effectively suggests that the war was 'irrational' and that the politics in Belgrade did not stir up the war in neighbouring BiH.

It is here that Zečević's[53] *The Fourth Man*, introduced at the beginning of this chapter, becomes important. The VHS tape of the massacre in the film alludes to video material that existed in reality: Serbian 'special' paramilitary recorded the massacres they were committing. The inserts of one such film (a video of genocide in Srebrenica in 1995) were actually shown on TV in Serbia after being screened at The Hague tribunal in 2005.[54] For a while it seemed that it might turn around the war-crime discussion in Serbia which denies Serbian responsibility for mass atrocities in the neighbouring states and which more or less completely dehumanizes victims who do not belong to the Serbian 'in-group'. As Eric Gordy puts it, 'it suddenly becomes impossible for even the most disingenuous people to claim that they do not know what they have known for 10 years'.[55] Even if the tested mechanisms of

'trivialization, relativization, and indecision' soon limited its impact (using Gordy's articulation), *The Fourth Man* opens some crucial issues, speaking about amnesia, personal and collective. Watching the tape, the major's memories start creeping back. The Muslim family had nothing to do with the death of his family. He himself accidentally shot his own son in a fight, and he tried to commit suicide afterwards. The problem of memory is symbolized by a motif of a wooden horse, which is used to retrieve the repressed, falsified memory, like the paper unicorn in Ridley Scott's *Blade Runner*. By and large, the film shows that memories can be used for contradictory purposes, in the same way as neighbours can be rendered in contradictory ways. Zečević's film is important because it introduces the neighbour figure in a new 'role', as a victim, while retaining, although through repressed memory, responsibility for war crimes committed by Serbians.

Conclusion

This chapter has tried to show the relationship between post-Yugoslav–Serbian cinema and specific ideas of its (new) neighbourhood. It tried to point to some basic directions in the mapping of the neighbourhood issue and of the neighbour figure in Serbian films in relation to the recent military history of Serbia's new neighbour states. In recent decades, the narratives about 'in-group' identity and the neighbourhood figure have been radically transformed in the Serbian system by the group recognized as the Serbs. Nationhood and neighbourhood narratives (and the neighbour figure) in Serbia co-exist, compete with and even contradict discourses about the conception of the neighbour in Serbian cinema. In other words, they vary not only according to place and time, but also in regard to official history, transmitted via the educational system and other forms of media (TV, press). Filmmaking in Serbia was and is marking, and interacting with, these changes all along.

Notes

1 The main characters are mainly referred to by their profession. As such, their names symbolize the character's unity with their profession and they can be seen as removed from individual blame or victimhood. The ultimate responsibility is certainly directed at the system; the government authorities and their manipulations and smokescreens during and after the war.

2 See Bernhard Leidner et al., 'Ingroup Glorification, Moral Disengagement, and Justice in the Context of Collective Violence', *Personality and Social Psychology Bulletin* 36:8 (2010), pp. 115–29.

3 Inspired by a lecture by Jo Shaw (University of Edinburgh), delivered at the University of Copenhagen in December 2011.

4 That premise would then include Serbs living in the neighbouring BiH's entity Republic of Srpska, which is led by Bosnian-Serbs.

5 The movement was founded in 1931/1932, 'exclusively on an anti-Yugoslav orientation' and 'tied to Germany's revisionist policy towards Europe's Versailles system' (Vjeran Pavlaković, 'Flirting with Fascism: The Ustaša Legacy and Croatian Politics in the 1990s', in Lorenzo Bertucelli and Mila Orlić (eds.), *Una storia balcanica. Fascismo, comunismo e nazionalismo nella Jugoslavia del Novecento* (Verona: Ombre Corte, 2008).

6 Later, in 1963, SFRY was set up, remaining in power until the early 1990s.

7 As Pavlaković writes, 'tens of thousands of others associated (or allegedly associated) with the Ustaša regime' suffered in postwar massacres (Pavlaković, 'Flirting with Fascism').

8 Pavlaković, 'Flirting with Fascism'.

9 Daniel J. Goulding, *Liberated Cinema: The Yugoslav Experience, 1945–2001* (Bloomington, IN: Indiana University Press, 2002), p. 189.

10 Nenad Polimac, '"Zona Zamfirova": milijun gledatelja srpskog nacionalnog ljubića', *Nacional* 369 (2002). Online. Available at <http://www.nacional.hr/clanak/13306/zona-zamfirova-milijun-gledatelja-srpskog-nacionalnog-ljubica> (accessed 15 February 2012).

11 Nebojša Jovanović, 'Fadil Hadžić u optici totalitarne paradigme', *Hrvatski filmski ljetopis* 65–66 (2011), pp. 47–61.

12 Jovanović, 'Fadil Hadžić u optici totalitarne paradigme', p. 47.

13 Jovanović, 'Fadil Hadžić u optici totalitarne paradigme', p. 47.

14 In the primordial approach, ethnic identity is understood as 'biologically given', as 'natural phenomena', based on 'common objective cultural attributes' (Rex, quoted in Ray C. Taras and Rajat Ganguly, *Understanding Ethnic Conflict* (White Plains, NY: Longman, 2002), p. 11).

15 Pavle Levi, *Disintegration in Frames* (Stanford, CA: Stanford University Press, 2007), p. 12.

16 Jelena Vasiljević, 'Citizenship and Belonging in Serbia: In the Crossfire of Changing Nationhood Narratives', *Working Paper* 17 (2011). Online. Available at <http://www.law.ed.ac.uk/file_download/series/327_citizenshipandbelonginginserbiainthecrossfireofchangingnationhoodnarratives.pdf> (accessed 7 February 2012), p. 2.

17 'Ancient hatred theory' became widely fashionable in the non-academic discourses in an attempt to explain the post-Cold War increase in ethnic conflicts.

18 World War II was primarily discussed in SFRY within the 'liberalization' discourse, and the issue of the civil war was avoided. However, in the course of the 1980s, the Serbian authorities manipulated the issues, loading them with an enormous emotional connotation – the memory was reconstructed around the mass suffering of Serbs in World War II, especially in the Jasenovac concentration camp in the independent Croatian state where the majority of victims were Serbs – to turn the population against the previous 'brothers', the new neighbours.

19 Levi, *Disintegration in Frames*, p. 69.

20 Eric J. Hobsbawm and Terence O. Ranger (eds.), *The Invention of Tradition* (Cambridge: Cambridge University Press, 1992).

21 In Irene Dioli, 'Myths of Founding and Martyrdom: Sabrina Ramet's *Dead Kings*', *Osservatorio Balcani e Caucaso*, 2 November 2010. Online. Available at <http://www.balcanicaucaso.org/eng/Regions-and-countries/Serbia/

Myths-of-founding-and-martyrdom-Sabrina-Ramet-s-Dead-Kings>
(accessed 7 February 2012).

22 The material was also used in a 1939 docu-drama *The Battle of Kosovo*
(*Kosovska bitka*) as a part of the documentary *Celebration of the 550th
Anniversary of the Battle of Kosovo*; the other part was a docu-drama titled
Slavery under Turks.

23 Dan Smith, 'Trends and Causes of Armed Conflict', in Alex
Austin, Martina Fischer and Norbert Ropers (eds.), *Transforming
Ethnopolitical Conflict: The Berghof Handbook* (Wiesbaden: VS Verlag für
Sozialwissenschaften, 2004), p. 112.

24 Dimitrije Vojnov, 'Politički aspekti savremenog srbskog filma', *Nova
srbska politička misao*, 23 March 2008. Online. Available at <http://
starisajt.nspm.rs/kulturnapolitika/2008_vojnov3.htm> (accessed 17
February 2012).

25 Using inspiration from Daniel Gerould, 'Melodrama and Revolution',
in Jacky Bratton, Jim Cook and Christine Gledhill (eds.), *Melodrama:
Stage Picture Screen* (London: British Film Institute, 1994), p. 185.

26 The phenomenon is not unknown in other Eastern European
cinemas, and it is notably similar to what Ewa Mazierska proposed to
label as 'Polish heritage cinema' and examined as commentaries on
contemporary, postcommunist Poland. The films, enormously popular
in Poland, such as *Pan Tadeusz* (1999), directed by Andrzej Wajda
and *With Fire and Sword* (*Ogniem i mieczem*, 1999), directed by Jerzy
Hoffman, focus on the nation's past, portraying Polish nobility in an
idealized manner, and usually, as Mazierska ('In the Land of Noble
Knights and Mute Princesses: Polish Heritage Cinema', *Historical
Journal of Film, Radio and Television* 21:2 (2001), p. 167) suggests, seem
to function as 'elements in a larger discourse', that of the Polish national
heritage, which is understood in terms of 'culture shared by all Polish
people', and form a part of the 'nostalgia business'.

27 Samuel Huntington, *The Clash of Civilizations and the Remaking of World
Order* (London: Simon & Schuster, 1997).

28 Alina Mungiu-Pippidi, 'The Balkans and Europe: A Bond with an
Ambiguous Past', paper prepared for the EU Conference, Indiana
University, April 2004.

29 Jurica Pavićić, 'Pregled razvoja postjugoslavenskih kinematografija', *Sarajevske sveske* 21–22 (2010). Online. Available at <http://www.sveske. ba/bs/content/pregled-razvoja-postjugoslavenskih-kinematografija> (accessed 7 February 2012).

30 Pavićić, 'Pregled razvoja postjugoslavenskih kinematografija'.

31 Pavićić, 'Pregled razvoja postjugoslavenskih kinematografija'.

32 Alexei Monroe, 'Balkan Hardcore: Pop Culture and Paramilitarism', *Central Europe Review* 2:24 (2000). Online. Available at <http://www. ce-review.org/00/24/monroe24.html> (accessed 7 February 2012).

33 The great relevance of the film certainly owed a great deal to the film's warm reception in the 'West'.

34 Igor Krstić, 'Re-Thinking Serbia: A Psychoanalytic Reading of Modern Serbian History and Identity through Popular Culture', *Other Voices* 2:2 (2002). Online. Available at <http://www.othervoices. org/2.2/krstic/> (accessed 7 February 2012).

35 Krstić, 'Re-Thinking Serbia'.

36 Špela Zajec, 'Boosting the Image of a Nation: The Use of History in Contemporary Serbian Film', *Northern Lights: Film and Media Studies Yearbook* 7:1 (2009), pp. 173–89.

37 See Vojnov, 'Politički aspekti savremenog srbskog filma'.

38 Andrew J. Horton, 'Vignettes of Violence', *Kinoeye* 1:18 (1999). Online. Available at <http://www.ce-review.org/99/18/kinoeye18_ horton1.html> (accessed 7 February 2012).

39 Ib Bondebjerg, 'Coming to Terms with the Past: Post-89 Strategies in German Film Culture', keynote presentation at *Postcommunist Visual Culture and Cinema: Interdisciplinary Studies, Methodology, Dissemination. The Eighteenth Annual/Postgraduate Conference*, University of St Andrews, 20–21 March 2009.

40 Horton, 'Vignettes of Violence'.

41 See Radovan Kupreš, 'Uslovni humanizam umetnickog angazmana', *Republika* 210 (1999). Online. Available at <http://www.yurope.com/ zines/republika/arhiva/99/210/210_11.html> (accessed 5 October 2008).

42 Kupreš, 'Uslovni humanizam umetnickog angazmana'.

43 The term 'Ustaša', Croatian fascists in the Second World War, was widely used by non-Croats in the recent armed conflict (as a derogatory term) to label the adversarial ethnic group.

44 See Horton, 'Vignettes of Violence'.

45 In 1998, *Judgement* was awarded Best Documentary at the Belgrade film festival, where *Markale* received the Grand Prix the following year.

46 Trnopolje was reported by the TV station ITN.

47 See Nebojša Jovanović, 'Film, žica, Srebrenica. 11 teza o srpskoj filmskoj laži' (2010). Online. Available at <http://www.centargrad. com/materials/reader2009/Reset/intervention_3_1_texts/Film_zica_ Srebrenica_final.pdf> (accessed 7 February 2012).

48 Krstić, 'Re-Thinking Serbia'.

49 Vasiljević, 'Citizenship and Belonging in Serbia'.

50 Vasiljević, 'Citizenship and Belonging in Serbia', p. 26.

51 Serbia has had a complicated relationship with EU states over the past two decades, with concerns over where Serbia's borders were and what its population was (see Vasiljević, 'Citizenship and Belonging in Serbia', p. 25).

52 Freud's term 'narcissism of small differences' designates 'the phenomenon that is precisely communities with adjoining territories, and related to each other in other ways as well, who are engaged in constant feuds and in ridiculing each other' (Sigmund Freud, *Civilization and Its Discontents*, trans. and ed. James Strachey (New York: W.W. Norton, 1961), p. 61).

53 Dejan Zečevič established himself as a 'capable genre filmmaker' with the slasher-horror *TT Syndrome* (*TT Sindrom*, 2002) and the campy comedy *Little Night Music* (*Mala noćna muzika*, 2002) (see Vladan Petković, 'Serbia vs. Croatia: 2007 in Film', *Neil Young's Film Lounge*, 11 August 2008. Online. Available at <http://www.jigsawlounge. co.uk/film/reviews/serbia-vs-croatia-2008-in-film-vladan-petkovic- surveys-the-scene/> (accessed 7 February 2012)). Recently, he made *The Enemy* (*Neprijatelj*, 2011), a supernatural thriller that is set entirely in BiH. In the film, a group of Serbian soldiers are trying to liberate a man that is revealed to be a devil responsible for the eruption of all the monstrosities in BiH. The end is significant – Serbs unite with their war adversaries Bosniaks to destroy the devil.

54 The footage is, as stressed by Nebojša Jovanovič (Jovanović: 'Fadil Hadžić u optici totalitarne paradigme'), 'effectively a snuff – six Bosniak men were executed precisely for the camera. The video was first shown at the International Criminal Tribunal for the former Yugoslavia (ICTY) in The Hague, in 2005 at Slobodan Milošević's trial (Eric D. Gordy, 'Serbia: Shocking, Yes. But is it Transformative?', *Transitions Online*, 23 June 2005. Online. Available at <http://www.tol.org/client/article/14216-shocking-yes-but-is-it-transformative.html?print> (accessed 7 February 2013)).

55 Gordy, 'Serbia: Shocking, Yes. But is it Transformative?'

References

Bondebjerg, Ib, 'Coming to Terms with the Past: Post-89 Strategies in German Film Culture', keynote presentation at Postcommunist Visual Culture and Cinema: Interdisciplinary Studies, Methodology, Dissemination. The Eighteenth Annual/Postgraduate Conference, University of St Andrews, 20–21 March 2009.

Dioli, Irene, 'Myths of Founding and Martyrdom: Sabrina Ramet's Dead Kings', *Osservatorio Balcani e Caucaso*, 2 November 2010. Online. Available at <http://www.balcanicaucaso.org/eng/Regions-and-countries/Serbia/Myths-of-founding-and-martyrdom-Sabrina-Ramet-s-Dead-Kings> (accessed 7 February 2012).

Freud, Sigmund, *Civilization and Its Discontents*, trans. and ed. James Strachey (New York: W.W. Norton, 1961).

Gerould, Daniel, 'Melodrama and Revolution', in Jacky Bratton, Jim Cook and Christine Gledhill (eds.), *Melodrama: Stage Picture Screen* (London: British Film Institute, 1994), pp. 185–98.

Gordy, Eric D., 'Serbia: Shocking, Yes. But is it Transformative?,' *Transitions Online*, 23 June 2005. Online. Available at <http://www.tol.org/client/article/14216-shocking-yes-but-is-it-transformative.html?print> (accessed 7 February 2013).

Goulding, Daniel J., *Liberated Cinema: The Yugoslav Experience, 1945–2001* (Bloomington, IN: Indiana University Press, 2002).

Hobsbawm, Eric J. and Ranger, Terence O. (eds.), *The Invention of Tradition* (Cambridge: Cambridge University Press, 1992).

Horton, Andrew J., 'Vignettes of Violence', *Kinoeye* 1:18 (1999). Online. Available at <http://www.ce-review.org/99/18/kinoeye18_horton1.html> (accessed 7 February 2012).

Huntington, Samuel, *The Clash of Civilizations and the Remaking of World Order* (London: Simon & Schuster, 1997).

Jovanović, Nebojša, 'Film, žica, Srebrenica. 11 teza o srpskoj filmskoj laži' (2010). Online. Available at <http://www.centargrad.com/materials/reader2009/Reset/intervention_3_1_texts/Film_zica_Srebrenica_final.pdf> (accessed 7 February 2012).

Jovanović, Nebojša, 'Fadil Hadžić u optici totalitarne paradigme', *Hrvatski filmski ljetopis* 65–66 (2011), pp. 47–61.

Krstić, Igor, 'Re-Thinking Serbia: A Psychoanalytic Reading of Modern Serbian History and Identity through Popular Culture', *Other Voices* 2:2 (2002). Online. Available at <http://www.othervoices.org/2.2/krstic/> (accessed 7 February 2012).

Kupreš, Radovan, 'Uslovni humanizam umetnickog angazmana', *Republika* 210 (1999). Online. Available at <http://www.yurope.com/zines/republika/arhiva/99/210/210_11.html> (accessed 5 October 2008).

Leidner, Bernhard, Castano, Emanuele, Zaiser, Erica and Giner-Sorolla, Roger, 'Ingroup Glorification, Moral Disengagement, and Justice in the Context of Collective Violence', *Personality and Social Psychology Bulletin* 36:8 (2010), pp. 115–29.

Levi, Pavle, *Disintegration in Frames* (Stanford, CA: Stanford University Press, 2007).

Mazierska, Ewa, 'In the Land of Noble Knights and Mute Princesses: Polish Heritage Cinema', *Historical Journal of Film, Radio and Television* 21:2 (2001), pp. 167–82.

Monroe, Alexei, 'Balkan Hardcore: Pop Culture and Paramilitarism', *Central Europe Review* 2:24 (2000). Online. Available at <http://www.ce-review.org/00/24/monroe24.html> (accessed 7 February 2012).

Mungiu-Pippidi, Alina, 'The Balkans and Europe: A Bond with an Ambiguous Past', paper prepared for the EU Conference, Indiana University, April 2004.

Pavičić, Jurica, 'Pregled razvoja postjugoslavenskih kinematografija', *Sarajevske sveske* 21–22 (2010). Online. Available at <http://www.sveske.ba/bs/content/pregled-razvoja-postjugoslavenskih-kinematografija> (accessed 7 February 2012).

Pavlaković, Vjeran, 'Flirting with Fascism: The Ustaša Legacy and Croatian Politics in the 1990s', in Lorenzo Bertucelli and Mila Orlić (eds.), *Una storia balcanica. Fascismo, comunismo e nazionalismo nella Jugoslavia del Novecento* (Verona: Ombre Corte, 2008), pp. 115–43.

Petković, Vladan, 'Serbia vs. Croatia: 2007 in Film', *Neil Young's Film Lounge*, 11 August 2008. Online. Available at <http://www.jigsawlounge.co.uk/film/reviews/serbia-vs-croatia-2008-in-film-vladan-petkovic-surveys-the-scene/> (accessed 7 February 2012).

Polimac, Nenad, '"Zona Zamfirova": milijun gledatelja srpskog nacionalnog ljubića', *Nacional* 369 (2002). Online. Available at <http://www.nacional.hr/clanak/13306/zona-zamfirova-milijun-gledatelja-srpskog-nacionalnog-ljubica> (accessed 15 February 2012).

Smith, Dan, 'Trends and Causes of Armed Conflict', in Alex Austin, Martina Fischer and Norbert Ropers (eds.), *Transforming Ethnopolitical Conflict: The Berghof Handbook* (Wiesbaden: VS Verlag für Sozialwissenschaften, 2004), pp. 111–27.

Taras, Ray C. and Ganguly, Rajat, *Understanding Ethnic Conflict* (White Plains, NY: Longman, 2002).

Vasiljević, Jelena, 'Citizenship and Belonging in Serbia: In the Crossfire of Changing Nationhood Narratives', *Working Paper* 17 (2011). Online. Available at <http://www.law.ed.ac.uk/file_download/series/327_citizenshipandbelonginginserbiainthecrossfireofchangingnationhoodnarratives.pdf> (accessed 7 February 2012).

Vojnov, Dimitrije, 'Politički aspekti savremenog srbskog filma', in *Nova srbska politička misao*, 23 March 2008. Online. Available at <http://starisajt.nspm.rs/kulturnapolitika/2008_vojnov3.htm> (accessed 17 February 2012).

Zajec, Špela, 'Boosting the Image of a Nation: The Use of History in Contemporary Serbian Film', *Northern Lights: Film and Media Studies Yearbook* 7:1 (2009), pp. 173–89.

8

New Neighbours, Old Habits and Nobody's Children: Croatia in the Face of Old Yugoslavia

Vlastimir Sudar

The concept of neighbourhood has had a significant meaning throughout history, in the Balkans, and in the territory once known as Yugoslavia. This is not to say that the concept does not carry considerable weight in probably every culture in the world, but the spectral aspect of its meaning has been literally multifaceted in this region. Everyone and everything that could be perceived as a 'neighbour' has been so considered – with varying qualities and in differing degrees – and has, naturally, played a key role in how individuals and groups define themselves. Again, a common case elsewhere – if not everywhere – it could be argued.

To illustrate the specificity of this concept for the now former Yugoslavia, a good example could be seen in an anecdote drawn from the abandoned socialist education system of that country. Particularly during the 1950s and 1960s, Yugoslav schoolchildren were taught that their country was surrounded by BRIGAMA. This – then Serbo-Croat – word, *brigama*, translates as 'worries',

or even 'problems'. While it is important to note that the word is in the plural, it is also important that in this instance it was written in capital letters, so that it operated equally as an acronym. BRIGAMA hence stood for Bulgaria, Romania, Italy, Greece, Austria, Mađarska (Hungary) and Albania: the seven countries that bordered Yugoslavia, seven countries that were its first neighbours. That a neighbour on an international level was something to 'worry' about is telling in many respects. It not only disclosed a distrustful relationship towards its neighbouring countries, but also denoted socialist Yugoslavia's actual political situation. Some of these aspects may be deciphered as follows: firstly, Yugoslavia was a socialist country and those countries belonging to the NATO alliance were outright enemies, namely, Greece and Italy. Austria, which was neutral but liberal–capitalist since the Soviet and Allied departure in 1955, was also perceived as being potentially dangerous in any conflict with the Western Alliance. On the other hand, in 1948, Yugoslavia had left the Soviet Bloc and decided to build Socialism independently of the Soviet Union, which Stalin had not taken lightly. Yugoslavia expected a possible military invasion from an alliance of communist countries, including its four other neighbours: Bulgaria, Romania, Hungary and Albania. Politically speaking, Yugoslavia did not share much with its neighbours.

This political mistrust was not only ideological. The old continental recipe – of border disputes – applied to this neighbourly situation as well. Italy, historically, had laid claim to Istria, as well as much of the Yugoslav coastline. Austria could claim the Slovenian Alps; Hungary and Romania the plains of Vojvodina; Bulgaria and Greece were uneasy about Macedonia and Albania had interests in Kosovo. For the Yugoslavs, their neighbours were potentially worrying and however much its socialism was portrayed globally as laid back and *laissez faire*, Yugoslavs always found themselves threatened from the outside, especially by their immediate outside. Without having to expand further, it could be said that Yugoslavia undoubtedly had a culture of being wary of its neighbours. This was

also the result of the lands constituting Yugoslavia being colonized by the Austro-Hungarian Empire and Venetian Republic, which held its western parts, while the Ottoman Empire occupied its eastern parts, for a significant historical period. Although Serbia and Montenegro gained independence in the nineteenth century, most of the Yugoslav territories remained colonized until the formation of the Kingdom of Serbs, Croats and Slovenes in 1919, renamed the Kingdom of Yugoslavia in 1929. It is this trauma of possible recolonization that has further reinforced Yugoslavia's untrusting outlook towards its surroundings.

For those familiar with what at least some of the ex-Yugoslav cultures used to pride themselves on, this initial exposé might come across as dubious, as on the other hand and on more personal levels, there were the opposite elements in the culture. In Serbia, as well as in many other areas of Yugoslavia, the notion of *domaćin*, which literally translates as 'host', is close to sacred.[1] To be a good *domaćin* was and still is an ideal to strive towards. On the same track and perhaps even more sacred was the notion, in Bosnia and Herzegovina, of – *komšijski odnosi* – good neighbourly relations. Furthermore, people took pride in the fact that this was a long-held tradition. Being good to neighbours was central to Yugoslav culture, even though the political and historical circumstances epitomized in the above-mentioned concept of BRIGAMA were providing a serious challenge. Needless to say, the concept of good neighbourly relations was put to an even more dramatic test as Yugoslavia broke apart, and when the internal neighbourly associations turned out to be much more worrying for these separate elements than those they had as 'one whole' with their outside. As the idea of what constructs one entity which can define itself against its other(s) proved to be shifting and amorphous, so the definition of who is actually a neighbour to whom – in the Yugoslav and post-Yugoslav context – became a sketch difficult to delineate. Even more so, the cultural ideals mentioned above – to celebrate the culture of being a good host and neighbour – have gravely melted away under the pressure of political and historical circumstances.

The amorphous understanding of 'self' has been a pervading characteristic of the Yugoslav film industry. As early as 1970, Slobodan Novaković, the Belgrade film critic and historian, explained that Yugoslav cinema is perceived as a whole when viewed from outside Yugoslavia, but as a set of separate cinema industries from within the country itself.[2] These separate cinematic cultures were defined by the separate Republics from which they came, the *de facto* states within Yugoslavia, which was a federation of six of these republics (Bosnia and Herzegovina, Croatia, Macedonia, Montenegro, Slovenia and Serbia). When building the film industry after the end of World War II, the Yugoslav authorities decided to set up film studios in each of the republics, thereby enabling each one of them to build its own distinct cinematic culture. When Yugoslavia disintegrated in the last decade of the twentieth century and the republics became *de jure* states, their cinematic cultures also helped to define and explain the entirely new set of neighbourly conditions and relations.

The rise of nationalism stemming from the collapse of the common entity – the Yugoslav state – was well documented throughout the 1990s in the world's media and press. This rise could be perceived as almost inevitable, since the loss of one – Yugoslav – identity necessitated its replacement with new – or in cases old – ones (Bosnian, Croatian, Serbian, etc.). The process of constructing these new national identities was not essentially characterized by any significant conceptual novelty, but it explored the fact that these identities were relatively tribal. Nevertheless, on the surface it appeared that the process followed the paradigms of nineteenth-century Romantic nationalism. For the analysis of the film below, it is this fundamental tribalism that is of greater interest. As Claude Lévi-Strauss famously explained, identity is easily built through binary oppositions, through defining oneself against the 'Other'.[3] Hence, as Yugoslavia collapsed, new identities were forged by magnifying the differences with the 'Other' parts of the once common identity, or rather with their now new close neighbours – the new potential BRIGAMA.

This chapter intends to survey how these new neighbours perceive themselves 20 years after going their separate ways. In order to construct a detailed picture of these relations, it would be ideal to look at several groups of films, from the different former Yugoslav republics. However, in this chapter one film that explores these relations in depth will be examined: indeed, one of the film's significant characters is known simply as the Neighbour. This film, *No One's Son* (*Ničiji sin*), is directed by Arsen Anton Ostojić. It was the most awarded film at Croatia's national film festival at Pula in 2008, and Croatia's official entry for the Oscars in 2009. Based on the already well-known Croatian play of the same title, written by Mate Matišić, who also adapted it for the screen, it is a film that tirelessly scrutinizes many aspects of the relations between neighbours. Therefore, the argument in this chapter will revolve around a close reading of the film against the political and historical background that its narrative is addressing. The argument will invoke theoretical concepts of *alterity*, as epitomized in the now 'overused' notion within the humanities – that of the Other. Following the discourse pursued by Emmanuel Levinas, the first to formulate an ethical philosophy of the 'Other',[4] this otherwise multifaceted notion will here implicitly understand alterity as the 'other' to identity.

> According to Levinas, the act of existing results in a tragic solitude and a materiality that besets us with needs ... This solitude is confronted with 'the face of the other' which defines us, establishes time and history and calls us beyond ourselves. It is this Other that remains eternally mysterious.[5]

The aim is thus to trace these confrontations between identity and its 'Others', as well as processes of 'otherization' – as portrayed in this film – in Croatia and former Yugoslavia, with a view to reaching a conclusion on their mutual neighbourly relations, those neighbourly relations that once upheld the tradition of generous hosting of strangers as sacrosanct, thus reminding us of the ethical

concepts instigated by Levinas. While commenting on his work, his friend Jacques Derrida remarked that an ethical adage worth remembering is the one on learning to be hospitable to the Other.[6]

No One's Son has had considerable acclaim in its native Croatia and its subject matter arguably represents a new sensibility within Croatian cinema's culture, as the film also contains a probing and more critical attitude towards the recent past. As always, and particularly within the tradition of East European filmmaking, the film's political and historical context needs to be understood. When Croatia won its independence in 1992, it was led by the nationalist and right-wing government of Franjo Tuđman, one of whose objectives was to convince Croats that they had little, if anything, in common with their neighbours within Yugoslavia. While this project could be perceived as nationalist, since it was inaugurated by a nationalist political party, it could also be perceived as politically practical, as it is easier to win a vote for independence where there is a case for the uniqueness of the country and its culture. As long as President Tuđman was alive and his party of Croatia's Democratic Union (HDZ – Hrvatska Demokratska Zajednica) in power, Croatian films supported the idea of Croatia's uniqueness within its former Yugoslav environment. These films almost regularly portrayed Croatians as victims, even going so far as to produce a rare – if not the only – revisionist film about World War II. In this work, the communist Partisans,[7] as well as units of Western Allied troops, are portrayed as bloodthirsty and duplicitous, while the defeated groups allied to (and including units belonging to) Nazi Germany are seen as defenceless victims. *In Four Rows (Četverored*, Jakov Sedlar, 1999) portrays the fierce settling of scores right at the end of World War II. The Yugoslav Partisans did not forgive the members of Croatia's Ustaša movement which had allied itself to Nazi Germany. Sedlar takes this bitter episode as the film's focus, although without setting it in a more detailed historical context, which – to be fair – an average length feature film cannot always facilitate. The larger context, however, might have involved explaining that the Croatian fascist regime led by the Ustaša was

one of the most vicious regimes of World War II, as their barbaric violence shocked even the Nazis. Such brutality cannot, of course, legally speaking, justify the above-mentioned retributions, but in the light of the last pan-European war it would certainly help to explain its causes. However, in their need to rewrite Croatia's history and justify its present course, as in many other cinematic histories elsewhere, the filmmakers chose to be selective about the points of view they portrayed.

Such cinematic policies in Croatia culminated in another curious situation. Before its dissolution Yugoslav identity overshadowed the individual identities of the republics of which it was composed. In practical terms, numerous films made in Croatia and its film studios featured actors and staff from the other Yugoslav republics, starting with Serbia. As for Croatia, Serbia represented the first point of distinction in the process of Yugoslavia's disintegration – Croatia's first 'Other', if I can dare to call it that – some peculiar policy decisions resulted. Out of approximately 200 films made in Croatia while it was still part of Yugoslavia (1945–91), 130 had significant participation from other republics, mainly Serbia. Initially, Tuđman's policymakers thus only embraced 70 films as truly Croat, and for several years allowed only these films to be screened on national television.[8] Such a discreet ban on the other 130 films had to be lifted, if only because some truly outstanding Croatian films could not be shown. The most blatant example was the classic 1967 film *The Birch Tree* (*Breza*, Ante Babaja), set in Zagorje, Croatia's bona fide heartland. In the main role, however, it featured Velimir Bata Živojinović, a true behemoth of Yugoslav acting with more than 300 film roles to his credit and who was of Serbian descent. To make matters even more problematic, when Yugoslavia started falling apart, he entered politics. The actor joined Slobodan Milošević's Socialist Party of Serbia no less, and became a Member of Parliament for that party. In Croatia, Milošević was perceived as the country's – if not President Tuđman's – archenemy, and the man behind the conflict and the armed rebellions of Croatia's ethnic Serbs. To show a film

starring one of Milošević's MPs would certainly have come across as unpatriotic. Interestingly, Živojinović took his film role very seriously: prior to the making the film he spent more than a month in a village in Zagorje in order to master their specific local – and arguably very Croat – accent. In one of the key scenes in the film, Živojinović's character Marko Labudan prances around merrily while waving Croatia's national flag. This was not enough for Tuđman's cultural lieutenants in the 1990s however, for one simple reason. As much as Živojinović's portrayal of a Croat from Zagorje is credible and as much as an outsider would never be able to spot the difference, all the 'insiders' – including Croats, Serbs and pretty much everyone else from Yugoslavia – knew that he was not from Zagorje. More significantly, he was a Serb – the most distinguished and contemptible of the new neighbours from the Croat point of view – the true new 'Other', while the melding of the two was unacceptable for Tuđman's Croatia. This example provides an illustration of Novaković's above-mentioned thesis: Yugoslav films were Yugoslav for outsiders, but insiders knew whether the film belonged to Croatia, Serbia or another of the Yugoslav constituent republics.

The history of cinema in Socialism (Yugoslavia included) can be traced through the political changes affecting the circumstances in which the films were made. It seems that this habit continues within these societies now in postcommunism, and all of former Yugoslavia – including Croatia – provides very good examples. In 2000, almost ten years after Croatia's independence, a coalition of liberal and left-wing political parties won a landslide victory over Tuđman's nationalist HDZ and started a new politics towards the country's former Yugoslav neighbours, once associate parts of a common entity. This change in politics also resulted in a new cultural rapprochement with these countries. At the time of writing, Croatia's president is Ivo Josipović, a Social Democrat, one of whose most distinguishing gestures was of re-establishing closer, and warmer, political ties with Serbia. His first prime minister was Jadranka Kosor,[9] who, albeit from the same political party as the

late President Tuđman, is from one of its more reformed branches. This government had to swallow the bitter pill of dealing with the initial judgement of the International Tribunal at The Hague that Tuđman's government had organized, and indeed perpetrated, war crimes on the territory of former Yugoslavia.[10] This rapprochement could also be perceived as a result of the process of self-examination that has emerged in Croatia as its political scene has become increasingly liberalized.

Arsen Anton Ostojić's film *No One's Son*, and the swathe of awards it received in Croatia, can be seen as a reflection of these liberal tendencies. Made in 2008, it appears to signify a frank re-examination of Croatia's recent past and the country's relationship with 'newly' established Other(s), and through that, a critical examination of (it)self. However, it is worth pointing out here that such a reading of the film could lead to a somewhat reductive view of what the film represents. It needs to be emphasized that such a reading is only a segment within a plethora of readings of equal significance, all of which are needed if the intricacies of this impressive film are to be understood. *No One's Son* can also be seen as deliberately somewhat distanced from the usual tradition of European auteur cinema – a tradition that was well nurtured during Socialism. The new tendency in postcommunist cinemas is to produce more genre-orientated films, hinting at Hollywood and popular cinema. Although these films are now still produced thanks to state subventions, their potential commercial success is also a significant factor in whether or not they get made. On this level, Ostojić's film can be described as a murder mystery, an almost classical 'whodunnit', where the above-mentioned political and historical context just provides additional flavouring to its chilling suspense and narrative twists.

The storyline can be simply described as follows. A mysterious man is shot dead in the suburban house of an average and quiet middle-aged couple, to the shock of their handsome wheelchair-bound son in his early 30s. As the narrative unfolds, it turns out that the man returned to reclaim his house in the town. Unbeknownst

to anyone, he had asked the husband-father of the family to give him the refurbishment money for the house, as there had been a shady deal between them in the past. In addition, also unbeknownst to anyone, the mystery man has confronted the housewife about a deep secret he shares with her: they once had an affair and the wheelchair-bound young man is actually his son. All these secrets eventually come into the open and the mystery man ends up dead, while the young man in the wheelchair, confronted with an identity crisis, is provoked to commit suicide. His suicide, we can assume, will have lasting consequences on his 'father's' career, as well as on the fate of the man in the wheelchair's own eight-year-old son, whose mother has remarried and is taking the child to New Zealand. The 'no one's son' from the title could apply equally to the fate of these two characters.

The storyline is laid out as a murder mystery and an important character in the film is a police inspector who is simply referred to as the Inspector. He wears a trench coat and ends up the victim of a false but successful accusation of bribery, instigated by the husband-father (well, patriarchal figure number one), who is a politician running to be elected for the Croatian parliament – Izidor Barić. Another film-noir-esque character is the family's neighbour, whose identity is also simply designated – he is referred to as 'The Neighbour' (*susjed* in Croatian). The screen presence this character occupies allows him to become a well-rounded figure. From his traits much can be read about how 'neighbours' are perceived in Croatian culture on the one hand, as well as about the film's relation to its happily embraced genre conventions on the other. The Neighbour is a middle-aged man, probably unemployed and living off some long worn-out inheritance. His suburban house implies that this inheritance might have been significant once, as does his frayed panama hat that has seen better days. The Neighbour looks 'slovenly' and is lonely. All he seems to do is to engage in perfunctory work around the house, which allows him constantly to look at his neighbours' home – the house of the politician Izidor Barić, his wife Ana and their disabled son Ivan. The goings-on in

Figure 8.1
Alen Liverić as Ivan in *No One's Son*

the house of the Barić family are frequently intercut with reaction shots of the omnipresent neighbour, who seems to have nothing else to do but somehow keep an eye on what may or may not be happening on the other side of the fence.

It is also clear that the Barić family is well aware of this latent intrusion into their privacy – nor can they do anything about it, notwithstanding their good manners and behaviour. This is most evident in the scene in which Izidor and Ana have locked Ivan in his room: he was seriously disturbed following a whole night of drinking after finding out about the family's darkest secrets – including the murder that has crowned them. As Ivan is disabled after losing his legs up to his knees, to ease his wheelchair access he is in a room on the ground floor. This also enables him to – in this exceptional situation – open his window and jump out of it onto the front lawn, and then escape to town while walking on his stumps. This peculiar scene, of course, could not escape the attention of the astonished Neighbour. However, this is something Ivan expects and all he can do is to try to elude the Neighbour by cheerily saying hello to him, as if nothing unusual is going on.

That the Barić family is fully aware of the Neighbour's permanently watchful eye is emphasized in the most delicate sequence. Izidor and Ana are trying to get rid of the dead body in their house in yet another stereotypical genre scene: it is – of course – the middle of the night and raining heavily. Before Izidor and Ana can take the cadaver, wrapped in plastic sheets, out of the house, Izidor first has to check that their ubiquitous neighbour is perhaps asleep. The fact that his intrusion into their privacy cannot be avoided indicates that neighbours are shown as a force that cannot be eliminated, but which one always has to take into account as given and thus learn to live with.

Such a conclusion might not present such a problem for the Barić family had their neighbour been a benevolent observer, the sort of guardian angel neighbour, described earlier in the ideal of good neighbour relations. The Neighbour in the film comes across as a lonely and embittered attention-seeker, who has no loyalties or affections other than towards fulfilling his own immediate emotional needs. He earnestly approaches Izidor in one scene, evidently taking more of Izidor's time than the latter can afford, in order to tell him how he will vote for him in the coming elections. This attempt at earning Izidor's sympathy comes across as strained and insincere. This becomes even more obvious when the police inspector arrives for the first time to question Izidor about the disappearance of the mysterious man. Izidor, without letting the inspector into his house, manages to convince him that he knows nothing about the disappearance and the inspector walks back towards his car. As Izidor goes back indoors, he goes to the window to see the inspector depart, but then realizes that something is going on which he might have anticipated. As the presence of the police car has not gone unnoticed, the Neighbour has emerged to volunteer his point of view. The Neighbour thus contributes a story of his own – whatever he thought might have been strange about his neighbours' behavioural pattern in the last few days. It is clear that he has no genuine interest in the Barić family, other than for his own entertainment: he takes no account of the possible

consequences of his intrusions and interventions. Izidor comments while seeing this: 'That old fool has to stick his nose in everywhere.' This is the only time he is openly hostile to the Neighbour, while also perceiving the Neighbour as such. Undoubtedly, neighbours are portrayed as a threatening and reckless force of which one should always be wary.

Such a reading could be connected to the initial opening of this argument and the fact that Yugoslavs perceived their neighbours as BRIGAMA, but such a reading in this instance would perhaps be about prioritizing a secondary, even incorrect, context. The character of the Neighbour fits much more easily within the tropes of the crime thriller genre. His actions, specifically the one when he decides to talk to the police inspector of his own accord, are used to increase the tension, or rather suspense, with the audience not knowing what impact his interference will have on the unfolding narrative. The most obvious reference to genre expectations is the fact that he admits in one scene that he shares his house with his old mother. The mother is never seen in the film and never leaves the house, turning him into a Norman Bates type character. Equally, he is socially inept, and in the same vein his intrusions into his neighbours' privacy could potentially result in the most unexpected actions. It is thus perhaps too much to read into the Croatian or Yugoslav culture of neighbours from this character named the Neighbour, as this figure is simply a genre convention expectedly written into the coda of the film. If a more detailed reading is sought of how neighbours are perceived in Croatia and what the culture of neighbours entails, then Croatia's recent political and historical context might have to be brought back into play. That this has relevance for the narrative of *No One's Son* might be illustrated by considering a few significant attributes of its main protagonists. The mysterious man who is murdered is a Serb from Croatia – Simo Aleksić – who was a refugee in Serbia until the recent political changes enabled him to return. He cannot move back into his house as it is occupied by a refugee from Bosnia and Herzegovina. His son Ivan, who believed that Izidor, a Croat

politician, is his father, has lost his legs as a Croatian volunteer in the conflict with the Serbs. It is these 'neighbourly' relations that allow this film to present a much more complex picture of how the new neighbours are perceived as the 'Other' in contemporary Croatia.

An even more telling fact is that the narrative is set in the industrial town of Sisak, with its famous oil refinery. Situated some 100 kilometres from Croatia's capital of Zagreb, the town had a sizeable population of ethnic Serbs before Yugoslavia was torn apart. As it was close to one of the areas of Croatia where ethnic Serbs seized control during the war, local Serbs in Sisak were brutally expelled. Sisak is on the river Sava, which flows down to Belgrade, capital of Serbia. The Sava also forms – for much of its length – the border between Croatia and Bosnia and Herzegovina. The film, in addition to its Croat characters, features numerous Bosnian and Serb(ian) characters and thus portrays their interrelations. As the previous parenthesis indicates the potential differences between Serb and Serbian, it is important to add a few notes on the issue of identity in former Yugoslavia. This notion of identity in relation to belonging to a nation did not really tally with the old Enlightenment concept of citizenship, so famously embraced by the French Republic – that everyone born in France is French. Not that this concept always quite worked in France, especially that of Nicolas Sarkozy, nor in many other European countries, but it is the gist of the concept that is relevant to explaining the matter in question. Following this Enlightenment line of reasoning, the ethnic Serbs in Croatia are actually Croats. They have been there for a historically significant period of time and the dialect they speak is local. However, they continue to identify themselves as ethnic Serbs. The same could be said about the Croats from Bosnia, who could be simply considered as Bosnians, in parallel to the above argument. One such character in the film, a Croat refugee from Bosnia, who has illegally moved into the empty house of a Serb from Croatia, is an important figure in moving the narrative along. The film also portrays characters that are Bosnian Muslims, who now often identify themselves as

Bosniaks, or Bosnians that only identify with Bosnia. This complex web of relationships is addressed in *No One's Son* in a number of different ways, while it is also clear that understanding national belonging in former Yugoslavia was closer to German Romantic blood-related concepts, than to French and Scottish Enlightenment.

It is important to emphasize that this complex web of loyalties evidently revolves around notions of identity, and national identity in particular. Without wanting to open a broad debate concerning the ethnic feelings of the various ex-Yugoslav groups, it might be useful to call to mind a few relevant considerations. By taking the concept of nation stemming from the philosophy of the Enlightenment into account, Andrew Wachtel, following Benedict Anderson, noted that many nations in former Yugoslavia are not nations due to established 'objective' parameters, but simply because they 'feel' that they are.[11] However, even this assessment might be considered obsolete, as what matters more in terms of nationhood – while prioritizing precisely how these nations 'feel' about themselves – is that these nations have continued their ongoing battle for the definition of their identities.

Figure 8.2
Alen Liverić in jail in *No One's Son*

This struggle to define one's identity is again nothing exceptional, quite the opposite. Theodor Adorno, for example, once famously explained that the whole history of Western philosophy is the history of establishing identity. In *Negative Dialectics*, Adorno deduced that this obsession with identity ultimately led to the Holocaust.[12] Shane Weller aptly summarizes Adorno's contention by explaining that 'only in the Holocaust's wake does it become possible to confirm the thesis that identity-thinking constitutes the greatest threat to human – and not just human – life and its value'.[13] Therefore, in the process of defining oneself against the other, it is the European Jews scattered across the continent, as well as the Roma-Gypsies and all the other 'strangers' and minorities, that became an obvious target for the mainstream European nations to reinforce their own feeling of self(hood) – of their own identity. This, as is well known, ended in the most heinous crime of the twentieth century. That the nations of former Yugoslavia found themselves in the midst of reinventing their identities at the end of that same century has ended in further massacres and displacement of civilians, or rather, in further denial of the other. It is these tragic events that provide a nuanced backdrop for the murder mystery of *No One's Son*.

The first 'Other' that the main character Ivan engages with in the film are Bosnians. Ivan goes to see a man called Mika, who, it seems, is a Croat from Bosnia or, rather, a Bosnian Croat. It soon transpires that he is also a pimp, running a brothel. Furthermore, amongst his 'girls' there are also Bosnian Muslims, or Bosniaks, such as Mersiha of whom Ivan is very fond. It could be inferred here that, within Bosnia, the difference between Bosnian Muslims and Bosnian Croats might be more significant, while in Croatia they both simply come across as Bosnians. This will become particularly crucial with another Bosnian-Croat character, but the scene in the brothel provides a telling comment on the issues of neighbourhood. Mika, the pimp, tells Ivan that he has two new European girls and that he will not have anymore Balkan – read Bosnian – girls. He also explains to Ivan that since he has never been to 'Europe, at least his dick will'. Mika then introduces him to two Romanian girls, to

Ivan's astonishment, as he does not, generally, consider Romanians to be 'Europeans'. This too has to be explained in some kind of ex-Yugoslav context.

There was, and sometimes still is, a deeply entrenched prejudice in former Yugoslavia which revolved around the habit of grading the level of 'Europeanness' of its internal parts according to their geographic position. There was a strong belief that whoever was more geographically west belonged more to 'Europe' – at least in the Yugoslav understanding of it, and thus also clearly reflecting a postcolonial mindset. Therefore, Slovenia was more European than Croatia, Croatia more than Serbia, and so on. In this context, as Romania was to the east of Yugoslavia, Romanians were automatically perceived as being less European than anyone in Yugoslavia. This bizarre idea is something that the well-known ex-Yugoslav thinker, the Slovenian Slavoj Žižek, has now – in his jovial manner – deconstructed in many of his lectures and writings.[14] This concept is also deconstructed in the film, in this very scene in the brothel. When the perplexed Ivan, evidently brought up to believe in the idea, is bemused that a Romanian is introduced as a European, he has no choice but to swallow Mika's explanation. The film was made in 2008, a year after Romania and Bulgaria were accepted as new European Union members. This EU act unintentionally crushed these long-established prejudiced beliefs about not only geographical positions, but also the belief that Catholic countries have precedence in EU membership over Orthodox Christian ones. Mika thus tells Ivan that he should follow the news and that Romania is now part of the EU, which effectively makes them European, while Croatians and Bosnians are not.[15] To Ivan however, this is not of major importance: what he wants is some kind of rapport with the girl. Once he strikes a tender understanding with her, it ultimately transpires that she is not Romanian at all, but is actually Bosnian. Although her 'manager' wants to sell her as some sort of European dream, these local identities, at least for the authors of the film, are clearly seen as interchangeable, including the major Balkan versus Europe relationship. In this instance, behind

the constructed veneers of their collective selves, the neighbours are shown as much closer and much more similar to each other than it might seem at first.

However, the veneers of the self are still shown as significant. A quietly tragic character in the film is also the one of whom it is difficult to say initially whether he is a neighbour or 'one of us'. This character, like Mika, is a Croat from Bosnia. His son died fighting in the Bosnian Croats' army, causing him deep grief, which this character carries throughout the film. When he arrived in Croatia as a refugee from Bosnia, the fact that he was a Croat and thus part of the collective self did not help much. He was only offered an abandoned house that belonged to a Croatian-Serb, our mysterious man – Simo Aleksić – the murder victim at the beginning of the film. This solution proves to be only temporary, as eventually the Serbs return to claim their property. At this point, the Croatian refugees have to leave, with nowhere to go while the Croatian state had nothing to offer them. Ultimately, Bosnian-Croats in Croatia are just neighbours and not part of the self, without the same identity. This character, once he realizes that the Serb owner of the house is back to stay, trashes the whole place in anger. This act of being a 'bad neighbour', an act that further compromises neighbour relations, opens him up to fatal vulnerability.

When the police inspector ascertains that the local politician Izidor Barić is behind the mysterious man's disappearance, Izidor decides to defend himself. He pulls in his political connections and the Inspector is suspended on the false charge of bribery. Considering he had spoken out publicly against the Serb who returned to his house and also demolished the house, the Bosnian-Croat refugee gets arrested for the mysterious man's – the Serb's – murder. As Izidor reads about this in the press, the portrayal of neighbour relations on this level becomes unambiguous. This place – Croatia – is for locals only, while even those who could be considered part of the self are not entirely welcome.[16] The good neighbourly relations – under the broad influence of political pressures – have completely atrophied in this cesspit of parochial provincialism.

The final contours of these neighbour relations can be traced through the key character in the film, the mysterious man and murder victim, Simo Aleksić. As we learn his story, and consequently the story behind the Barić family, the fragile ex-Yugoslav notions of identity crumble as easily as the 'good neighbour relations' between them. In order to spice up the story the authors start with the murder and its immediate aftermath, they then go back into the past, halfway through the film, in order to explain what has preceded the murder as well as the murder itself. In the second part of the film, the audiences get to know the mysterious man and his story.

Simo Aleksić was head of the police force in the town before the war for Croatia's independence, and also – quite naturally – a high-ranking member of the Yugoslav Communist Party. With the beginning of the conflict he had to leave for Serbia, where he lived as an impoverished refugee. It is telling that Simo is shown as a former high official of the Croatian, and at that time Yugoslav, state, for there are two particular points the authors are playing with here. The first one concerns the fact that under Socialism, Serbs in Croatia were favoured for positions in the police force. This was explained by the fact that the Serbs in Croatia had been gravely intimidated by the genocide perpetrated against them during World War II by the Croatian Fascist Ustaša, in Hitler's satellite Independent State of Croatia (NDH). The communists sought to make Croatia's decimated ethnic Serbs feel more secure by pursuing this policy of positive discrimination. The positive discrimination eventually became a thorn in the side of non-Serb Croatians – in particular, Croatia's ethnic Croats – who started believing that they found themselves in some postcolonial position with the Serbs being the colonizers. The second point is that Simo was not a nationalist Serb, pejoratively called a Chetnik, but a pro-Yugoslav communist. When Tuđman's government took over in 1990, it reversed the ethnic policies cultivated under Socialism and legally erased Croatia's Serbs as a constitutive ethnic group native to Croatia. This inevitably inflamed relations between Croats and

Serbs in Croatia, contributing to the causes of the tragic conflict and break-up of the country. There is no intention of suggesting that this was the sole issue that provoked the conflict: on the contrary, there were of course many other reasons. This point is important, however, for understanding how neighbour relations are portrayed in the film and why the subsequently murdered victim had come back from Serbia. The film thus emphasizes that neighbour relations collapsed viciously in Croatia, as its native Serbs and Croats started a conflict in which they drove each other from their houses. The film hints, through its Bosnian characters, that this collapse of inter-neighbour relations was not exclusive to Croatia, but was rather indicative of all the other Yugoslav conflicts. It was as if the trauma of Yugoslavia's external BRIGAMA had inscribed itself on the country's interior psyche.

Even more complex and telling are the personal relationships amongst these once neighbours. Simo was a communist policeman who had arrested Izidor Barić, then a university professor, who had questioned the position of Croatia within Yugoslavia. The film also hints that this happened during the so-called Croatian Spring of the early 1970s, a movement that the communists dismissed at the time as nationalist. As Izidor was preparing a mutiny in prison, Simo allegedly saved him from being executed, which would have been covered up as suicide. At some later point, Izidor agreed to inform on his former clandestine political colleagues to the communist secret police – UDBA. In addition, Simo started a long-lasting affair with Izidor's wife Ana, which resulted in her giving birth to Ivan. The two agreed that she would go back to Izidor once he was out of prison, and that the son would be brought up as her husband's. However, Ana kept in touch with Simo (who remained single) up until the war, sending him pictures of Ivan. Simo's return stirred up these secrets from the past, which have, due to the break-up of the country and the new inter-ethnic relations, acquired a more serious dimension. Considering that Ivan has lost his legs fighting for Croatia, finding out that he has another father would in this instance not only mean a possible change of surname, but of

Figure 8.3
Mustafa Nadarević as Izidor in *No One's Son*

ethnic identity too. In order to protect him from this, Ana, perhaps accidentally, murders Simo with his own handgun which he carried for protection in a hostile environment, being a Serb in Croatia. As all these secrets come out in the open Ivan commits, or provokes rather, his suicide.

Ivan confronts Izidor and his mother in great disappointment, claiming that he has two fathers and that both of them are 'cunts': one was a manipulative political policeman and the other an informer. It is deliberately not quite clear from the film to what extent Izidor was really coerced into cooperating with the secret police and to what extent Ana was truly bullied into a relationship with Simo. We can only guess to what extent this happened out of choice, as well as Simo's true reasons for going back to haunt them, starting with his dishonourable financial blackmail. There is no doubt that these dark neighbourhood secrets continue with more unmarked graves amassing, to the detriment of all the parties involved. As the Croat war veteran and hero Ivan turns out to be half-Serb, and he only manages to relate to Bosnians in his native Croatia, the real question extracted from the film could be: to what

extent are Bosnians, Croats and Serbs actually 'Other' to each other, if at all? Alternatively, to what extent are these people just fragments of one whole self – fragments that frighteningly mirror each other's similarities? Whatever the answer might be is overshadowed by a more significant fact that life for Ivan was impossible without a fixed and clearly defined identity in contemporary Croatia. If Croatia can be taken as an index of the rest of former Yugoslavia, then a similar conclusion may be drawn for the rest of the country, in relation to the continuing problems that still lurk behind these new – or rather current – neighbour relations.

According to *No One's Son*, therefore, neighbours are unwelcome for the mainstream of contemporary Croatia. They are perceived as dangerous since they represent repressed desires and knowledge, which mirror a complex picture of oneself. Or rather, neighbours probe the idea of the boundaries of this self altogether. The fact that a child of these neighbour relations condemns himself to death at the end of the film speaks volumes about the low levels of neighbour relations in former Yugoslavia. From having a fixed identity, the process of this child's 'Otherization' went to its extreme, as for Levinas 'death is absolutely other'.[17] It is also telling that this child's own young son will perhaps find salvation through emigration to a far away New Zealand. The fact is that he too will be no one's son himself, but his story there will hopefully be an entirely different one.

Notes

1 The meaning of *domaćin* is quite complex and involves considerably more than just being a 'good host', but for the sake of brevity and in regard to the subject discussed here, I will stick to this literal meaning only.

2 Slobodan Novaković, *Vreme otvaranja: Ogledi i zapisi o 'Novom Filmu'* (Novi Sad: Kulturni centar, 1970), p. 7.

3 Claude Lévi-Strauss, *Structural Anthropology*, trans. Claire Jacobson and Brooke Grundfest Schoepf (New York: Basic Books, 1974).

4 Starting with Emmanuel Levinas, *Time and the Other* [1947], trans. Richard A. Cohen (Pittsburgh, PA: Duquesne University Press, 1987).

5 Clive Hazell, *Alterity: The Experience of the Other* (Bloomington, IN: Author House, 2009), p. 21.

6 See Jacques Derrida, *Politics of Friendship*, trans. by George Collins (London: Verso, 2006) and *Psyche: Inventions of the Other*, vol. 1, ed. Peggy Camuf and Elisabeth Rottenberg (Stanford, CA: Stanford University Press, 2007).

7 The communist Partisans were the major resistance force against the occupying forces of Nazi Germany during World War II throughout the territory of former Yugoslavia. The Partisans were well known for being pro-Yugoslav.

8 Ranko Munitić, *Adio, Jugo-film!* (Beograd, Kragujevac: Srpski kulturni klub, Centar film, Prizma, 2005), p. 35.

9 In the following elections she was replaced by a Social Democrat prime minister, thus the government had fully shifted to be politically centre left.

10 These crimes were predominantly committed against the Serb minority in Croatia, as well as against the Bosnian Muslims in Bosnia through the interventions of the regular Croatian army in the Bosnian war. However, the judgement was repealed a year later, it could be said controversially, as two of the five judges resigned in protest against such a decision. This then led to varied reactions, such as the one by David Harland of the Centre for Humanitarian Dialogue in David Harland, 'Selective Justice for the Balkans', The *New York Times*, 7 December 2012. Online. Available at <http://www.nytimes.com/2012/12/08/opinion/global/selective-justice-for-the-balkans.html?_r=2&> (accessed 31 January 2013).

11 Andrew B. Wachtel, *Making a Nation, Breaking a Nation: Literature and Cultural Politics in Yugoslavia* (Stanford, CA: Stanford University Press, 1998), p. 2.

12 Theodor W. Adorno, *Negative Dialectics*, trans. E.B. Ashton (London: Routledge and Kegan Paul, 1973).

13 Shane Weller, *Beckett, Literature, and the Ethics of Alterity* (Basingstoke: Palgrave Macmillan, 2006), p. 1.

14 Žižek has over time presented slightly different versions of this concept of how a Western neighbour perceives an Eastern one with distrust, extending it from a Balkan to a European context. However, for those who might be frustrated with the famous thinker's elusive methodologies, a surprisingly concise and cogent argument on the relationships of Slovenia, Croatia and Serbia towards the EU can be found in Slavoj Žižek, 'What Lies Beneath', The *Guardian*, 1 May 2004. Online. Available at <http://www.guardian.co.uk/ books/2004/may/01/featuresreviews.guardianreview2> (accessed 31 January 2013).

15 Croatia joined the EU in 2013, and Bosnia and Herzegovina are due to in the foreseeable future.

16 Whether these people are Bosnian Croats, so that as Croats they could be perceived as belonging to Croatia, or whether they are Croatian Serbs, in which case they should be native to Croatia.

17 Hazell, *Alterity*, p. 22.

References

Adorno, Theodor W., *Negative Dialectics*, trans. E.B. Ashton (London: Routledge and Kegan Paul, 1973).

Derrida, Jacques, *Politics of Friendship*, trans. by George Collins (London: Verso, 2006).

Derrida, Jacques, *Psyche: Inventions of the Other*, vol. 1, ed. Peggy Camuf and Elisabeth Rottenberg (Stanford, CA: Stanford University Press, 2007).

Harland, David, 'Selective Justice for the Balkans', The *New York Times*, 7 December 2012. Online. Available at <http://www.nytimes.com/2012/12/08/opinion/global/selective-justice-for-the-balkans.html?_r=2&> (accessed 31 January 2013).

Hazell, Clive, *Alterity: The Experience of the Other* (Bloomington, IN: Author House, 2009).

Levinas, Emmanuel, *Time and the Other* [1947], trans. Richard A. Cohen (Pittsburgh, PA: Duquesne University Press, 1987).

Lévi-Strauss, Claude, *Structural Anthropology*, trans. Claire Jacobson and Brooke Grundfest Schoepf (New York: Basic Books, 1974).

Munitić, Ranko, *Adio, Jugo-film!* (Beograd, Kragujevac: Srpski kulturni klub, Centar film, Prizma, 2005).

Novaković, Slobodan, *Vreme otvaranja: Ogledi i zapisi o 'Novom Filmu'* (Novi Sad: Kulturni centar, 1970).

Wachtel, Andrew B., *Making a Nation, Breaking a Nation: Literature and Cultural Politics in Yugoslavia* (Stanford, CA: Stanford University Press, 1998).

Weller, Shane, *Beckett, Literature, and the Ethics of Alterity* (Basingstoke: Palgrave Macmillan, 2006).

Žižek, Slavoj, 'What Lies Beneath', The *Guardian*, 1 May 2004. Online. Available at <http://www.guardian.co.uk/books/2004/may/01/featuresreviews.guardianreview2> (accessed 31 January 2013).

9

The Distant Among Us: *Kolonel Bunker* (1998) in a Postcolonial Context

Bruce Williams

Communist Albania's breach with the Soviet Union, the Warsaw Pact, and ultimately with China has led the outside world to picture the nation as steeped in isolationist politics and an air of mystery. Indeed, for many years, Albania and North Korea were arguably the least accessible countries in the world. This being said, we must recall that, during the first 15 years or so of the existence of the People's Republic of Albania, the nation maintained ties with the Soviet Union, the majority of the Warsaw Pact nations and even, for a short time, promised the same with the USA and the UK. All such links and overtures were eradicated, or greatly reduced, as Albania slowly became, by virtue of the paranoia of its regime, sequestered from the rest of the world. Although it maintained particularly strong ties with France and, like North Korea, allowed foreigners to enter on occasion under tightly controlled conditions, in comparison with its neighbours, Albania's heritage of isolation is quite distinct. From a postcolonial perspective, Albania is arguably the most multifaceted case of the ex-socialist nations, given the complexity of and rapid shifts in its history.

Kujtim Çashku's *Kolonel Bunker* (1998), Albania's first major co-production following the collapse of communism, offers considerable insight into this intricate historical context. The film astutely textualizes the notion of 'neighbours' during the Enver Hoxha regime. It explores the heartrending relationship between an Albanian military officer, charged with Hoxha's 'bunkerization' campaign, and his wife, a Polish concert pianist and professor at the University of Tirana. The storyline develops a parallel between the growing isolationism of the regime and the psychological breakdown of an individual linked to what he increasingly perceives as national madness. Protagonist Nuro Meto learns that he must champion the construction of tens of thousands of concrete bunkers to protect the country against attacks from either the West or the Warsaw Pact nations. Such capacity leads to his own mental unravelling and to the destabilization of his marriage. Meto, due to behaviour the regime deems irrational and threatening, is imprisoned for many years, and his wife, Ana, is sent to a concentration camp and ultimately deported to her native Poland. Following his release from prison upon the toppling of the Communist regime, Meto dies, unable to locate his wife. *Kolonel Bunker* articulates dual and contradictory perspectives regarding Albania's position *vis-à-vis* other Eastern European nations. The notion of strangeness or neighbourliness is, on the one hand, developed through the relationship between husband and wife, each of whom is engaged with the other's culture. On the other hand, the film investigates the bunkerization project implemented by the Albanian government as an outward expression of the country's distrustful view of neighbours who might pose a threat. The film thus interweaves personal stories with national history to foreground the inherent contradictions in the Hoxha regime.

What is Albania? Five prongs of postcolonialism

In order to fully ascertain the significance of *Kolonel Bunker* and, specifically, of the disconnect between an engagement with a

neighbour's culture and a state of paranoid isolationism, one must understand the complex relationship in the case of Albania between postcommunism and postcolonialism. These terms will further shed light on Albania's relationship with its Eastern European neighbours. Although the closely-related (but not identical!) term 'neo-colonialism' has been primarily employed to denote the way in which former colonial powers continue to maintain control over successor states, it can also be used to describe the relationship between economic powers and the countries they exploit. Robert J.C. Young draws upon the discussions of Hobson and Nkrumah[1] to explore how neo-colonialism constitutes a 'continuation of traditional colonial rule by another means'.[2] He stresses that such control has as its intention the draining of the peripheral nation by the neo-colonial power for its own interest. Although neo-colonialism has been discussed primarily in the context of Western imperialism, its applications to the former Eastern Bloc cannot be ignored. The Soviet Union needed Albania to help prevent a strong Yugoslav communist faction; China needed it to solidify its influence over the Russians in Vietnam. Moreover, the frame of neo-colonialism partially explains the precarious position of Albania, during both the waning years of communism and the transition to democracy. The terms of 'traditional colonial rule', as demonstrated in what follows, include the heritage of the Ottoman Empire, the impact of the Fascist occupation, the legacy of Stalinism, the orthodoxy of Maoism and Albania's own totalitarian path. Thus, we encounter a process somewhat different than simply a state that 'is being directed from the outside', since certain vestiges of a fallen regime remain in place.

As a preface to a discussion of Albanian postcolonialism, especially in contrast to other former communist nations, it is necessary to look at a linguistic factor that complicates the situation. Although an Indo-European language, Albanian belongs to neither the Romance nor Slavic languages, although its lexicon has been highly influenced by Latin. Albanians have been fiercely proud of their language, as evidenced by its *Rilindja*, or 'National

Awakening', which took place between 1870 and 1912. The strength of Albanian nationalism in the early twentieth century can be evidenced by the writings of Edith Durham[3] and Rose Wilder Lane,[4] two ethnographers who experienced journeys from the country's remote northern mountains. We must note that, with the exception of Greek and Turkish, all other major languages of the Balkans were either Slavic or Romance. Whereas differences in religion were of strong concern in the Balkans, a number of peoples were at least united by their Slavic roots. Albania was left out of the equation, and sternly defended its cultural and linguistic identity.[5]

Unlike the case of other nations of the former Eastern Europe, Albania's postcolonial heritage is arguably five-pronged. It has been dominated at different times by the Ottoman Empire, fascist Italy, Soviet Stalinism and Maoist China. Finally, following its break from Moscow, the Warsaw Pact and ultimately Beijing, Albania's own isolation provides yet another postcolonial context with which its present-day society must come to grips. The emerging democracy needs to confront vestiges of its former regime which are still in place or felt in Albanian society. The complexity of Albania's history can, in part, be explained by its geographical location. On the southeastern edge of the Balkan peninsula, Albania has traditionally looked towards Italy as both a trade and cultural partner. This provided it, at least during the late Middle Ages, the early Italian Renaissance and the Mussolini period, with strong ties to the West. Its position worked to its favour during the communist period. Its southwestern location provided the country with a certain 'distance' from Moscow. Lacking geographical borders with the Soviet Union, Albania did not succumb to the fate of Hungary in 1956 or Czechoslovakia in 1968. In contrast, Albania proved to be 'too far east and too far south' to escape domination by the Ottomans for well over 400 years.

Although one could arguably begin a study of Albania's subjugation with the Romans, the Ottoman Empire suffices as a starting point inasmuch as its residues have been felt in recent

years. As Ramadan Marmullaku stresses, one of the aspects of the Ottoman Empire was that non-Turks could attain high positions in government provided that they were Muslims. He asserts, '[t]he large participation of Albanians in the political life of the Ottoman empire caused the Albanians to link their fate with that of the Turkish empire for five centuries'. The mountain tribes, as Marmullaku points out, retained tribal autonomy on the basis of the payment of a tax.[6]

The heritage of the Ottoman Empire thus rendered Albania the least 'European' of all European nations. The vast majority of its population, at least for bureaucratic expediency, had converted to Islam. Tribalism prevailed, and the mountainous northern regions in particular had little, if any, contact with the rest of the world. Nevertheless, as Albanians gradually came to realize that what was best for the Turks was not necessarily best for them, a strong sense of nationalism arose, giving way both to the *Rilindja* and the efforts of the League of Prizren (1878–81), which sought Albanian autonomy. Yet, as Stavro Skendi asserts, there were issues which delayed Albanian independence. Skendi stresses that Albania lacked the cultural preparation for independence enjoyed by other Balkan nations. National awakening came gradually, and 'the fate of their country now lay mostly in the hands of the great powers'.[7] From a European perspective, moreover, Albania was still a land of mystery.

Nicholas C. Pano has explored how Albania as a fledgling independent nation was unable to transform itself from a 'backward province of the Ottoman empire' into a modern state.[8] When its appeal to the League of Nations for assistance was denied, it turned to Italy. After all, parts of Albania had belonged to the Republic of Venice in the fifteenth century. But such aid was a wolf in sheep's clothing. In the 1930s, Albania became increasingly cognizant of the threat Italy posed to its sovereignty, yet the nation was already in its neighbour's full clutches. The fascist occupation of Albania was inevitable. Albania under Mussolini was a mixed bag. On the one hand, the occupation paved the way for a strong sense of national pride and identity that would lead to the growth of

partisan movements in the 1940s. On the other hand, it fostered an increased identification on the part of Albanians with Italy. We must recall the close trade ties between the two nations prior to the Ottoman invasion of Albania. Moreover, in light of Albania's southwest position in the Balkan peninsula, the proximity to Italy has rendered the latter Albania's window to the West.

During the communist period, families in the Catholic north taught their children Italian through textbooks from the Mussolini era, despite the fact that Russian was the main foreign language taught in schools. In the 1980s, Albanians clandestinely tuned into Italian radio and television via makeshift antennas, often constructed from carefully-split soda cans and wires. Although many Albanians spoke pidgin Italian with simplified verb tenses, others had true fluency.[9]

In the early communist years, the development of close ties between Albania and the Soviet Union was partly due to Stalin's opposition to Tito's late 1940s plans to incorporate Albania into Yugoslavia. However, as Khrushchev initiated a rapprochement with Belgrade, Albania feared that it would become a concession to the new alliance and ultimately incorporated into Yugoslavia. The breach between Tirana and Moscow and the former's realignment with Beijing was, for the Soviet Union, an especially embarrassing event. As Pano stresses, the Soviet Union 'failed above all, to crush a country so small, so Balkan, so poor, so isolated, and to the world at large so nearly ridiculous that Moscow itself ever since has run the risk of being thought impotent'.[10] What is significant for Albania, in this case, is that the breach with Moscow emphasized, in the world's view, just how small, isolated and unknown the Balkan nation was. In turn, Pano has explored the complexity of Albania's mistrust of the Soviet Union and argues, '[t]he vehemence with which the Albanians have waged their campaign against Moscow stems from the belief of their leaders that they are fighting for the preservation of Albania's independence'.[11]

When Hoxha called for all communist parties to join Beijing and Tirana in a 'bloc' against breaches with Stalinism, he felt that

the Chinese Cultural Revolution was the most effective weapon to prevent the spread of bourgeois ideas.[12] One of the most significant factors of the Albanian–Chinese link was a certain ideological tie between Hoxha and Mao Zedong, which originated in Mao's rejection of three bonds of the Confucian code of ethics. As Logoreci stresses, Mao rejected bonds between ruler and subject, father and son, and husband and wife.[13] He explains that Hoxha was quick to abolish traditional loyalties so that the modernization of the country along communist lines could be accomplished.[14]

A final postcolonial thread may well be unique to Albania among postcommunist nations: the vestiges of Albania's own totalitarian regime, as felt in the present. Logoreci has described Hoxha's leadership as 'an enclosed camp where Mao's totalitarian doctrines, interlaced with Stalinist practices, have been tried out under perfect laboratory, almost test-tube conditions'.[15] He considers that the same practices that improved industry, education, public health, social welfare, etc. were also responsible for 'squeezing Albanians into a totalitarian straightjacket of an all–enveloping character and vicious strength'.[16] Logoreci concludes his analysis of Albania's totalitarian regime by asserting that the difficulty Albania experienced in its attempts to release itself from totalitarianism was just as hard as the escape from foreign domination, due largely to the indifference of the rest of the world.[17]

Thus, Albania's postcolonial heritage draws upon a combination of extended periods of subjugation and a condition of isolation. Firstly, it inherited Islam from the Ottomans, and a strong resurgence of this religion can be found in Albania today. Moreover, the Ottomans, by virtue of their feudal system and the autonomy they granted to Albania's remote, mountainous regions, facilitated the perpetuation of tribal systems. Albania is still deemed 'primitive' in the eyes of its neighbours and the rest of the world and, to a large degree, perceives itself as such. Secondly, the vestiges of Italian Fascism have served as a counterpoint to Albania's fierce nationalism. Following the fall of Communism, Albanians urgently sought to link to the West, and Italianism appeared to be the most

auspicious path. Finally, the heritage of Communism is felt not only in the history of Stalinism and Maoist totalitarianism, but also in Albania's strong trepidation about its neighbour, Yugoslavia. Its close ties with China strengthened both its anti-revisionist character and its totalitarian stance. Today, it is difficult to determine, from a postcolonial standpoint, which features of Albanian totalitarianism stemmed from the nation's co-option of the Chinese Cultural Revolution, or which were more autochthonous in nature.

From a postcolonial perspective, Albania demonstrates certain clear commonalities with its postcommunist neighbours. All have shared the experience of some 45 years of socialist regimes, although they have varied as to the level to which their respective governments deviated from Stalinist orthodoxy. With the Balkans, moreover, Albania shares the heritage of the Ottoman Empire, which kept the region the least Western of all of Europe. But what is special, in Albania's case, is the impact of two highly disparate pressures, those of Italy and China, as well as its own history of isolationism, which transcended that of any other European communist nation at any time.

A milestone for Albania

Upon the demise of the state-run Kinostudio in 1991, Albanian cinema was left with four new entities: Albafilm, Albafilm Distribution, Albafilm Animation and the Albanian State Film Archive. During the initial phases of the new system, feature filmmaking was heavily hit by the dissolution of the former production mechanism and the lack of funds. For this reason, many film professionals were forced to leave the profession. In 1996, the National Film Centre (Qendra Kombëtare e Kinematografisë) was founded to fill part of the gap left by the closure of Kinostudio by aiding in the financing and promotion of all genres of film. But things were not easy; the National Film Centre never enjoyed the same level of government funding that had been offered to Kinostudio as an integral part of the state's propaganda and

education efforts. It is significant to note, moreover, that Albania's transition to a market-run film industry was, in comparison with those of other postcommunist countries, particularly arduous. Only six years following the fall of Communism came the financial collapse of a number of pyramid schemes, which led to civil war and unrest. Despite such chaos, both *Kolonel Bunker* and Vladimir Prifti's *Sako's Wedding* (*Dasma e Sakos*, 1998) were released shortly following the restoration of order.

Çashku was a veteran of the Kinostudio period, who had made numerous films during the communist era.[18] Upon the fall of the old regime, he became one of the directors who made the most successful transition from a state-run to an independent cinema. In 1993, he had the good fortune to travel to the Rencontres Cinématographiques de Beaune, under the auspices of the French-based ARP (Auteurs, Réalisateurs, Producteurs), which has as its stated goal the defence of 'the diversity of French and European film, the interdependence of authors, directors, and producers, and the economic transparency of film production'.[19] In Beaune, Çashku met French producer Jean Bréhat and Polish producer and well-known film director Filip Bajon, both of whom were extremely interested in the concept of *Kolonel Bunker*. In a May 2011 discussion with the author, however, Çashku articulated that, despite their enthusiasm for the project, both were hesitant to embark on an unprecedented co-production venture with, of all places, Albania, whose former isolationism cast doubt on its viability as a business partner. *Kolonel Bunker*, nonetheless, was ultimately funded almost equally by Albania, France and Poland. In contrast to the active Albanian and Polish presence in the cast and crew, the French participated primarily in the capacity of production funding. While the majority of the cast and crew are credited as Albanian, a number of Poles are listed. Together with actress Anna Nehrebecka, who is cast as the film's Polish-born female protagonist, are actresses Teresa Lipowska and Aniela Świderska-Pawlik. Andrzej Krauze served as music composer and Jerzy Piaseczny as production manager. Given that Nehrebecka did

Figure 9.1
Anna Nehrebecka and Agim Qirjaqi in Kujtim Çashku's *Kolonel Bunker*

not speak Albanian and was forced to learn her lines phonetically, a Polish woman who had managed to remain in Albania, despite the persecution effected by the Hoxha regime, became her language coach.

Kujtim Çashku as transnational subject

Çashku's excitement over producing the first Albanian film with Western co-production assistance was not only due to his understanding of the need for foreign resources for the mere survival of the Albanian film industry, but also to his international perspective, which was distinct from those of many other Albanian filmmakers. Although the heyday of the training of Albanian film professionals abroad had long passed, Çashku, in the 1970s, had won a scholarship to study at the Institute for Theatre and Cinematography in Bucharest. Such an experience not only allowed him the opportunity to experience life abroad – a *rara avis*

for an Albanian – but also to see a great number of foreign films unavailable in Albania. This is the time in which he gained insight into other modalities of communism. Some two decades later, in 1993, Çashku was awarded a Fulbright grant to study at Columbia University, and he and his family were able to experience New York City. Fluent in English, French and Romanian, he, of all Albanian directors, is arguably the one who has travelled the most to international festivals and meetings.

In 2005, Çashku founded the Marubi Academy of Film and Multimedia, Albania's only film school. In line with its creator's international outlook, Marubi relies not only upon a cadre of Albanian faculty members, who provide the core of the Academy's instructional content, but also upon visiting faculty members from France, Germany, Spain, Italy, Sweden, Serbia, the USA and the UK. The Marubi Academy furthermore is home to the International Human Rights Film Festival in Albania, which Çashku initiated in 2006 and which is at the time of writing is preparing its eighth edition. Unfortunately, the Marubi Academy has suffered greatly under the postcommunist condition of contemporary Albania. On 24 February 2009, the premises were raided by state and private police over alleged property disputes with Alba Film and Top Channel TV, forcing the school to operate for over two years behind barbed wire. As of the date of the writing of this chapter, the dispute is still pending litigation. Despite aggressions against the Academy, Marubi is still at the forefront of Tirana's progressive scene, presenting controversial screenings and providing a safe space for special interest groups, including LGBT organizations.[20] The history of the Marubi Academy thus constitutes an interesting parallel with the dual narrative threads of *Kolonel Bunker*. All the while evidence of Çashku's openness to neighbours, both postcommunist and Western European, it demonstrates that postcolonial forces of the old regime are still very much at play in Albania's cultural scene.[21]

Moreover, as an individual having enjoyed extended periods of residency abroad, both during Communism and after, Çashku is especially sensitive to the overall context of Albania's postcommunist

neighbours. Not only has he, through *Kolonel Bunker*, examined the relationship between Albania and other communist countries during the height of paranoia of the Hoxha regime, but moreover, his work as rector of Albania's only film school, the Marubi Film and Multimedia Academy, and as director of the International Human Rights Film Festival in Albania, has put him in close contact with professionals in such countries as Serbia and Bulgaria.[22]

Public and personal histories

Especially when read from a postcolonial standpoint, the film provides considerable insight into the mechanics of a regime bent on defending its isolationist path, despite vestiges present in its society that evoke its bygone closer ties with other communist states. Rather than offering a close reading of *Kolonel Bunker*, this analysis will draw upon it to weave together a tapestry of postcommunist Albania's notion of neighbours, particularly with regard to the cinema.

The first historical thread present in the film is that of the foreign wives of Albanian military men, mainly from the Soviet Union, Poland and Czechoslovakia, who, although having come to Albania while the country still co-opted the ideal of a fraternity among communist nations,[23] suffered persecution as the Hoxha regime grew increasingly paranoid and isolationist. The plight of these wives has recently been explored by Bulgarian documentarian Adela Peeva in *Divorce Albanian Style* (*Razvod po albanski*, 2007), which offers an in-depth study of the long-term fruits of this little-known campaign. Following Albania's break with Moscow in the early 1960s (which was a gradual rather than a sudden process) and its ultimate withdrawal from the Warsaw Pact in 1968, the presence of foreigners on Albanian turf grew of increasing concern to the regime, which feared foreign invasion. *Divorce Albanian Style* details how foreign wives were charged with espionage and forced to leave Albania. Couples were separated, with husbands and wives being sent to separate prisons or labour camps, only to be released

in the late 1980s. Different stories were often told to each partner; a wife may have been led to believe that her husband was dead, or a husband may have been told that his wife had informed on him. Peeva's film focuses on three women, two Russians and one Pole, who were persecuted during this period. The case of the Polish woman is particularly heartrending. Left mentally defective after having suffered inhumane treatment and most likely harsh beatings in an Albanian prison, the woman returned to Poland, believing that her Albanian husband had died. When the husband was ultimately released from prison and attempted to contact her, she was unable to grasp that he was truly alive and seeking reconciliation. The couple remains separated to this day. Such a tragic story mirrors that of the fictional Nuro Meto and his wife, Ana.

A second historical thread upon which *Kolonel Bunker* is constructed is that of Enver Hoxha's obsession with 'bunkerization' as the country became increasingly isolated. Anton Logoreci has stressed that, prior to its break with Moscow, Albania was dependent upon the Soviet Union for its defence supplies. Following the breach, Albania was now on its own to devise a defence scheme. The fanatical bunkerization campaign, however, did not begin until 1974, as Albania's relationship with China cooled and it entered its period of most complete isolation. During the campaign, which lasted until the early 1980s, some 800,000 concrete bunkers were constructed throughout the country. Miranda Vickers and James Pettifer have described Albania's politics of isolation during this period and have viewed the process of bunkerization as part of the notion of a 'people's war', which went hand-in-hand with an armed populace and a 'bizarre "do-it-yourself" air defence system against airborne invasion: units of Young Pioneers were taught how to fix long pointed spikes at the tops of trees to impale foreign parachutists as they descended on the soil of Albania'.[24] Bunkerization can thus be viewed as one of a number of extremist strategies intended to ensure Albania's territorial integrity and self-determination. And it is one of the key vestiges of Stalinism from Albania's past which renders *Kolonel Bunker* a significant historical testimony.

Not only does Çashku's film draw upon historical anecdotes germane to Albania's history of isolation, but moreover, it uses real-life prototypes for its protagonists, although the relationships among these have been transformed and repositioned. The prototype of protagonist Nuro Meto, aka 'Kolonel Bunker', was Josif Zegali, the military officer entrusted by Enver Hoxha with the massive bunkerization campaign. Zegali would later serve as consultant to the scriptwriting process of Çashku's film.

Far less known than the life of the Zegali prototype is that of Hungarian pianist Maria Rafael, upon whom Çashku's female protagonist was modelled. Rafael, not unlike the wives in Peeva's documentary, spent many years in Albania, despite the difficulty implicit for a foreign woman. The regime tolerated her presence, but forced her to live as a piano teacher in the southern Albanian city of Fier, rather than having the opportunity to perform on the Tirana stage or become a part of the music scene in the capital. Despite this 'internal exile', Rafael was extremely devoted to Albania and made considerable contribution to her adopted country through her teaching. She ultimately returned to Hungary, upon the fall of the Albanian communist regime. Çashku became familiar with Rafael's story through his wife, Nora, who, as a pianist and university professor of music, had felt considerable compassion for the foreign artist, particularly in light of the latter's relative seclusion in a small city. Part of the power of *Kolonel Bunker* is thus the way in which Çashku has integrated historical discourses with personal testimony, emphasizing the affective and psychological impact on individuals that the increasingly paranoid regime had wrought.

Kolonel Bunker and its postcolonial context

Kolonel Bunker has been read both within Albania and in Western Europe from the perspective of historical memory, although positions regarding the film's effectiveness have varied. Dina Iordanova believes that the protagonist's inner contradictions are difficult to grasp in part 'because the very authority that generates

the paranoia does not figure in the film'.[25] She contrasts *Kolonel Bunker* with Gjergj Xhuvani's *Slogans* (*Sloganat*, 2001), which she feels offers 'a more credible human dimension on the same period'.[26] From a more favourable light, Gareth Jones has emphasized the film's epic scope:

> An almost profligate display of military hardware … is useful in conveying the terror of the totalitarian state, especially when juxtaposed with moments of bizarre humour, such as when Nuro is daubed with a coal-dust moustache by his fellow convicts, a sly reference to the Great Dictator (more Chaplin than Hitler) that leaves us laughing at this ritual humiliation while crying for its victim.[27]

In an analysis of cinema at the turn of the millennium published by the Albanian Academy of Science, Abdurrahim Myftiu lauds the visual mastery of Çashku's film and the kinetic energy of its images.[28] He foregrounds that, visually, *Kolonel Bunker* captures the atmosphere of the times and reveals the absolute and absurd depersonalization of the human condition.[29]

The production of *Kolonel Bunker* anticipated plans to open the Marubi Academy by some eight years. The choice to cast Anna Nehrebecka in the role of the Polish protagonist was largely a result of Çashku's fascination with her work in Polish cinema from the time of his studies in Bucharest. Nehrebecka had specialized in the roles of very 'Polish' women, typically from upper-class houses in literary adaptations, most importantly in Andrzej Wajda's *Promised Land* (*Ziemia obiecana*, 1975), in which she played an impoverished Polish aristocrat. The Polish co-production mechanism worked very well for the historical context of the film. Although the prototype for Nehrebecka's character was Hungarian, more Albanians had married Poles than Hungarians during the Warsaw Pact years. Likewise, the prototype for Nuro Meto had actually received training in Stavropol; Warsaw made a credible substitute. Çashku originally intended to internationalize the role of Meto as well by casting ethnic-Albanian-Yugoslav actor Bekim Fehmiu.

Figure 9.2
Agim Qirjaqi in Kujtim Çashku's *Kolonel Bunker*

When the latter ultimately turned the project down, Albanian actor Agim Qirjaqi was selected.

The film weaves together two discourses of strangeness, that of the almost hallucinogenic depiction of bunkerization and that of the Polishness of its female protagonist, Ana. The two discourses meet in the pre-title sequence, in which Ana opens the door for the military official who is summoning Meto to appear at headquarters to receive his bunkerization charge. As Ana speaks, her Polish accent in Albanian is heard for the first time. This alone evokes strangeness inasmuch as, during the years of isolation and the early period of postcommunism, it was rare to hear a foreigner speaking Albanian. Few Albanians, moreover, would have ascertained that the accent was Polish, although they may have recognized it as something vaguely Slavic. Again, with the exception of the presence of Polish wives in Albania, Poland remained a very distant notion in the minds of Albanians; of all European communist countries outside the Soviet Union, it and East Germany were the most remote.

A number of sequences fully explore communist Albania's debt both to Stalinism and Maoism and its own totalitarian past. In an episode in which Meto surveys the coastal region by helicopter, identifying locations for bunkers, the histrionic obsession with defence is underscored. At this point, a military officer alludes to the mountains, which have provided Albania with both isolation and protection and which, by implication, have been a key factor in the rest of the world's conception of the country. In a later sequence, at a military gathering, an official contrasts Albania's fortification with that of other nations such as Greece, Turkey and France, accentuating that no foreign power has ever conquered *all* of Albania. He perhaps purposefully ignores the fact that the Fascist occupation of Albania involved the entire national territory of Albania *per se*! Secondly, the frequent depictions of group executions, the conditions of labour camps and the fear of being 'overheard' are well in line with the assessment of the totalitarian regime that characterized the first generation of films made after the fall of Communism. The issue of the treatment of Albanian men married to foreign women, as explored in Peeva's documentary, resurfaces when Ana, immediately prior to her release from the labour camp, is told that her husband is dead and that she cannot see his grave since, even dead, he is still a prisoner. (The grave can be visited only upon his release.)

Ana's Polish nationality is textualized throughout the film by the frequent use of Chopin and Polish-language utterances. As the horror of bunkerization destabilizes her marriage, the composer's work leads to memories from the past. When she arrives at the conservatory where she teaches, a young pianist is practising Chopin. Ana urges the woman to continue, gazes out of the window and, for a moment, the cityscape of Tirana transforms itself to that of Warsaw. She recalls her wedding to Meto in Poland and their happiest moments together. (Ana, unlike prototype Maria Rafael, is a concert pianist, as indicated by a sequence in which she rehearses Chopin with an orchestra.) Language unites with music in the laying down of Polishness in the film. Ana's only extended

utterances in Polish occur while she is alone in her apartment, singing a Polish lullaby and contemplating photographs of children whose identity is never explained. Nonetheless, her song and melancholy gaze indicate maternity. It is only upon her entry to a labour camp that her Polish name is uttered – Anna Jakubowska.

Meto as well has fond remembrances of Poland. Returning home after having served as a guinea pig in a test bombing of a bunker, he recalls the times he spent with his wife along Warsaw's Nowi Świat and at Ostrogski Palace. Ana, in turn, lovingly speaks of visits to Żelazowa Wola, Chopin's birthplace, and asks Meto if those days will ever return. He stresses that they are stored forever in their memory. On this same night, the couple go to a restaurant, most likely the dining room of the Hotel Dajti, where high-ranking communist officials have gathered. They dance endlessly to traditional Albanian music, which contrasts starkly with the Chopin works that Ana so worships. Memory and music thus are linked in their contrastive relationship to both East and West. The recollections Meto treasures evoke a forced socialist neighbourhood, which is unlikely to return in the postcommunist European context. In contrast, the pre-eminence of Chopin, especially when played on Ana's Berlin-made Bechstein piano, suggests Albania's colonization, by both the West and its proxy, that of an Eastern European country which might well be deemed 'higher' than Albania.

Kolonel Bunker depicts Ana's ultimate deportation in a most realistic way. As Meto observes her from within the air terminal (without being permitted to speak to her), she boards a Malév flight to Budapest, which was one of the few indirect routes from Albania to Warsaw. (During the height of Albania's isolation, Malév and Austrian Airlines were two of the few carriers that serviced Tirana. Such lack of a direct connection to Warsaw foregrounds the distance between communist Albania and Poland.) Following the fall of communism, Meto phones several numbers in Warsaw in search of Ana. His use of the Polish language reveals his enduring attachment to the culture. At one of the numbers, an older woman (Ana's mother?) states in Polish that she is in Albania. Such an

Figure 9.3
Albanian work camp in Kujtim Çashku's *Kolonel Bunker*

utterance suggests that Ana, upon her return to Poland, never entered into contact with her family. Once again, *Kolonel Bunker* is replete with the same sense of pathos and futility that we have seen in the story of the Polish woman in *Divorce Albanian Style*. The ties forged between Albania and Poland in *Kolonel Bunker* foreground Çashku's attempts to thwart ethno-nationalist sentiments and build dynamic cross-cultural lines that can be opened in the postcommunist context.

Visually, *Kolonel Bunker* is indeed as dynamic as Myftiu has asserted. The absurdity of the regime and the bunkerization campaign is reflected by oneiric, often surreal images. When Meto introduces the concept to Ana over the dinner table in their small apartment, he draws a sketch of a bunker, which appears unworldly, almost like a spaceship. Ana's look is incredulous and suggests that, at this very moment, her life has changed forever. Such strangeness is further inscribed when the protagonist presents his wife with a wrapped gift – a miniature bunker for them to keep in their

apartment. Actual bunkers, moreover, serve as unique settings for minor plot threads. When a young Albanian woman and her foreign lover turn a bunker into a love nest, replete with candles and peace slogans, the images of 1970s sensuality contrast sharply with those of massive military gatherings where the bunkerization campaign is lauded. Near the end of the film, moreover, a full Orthodox funeral for an Elvis impersonator is held in a bunker, which is visually transformed into a sanctuary.

The absurdity and contradictions implicit in Ana's imprisonment are best textualized by her being allowed to transport her beloved piano to the work camp. She is able to play Chopin, her piano partially protected by a tattered plastic curtain, while other inmates watch patriotic newsreels on an outdoor screen. Once again, we see the sharp disconnect between a love for the foreign, in this case Polish, on a personal level and a need to heighten isolationism on the national. Inasmuch as the curtain renders Ana's music a private phenomenon, it recalls an earlier sequence in which Meto wraps himself and his wife in a shower curtain to stifle her protests against the histrionics of bunkerization. Meto had become so affected by his position and knowledge of the absurdities of the state that the sense of paranoia had even invaded the private realm of the bathroom.

Both *Kolonel Bunker* and the production context in which it was made attest to the need for Albanian cinema, in the 1990s, to explore its communist/colonial past. And specifically, it allowed the cinema to tackle the disparate visions of Eastern European neighbours both between the private and public realms and over the course of the Hoxha regime. The production of *Kolonel Bunker* was indeed a daunting one, for there were no blueprints for Albanian co-production with other European nations, let alone for sustained collaboration with its former communist neighbours. The end result, nonetheless, is an interweaving of discourses of isolationism, tyranny and otherness, which attests to the 46 years of the totalitarian regime. This being said, for Albania, *Kolonel Bunker* announced a new paradigm in the relationship between Albanian film and those 'other cinemas' of the postcommunist world.

Notes

1 J. A. Hobson, *Imperialism* (London: George Allen & Unwin, 1938); Kwame Nkrumah, *Neo-Colonialism: The Last Stage of Imperialism* (London: Heinemann, 1965).

2 Robert J.C. Young, *Postcolonialism: An Historical Introduction* (Malden, MA and Oxford: Blackwell, 2001), p. 47.

3 Edith Durham, *Twenty Years of Balkan Tangle* (Springfield, MO: Jungle, 2008).

4 Rose Wilder Lane, *The Peaks of Shala* (New York: Harper Brothers, 1923).

5 It must be noted that in the broader context of the European communist world, Hungary had a language dynamic somewhat similar to that of Albania. Since Hungarian is a non-Indo-European language, it is unrelated to Slavic or Romance languages in the region. Nonetheless, the strong presence of German under the Austro-Hungarian Empire served to bring Hungary somewhat more into the European mainstream.

6 Ramadan Marmullaku, *Albania and the Albanians* (London: Archon, 1975), p. 15.

7 Stavro Skendi, *The Albanian National Awakening: 1878–1912* (Princeton, NJ: Princeton University Press, 1967), p. 472.

8 Nicholas C. Pano, *The People's Republic of Albania* (Baltimore, MD: Johns Hopkins University Press, 1968), p. 24.

9 The deeply felt impact of Italian culture on Albania can best be felt in a sequence from Gianni Amelios's *Lamerica* (1994), in which a group of Albanians from the northern countryside en route to the port of Durrës to board ferries to Italy break into a chorus of 'Io sono italiano, italiano vero'.

10 Pano, *The People's Republic of Albania*, p. 176.

11 Pano, *The People's Republic of Albania*, p. 182.

12 Pano, *The People's Republic of Albania*, pp. 177–8.

13 Anton Logoreci, *The Albanians: Europe's Forgotten Survivors* (Boulder, CO: Westview, 1977), p. 181.

14 Logoreci, *The Albanians*, p. 181.

15 Logoreci, *The Albanians*, p. 213.

16 Logoreci, *The Albanians*, pp. 213–14.

17 Logoreci, *The Albanians*, p. 214.

18 For a detailed discussion in Albanian of Kujtim Çashku's career see Abaz T. Hoxha, *Enciklopedi e kinematofragisë shqiptare* (Tirana: Toena, 2002), pp. 70–2. It is essential to note that of all of the entries in the *Enciklopedi* that of Çashku is one of the most extensive.

19 ARP, Société Civile des Auteurs-Réalisateurs-Producteurs, *Missions* (n.d.). Online. Available at <http://www.larp.fr/home/?page_id=4> (accessed 26 May 2011).

20 In spring 2008, Çashku's Western and progressive ideas were indicted by the Iranian Embassy for eventual harm to the relations between Albania and Iran by virtue of Marubi's screening of Marjane Satrapi's animated feature *Persepolis* (2007) (Embassy of Islamic Republic of Iran in Tirana, *Në emër te Zotit [In the Name of Allah]*, letter, Tirana, 31 March 2008).

21 The attacks against Marubi have been viewed as unwarranted and dictatorial by the international diplomatic community in Tirana. In a joint letter from the French and German Embassies in Tirana dated 8 February 2009, Bernd Borchardt (Germany) and Maryse Daviet (France) decry the blockade and underscore that Marubi offers 'a privileged window on the West' (my translation) (Bernd Borchardt and Maryse Daviet, letter to Prime Minister Sali Berisha, Tirana, 18 February 2009). Two days later, US Ambassador John L. Withers II offered precisely the converse, arguing that Marubi constituted a 'window on Albania for the world' (John L. II Withers, letter to Prime Minister Sali Berisha, Tirana, 20 February 2009).

22 Such a stance is further evidenced by Çashku's implementation of a Tirana/Belgrade film school exchange during the early phases of Marubi's existence, an initiative that served to bring Albanians and Serbs together for the common goal of film study and production.

23 The relative warmth between Albania and its communist neighbours during the period can be witnessed by the number of the founders of Albania's state-run Kinostudio who studied in Budapest or Moscow from the late 1940s to the early 1950s.

24 Miranda Vickers and James Pettifer, *Albania: From Anarchy to a Balkan Identity* (New York: New York University Press, 1997), p. 213.

25 Dina Iordanova, 'Whose Is this Memory: Hushed Narratives and Discerning Remembrance in Balkan Cinema', *Cinéaste* 32:3 (2007), pp. 22–27, p. 26.

26 Iordanova, 'Whose Is this Memory', p. 25.

27 Gareth Jones, '*Kolonel Bunker/Magic Eye*', *Cinéaste* 32:3 (2007), pp. 52–3, p. 52.

28 Abdurrahim Myftiu, *Filmi në kapërcyell të shekullit* (Tirana: Akademia e Shkensave e Shipërisë Qendra e Studimeve të Artit, 2004), p. 102.

29 Myftiu, *Filmi në kapërcyell të shekullit*, p. 103

References

ARP, Société Civile des Auteurs-Réalisateurs-Producteurs, *Missions* (n.d.). Online. Available at <http://www.larp.fr/home/?page_id=4> (accessed 26 May 2011).

Borchardt, Bernd and Daviet, Maryse, letter to Prime Minister Sali Berisha, Tirana, 18 February 2009.

Durham, Edith, *Twenty Years of Balkan Tangle* (Springfield, MO: Jungle, 2008).

Embassy of Islamic Republic of Iran in Tirana, *Në emër te Zotit* [*In the Name of Allah*], letter, Tirana, 31 March 2008.

Hobson, J. A., *Imperialism* (London: George Allen & Unwin, 1938).

Hoxha, Abaz T., *Enciklopedi e kinematofragisë shqiptare* (Tirana: Toena, 2002).

Iordanova, Dina, 'Whose Is this Memory: Hushed Narratives and Discerning Remembrance in Balkan Cinema', *Cinéaste* 32:3 (2007), pp. 22–7.

Jones, Gareth, '*Kolonel Bunker/Magic Eye*', *Cinéaste* 32:3 (2007), pp. 52–3.

Logoreci, Anton, *The Albanians: Europe's Forgotten Survivors* (Boulder, CO: Westview, 1977).

Marmullaku, Ramadan, *Albania and the Albanians* (London: Archon, 1975).

Myftiu, Abdurrahim, *Filmi në kapërcyell të shekullit* (Tirana: Akademia e Shkensave e Shipërisë Qendra e Studimeve të Artit, 2004).

Nkrumah, Kwame, *Neo-Colonialism: The Last Stage of Imperialism* (London: Heinemann, 1965).

Pano, Nicholas C., *The People's Republic of Albania* (Baltimore, MD: Johns

Hopkins University Press, 1968).

Skendi, Stavro, *The Albanian National Awakening: 1878–1912* (Princeton, NJ: Princeton University Press, 1967).

Vickers, Miranda and Pettifer, James, *Albania: From Anarchy to a Balkan Identity* (New York: New York University Press, 1997).

Wilder Lane, Rose, *The Peaks of Shala* (New York: Harper Brothers, 1923).

Withers, John L. II, letter to Prime Minister Sali Berisha, Tirana, 20 February 2009.

Young, Robert J.C., *Postcolonialism: An Historical Introduction* (Malden, MA and Oxford: Blackwell, 2001).

10

The 'Far East' Neighbour in Nikita Mikhalkov's *Urga* (1991)

Lars Kristensen

There are two major events that characterize the changes that the relationship between Russia and its neighbours have endured in recent times. The first event happened in 1989, when Eastern and Central European nations disengaged from the Warsaw Pact. This region, previously controlled entirely by Soviet Russia, went from being a 'brotherly friend' to a postcolonial 'adversary'. The second event is, of course, the dissolution of the Soviet Union itself two years later, in 1991. With former Soviet republics forming independent post-Soviet states, ethnic Russians from the republics suddenly found themselves living in territories now located outside Russia proper – and suddenly living in diaspora without ever having planned to do so. In the context of this volume, this chapter aims at highlighting how in Russia the emerging dismantlement of the Soviet Union brought about a new set of concerns, when addressing issues of the neighbour. These new Russian concerns are discerned more tangibly through questions such as whether post-Soviet Russians should relate to their old as well as new neighbours as a friend or foe. And where in the new geopolitical spectrum should Russians

position themselves? As a former colonizer or as postcolonized? Nancy Condee argues that imperial Russia's relationship with its periphery was that of heartland, which runs contrary to that of other European empires where the heartland was at home and the racial or religious Other was in overseas territories at 'the periphery of the world'.[1] Rejecting the term self-colonization, taken from Alexander Etkind and Boris Groys, Condee puts forward the idea that the relationship between centre and periphery happens through a contiguous 'updating' of metropolitan Russia and the peripheral fringes, 'inscribing onto the heartland its own relations of domination and difference as a creative, local improvisation on Western imperial practices'.[2] It is this continuous 'update' that can be useful when describing how a new set of concerns is triggered by first the fall of the Berlin Wall and subsequently of the Soviet Union. While Condee addresses imperial traces through internal colonization, the imperial 'update' also takes place on a geopolitical level, where new allies and enemies are located and where the paradigms of colonizer and colonized are tested. In particular, in the late 1980s, there was increased demand for a revision of Soviet terminology, such as 'socialist friendship' or 'friendship of people's', caused predominantly by nationalism in the Baltic States.

Rather than surveying Russian cinema, my aim is to show how these new post-imperial concerns impact on Nikita Mikhalkov's *Urga, the Territory of Love* (*Urga*, 1991). In my view, this is a film that addresses early concerns about the changing attitudes of the Russian neighbour, but was also made within a transnational co-production context that would be emulated in the years to follow. Its preoccupation with the placement of a Russian worker abroad makes it a unique example of how imperial colonial history and Soviet brotherhood can be seen as 'up in the air' at the time. Nobody knew how the balls would come down and in what shape or form the postcommunist Russian would appear – as colonizer or as colonized? In contrast to other chapters in this volume, which have Russians as the embodiment of the colonizer, either explicitly or implicitly, this chapter will describe the perspective of

Figure 10.1
Sergei's truck immobilized on the steppes in Nikita Mikhalkov's *Urga*

a Russian's encounter with the 'Far East' neighbour and how the narrative of *Urga* circumvents issues of Soviet colonialism through friendship with the ethnographic Other. It will be argued that the Mongolian neighbour encountered in northern China replaces the internal 'Other' of the Russian imperial heartland to illuminate Russia's own post-imperial and post-Soviet identity. In other words, I am arguing that Russian internal colonization necessitates a search elsewhere when addressing concerns over the changing geopolitical dynamics caused by emerging dislocation of the 15 Soviet republics. *Urga* is a rare example of Russian renegotiation of dominance and differences in the Far East as opposed to the nominal West, which would feature frequently in later films of the postcommunist era.[3] Emphasizing the Russian perspective of the film, as opposed to a more common international reading,[4] the chapter will highlight particular Russian concerns over a possible scenario without the Soviet Union.

Urga in the context of Soviet disintegration

The film tells the story of Gombo and his family, who live in northern China. Also known in Chinese as inner Mongolia, this region borders with Russia and Mongolia to the north, but is an autonomous region within the People's Republic of China. Entering the picture is truck driver Sergei, a middle-aged Russian who lives abroad with his wife and daughter in a nearby industrial town. He crashes his truck into a river and is subsequently helped by Gombo. After a night in his rescuer's hut, Sergei takes Gombo with him into town on his truck. While Sergei returns to his wife and daughter in town, Gombo goes in search of condoms as his wife refuses to have more children. While in town, Sergei and Gombo meet up at the local disco where drunken Sergei ends up in jail. Freed by Gombo, the two characters form a cross–cultural friendship which is cemented at the end of the film by Sergei again appearing on the Mongolian steppes.

Made at the very end of the *glasnost* period, the film explores the Russo–Asian connection through its narrative of displaced versus indigenous people, of ethnicity versus national identity. Before examining the narrative of the film, I want first to discuss its context, its production values and the position of the film's director within late *glasnost* and postcommunist Russian cinema. The film can be seen as an example of a small group of films of the late 1980s and early 1990s, which are marked by the changing economics of the Russian film industry, where new avenues were sought in order to survive. Co-production was one way out of this situation, and this is the case with *Urga*. However, despite being a transnational co-production, it stands out from other films made during the same period by articulating the director's search for a wider audience. The film can be seen as being in relation to Mikhalkov's Chekhovian corpus[5] or as the beginning of his 'kitsch' films, which would continue throughout the 1990s.[6] Mikhalkov's response to the accusation of making kitsch was to hit back at the critics and audiences.

> Loathsome and godless, we have lost the will to live, and in particular, the respect for things – the past, the present, and our selves ... But then Russia appears [in my films] full-blooded and beautiful... And the talk about kitsch begins, about the fact that Mikhalkov has made a film for foreigners ... Yes, [I have catered] for foreigners. For one hundred million foreigners living in my country, who do not know its culture, its history, and – most importantly – who do not love it.[7]

Mikhalkov's project, crystallized in *The Barber of Siberia* (*Sibirskii tsiryul'nik*, 1999), is to glorify what has been left behind, or lost, in the dark images of Russia's postcommunist transition, and *Urga* constitutes an early attempt to unearth Russia's past to construct a new post-Soviet Russian national identity, a glorious (imperial) past that will ignite and renew the love of the country. In this view, *Urga* is a pre-articulation of the postcommunist condition, of the end of empire, addressing the postcoloniality of post-imperial Russia. *Urga* and its makers are concerned with colonialism: the colonialism that the Russian Empire instigated and the (neo-)colonial influence of Western hegemonies that holds sway over post-Soviet Russia. Both these quite different features of colonialism inform the film, because, as I will argue, they are two sides of the same coin. It can be called Eurasianism, Slavophilia or anti-Eurocentrism, but the bottom line is that the 'coin' hails Russia as different from, on the one hand, the West and, on the Other, the East and Asia. Therefore, the theme of 'the abroad' in connection to the older Soviet abroad, as seen in *Urga*, is ideally situated for the narration of self through the neighbouring Other. However, what makes this Russian narrative about abroad stand out from the older Soviet narratives is the Russian nationalistic discourse, which is not exclusively characteristic of Mikhalkov, but rather prevalent in popular, mainstream Russian cinema.

Nationalism across the Soviet republics led to the most threatening challenge to the Soviet Union, which saw repeated demands for the right to self-determination. But Russian nationalism is to be distinguished from the nationalism in the Soviet republics and

Eastern Europe, because the latter countries 'all had "Russians as communists" to serve them well in developing a common reconstruction of identity'.[8] Russian nationhood eschews a 'natural' liberation from communist rule, because Russians are the 'empire-upholders' and the colonizers within the empire.[9] Thus, the aspirations of Russians for an independent (postcolonial) statehood were directed towards the communist (neo-colonial) ideology. During *glasnost* and *perestroika*, nationalist sentiments surfaced, professing that Russians had been treated unfairly in the 'affirmative action empire' of the Soviet Union.[10] For example, Russians did not have their own parliament as the other Soviet republics did, which led to sentiments that Russia too was a victim of Soviet occupation. Following this line of thought, postcolonial victimhood arrives from the inability to express one's national identity. With the communist regimes overthrown, Russian nationalism came into full view and eventually began to function as a weapon in a nationalistic fight against the neo-colonial influence of the West.[11] It is within this framework of resurgent postcolonial nationalism and opposition that I want to examine Mikhalkov's film and the Russian encounter in neighbouring Mongolia/China. A postcolonial reading of the film reveals how it addresses concerns that emerged during this period. By having a Russian crashing in on a Mongolian family living in northern China, the film speaks less about ethnic minorities and hybrid identity issues in postsocialist China than about the ex-colonial settler and the ex-colonized subject suddenly living 'abroad' in a post-imperial era.

Production and reception history of *Urga*

As mentioned, *Urga* was a co-production between Michel Seydoux's Caméra One and Mikhalkov's own film studio, TriTe. Seydoux would become Mikhalkov's main collaborator, co-producing the majority of his films. The French involvement in Russian cinema comes as a natural extension of a film industry in search of foreign investment to produce films and foreign markets to distribute

them. However, from a postcolonial perspective, we also need to address the issue of what interests there are for the investor in a film that concerns a Russian intrusion into northern China. One way of reading this is to highlight how postcolonialism has influenced French cinema since the country's colonies gained their independence. Whether it is through actively encouraging French hybridity on-screen or through financially supporting filmmaking in former colonies, French cinema has become global through its own colonial history. In a similar postcolonial trend, the issue of the colonial settler has greater resonance in the French consciousness than in the British, which can be seen in the rise of Claire Denis within French filmmaking and the way her films interrogate French nationals in Africa, as in *Beau Travail* (1999) and *White Material* (2009). It is notable in this respect that the film to which *Urga* lost at the US Academy Awards was, in fact, Régis Wargnier's *Indochina* (*Indochine*, 1992), a film about a French colonial settler in Vietnam. From this, we can detect the attractiveness of Mikhalkov's film in the eyes of the French producer – who clearly sees potential for the film's distribution amongst French audiences.

Urga's reception crosses over as a culturally 'unmarked' film: no single nation or culture can claim the film as theirs, as being explicitly about their nation and culture. Culturally, the film hangs in a transnational no man's land, being neither Chinese nor Mongolian nor completely Russian. This specific feature of the film is important to bear in mind when the perspective of the Russian abroad is highlighted, because it is precisely with this apparent load of unfixed natural affiliation that the film makes its most pertinent nationalist points. Scriptwriter Rustam Ibragimbekov, who will be dealt with later, and director Mikhalkov put together a story that fuses three cultural contexts, of which the Russian, a seemingly secondary character, is, in fact, the primary concern. According to the director, '*Urga* was virtually unshown in Russia' on its release.[12] For this particular film, Nikita Mikhalkov had to go on a self-promotion tour in order to get it screened and to reduce piracy, because at this point in time the 'normal' (Soviet) distribution

system was almost absent. Despite *Urga*'s transitional release pattern, it has subsequently been aired on television and was circulated in pirated copies, which were the main viewing forms for Russian cinema during this period, and therefore the film has become familiar to Russian audiences.

However, it is only the Russian critics that notice the Russian military connotation in the film, which arises from the fact that *Urga* is set on the same territory as the Russo–Japanese War (1904–5), which Russia lost. M. Ivanov writes that the military connotations are there, 'as if reminding us about who we were in order to remember that we should know where we are heading'.[13] However, the issues of remembrance and the fallen soldiers are neglected elsewhere, including at the Western festivals. In this regard, it is interesting to apply a performance-based framework. In his study of acting Jewish, Henry Bial describes how different readings take place among Jewish and Gentile audiences. For Bial, a Jewish performance, on screen or stage, is encoded by accents, rhythms of speech and emotional affects, which in turn are detected by Jewish audiences. It is, however, 'not necessary to be or identify as Jewish but simply to be able to read the codes'.[14] This double coding, which signals one thing to an ethnic group and another to Gentile groups, is, I argue, also taking place in *Urga*. Russian audiences are able to decode Sergei's song, while non–Russian audiences are left to assert Sergei's performance as intrinsic to the character and not the Russian nation. Western film scholars on Russian cinema are also able to decode the signals and they support the view that Mikhalkov's underlining of Russian military historical presences in the region imbues the film with nationalist sentiments.[15] The Russian character emphasizes the setting and *mise-en-scène* as safeguarding traditional Eastern values and views of life. The film is classified within Soviet and Russian cinema as an ethnographic drama,[16] a peculiar Russian/Soviet genre that purports to take the viewpoint of the indigenous people, but which nonetheless mourns 'the passing of what [the colonizers] themselves have transformed'.[17]

Divergent love on shared territory

The extraordinary point about *Urga* is that it is exclusively set on foreign territory in northern China, an approach quite exceptional in Russian cinema, and only a few Russian characters are added to the predominately Mongolian cast. This makes the film illustrative in the context of examining neighbours, because although it is a Russian/French production, it purports to speak of Mongolians living in northern China. It is narrating from across the border, thereby highlighting its concern with Russia's relationship with its Other. As Stephen Hutchings explains, it is through the construction of self and the Other that we can detect what it meant/s to be Soviet or Russian.[18] Sergei is the Western 'normative', the white-skinned occidental that appears as universal, and Gombo and his family represent the Eastern Oriental 'exotic' object worthy of 'ethnographic' study. Sergei lives with his family in a small Chinese industrial town where he has, it is assumed, contractual work in the oil industry. He is representative of a Soviet Russian social class which was sent abroad to help build up socialism in other brotherly countries. In a postcolonial syncretism, as elaborated by Robert Stam,[19] he is somewhere in between a colonizer and colonial settler, for whom 'abroad' has become home. Sergei is a truck driver, neither highly educated nor a bearer of any obvious cultural capital. The truck is of an older date, the front window is broken and it is clearly recognizable to Russian spectators as a Soviet brand, GAZ-51,[20] despite the Chinese characters written on its doors and the sides of the truck bed. A frontal shot of Sergei in the truck shows him wearing goggles because of the broken front window, but these glasses are also the first of several pointers to military machinery, in particular tanks. This is a theme that follows Sergei in the first part of the film. Also worth mentioning is the music playing from his truck radio, which is played at maximum volume in order to keep him awake.[21] At first it is Chinese opera music, but Sergei drifts off and he changes the music to Wagner's opera *Lohengrin*,[22] which, significantly, is neither Russian nor Chinese,

Figure 10.2
Vladimir Gostyukin as Sergei in Nikita Mikhalkov's *Urga*

but profoundly European. This neatly sets up the frame of Sergei as from outside the East and the West, but located in between the two poles, just as the native Mongolians in the film are.

While the film is not set in Mongolia, Russia's role in this region is significant. Mongolia gained independence from China in 1911 with Russian help, and the close relationship continued after 1924, when Mongolia was pronounced a People's Republic under communist rule. The Sino-Russian conflict led to Mongolia siding with the Russians, despite their apparent affinities – in terms of trade and shared historical past – with their Chinese neighbours. None of the radio stations, East or West, can keep Sergei awake and he dozes off, with the consequence that he veers towards a cliff over a river. From a Russian perspective, looking at their Mongolian neighbour, whether in Mongolia or in inner Mongolia, Russia is the good Western colonizer that brings civilization to its barbaric Eastern borders and central China is the incomprehensible Orient; not unlike the way Ottoman legacy is perceived in Balkan imagination. In this constellation, China is the Oriental where another civilization begins. On the other hand, in Chinese

films, such as Jia Zhangke's *Platform* (2000), Mongolia and Russia function as sites of the Other; an unreachable place that triggers the imagination of the characters.[23]

The truck stays on the cliff and Sergei, now wide awake, considers himself lucky. He wanders away from the truck dancing and screaming, and he begins to perform an army attack, simulating machine-gun noises, again connoting his army affiliations. Stumbling over a decaying corpse in the high grass, Sergei runs horrified back to his truck to drive off, but instead of reversing from the cliff edge, he drives the truck fully into the river. In other words, if Sergei is seen as a military colonial subject advancing on the pristine steppes of the East, then when faced with the barbarism (as he sees it) of the corpse, he tries to retreat. However, despite his efforts, he is doomed to engage with the Other. The retreat from the Chinese battlefield was one of the causes of Russia's defeat in the Russo-Japanese war. Sergei literally becomes the 'bearer' of this war in the film through his body; his back is covered by a tattoo with the score of the song 'On the Hills of Manchuria'. Sergei's tattoo underlines the body as a construction,[24] but also a construction that is coded, as the song celebrates the soldiers that fell in the Russo-Japanese war and, in particular, in the battle of Mukden, where some 110,000 Russian soldiers died.

In the film, these connotations of the Russian military, naivety and the cultural gap are continued when Sergei arrives at Gombo's hut (*iurta*). Firstly, when Sergei takes off his shirt to wash himself, he reveals a torso covered with many army tattoos. Sergei explains that he was in the army band and that he was young and foolish. These explicit references to music and youth underline Sergei's non-threatening (soft power) construction in the film. Nonetheless, Gombo's son looks at the tattoos flabbergasted. However, it is Sergei who is equally stunned when, in honour of Sergei, Gombo kills a sheep for dinner. Moreover, in this scene, where Gombo kills, skins and dismembers the sheep, viewers are positioned with Sergei, looking on at the slaughter. This reinforces the spectator identification as non-Mongolian, but rather as Western/Russian

ethnographers. At first, Sergei refuses to partake in the eating, but he eventually complies and eats the food on offer with relish. Well into the meal and after a couple of *Russkie obychai* ('Russian customs'), i.e. toasts, Sergei jokingly makes an army honour gesture to Buyin, Gombo's son, but the little boy refuses to do the same in return. Instead, Buyin puts a finger to his head, turning it, by which he indicates that Sergei is a (crazy) idiot. The representation of Sergei is meant to infuse a comic element into a simple Soviet prototype, while in the process, keeping a certain aloofness and sense of 'superiority' about the characters.[25] Sergei is simply out of place in the tent, and seems brash, intrusive and foreign, but nonetheless feels a (Western) superiority to his environs. The superiority is expressed through his ignorance rather than his morality; Sergei leaves the spectator with no inkling that he is interested in understanding the daily lives of Mongols in China. Furthermore, the military connotations that are attached to Sergei point in the direction of a less innocent Russian presence in this territory, because they embed the story with the colonial sentiment of a 'barbaric' pristine society that is not explicit within the narrative, but visible from Sergei's tattoos. The image that follows Sergei's comic dinner and his tears when Gombo's daughter plays the accordion is a pan shot of the moon over the steppes to a zoom in on Sergei's truck, stuck in the river. In conjunction with the military references, this becomes an image of Russian colonial adventure gone wrong, or, at least, a failed intrusion of Soviet 'Western' civilization. Both Sergei's anachronistic truck and his own low cultural capital suggest a failed colonial endeavour.

When Sergei returns to his wife and daughter in town, he is asked by his wife: 'What are we doing here?' This hanging question is left unanswered as the camera pans to the windowsill and a miniature of a Russian Orthodox church, hinting at the homeland or at least a projection of such a place. This image is repeated later at a gathering at the local disco. At the disco, Sergei is again drinking, this time not only with Gombo but also with a Russian compatriot. The two Russians discover that they have lost contact with their history

as they are unable to remember the names of their ancestors, again enforcing the view that Mikhalkov expressed in the quote above. This loss ignites a desire in Sergei to sing his tattooed song, but before this the viewers get treated to yet more of Sergei's blurry imagined homeland. As the music fades from disco into a non-diegetic Russian balalaika playing 'On the Hills of Manchuria', Sergei walks away drunk and dismayed at being 'cut off' from his ancestors. The melody disappears, leaving only the beat, identical to a heartbeat. Sergei pushes the doors open (resembling western saloon doors) and gets a vision of black and white footage from a war-torn building on a barren landscape. In the decolonizing project of thinking post-Soviet Russia anew after gaining its independence from the Soviet colonizer, the postcolonial cultural producers, Nikita Mikhalkov and Rustam Ibragimbekov, need to reach back to the pre-colonial era (pre-Soviet), fusing it with the awareness of the colonial history (Soviet) and thereby rewriting a new postcolonial identity as a hybrid of the two. The job is not to resurrect the past, but to make that past work in the present and through the colonial history. Sergei's insistence on singing 'his'

Figure 10.3
Yongyan Bao as Bourma plays Sergei's tattoo on the accordion

song is a good example of lifting history from the past through the colonial, namely his Soviet manners.

Sergei mounts the stage and takes off his shirt, to the amusement of the crowd. The spectators of the film expect Sergei to embarrass himself yet again. However, he just asks the band to play the music notes on his back. As he starts, the band begins to pick up the tune and the crowd begins to dance again. The further Sergei gets into his song, the further behind he leaves the disco and enters 'his own world', a change that is reinforced by the intercutting of a snow-ridden landscape with a Russian church on a hilltop. Again, it is a pan shot which zooms in on the church as the music fades to a single accordion with the added sound of the wind and the shriek of a lone crow. This is Sergei's projection of the nostalgic homeland, but also the projection of both the protagonist's and the filmmaker's commemoration of all the soldiers who perished in the Russo-Japanese War and whose souls now rest in foreign lands. Thus, the title of the film and, in particular, its added sub-title, *The Territory of Love*, is ambiguous, as it can also be attached to the soldiers who died for their beloved Russian homeland,[26] and not just to the love story of Pagma and Gombo, which is at the centre of the film. In particular, the Orthodox church with the screeching crow ties in with Mikhalkov's ideological outlook, where imperial Russian values, ideals and ethics are thought to be lost in contemporary life.[27] *Urga* and its connotations of the war with Japan are viewed as an emotional eye-opener for what Russia has lost during Soviet modernization. In particular, the lost connection to land, to ancestors and to immaterialist living seems to be bemoaned in the film. As Michael Rouland concludes: 'this is not Russian rule of Mongolians, rather Russia can still learn from the Steppes and harness its heritage of power of Eurasia.'[28] Moreover, as the film is constructed from the point of view of the Russian settler, *Urga* can be viewed as part of a longer tradition of Soviet cinema making films according to the genre of the western.

For many ethnic Russians living in the Soviet republics in the late 1980s and the early 1990s, these were unsettling times where

everything was up in the air. If the Soviet Empire fell, what would happen to generations of ethnic Russians living in the newly liberated national states of the Baltic, Central Asia and the Caucasus? This is the concern addressed in *Urga* by the representation of Sergei and his 'memory' imprinted on his back. Through explicit reference to Sergei's and his compatriots' presence in China, the viewers, and in particular the Russian 'home' viewers, are to question the feasibility of the Russian settler in changing times. Mikhalkov partly answers this question by infusing Sergei into the closing scene of his film. The settler has a legitimate claim to be present abroad. The return 'home' is not an option for Mikhalkov and his character Sergei, who together establish the naturalization of the Russian settler by inserting the white Russian into the last image of the film. Hence, it is necessary to examine how Sergei ends up in the final frames. This happens through projecting a shared marginality between Gombo and Sergei; they are, so to speak, together in the same boat of having to locate, or visualize, as Sergei did, their cultural heritage.

Sergei stays right until the end

Having dealt with the scenes of Sergei's/Mikhalkov's projected collective memory, it is also necessary to account for Gombo's dream sequence, in which Pagma suddenly appears in her traditional Mongolian dress with Genghis Khan. In this image there is a reverse of 'Russia's sensitivity with the Mongol yoke'.[29] The Mongolian invasion of Russia during the thirteenth century is usually associated with harsh taxation, but also the notion that Russia sacrificed herself and thereby saved the Europeans from Mongolian oppression. Here, similar to Mikhalkov's idea of resurrecting Russia from the Soviet Union, Genghis Khan rejects (foreign) modernist interventions and ridicules Gombo for his desire to be modern. It is not only Gombo who is being taught a lesson, but also the Russians. The bicycle bought in the town proves to be no match for the horse and, while showing the clip from *Rambo III* (Peter

McDonald, 1988) (in which Rambo beats the Mujahideen in a horse game), the TV set is destroyed with a lance.

Reference to Sylvester Stallone is also made at the opening of the film, as Gombo's drunken horse-riding neighbour brings a poster of Stallone as Lieutenant Marion 'Cobra' Cobretti in *Cobra* (George P. Cosmatos, 1986). The neighbour claims it is a picture of his brother in America. The references to Rambo are infused with US imperialistic sentiments. On a more intertextual and family-related level, the whole reference to Stallone could also be seen as a strong nod towards Mikhalkov's brother, Andrei Konchalovsky, who made the Hollywood film *Tango and Cash* (1989), which stars Stallone in one of the leading roles.[30] Obviously, the reference is to Western commodities, and in particular to a US influx of Hollywood-style values. The bicycle, on the other hand, refers to the Chinese influence. This defines ethnic Mongolia as interstitially positioned in between two powerful forces that affect its identity. These images are complicated by the arrival of Sergei to this dream-meditative scene, but, as with the other material goods, Sergei's truck is sunk into the valley while on fire, thus highlighting its 'Western' intrusive features, Chinese or Soviet. However, Sergei is reunited with Gombo when ridiculed, because he too is rolled into a carpet and dragged across the fields. Bringing them together emphasizes that both have lost touch with their ancestors; both have been disconnected from their (shared?) past – Gombo from his Mongolian ancestors and Sergei from the pre-Soviet military men who died for their country.

Another way in which Gombo and Sergei's shared marginality can be detected is when Gombo arrives back home and sets up the TV that he has bought. It seems that Gombo has two channels to choose from, and on one there is a meeting in front of the White House in Washington DC between President Gorbachev and President Bush Sr. On the other channel, however, a people-of-the-street singing programme is broadcast from Beijing,[31] which again points to the shift of political power to the south. This reinforces the dual cultural powers present in the worlds of Sergei and Gombo. The

two powerful capitals, Washington and Beijing, not only spell out their authority over Mongolian Gombo and his family as they watch the programmes, but the two cities also flank the Russian Sergei, who later arrives at the hut. It is in this context that the neighbour friendship between Gombo and Sergei should be seen, because it is here that they share values of in-betweenness, and for both the rejection of the power capitals, the Chinese as well as the US, is vital for their survival. It is through the Mongolians that the liminal position of the Russian can be detected; it is through the projection of our neighbours that we detect our selves. Sergei is not the big brother; rather, he has been reduced to service alongside his fellow Soviet compatriots in between two versions of postcommunism, Americans as Cold War winners and China as the defender of a dying ideology. This is enforced by the film's conclusion.

The final scene of the film shows Gombo and Pagma making love in the fields under the 'protection' of the Urga, which is a long stick with a cloth tied to it. The Urga signals to the surrounding people that the couple would like to be left alone. However, because the 'territory of love' is not only dedicated to the Mongolians but is also shared by the dead Russian soldiers, as seen earlier, the Urga sign of 'leave-us-alone' can also be seen as a Russian sign, saying leave our soldiers alone – do not try to take this land from us. This is reinforced by having Sergei sing 'On the Hills of Manchuria' with his shirt up so that Gombo's daughter can play the tune on her accordion.

In the epilogue, the Urga planted in the field turns into a smoking chimney. Over this image Gombo's fourth child, Temujin, the birth name of Genghis Khan, narrates that where the Urga once stood now stands this chimney, which he can see from the window of his flat in the house where he lives. He works at a gas station; he is married but has no children yet and loves to travel. Last year they were at the Baikal where there was once a lake and the Russians once lived. This year they want to go to Los Angeles – to see the Japanese. This last voice-over of Temujin positions the film in a future context and purports that the Japanese live

in the USA and non-Russians live in the far east of Russia, thus hinting at a changing world where power structures reverse. For the Russian viewer the voice-over is more importantly presented by the director himself who on the Russian DVD version released in 2003 'translates' the Mongolian dialogue, thus seemingly implying that if this evolution, Mongolian or Russian, is accepted, ideals may be lost and the profound linkage to mother Russia – gone forever.

Urga in a (post)colonial perspective

The closing image of Sergei, the Russian settler, sitting on the grass steppes of inner Mongolia, singing the song imprinted on his back accompanied on the accordion by Bourma, Gombo's daughter, is important, because it installs the Russian as an intrinsic part of the post-Soviet abroad, where their future was in question. When Sergei returns to his wife, she asks a (rhetorical) question that is never answered: why are we here? The answer seems to come from the filmmaker, saying that we (Russians) are here because of our honourable imperial past, when we defended the Mongols from the Japanese, and that we are not only a natural part of this abroad, but should also claim a leading role in it. This glosses over the guilt of colonialism, which is often part of a settler narrative (e.g. in *The Battle of Algiers/La battaglia di Algeri*, Gillo Pontecorvo, 1966), and instead narrates Russian imperialists, through the Russian settler, as protectors of humanistic values and ideas. Just as the settler narratives are ambiguous towards the colonial, so are *Urga* and Mikhalkov. Rouland asserts,

> The confrontation of these two worlds, the steppes and the modern world, serves as the milieu and message of a film about Russia's crisis with modernity at the collapse of the Soviet Union. In Eurasianist terms, they are also exaggerated moments in Russia's self-image: one of the power of the steppe, invoking the prestige of the Mongolian Empire, and the other of the success of hyper-industrialization and of campaigns to canvas Eurasia with road and train-tracks.[32]

Urga is a film of the western genre where the Russian protagonist shares with the postcolonial settler a similar in-betweenness, a feeling of being stranded in a foreign land that he/she once ruled/controlled. It is noteworthy that Russian Sergei does not even attempt to return to Russia. This is because the drama is constructed as a confirmation of Russian's presence in the neighbouring abroad as natural and proper.

What is peculiar about this settler narrative is that the script for the film was co-written by Rustam Ibragimbekov, a prominent Soviet screenwriter who is Azeri by origin and was born in Baku, Azerbaijan. A scriptwriter who has come to embody a post-Soviet filmmaker's ability to float on the waters of postcommunist national cinemas, Ibragimbekov is behind several award-winning scripts written with Mikhalkov during the 1990s. The two have worked together on nearly every film project that Mikhalkov has initiated since the late 1980s, from *Avtostop* (1990) to *The Barber of Siberia* (1999) and the *Burnt by the Sun* films (*Utomlyonnye solntsem*, 1994 and 2007). However, Ibragimbekov was also the writer and producer of *Nomad* (2005), the Kazakh film that was adapted first by Ivan Passer and then Sergei Bodrov. Within post-Soviet Russian cinema, Ibragimbekov is associated with Russian 'Hollywood' filmmaking,[33] in particular through Mikhalkov's films of the 1990s, but also through one of the first films that Ibragimbekov wrote, *White Sun of the Desert* (*Beloye solntse pustyni*, 1970), the quintessential Soviet western. Being Azeri and working within the Russian film industry gives Ibragimbekov a liminal yet advantaged position with regard to national identity; this liminality informs all of his work. Ibragimbekov tells Elena Stishova that he is 'a person of two worlds – of the East and the West'[34] and that the Eurasian idea can be transferred to a post-Soviet, postcolonial situation. Ibragimbekov's experience of liminality infuses the ideology of *Urga* with the in-betweenness of its two major characters, Gombo and Sergei. However, Ibragimbekov cannot completely avoid accusations of partaking in a Russian national revival in the cinema of Mikhalkov. There is no question of Ibragimbekov adding to the

dual perspective in *Urga* or of his commitment to the same Eurasian idea that Mikhalkov cherishes. For Ibragimbekov, though, this idea constitutes a post-Soviet/postcolonial working relationship where real connection informs the older, colonial ties that were heralded under the banner of 'friendship of people's' (*druzhba narodov*) during the Soviet period.

There is no nostalgic take on the Soviet period for Ibragimbekov. He says, 'I have lived through very painful excessiveness and formality of the "friendship of people", which destroyed sincere friendship and informal connections that existed at the same time'.[35] The return of the Soviet international 'friendship', which functioned on the level of Marxist-Leninism, is thus exposed by Ibragimbekov, who favours the emergence of new cooperations in post-Soviet cinema. Here, the former colonial connections are re-established in the formation of a postcolonial working context, which brings together the colonizer and the colonized. The old colonial ties are not severed by the postcolonial condition; rather, the syncretism of the postcolonial and its unevenness are challenged and resolved within a new configuration of powers.

In conclusion, I will argue that there are distinctive features in *Urga* that make it a prime subject for postcolonial analysis, in particular, the imperial 'update' on the relationship between centre and periphery, as well as the film's viewpoint of the Russian settler and its ethnographic concerns for the neighbour Other through the representation of Gombo and his family. These are all hallmarks of postcolonial discourse. As far as the representation of Sergei is concerned, he stands in for the liminal space occupied by the postcolonial, but also for the fact that this Russian has features of imperialism (e.g. his ignorance/naivety) in relation to the Mongolians living in the Chinese borderlands. Both Gombo and Sergei are products of postcommunism, who, according to the film's director and scriptwriter, need to reject the power centres (USA and China), thereby finding their roots: Gombo in Genghis Khan and Sergei, paradoxically, in imperial Russia. Thus pre-Soviet values and ideas are put forward in the formation of a post-Soviet

postcoloniality.

Notes

1 Nancy Condee, *The Imperial Trace: Recent Russian Cinema* (Oxford and New York: Oxford University Press, 2009), pp. 31–2.

2 Condee, *The Imperial Trace*, pp. 32–3.

3 See Yana Hashamova, *Pride and Panic: Russian Imagination of the West in Post-Soviet Film* (Bristol and Chicago, IL: Intellect Books, 2007).

4 The film was distributed outside Russia under the title *Close to Eden.* Only later was the subtitle 'The Territory of Love' added, which is now also used when referring to the Russian title.

5 Condee, *The Imperial Trace*, p. 107.

6 Birgit Beumers, *Nikita Mikhalkov: Between Nostalgia and Nationalism* (London, New York: I.B.Tauris, 2005), p. 97. The film was well received on the international festival circuit, winning the Golden Lion at the Venice International Film Festival in its year of release. Subsequently, in 1993, the film won a Felix at the European Film Academy, got nominated for Best Foreign Film at both the US Academy Awards and the French Césars, and won Best Director at the Russian Nika awards.

7 Liubov' Arkus, 'Nikita Mikhalkov: Ya sdelal kartinu dlya sta millionov inostrantsev zhivuzhikh v moei strane …', *Seans* 17–18 (1999), pp. 89–91, p. 89.

8 David D. Laitin, *Identity in Formation: The Russian-Speaking Populations in the Near Abroad* (Ithaca, NY, and London: Cornell University Press, 1998), p. 313.

9 Ronald Grigor Suny and Terry Martin (eds), *A State of Nations: Empire and Nation-Making in the Age of Lenin and Stalin* (Oxford and New York: Oxford University Press, 2001), p. 3.

10 Terry Martin, 'An Affirmative Action Empire: The Soviet Union as the Highest Form of Imperialism', in Ronald Grigor Suny and Terry Martin (eds), *A State of Nations: Empire and Nation-Making in the Age of Lenin and Stalin* (Oxford, New York: Oxford University Press, 2001), pp. 67–90, p. 78.

11 See, in particular, Hashamova: *Pride and Panic*.

12 George Faraday, *Revolt of the Filmmakers: The Struggle for Artistic Autonomy and the Fall of the Soviet Film Industry* (Pennsylvania, PA: Pennsylvania State University Press, 2000), p. 191.

13 Ivanov, M., *Urga: territoriia lyubvi* (n.d.). Online. Available at <http://www.videoguide.ru/card_film.asp?idFilm=19322> (accessed 24 January 2012).

14 Henry Bial, *Acting Jewish: Negotiating Ethnicity on the American Stage and Screen* (Ann Arbor, MI: University of Michigan Press, 2005), p. 64.

15 Faraday, *Revolt of the Filmmakers*, p. 188; Beumers, *Nikita Mikhalkov*, pp. 93–8.

16 Miroslava Segida and Sergei Zemlyanukhin, *Fil'my Rossii: Igrovoe kino (1995–2000)* (Moskva: Dubl' D, 2001).

17 Renato Rosaldo, *Culture and Truth: The Remaking of Social Analysis* (Boston, MA: Beacon Press, 1989), p. 69.

18 Stephen Hutchings (ed.), *Russia and Its Other(s) on Film: Screening Intercultural Dialogue* (Basingstoke: Palgrave Macmillan, 2008), p. 4.

19 Robert Stam, *Film Theory: An Introduction* (Malden, MA, and Oxford: Blackwell Publishers, 2000), p. 294.

20 Michael Rouland, 'Images of Eurasia: Conceptualizing Central Eurasia through Film', unpublished paper presented at Soyuz Symposium, University of Princeton, 12 April 2007, p. 12.

21 In the colonial discourse, the radio holds a significant place, particularly for the colonial settler. Fanon writes on the French broadcasting of Radio-Alger, that 'it gives [the settler] the feeling that colonial society is a living and palpitating reality, with its festivities, its traditions eager to establish themselves, its progress, its taking root. [I]t is the only link with other cities, with Algiers, with the metropolis, with the world of the civilized' (Frantz Fanon, *A Dying Colonialism*, trans. Haakon Chevalier (Harmondsworth: Pelican Books, 1970), p. 55; see also Brian Larkin, *Signal and Noise: Media, Infrastructure, and Urban Culture in Nigeria* (Durham, NC, and London: Duke University Press, 2008), pp. 48–72).

22 Beumers, *Nikita Mikhalkov*, p. 93.

23 Yün Peng, 'Truancy, or Thought from the Provinces: On Jia Zhangke's *Platform*', in Lars Kristensen (ed.), *Postcommunist Film – Russia, Eastern Europe and World Culture: Moving Images of Postcommunism* (London and New York: Routledge, 2012), pp. 154–70, p. 158.

24 Bial, *Acting Jewish*, p. 92.

25 Beumers, *Nikita Mikhalkov*, p. 94.

26 The horror of Sergei stumbling on the dead corpse of Gombo's relative earlier in the film could be the subconscious discovery of the reality of this war; ironically, a war that is tattooed on his back, but with which a direct connection is never made. In turn, this could be the horror of colonialism that he sees, as the horror identified in Conrad's novel *Heart of Darkness*.

27 Susan Larsen, 'National Identity, Cultural Authority and the Post-Soviet Blockbuster: Nikita Mikhalkov and Aleksei Balabanov', *Slavic Review* 62:3 (2003), pp. 491–511, p. 511; Beumers, *Nikita Mikhalkov*, p. 2.

28 Rouland, 'Images of Eurasia', p. 16.

29 Rouland, 'Images of Eurasia', p. 15.

30 For an analysis of the two brothers' view on history see David Gillespie, 'Reconfiguring the Past: The Return of History in Recent Russian Film', *New Cinemas* 1:1 (2002), pp. 14–23. Michael Rouland (Rouland, 'Images of Eurasia', p. 15) also points out the connection between Stallone and Konchalovsky.

31 A special thanks to Ruby Cheung for pointing this out.

32 Rouland, 'Images of Eurasia', p. 11.

33 Elena Gorfunkel', 'Rustam Ibragimbekov', in Lyobov' Arkus (ed.), *Noveishaya istoriya otetsestvennogo kino 1986–2000: Kinoslovar*, vol. 1 (Sankt-Peterburg: Seans, 2001), pp. 449–50, p. 449.

34 Elena Stishova (ed.), '*Aktual'nye dialogi*', *Territorya kino: Postsovetskoe deasyatiletie* (Moskva: Pomatur, 2001), p. 12.

35 Stishova, '*Aktual'nye dialogi*', *Territorya kino*, p. 12.

References

Arkus, Liubov', 'Nikita Mikhalkov: Ya sdelal kartinu dlya sta millionov inostrantsev zhivuzhikh v moei strane ...', *Seans* 17–18 (1999), pp. 89–91.

Beumers, Birgit, *Nikita Mikhalkov: Between Nostalgia and Nationalism* (London, New York: I.B.Tauris, 2005).

Bial, Henry, *Acting Jewish: Negotiating Ethnicity on the American Stage and Screen* (Ann Arbor, MI: University of Michigan Press, 2005).

Condee, Nancy, *The Imperial Trace: Recent Russian Cinema* (Oxford and New York: Oxford University Press, 2009).

Fanon, Frantz, *A Dying Colonialism*, trans. Haakon Chevalier (Harmondsworth: Pelican Books, 1970).

Faraday, George, *Revolt of the Filmmakers: The Struggle for Artistic Autonomy and the Fall of the Soviet Film Industry* (Pennsylvania, PA: Pennsylvania State University Press, 2000).

Gillespie, David, 'Reconfiguring the Past: The Return of History in Recent Russian Film', *New Cinemas* 1:1 (2002), pp. 14–23.

Gorfunkel', Elena, 'Rustam Ibragimbekov', in Lyobov' Arkus (ed.), *Noveishaya istoriya otetsestvennogo kino 1986–2000: Kinoslovar*, vol. 1 (Sankt-Peterburg: Seans, 2001), pp. 449–50.

Hashamova, Yana, *Pride and Panic: Russian Imagination of the West in Post-Soviet Film* (Bristol and Chicago, IL: Intellect Books, 2007).

Hutchings, Stephen (ed.), *Russia and Its Other(s) on Film: Screening Intercultural Dialogue* (Basingstoke: Palgrave Macmillan, 2008).

Ivanov, M., *Urga: territoriia lyubvi* (n.d.). Online. Available at <http://www.videoguide.ru/card_film.asp?idFilm=19322> (accessed 24 January 2012).

Laitin, David D., *Identity in Formation: The Russian-Speaking Populations in the Near Abroad* (Ithaca, NY, and London: Cornell University Press, 1998).

Larkin, Brian, *Signal and Noise: Media, Infrastructure, and Urban Culture in Nigeria* (Durham, NC, and London: Duke University Press, 2008).

Larsen, Susan, 'National Identity, Cultural Authority and the Post-Soviet Blockbuster: Nikita Mikhalkov and Aleksei Balabanov', *Slavic Review* 62:3 (2003), pp. 491–511.

Martin, Terry, 'An Affirmative Action Empire: The Soviet Union as the Highest Form of Imperialism', in Ronald Grigor Suny and Terry Martin (eds), *A State of Nations: Empire and Nation-Making in the Age of Lenin and Stalin* (Oxford, New York: Oxford University Press, 2001), pp. 67–90.

Peng, Yün, 'Truancy, or Thought from the Provinces: On Jia Zhangke's *Platform*', in Lars Kristensen (ed.), *Postcommunist Film – Russia, Eastern Europe and World Culture: Moving Images of Postcommunism* (London and New York: Routledge, 2012), pp. 154–70.

Rosaldo, Renato, *Culture and Truth: The Remaking of Social Analysis* (Boston, MA: Beacon Press, 1989).

Rouland, Michael, 'Images of Eurasia: Conceptualizing Central Eurasia through Film', unpublished paper presented at Soyuz Symposium, University of Princeton, 12 April 2007.

Segida, Miroslava and Zemlyanukhin, Sergei, *Fil'my Rossii: Igrovoe kino (1995–2000)* (Moskva: Dubl' D, 2001).

Stam, Robert, *Film Theory: An Introduction* (Malden, MA, and Oxford: Blackwell Publishers, 2000).

Stishova, Elena (ed.), *'Aktual'nye dialogi', Territorya kino: Postsovetskoe deasyatiletie* (Moskva: Pomatur, 2001).

Suny, Ronald Grigor and Martin, Terry (eds), *A State of Nations: Empire and Nation-Making in the Age of Lenin and Stalin* (Oxford and New York: Oxford University Press, 2001).

11

The Women Who Weren't There: Russians in Late Soviet Estonian Cinema

Eva Näripea

While Russia and Russians have played a crucial role in Estonian history, having held sway over its territory and nation in various forms of political regime for extended stretches of time, it is somewhat surprising to discover that throughout the better part of the Soviet period Estonian films were characterized by a relative scarcity of Slavic presence. It is all the more remarkable considering the lingering common perception of Soviet Estonian cinema as something essentially alien to the local cultural ecology, precisely because it was a 'Russian invention'. Arguably, in the mid-1940s, the central authorities in Moscow introduced the Soviet film industry to the newly incorporated Estonian SSR 'as a transplant', which for decades to come had very little to do with the organism of native culture, as Lennart Meri noted in 1968.[1] In the following discussion I will provide some insights into the scene of ethnic representations in Soviet Estonian narrative cinema, concentrating on the absences and appearances of the country's eastern neighbours. I will begin by investigating the reasons behind the notable deficit of Russian characters during the first four decades of Soviet rule. In the second

part of the chapter I will take a closer look at a series of films by Leida Laius and Arvo Iho from the final years of the Soviet period, which stand out for their Slavic heroines, as well as for sensitive and intriguing portrayals of the complexities of the late Soviet colonial situation. These films from the period that serves as a transitional era between Communism and postcommunism capture a shift in the attitudes of directors, as well as a certain instability of identities of people represented in them. In my reading I will draw on a few concepts of postcolonialism, including Edward Said's idea of Orientalism and Homi K. Bhabha's notions of 'unhomeliness' and 'double time of the nation', suggesting finally that the female protagonists in Laius's and Iho's films anticipate in a certain respect the fate of Russian minorities in Estonia (and perhaps also in other Baltic republics) after the collapse of the Soviet Union.

No country for Russians?

In the first period of Soviet Estonian film history – between the end of World War II and 1962, the year of a noticeable generation shift – the majority of filmmakers, as well as specific visual and narrative formats, were 'imported' to the Baltic periphery from the Soviet heartland. The plots communicated values and ideologies of the recently instated regime, offering blatantly hollow images of a radiant communist future and whitewashing the atrocities of occupation. Yet a single glance at the lists of their characters reveals to the examiner's astonishment that this freshly established cinematic terrain was populated almost without exception by Estonians. This conspicuous lack of Russian characters can be interpreted as a symptom of a situation where the architects of Soviet ideology strove to create an impression that the country and the local nation had joined the 'friendly international family' of the Soviet Union voluntarily, while in reality they had been subjugated to Russo-Soviet rule by force. That is, from very early on, the conflict was staged as one between ideologies and not between nations, while in reality it was first and foremost the latter. A striking example of this

inclination is *Light in Koordi* (*Valgus Koordis*, Herbert Rappaport, 1951), a story about collectivization in a postwar Estonian village: while Russia is identified as a model, the process itself is shown as carried out by the native inhabitants, among whom the progressively minded young communists triumph over old reactionary farmers and sly schemers.

The tendency to downplay the ethnic conflict and to highlight the purely ideological nature of the battle for the Soviet regime was also testified by the fact that in Estonian narrative cinema of the 1950s the 'bourgeois' West was typically not represented by natives of Western nations, but rather by means of exiled Estonians who returned to their fatherland as capitalist spies, as in films like *Yachts at Sea* (*Jahid merel*, Mikhail Yegorov, 1955) or *Uninvited Guests* (*Kutsumata külalised*, Igor Yeltsov, 1959). Somewhat paradoxically, in this fictional universe of ethnic homogeneity[2] it is not difficult to recognize the workings of the Stalinist narrative of the 'Friendship of Peoples', the two-faced ideology of equality, which under the veil of ethnic egalitarianism or apparent post-nationalism[3] actually strove towards neutralizing non-Russian nations, alongside their allegedly 'counter revolutionary' cultural traditions.[4] This was done by singling out and museumizing certain 'authentic' ethnographic layers of their heterogeneous cultural stratum, as if under a tourist gaze,[5] and deducing constantly evolving practices into static constellations of 'national form', conveniently emptied and ready for a charge of 'socialist content'. Last but not least, the eschewal of national variety also distorted the historically multiethnic structure of Estonian population.

While the generation shift of 1962 led to a greater input from the local filmic talent, more varied patterns of expression and a more nuanced range of cultural values and ideological stances,[6] the overall national structure of film characters diversified only to some extent over the course of the subsequent decades, and eastern neighbours in particular continued to make only rare cinematic appearances. Especially in films with contemporary setting, the screen struggles still tended to pertain to ideological tenets and

general moral values, rather than to different national identities, as seen in films like *Traces* (*Jäljed*, Kaljo Kiisk, 1963), *What Happened to Andres Lapeteus?* (*Mis juhtus Andres Lapeteusega?*, Grigori Kromanov, 1966), *White Ship* (*Valge laev*, Kalju Komissarov, 1970) and many others. *Fellow Villagers* (*Ühe küla mehed*, Jüri Müür, 1962) stands out as an exception, featuring Finns, the northern neighbours and Finno–Ugric 'brothers' of Estonians and projecting thus a fragment of 'actual capitalist West' onto the local screens. At the same time, the sensitive subject of World War II and recent traumas of historical turmoil gained firmer footing on the cinematic arena, and, as a consequence, the cine-ethnic spectrum broadened to a degree. In addition, several films with ethnically mixed casts were set in a slightly more distant history, in the late nineteenth century or the first four decades of the twentieth century.[7] In historical films, Russians and Estonians tended to stand on the same side, sharing the enemy, which most frequently took the shape of a German, be it the Baltic German nobleman (who had been the historical master of the Estonian territory between the Middle Ages and the establishment of the Estonian Republic in 1918[8]) or the Nazi soldier.[9] Nevertheless, it was more typical to see only Estonian protagonists confronted with Germanic antagonists.

How, then, to explain this curiously infrequent appearance of Russian characters on the Soviet Estonian screen? Their relative absence is even more conspicuous considering that the local film ecology was part of the Soviet film industry: the work of republican studios was centrally coordinated in terms of ideological instruction and control, as well as allocation of finances; filmmakers, whatever their ethnic background, were trained exclusively in the metropolitan centre of Moscow; and in theory all films were made for the ethnically diverse audiences in all parts of the USSR. In the first 15 years after the war, when the Estonian film industry was mainly peopled with 'imported' directors and administrators, the high concentration of Estonian characters was, as already suggested above, a result of a conscious ideological strategy, designed to camouflage the rapid change of regime as a forced, involuntary,

enterprise, and intended as an attempt – albeit a futile one – to win over the local audiences. As noted by a number of historians of nationalism in the Soviet Union,[10] a fundamental antinomy split the official policies: on the one hand, Stalin understood a nation as a 'stable community' that shared a 'common language' and his metaphorical 'Friendship of Peoples' 'celebrated non-Russian folk songs, dances, material culture and theater';[11] on the other hand, however, the 'hard-line'[12] institutions (NKVD, KGB) were set up for persecution of 'bourgeois nationalism'. This dissonance, it is suggested, and the inability of the party leaders to find meaningful resolutions, ultimately led to the emergence of nationalist independence movements with *glasnost* in the mid-1980s, resulting in the disintegration of the USSR. Thus it was only natural to emphasize a version of officially sanctioned 'Estonianness' when modelling a new Soviet Estonian cinema in the 1940s and 1950s; one that was firmly rooted in a decorative rendition of airbrushed folk culture. In the 1960s, after the local 'cadres' had taken over the cinematic field from the 'guest artists', the pre-eminence of the native population in film demonstrated, as Joshua J. First has convincingly argued, the fact that '"national cinemas" in the republics [strove to] emphasize national difference over Soviet unity and the "Friendship of People's"', even if the authorities 'later questioned the loyalty of many People's filmmakers who constructed such images of national difference'.[13] I would add, however, that although the apparent prominence of Estonian characters was partly a result of official nationality policies and partly expressed a nationalistic stance of local directors, their choice to abstain from portraying Russians was also an act of self-censorship. First, it could have easily caused controversy with central cinema authorities, in case a story suggested anything but the warmest friendship between the neighbouring communities. Secondly, the filmmakers perhaps sought conciliation with local audiences, who suspected (and not completely without reason) the entire film industry of functioning as a Trojan Horse of Soviet ideology and a carefully masked agent of colonization.

Sleeping with the enemy: only for the crazy?

When Mikhail Gorbachev took office in 1985, ending the gerontocracy of the 'stagnation' era and soon introducing the policies of *perestroika* and *glasnost*, the rules of the game changed considerably. In cinema, the ebbs and flows of creative liberties and censorship gave way to an unconstrained freedom of expression, 'a polyphony of divergent voices'.[14] Previously forbidden topics, the seamy side of the socialist everyday as well as the darkest chapters of history, came to be, as George Faraday has noted, 'pervasive feature[s] of most sectors of cultural production'.[15] Contemporary Russian commentators labelled this general trend with a slang term, *chernukha* (or 'black wave' in Graham's[16] befitting translation), one of the chief characteristics of which was 'an all-encompassing sense of decay and hopelessness that permeates both society and environment'.[17] Importantly, however, as Lynne Attwood[18] has argued, '[g]lasnost' and *perestroika* were interpreted in a distinctly nationalist form in the other republics' and the focal points of the non-Russian films often tended to be slightly different, even though these 'chronicle[s] of social horror' invariably mapped 'a movement away from the visible and the public to the hidden and undiscussed',[19] be it in a contemporary framework or from a historical perspective. Many Estonian feature-length narrative films of the final years of the Soviet system concentrated on the disturbing and sordid facets of both the contemporary and historical times, reflected upon traumatized identities and scarred psyches, both individual and collective, and threw into cinematic relief deformed souls and destinies caught between the cogwheels of epic historical events. The 'liberated' history, unchained from the limitations of ideological shackles, burst with the vigour of a long-grown abscess, leaving no doubt about who and what was to blame for the misery of the violated and abused nation. Russians quickly came to be vilified as the archenemy of the native population, and crimes of the Russo-Soviet regime were unearthed with almost masochistic thoroughness.[20]

Perhaps more intriguing, however, is the way several films explored the colonial situation[21] of the late Soviet period, which over a couple of decades preceding the break of the 'Singing Revolution' in the late 1980s had been generally characterized by adjustment to the regime, rather than by overt resistance to it.

In Soviet Estonian society of the time, the existence of a large non-native community – after all, by 1988 around half of the population of the capital city of Tallinn were mostly Russian-speaking migrants from other parts of the Soviet Union[22] – was an inescapable fact of life, and the different ethnic communities had to communicate on a daily basis. Even though mutual distrust separated the camps of native and non-native inhabitants, their relationships involved a whole gradation of shades, rather than only black-and-white contrasts. Accordingly, a number of films with contemporary subject matter offered valuable insights into these complicated relations. In what follows I will study in more detail three of the perhaps most outstanding examples of the period: Leida Laius's *Stolen Meeting* (*Varastatud kohtumine*, 1988), Arvo Iho's *The Birdwatcher* (*Vaatleja*, 1987) and *The Sister of Mercy – Only for the Crazy* (*Halastajaõde – Ainult hulludele*, 1990).

Stolen Meeting was the last film directed by Leida Laius, the grand lady of Estonian cinema whose oeuvre focused on portrayals of strong female characters.[23] *Stolen Meeting* is no exception in this regard, telling a story of Valentina (from Latin *valens*, 'healthy, strong'), an ex-convict who returns to Estonia after incarceration somewhere in Russia, determined to reunite with her 8-year-old son. Valentina spent her childhood in an orphanage and never knew her parents or their background, yet her name, as well as her temperament, suggests Slavic origin. She went to prison for a small-scale fraud, taking the blame partly for her boss Lembit, an ethnic Estonian. Jüri, their son, was taken to an orphanage after Valentina had officially given him up, but was soon adopted by a childless family of Estonian professionals. Upon her return, Valentina acquires the classified details of the stepfamily, relying on her usual methods of persuasion – lies and blackmail. She then

confronts the step parents who refuse to give up their legal rights to the child or to give in to her threats of exposure, revealing that they have never lied to Jüri about his roots. Valentina, determined to achieve her ultimate goal of raising Jüri herself, kidnaps the child, convinces him that she is his biological mother, but by the end of the day realizes that she is not capable of providing him with a life comparable to or better than he already has. She gives him up for good with one last lie: that she is not his mother after all. The screenplay was created by a Russian scriptwriter, Maria Zvereva, in the early 1980s for Mosfilm, to be directed by her husband, Pavel Chukhrai, but proved to be too controversial for the time. Later, when commissioned by Tallinnfilm to write something for the Estonian studio, Zvereva offered this unused script, which instantly fascinated Laius, who decided to adapt it to suit the current local situation.[24]

The Birdwatcher, released slightly more than a year before *Stolen Meeting*, was the solo directorial debut of Arvo Iho, who had previously collaborated with Leida Laius as a cinematographer on several documentaries and in 1985 as her co-director of *Well, Come On, Smile* (*Naerata ometi*, in Russian *Igry dlya detey shkolnogo vozrasta/ Games for Schoolchildren*), a grim late-Soviet portrayal of an orphanage and its inhabitants. *The Birdwatcher* features a middle-aged Russian woman and a 24-year-old Estonian man. Aleksandra is a forester and poacher who lives on a remote island in a national park in the border zone of the Russian North. Peeter, a student of ornithology at Tartu University, comes to the national park for fieldwork (birdwatching). Their cougarian romance oscillates between love and hate, lust and contempt, and comes to a tragic finale when Peeter dies because of a crossbow trap hidden in the woods by Aleksandra. In Iho's next film, *The Sister of Mercy*, it is the 'older woman' who has to die. Margarita, a Russian nurse working in an Estonian small-town hospital tends to a young Estonian man, Johan, after his suicide attempt. While the doctors resort to conventional means of treating depression, including drugs and psychological counselling, Margarita successfully employs

an unorthodox technique – mercy sex. As suggested later in the film, this is not the first time she has done so, but this time she is stigmatized publicly for her unusual compassion: a local newspaper discloses and condemns her immoral and un-Soviet behaviour, and even though it is done apparently 'anonymously', her identity is unmistakable to the inhabitants of the provincial town. In addition, Viktor, Johan's jealous father-in-law, is eager to seek revenge for the unfaithfulness of his daughter's husband. Besides being overprotective of his daughter, Viktor also projects onto Margarita his own misogyny, caused by his 'cuckoo mother' wife who left him and their infant daughter for another man. After running into Margarita and Johan while they are taking a rather romantic early-morning (yet, importantly, not post-coital) stroll, Viktor beats her up and Margarita dies of her injuries in an ambulance.

Both *The Birdwatcher* and *The Sister of Mercy* were scripted by Marina Sheptunova, a young Russian author who had earlier written the screenplay for *Well, Come on, Smile*. Laius's and Iho's decision to collaborate with Russian scriptwriters testifies to an important shift of attitude by Estonian filmmakers towards their Russian colleagues. Over the previous decades, script-consultants (and also scriptwriters) had been appointed to the peripheral studios by the central authorities in Moscow as part of censorship strategies. Voluntary cooperation with Russians beyond the republican borders was rather untypical in the 1960s and the 1970s – invited artists, most often actors, cinematographers and occasionally also scriptwriters, came predominantly from the republics situated in the western part of the USSR, i.e. Latvia, Lithuania, the Ukraine and Byelorussia. Laius's and Iho's decisions are thus unconventional, but also symptomatic of their identity as 'hybrids', in Homi K. Bhabha's sense, of the late-socialist colonial situation. Moreover, neither Laius nor Iho were 'pure' Estonians, neither ethnically or culturally: Laius, who had been born (to Estonian parents) and educated in Russia, was tainted for life in the eyes of Estonian nationalists because of speaking Estonian with a noticeable Russian accent, while Iho's ancestors were Ingrian Finns, members of a small

ethnic group with a very complicated history; at the same time he shared 'the same blood type' with Russians,[25] as testified by a fellow Estonian filmmaker, and sought their company through both professional and personal contacts, eschewing thus the distrust of the eastern neighbours typical of his Estonian colleagues. In addition, both directors cast Russians in the main roles: Laius's Valentina is played by Maria Klenskaja, an Estonian actress of Russian descent (and another 'hybrid' personality), Iho cast Svetlana Tormakhova in Aleksandra's role and Margarita Terekhova, known to international audiences from Andrei Tarkovsky's[26] *Mirror* (*Zerkalo*, 1975), in Margarita's role.

Although Valentina, Aleksandra and Margarita are undoubtedly women of strong character; courageous and uncompromising figures, they are also equally clearly inhabiting the margins of society, one way or another: Valentina as a homeless and unemployed ex-prisoner; Aleksandra as a forester and poacher on an extremely distant island, literally on the border of (Soviet) civilization; and Margarita as an outcast nurse in a provincial hospital. Indeed, the films are torn by a number of apparent dissonances. Perhaps most conspicuous of them is the fact that although scripted by Russian women, their Slavic female protagonists are portrayed in a clearly Orientalizing manner. This becomes especially evident in *The Birdwatcher* where the polarities of the two main characters work for the effect of mutual amplification. Conflicts of this kind testify to the fact that has been recognized by several commentators of postcolonial thought: namely that in addition to power relations of a colonial type the inequalities of 'gender power' have to be taken into account.[27]

Aleksandra has a criminal mind, in the manner of a true *Homo Sovieticus* – she poaches endangered animals and valuable fish, and stops at nothing when the well-being of her loved ones is at stake; ready to bribe her superiors for a new roof or doctors for a permit to send her sick child to a sanatorium; or selling illegally acquired meat on a market, thus risking a penalty for profiteering;[28] she is even prepared to kill another human being when her livelihood and way

Figure 11.1
The Birdwatcher. A production still. Photo by Arvo Iho

of life are in danger. The 24 year-old student, Peeter, conversely, appears to stand for law and order, threatening to denounce Aleksandra's illegal activities to the authorities and cutting up her fishing nets when the wild huntress refuses to take him to the nearest centre on her boat. Peeter's rationality – he is, after all, a scientist – sophistication and contemplative nature (birdwatching!) stands in sharp contrast to Aleksandra's relatively uncultured manners, even barbarity and aggressive sexuality – it is she who makes the first move in their romance. Peeter's occupation is by definition non-intrusive, while Aleksandra exploits nature and the reserve to her own advantage; for example, she brings a rabbit to Peeter as a pet and soon serves it for dinner, to Peeter's utter shock. Peeter cleans and repairs Aleksandra's humble property, while Aleksandra pollutes the environment aurally with her portable radio. The binary oppositions of the two figures can be summarized as mind versus body; sanity versus passion; naiveté/idealism versus cynicism.

At the same time, Aleksandra behaves as a colonizer, invading space and using up nature without thinking of the consequences, which renders her a savage, orientalized, colonizer.

Indeed, it is not difficult to see in these opposed characters a correlation with ideas proposed by Edward Said who demonstrated in his seminal study, *Orientalism*,[29] that Orientalist discourse is 'based upon an ontological and epistemological distinction between "the Orient" and "the Occident"',[30] describing the West as 'rational, developed, humane, superior' and the Orient as 'aberrant, undeveloped, inferior'.[31] More precisely, Easterners are

> irrational, [while] Europeans are rational; if the former are barbaric, sensual, and lazy, Europe is civilization itself, with its sexual appetites under control and its dominant ethic that of hard work; if the Orient is static, Europe can be seen as developing and marching ahead; the Orient has to be feminine so that Europe can be masculine.[32]

While I also agree with Ewa Mazierska's observation that according to Said, 'Orient is a Western creation … even a disguised self-reflection', it is clear that in *The Birdwatcher*, but also in *Stolen Meeting*, besides being 'a spitting image of the West',[33] Russia functions to a considerable degree as a negative model against which Estonian 'Westernness' is constructed. This is not surprising if one is to consider that the roots of Estonian nationalism reach back to the Baltic-German Estophilia of the Enlightenment era and that throughout the subsequent decades of national awakening in the late nineteenth and early-twentieth centuries, as well as in times of conscious nation-building during the interwar years of independent statehood, the Estonian and Baltic collective imaginary strove towards the Western world, acquiring eventually the status of 'Soviet West' of the USSR, *un occidente kidnappé*, just as Central Europe had been according to Milan Kundera.[34]

Aleksandra and Peeter's affair is indeed symbolic of the complicated relationship between Russia and the Baltic countries it subjugated to its power: the fear and loathing of the 'Russian bear'

– here incarnated as Aleksandra, the 'Mother Russia' – by its small powerless neighbours who consider themselves as representatives of enlightened and rational Western civilization, standing culturally 'above' their 'savage colonizers'; at the same time, however, they will not turn down an opportunity to exploit the advantages the 'motherland' has to offer for their own personal gain and pleasure. But the ultimate sympathies of the film seem to lie with neither and with both: Aleksandra is admired for her exotic otherness, for her untamed passion, which is at the same time precisely what makes her the appalling Other; Peeter's sensitivity towards wildlife – another marker of an Orientalizing viewpoint – is unquestionably appreciated, especially in comparison with Aleksandra's abrupt mercilessness, yet his shallow obedience to law signals hypocrisy and cowardly self-absorption and in general he seems to embody a certain kind of Western ethos, described as 'puritanical, Manichean, utilitarian [and] productivist' by Robert Stam,[35] that is not presented in a flattering light. Furthermore, his inability to survive casts him as a victim of his own failure to adapt to (let alone conquer) the *terra incognita* of Aleksandra's world.

At the same time, however, *The Birdwatcher* communicates additional standpoints that undermine this Orientalizing reading, the main one being precisely the fact that it is Peeter who dies in the end. Aleksandra is the one who conquered nature and outsmarted the 'system', being thus more active, while Peeter, although more dynamic in terms of travelling long distances, is strikingly disempowered and passive (including towards Aleksandra's illegal activities), which leads to his ultimate demise. Thus, even though Aleksandra is portrayed in an Orientalizing manner, Peeter, a member of a small colonized nation, is not – and cannot become – the source of the colonial gaze. Furthermore, his death is hardly that of a martyr, even if it is not difficult to read him as a symbol of the Estonian nation; rather, the film employs Aleksandra and Peeter as loci for highlighting and critiquing certain national stereotypes, shaped and sustained due to the above-described Soviet nationalism policies and Estonian resistance to them.

Figure 11.2
The Sister of Mercy. A production still. Photo by Arvo Iho

By contrast to vigorous and down-to-earth Aleksandra, who is almost intolerably carnal and aggressive, making her somewhat repulsive, Margarita's Mary Magdalene-like subtle sexuality and almost literal martyrdom render her the most sympathetic character of *The Sister of Mercy.* Her presentation as a saintly figure comes especially to the fore in a scene towards the end of the film, immediately before she is beaten to death by Viktor, where Olav, the hospital's lascivious head of surgery, demotes Margarita to orderly, because her improper liaison with Johan has become public, and at the same time asks for her hand in marriage, suggesting that it might make him reconsider. Margarita declines his offer and in the next shot the camera pans from an Orthodox icon depicting the Archangel Michael to Margarita scrubbing the hospital floor on hands and knees, the corridor resembling an aisle of a church. The camera then follows her upward gaze to show an image of a church vault, as the soundtrack plays a sequence from Gustav

Figure 11.3
Margarita Terekhova as Rita in *The Sister of Mercy*

Mahler's Symphony No. 4, a part of a song *Das himmlische Leben* that presents a child's vision of Heaven. Soon the song, presented as a diegetic melody coming from a radio, is accompanied with the same tune played on a flute by Johan, suggesting thus that his admiration of and gratitude to Margarita reach beyond merely sexual favours. Yet, on closer inspection, despite Margarita's ethnic belonging, the film's lines of fire refuse to run unproblematically along the ethnic lines of division. For instance, Viktor speaks Estonian but his name suggests that he might not be Estonian after all. Similarly, even though Rita's husband, Andres, has an Estonian (or more broadly Western) name and speaks Estonian with his wife and daughter, his mother, Siina, communicates only in Russian, but her ethnic belonging is blurred by the fact that she is played by a Latvian actress, Vija Artmane. All in all, these ambiguities refer to the intricate intertwining of personal and social relations in the late Soviet colonial situation on the one hand, and to an

opinion that Iho's films 'subordinate the social to the moral, not to the political'[36] on the other hand. It is quite difficult to detect any straightforward subscription to Estonian nationalism in Iho's films; rather, they speak of the corruptive influence of the officially atheist and essentially duplicitous Soviet regime on ordinary citizens, no matter what their nationality, as well as on the natural and man-made environment. Equally, Iho suggests that kindness and grace, but also viciousness, are supranational traits, and that one should value the former and denounce the latter without any consideration of ethnic belonging. Yet, it is also clear that Iho's avoidance of overtly nationalistic stances is in itself a political, not just a moral position. In addition, his choices of representation regarding characters point to the hybrid nature of Estonian society after over 40 years of Soviet rule.

A sense of universal social alienation and of fundamental unhomeliness is perhaps the most remarkable common denominator of all three films, being especially prominent in *Stolen Meeting*. As Homi K. Bhabha has suggested, 'the "unhomely" is a paradigmatic colonial and post-colonial condition';[37] 'the "unhomed" subject lives *somewhere* in the purely physical sense, yet figuratively occupies an intermediary space which makes it difficult for her to know where she belongs, socially and culturally. The "unhomed" subject dwells in a border zone, "as though in parenthesis"'.[38] Valentina in *Stolen Meeting* is an unhomed subject *par excellence*, having grown up without any idea of her background, in an orphanage in north eastern Estonia, a part of the country bordering Russia that was turned into a veritable no man's land during the Soviet period when industrial oil shale mining played an important role in populating the area with workers sent from different parts of the USSR. In the film, this region, with its dilapidated Stalinist architecture, polluted environment and damaged industrial landscapes, signifies the utter deterioration of the Soviet system. Valentina, its true 'child', knows no home other than the orphanage, the prison camp and dirty workers' dormitories, she has no private space and no address, as she confesses to Jüri in the

final scene. Meanwhile, Jüri and his stepfamily live in Tartu, Estonia's university town, in the district of Tähtvere, which is the environment of the Estonian intellectual elite, designed and developed in the interwar period by the best Estonian architects. On the face of it, Laius, then, paints an intensely polarized picture: the 'unhomely' Ida-Viru/Valentina on the one hand, and the deeply nationally rooted Tartu/Jüri's stepparents on the other hand. Yet at the same time Ida-Viru is not exclusively populated by Russians, just as there is a darker side to Tartu's air of sophistication. The home of Jüri's stepparents is 'unhomed' not only by Valentina's intervention; it is unhomed by the fact that it is located in Soviet Estonia, and is therefore firmly embedded in the colonial situation. Thus I would suggest that in Laius's film, as well as in Iho's works, the apparent rootedness of Estonian characters is severely compromised by the prevailing sense of the 'unhomeliness', generated in the late Soviet 'condition of extra-territorial and cross-cultural initiations'.[39] According to Bhabha, the 'unhomely moment creeps up on you as stealthily as your own shadow'.[40] Laius's and Iho's Slavic protagonists indeed function as shadows of this kind, highlighting the 'real sameness of the colonized population'.[41] Ultimately, then, these films seem to communicate the idea that the two neighbouring ethnic communities, no matter how arguably different by some essentialist 'nature', share the same mental territory, determined by the all-embracing colonial situation. By refusing to simply vilify their Russian heroines or to reserve only positive traits for Estonian characters, Laius and Iho occupy a position which could perhaps be considered as genuinely post-national and postcolonial, critiquing both nationalist misconceptions (e.g. that all Russians equal colonizers and all Estonians equal victims of violent colonization) and the disastrous effects of Soviet imperialism.

In sum, I propose that Laius's and Iho's films, for their 'agonizing and traumatic negotiations'[42] of colonial relations, can be read in the framework of Bhabha's 'double time of the nation' as examples of the 'performative temporality', 'representing those residual and

emergent meanings and practices that [reside] in the margins of the contemporary experience of society'.[43] In opposition to a number of other Estonian films of the period that took the chance of reconstituting the 'homogeneous time of a pedagogy of the nation', narrating the previously suppressed historical traumas of World War II, Laius and Iho create 'space for negotiating new cultural demands, changes, resistances', destabilizing the pedagogical narrative of the nation and providing 'other narratives, narratives from the marginalized, migrants and minorities', producing thus 'a space where minority discourses emerge'.[44] As Russian women in Estonia, Margarita and Valentina represent an unprivileged segment of the population who became even more marginalized in the postcommunist Estonian nation state, displaced in the turmoil of history and disempowered in the process of radical redrawing of the region's political map. Their cases also testify to the fact that any (post)colonial situation is deeply affected by other forms of domination besides those induced by colonialism.

Notes

1 Lennart Meri, 'Suur üksiklane', *Sirp ja Vasar*, 9 February 1968; see also Tatjana Elmanovitš, 'Väljamurd üksildusest. Kaotused ja võidud', *Sirp ja Vasar*, 6 June 1987 and Tiina Lokk, 'Eesti kultuuri Suur Üksiklane – kaua veel?', *Postimees*, 7 April 2004.

2 For the sake of a fair picture it has to be mentioned that a few films with entirely Russian and/or non-Estonian cast were also made during the Soviet period, such as *Captain of the First Rank* (*Esimese järgu kapten*, Aleksandr Mandrykin, 1958) or *Diamonds to the Dictatorship of the Proletariat* (*Briljandid proletariaadi diktatuurile* / *Brillianty dlia diktatury proletariata*, Grigori Kromanov, 1975), both of which are, rather unsurprisingly, more or less 'written out' of Estonian film history, although the latter is extremely popular in Russia even to this date.

3 See, for example, Joshua J. First, *Scenes of Belonging: Cinema and the Nationality Question* (unpublished PhD thesis, University of Michigan, 2008), pp. 3–4.

4 Cf.: 'Soviet propaganda, while praising internationalism and demanding freedom for the oppressed movements and nations of the "Third World", was quite simply diverting attention from its own actions: Russification, the total subordination to itself and the economic exploitation of the non-Russian republics and the political and economic domination of the countries and nations incorporated into the Eastern Bloc' (Janusz Korek, 'Central and Eastern Europe from a Postcolonial Perspective', *Postcolonial Europe* (n.d.). Online. Available at <http:// www.postcolonial-europe.eu/index.php/en/essays/60--central-and-eastern-europe-from-a-postcolonial-perspective> (accessed 26 May 2011)).

5 John Urry, *The Tourist Gaze: Leisure and Travel in Contemporary Societies* (London: Sage, 1990).

6 See Eva Näripea, 'Nature, Movement, Liminality: Representing the Space of the Nation in 1960's Estonian Cinema', *Regioninės studijos* 5 (2010), pp. 89–107.

7 For example, *Spring* (*Kevade*, Arvo Kruusement, 1969), *Windy Shore* (*Tuuline rand*, Kaljo Kiisk, 1971), *Red Violin* (*Punane viiul*, Kaljo Kiisk, 1974), *Indrek* (Mikk Mikiver, 1975), *For the Price of Death, Ask the Dead* (*Surma hinda küsi surnutelt*, Kaljo Kiisk, 1977), *Christmas in Vigala* (*Jõulud Vigalas*, Mark Soosaar, 1980), *Lurich* (Valentin Kuik, 1984).

8 Baltic-German noblemen appeared in films like *Milkman of Mäeküla* (*Mäeküla piimamees*, Leida Laius, 1965), *The Last Relic* (*Viimne reliikvia*, Grigori Kromanov, 1969), *Between Three Plagues* (*Kolme katku vahel*, Virve Aruoja, 1970), *Stone of Blood* (*Verekivi*, Madis Ojamaa, 1972), *Pastor of Reigi* (*Reigi õpetaja*, Jüri Müür, 1978), *The Age of Dog-Eat-Dog* (*Hundiseaduste aegu*, Olav Neuland, 1984).

9 Nazis were portrayed in *Ice-Drift* (*Jääminek*, Kaljo Kiisk, 1962), *Dark Windows* (*Pimedad aknad*, Tõnis Kask, 1968), *Madness* (*Hullumeelsus*, Kaljo Kiisk, 1968), *Little Requiem for Harmonica* (*Väike reekviem suupillile*, Veljo Käsper, 1972), *Light in the Night* (*Tuli öös*, Valdur Himbek, 1973), *Dangerous Games* (*Ohtlikud mängud*, Veljo Käsper, 1974), *Requiem* (*Reekviem*, Olav Neuland, 1984), *Trees Were ...* (*Puud olid ...*, Peeter Simm, 1985), *Under a Foreign Name* (*Võõra nime all*, Peeter Urbla, 1986).

10 For example, Yuri Slezkine, 'The USSR as a Communal Apartment, or How a Socialist State Promoted Ethnic Particularism', *Slavic Review* 53:2 (1994), pp. 414–52; Ronald Suny, *Revenge of the Past: Nationalism, Revolution, and the Collapse of the Soviet Union* (Stanford, CA: Stanford University Press, 1993); Terry Martin, *The Affirmative Action Empire: Nations and Nationalism in the Soviet Union, 1923–1939* (Ithaca, NY: Cornell University Press, 2001).

11 First, *Scenes of Belonging*, pp. 2–3.

12 Martin, *The Affirmative Action Empire*, pp. 21–3.

13 First, *Scenes of Belonging*, p. 5.

14 Andrew Horton and Michael Brashinsky, *The Zero Hour: Glasnost and Soviet Cinema in Transition* (Princeton, NJ: Princeton University Press, 1992), p. 5.

15 George Faraday, *Revolt of the Filmmakers: The Struggle for Artistic Autonomy and the Fall of the Soviet Film Industry* (University Park, PA: Pennsylvania State University Press, 2000), pp. 174–5.

16 Seth Graham, '*Chernukha* and Russian film', *Studies in Slavic Cultures* 1 (2000), p. 9.

17 Gerald McCausland, 'Katia Shagalova: Once upon a Time in the Provinces (*Odnazhdy v provintsii*, 2008)', *Kinokultura* 24 (2009). Online. Available at <http://www.kinokultura.com/2009/24r-odnazhdy.shtml> (accessed 18 May 2011).

18 Lynne Attwood (ed.), *Red Women on the Silver Screen: Soviet Women and Cinema from the Beginning to the End of the Communist Era* (London: HarperCollins, 1993), p. 102.

19 Emma Widdis, 'An Unmappable System: The Collapse of Public Space in Late-Soviet Film', *Film Criticism* 21:2 (1996), p. 13.

20 In films like *Awakening* (*Äratus*, Jüri Sillart, 1990), *A Human Who Wasn't There* (*Inimene, keda polnud*, Peeter Simm, 1990), *The Only Sunday* (*Ainus pühapäev*, Sulev Keedus, 1991), *Peace Street* (*Rahu tänav*, Roman Baskin, 1991), *The Sunny Kids* (*Noorelt õpitud*, Jüri Sillart, 1992), all produced before the collapse of the USSR.

21 Epp Annus proposes that in the case of the Baltic countries it is more pertinent to talk about Soviet occupation that 'developed into a colonial situation' (Epp Annus, 'The Problem of Soviet Colonialism in

the Baltics', *Journal of Baltic Studies* (2011), DOI:10.1080/01629778.20
11.628551. Online. Available at <http://dx.doi.org/10.1080/0162977
8.2011.628551> (accessed 5 February 2012).

22 While in 1934 Estonians formed c. 85 per cent of the population of
138,000 inhabitants of Tallinn, in 1988, out of more than 0.5 million
Tallinners, only 47 per cent were ethnic Estonians.

23 On her earlier films and a short biography, see Olev Remsu, 'Aastad
ja filmid. Essee Leida Laiusest', *Teater. Muusika. Kino* 11 (1986), pp.
20–33.

24 See also Attwood: *Red Women on the Silver Screen*, pp. 247–8. Significantly,
we learn from Attwood's book that 'Zvereva had tentative plans to
write another script for the same director. This would be a modern
version of the Romeo and Juliet story, about an Armenian boy and an
Estonian girl. "Estonians are from the north, so the cultures are very
different. Estonians don't even want to deal with Russians, and they see
Armenians as still worse. We are the "last empire" – we have so many
nationalities and we are being torn apart by the tensions between them.
I want to show that love can be stronger than nationalism' (Attwood:
Red Women on the Silver Screen, p. 248).

25 However, this has not prevented him from admiring the numerous
Finno-Ugric ethnic groups living in Russia and especially in Siberia
and the extreme North who belong to the 'Fourth World' of indigenous
peoples. Iho's later film, *The Heart of the Bear* (*Karu süda*, 2001) is an
expression of his somewhat essentialist sympaties towards their ancient
cultures.

26 Andrei Tarkovsky had been the advisor of Iho's and Peeter Simm's
diploma films at VGIK (*Promenade/ Promenaad* and *Tattoo/ Tätoveering*),
released as parts I and III of an anthology film *Daisy Game* (*Karikakramäng*,
1977). Iho also assisted on the shoot of Tarkovsky's *Stalker*, filmed
between 1975 and 1978 partly in and near Tallinn (see Arvo Iho,
'Kummardus Andrei Tarkovskile', in Riina Schutting (ed.), *Kummardus
Andrei Tarkovskile* (Tallinn: Püha Issidori Õigeusu Kirjastusselts, 2001),
pp. 251–8).

27 See, for example, Robert J.C. Young, *Postcolonialism: An Historical
Introduction* (Malden, MA, and Oxford: Blackwell, 2001), pp. 9–10;

Anne McClintock, 'The Angel of Progress: Pitfalls of the Term "Post-Colonialism"', *Social Text* 31–32 (1992), p. 92.

28 It is important to remember that the late 1980s were the times of severe food shortages in the Soviet Union, and even the most basic goods were in short supply.

29 Edward W. Said, *Orientalism* (New York: Vintage Books, 1978).

30 Said, *Orientalism*, p. 3.

31 Said, *Orientalism*, p. 300.

32 Ania Loomba, *Colonialism/Postcolonialism* (London and New York: Routledge, 1998), p. 47.

33 Ewa Mazierska, *Nabokov's Cinematic Afterlife* (Jefferson, NC: McFarland & Company, 2011), p. 106.

34 Cited in Iver B. Neumann, *Uses of the Other: "The East" in European Identity Formation* (Manchester: Manchester University Press, 1999), p. 103.

35 Robert Stam, 'Eurocentrism, Afrocentrism, Polycentrism: Theories of Third Cinema', *Quarterly Review of Film & Video* 13:1–3 (1991), p. 231.

36 Horton and Brashinsky, *The Zero Hour*, p. 237.

37 Homi K. Bhabha, *The Location of Culture* (London and New York: Routledge, 1994), p. 9.

38 Kathleen J. Cassity, 'Emerging from Shadows: The "Unhomed" Anglo-Indian of *36 Showringhee Lane*' (n.d.). Online. Available at <http://home.alphalink.com.au/~agilbert/chowri~1.html> (accessed 23 May 2011).

39 Bhabha, *The Location of Culture*, p. 9.

40 Bhabha, *The Location of Culture*, p. 9.

41 David Huddart, *Homi K. Bhabha* (London and New York: Routledge, 2006), p. 5.

42 Patricia Pisters, 'Homi K. Bhabha', in Felicity Colman (ed.), *Film, Theory and Philosophy: The Key Thinkers* (Durham: Acumen, 2009), p. 300.

43 Bhabha, *The Location of Culture*, p. 148.

44 Pisters, 'Homi K. Bhabha', p. 302.

References

Annus, Epp, 'The Problem of Soviet Colonialism in the Baltics', *Journal of Baltic Studies* (2011), DOI:10.1080/01629778.2011.628551. Online. Available at <http://dx.doi.org/10.1080/01629778.2011.628551> (accessed 5 February 2012).

Attwood, Lynne (ed.), *Red Women on the Silver Screen: Soviet Women and Cinema from the Beginning to the End of the Communist Era* (London: HarperCollins, 1993).

Bhabha, Homi K., *The Location of Culture* (London and New York: Routledge, 1994).

Cassity, Kathleen J., 'Emerging from Shadows: The "Unhomed" Anglo-Indian of *36 Showringhee Lane*' (n.d.). Online. Available at <http://home.alphalink.com.au/~agilbert/chowri~1.html> (accessed 23 May 2011).

Elmanovitš, Tatjana, 'Väljamurd üksildusest. Kaotused ja võidud', *Sirp ja Vasar*, 6 June 1987.

Faraday, George, *Revolt of the Filmmakers: The Struggle for Artistic Autonomy and the Fall of the Soviet Film Industry* (University Park, PA: Pennsylvania State University Press, 2000).

First, Joshua J., *Scenes of Belonging: Cinema and the Nationality Question* (unpublished PhD thesis, University of Michigan, 2008).

Graham, Seth, '*Chernukha* and Russian film', *Studies in Slavic Cultures* 1 (2000), pp. 9–27.

Horton, Andrew and Brashinsky, Michael, *The Zero Hour: Glasnost and Soviet Cinema in Transition* (Princeton, NJ: Princeton University Press, 1992).

Huddart, David, *Homi K. Bhabha* (London and New York: Routledge, 2006).

Iho, Arvo, 'Kummardus Andrei Tarkovskile', in Riina Schutting (ed.), *Kummardus Andrei Tarkovskile* (Tallinn: Püha Issidori Õigeusu Kirjastusselts, 2001), pp. 251–8.

Korek, Janusz, 'Central and Eastern Europe from a Postcolonial Perspective', *Postcolonial Europe* (n.d.). Online. Available at <http://www.postcolonial-europe.eu/index.php/en/essays/60--central-and-eastern-europe-from-a-postcolonial-perspective> (accessed 26 May 2011).

Lokk, Tiina, 'Eesti kultuuri Suur Üksiklane – kaua veel?', *Postimees*, 7 April 2004.

Loomba, Ania, *Colonialism/Postcolonialism* (London and New York: Routledge, 1998).

Martin, Terry, *The Affirmative Action Empire: Nations and Nationalism in the Soviet Union, 1923–1939* (Ithaca, NY: Cornell University Press, 2001).

Mazierska, Ewa, *Nabokov's Cinematic Afterlife* (Jefferson, NC: McFarland & Company, 2011).

McCausland, Gerald, 'Katia Shagalova: Once upon a Time in the Provinces (Odnazhdy v provintsii, 2008)', *Kinokultura* 24 (2009). Online. Available at <http://www.kinokultura.com/2009/24r-odnazhdy.shtml> (accessed 18 May 2011).

McClintock, Anne, 'The Angel of Progress: Pitfalls of the Term "Post-Colonialism"', *Social Text* 31–32 (1992), pp. 84–98.

Meri, Lennart, 'Suur üksiklane', *Sirp ja Vasar*, 9 February 1968.

Näripea, Eva, 'Nature, Movement, Liminality: Representing the Space of the Nation in 1960's Estonian Cinema', *Regioninės studijos* 5 (2010), pp. 89–107.

Neumann, Iver B., *Uses of the Other: "The East" in European Identity Formation* (Manchester: Manchester University Press, 1999).

Pisters, Patricia, 'Homi K. Bhabha', in Felicity Colman (ed.), *Film, Theory and Philosophy: The Key Thinkers* (Durham: Acumen, 2009), pp. 296–307.

Remsu, Olev, 'Aastad ja filmid. Essee Leida Laiusest', *Teater. Muusika. Kino* 11 (1986), pp. 20–33.

Said, Edward W., *Orientalism* (New York: Vintage Books, 1978).

Slezkine, Yuri, 'The USSR as a Communal Apartment, or How a Socialist State Promoted Ethnic Particularism', *Slavic Review* 53:2 (1994), pp. 414–52.

Stam, Robert, 'Eurocentrism, Afrocentrism, Polycentrism: Theories of Third Cinema', *Quarterly Review of Film & Video* 13:1–3 (1991), pp. 217–37.

Suny, Ronald, *Revenge of the Past: Nationalism, Revolution, and the Collapse of the Soviet Union* (Stanford, CA: Stanford University Press, 1993).

Urry, John, *The Tourist Gaze: Leisure and Travel in Contemporary Societies* (London: Sage, 1990).

Widdis, Emma, 'An Unmappable System: The Collapse of Public Space in Late-Soviet Film', *Film Criticism* 21:2 (1996), pp. 8–24.

Young, Robert J.C., *Postcolonialism: An Historical Introduction* (Malden, MA, and Oxford: Blackwell, 2001).

Index

INDEX

6. For a full account of the Bartholome case, see the *Los Angeles Times* for Sunday, October 19, 1986, Part II, p. 1.

13. Society

1. Richard J. Gelles, College of Arts and Sciences, University of Rhode Island, and Murray A. Straus, Department of Sociology, University of New Hampshire. Paper presented at the Seventh National Conference on Child Abuse and Neglect, Chicago, November 11, 1985.
2. Timothy A. Smith and Jon R. Conte, unpublished data taken from a survey of offenders at Northwest Treatment Associates, Seattle, Washington, 1984.
3. Following a year-long investigation, the Senate Permanent Subcommittee on Investigations concluded that there were, at most, about two thousand pedophile-pornographers at work in this country, that organized crime played no part in the trade, and that "what commercial child pornography does exist in the United States constitutes a small portion of the overall pornography market and is deeply underground."
4. Pornography featuring adults must still meet the obscenity test, as embodied in the Supreme Court's 1973 decision in *Miller v. California*, before it can be judged illegal. Such a test, the Court wrote, should determine whether an "average person," applying contemporary community standards, would find that the work in question, taken as a whole, appeals to the "prurient interest," whether it depicts sexual conduct "in a patently offensive way," and whether the work, taken as a whole, "lacks serious literary, artistic, political, or scientific value."
5. *Atlantic Monthly*, September 1986, p. 37.
6. Roman Polanski, *Roman* (New York: Ballantine Books, 1985), 358.

10. Justice

1. As with other fundamental constitutional questions, the answer will probably not come all at once. Rather, it is likely to emerge over several years, in the form of decisions in a series of related cases. In one such case, decided in February 1987, the Supreme Court said that a father accused of sexually abusing his daughters did not have the right to examine confidential state records for clues to who had accused him. A potentially more significant opinion was handed down in June of the same year, when the Court suggested — really for the first time — that it might be willing to provide substantial special protections for the victims of child abuse, and at the expense of those accused of having abused them. By a vote of six to three, the justices ruled that a defendant in a Kentucky child abuse case did not have a constitutional right to attend a pretrial competency hearing for his victims. The ruling reinstated the conviction of a man who had been found guilty of sodomizing three young children but whose sentence had been overturned by the Kentucky supreme court on the ground that the trial judge's decision to exclude the man from the victims' competency hearing had violated his Sixth Amendment rights. Writing for the majority, Associate Justice Harry A. Blackmun noted that the Sixth Amendment guaranteed a defendant the right to be present at any stage of the criminal proceeding that is critical to the outcome of the proceeding, "if his presence would contribute to the fairness of the procedure." But the defendant's presence at a competency hearing was deemed not to be critical, since it had not involved the discussion of substantiative testimony by any of the victims. In its decision, the Court did not address any of the really big questions raised by child abuse cases, such as whether such a defendant has a right to confront his or her accuser at the trial itself.
2. *Los Angeles Times*, February 11, 1985, p. 14.

11. Therapy

1. Peggy Smith, Marvin Bohnstedt, Elizabeth Lennon, and Kathleen Grove, "Long-Term Correlates of Child Victimization: Consequences of Intervention and Non-Intervention," National Center on Child Abuse and Neglect, 1985.
2. Judith V. Becker, Jerry Cunningham-Rathner, Meg S. Kaplan, "The Adolescent Sexual Perpetrator" (in press).

12. Prevention

1. New York: Tom Doherty Associates, 1985.
2. Jon R. Conte, Carole Rosen, and Leslee Saperstein, "An Analysis of Programs to Prevent the Sexual Victimization of Children," presented to the Fifth International Congress on Child Abuse and Neglect, September 16–19, 1984. Montreal, Canada.
3. Douglas J. Besharov, " 'Doing Something' about Child Abuse," *Harvard Journal of Law and Public Policy* 8 (1985): 539–589.
4. October 10, 1984, Part II, p. 1.
5. C. Henry Kempe, "The Pediatrician's Role in Child Advocacy and Preventive Pediatrics," *American Journal of Diseases of Children* 132 (1978): 255–260.

child, except for its cultural conditioning, should be disturbed at having its genitalia touched, or disturbed at seeing the genitalia of other persons, or disturbed at even more specific sexual contacts."

6. Unpublished data compiled by Rob Freeman-Longo, director, Sex Offender Unit, Oregon State Hospital, Salem, Oregon.

7. Lewis Carroll was the pen name of nineteenth-century Oxford mathematician Charles Dodgson, the author of the classic children's stories *Alice's Adventures in Wonderland* and *Through the Looking-Glass*. Dodgson's penchant for photographing young girls in various stages of undress is less well known.

8. J. A. Inciardi, Division of Criminal Justice, University of Delaware. U.S. Congress. Senate. Committee on Governmental Affairs. *Child Pornography and Pedophilia*. 2 vols. 99th Cong., 1st sess., 1985.

9. Testimony of Joseph Henry. U.S. Congress. Senate. Committee on Governmental Affairs. *Child Pornography and Pedophilia*. 2 vols. 99th Cong., 1st sess., 1985.

10. Costello, John, *Virtue under Fire* (Boston: Little, Brown and Company, 1986).

11. Kenneth V. Lanning and Ann W. Burgess, "Child Pornography and Sex Rings," *FBI Law Enforcement Bulletin*, January 1984, p. 10.

12. Testimony of Joseph Henry. U.S. Congress. Senate. Committee on Governmental Affairs. *Child Pornography and Pedophilia*. 2 vols. 99th Cong., 1st sess., 1985.

13. Luis Johnson, sentenced to 527 years, a California record, is being held on death row at San Quentin, the only place where prison authorities say they can protect him from other inmates. Whether or not they succeed (he has been attacked at least once by another inmate with a knife), Johnson will die in prison. So, probably, will Alex Cabarga, who pleaded not guilty by reason of insanity and is appealing a sentence of more than one hundred years.

9. Lawyers

1. Findings based on the examination of 247 Denver, Colorado, girls under age thirteen, reported by Hendrika B. Cantwell in the *International Journal of Child Abuse and Neglect* 6 (1983):75. "Enlarged" was defined as a vaginal opening dilated to more than four centimeters in diameter.

2. At the moment, medical technology permits prosecutors to argue only that a defendant *might have* committed a particular crime, since samples of blood, semen, hair, or skin cells taken from the victim of an assault can be assigned to one of several broad genetic categories. Because such evidence can also be used to show that a defendant who does not fall into the given category could not have committed the crime in question, it often proves to be exculpatory. But a very new technique being developed in England, which involves the analysis of the nuclear DNA contained in skin cells and bodily fluids, may make it possible to link a semen sample or a pubic hair with a particular individual.

3. Jan Hollingsworth, *Unspeakable Acts* (New York: Congdon & Weed, 1986).

4. A study by Jon R. Conte and Lucy Berliner of eighty-four Seattle men charged with child sexual abuse found that sixty-two pleaded guilty before trial. See "Prosecution of the Offender in Cases of Sexual Assault against Children," *Victimology* 6 (1981):102–109.

5. Families

1. The Appalachian stereotype was reinforced in late 1986, when police in the tiny mountain community of Salyersville, Kentucky, charged seventeen members of seven related families with the sexual abuse of two dozen of their children, ranging in age from nine months to eleven years. "From all appearances, we're talking cousins, uncles, aunts, sisters, brothers, fathers, mothers, and grandmothers," one state trooper said.

2. In *The Psychoanalytic Theory of Neurosis* (New York: W. W. Norton & Co., 1945), Otto Fenichel writes that "in any sort of permanent community there are always adults who serve as substitutes for the parents, but the fact that they were not the real parents will reflect itself in the special form of the Oedipus complex . . . [i]t would be wrong to imagine that in childhood there are no other love objects than the parent of the opposite sex. Also siblings, uncles, aunts, grandparents, friends, and acquaintances of the parent may be of decisive influence."

3. *The New York Review of Books*, December 4, 1986, p. 39.

4. U.S. Children's Bureau, *National Study of Social Services to Children and Their Families* (Washington: U.S. Department of Health, Education and Welfare, 1979), 120.

6. Pedophiles

1. Although Sonenschein was convicted for the dissemination of child pornography, his conviction was later reversed by a Texas appeals court, which maintained that prosecutors had not presented enough evidence to corroborate the testimony of their star witness — the man to whom Sonenschein had allegedly given the photograph. The state is appealing the reversal.

2. Testimony of Joseph Henry. U.S. Congress. Senate. Committee on Governmental Affairs. *Child Pornography and Pedophilia*. 2 vols. 99th Cong., 1st sess., 1985.

3. Testimony of Bruce Selcraig. U.S. Congress. Senate. Committee on Governmental Affairs. *Child Pornography and Pedophilia*. 2 vols. 99th Cong., 1st sess., 1985.

4. To support this position, pedophiles often cite a study by a Dutch psychologist, Dr. Frits Bernard, who claims to have discovered a number of adults who had sex as children and were unharmed by the experience. A few researchers in this country have also reported encountering such adults. A study of sixteen New York City–area adolescents who had had sex with their parents and other adults was published some years ago by Lauretta Bender and Abram Blau in the *American Journal of Orthopsychiatry* 7 (1937). The researchers noted that "[t]he most remarkable feature presented by these children . . . was that they showed less evidence of fear, anxiety, guilt, or psychic trauma than might be expected. On the contrary, they more frequently exhibited either a frank, objective attitude or they were bold, flaunting, and even brazen about the situation . . . [t]he emotional reaction of these children was in marked contrast to that [of] their adult guardians, which was one of horrified anxiety and apprehensiveness regarding the future of the child . . . [a]nother striking characteristic shown by these children was that they had unusually attractive and charming personalities. They made personal contacts very easily."

5. The pedophiles are particularly fond of quoting Alfred Kinsey's assertion, in *Sexual Behavior in the Human Female*, that "it is difficult to understand why a

23. In *The Psychoanalytic Theory of Neurosis* (New York: W. W. Norton, 1945), Otto Fenichel admits that "It is not easy to answer the question about castration anxiety in women. First, it can be asserted that the Oedipus complex in women actually is not combated to the same degree and with the same decisiveness as it is in men. There are many more women who all their life long remain bound to their father or to father figures, or in some way betray the relationship of their love object to their father, than there are men who have not overcome their mother fixation."

24. From then on, it was the oedipal experience Freudian psychoanalysis would focus on, by breaking through the repressive barrier and integrating the childish fears and longings into the whole of the adult personality. As Otto Fenichel explained it half a century later, "after the infantile defenses have been canceled, the isolation is undone and the warded-off strivings are connected again with the total personality. They now participate in the maturity of the personality; infantile drives turn into adult ones, which can be discharged. Thereafter, remainders can be handled by sublimation or by other more effective types of suppression."

25. Masson, 147.

26. Masson, 148.

27. Letter from Anna Freud to J. M. Masson, dated September 10, 1981, quoted by Masson.

4. Abusers

1. Able has since joined the faculty of Emory University in Atlanta.

2. Heinz Kohut, *The Analysis of the Self* (New York: International Universities Press, 1971).

3. Christopher Lasch, *The Culture of Narcissism* (New York: W. W. Norton & Co., 1979).

4. Though he does not specifically speak about incestuous parents, in *The Restoration of the Self* (New York: International Universities Press, 1977) Kohut writes that "the seductive parent is not primarily harmful to the child because of his seductiveness; it is his disturbed empathic capacity (of which the grossly sexual behavior is only a symptom) that, by depriving the child of maturation-promoting responses, sets up the chain of events leading to psychological illness." And: "The child's deprivation from the side of the parental self-object is not as easily discerned — indeed, evaluated in terms of behavior, these parents give an appearance of overcloseness to their children. But the appearance is deceptive, for these parents are unable to respond to their children's changing narcissistic requirements, are unable to obtain narcissistic fulfillment by participating in their children's growth, because they are using their children for their own narcissistic needs."

5. Lasch writes that "the fusion of pregenital and Oedipal impulses in the service of aggression encourages polymorphous perversity." Kohut suggests that the sexuality of the acute narcissist tends toward the perverse both because he can "trust no source of satisfaction" and as a means of relieving the "painful narcissistic tension" created by the conflict between self-love and self-hate.

6. In mid-1987 Michael Reagan, the President's adopted son, disclosed that he had been sexually abused for a solid year at the age of seven by a day-camp counselor who had taken the place of his distant movie-star father in the boy's affections. It was because of that experience, Reagan said, that he had feared for many years that he might really be a homosexual.

on the possibility of a sexual relationship between Freud's mother and one of his much older half-brothers. Freud's affair much later in life with Minna Bernays, his wife's sister, has also been speculated upon by Peter Swales and others.

21. Freud suggested that an integral part of this equation was a son's unconscious wish to murder his father, in order to get him out of the way. Matricide is a rare event, but it is a matter of record that many more sons kill their mothers than their fathers, which points up an element of oedipal theory that is often overlooked — the son's unconscious hatred of his mother because of his perception that, in preferring the father, she has rejected him as a love object.

22. Despite the numerous attempts by historians of psychoanalysis to explain what Freud meant, the man himself often remains the best expositor of his theories. Nowhere is there a better description of repression than the one he offered in a 1909 lecture at Clark University in Worcester, Massachusetts:

> Let us suppose that in this lecture room and among this audience, whose exemplary quiet and attentiveness I cannot sufficiently commend, there is nevertheless someone who is causing a disturbance and whose ill-mannered laughter, chattering, and shuffling with his feet are distracting my attention from my task. I have to announce that I cannot proceed with my lecture; and thereupon three or four of you who are strong men stand up and, after a short struggle, put the interrupter outside the door. So now he is "repressed," and I can continue my lecture. But in order that the interruption shall not be repeated, in case the individual who has been expelled should try to enter the room once more, the gentlemen who have put my will into effect place their chairs up against the door and thus establish a "resistance" after the repression has been accomplished. If you will now translate the two localities concerned into psychical terms as the "conscious" and the "unconscious," you will have before you a fairly good picture of the process of repression . . . [but if] you come to think of it, the removal of the interrupter and the posting of the guardians at the door may not mean the end of the story. It may very well be that the individual who has been expelled, and who has now become embittered and reckless, will cause us further trouble. It is true that he is no longer among us; we are free from his presence, from his insulting laughter and his sotto voce comments. But in some respects, nevertheless, the repression has been unsuccessful; for now he is making an intolerable exhibition of himself outside the room, and his shouting and banging on the door with his fists interfere with my lecture even more than his bad behavior did before. In these circumstances we could not fail to be delighted if your respected president, Dr. Stanley Hall, should be willing to assume the role of mediator and peacemaker. He would have a talk with the unruly person outside and would then come to us with a request that he should be readmitted after all: he himself would guarantee that the man would now behave better. On Dr. Hall's authority we decide to lift the repression, and peace and quiet are restored. This presents what is really no bad picture of the physician's task in the psycho-analytic treatment of the neuroses.

The entire lecture is reprinted in *Five Lectures on Psycho-Analysis*, translated and edited by James Strachey (New York: W. W. Norton & Company, 1977).

9. Gail E. Wyatt, "The Sexual Abuse of Afro-American and White-American Women in Childhood," *International Journal of Child Abuse and Neglect* 9 (1985), 507–519.

10. Diana E. H. Russell, "The Prevalence and Seriousness of Incestuous Abuse: Stepfathers vs. Biological Fathers," *International Journal of Child Abuse and Neglect* 8 (1984): 15–22.

11. *Sexual Offences Against Children: Report of the Committee on Sexual Offences Against Children and Youths* (Ottawa: Canadian Government Publishing Centre, 1984).

12. Anthony W. Baker and Sylvia P. Duncan, "Child Sexual Abuse: A Study of Prevalence in Great Britain," *International Journal of Child Abuse and Neglect* 9 (1985): 457–467.

13. G. Gorer, *Himalayan Village* (London: Michael Joseph, 1938).

14. C. S. Ford and Frank A. Beach, *Patterns of Sexual Behavior* (New York: Harper & Row, 1951).

15. For a discussion of the outbreeding propensities of chimpanzees and elephants, see W. Arens, *The Original Sin: Incest and Its Meaning* (Oxford: Oxford University Press, 1986).

16. Guido Ruggerio, *The Boundaries of Eros: Sex Crime and Sexuality in Renaissance Venice* (Oxford: Oxford University Press, 1984).

17. *Centuries of Childhood* (New York: Alfred A. Knopf, 1962), 33. Aries also sees the conception of children as little adults reflected in the styles of their clothing. Until the seventeenth century, he writes, "as soon as the child abandoned his swaddling-band — the band of cloth that was wound tightly round his body in babyhood — he was dressed just like the other men and women of his class."

18. Jeffrey M. Masson, *The Assault on Truth: Freud's Suppression of the Seduction Theory* (New York: Farrar, Straus & Giroux, 1984), 25.

19. Letter from Freud to Fliess dated September 21, 1897, quoted in Masson, 108–110.

20. In recent years, there has been speculation about the possibility that Freud was himself a childhood victim of incest. In the letter to Fliess, Freud notes that one of the factors leading to his decision was his recognition that, if the seduction theory were allowed to stand, "in all cases the father, not excluding my own, had to be accused of being perverse. . . ." What Freud meant by this remains unclear, and has become the subject of much conjecture. According to one interpretation, he might have been suggesting that to consider his own father capable of such perversity proved the implausibility of the seduction theory. Others have read the phrase as a veiled hint that Freud or his siblings might have been sexually abused as children. In *Freud and His Father* (New York: W. W. Norton & Co., 1986), Marianne Krull raises the possibility that Freud abandoned the seduction theory in part because to continue with it would have required him to acknowledge that he "had come up against the most crucial event in his self-analysis: he had reached the point where he had to hold his father responsible for his own neurotic symptoms," and would have been forced to accuse his own father of being a seducer of children. There is no evidence that Jacob Freud ever sexually abused his own children. But Krull also writes of the close relationship between the young Sigmund Freud and his nursemaid, and she speculates

NOTES

Preface
1. Hawkins was defeated for reelection in November 1986.

1. Questions
1. Douglas J. Besharov, " 'Doing Something' about Child Abuse," *Harvard Journal of Law and Public Policy* 8 (1985): 539–589.
2. New York: Lyle Stuart, 1986.
3. Hanke Gratteau and R. Bruce Dold, *Chicago Tribune*, Oct. 6, 1986, p. 1.

2. Numbers
1. A. C. Kinsey, W. B. Pomeroy, C. E. Martin, and P. H. Gebhard, *Sexual Behavior in the Human Female* (Philadelphia: W. B. Saunders Co., 1948).
2. In what is considered the classic essay on the *Kinsey Report*, Lionel Trilling notes that "the way for the Report was prepared by Freud, but Freud, in all the years of his activity, never had the currency or authority with the public that the Report has achieved in a matter of weeks."
3. S. K. Weinberg, *Incest Behavior* (Secaucus: Citadel Press, 1955).
4. David Finkelhor, *Sexually Victimized Children* (New York: The Free Press, 1979).
5. Diana E. H. Russell, "The Incidence and Prevalence of Intrafamilial and Extrafamilial Sexual Abuse of Female Children," *International Journal of Child Abuse and Neglect* 7 (1983): 133–139. Reprinted in *Sexual Exploitation* (Beverly Hills: Sage Publications, 1984).
6. Child sexual abuse is generally defined as what happens to victims under eighteen, since in most states that is the age of consent. The distinction is really artificial. A recent study by the Association of American Colleges found that "gang rapes" of college coeds had taken place on more than fifty campuses over a two-year period, 90 percent of them at fraternity parties. "On some campuses, we heard reports of gang rapes happening every week at parties," said Julie Ehrhart, the report's author.
7. In two-thirds of the cases, the abuse only happened once. But in 20 percent it had gone on for up to a year, and in 15 percent for up to ten years. Lewis's findings are summarized in the *Los Angeles Times* in two articles published on August 25 and 26, 1985, both on page 1.
8. Because of the large sample size, Lewis's margin of error was quite small — less than 2 percent, compared with around 2.5 percent for a standard Gallup or Harris survey. This meant that the percentages in the *Times* survey might differ from reality by two percentage points in either direction, but no more.

plunged into an emotional and physical relationship with an adult. The trouble with such a relationship is that it places a child of any age at a developmental level it has not yet achieved on its own. Any sexual relationship involves much more than just sex, and when adults have sex with children, there is a clear danger of emotional exploitation by the more powerful member of what Freud termed "the incongruous pair." Henry Giaretto puts it most succinctly when he says, "It's like matching a high school boxer with Muhammad Ali."

To say that society will sanction sex between adults and those few children who might not be harmed by the experience is absurd. No one can make a determination about the potential for harm — neither society nor the pedophile, and least of all the child. What society does instead is the only thing it can do: it issues a flat prohibition against having sex with children. Claude Levi-Strauss observed that people do not choose their cultures, they are "delivered into" them. Because they are, the pedophile's logic is in some sense ultimately correct. Sex with children *is* wrong because society says it's wrong. No better reason is required.

But Fernando Guerra, a professor of pediatric medicine from the University of Texas, didn't agree. "As I spend more time in the practice of pediatrics," he told the conference, "I am convinced that we can no longer stop the tremendously overpowering problem of child abuse and neglect. There are people in each of our communities who are totally overwhelmed by stressful events, who face one crisis after another, and the groups that remain at greatest risk continue to fall outside the system of resources that has been developed to do something about this." Michael Wald, a law professor from Stanford, concurred. "Unless we fundamentally change the type of society that we are," he said, "there really is no hope for child protection."

If such fundamental change seems beyond reach, it may be because some of the same trends that appear to correlate with child abuse — the disintegration of the nuclear family, an increase in the numbers of working couples and single and divorced mothers, more second and third marriages, the emergence of a permanent underclass, and an apparent increase in the number of sexually abused children — show no sign of reversing themselves. Even if they did, it seems unlikely that child sexual abuse can ever be eradicated, or even significantly diminished, by a society that has been unable to do the same for alcohol and drug abuse or the physical mistreatment of children. Perhaps the sexual attraction to children is so fundamental and so powerful that it can never be erased. But in spite of the obstacles and frustrations involved, not to redouble the attempt would be to relinquish any claim to civilization and humanity. Dr. Jaap Doek, president of the International Society for the Prevention of Child Abuse, put it best when he declared that "the effort to bring about the abolition of child abuse must be made. It may be doomed to failure, but to make no effort at all is far worse than failure. It is demeaning to the human spirit."

While child abuse researchers continue to seek the elusive remedy, some child molesters offer a solution of their own. Sex with children is wrong, they say, only because society says it's wrong; the way to resolve the problem is simply to stop calling it a problem. It may be true, as the pedophiles contend, that some children — it must be a small number — not only survive a sexual relationship with an adult but benefit from it in some way. It is probably also true that there are some pedophiles who would never conceive of forcing a child to engage in sex against his or her will, and whose narcissistic interest is in what they see as the fair exchange of pleasure for pleasure.

But everything that is known about how children grow up suggests that it is ultimately destructive for the huge majority of them to be

child molesters will leave some readers, including the molesters themselves, with the impression that society really does not take such offenses very seriously.

A good measure of social change in any society, in fact, is the texture of its humor. A decade ago, a frequently repeated joke concerned two child molesters who were discussing their latest conquests. "Lemme tell ya about the eight-year-old kid I met last night," the first molester says. When the second molester hears the child's age, he makes a face. "I know, I know," his friend quickly adds, "but she had the body of a four-year-old." Except in places like *Hustler* and *Playboy*, child-molester jokes aren't seen or heard very often anymore, and there can be little question that social attitudes about the sexual abuse of children are beginning to change. But changing the public perception of a problem is not the same as resolving the problem itself.

In November 1985, more than two years after Jim Rud was arrested in Jordan, more than a year after the first indictments had been handed down in the McMartin case, three thousand child therapists, clinical researchers, prosecutors, physicians, teachers, police officers, and social workers, including all the members of the original Wingspread group, assembled in Chicago for the Seventh National Conference on Child Abuse and Neglect. It was the largest gathering of its kind in history, and those in attendance knew more than anybody about the dangers and dimensions of sexual abuse in America. They had also done more than anybody to raise the public perception of the problem, but now they found themselves divided over whether some solution to it would ever be found.

Jim Gabarino, a former professor at Pennsylvania State University who now heads the Erikson Institute for Advanced Study in Child Development, was among the most optimistic. Gabarino asked the congregants to think for a moment about all of the other ills and evils that had been abolished in the last hundred years — slavery, cholera, smallpox, maternal death in childbirth — through the force of advocacy, research, social engineering, and sheer good will. It is far easier to be a child these days, Gabarino said, than it was a hundred years ago. Society no longer puts children to work at an early age, no longer indentures them or marries them off at twelve. Instead, we have compulsory education, state and federal child protection agencies, and child abuse reporting laws. What was once considered strict discipline is now called physical assault against children. With enough ingenuity and gumption, Gabarino seemed to be saying, we will find a solution in time.

advertisements that use suggestive pictures of adolescent and even preadolescent girls to sell clothing, perfume, and shampoo, they might be forgiven for concluding that the same society that condemns them so loudly in public is speaking with more than one voice.

The message about double messages hasn't yet gotten through to the United States Congress, as became clear when several members expressed their outrage over a U.S. Justice Department study of the sexual portrayal of children in *Playboy, Penthouse,* and *Hustler,* the three leading "men's magazines," which together are read each month by one American in ten. One of those who objected was Pennsylvania senator Arlen Spector, whose own subcommittee three months earlier had heard Joseph Henry testify about his experiences as a pedophile. Spector, quick to attack the study as a $750,000 example of idiocy by the Reagan Administration, said he had "never seen pictures of crimes against children appear in those magazines."

Perhaps not, but it is difficult to see how anyone could overlook *Hustler's* regular full-page cartoon featuring the continuing efforts of "Chester the Molester" to ensnare small girls. In one cartoon, Chester lurks behind a fence while a very young girl approaches a bag of candy he has placed as a lure on the sidewalk. In another, he hides in some bushes as an equally young girl walks by, his penis protruding from the leaves beneath a sign that reads "Free Hot Dog!" Larry Flynt, the publisher of *Hustler,* calls child abusers "disgusting perverts," and takes credit for having "spoken out against this problem long before it became the hot topic it is today." Like *Hustler, Penthouse* is on record as opposing the sexual abuse of children. But while columnist Emily Prager fulminates about sexual abuse in day-care centers and "kiddie porn," *Penthouse* publishes nude photographs of a thirty-five-year-old mother and her (barely) eighteen-year-old daughter touching one another more than a little suggestively.

Hugh Hefner, the publisher of *Playboy,* has also taken a strong public stand against child sexual abuse. Hefner has even turned over his sybaritic Los Angeles mansion for a party that raised several thousand dollars to help build a Hollywood shelter for child prostitutes. A report on the party appeared in the same issue of *Playboy* as a cartoon showing a factory where assembly-line workers are adjusting the voice boxes of talking dolls. All of the dolls in the cartoon say "Momma" except for the one being adjusted by a leering technician who resembles Chester the Molester, which says, "Wanna have a party, big boy?" Such cartoons do not approach the legal definition of child pornography. But there is a danger that cartoons poking fun at

sexual assault, and organized crime. Go after the rapist, go after organized crime, go after those who sexually abuse children."

The fact that child pornography has been removed from public view makes an important statement about society's view of child sexual abuse. But it is equally important that the same society stop sending a double message about its view of children as sexual objects. While the prohibition against sex with children is declared in a loud voice, the unspoken idea that sex with children might be acceptable after all is communicated in a number of more subtle ways, particularly the sexualization of children in the mass media and in advertising. Among the questions overlooked in the pornography debate is the issue of when artistic or humorous portrayals of children in an erotic vein cease to be art or humor and become something else.

Roman Polanski, the Polish film director, is remembered for fleeing the country after pleading guilty to having had intercourse with a thirteen-year-old Los Angeles girl. What is less often remembered is that Polanski abused the girl only after photographing her nude for the same popular French fashion magazine that had previously published seven pages of David Hamilton's photographs.[6] Though pictures of children undressed are not illegal in themselves unless they are deemed to be "sexually explicit," such photographs have been relatively rare in legitimate American publications. A few have appeared in the trendier fashion magazines, and *Playboy* has published nude photographs of Brooke Shields taken when she was ten. (Prints of those pictures now sell for five hundred dollars apiece. The Manhattan photographer who took them with the approval of Shields's mother calls Shields "the first prepubescent sex symbol in the world.")

The portrayal of young girls in a sexual light for commercial purposes seems to have reached its apogee in the many television and print advertisements by the makers of expensive blue jeans. The first examples of the genre, created for Calvin Klein, featured a sultry Brooke Shields confiding that nothing came between her and her "Calvins." A television campaign by rival jeansmaker Jordache that showed even younger models dancing suggestively was taken off the air after the company and the networks received a torrent of viewer complaints. Guess Industries, which manufactures its own brand of blue jeans, has produced a still more controversial magazine spot in which two young girls of indeterminate age, one wearing a torn dress and the other a slip, embrace in a woodsy dell. Such images are not child pornography. Rather, the concern is with the subliminal message they send. Most pedophiles know that sex with children is taboo, but when they see

while they might have viewed child pornography at some point during their lives, it could not be held responsible for their abusive behavior. Mainly because of such studies, most researchers now believe that an interest in child pornography follows, rather than precedes, a sexual interest in children. One is Rob Freeman-Longo, a researcher at Oregon State Hospital, who has studied the question extensively and who flatly maintains that "pornography does not create sex offenses. It doesn't make men go out and commit sex crimes.

"Some of these fixated pedophiles," Freeman-Longo says, "the better part of their waking hours are spent fantasizing about children. What pornography does do for the man who has those kinds of fantasies is that it reinforces that. A man doesn't need pornography to go out and molest a child. The absence of pornography has never stopped a child molester from molesting a kid." Freeman-Longo also points out that pornography is in the eye of the beholder. "A pedophile can look at the children's underwear section of a Sears catalogue and become aroused," he says. "He can read *Boy's Life* magazine and watch films on the Scouting Jamboree and get a throbbing erection, and those are totally nonpornographic materials."

The difficulty of eradicating underground child pornography, the constitutional protections for private behavior, and the doubts about whether child pornography actively contributes to child abuse have led some to question whether more and stricter antipornography laws are worth the effort required to pass them. In raising such questions, however, it is critical to draw a distinction between the production of child pornography and its reproduction, distribution, and possession. No one is suggesting that the effort to stamp out the actual production of child pornography be abandoned or even scaled down, since in order to produce such pornography it is necessary to sexually abuse a child. But the possibility must be considered that a more intensive effort to wipe out the clandestine exchange of existing child pornography amounts to treating the symptom and not the disease.

The argument that the resources necessary to broaden the battle against child porn might be better spent in arresting the child molesters themselves was offered by a staff lawyer for the American Civil Liberties Union who testified before the Reagan pornography commission. "There have been other attempts to get at the problems in a society by regulating speech," the ACLU attorney said, "and those attempts have not worked. Attempts to regulate child pornography are a perfect example. Regulating speech does not stop the crime, so I suggest to you to reject the attempt to link pornography with rape,

ago, when questions were raised about whether viewing adult pornography encouraged sex crimes by adults against other adults, a commission appointed by President Nixon concluded that pornography had no significant impact on the behavior of the viewer. Though the Nixon commission's conclusions were backed up by scientific research, a new commission appointed by President Reagan concluded last year that viewing some forms of violent pornography does contribute to violent sexual behavior.

Unlike its predecessor panel, the Reagan commission did no quantitative research of its own, choosing instead to hear dozens of hours of testimony from experts who were mostly connected in some way with law enforcement. When a few social scientists testified that viewing pornography had no perceptible effect on sexual behavior, the commission chose largely to ignore their testimony. Judith Becker of the New York State Psychiatric Institute, the only real scientist on the panel, was dismayed. "I've been working with sex offenders for eleven years," Becker said, "and I would think that if there were a link between pornography and sexual behavior, we would have found it before now."

The Reagan commission did not specifically consider the question of whether child pornography contributes to the sexual abuse of children. But it is worth nothing that, while graphic pornography featuring children first became commercially available less than twenty years ago, there appears to be nothing new about sex crimes against children. Nor does there seem to be a connection in other cultures where such pornography has been even more widely available. A recent Swedish survey of a thousand citizens between the ages of eight and seventy found that only 9 percent of the women and 3 percent of the men admitted having been abused as children. James Fallows, a former speechwriter for Jimmy Carter who recently moved his family to Japan, has reflected on the fact that Japan is awash in cheap pornography that focuses on young girls "being accosted, surprised, tied up, beaten, knifed, tortured, and in general given a hard time." Fallows concluded that "in the United States more and more people are claiming that pornography contributes to sex crimes. If you look at Japan — with its high level of violent stimulation but reportedly low incidence of rape and assault — you have your doubts."[5]

Such evidence as exists, in fact, tends to deny the possibility of a connection between child pornography and abusive behavior. Nearly three-quarters of 531 child abusers studied by Judith Becker and Gene Able at the New York State Psychiatric Institute told researchers that

make sure his prospective customers were who they said they were.

To make such prosecutions even more difficult, in the absence of a live victim it is often impossible to prove the age of the children at the time they were photographed. There is little problem where very young children are concerned, but older children and teenagers are another matter. Prosecutors can call physiologists to testify that the child in question was probably not more than seventeen, but expert opinions are open to interpretation, and such testimony does not always result in a conviction. Another technique used by law enforcement officials has been to put photo processing labs on notice that developing child pornography is a federal crime, and that they are required by law to notify authorities whenever such photos are submitted for developing. The effort has produced some convictions, but these are mostly a matter of luck, since most photographs are now processed with automated equipment and are never seen by anyone. With the advent of inexpensive home video recorders, it is no longer necessary for pornographers to rely on the services of professional developers. Not only do VCRs make the production of child pornography much easier, but it is also possible to duplicate a particular tape any number of times by connecting one machine to another.

Some of the loopholes contained in the 1978 law were tightened in 1984, when Congress prohibited the free exchange of child pornography, a common practice among pedophiles who trade pictures of children like baseball cards. Moreover, the revised statute does away with the requirement that sexually explicit pictures of children must also qualify as lewd or obscene in order to be illegal.[4] Penalties for violating the anti-child-pornography statutes were increased tenfold, to a maximum of two hundred thousand dollars and fifteen years in prison. A few important loopholes, however, remain. The new law, like the old one, covers only "visual depictions" and not written materials, and because the federal laws still apply only to interstate trafficking, the private possession of child pornography is still legal, except in the six states that forbid it. Most constitutional scholars doubt that the Supreme Court, which over the years has drawn firm distinctions between private and public conduct, would ever uphold a federal statute prohibiting the private possession of child pornography.

Some civil libertarians argue that any discussion of what to do about child pornography must go beyond its intrinsic repugnance to the role it plays in actually encouraging the sexual abuse of children. Though it has been debated avidly for years, the question of what effect pornography has on the viewer is still unresolved. Nearly two decades

Hancock Park neighborhood of Los Angeles with her five children, a Mercedes-Benz, and a Rolls Royce. The thirty thousand customers on what Wilson called her "golden list," among them an Episcopal priest from Baltimore, sent their orders to one of the Scandinavian addresses. The orders were forwarded to Los Angeles after the money was deposited in a Swiss account. Wilson, driving one of her expensive automobiles, filled the orders by mailing packets of pictures from post offices across the Southwest.

Seizures of illegal pornographic materials from abroad nearly doubled after it became a federal felony to order child pornography by mail. In 1984, more than half of the forty-two hundred shipments of pornography impounded by U.S. Customs included pictures of children. Some foreign producers tried different ruses to get their pictures past the customs inspectors, including sending the material in envelopes stolen from hotels popular with foreign tourists in hopes that they would be mistaken for letters from vacationing Americans. But the ruses have not worked very well, and many producers appear to be giving up the American market altogether rather than go through such machinations. When a California police officer posing as a pedophile sent fourteen letters of inquiry to Scandinavian pornographers in late 1975, most wrote back to say they were no longer shipping their products to the United States. The fact that customs seizures of foreign-produced child pornography have lately begun to decline also suggests that not as much is being shipped through the mail as once was.

The battle against the domestic child pornographers is a different story. Prosecutions of domestic producers have increased, from thirty-four in all of 1984 to more than a hundred during the first six months of 1986. But those on the side of law enforcement say that such cases are the hardest to put together, because the pedophiles who sell or trade such material are extraordinarily careful about whom they deal with. An example is Earl William Magoun, the sixty-year-old pornographer to whom Walter Holbrook sold the photographs of the children he sexually abused. Magoun did his mail-order business under the name "Betty Adams," and one policeman says that "until Betty Adams knew who you were and knew that you weren't a cop, he generally didn't put out the child pornography or the animal stuff until you had bought his bondage and torture pictures, or bought the spanking pictures or the nun pictures. These people are not stupid." Another child pornographer who held a full-time job with the New York State Department of Tax and Finance used the department's computer to

attention seems to be paid to those areas where it is easiest to accomplish something visibly and quickly, and the sexual abuse of children is no exception. The aspect of child sexual abuse that has been most vigorously attacked by American society in recent years is child pornography, and on the surface the antipornography effort has met with considerable success.

Before 1978, when Congress passed the first federal law prohibiting the production and sale of child pornography, it was possible in this country to purchase more than 250 different magazines filled with pornographic pictures of young children, most of them imported from abroad. The 1978 law did not bar the free exchange or private possession of obscene pictures of young children, but it marked the federal government's first major step toward eradicating a form of commercially available pornography that no one except pedophiles argued was a legitimate expression of free speech. Because of the 1978 law, there is no longer any city in the United States where child pornography is openly sold; virtually all the child pornography produced in this country nowadays is traded and sold among a few thousand practicing pedophiles.[3]

Some commercial child porn is still mailed from abroad, the majority of it from Denmark, Sweden, and the Netherlands, but there appears to be far less than there once was. Denmark legalized all pornography in 1972, but in 1981 it made the production and sale of pornographic pictures of children under fifteen illegal. Pornography has been technically illegal in the Netherlands since the turn of the century, but only during the past two or three years have the antipornography statutes actually been enforced. In view of their recent efforts, Scandinavian officials take offense, and with some justification, at suggestions that their countries are responsible for polluting the United States with child pornography. The chief of Swedish Customs has claimed, and U.S. Customs officers agree, that many of the photos published in Scandinavian magazines are actually made in the United States and Canada by amateur pedophile-photographers and then sent abroad for distribution.

U.S. officials also assert that some Scandinavian distributors are fronts for American producers, and there is some basis for such complaints. A few years ago, investigators tracking an "international child pornography ring" with post office boxes in Sweden and Denmark traced it to a California woman who was netting five hundred thousand dollars a year from her mail-order pornography business. The woman, Catherine Wilson, lived in the affluent

and stuff," she says. "It happened every day, it seemed like. I remember him chasing me and me screaming. I was scared of him, but I didn't know what to do." The man's wife proved unsympathetic. "She told me if I said anything, she was going to tell my social worker that I was messing up in school," Liza says. "Even after I told her that, she still left me in the house with him alone."

The Illinois Department of Child and Family Services says it knows of forty-nine children under its supervision who were sexually abused by their foster parents in 1986, and there are no doubt others who have not come to its attention. Most states perform fingerprint checks on prospective foster parents, but the checks have all the same loopholes as those for day-care workers and teachers, and they can only turn up child abusers who have been convicted. When the New Jersey foster parents program tried to screen out people who had been accused of child abuse as well as those who had been convicted, the American Civil Liberties Union objected to the "abuse of due process" involved, and the plan was scrapped.

Foster homes and day-care centers are at least subject to some governmental regulation. The many private youth organizations in this country are not, and for them keeping child molesters away from children is even more difficult than it is for regulated institutions. The Big Brothers and Big Sisters Association of America has placed what one official calls "a terribly high priority" on screening its eighty thousand volunteers, and the organization has lobbied in several states for legislation that would allow it to check the names of applicants against arrest and conviction records. It has also adopted an extensive vetting process that includes thorough background checks and a series of personal interviews. Other private youth organizations, no less concerned, are prevented by state privacy laws from going any further.

The YMCA's national headquarters has drawn up a set of recommended guidelines to help in selecting those who run its many programs. But each local YMCA is an independent corporation, and beyond urging caution in hiring, there is little the national organization can do to help. The Boy Scouts of America maintains a nationwide list of convicted child abusers that it checks against the names of those who apply to become adult leaders. But the ultimate responsibility for selecting leaders rests with the churches, schools, and other organizations that sponsor individual troops. "The only thing we can do is get the organization to be sure they know the individual," a Boy Scouts executive admits.

In the effort to combat most social problems, the greatest public

being preyed on by outsiders. In Chicago, two men and a woman were convicted of having used drugs and threats to recruit a number of young girls for their juvenile prostitution ring from among the residents of the Mary Bartelme Homes, a state-funded institution for neglected children. Several of the girls, some of whom were from middle-class suburban families, had been placed in the facility to get them away from sexually abusive parents.

Because state-run facilities are chronically overcrowded, the warehousing of neglected or unwanted children has become a growth industry in America. There are thousands of private children's homes around the country that provide — for sizable fees — room, board, and schooling for children whose parents no longer want them at home. Lately, a number of states whose children's institutions are filled to overflowing have begun contracting private homes, many of which are operated as a fund-raising device by fundamentalist religious organizations, to take in children who have been abused and neglected by their parents. Because most of those who staff such homes are even less qualified and less closely supervised than warders in public institutions, the potential in such settings for abuse is even greater.

Private foster homes have a better record for protecting children than public institutions, but those who apply to become foster parents are not screened nearly as thoroughly as they might be, nor are they closely supervised. Many of the men and women who care for the two hundred thousand American children living under private foster care are well-meaning couples who are concerned for the welfare of children. Though the stipends paid by state welfare agencies have not increased nearly as fast as inflation, for some, being a foster parent is little more than a source of extra income. Others become foster parents as a means of gaining access to children.

When Liza was nine, her father went to prison for abusing her and her thirteen-year-old sister. Left with no way to make ends meet, Liza's mother moved the family to a shabby hotel in downtown Los Angeles and put the girls to work on the street. "My mom would talk to the men, and then they would come and talk to me," Liza recalls. "They weren't all that smart, but they had a lot of money. We'd tell them what to do, and they'd do anything we'd tell them. It was fun. It was like a game." When the state of California found Liza, it put her in a foster home, a nice two-story house with a swimming pool and a Jacuzzi where a prosperous businessman lived with his family. But Liza's foster father turned out to be like the men her mother had brought to the hotel room. "He used to come in at night and feel me

institutions for abused or neglected children have been a fixture in America since the early part of this century, when churches and private charities first recognized that such children should be kept away from adult criminals. Every state now operates at least one children's institution, and most have several, but few are models of safety and care. The foster placement of sexually abused children can involve a number of emotional and physical dangers, but the greatest is that the child will be abused again by those who are responsible for his protection.

The great majority of children who find themselves in juvenile institutions, perhaps as many as 90 percent, have not committed any serious crime. Most are status offenders, which means that their offence, such as running away from home or truancy, would not be against the law if they were not underage. Many have committed no crime at all. Some are physically or emotionally disabled, some have been declared "unmanageable" by their parents, and others are there because they have been physically or sexually abused at home. Like institutions for adults, most of this country's training schools, children's shelters, and guidance centers are overcrowded, understaffed, and in serious need of funds. Because it is difficult to find trained guidance counselors willing to work for low wages in such Dickensian settings, many children's institutions attract sexually abusive men and women.

Three years ago, the state of Oklahoma was rocked by newspaper reports of thousands of cases of physical and sexual abuse of girls and boys by employees of that state's juvenile institutions. Some of the children had been forced to engage in prostitution by those assigned to protect and counsel them, including a senior Oklahoma official who turned out to have a prior record of arrests for sexual abuse. Though the Oklahoma scandal stands as something of a landmark in the annals of child abuse, such horrors are not limited to backward states or small towns. In 1985, after hearing reports that a child prostitution ring was operating out of Los Angeles County's emergency children's shelter, a grand jury uncovered fifty cases of child abuse by staff members during the first six months of that year, most of which had never been reported to police. A three-year federal study of child care institutions in New York found that child guardians had failed to report more than 80 percent of the abuses, including sexual assaults, that occurred under their supervision.

Even when official guardians do not commit such abuses themselves, the supervision they provide can be so lax that their charges risk

with parents. "If the parents aren't alert and the parents don't take care, all the legislation in the world will not make that big a difference," says Ted Dewolf, who oversees Michigan's twenty-five hundred licensed day-care centers. "You've got to get the parents educated so they know what to look for, how to select day care. When they buy a car, they spend an enormous amount of time. They spend very little time in selecting day care for their children."

Day-care centers are not the only places where pedophiles have managed to slip through the large cracks in the child protection system. In April 1985, a nine-year-old girl in Waukegan, Illinois, complained that she was being molested by her elementary school teacher. When police searched the teacher's suburban home, they found more than ten thousand photographs of naked children, among them fourteen former students, which had been taken through a two-way mirror in his bathroom door. The man was convicted of abusing that girl and six of his other students. Only after his arrest did the authorities discover that he had been convicted nearly twenty years before of "taking indecent liberties" with a student. Somehow the man had continued teaching until three other children accused him of abuse. Convicted again, he nevertheless managed to obtain a substitute-teaching certificate and the job that led to his most recent conviction. Any of the schools that had hired the teacher during the two decades he was molesting children could have asked police to check his record. But because they were not required to do so by law, none of them ever did.

School officials in some states claim that they are prohibited by Supreme Court decisions in the realm of privacy from even inquiring whether a prospective teacher has an arrest record. Though such interpretations of the Court's rulings are open to argument, the principal opposition to requiring background checks for teachers comes from the teachers themselves, whose unions have flatly opposed any official attempts at scrutinizing the qualifications of their members. When five Chicago teachers were charged with child abuse during a single two-week period, the city's school board announced that it would begin fingerprinting all prospective teachers. Even though the policy was intended to apply only to the newly hired, the Chicago Teachers Union opposed the plan as "an indictment of all teachers," and union officials pointed out that none of the five teachers arrested had had criminal records.

Another venue regulated by the state that has proved a magnet for child molesters is that of institutional care. Public and private

of those who do register give addresses that are false. Only a few other states even require the registration of convicted sex offenders.

Screening those who hold jobs that give them access to children is only a first line of defense. The second defense is to monitor day-care centers and other places where children are at risk of being abused. But not only are day-care licensing standards in most states lax, they are loosely enforced at best. The number of Texas day-care centers has more than doubled in recent years, but a shrinking state budget has cut the number of inspectors in half. Instead of four visits a year, most Texas centers now receive two or even one, but that is still better than the national average. Illinois manages a single visit every year, but California day-care centers are inspected only once every three years. Michigan uses a "self-certification" system, which means that once a day-care home has been licensed, it is never inspected unless someone makes a complaint.

When day-care inspections do occur, they are likely to include merely the most rudimentary checks for such things as the number of teachers and bathrooms per child, which is why most of the child abuse that occurs in day-care centers is only discovered by the parents of its victims. Some inspectors are negligent, but most are simply overworked. In order to get a sense that something is amiss, it is necessary to spend time with the children, and most day-care inspectors do not have the time. Each of the twenty-six inspectors in the San Francisco area is responsible for monitoring nearly 250 facilities, and caseloads in other cities are not much smaller.

One possible solution to the day-care problem might be hiring more inspectors. But hiring more inspectors means spending more public funds, and money for social services has been the first budget item to fall in the face of taxpayer revolts and declining state revenues. Another potential solution is the one hit upon by a handful of enlightened corporations that are trying to hold on to valued employees by moving day-care into the workplace. When a child is being cared for in a corner of the factory or the office building where her mother works, and when the mother is free to visit the child during coffee breaks and lunch, the chances of abuse are greatly diminished. But day care in the workplace is an idea whose time has not yet come. Of the six million employers in this country, only about six hundred, most of them hospitals, offer their employees in-house day care.

The reality, child protection officials say, is that the current level of day-care regulation is about as much as can realistically be hoped for. The primary responsibility for children's safety, they say, must lie

regulated facilities, but an estimated four million others are looked after in unlicensed ones, many of them private homes that either are too small to need a license or are owned by people who have simply failed to apply for one. Because there is no official record of their existence, such places are never visited by day-care inspectors, which means that there is nothing to prevent a convicted child molester from caring for children in his or her home. A California man convicted of abusing three children in an unlicensed day-care home run by his wife had previously been arrested by police with dozens of photographs of nude children in his possession.

Though they are beyond the government's reach, such unlicensed facilities are not necessarily illegal. In many states, those who care for fewer than a half-dozen children are not required to apply for a license. Licensed centers, however, are not beyond reach, and in an effort to keep known pedophiles away from children, some states have passed laws requiring that new day-care workers be fingerprinted and their records checked against state and federal criminal data bases. But many states do not have such requirements, and some of those that do say they cannot afford to pay the twenty dollars that each record check costs. The lack of funding is unfortunate, because background investigations appear to have some value. When New York City began fingerprinting new child care workers in the wake of the Bronx day-care scandals, 240 of the first six thousand applicants turned out to have criminal records. "It's hard to believe," says a lawyer for the California Department of Social Services, "but we do get people applying for day-care licenses that have sexual molesting convictions. You would think they would realize that when they turn in their fingerprints, we're going to find out."

Fingerprint checks are not infallible, because many child abusers manage to plea-bargain their convictions down to a charge of assault or neglect that does not identify them as a child molester. Even the most thorough background investigation can turn up only those child abusers who have already been caught, and records of convicted child abusers are often incomplete. According to the *Miami Herald*, the Florida Child Abuse Registry was so poorly organized that twelve thousand reports identifying known abusers were thrown out because there was no place to store them. For nearly four decades, California law has required convicted sex offenders to register with the authorities, but according to the *Los Angeles Times*, the law is neither widely obeyed nor effectively enforced. Some offenders never register at all, others fail to tell police when they change their addresses, and many

really are minimal. When the federal government drew up a set of minimum standards for day-care centers, a Yale University study found that they were higher than the standards set by forty-seven states.

Only ten states require the head of a licensed day-care center to have any training in child development, and only eight require day-care workers to have any experience at all in caring for children. California day-care teachers need six semester units in early childhood education, but in New York City anyone who is eighteen and can read and write at an eighth-grade level can become a teacher's aide. Thirteen states have no educational or professional requirements for child care workers, and the National Association of Social Workers says that only a quarter of those who earn their living caring for children have any professional training at all. Many day-care centers are owned by nationwide chains that pay their employees the minimum wage. Others pay more, but the national average is still around four dollars an hour. Even those workers who are most committed to children say they do not find the work, which often amounts to a combination of diaper changing and crowd control, very rewarding. Because it is hard to keep qualified and dedicated people in such low-paying, dead-end jobs, day-care centers are targets of opportunity for pedophiles.

Even among licensed day-care facilities, there are wide variations in the quality of care. The best centers may allocate one staff member for every half-dozen children, but in others the ratio is one worker to fifteen or twenty. The greater the ratio, of course, the greater the possibility that a day-care worker can molest children undetected. In hopes of improving the quality of care, several state legislatures are considering imposing more stringent requirements on day-care centers, in terms of both the workers they employ and the number of workers per child. But hiring more, and more qualified, caretakers will also increase the cost of day care. Many day-care programs already charge parents between eighty and a hundred dollars a week, which means that some working mothers with preschool-age children must pay up to a third of the average take-home salary for nonprofessional women. An inevitable result of raising child-care standards is to raise the cost of day care past the point that most single mothers, and even many married couples, can afford, which will drive some day-care centers out of business and others underground.

Improving licensing requirements is a partial solution at best, since the greatest danger to children comes from day-care facilities that are not licensed at all. About two million children are cared for in

what I was doing was wrong at the time, and I should have stopped. Please don't go through what I've gone through. Seek help and stop. Believe me, it's just not worth it!"

Those child abusers who actually turn themselves in to the police, and they add up to a tiny number, usually do so only when it begins to look as though their victims are about to blow the whistle. If public service messages are ever broadcast, they will probably have the greatest impact on men who have only recently begun to abuse. A third of the men in the Seattle study said they would have been most vulnerable to such an announcement just after they began molesting children. Asking a neophyte abuser to stop and seek help may be asking him to give up something he doesn't really want in the first place, but if such an approach works, it is most likely to work with middle-class child molesters, those with good jobs, homes, families, and reputations who have the most to lose. It is also worth remembering that abusers who say they would have been deterred by the public service approach have already been caught and convicted.

It is the dedicated pedophile who is least likely to be moved by any public appeal, and David Finkelhor, another of the Wingspread participants, suggested that most of those who abuse children do so in part because they are convinced that they will never be found out. A public service campaign, Finkelhor thought, might at least increase the abuser's awareness of his chances of getting caught, but it is difficult to persuade the narcissistic abuser that he's as vulnerable to the law as ordinary mortals. Police records are filled with examples of men who have taken extraordinary chances in order to have sex with children, such as the Wisconsin child molester charged with sexually assaulting a five-year-old girl in the visitors' center at the prison where he was incarcerated.

A public service campaign of some sort is probably worth the effort, if only to see what results. But the Wingspread group also thought much more could be done by state and local governments to keep child molesters away from children, particularly in regulated institutions like schools, foster homes, and day-care centers. It has always been the case that some children who are too young to attend school have been cared for outside their homes, but the enormous increase in demand for day care over the last decade has made it a new American institution. Many of the day-care centers that have sprung up in suburbs and city centers hold state and local licenses, but such licenses are no guarantee of anything beyond the fact that minimal health and safety standards are being met — and in most cases they

more reluctant to acknowledge beating their children. "Even if the change is only one of attitudes," they wrote, "we believe this is significant for a ten-year period, a change that may well lead to an actual change in behavior. If all we have accomplished in the last ten years is to raise parents' consciousness about the inappropriateness of violence, then we have begun the process of reducing violence towards children."[1]

There are any number of public service campaigns aimed at Americans who abuse drugs and alcohol, but so far none has been directed at those who have sex with children. Was it possible, the Wingspread group wondered, that the public service approach might persuade those who sexually abused children to stop or even turn themselves in? One of the conference participants, the University of Chicago's Jon Conte, showed the group a videotape of a public service announcement he had written. Narrated by Mike Farrell, the actor who played B. J. Hunnicutt on the television series "M*A*S*H," it was short and to the point: "If you are a man and you are sexually involved with children, you may be saying to yourself, 'She likes it,' or 'He asked for it,' or 'I'm teaching her about sex.' You're lying to yourself. Real men are not involved sexually with children. If there's any part of you that really cares about that child, stop it. Get help now."

The possibility that such an appeal might have some effect is supported by a Seattle study of 175 child sexual abusers, all of them men, who were asked whether hearing or seeing a public service message would have kept them from abusing their victims. Nearly three-quarters of the men said it would have stopped them cold; only one in ten said it would have had no impact at all.[2] The ideal message, the abusers said, should stress the options that were available — that it was possible, for example, to avoid jail through a pretrial diversion program — compared to the consequences if the abuse were reported by the victim. "I never really knew there was help for this," one of the men said. "I thought it was just that you went to jail, period."

Rather than use a celebrity to present the message, the abusers thought it would be more effective to use a real abuser, or for that matter a real victim. One of the men even composed his own sample message: "I am a sex offender," he wrote. "I was discovered two years ago. My entire family has been hurt. I have been to jail and had to pay numerous fines and court costs. I am presently in treatment. That is not cheap either. I hope to be cured and to learn to control my problem. It hasn't been easy. I wish I never would have started. I knew

THIRTEEN
Society

THE WINGSPREAD conference was organized by the National Committee for the Prevention of Child Abuse, which for the past several years has conducted an extensive public service campaign aimed at adults who beat and batter children. "Take time out," the committee's slogan goes, "don't take it out on your kids." No one who has heard the announcements can help wondering whether such appeals really make a difference, but apparently they do. A decade ago, researchers at the Universities of Rhode Island and New Hampshire conducted a nationwide survey in which hundreds of parents were asked whether they had displayed any form of violence toward their children during the previous year. The categories ranged from pushing, grabbing, and spanking, to punching, biting, kicking, and beating, to using or threatening the use of a gun or a knife. When the same survey was repeated a decade later, the researchers found that while the overall level of violence by parents against children had remained about the same, the use of the severest punishments had diminished by 47 percent.

In attempting to explain the decrease, the study pointed to some social trends that might have made a difference. One was that many couples were marrying later than before, and more mature parents are statistically less likely to inflict serious violence on their children. Another was that many families were having fewer children, which meant there were fewer unwanted children, and unwanted children are more likely to become the victims of physical abuse. The researchers also considered the possibility that those parents who claimed not to have brutalized their children were lying. But they pointed out that whether or not the real incidence of serious physical violence against children had decreased, many parents were at least

you suspect anything. I called the hotline, to see if we could prove that this was true or what. They gave me three different numbers to call, clinics where they do child therapy. I called one of the clinics, but this woman was so busy that she never called me back. I kept calling her every day. She finally said her boss was out sick. She said, 'Well, you'll have to wait until he comes back. He had an accident.' So I waited another whole week. Then they called and gave us an appointment. Two days later the police came and took a report. They sent a caseworker with the anatomical dolls, and he said, 'Definitely, this child has been molested.' He said, 'You keep a record of whatever she tells you.' So I started writing it all down.

"They gave me temporary custody of Tiffany, and they started an investigation. But when we got to the police station that day, Tiffany's mother was there, and she called Tiffany into a room. I thought the caseworker was in there with them, but it turned out they were alone. When Tiffany came out she said, 'Mommy said she'd beat me if I talk about Ralphie. Ralphie is a good boy, Grandma, and I can't talk about him.' I talked to her mother later, and I said, 'What did you tell that child?' She said, 'You went and reported Ralph, and he's innocent. Ralph did not do this, and you're in trouble.' She threatened me several times. She said, 'I'm going to get even with you if it's the last thing I do.'

"There was no state's attorney to question this child. We waited and waited. Finally they told me the courts won't do anything about a three-year-old, because she's too young to get on the stand. They told me, 'No judge is going to stand for that.' They told me there was no physical evidence, because the hymen grows back on small children. But they let me keep custody of her, and I'm trying to get permanent custody. She doesn't want to go back to live with her mother, and she doesn't want anything to do with Ralph. Her mother has only asked for two visitations in seven and a half months, but she's trying to get her daughter back. All the cases are continued five times. They're so overloaded. The caseworker told me they're refusing people, there's so much sexual abuse among children."

mothers who *would* do it over again. But even kind and decent parents or guardians who suspect that their children may have been sexually abused are often reluctant to call the police. The subject at hand may embarrass them, or maybe they're afraid of being wrong or fear retaliation from the suspected abuser. Perhaps they're unwilling to acknowledge, to themselves as well as to others, that they have failed to protect their child as well as they might have. When, like Tiffany's grandmother, they overcome their doubts and summon their courage, they often have difficulty finding anyone who will take their suspicions seriously.

"One day Tiffany was bleeding from her rectum," the grandmother recalled, "so I called her mother and I told her. She said, 'Well, it could be from the detergent, or maybe she's constipated.' But it wasn't just the bleeding. Ralphie is her mother's boyfriend, and Tiffany had started talking about her and Ralphie playing mommy and daddy. She said, 'It feels good. I love him.' I didn't know what she was talking about. Then she came down with a sore mouth. She said her tongue hurt her. So I told this to her mother one Sunday afternoon. She said, 'Well, she should have a sore tongue, because she tells a lot of lies.' "

To the child's grandmother, it seemed as though Tiffany's personality had undergone a change. "She was always so outgoing," the woman said. "But she got real withdrawn, and she looked tired. She started wetting the bed. She said, 'I can't talk to you,' and when she did talk she had a horrible vocabulary. Then she'd say, 'Where's your camera? What did you do with your camera?' She'd start posing, like when we took pictures she'd pose with her legs up. One day we were coming home in the car, and she said, 'Grandma, take off all your clothes. I'm going to take your picture.' This went on for a while before I started putting two and two together — the soreness between her legs, the sore tongue, all these things she was saying. I started thinking this must be a fact, Ralphie really is doing these things to her.

"I took her to the pediatrician, a lady doctor. The doctor said, 'Well, everything seems to be all right.' I didn't tell her what Tiffany was saying, because I wasn't sure and I didn't want to get in any trouble. Because children do fantasize, or so I was told. So I asked my own doctor's wife. I said, 'Could this be possible, or is she imagining these things? I want to be sure that these things are actually occurring, because I don't want to go to jail. I'm scared to death to accuse anybody if it's not so.'

"Then I saw it advertised on TV about the hotline, who to tell if

The day before the new grand jury began its investigation, Weber said, "the president of the teacher's union came to see me. He told me they were not happy with me, and that if things didn't come out well at the grand jury the next day, I wasn't going to be reelected. A teacher sat outside the grand jury room and took down the names of every single student that testified, then printed them up and distributed them to all the teachers in the school district with the warning, 'You have to watch out for these people, because they're liars.' We finally got a conviction, but two days before Vanhook was scheduled to be sentenced, he committed suicide. He had the biggest funeral in the history of Collinsville, Illinois."

The Wingspread group agreed that there was little question that doctors, teachers, and others who have temporary responsibility for children can do much more than they presently are doing to find and get help for those who are being sexually abused, but the panelists acknowledged that doctors and teachers could only do so much. The ultimate responsibility for protecting children, the group thought, lay with parents and primary guardians, but the biggest problem facing child protection workers and others concerned with the safety of children is that there are so many parents who should never have become parents to begin with. Either such men and women never intended to have children in the first place, or they are so out of touch with themselves and the real world that they had no notion of the sacrifice and struggle that child-rearing entails, or they are impaired by drug or alcohol abuse, or they themselves were so badly treated as children that they have no model of decent parental behavior on which to draw. Whatever the reason, they simply aren't cut out to be parents. But who's going to tell them so? In this society, as in virtually all others, bearing children is looked upon as a fundamental human right. State and local governments may invoke their power to take children from their homes after abuse is suspected or discovered, but no government is ever going to assert the power to license potential parents in advance, to decide which of its citizens may bear children and which may not. And in a way that's too bad, because there are an awful lot of miserable parents in the world — a recent public-opinion poll found that 70 percent of American mothers questioned would not have children if they had it to do over again. Whether or not they are abusive themselves, unhappy parents are unlikely to do nearly enough to keep their children out of harm's way.

On the other hand, many parents are at least adequate protectors of their children — including, presumably, the 30 percent of

mandatory reporting law. Particularly stressed was the requirement that the teachers and principals were obligated to call the police themselves when they suspected that a child was being abused, rather than pass the responsibility to their superiors. The teachers were given explicit instructions on how to make such reports, and were even provided with a list of telephone numbers to call. They were also required to watch an hour-long television program that explained the reporting laws in still greater detail. The message apparently got through. During the first four weeks of classes, the school district's child abuse office received 602 reports of suspected abuse, compared to an average of 150 reports a month the year before.

Terry Bartholome's colleagues, at least, didn't try to defend him. When he approached the teacher's union for assistance in hiring a lawyer, he was told, in the words of the union's president, to "get lost." But when a sexual abuse case involving a teacher reaches the criminal justice system, it is not unusual for the other teachers to close ranks behind the one who has been accused. Richard Vanhook, a junior high school teacher from downstate Illinois, used a classic line with his victims. "Do you want me to treat you like my student," he would ask them, "or do you want me to treat you like my girlfriend?" The Vanhook case surfaced in much the same way the Bartholome case had, after five fifth-grade girls reported that Vanhook had been fondling and kissing them in the library and the girls' bathroom. But when the local grand jury weighed Vanhook's reputation against the girls' stories, it refused to return an indictment. "This guy was a teacher, he was a swimming coach, nobody in the community could believe that he would do this," said Don Weber, the prosecutor in neighboring Madison County.

According to Weber, what followed the grand jury's decision not to indict was "the most sickening two weeks of media coverage I've ever seen in my life. The man was hailed as a hero, there were stories about the trauma to him and his family. The police came over to my county — the school district is in both jurisdictions — and they said, 'Can you do anything about it?' I really didn't want the case, but I took this oath to uphold the law, so I said OK. The police by then had uncovered more victims, some going back as far as ten years. The investigation involved sexual molestation of young girls at Edwardsville Junior High School, at Collinsville Junior High School, at the new Collinsville High School and the old Collinsville High School. Of the two hundred girls they interviewed, at least half had been molested in some fashion by Mr. Vanhook."

conduct. When the complaints about Bartholome continued, Bernstein told the woman to gather "more information" and to have the third-graders put their accusations in writing. Not until another two weeks had elapsed did Bernstein finally call the police, and only then after learning that Bartholome had already confessed his pedophilia to a teacher's aide.

"This is a very, very bad situation," a school board official said later. "Nobody is trying to downplay it. We had the facts. Why we didn't move faster, I don't know." Said another board member, "The administrators never rose above memo writing, paper shuffling, and telephone conversations between the school and the regional office." When the full story was pieced together, it emerged that not only had Bartholome fondled his students, he had lain down on a classroom table and masturbated in front of them. On days when Bartholome wore a special pair of trousers from which the pockets had been removed, he encouraged his girl students to reach inside and "take out the change." One girl quoted the teacher as having said, "My wife won't give me none, y'all are going to give me some." After his arrest, Bartholome blamed the children. The girls, he told police, had been "very mature" for their ages, and had "giggled and dared each other to do sexual things to me."

When Bartholome took the witness stand at his trial, he admitted having twice masturbated in front of his students but denied having molested or raped them. Convicted of the sexual abuse of seventeen children, Terry Bartholome was sentenced to forty-four years in prison. Regional administrator Bernstein, charged with five counts of failing to report suspected child abuse, said at his own trial that he had delayed calling the police because he had no facts to support a "reasonable suspicion" that the allegations were true. When Bernstein checked Bartholome's file and found a record of the allegations made against him at his first school, he testified that he discounted them, because "we receive anonymous letters all the time regarding employees." He was convicted in a second trial of failing to report a reasonable suspicion of child abuse. "I don't think there's any question that what happened could have been prevented," the prosecutor in the case said later. "There were enough red alerts and enough signals given to people whose concern for children should have caused them to act immediately and definitively."[6]

The Bartholome case broke during the summer of 1985, and when school resumed that fall, the city made its teachers and principals sign a statement attesting to their understanding of the

themselves, many principals instinctively try to find some way to sweep the matter under the rug. When an eleven-year-old girl accused a Chicago teacher of abusing her, the principal allowed the man to continue teaching — and left it to the girl's parents to inform police. When the police examined the teacher's personnel file, they found two letters from parents accusing the man of having fondled their daughters and a year-old letter from the principal warning the man not to be alone in his classroom with any of his students.

If there is a record for the longest-running sexual abuse cover-up, it must be held by the Los Angeles public school system. The cover-up began to unravel in December 1984, when three girls at a south-central elementary school told their parents that female students were being touched, rubbed, hugged, fondled, and otherwise molested during recess and lunchtime by forty-eight-year-old Terry Bartholome, a seventeen-year veteran of the Los Angeles schools. On paper, Bartholome was an outstanding educator whose official record was filled with commendations. But the record also showed that when he was first hired, school officials were aware that Bartholome had been charged with having exposed himself to a group of nurses in Tacoma, Washington, six years before.

Worse yet, there was evidence in the file that students at the two schools where Bartholome had taught had been accusing the man of sexually molesting them for more than three years. Confronted by his principal when the first accusations were made, Bartholome denied all. When another teacher heard the rumors about Bartholome and approached the principal, she was told to "leave it alone." When the reports persisted, Bartholome was transferred to another school and assigned to a class of third-graders in the belief that he would not molest the younger children. "What else could we do?" a school board official asked later. "He was a fully qualified teacher, and we couldn't prove a thing." To the teachers in the Los Angeles school system, the practice was known as "Pass the Trash."

The principal at Bartholome's new school was told the reason for the transfer and asked by her superiors to keep an eye on the man. In November 1983, she received the first of what would be several new complaints from parents that Bartholome was "bothering little girls in the classroom." Though the principal was required by law to report the complaints to police, she said she had been instructed to direct them instead to her immediate superior, a regional administrator named Stuart Bernstein. Bernstein's response had been to tell her to call Bartholome into her office and to order him to correct his classroom

The Wingspread group acknowledged that while doctors might in theory be better equipped than other professionals to spot the symptoms of sexual abuse, they had less opportunity to do so. A child's pediatrician sees a child once or twice a year; his teacher sees the same child for five or six hours a day. Like doctors, however, teachers often don't recognize abuse for what it is. Some teachers in Jordan, Minnesota, recalled that several of the children there who later claimed to have been abused had behaved oddly for months before the first charges in the case were filed. One boy was described by his teacher as having had "a lot of nervous energy. He couldn't sit down in his chair. He would stand by his desk. He had a hard time concentrating on anything." Another boy drooled constantly. "He was very oral about things," his teacher said, "and he'd always cram things in his mouth, like shoelaces and crayons."

A third child, "a very cute little girl," developed a sudden craving for affection. "She would tell me things that were not true to get attention," her teacher said. "One time, she brought me a necklace for nothing. It was kind of sad." Another child, a second-grader, "was always tired. She would lay on her desk on one side. She was in the back of the room sleeping when twenty-two other kids were romping around the room. Her expression, her body language, both were the absolute absence of emotion. She had the longest face of any child I've ever had in my room — not even sad, just a lack of expression. All these kids had symptoms of something definitely bothering them, but I had no idea this was going on. I didn't know what to look for."

Apart from their inability to recognize many of its symptoms, teachers have the same disincentives as doctors for reporting suspected child abuse — fears of angry parents, of involvement in the criminal justice process, or of being wrong — and those who don't want the aggravation that goes with making such a report often find it easier to say nothing. To compound the dilemma they face, teachers who do try to act on their suspicions are likely to encounter resistance from their own superiors. A principal who fears publicity or angry parents may say he will "handle the problem" and then do nothing, and the teacher who takes it upon himself to call the police may be told that he's causing trouble and warned to stop, even threatened with losing his job.

The reluctance of school administrators to act when they suspect that a student is being abused pales beside their reaction when a teacher is accused of abuse. Anticipating reprisals from the teacher's union and suggestions by the school board that they have been derelict

is in their own best interest to do nothing. When 120 Denver pediatricians were asked how they viewed sexual abuse cases, the most common response was that they took too much time out of the doctor's schedule. "When you've got an office full of children with temperatures of a hundred and four and suddenly you're confronted during the middle of a well-child exam with a vaginal discharge, you're an hour behind," a pediatrician says. "These aren't quick cases. This isn't like an ear check. If you're going to do an adequate history, these cases are going to take a long time.

"Also, pediatricians are about the lowest-paid group. If you have to have three kids an hour to make a living, you would be very reluctant to shut down your practice for three hours to do the kind of sexual-abuse evaluation that's needed. Where are the incentives? You can't sit in an office with a parent who's raised the question of sexual abuse and say, 'We'll do this lab test, call me in the morning.' That's an emotionally charged situation. The minute you start talking about the potential of a child being sexually abused, you better take some time to talk to that mother." Even a doctor who takes the time runs the risk of provoking the parent's anger. "I often get told that I'm going to get sued," another pediatrician says. "Families say to me, 'I'm going to sue your ass off, and I'm going to sue the hospital,' and things like that. I get told that five times a week, even when I explain to them that it's my legally mandated responsibility to report the situation."

The doctor who brushes all other considerations aside and reports his suspicions can look forward in the weeks and months ahead to devoting a good deal of time to the case he has spawned. As the discoverer of the abuse, he will be interviewed by a steady stream of police officers, child welfare workers, and prosecutors. Unless the abuser pleads guilty, the doctor will have to testify at a preliminary hearing and then at a trial, and since he is appearing for the prosecution, he is not likely to be well treated by the defendant's lawyer. "I used to have very little sympathy for physicians who didn't want to cooperate and take time out of their busy schedules to go to court," says a pediatrician who has testified in a number of sexual abuse cases. "But having been abysmally treated at times by the legal profession, I can see why physicians just don't want to expose themselves to that sort of trauma. Unless you do it anonymously, reporting puts you in the position of being further involved in what happens. You find that quite often the lawyers and sometimes the courts are not very considerate of your time and of what this costs you, just not very considerate of you as a professional."

often accompany abuse, such as abdominal pain, headaches, and overly passive or withdrawn behavior, are even less often seen for what they really are.

C. Henry Kempe, the late Denver pediatrician who coined the term "Battered Child Syndrome" back in 1962, once wrote that "the child who does not cry when he is stuck with a needle is either very sick with his basic illness, or he is very sick emotionally, because he has been trained at home not to cry when he is hurt." Kempe also warned his fellow physicians that the child "who is going around saying to one and all, 'I like you,' in an indiscriminate fashion, the child who does not object to being separated from his parents, [and] the child who lies perfectly still when being dressed and undressed . . . is telling you that he is doing those very things at home."[5]

Despite the persuasive evidence to the contrary, some doctors still refuse to believe that any children are sexually abused. One social worker recalled that "one of the most shocking, painful experiences I ever had was when I was working with a young woman who was drug-addicted, and she made an attempt to kill her mother. I don't think it was a serious attempt, but we chose to commit her to an adolescent unit at a teaching hospital. I called the head resident — this is a man who's in a teaching position. I said, 'Have you been able to talk to this child about sexual abuse? Because she was also molested by her mother's boyfriend.' And he said, 'Well, it really takes two to tango.' I couldn't continue my conversation with this person."

A doctor's reluctance to report the possibility of sexual abuse stems less often from disbelief than from other motives, not all of them conscious. Even when a doctor half suspects that abuse has occurred, it's easy for him to deny the possibility to himself when there are no overt symptoms at all. "You have to remember that doctors, like lawyers, look at the world in a very specific way," one pediatrician says. "They're very factually oriented. Doctors are used to dealing with very clear evidence of a known disease. There's still a feeling out there that unless there's a clinical symptom, you don't have to do anything, even though we all know there may be no clinical symptoms."

"We're human too, despite public opinion," another pediatrician says. "A lot of doctors have known their patients for a long time, and if a thought crosses their minds, particularly about sexual abuse, there's first the denial and then, 'Well, I'll see how I can handle it myself, gently and over a period of time, because I don't want to alienate this family.' "

When such suspicions do occur, some doctors may decide that it

sexual abuse also seems to stem in part from their lack of knowledge about its prevalence and character.

It is a shortcoming the medical profession is moving slowly to correct. Not until 1983 did the American Medical Association hold its first national conference on the subject, and only in the past couple of years has the American Board of Pediatrics begun to require some sexual-abuse training in hospital residency programs. The symptomatology of sexual abuse is not yet a required subject for board certification examinations in pediatrics, psychiatry, or other related fields, and most medical students still receive a single two-hour lecture on the topic. Because so little is known about why adults have sex with children and how victims should be treated, the subject of sexual abuse, unlike that of pneumonia or liver disease, doesn't come with any conclusive theory attached.

Since there's no commonly accepted etiology, some professors of medicine who might otherwise be willing to teach the subject aren't sure of what to teach. Others object to it on the grounds that the available research is sketchy and the subject matter "more emotional than intellectual." As a result, whatever expertise a practicing physician does have is likely to have been acquired during an internship or residency at a receiving hospital. But even highly trained specialists are less than likely to spot the symptoms of sexual abuse. It may never occur to the urologist, for example, that a child with a urinary tract infection or who is a chronic bed wetter might be the victim of abuse.

Because they see children exclusively, pediatricians are becoming more quickly attuned to such subtleties than most other doctors. When a child who is suspected of having been abused is taken to a pediatrician, the chances are good that some of the most appropriate things will be done. Bruises, abrasions, and lacerations of the genitals and the surrounding area will probably be noted, and most pediatricians will order a vaginal culture for gonorrhea. But the child's throat and anus may not be cultured, and diseases like chlamydia and herpes may not be tested for at all. A new and simple test for the presence of sperm, important because it can also help to identify the child's abuser, is even less likely to be performed.

Unless the possibility of abuse has been raised in advance of a pediatric examination, however, it is unlikely that any of these procedures will be performed. Rather than suspecting gonorrhea, a doctor who encounters a vaginal discharge in a "well" child is likely to blame it on underwear that is too tight or to suggest that the child's mother change her bubble bath. The psychosomatic symptoms that

covered by such laws are aware of their responsibilities, and many have also passed amendments protecting such individuals from civil lawsuits for making an erroneous report in good faith. But a great deal of suspected child abuse is still going unreported. A 1985 study by New York City found that four out of ten teachers there had failed to report at least one case of suspected abuse, as had 18 percent of the city's hospital personnel and 8 percent of its police officers. Nearly all of those questioned said they were aware of what the law required, and most had received some sort of training in identifying the symptoms of abuse. But many said that nothing had been done when they had made such reports in the past, and they had come to doubt the ability or the willingness of the child protection authorities to act.

Not all of the blame for the failure to report can be attributed to the professionals. State child protection authorities must make it easier to make a child abuse report. The Illinois child abuse hotline, considered by many a model system for reporting, has often been a failure in practice. In one study reported by the *Chicago Tribune*, 28 percent of hotline callers either hung up after reaching a recording or had to wait for more than an hour and a half before a child protection worker called them back. "That's not a hotline, when you call people back," one state official said. "The idea of a hotline is to take a call and deal with it, and we're not doing that."

Sometimes the reluctance to report suspected child abuse is a matter of conscience, as with clergymen who fear that to make known what they are told in confidence will have a chilling effect on parishioners seeking forgiveness. Doctors have no such excuse, but the 1980 federal study found that almost half of the cases of abuse suspected by doctors were going unreported. Only 14 percent of the child abuse reports made in this country last year came from physicians, and according to the *Los Angeles Times*, fewer than half of the children in Los Angeles County found to have venereal disease are ever reported by doctors to that county's child protection agency.[4]

The tardiness of doctors in recognizing and reporting the sexual abuse of children follows their earlier reluctance to acknowledge that children were being physically abused. Barely twenty years ago, children who had been beaten and battered were often diagnosed as suffering from "spontaneous subdural hematoma," a brain hemorrhage that appears for no reason, or "osteogenesis imperfecta tarda," a congenital weakness of the bones. Such diagnoses have become less common as the physical abuse of children has gained recognition as a major problem, and the failure of many doctors to report cases of

all of them agreed that it was unfair to put the burden of preventing sexual abuse on children. The fact that most prevention programs were so flawed, the group thought, made it imperative that the prevention effort be directed elsewhere. Another thing they agreed on was the urgent need to find those victims who were going undiscovered. For every victim who spoke out, some thought, there were ten who remained silent. Others thought the real number was closer to a hundred for every one. Finding more victims might not solve the problem of sexual abuse, since victims by definition have already been abused. But not only will identifying such children take their abusers out of commission, treating them may also reduce the future population of abusers.

If many such children weren't coming forward, the Wingspread group thought, then it was incumbent upon doctors, teachers, and other professionals who have contact with children to learn to recognize the symptoms of sexual abuse. During the first half of this century, most states enacted some sort of law prohibiting the mistreatment of children, but not until the mid-1960s were laws passed requiring mistreatment to be reported to child protection authorities. The first mandatory reporting statutes were aimed only at doctors, but they have since been broadened to include many others who have temporary custody of, or responsibility for, children. Every state now has such a law, and most are directed at teachers, mental health professionals, police officers, and clergymen. Some even include dentists, paramedics, audiologists, podiatrists, optometrists, and barbers. In most cases, those covered by reporting laws must notify child protection authorities immediately if they suspect that a child has been sexually or physically abused, and most laws carry criminal penalties for failing to do so.

Despite the rise in the number of child abuse reports, from 150,000 in 1963 to more than 1.3 million in 1982, there is evidence that the reporting laws still do not work as well as they might.[3] Seven years ago a federal government study found that two-thirds of all cases of suspected child abuse were not being reported by those covered under the statutes, including 87 percent of those cases known to teachers and other school personnel. The explanations the teachers gave for keeping quiet included their ignorance of what the law required, their misconception that solid evidence of abuse was necessary before a report could be made, and their fear that they would be sued by the alleged abuser if their suspicions were incorrect.

Since then, most states have taken steps to ensure that those

they'd tell about being abused, they may say their mother or their father, but when the time comes, there may be a gap between saying and doing.

It is a basic principle of education that people, especially young people, learn much more efficiently if they have some personal experience that bears on what they're learning. Trying to explain the dangers of sexual abuse to a child who hasn't been abused is difficult, particularly when the presentation is not straightforward. A child who *has* been abused, on the other hand, is likely to understand immediately what is being said. If prevention programs have any real value, it may be that they prompt some victims to come forward. "We know that these programs are good for one thing," says a pediatrician who has studied the question. "They're good for identifying kids who have already been sexually abused. When you do one of these shows, inevitably one or two kids out of a group will come forward and say, 'Well, that happened to me.' "

Even in such cases, however, sexual-abuse prevention programs are likely to be effective primarily with younger children who are being abused by someone outside their families. Far less clear is the value of such programs in preventing the most prevalent kinds of abuse, mainly incest and voluntary relationships between older children and pedophiles. The fact that such programs do encourage some victims to report may be reason enough to continue with them. But the content of most programs needs to be vastly improved to reflect what happens in the real world. In view of some of the testimony in recent child abuse cases, for example, one thing children should be taught is how to overcome the fear created by watching small animals killed before their eyes.[2] But no matter what information the prevention programs contain, teaching children to "say no" to sexual abuse is a simplistic answer to an extraordinarily complicated problem.

On a snowy Sunday afternoon in January 1985, Judith Becker, Kee MacFarlane, David Finkelhor, and a dozen other child abuse researchers from the United States and Canada gathered at "Wingspread," the largest and last of Frank Lloyd Wright's prairie houses, just outside Racine, Wisconsin. It was an eclectic group — child therapists, social workers, a sociologist, several psychologists, two psychiatrists, even a writer. For three days and nights they talked, in panel discussions and among themselves, but no matter how the discussions began they inevitably returned to a single question: Could the sexual abuse of children in America ever be eradicated?

Some of those in attendance were less pessimistic than others, but

kids. I had a gynecologist come up, and from what he said I had real concern about what he was doing with his own daughter. They don't see any relationship between what I've been talking about for the last hour and what's going on in their homes."

Parents are not the only ones who object to such programs. As one California social worker points out, teachers who are called on to administer such programs "feel like this burden has been dumped on them, and their response is that this is something that should be taught at home. This is an area that they just don't see as their business. Teachers are loaded with a million different things to do that don't have anything to do with teaching kids, and they think that anything that doesn't have to do with teaching kids just shouldn't be part of their job. They're tired of the community looking to them for the solution to all its problems."

When teachers object to presenting such programs to their students, the only recourse open to school administrators is to bring outside presenters into the classroom. Whether they are local police officers or social workers or simply well-intentioned parents, such presenters are not likely to be very well versed in the subject at hand, which renders the presentation even less effective. A few have no business being near children at all, like the Maine man who, as "Sparky the Clown," put on plays about the dangers of sexual abuse until he himself was charged with the sexual abuse of twenty-eight children.

Prevention programs may give those who prepare and produce them a sense that they're doing something about child abuse, but there are serious questions about whether even the best programs are worth the effort. When children who have been exposed to prevention programs are asked later about what they remember, the answer is usually "Not very much," and the level of recall doesn't seem to depend on the quality of the program. One study found that children who were exposed to one of the better programs had forgotten much of the information it contained after only two months, and nearly all of it after less than a year.

Even when children do remember a particular concept, they're less than likely to be able to apply it to a real-life situation. Another study found that, while nearly all the children exposed to an assertiveness program could later repeat the definition of "assertiveness," fewer than half could give an example of an assertive reply to be used in an abusive situation. Younger children especially tend to parrot the answers they've been taught. When they're asked whom

A brochure distributed to parents by the Fairfax, Virginia, police department goes further still, saying, "It should be emphasized to children that only doctors or a parent or guardian are permitted to touch them in a personal manner." Considering the number of doctors who have been convicted of abusing children sexually, they hardly deserve a special exemption. But the real problem with sexual-abuse prevention programs is that they ignore the vastly greater danger to children from adults they know, particularly their own parents. Very few programs warn children about the possibility of sexual abuse by relatives, and there are almost none that discuss parent-child incest. Those who design such materials defend their skittishness by pointing to the parent-teacher protests that have sprung up even when the most innocuous programs have been introduced into local schools.

"I'd walk into gymnasiums with two hundred and fifty parents, and they'd be saying things like 'Rape crisis for my kindergartner, no way,'" one Utah child abuse counselor recalls. "I was in a parent meeting once where a woman got up and said, 'I'm running for PTA president next year so we won't have programs in the schools like this one.' I remember doing training in one school system where the principal just got outraged. He said, 'You make this sound like it's happening everywhere. I've been an administrator here five years, and we haven't had this problem.' And one of the assistant principals stood up and said, 'Well, there's six kids right now in the school, and furthermore I was a victim.'"

Some parents oppose prevention programs on the ground that they "put ideas about sex in children's heads." Others are concerned that sexual-abuse prevention might somehow be akin to sex education. Because many parents find it hardest to acknowledge the possibility that their children may be at risk from family members, sexual abuse counselors argue that in most cities an "incest prevention program" would have no chance of gaining acceptance. "To be perfectly honest with you, we're not all that upfront about it," says a sexual-abuse prevention worker in Greenville, South Carolina, the ultraconservative home of fundamentalist Bob Jones University. "That would make a lot of people real nervous."

Perhaps surprisingly, the bulk of the opposition to such programs appears not to come from parents who are abusing their children sexually. "Most abusive parents don't consider what they're doing to be abuse," says a counselor who administers prevention programs for both children and adults. "It's wild. I've had people come up to me after I've given my talk and explain in great detail what they're doing with their

zones" or "places where your bathing suit covers." The *Red Flag,
Green Flag* coloring book contains a drawing of an androgynous child
whose arms, legs, chest, and other body parts are identified for what
they are, while the region beween the child's legs is merely labeled
"genitals (private parts)." Upon closer inspection, it becomes apparent
that the child in the drawing has no genitals or private parts.

Another serious shortcoming is the exclusive focus of many pre-
vention programs on the danger posed by strange adults. One film,
produced by the Boulder, Colorado, police department, shows a shady-
looking character luring a little girl into some bushes, where she is heard
to scream — the same sort of "stranger danger" movie that American
schoolchildren have been watching for decades with no noticeable effect
on the incidence of sexual abuse. There's nothing really wrong with
warning children never to accept candy or a ride from adults they don't
know or never to open the door for a stranger, since some pedophiles do
abuse strange children. It's just that most of them do not. Of the adult
victims surveyed by the *Los Angeles Times*, only a quarter recalled
having been abused by someone they didn't know.

Programs that teach children to memorize their home telephone
number or that of the local police department might be helpful for a
child who becomes lost, but they have very little to do with preventing
sexual abuse. Some programs feature "assertiveness training" for
children, teaching them to defend themselves physically by stomping
on an abuser's foot or bending his pinky. But the idea that a child can
repulse an attack by an adult is both ludicrous and dangerous to the
child. Those who promote such programs maintain that, while
warning children about strangers may not cover the spectrum of child
abuse, such advice cannot hurt. Apart from the possibility that such
messages may frighten some children unduly, the distinctions they
draw about which adults should be trusted and which should not are
often vague.

Never Talk to Strangers suggests that it's fine for a child to talk to
any adult who is introduced by someone the child knows. "If your
father introduces you to a roly-poly kangaroo," the book advises, "say
politely, 'How do you do?' That's not talking to strangers because your
family knows her." Or: "If your teacher says she'd like you to meet a
lilac llama who's very sweet, invite her over and serve a treat. That's
not talking to strangers because your teacher knows her." Worst of all:
"If a pal of yours you've always known brings around a prancing roan,
welcome him in a friendly tone. That's not talking to strangers because
your pal knows him."

cautionary words about neighbors, teachers, and baby-sitters thrown in. But *It's O.K. to Say No!* never says what it's OK to say no to. In one story, a girl named Tina spends the night at the home of Lucy, her friend. After Tina's in bed, Lucy's big brother comes into her room and starts saying "strange things" that make Tina feel "uncomfortable." But what things? Why does Tina feel uncomfortable? The reader never finds out. Because *It's O.K. to Say No!* and similar storybooks are designed for parents to share with their children, their squeamishness may be an acknowledgment that many parents feel uneasy talking with their children about any aspect of sex. But those programs designed for presentation in the classroom or to youth groups by trained instructors are scarcely more forthcoming.

One of the most popular is *Red Flag, Green Flag*, a multimedia program developed by the Rape and Abuse Crisis Center of Fargo-Moorhead, North Dakota, the centerpiece of which is a coloring book that helps children learn the difference between a "green flag touch" and a "red flag touch." The program is typical of those that, in seeking ways to avoid actually talking about sex, distinguish between "good" touches, such as a hug or a pat on the head, and "bad" touches. Such jargon involves a number of potential contradictions, such as the possibility that a child whose genitals are being fondled might find the sensation pleasant. A few programs have tried to resolve such contradictions by introducing a third category called "confusing" touch, which they define as a touch that might feel good but is bad nonetheless. But the idea of confusing touches is just that, because it doesn't address what often happens in the real world.

Nor do such programs recognize that children often take things literally. Is an abuser who asks a child to perform fellatio touching the child, or is the child touching the abuser? Programs that warn children about adults who might "bother" or "hurt" them are equally misleading, since a child who's being sexually abused is probably not being physically hurt. "We're giving children an outrageous double message," says Cordelia Anderson of the Illusion Theater in Minneapolis, which produced the first live-theater prevention program back in 1979. "We're saying that we want to talk to you about *it*, that if you have any questions about *it* I want you to ask me about *it*, that it's not OK if someone does *it* to you, and that if *it* happens it's not your fault. But what *it* means is so bad that I can't even say the words."

With the same misguided decorum they reserve for talking about "touching," most prevention programs refuse to call penises and vaginas by their proper names, referring instead to mysterious "private

Though prevention programs differ widely in approach, nearly all attempt to establish three fundamental ideas: that a child's body is the child's "property," that a child can "say no" to an abusive adult, and that a child who is molested must immediately "tell someone" who will take action. Such messages are hard to argue with on their face, but they are conveyed in a variety of ways. Some are silly, like Trooper B. Safe, a fifteen-thousand-dollar robot with a flashing red light and siren that is used by police in several states to teach children to avoid child molesters. Dressed in a state trooper's uniform and speaking through a voice synthesizer, the robot promises to protect "humanoids who live in the intergalactic space-sphere called Earth," paying special attention to the "small, younger human units." Most prevention programs adopt a more serious tone, but many are flawed in other ways, and some are downright dangerous.

One of the best-selling books on the subject is *Never Talk to Strangers*, first published by Golden Books in 1967 and reissued last year. The book uses what its publisher describes as fantasy and humor to convey its message "in a nonthreatening way." The illustrations it contains show children in familiar settings — at home, at the store, at the bus stop, at the playground — when an unfamiliar and presumably threatening character appears on the scene. None of these strangers, however, is human. "If you are hanging from a trapeze," the book begins, "and up sneaks a camel with bony knees, remember this rule, if you please — Never talk to strangers!" It goes on to warn children about grouchy grizzly bears, parachuting hawks, a rhinoceros waiting for a bus, coyotes who ask the time, cars with a whale at the wheel, and bees carrying bass bassoons.

The use of animals to represent potential abusers is no doubt inspired by the idea that children will be less frightened by a picture of a rhinoceros wearing a tutu than by one of a malevolent stranger in a raincoat, and other prevention programs use chipmunks, mice, or bears to make their point. The problem with such anthropomorphic presentations is illustrated by a filmstrip featuring Penelope Mouse, who has an otherwise unidentified "strange experience" at her Uncle Sid's house. When a group of schoolchildren who had been shown the filmstrip were asked later what its message was, they agreed that sexual abuse must be a serious problem among mice.

Another best-selling book is *It's O.K. to Say No!*,[1] endorsed by the Catholic Youth & Community Service and the Children's Justice Foundation. The book mostly contains warnings about "child molesters" who frequent public restrooms and video arcades, with a few

Prevention

A MERICA SOMETIMES seems to be the most prevention-minded nation on earth. It's practically impossible to turn on a television or radio without being overwhelmed by appeals for help in preventing everything from heart attacks to forest fires to accidents in the home. As reports of child sexual abuse continue to rise faster than those of any other crime, many who are concerned for the welfare of children have begun a campaign to prevent child sexual abuse. At the moment, the most popular approach is teaching children how to protect themselves from child abusers. If children can only be taught to say no to adults who want sex, or so the thinking goes, the problem will be solved of its own accord. But most sexual-abuse prevention programs have serious shortcomings, not the least of which is their squeamishness about the subject at hand, and there are questions about how well even the best of them work.

There are hundreds of prevention materials available, most produced by child therapists, rape crisis centers, teachers, hospitals, and writers of children's books. New programs arrive on the market each week in such numbers that newsletters are now being published to help keep track of them all. In attempting to convey their message, they use every device imaginable — storybooks, movies, videotapes, television programs, filmstrips, comic and coloring books, puppets, even live theater. A few have enlisted Hollywood stars such as John Houseman and Henry Winkler to instruct children on how to protect themselves. Most of the programs are produced by nonprofit organizations, but some writers and publishers have discovered that they can cash in on parents' fears, and the competition is so intense that a few authors have resorted to hucksterism and outright scare tactics.

of solid research on all aspects of sexual abuse is remarkable. The Child Abuse Prevention and Treatment Act of 1974 established NCCAN to coordinate federal funding for treatment and research. But NCCAN has never had enough money, and nowadays it has even less. When Jimmy Carter was in the White House, the agency's four-year budget totaled $79 million; during the four years of the first Reagan Administration, it fell to $71 million total.

In 1986, after two years of intensive publicity on the subject of child abuse, NCCAN's annual budget was increased to $26 million — less than half the amount of foreign aid given during the same period to the government of Haitian dictator Jean-Claude Duvalier. The low priority accorded child abuse research reflects the degree to which the scope and seriousness of child abuse in America are still not recognized for what they are. But it is also a measure of the failure, by government and by large segments of the academic community as well, to acknowledge the necessity and legitimacy of such research.

sexual-abuse treatment for children is less than ten years old, which means that hardly anyone in it has more than a decade's worth of experience. The number of qualified sexual-abuse therapists with even half that much training would not fill a large hotel ballroom, and most of those are self-trained practitioners who have picked up their knowledge on the job. "Little kids are hard to figure out," one child therapist says. "It's like learning a foreign language, and every child speaks his or her own dialect. Just as a person coming from another country needs an interpreter, so do children. Children are not miniature adults. Even those of the same age are quite different. I keep feeling like every month I learn more about what I don't know. If I'm an expert at anything, it's in what not to do."

The understanding of why some victims are more traumatized than others by sexual abuse, and how best to treat those who fall into each category, awaits a good deal more research. The answer is likely to be found only through monitoring young victims closely as they grow into adolescence and adulthood, but nearly all the information now available on victims consists of individual profiles gleaned over a brief period of time. If child sexual abuse victims are lucky enough to be among the relatively small number who receive any therapy at all, they may be evaluated over a few weeks or months or at most a couple of years. Since the data comes from hospitals and clinics scattered across the country, it lumps together victims who have been abused in many different ways by many different kinds of people.

Such information has its uses, but many researchers believe that if the abusive cycle is ever to be understood, it will be necessary to study the same victims for the rest of their lives. Because these so-called longitudinal studies require keeping close tabs on children as they grow up, marry, have children of their own, and move from place to place, they are extraordinarily expensive. Researchers at UCLA were recently awarded $450,000 by the National Center on Child Abuse and Neglect (NCCAN) to pay for just the first three years of a proposed longitudinal study of some of the McMartin preschool students. The project may ultimately prove invaluable, since the advantage of conducting such a study in a macro day-care case is that it permits the long-term observation of children from similar social and economic backgrounds.

Because longitudinal studies take decades to complete, the answers they offer will not be quick in coming, and because research into child behavior is not accorded the same status as research on adults, there are not many such studies under way. In fact, the paucity

If the adult victim of sexual abuse has the funds to suffer trial and error, sooner or later she may come across a therapist who comprehends the source of her distress and knows how to resolve it. "Probably the most important thing I got from therapy," one such victim says, "is the realization that the things I'm frightened of are much smaller than the fears they generate. Having confronted my biggest, darkest secret and lived to tell about it has given me more confidence about dealing with all the other dark parts of my life. It's one thing to have a person on the outside tell you to 'get over being molested.' It's quite another to talk about what such an incident does to your life and how you can learn to live with it, with someone else to whom it has happened. I don't know that any of us ever overcome it or truly forget it. I have been able to recognize, consciously at least, that what happened was not my fault. I'm beginning to realize that unconsciously as well, to let my guilt go, but it's taking longer. I realized that I would never think that what happened to everyone else in the group could possibly have been their fault, and this helped me to see that no rational person would believe that what happened to me was my fault either. One of the biggest benefits was realizing that it was perfectly normal to still be bothered about it all these years later."

As the woman's experience illustrates, successful treatment can sometimes be a relatively straightforward matter of convincing the adult victims of child abuse that they are not responsible for having been abused. But those adults who have been abused in more serious ways or over a longer period of time are more difficult to treat, and those without the money to finance the search for effective therapy are likely to be less than successful in finding it. Most large cities have community mental health programs that offer counseling for free or at reduced rates, but such programs have never had adequate funding, and recent cutbacks in federal and state aid to social services have further diminished their capacity to render help.

For the parents of a son or daughter who has been sexually abused, pursuing adequate child therapy can be a supremely frustrating experience. Because not much is known about how children's minds really work, there's no real consensus on how to treat abused children. Even though most adult disorders have their roots in childhood, modern psychiatry has chosen to concern itself almost entirely with the finished product. The few psychiatrists who acknowledge what seems a principal shortcoming of their profession admit that most of their colleagues do not find children very interesting patients, and also that child psychiatry does not pay very well.

To the extent that it can be called a field at all, the field of

may be the nature and severity of the abuse, the length of time that it goes on, and the child's relationship to the abuser. Although far more research is needed into the importance of these factors and probably others not yet identified, the impression that some victims are left untouched by sexual abuse can be deceiving, and it is a mistake to minimize the potential impact of even the least serious occurrences of sexual abuse.

Whatever the nature of their experience, it is much harder than might be imagined for the victims of sexual abuse to find effective psychotherapy. Psychoanalysts and psychiatrists who spend years studying such disorders as schizophrenia and manic-depressive psychosis are often reluctant to become involved in what they view as counseling, and some still hold the view that women who claim to have been sexually abused as children are merely fantasizing.

One well-known psychiatrist suggests that, despite their medical degrees and other impressive credentials, some of his colleagues have no business treating anybody for anything. "Some of the least well-adjusted people I've ever met are in this profession," he says. "Thirty percent of them I wouldn't trust with my dog." When the *American Journal of Psychiatry* surveyed 1,442 of its psychiatrist subscribers, 7 percent of the men and 3 percent of the women acknowledged that they had had sex with their patients during therapy. A Minneapolis psychologist who reviewed some four hundred complaints of sexual misconduct by psychotherapists concluded that many of the therapists were themselves suffering from narcissistic personality disorders, and that a smaller number were actually schizophrenic or psychotic.

Further down the treatment ladder are the counselors. The Los Angeles telephone directory contains listings for twenty-one different kinds, including crisis counselors, divorce counselors, drug abuse counselors, parental guidance counselors, and spiritual counselors, who offer a host of therapies identified as primal, humanistic, encounter, stress, growth, gestalt, Reichian, "feeling," rational, core, orgonomy, Jungian, group, bioenergetics, existential, holistic, behavior, and Rolfing. Some of these therapists are skilled clinicians with graduate degrees in psychology, but because there's no academic specialty in sexual abuse therapy, no special credentials or experience are required to treat its victims. Even in the relatively few states that regulate the field strictly, those with training in anthropology, literature, and religion can qualify as licensed marriage, family, and child counselors. In some states, anybody with the money to rent a suite of offices and some Scandinavian furniture can call himself a psychotherapist and charge patients for counseling.

Becker ascribes her findings to a characteristic she calls "learned helplessness," a personality trait acquired by a child who is being abused and who realizes that he or she is powerless to fight back. "It's a myth that rapists are looking for attractive women, women in high heels and shorts," Becker says. "That's not it. It's the woman who looks very vulnerable, who looks like she's not going to fight. And if you've developed this phenomenon of learned helplessness, then you're really at risk for being violated by one of these rapists." Many of the rape victims surveyed by Giaretto went further, admitting that they had consciously put themselves in unnecessarily hazardous situations by walking down dark and dangerous streets or striking up suggestive conversations with strange men.

Not all sexually abused children become prostitutes, drug addicts, child beaters, or rape victims. Most, in fact, do not, but the majority of these do not go on to lead happy lives. The victims surveyed by the *Los Angeles Times* seemed much more distressed and unsettled than the nonvictims, and many others complain of depression and anxiety, of relationships that are superficial and empty, and of feeling that everyday events are beyond their control. The uncertainty that surrounds the question of how victims respond to the trauma of sexual abuse is compounded by some fresh evidence, not yet fully evaluated or understood, that a minority appear to suffer no lasting emotional harm.

According to UCLA's Gail Wyatt, some of the victims in her study reported that their abuse "was done in such a loving and warm way that the child never knew this was something inappropriate, until years later when someone labeled it for them. It was a pleasurable experience, not traumatic, there was no physical coercion involved. But you can look at someone else who had that very same experience, being fondled by an uncle every time the uncle came over for a holiday, and that woman might say it was one of the most horrendous experiences of her life, shaped her attitude toward men, created difficulty in her sexual relationships, and on and on and on. I don't think we know enough about the personalities of individuals, their coping mechanisms, to really say which incidents have an impact and which ones don't."

One possibility is that younger victims may suffer less anguish than older ones, simply because they're too young to understand the significance of what's happening to them. Personality differences are also likely to be a factor, since some children are simply more rugged than others and better able to survive any trauma. Other determinants

Although most reactions are less extreme, they are not necessarily less serious. When the University of Chicago's Jon Conte compared 369 sexual abuse victims with children who had not been abused, he found that the victims had more nightmares, were more depressed, had more problems in school, daydreamed more, and had more trouble remembering things. They were more "aggressive and fearful," less "rational and confident," and more likely to withdraw from the normal activities of life. Their self-images were poorer, and they were more anxious to please adults.

Because the probable magnitude of child sexual abuse has not been recognized until so recently, much less is known about what happens to such children as they grow up. So many adult victims have never told anyone about their childhood abuse that it's difficult to make generalized statements about the long-term psychological and social results. Still, there are some clues. Sixty percent of two hundred prostitutes interviewed in San Francisco had histories of childhood sexual abuse. So did 75 percent of those in New York City, 65 percent in Seattle, and 90 percent in San Diego. When five hundred older teenagers in a California drug abuse rehabilitation program were asked about their childhood sexual experiences, 70 percent said they had been abused.

A survey of seventy-five women in a Minneapolis alcohol dependency program found that more than half had been abused as children, mostly by their fathers. When 118 adult female drug addicts in New York City were asked the same question, nearly half said they were victims of incest. When women who admitted severely beating their children were questioned in a California survey, 82 percent said they had been sexually abused by their fathers. In another study, nearly half of a group of women who compulsively cut their arms and legs with knives, burned their bodies with cigarettes and acid, swallowed toxic substances, or poked themselves with pins and needles had suffered sexual abuse as children. Most of the other women in the group had suffered serious physical abuse.

There is also some evidence that the percentage of rape victims who were sexually abused as children may be higher than for the female population as a whole. When Henry Giaretto asked female victims of child sexual abuse whether they had been raped as adults, 60 percent said they had. When Columbia-Presbyterian's Judith Becker approached the question from the opposite direction by asking women who had been raped if they had been sexually abused as children, a third said they had.

have also been sexually abused. "I don't know what you find in a seven-year-old that makes them do sexual violence to a two-year-old if they haven't had that in their own backgrounds," a child therapist says. "I really worry about these kids being out in the community, and some of them are seven and eight."

It is sexually abusive children who ultimately do the most damage, since the abuser who begins abusing while still a child is likely to commit hundreds of sex crimes during his lifetime.[2] If such children could be placed in treatment the moment they began to make the transition from victim to victimizer, it might be possible to interrupt the abusive cycle at the outset. But the treatment of adolescent abusers depends on the identification of abusive children, and most sexual abuse committed by children is not recognized for what it is. Children who abuse other children tend to be what therapists call "pseudo-mature." They look and act like other children their age, but because they're emotionally underdeveloped, they prefer to spend time with those who are younger than themselves.

When abuser and victim are both very young, the beginnings of a lifelong compulsion to have sex with children may be easily passed off as "playing doctor." In somewhat older children, what may be the emergence of a grown-up pedophile is likely to be dismissed as preadolescent sex play. A teenage boy who sexually assaults a girl his own age is often seen as "overamorous," or the victim of a teenage tease. Even when sexually abusive children do come to the attention of authorities, most states have no effective way of ensuring that they receive the intensive treatment necessary to short-circuit their attraction to sex with other children. For fear of branding children with a lifelong stigma, most juvenile courts and child protection agencies are still reluctant to label juvenile sex offenders as what they are.

The question of whether those who sexually abuse children can be successfully treated, and if so, how, is in urgent need of an answer. But the urgency should not eclipse another question of equal importance: What are the effects of sexual abuse on those who do not grow up to become child abusers, and how can such victims best be treated? The psychological consequences of sexual abuse are far too little understood. What is known is that, one way or another, not many children emerge from such an experience unscathed. Many younger victims revert to infantile behavior like sucking their thumbs and wetting their beds. Some set fire to their houses or mutilate their pets, and a few even attempt suicide by stabbing themselves with knives, running in front of moving cars, or jumping from high places.

male sex hormone, and with it the sex drive, it is not an infallible remedy. Some European studies have found that a third of the men who are castrated are able to continue having sex, and the effects of castration are also reversible. A California man who agreed back in 1946 to be castrated in lieu of going to prison was in court again forty years later, to plead guilty to having abused three young girls he met by answering a newspaper advertisement for a baby-sitter. When the judge asked the obvious question, the man explained that he had been injecting himself with male hormones to offset the effects of the castration.

Less offensive to many is the use of a female hormone, marketed as a birth-control aid called Depo-Provera, that also diminishes the male sex drive. The drug made headlines in 1984 when Roger Gauntlett, a forty-three-year-old Michigan man convicted of abusing his teenage stepdaughter, was sentenced to be treated with Depo-Provera; Gauntlett happened to be the great-grandson of W. E. Upjohn, the founder of the pharmaceutical company that produces the substance. When Gauntlett appealed his sentence as unconstitutional, the Michigan Court of Appeals agreed and resentenced him to five to fifteen years in state prison.

Despite the questions of constitutionality that the use of Depo-Provera entails, its proponents insist that the drug holds great promise for the treatment of pedophilia, and experiments at Oregon State Hospital, Johns Hopkins University, and elsewhere suggest that some child abusers who genuinely wish to lose their attraction for children may be helped by the drug. Most others, however, are not helped, because Depo-Provera does nothing to diminish nonsexual, narcissistic drives like the need for control and affection. The drug's future is also called into question by studies showing that as many as a third of the men who are injected with Depo-Provera can still become sexually aroused, and it is useless where female abusers are concerned.

While the search for ways to find and stop those who are sexually abusing children continues, most of the research currently under way involves developing better methods of treating adult men and women who have been having sex with children, many of them for years. What such an approach overlooks is the fact that most confirmed pedophiles don't begin molesting children on the day they turn twenty-one. When pedophiles are asked how old they were when they began having sex with children, many place the onset of their behavior in their teenage years or even earlier; more than three-quarters of one group studied said they began abusing younger children before they were twelve. Not surprisingly, most children who abuse other children

thing. It keeps child molesters away from children. The problem is that there aren't enough prisons to hold all the pedophiles. The half-million inmates in this country are already jammed into facilities built to hold half that number, and the inmate population goes up every year by enough to fill California's Folsom Prison four times over. But even if there were room enough, warehousing child abusers is not a permanent solution to the problem of child abuse, because even with the current trend toward harsher sentences, most of them eventually get out.

In most states, an inmate must serve only a third of his minimum term before he is eligible for parole, which means that a child molester who receives a fairly stiff sentence of twenty-five to forty years will come up for release in a little over eight years. Unless he is a genuinely regressed abuser, the child molester who cannot be successfully treated or otherwise dissuaded from having sex with children has probably been abusing them for years. The longer the compulsion to have sex with children goes on, the stronger it becomes, and by the time a pedophile has had four or five victims, it's usually too late. When such men are released from prison, the chances are excellent that they will abuse again. Muggers, armed robbers, and other violent criminals tend to outgrow their criminal behavior, or at least the violent aspects of it, as they approach middle age, but unless it is successfully treated, the sexual attraction to children lasts a lifetime. As one therapist puts it, "Just when I set an upper age limit, I find a man who commits his first offense at the age of seventy-seven."

Efforts to find some solution more permanent than incarceration have not met with much success. One option is castration, the surgical removal of the testicles. Though a number of European countries offer convicted sex offenders castration as an alternative to lengthy prison sentences, it has been used rarely in this country because of public squeamishness and the reluctance of American surgeons to perform the operation. A few years ago, when a San Diego judge gave two convicted child abusers the option of going to prison or being castrated, both men chose castration. But then, the judge recalled, "the local ACLU chapter decided to take a stand. The main obstacle was a vocal group within the local medical society, which said it harked back to Hitler's medical experiments, and that no ethical doctor could participate. So it became impossible to get either a doctor or a hospital to perform the surgery. In spite of their stated desire, they went to prison. I gave up after that."

Even though castration diminishes the supply of testosterone, the

The therapist may begin by showing the pedophile erotic pictures of young girls and allowing him to become sexually aroused. Eventually the pictures are paired with, and then replaced by, pictures of older girls, and then of young women. Finally, only pictures of grown women are presented. In several cases where this technique has been used, the subject's erotic interest in young girls appears to have declined, particularly when the correct responses to the pictures are accompanied by rewards like allowing the subject to masturbate to orgasm. But the question of recidivism where pedophiles are concerned is just as murky as for incest abusers, and behavior alteration programs have other shortcomings. Because they can take years to complete, such programs are very expensive, and many therapists are opposed to any form of treatment that involves discomfort or pain. Not all pedophiles, moreover, are susceptible to such therapy.

Though Stephen Boatwright's doctors thought he might have made a good candidate for a behaviorist approach, it is doubtful that any amount of therapy would have been successful for Theodore Frank. To the extent that such an approach succeeds at all, it will be with the relatively small number of pedophiles who genuinely wish to rid themselves of their attraction for children. Looked at in this light, the almost total lack of prison therapy for child abusers doesn't really matter, because it is those who commit the most serious abuses, who have had the most victims, and who display the least remorse over what they've done who tend to draw the longest prison terms. Although there are fine shadings of disagreement, many therapists believe that such confirmed abusers are unlikely to benefit from any kind of treatment.

"When you have a man who has been involved in this kind of deviance, you find that if he's not been involved in molesting kids most of his life, he's thought about it," says Rob Freeman-Longo, who works with Roger Smith at Oregon State Hospital. "His sexual orientation to children has always been there. When you're working with a person like that, it's like me telling you that as of tomorrow you will not have sex with adult women or men, you can only have sex with a kid. You're saying to a pedophile, 'OK, you've been interested in kids for thirty years now, but we're going to say you can't have sex with anybody but adults.' Some people will say that guy's not treatable, but I hate to use that term. I don't think it's the person who's not treatable — we just don't have the technology to treat that person yet, or the knowledge."

Therapy or no therapy, prison does accomplish one important

of researchers thinks the desire to have sex with children might be biological, and they point to evidence that some individuals who are sexually attracted to children exhibit a higher than usual incidence of a genetic phenomenon known as Klinefelter's syndrome. A few psychotherapists, on the other hand, claim to have successfully used the techniques of classical psychoanalysis to treat pedophilia, or at least the narcissism that surrounds and inspires it. But psychoanalysis is an emotionally consuming process that requires a great deal of commitment and effort by the patient, qualities most pedophiles do not bring to therapy.

At the moment, the main approach to the treatment of pedophilia is one derived from the theory of behavior modification proposed by J. B. Watson fifty years ago and since refined by B. F. Skinner, the Harvard psychologist. Rather than locating and attacking its root psychological causes, behavior therapy strives to eradicate unwanted behavior by replacing it with other behavior. Behaviorists believe that all behavior, including the desire to have sex with children, is learned, and that it can also be unlearned. Behaviorists aren't interested in the infantile origins of the pedophile's narcissism, or in the childhood experiences that helped to form his compulsive-addictive personality, or in how his faulty relationships with adult women have contributed to his sexual attraction to children. "Men molest children because they're attracted to children," declares Emory University's Gene Able, a prominent behaviorist. "It's that simple. Analytical treatment is a waste of time. We see lots of people who have spent years learning they didn't get a little red wagon when they were six. We don't care about little red wagons. We're interested in changing behavior, because once it gets started, the behavior takes on a life of its own."

Whether its subjects are pedophiles or laboratory rats being taught to run a maze, behavior therapy is fundamentally a reeducation process. With some pedophiles, as with some rats, it appears to work. In one kind of program, an icon of the unwanted behavior, such as a picture of a naked child, is associated with something unpleasant — a painful electric shock, a drug that induces vomiting, or a chemical with a putrid smell. A less drastic form of behavioral therapy involves shifting the pedophile's fantasy structure away from children through the use of denial and reward. Because much of the pedophile's attraction to children is reinforced through fantasy, the therapeutic aim is to change not only what the pedophile does but what he thinks about doing — in clinical terms, to alter his nondeviant arousal patterns.

thing they do is they get religion in prison, which is very common for child molesters. They come in reporting born-again experiences, that all their guilt has been taken away, and that they're totally forgiven. We've got nothing to work with at that point. I think it's a major problem, because it's an easy way out. It seems to resolve all their guilt, and it doesn't touch their fantasy structure at all."

Therapists are the first to acknowledge that predicting who can be successfully treated and who cannot on the basis of a psychological assessment is risky business, and many are growing uncomfortable with the seer's role into which they have been cast by the courts. "Why are we locking people up on the testimony of psychiatrists, or giving them probation?" one psychiatrist asks. "One of the things we always struggle with is whether people in these situations are telling us the truth. Therapists are pretty good at telling when people are fooling themselves, but society looks to us to do this other thing, which is to tell when they're lying to us, and that I don't think we do well at all. We have grossly misled the public about our ability to predict things."

Whenever there is doubt about whether an abuser will abuse again — and with the confirmed pedophile it is usually not a matter of whether but when — the most prudent course is to lock the person up. Despite the fact that a few pedophiles say they find prison beneficial and talk about their psychological need to be punished, prison is not a therapeutic experience. No state has what professional therapists consider adequate psychotherapy available to its prison inmates, and many states have none at all. In most states there is a prison hospital to which child abusers can be remanded, but such institutions are usually more custodial than anything else.

For convicted abusers who are sent to regular prisons, there may be at most a weekly, and not a very productive, hour with the prison psychologist. A few of the more enlightened states have set up special treatment and evaluation programs for child sexual abusers. But funds are not readily forthcoming from legislators, who fear accusations that they are "coddling" child molesters, and those programs that do exist are quite limited in scope. The sex offender program at the Menard Institute has room for only forty inmates, and only fifty are accepted into a California program that permits child abusers to spend the last two years of their sentence undergoing treatment and observation at a hospital.

To compound the therapeutic problem, the relatively few therapists who are attempting to devise treatment programs for pedophiles are themselves divided by a debate over how such individuals can best be treated, and even whether they are treatable at all. One small school

narcissistic abuser may eventually turn again to sex with children, and if he is one of those who fit the description of the "crossover" abuser, they may be other people's children.

For these reasons, some judges and therapists think that incest abusers are among the worst candidates for treatment rather than the best. "You have a man who's thirty-seven years old, and you find out that for the past twelve years he's been involved in incestuous relations with his daughters," says a Boston judge. "And you're telling me he's a good candidate for treatment? You're telling me he's not a pedophile?" One therapist who thinks no incest abuser is a good risk is Mike Ryan, a psychologist on the staff of the Menard Institute, the psychiatric treatment facility of the Ilinois prison system. "I used to think there were some folks that were excellent candidates for therapy," Ryan says, "and we spent a lot of time trying to discriminate who was who. Time and time again we thought we'd built the safeguards in — we thought Dad was a good treatment candidate, we thought the family was viable — and all of a sudden something surfaces where the kid is becoming sexually involved with Dad again."

Because successful psychotherapy requires a large degree of willing participation by the patient, most therapists agree that anyone who is ordered to seek therapy by a court is a less than ideal candidate, no matter how willing he may seem to be. One lawyer who specializes in the defense of child abusers admits that, in an effort to obtain the lightest sentence possible for his clients, "I always advise them to emphasize their remorse, their concern for the victim's family, and their sincerity in starting an effective therapeutic plan." Among child abusers, therapists say, the only first-rate candidates are those who turn themselves in, and they are few and far between.

As with an incestuous father, the central question a judge must confront in deciding whether to send a hard-core pedophile to prison is whether the person is likely to abuse again. Here, too, judges depend mainly on psychiatric evaluations for guidance, but the therapists who are called on to render such opinions are in much disagreement about whether any pedophile constitutes a "good risk." "Let me tell you who's not treatable," says Roger Smith, a therapist at Oregon State Hospital. "First of all, the people who continue to deny the crime. With child molesters, denial is the major thing you have to overcome. 'I don't know about you, Doc,' they'll say, 'but there ain't nothing wrong with me. I didn't even do it — the girl's lying.' What often happens to people who are convicted is that they rationalize that they're doing the kid a favor, they're teaching him about sex. The other

who may feel resentment, jealousy, and anger toward her child, either for having reported the abuse or for having allowed it to happen in the first place. The principal therapeutic aim for the abuser is his acknowledgment that he, and not his child, is responsible for what has happened. Only when the abuser assumes that responsibility do he and his child finally meet in counseling.

Eventually the whole family undergoes counseling together, but they are reunited under the same roof only when everyone agrees that the abuse will not recur. The victims who enter Giaretto's program spend an average of only ninety days in temporary foster care, and 90 percent are ultimately reunited with their fathers and mothers. Giaretto says that very few later display self-destructive or promiscuous behavior, and that a majority of the parents say their marriages are actually improved by the court-ordered counseling.

Giaretto's statistics are impressive, but the idea that incest offenders are more easily treatable than other abusers depends mainly on whether their recidivism rate is lower. Giaretto reports that fewer than 1 percent of the incestuous fathers who have been through his program have been caught abusing children afterward; but where incest is concerned, the question of recidivism is cloudy. Vernon Quinsey, a Canadian researcher, puts the recidivism rate for all incest abusers at around 5 percent, whether they have undergone therapy or not. Other studies have produced much higher figures, including one that puts the number at 19 percent, compared to 29 percent for those who abuse unrelated children. [1]

As with any crime, the recidivism statistics for incest don't count every offender who abuses children again, only those who get caught, and because most pretrial diversion programs are so new, they have not yet produced very good statistics on what happens to the participants over the longer term. Whether as a practical matter or a moral one, however, it is unlikely that an incestuous parent will abuse again within the first few months of being caught, or in some cases even within the first few years. Because most incest relationships end as the victim enters adolescence, it is possible that by then there may be no other child home to replace her.

Even if psychodynamic therapy does play a role in lowering the short-term recidivism rate for incest, it is likely to leave the abuser's fundamental narcissism relatively untouched. The resolution of serious narcissistic personality disorders cannot be achieved without intensive psychotherapy, and even then such disorders are among the most resistant to treatment. Without long-term psychotherapy the

women have incredible systems of rationalization. I had one case where this guy came into court and admitted to cunnilingus and intercourse with his stepdaughter over a period of years. He went into detail about where they were, what he did, what she did. And he walked out of the courtroom and told the mother that he really hadn't done any of those things, that he just said that to satiate me. And she believed him, because she wanted so badly to believe him."

Because of the observation that incest is symptomatic of a multitude of other problems — the abuser's inability to handle stress and to emphathize, his troubled relations with his wife or his employer, even his alcohol or drug abuse — the fashion of the moment is to take a "holistic" approach to treatment that may combine "empathy training" with instruction in "interpersonal relations," participation in Alcoholics Anonymous, and even marital counseling. A widely used approach is the one developed fifteen years ago by Henry Giaretto, a California psychologist who founded the Child Sexual Abuse Treatment Program for Santa Clara County, south of San Francisco, and who by now has seen something like twenty thousand incestuous parents.

The Giaretto approach is loosely based on the psychodynamic theory of personality disorders, an idea set forth by Sandor Rado, a Hungarian-born psychoanalyst who established the first American graduate school of psychoanalysis, at New York City's Columbia University. Reduced to its essentials, psychodynamic theory suggests that while inherited predispositions cannot be overlooked entirely, much of what is wrong with people is a product of flawed relationships between themselves and their parents, their spouses, and their children. Though Giaretto's theories do not speak directly to the issue of narcissism, his solution is to repair the troubled "dynamics" within the family by raising the self-esteem of father, mother, and victim alike. A court order mandating diversion to Giaretto's program usually requires the incestuous parent to leave the home. Often, the victim will also be moved temporarily to the home of a close relative or a foster parent.

What occurs next is essentially a slow reunification of the family. All of those involved receive individual counseling, as well as separate sessions for mother and daughter together, father and daughter together, and father and mother together. The chief goal of such therapy for the child is to convince her that the responsibility for what happened lies with her abuser — and also with the other parent, who failed to protect her from the abuse. Among Giaretto's other concerns is establishing a sound relationship between the victim and a mother

I think you have to try to do some things with the family. I think it's imperative that the child receive counseling, and that the father admit to the child that it was his doing, not the child's doing, to relieve the child of the guilt and anxiety that go along with these things. I put an awful lot of these guys on probation. I usually give them some time in the county jail, like thirty days, but that's an attention-getting thing more than anything else. I want these people to know this is damn serious. Also, I think it's a pretty visible symbol for the girl that Dad did something wrong, because Dad's in jail. Kids know that people go to jail because they've been naughty."

Mainly because of such opinions, several states have begun "pretrial diversion" programs in which incest offenders who acknowledge their guilt are sentenced to undergo psychotherapy rather than go to prison. But such programs are not open to everyone. "We have very strict guidelines here," says Dennis Moore, the district attorney for Johnson County, Kansas, whose program has become something of a national model. "For a father who's sexually molesting a daughter and who is otherwise apparently amenable to treatment — and I rely on treatment personnel to give me that recommendation — if they have no prior convictions, if there was no force or threat of force used, they may be admitted into a diversion program. They're required, if that happens, to move out of the home, to have no contact with the child or any other children at risk until we give them the OK to do that, and you're talking probably four to six months. The father is required to involve himself in weekly individual treatment and weekly group treatment."

Diversion programs are becoming popular because they save the state the time and money involved in prosecuting an abuser and imprisoning him if he is convicted, but there are other arguments in their favor. One, as the case of Stephen Boatwright shows, is that very little therapy worthy of the name is available behind bars; another is that sending an incestuous parent to prison is likely to heighten the guilt his victim probably feels for having reported the abuse. Some judges also believe that only through the sort of family therapy many diversion programs entail are some incest victims' mothers likely to come to terms with their failure to recognize what was taking place.

"One of the things you usually see in these cases is a very passive, dependent woman," Judge O'Brien says. "Usually you see some role reversal with the mother and the daughter. In probably ninety percent of the cases, the mother herself was sexually abused as a child. You have to convince the mother that it happened, because most of these

Therapy

UNLIKE BANK ROBBERY or even murder, the sexual abuse of children is the pure product of an emotional disorder. As such, the concerns it poses for society are unique. Nobody talks about "curing" bank robbers, but the question of whether some child abusers can be cured — and, if so, which ones — is still open. Many judges do think that some kinds of child abusers can be successfully treated, and that not all of them need to be locked up while the treatment is taking place. "The first thing you have to consider is that there are child sex abusers and there are child sex abusers," says Mike Fondi, a Nevada judge who sees many such cases. "There's the first-time offender who did this thing not realizing why he was doing it, felt guilt, reported to a clergyman or a counselor, or turned himself in to the cops. This guy is crying out for help. This kind I would deem the person who is most able to be worked with. If he pleaded guilty, I'd put him on probation with a prison sentence hanging over his head and require him to get counseling."

The notion that incest results as much from the abusive parent's troubled relationship with his family — and his family members' faulty relationships with one another — as from a sexual attraction to children has led many judges to conclude that incest offenders have the best chance of controlling their behavior through psychotherapy. "The thing that has always struck me is that incest is a family problem," says Terry O'Brien, a Wyoming judge. "It's not one, in my view, that's owned exclusively by the male. If you look at the circumstances, usually you find a failed family in any number of respects. The family is typically introverted. Normally they don't belong to clubs, they don't go out and socialize. A lot of times they have very strong religious convictions, very puritanical sorts of things.

197

social welfare approach to sexual abuse in favor of the criminal justice approach. Worst of all, Newberger said, the prosecutions led to the mistaken impression that a solution to a complex and disturbing problem had been found.

on criminal abuse. Under the Minnesota "incest laws," however, a judge can stay whatever sentence is mandated by the guidelines if he finds doing so to be "in the best interests of the family." The Minnesota guidelines are less than six years old and so far have worked rather well, but not many states have yet followed their example. Perhaps surprisingly, the principal opposition to mandated sentences for child abusers comes not from defense lawyers but from psychotherapists. "The treatment community is very much in favor of considerable discretion," Knapp says. "They like to have all kinds of flexibility, and they like huge clubs hanging over offenders' heads so they have a lot of power over the offender when they're in a treatment program. They almost always want a twenty-year sentence hanging over the guy, and then if they don't do well in treatment they want them to get all twenty years."

Whether they involve the rule of cross-examination or sentencing guidelines, calls for the reform of judicial procedure in sexual abuse cases arise from an overriding determination that those who sexually abuse children must not go unpunished. But as states move further away from a strict interpretation of constitutional protections for criminal defendants, they threaten to infringe upon the philosophies of equal justice and individual rights that are central to the nature of American society.

Few would agree with Ralph Underwager, a Minneapolis psychologist who testified on behalf of several defendants in the Jordan case, and who declared it "more desirable that a thousand children in abuse situations are not discovered than for one innocent person to be convicted wrongly."[2] In the wake of Jordan and McMartin, however, some of those who have devoted their careers to the protection of children are beginning to wonder whether such prosecutions are worth the cost, either to society or to the victims of abuse.

Eli Newberger, a pediatrician on the staff of Boston's Children's Hospital and a principal authority on the sexual abuse of children, surprised many of his colleagues recently when he declared that prosecuting child abusers had become "an increasingly prevalent form of child abuse." Child molestation trials, Newberger said, were really morality plays that also happened to provide work for lawyers and publicity for prosecutors. The children who had been abused were being treated primarily as bearers of evidence, with little concern shown for their well-being. Such prosecutions also permitted society to "shoot the messenger," the social workers and therapists who spoke for the victims of child abuse, and made it easy to justify abandoning the

In many cases, however, harsher sentences are more a response to public opinion than the result of a careful determination of the facts in the case and a consideration of the likelihood that the defendant will abuse again.

"First of all," says Andrew von Hirsh of the Rutgers law school, "most states don't have guidelines on this subject. Guidelines on sentencing are a fairly new development. Then, because a lot of sex abusers are middle-class, you get all these rehabilitative and other urges, either to treat people lightly or very severely. It's also a fashionable issue, and a fashionable issue will mean that judges will oscillate between throwing away the key to make an example of the fellow and 'Poor Schmidtlapp, he's a family man . . .' "

Because of child molesters, like Theodore Frank, who have been pronounced cured and set free only to abuse again, the indeterminate sentence is rapidly falling out of legislative vogue. In the aftermath of the Frank case, the California legislature rescinded the Mentally Disordered Sex Offender law, and several other states have followed suit. In their search for an alternative means of sentencing child sexual abusers, state legislators might consider Minnesota's guidelines, which are held up as a model by von Hirsh and other experts in the law. "We have guidelines for all our offenses," says Kay Knapp, the director of that state's sentencing guidelines commission, "and that includes the sexual abuse of children. Every offense is ranked under the guidelines, and the sentence is based on the severity of the offense and the criminal history score of the offender."

In Minnesota there are actually two parallel sets of statutes, the first a criminal sexual conduct law that covers offenses ranging from the first to the fourth degree. In cases of sexual abuse, a first-degree offense includes either penetration, or the less serious abuse of a very young victim, or the use of force that results in some kind of injury to the child. A second-degree offense involves any sexual contact with a very young victim. A third-degree violation includes penetration accomplished without the use of physical force, though with some other kind of coercion. A fourth-degree offense involves neither force nor coercion. For those convicted of a first-degree violation, the sentence is forty-three months in prison, no more and no less; a judge can depart from that sentence only if he can show that there are "substantial and compelling circumstances" that warrant such a departure.

The second set of Minnesota statutes covers sexual abuse within the family, and it carries the same presumptive sentences as the statutes

As the moment arrived for the court to pass sentence, a Baptist minister appeared to testify that the husband had begun attending Bible study sessions since his arrest. He was "truly penitent," the minister said, "very sorry about it happening, not just sorry he was caught." A clinical psychologist who had seen the couple a dozen times testified that stress due to marital difficulties and financial problems was what had really triggered the abuse. But the couple's relationship had been improving, and he predicted that the husband was "not at all likely" to repeat his behavior. "He is deeply remorseful about his conduct and the harm he has done to the children he molested," the psychologist intoned. "I do not believe incarceration would benefit society or the victims of this offense."

The expert testimony was not lost on the judge, who sentenced the couple to twenty days in the county jail, to be followed by two years' probation. Shortly after their release, the couple left town and transferred their probation to their new home in Texas. "Most people say, 'Well, once they get on probation then they're going to be helped, and all the wrongs are going to be made right,' " said the angry prosecutor in the case. "And that just ain't so. Probation can only do certain things. About the best you can hope for is some type of minimal supervision, and that's only for a limited time. I don't know what the probation departments in Texas are like, but I imagine they're the same as they are here, which means overworked and understaffed."

As the issue of child abuse has garnered more public attention, judges whose instinct is to go easy on child molesters are discovering that they run an increasing risk of provoking the public ire. In St. Louis, fifty people held a candlelight vigil outside the home of the judge who imposed a sentence of two years' probabion for the rape of an eight-year-old girl. There was an even angrier protest in Cincinnati, after a judge sentenced two men who admitted raping another eight-year-old to ninety days in jail and then justified the sentence on the grounds that the child had been a "willing participant" in the abuse.

Much of the pressure for harsher sentences comes from Society's League Against Molestation, a national organization known as SLAM that was founded by a California woman named Patti Linebaugh, the grandmother of Amy Sue Seitz. "Whether molestation is or is not an illness," Linebaugh says, "it is a crime. And no matter what the root causes, one way to stop it is to lock the molesters up." It is largely because of such outcries that some sentences for child abusers have lately become much less forgiving: like Stephen Boatwright, a number of child abusers have recently been sentenced to consecutive life terms.

made to order outlet for my anger and sex," Frank had written. "Innocent, trusting, scared, vulnerable, and submissive. I want to give pain to these little children. I want to molest them. I want to be sadistic. I want to harm them."

Stephen Lawrence Boatwright never killed or tortured any of the children he abused. "I loved every one of them," he told the judge, and most of the parents who dropped their children off at the Reno day-care center where he worked agreed that Boatwright had been an outstanding teacher. Though he was thirty-five and had served a hitch in the Air Force, Boatwright admitted to the doctors who examined him that he had never felt comfortable around adults. He hadn't been successful at much of anything, in fact, until his mother, who owned the center, gave him a job. For the first time he could remember, Boatwright felt like a capable, competent human being.

When Boatwright said he had never meant to harm the children, the doctors believed him, and the children agreed that he had always asked their permission before he touched them. Even the prosecutor in his case acknowledged that "sick as he may have been, he actually loved the children in his own way. He never threatened the kids, never told them not to tell anybody. He was very loving toward them, as opposed to people that show acts of violence to kids and say, 'This is going to happen to you or your parents if you don't cooperate.' " After his conviction, Boatwright plunged into an acute depression. He understood that he could not be allowed to remain free, but he asked the court to send him someplace where he could get help, and the three doctors who examined Boatwright endorsed his appeal. "He had some things going for him that many pedophiles don't have: a strong sense of conscience and a young, malleable personality that was essentially still unsocialized," one said. Boatwright got four life terms in prison, but he didn't get any help. As his lawyer put it later, the psychotherapy available at the Nevada state pen is "somewhere between slim and none."

Whether Stephen Boatwright's sentence seems overly harsh or not harsh enough, he is clearly an exception, because the sentences handed out to child abusers have traditionally been quite lenient. In many states, those convicted of sexually abusing children, particularly their own children, have received lighter sentences than those who rape other adults. A typical case is that of a young Colorado couple who pleaded guilty to sexually abusing an eight-year-old neighborhood girl. The husband assumed the role of abuser, while his wife prepared the girl by giving her liquor and dressing her in one of her own frilly blouses, then cleaned her up after her husband had finished.

if it weren't for the statute of limitations I would prosecute, and the likelihood of felony convictions would be quite high." Another rationale is that abusers whose victims wait too long to speak up will be free to abuse again. But there is a danger that a child who makes an accusation years after the fact may not remember important details about who did what to whom. There is also the more fundamental question of why someone who abuses a child should be held answerable for ten or even twenty years after the fact, when the longest period of accountability for most other serious crimes is five years.

The statute of limitations is intended to moderate the already enormous prosecutorial power of the state by denying the prosecutors the ability to reach very far backward into history. Such important safeguards should not be easily tossed away, and the current effort to make those who sexually abuse children into a special class of criminal also overlooks the fact that many judges have difficulty in knowing what to do with such offenders even after they are convicted.

When Theodore Francis Frank was committed to California's Atascadero State Hospital, his sentence appeared to be an enlightened one. Rather than running for a certain number of years, it would expire when a panel of psychiatrists decided that Frank had been "rehabilitated." With his gray beard and bushy gray hair, Frank could have passed for a university professor, and to the staff at Atascadero he seemed to be a model patient. Unlike most of the child abusers there, he didn't try to deny his guilt or to blame his victims for having led him on. He readily described himself as a "good, clean child molester," and he acknowledged having abused more than 150 children. The admission went a long way toward convincing hospital officials that Frank had come to terms with his problem, and finally that he had conquered it altogether.

When Theodore Frank was released with a clean bill of mental health, his case was cited as an example of the legislative wisdom behind California's Mentally Disordered Sex Offender statute, the law that made such indeterminate sentences possible. Six weeks after he walked through Atascadero's front gate, Frank kidnapped a two-year-old girl named Amy Sue Seitz, tied her up, forced her to drink beer, raped her, tore off her nipples with a pair of pliers, then slowly strangled her to death. While the police were searching for Amy Sue's killer, Frank kidnapped, raped, and tortured two other young girls. When he was arrested, police found a diary in his Southern California apartment that was filled with fantasies of torture, rape, and murder — fresh fantasies composed since his release from Atascadero. "Children,

had much to say about the Sixth Amendment in quite some time. Most of its landmark decisions in the realm of criminal procedure have concerned such things as a defendant's right to legal counsel and the circumstances under which a suspect's home and automobile may be searched.

No one suggests that the right to cross-examination includes the right to intimidate or frighten any witness. But is the constitutional requirement satisfied when a defendant watches his lawyer question a child on television? Is it satisfied by questioning the person to whom the child reported having been abused? Or is a defendant entitled to a verdict from a jury that has had the opportunity to gauge the nuances of his accuser's testimony firsthand? Sooner or later, the Court will have to decide precisely what confrontation and cross-examination must entail when the accuser is a frightened child, and it is hard to imagine even the current Court agreeing to anything that involves more than a token surrender of Sixth Amendment rights by one accused of a crime.[1] If that proves to be the case, then the movement toward procedural reforms in child sexual abuse cases will have been dealt a fatal blow.

Criminal defense lawyers understandably oppose the reform of hearsay laws and other new statutes that give judges greater authority to ease the burden of young witnesses. The American Bar Association, which has never been entirely representative of its rank and file, not only endorses such reforms but has proposed some of its own. One of the ABA's proposals involves an extension of the statute of limitations in crimes involving the abuse of children. At the moment, the limitations on reporting sexual abuse vary from place to place. Victims in Illinois must speak out within three years, but California gives them six years, and in most other states they have five. The problem, according to an ABA resolution adopted in 1985, is that "children who suffer sexual abuse are often quite reluctant to report their victimization. They are frequently likely to repress these incidents for years. The statute of limitations in criminal cases usually begins running on the day the crime was committed. In many cases, the statute may have expired by the time the abuse has come to light, and it is thus impossible to bring the accused offender to justice."

The best argument for extending the statute of limitations is a case in the small Northern California town of Quincy, where the district attorney was unable to act after several children accused the county sheriff of having abused them seven years before. "The crimes were serious," the prosecutor said later. "The evidence is strong enough that

to testify over live, closed-circuit television. The technique was tried for the first time in mid-1984, in the case of Campbell Hugh Greenup, the principal of an exclusive private elementary school in a Los Angeles suburb, who was charged with sexually abusing eight of his students, all girls, the youngest of them age five. The children and their parents sat not in the courtroom where Greenup's preliminary hearing was taking place, but in an empty jury room next door. In the jury room were two television monitors, one showing the general courtroom scene and another that displayed either Ken Freeman, the prosecutor, or Greenup's lawyer, depending on which one was asking the questions. A monitor perched on the witness stand in the courtroom showed the face of the child who was testifying.

"It's never easy to testify," Freeman said after Greenup had been ordered to stand trial. "But we had kids who would never have been able to make it in a normal courtroom situation. I talked to one child later and said, 'Well, what did you think?' and she said, 'I was so happy I didn't have to go and sit in that chair.' It was so scary to her, and she was a seven-year-old."

Like videotape, however, closed-circuit television is no guarantee of success — a mistrial was declared in the Greenup case when the jury could not agree on a verdict. When Greenup was retried the following year Freeman abandoned the closed-circuit television setup, in hopes that the children who had survived the first trial had probably gained enough confidence to testify effectively in person at the second one. He was right — after hearing five months of testimony from more than 140 witnesses, the second jury took only two hours to convict Campbell Hugh Greenup of sexually abusing six of his former students. Greenup was sentenced to thirty-six years in prison, the maximum possible, by a judge who condemned the man for having violated his "sacred trust" as a teacher. "You put parents in the situation of not believing their children," the judge said.

Campbell Greenup waived his right to confront his accusers face-to-face, but not all defendants are willing to make it easier for children to testify against them. Most defense lawyers, in fact, have continued to argue that anything that diminishes their ability to fully and fairly cross-examine a live witness before a judge or jury, whether it is a piece of videotape, a television monitor, a hearsay witness, or a child sitting on his mother's lap, abridges the defendant's constitutional rights. The ultimate arbiter of efforts to reform the judicial process is the United States Supreme Court, and none of these innovations has yet passed the Court's final test. The Supreme Court, in fact, hasn't

videotaped deposition can be used instead of live testimony only at a pretrial hearing. In others it can also be used at the trial itself, if the judge decides that appearing in person would cause the victim substantial psychological harm. In Texas, where one of the first authorizing statutes was passed, videotape is admissible only if the child witness in question is otherwise competent and is available to testify should he or she be called by the defense.

Videotape may make things easier on children, but it does not guarantee a conviction, as a Connecticut prosecutor discovered during the 1985 trial of a thirty-three-year-old woman charged with abusing a four-year-old neighborhood girl. Instead of seeing and hearing the girl herself, the jurors in the case watched a tape of the child answering questions, through a mouthful of cracker crumbs, from the defendant's lawyer. The tape had been made a week earlier, after the judge had concluded that testifying in person would impose an undue psychological burden on the child. The judge was present at the taping, as were his clerk and the prosecutor — but not the defendant, who was watching the proceedings on a television monitor in another room while communicating with her lawyer over the telephone. "Are we watching a movie?" the woman's lawyer asked while the tape was being played in court. "Or are we here for justice? This child knows she's in the movies. It's just like 'Sesame Street.' " His objection that the defendant's Sixth Amendment rights had been violated was overruled by the judge, but the woman was acquitted anyway.

Because so many important legal questions remain unresolved, even in those states where videotaped testimony is authorized, it is not used nearly as often as it might be. Some prosecutors are afraid that whatever convictions they obtain will be overturned on appeal, while others believe that a televised picture of a child lacks the emotional impact on jurors of seeing and hearing the child himself. Some also point out that, because such tapes are often made fairly early in the case, at a time when many children are not yet fully forthcoming about having been abused, the portrait they present to the jury can be a less than convincing one. Still others, watching the McMartin case unfold, have grown concerned that tapes made by child therapists may lend support to charges of brainwashing leveled by the defense.

In hopes of satisfying the Constitution's requirements while minimizing the trauma to the child witness and also circumventing the brainwashing problem, a few states have approved an arrangement, like the one used in the Bronx day-care case and also briefly at the end of the McMartin hearing, in which children of a certain age are able

worker, the prosecutor, and finally a therapist. If there are delays, misunderstandings, and all the other confusions that result from overwork and a lack of coordination, she may have to repeat the process again and again. When discrepancies are noticed between the story the child gave the police and the version she told the prosecutors, both ask her to tell it over. When the prosecutors see that she's told her therapist something she forgot to tell them, back she goes to the courthouse for another interview.

It is not unusual for sexual abuse victims to be interviewed dozens of times before the date for the first courtroom appearance finally arrives. Even then, few children testify only once. Two child witnesses in one California sexual abuse case testified on fifty-five separate occasions, not including investigative interviews, motion hearings, and juvenile proceedings. "These children," the prosecutor said later, "have been victimized twice, first by their parents, who now are in prison, and secondly by a system that forces them to undergo — hour after hour, day after day — grueling cross-examination concerning their molestation. They become passive and zombielike whenever they are asked to recall the acts of abuse they have suffered. The bottom line is, we just can't put these kids on the stand again."

Only a year or so ago, the use of videotape was being heralded as the solution to the problem of multiple interviews and repetitive testimony for such witnesses. Children who could not testify effectively in open court, it was thought, might be able to do so in front of a television camera; the resulting tapes would not only be available for reference by other members of the investigative team, they could also be shown to the grand jury, at a preliminary hearing, and again to the judge and jury at trial. It seemed a promising idea. The child's story would be permanently recorded, so there should be no subsequent misunderstanding of what had been said. The story would be told in the child's own words, not by an extended outcry witness to whom the child had reported being abused. And the child would be spared the rigors of cross-examination in the defendant's presence.

The use of videotape is currently authorized in fourteen states, but the statutes that permit it vary widely. In an effort to comply with the demands of the Sixth Amendment, some states require that the defendant be present when the tape is made, though "out of sight and sound" of the child witness. Others leave it up to the defendant to decide whether to be present or not. A few go so far as to preclude a face-to-face confrontation when the defendant's alleged treatment of the child has involved torture or extreme brutality. In some states a

loophole, at least nine states have broadened the definition of an excited utterance to include statements made later by the victim. Similar proposals are awaiting action in several other states, and in a few, including Wisconsin, the hearsay exclusion has been broadened by judicial decisions.

The state with one of the broadest hearsay exceptions is Washington, which allows the admission of any testimony about a child's statements as long as the child is under ten and the circumstances under which the statement was made suggest that it is true. Robert Lasnik, a Seattle prosecutor who helped draft the Washington law, recalls a case in which a child told her mother and father while they were cooking dinner about having been abused some days before. "The little girl, who's three, says, 'Mommy, does milk come out of Daddy's penis?' " Lasnik said. "And the mother says, 'Well, no, why do you ask?' And the girl says, 'Well, it comes out of Uncle Joe's penis, and it tastes yucky.' " Because it had been a week since Uncle Joe last visited the family, the child's statement was not technically an excited utterance, but the Washington statute permitted the child's parents to testify anyway about what their daughter had said.

In most states where they are allowed at all, such "extended outcry" witnesses can be used only to buttress the courtroom testimony of the alleged victim. But in Washington, Texas, and a few other states, they can be used in place of the victim under certain circumstances. In the El Paso day-care case mentioned in chapter 6, the only prosecution witnesses to testify against the two defendants were the parents of the children who had been abused, the doctor who examined them, and the social worker who interviewed them. Because such broad hearsay exceptions make it possible to convict someone of child abuse entirely on the basis of secondhand evidence and testimony, they raise serious constitutional questions about whether a criminal defendant's Sixth Amendment right "to be confronted with the witnesses against him" and to question them through an attorney is being abridged.

Most of the attempts at judicial reform are intended to ease the sexual abuse victim's burden of testifying in court. But for many victims, the journey through the criminal justice system can be an ordeal that matches, and sometimes even surpasses, the abuse itself. The ordeal begins the moment the child tells someone about having been abused, and even under the best of circumstances the victim may be required to tell her story not once but several times — first to her parents, then to the doctor, then to the police, the child protection

children can go on. In others, they have been authorized to control the way in which questions are asked of children by the defense. Some states permit questions to be directed to the child through the judge, and other jurisdictions allow a parent or another trusted adult to take the witness stand along with the child. In a small but growing number of states, adults are even permitted to testify in behalf of a child who has told them about having been sexually abused.

Testimony about what one person tells another is called hearsay, and it is almost never admissible as evidence. Because hearsay statements aren't made in court and under oath, they are considered inherently unreliable. Perhaps the person who made the statement was mistaken, or wasn't telling the truth. Perhaps the person who heard the statement misunderstood it or has forgotten what was really said. Because it is next to impossible for a judge and jury to assess such pitfalls, only in two very special cases is hearsay testimony ordinarily admitted into evidence.

When one person tells another that he has committed a crime, the second person will usually be allowed to testify about the conversation. It's not likely that a person would lie about committing a crime or confess to one by mistake, and such concerns are overwhelmed by the potential significance of the statement. The other hearsay exception, known as an excited utterance, includes statements made by the victim of a crime that has just been committed. Declarations like "I've been robbed!" are considered likely to be true, because a person who is speaking during or immediately after a traumatic event is presumed not to have had the time or presence of mind to make something up. Those who overhear excited utterances and testify about them later are known as outcry witnesses.

The first hearsay exception doesn't play much part in sexual abuse cases, since most abusers don't often admit to others that they have sex with children. The second exception is more germane. If a child runs from a public restroom crying, "Mama, that man just touched me," the child's mother can testify, under the excited utterance exception, to having heard the statement. Time, however, is of the essence. The mother whose child arrives home from school and tells of having been abused by a teacher earlier in the day does not qualify as an outcry witness. It may be the first statement the child has made to anyone about the abuse, but it's already several hours old. Since an excited utterance by definition is one that happens at the moment, outcry witnesses are rarely available in sexual abuse cases. But in an attempt to plug what many prosecutors and judges now see as a crucial

remember either the woman or the umbrella. But a quarter of the nine-year-olds and three-quarters of the six-year-olds could.

Though fewer than half the states have taken such a step, in those where special competency requirements have been abolished, young children have given testimony that is more than adequate. "Three-year-olds are capable of giving you evidence which is useful," says Terry O'Brien, a Wyoming judge, "in spite of the fact that they may not know what an oath is and they may not know what telling the truth is. Most kids, unless they're very, very young, understand an obligation to be truthful. And even if they don't, that doesn't trouble me very much, because of the ability of the jury to assess that."

Another judge, Milwaukee's Charles Schudson, recalls a case in which he decided not to hold a competency hearing even though the principal witnesses were three, four, and six years old. "The three-year-old really was not responsive at all," Schudson said, "but I didn't declare that witness incompetent. I just let him go up there and do the best he could. With the four-year-old, the defense attorney took out a picture of a dog and said, 'What is this?' And the child said, 'That's a doggie.' He asked the child, 'What color are my shoes?' and this sort of thing. Those are the kinds of examinations that would have been used in a prerequisite competency state. They weren't being used in that way, but it was still proper. The four-year-old was able to say something, but not a whole lot.

"The six-year-old was crucial, the six-year-old was a key witness, and despite the fact that he gave some incorrect answers on the questions about colors and animals, and despite the fact that he said he didn't know the difference between what was true and what was false, I allowed him to testify. He did fine. Well, he did fine once I put him on his daddy's lap. He wouldn't say a thing when he was in the cold, hard chair and the father was in the courtroom just a few feet away. When he was clamming up, I just said, 'I'll bet you'd feel a lot better if you were on Daddy's lap.' The father wasn't involved in the case in any way. So he got on his dad's lap and described what he'd seen the baby-sitter do to his two little brothers. He did great."

Many of the attempts to facilitate the prosecution of child abusers have taken the form of new laws, but some have come in the form of appellate decisions that broaden the interpretation of existing statutes. On the theory that the prosecution's best weapon is a confident witness, most of the reforms are aimed at reducing the rigors of cross-examination for children. In some states, judges have been empowered to place limits on how long the cross-examination of

say, 'Point him out,' and she kind of looks the other way and timidly points to the man. Well, I say, 'Was there ever a time when you were alone with your dad and something happened?' She'll nod, and the judge will say, 'You have to say yes or no.' She'll start to get nervous, and she'll say yes. Then she'll start to cry. It's not just having to say something embarrassing — it's not just being in the courtroom, it's not just the public looking at them. They're terrified of the defendant. The kids have this feeling that here is this all-powerful individual, and they feel that somehow retribution is going to visit them if they testify."

The American judicial system traces its roots back to the thirteenth century and the Magna Carta, and in safeguarding the rights of adults accused of crimes, it has worked rather well. But neither the English noblemen who gathered in the meadow at Runnymede nor the framers of the Constitution envisioned a day when large numbers of children would be accusing adults of serious crimes.

When children commit crimes, their cases are usually heard by juvenile judges in courtrooms that are closed to the public. Until recently, however, no special considerations have been available to children who are the victims of crime. In response to a growing public pressure to "do something" about child sexual abuse, state legislatures have been searching for ways to make it easier for the victims of sexual abuse to testify against their abusers. During 1985 alone, more than 250 bills proposing some kind of judicial reform were introduced by legislators across the country. Though some of the reforms seem well advised, others have been conceived in anger and adopted in haste. Because many of them tend to confer an advantage on the prosecution, they involve potentially dangerous tinkering with the switches and dials of the Constitution.

As Oliver Wendell Holmes, Jr., once observed, "It is revolting to have no better reason for a rule of law than that it was laid down in the time of Henry IV. It is still more revolting if the grounds upon which it was laid down have vanished." Holmes might have been speaking of the need for a special hearing to assess the competence of young witnesses, a need that is called into question by new evidence that young children are often better able than adults to recall the details of recent events. When researchers at Atlanta's Emory University asked a group of adults and children to watch a videotaped basketball game, they instructed the audience to pay particular attention whenever the players passed the ball to one another. Midway through the game, a woman carrying an open umbrella strolled casually down the sideline. Afterward, none of the adults who had been watching the ball could

Justice

Y OU'RE SEVEN YEARS OLD, and you're about to testify in court. The courtroom is the biggest room you've ever seen. Way up high, above everyone else, there's a man wearing a black robe. He has a hammer in his hand. If you make him mad, will he hit you with it? As you climb the steps to the witness stand, you're at the second highest place in the courtroom. When a policeman with a badge and a gun walks over, you wonder whether you've done something wrong. Is he going to arrest you and put you in jail? Instead, the policeman tells you to put your hand on a Bible while you repeat some words. When you sit down and look around, the person who abused you is right there in front of you, and he doesn't look very happy. Is he going to jump up and hurt you?

Unless you're an incest victim, your parents are sitting in the audience behind him, and behind them are dozens of people you don't know. Some of them look mad too; they must be friends of the person who abused you. A few of them seem to be paying close attention to what's going on, and they're writing in little notebooks. Depending on what state you're in, there may even be a television camera at the back of the courtroom. Off to one side sits a lady with a funny-looking typewriter and a thing stuck in her ear. Maybe that's the machine that tells whether or not you're lying. Two more policemen with guns are standing by the back door. Are they supposed to shoot you if you try to make a run for it? Which by now is exactly what you feel like doing.

"You'll have an eight- or nine-year-old who'll come into court," says Ken Freeman, a Los Angeles prosecutor who has tried more than a hundred sexual abuse cases, "and they'll be very, very nervous, rocking back and forth and fidgeting, and their mouth will be dry. I'll say, 'Susie, do you see your dad in the courtroom?' She'll say yes. I'll

The police, Sands said, had arrested his client not only without any corroborating evidence, but without even interviewing him about the girl's accusations. They had misinterpreted the initial medical evidence, and they hadn't taken particular pains to reconcile the discrepancies in the girl's statements. "She began to complain about Brian Taugher hurting her, and very possibly being pregnant," Sands recalled. "But from her description of what Brian Taugher did to her, she said she knew she couldn't be pregnant. Other statements she made were really inconsistent — she kept saying, 'Well, I think he did this, but I'm not sure.' She was very equivocal. We had all the girls who were in the same room testify. One of them woke up in the middle of the night and heard the alleged victim snoring. Those who had awakened in the middle of the night never saw Brian. They were asleep in the middle of the floor — he would have had to walk around them, or past them, to somehow get over to the couch."

There were other flaws in the official investigation, among them the fact that the sheriff's department had never checked the doctor's records to find out when the first complaint was made. But as. it turned out, the biggest flaw of all had been the failure of the prosecutors and the police to reenact the abuse themselves before Mike Sands did it for them in court. "Once they knew they were dealing with somebody who was a high-ranking official of the Department of Justice, they rushed it faster than they should have," Sands said. "Then once they made the arrest, it hit every news media in town. If they had dismissed it, it would have been political suicide for the DA."

John Van de Kamp, the state attorney general and Brian Taugher's boss, said later that the Taugher case had been "a paradigm of how not to handle such cases." If the prosecution had done its job properly, he said, the case would never have come to trial. Twenty-seven thousand dollars in debt to his lawyer, Brian Taugher got his old job back and resigned himself to living with the indelible stain the experience had left on his reputation. "There are two crimes in America, treason and child molestation, that affect a person for the rest of his life," he said. "I will just have to deal with it."

Probably because of his background, Taugher was more sanguine than another in his situation might have been. Child abuse, he said, remained "one of the most heinous of all crimes. We didn't find child abuse when it was there, but now we are in danger of finding it when it is not there." A child abuse investigation that "boxes a child into pursuing a false accusation does as much harm to the child as to the person falsely accused," he said. "We owe it to ourselves to have the benefit of a full investigation before we start throwing charges around."

sexually abused. Nor would she for several days, until she told her mother while riding in the car that "Brian hurt me." The woman took her daughter to the family doctor, who thought he thought he saw some bruising near her vagina. As he was required to do under the California law that Brian Taugher himself had drafted, the doctor advised the Department of Social Services that one of his patients might have been sexually abused.

As Taugher's trial proceeded it became clear that, apart from the girl's testimony, the prosecution's case was hugely circumstantial. What had seemed to the doctor to be bruises on the girl's thighs proved upon further examination to be normal skin discoloration. Laboratory tests had found no trace of semen or pubic hair on the girl's nightgown or sleeping bag. None of the other girls who had been sleeping a few feet away could remember seeing or hearing anything. All that remained was the girl's testimony, and when she told the jury her story she did it in what some of those who attended the trial thought was a rather matter-of-fact way. When the girl was asked during cross-examination why she hadn't called for help, she was unable to answer, and something about the girl's description of the assault bothered Brian Taugher's lawyer enough that he decided to reconstruct the scene right there in the courtroom.

The lawyer, Michael Sands, had the sofa from Taugher's living room trundled into court, and on top of it he laid the girl's quilted blue sleeping bag. Then he invited the members of the jury to reenact the crime. Diane McKenzie, the jury foreman, played the part of the girl, with a juror named Darold Bott taking Taugher's role. Taugher stood six feet two inches tall, and Bott quickly discovered that, because the sofa's armrests were so high, there was no way someone as tall as that could lie down without bending his legs upward at the knees. In order to keep from falling over, a tall man in that position would have to support himself with one hand, which left only the other hand to unzip the sleeping bag. No matter how many times Bott tried to unzip the bag one-handed, he never could. "We tried it over and over again," he said later. "Her story just didn't stand up." Before the reenactment, at least two jurors had been dead-set for conviction, but now even they agreed the equation had been changed. There had been no way, they said later, that they could have found the defendant guilty beyond a reasonable doubt. Almost six months to the day after his arrest, Brian Taugher was acquitted.

Mike Sands didn't blame the girl as much as he blamed the prosecutors, the police, and the Department of Social Services for what he considered to have been a hasty and inadequate investigation.

and a pair of handcuffs. Locked in the backseat of a patrol car, Brian Taugher was taken to the sheriff's department for booking and fingerprinting; Kathy and her sister spent the night at the county children's home. Before the girls were allowed to go to sleep, they were examined by a doctor and questioned about whether their father had ever "touched" them. Both said he had not.

The arrest of an assistant attorney general on child molesting charges is not an everyday event, and by sunup camera crews from the local television stations had staked out Taugher's front yard. When those who knew Brian Taugher turned on their television sets that morning, they were astonished at what they saw and heard. Taugher had seemed a model of the bright, young professional on the way up, a first-rate lawyer with an important job in state government and a second career teaching law school at night. But there was something else that set Brian Taugher apart from the thousands of men and women charged with sexually abusing children during 1984. In his role as a top aide to attorney general John Van de Kamp, Taugher had drafted legislation to strengthen California's sexual abuse reporting laws.

Suspended from his sixty-two-thousand-dollar-a-year job, Taugher hired the best criminal lawyer he could find and prepared to stand trial against his ten-year-old accuser. According to the story the girl told police, the incident in question had taken place a couple of weeks before, following Kathy Taugher's ninth birthday party. The party hadn't been anything special, just a swim in the backyard pool and a treasure hunt, followed by hot dogs and a birthday cake and the unwrapping of presents. When the cake and hot dogs were gone, three of the girls went home, leaving the five others to spend the night in sleeping bags in Taugher's living room. Four of the five had spread their bags out on the floor. The fifth, several months older than the others and tall for her age, had rolled her sleeping bag out on the sofa. It was sometime during the night, the girl said, that a naked Brian Taugher had walked into the living room, unzipped her sleeping bag, pulled up her nightgown, and lain down on top of her. Their genitals had touched, but Taugher hadn't moved or spoken, nor had he tried to have intercourse with her. She was sure he hadn't had an orgasm.

The girl knew about intercourse and orgasm, she explained to the court, because she had recently received a fairly detailed lecture about sex from her mother that even included learning to learn to spell *penis* and *vagina*. After about five minutes, the girl said, Taugher got up and went away. When morning came, the group had breakfast and went for a last swim before being picked up by their parents, but the girl who had slept on the sofa said nothing to anyone about having been

In many cities the CP worker carries twice that number of cases. If she sees each family twice a month, that means she must fill out more than fourteen thousand pieces of paper every year. If she takes any serious action, such as removing a child from his family, the number of forms rises exponentially. With the long hours, low pay, red tape, and personal anguish that such work involves, it is not surprising that nearly every child protection agency is dangerously understaffed. "I'm not allowed to do real social work anymore," one Los Angeles worker says. "You can't go out and see ten children and just say hello and goodbye." Says another, "You just hold your breath and hope nothing will recur."

When the police officers, prosecutors, and caseworkers who face such pressures are handed yet another sexual abuse case to investigate, the chances are improving that the interviewing and other preparation will be less than complete. On top of that, even the best prosecutors and caseworkers burn out after a few years, and their replacements must begin the initiation process all over again. As appears to have happened in the case of Brian Taugher, it is because so many of those assigned to investigate sexual abuse cases are so harried or have such limited experience that so many recent prosecutions appear to have gone wrong.

Taugher, a senior staff lawyer in the California state attorney general's office, was separated from his wife, and the couple's two daughters were spending the day with their father. The sixteen-year-old was content to stay by the backyard pool, so Taugher and his nine-year-old daughter, Kathy, climbed into the car and headed for the beaches south of San Francisco. When they started home the sun had set, and by the time they arrived, Kathy had fallen asleep in the backseat. Thinking that it would be easier to carry the girl to her bed without having to fumble for his keys, Taugher left her in the car while he went to open the front door. As he unlocked the door, the telephone rang, unusual at that hour. The caller was the mother of one of Kathy's friends. "I'm very upset," the woman began, her voice rising with every word, "and I need to talk to you about something. You have molested my daughter. I want to know why you did this to my child."

As it turned out, the call had been placed at the suggestion of the Sacramento County sheriff's department, which was recording the conversation from the woman's house and which had already dispatched a car full of deputies to the Taugher residence. By the time Brian Taugher had hung up and headed back to the car to retrieve his daughter, the deputies were waiting outside with a warrant for his arrest

anything else, and then there's this uproar in the community. They decide they can't take the heat, and they figure the path of least resistance is not to prosecute. It's a very serious problem. You have to do this or you have to go get another job, because there's no place in this type of prosecution for weak-kneed yellowbellies."

No matter how determined a prosecutor may be, he is a prisoner of the system that prepares and presents him with such cases. In many places, that system is seriously flawed. In theory, whenever a child reports having been sexually abused, a number of agencies are alerted — the receiving hospital, one or more police departments, the state child protection bureau, the county family services agency, and perhaps a child counseling center. In a few cities, the management of sexual abuse cases is handled by integrated teams of highly trained specialists who have years of combined experience in interviewing and treating child victims. But the recognition of child sexual abuse as a major crime is so new that most agencies lack such training, experience, and coordination, and even the best of them is likely to be understaffed.

In Seattle, which has led the rest of the nation for years in acknowledging the scope and seriousness of child sexual abuse, there are still only eight prosecutors assigned to review 650 cases a year. Indianapolis, which files about eight hundred felony sexual abuse charges annually, has only seven, and in Denver there are only two prosecuting attorneys assigned exclusively to try such cases. Las Vegas has none, and though they often have more than their share of sexual abuse cases, neither do most smaller and middle-sized district attorney's offices. Police departments are equally shorthanded. In 1983, San Diego had nine officers assigned to investigate allegations of child sexual abuse, about the right number for a department that was opening thirty new cases a month. Over the next two years, the number of new cases rose to more than a hundred a month, but the number of officers assigned to handle them remained the same.

The problems faced by prosecutors and police are minimal compared to those encountered by the social workers — or, as they now prefer to be called, child protection workers. For an average starting salary of twelve thousand dollars a year, less than most dogcatchers or bus drivers earn, child protection workers subject themselves to a daily stream of battered, starving, and sexually abused children and do battle with a formidable bureaucracy at the same time. CP workers in some states must complete a dozen different forms after visiting a family with three children, and the average worker has a minimum of thirty such families on her case list.

the case that many who enter clinical social work or clinical psychology, the two professions from which most therapists are drawn, bring with them a bias in favor of victims. Not a few therapists have had troubled childhoods themselves, and for them their work is a means of exorcising their own experiences.

Even if they were not themselves abused as children, social workers in particular tend to be highly empathetic people. When they are confronted with what appears to be the mistreatment of children, their first response is often to begin building a case against the abuser rather than to sort through the objective facts in an evenhanded effort to establish what really happened to whom. When California attorney general John Van de Kamp examined the failed prosecution of the Bakersfield "Satanic" case, he reserved the largest measure of criticism for a social worker–cum–therapist, attached to the county's Child Protective Services agency, who "contributed greatly to the confusion and unprofessionalism surrounding the case by assuming the role of criminal rather than civil investigator."

Having discovered the multitude of difficulties in bringing a child sexual abuse case to court, prosecutors are beginning to back away from cases that are not open-and-shut. Most likely to come to trial are those cases in which the defendant is accused of abusing unrelated children and also has a previous conviction — in other words, a hard-core pedophile. Less likely to reach a courtroom are cases in which the complaining witness is under the age of five or over the age of twelve. Least likely of all are those in which the defendant is a woman, because of the difficulty of convincing jurors that women are capable of abusing children sexually. The degree of prosecutorial reluctance varies from state to state, even from county to county. "If you go to one place in the state," an Illinois therapist says, "there's an eager state's attorney who wants to 'get them all' and is realistic about his chances of that. You go to another place and he wants nothing to do with these cases, because he firmly believes that kids are just making it up and will back out at the last minute."

One prosecutor who wants to "get them all" is Don Weber, the state's attorney for Madison County, Illinois. "Every once in a while," Weber says, "some case will crop up in the newspapers — a nursery school, a schoolteacher. Then, three or four months later, the district attorney says, sort of sheepishly, 'Well, there's not enough evidence here, the girls were obviously put up to this,' and the case is dismissed. I think what's going on around the country, and it's very alarming, is that prosecutors are filing these charges and they expect it to be just like

people in prison where I work," one therapist says. "We're interested in helping children cope with things that have happened to them."

In seeking the therapeutic truth, however, the therapists raise the potential for suggestibility to new heights. The nexus of the problem they face is that many children who have been sexually abused are reluctant to talk about it. Perhaps they're afraid of getting in trouble themselves or of getting their abusers in trouble, or maybe they've been threatened with revenge. Maybe they're just too embarrassed to talk about what happened. Whatever the reason, when a child initially denies having been abused, a responsible therapist must consider the possibility that he is lying — or, to use the clinical term, is in denial.

"A child who has been frightened into not talking about being abused," one therapist says, "will behave with the therapist the way he's been behaving with his parents and everybody else until then, like everything is just fine. The child has been living a lie, maybe for weeks or months, maybe for years. He's learned long ago how to act like everything is normal. He's not going to give that up just because he's talking to a therapist. When you have children that are this frightened, who have been in secrecy and denial about something for years, who run in the corner and tell you they never went to that school, you know you've got a problem."

To break through what may be the barrier of denial, the therapist asks questions that a court would term unduly suggestive. "You can ask children generalized questions like 'What, if anything, unpleasant ever happened to you when you were at that school?' and they are not going to give you anything," one therapist says. "My experience is that they will not tell you a thing unless they either are asked very directly or have some sense that you already know something." The therapist also defends the technique, which defense lawyers are quick to label suggestive, of reassuring a child that other children have already told her about being abused. "I'm trying to let Billy know that it's all right to talk to me," the therapist says, "that all his friends have told me stuff and nothing happened to them, that they're fine, their parents are fine. It's a problem with the defense, of course."

The overriding dilemma, which is best illustrated by the Jordan and McMartin cases but is also now becoming a factor in most sexual abuse cases, is whether therapists should be used as part of a police and prosecution team. Many therapists are used in just this way, primarily because they are mostly women, while most police officers and prosecutors are men who feel less comfortable with children. Apart from the problems posed by legitimate therapeutic techniques, it is also

her daughter's preschool reported having been abused by a teacher, one worried mother took matters into her own hands. "I got out a Care Bear book that she'd gotten for Christmas," the woman recalled, "and I pretended to start reading her the story. But I didn't really read the story. I made up something to the effect that there were these two little girls, and they used to run and play together and have lots of fun. And then this bigger girl tried to become their friend, but the big girl was really only pretending to be nice, and she ended up hurting the little girls. And after about ten pages my daughter goes, 'Just like Marcia did to me and Tawny, huh, Mommy?' "

Sensing that she had a receptive audience, the child went on to name a dozen other children who had been similarly abused. Several other mothers were conducting the same sort of interrogation, and they formed a "support group" that met once a week to compare notes. When one of the mothers reported that her child had seen a rabbit killed by one of the teachers, all of the other mothers asked their children about the rabbit. Those children who said they hadn't seen any rabbit were reminded that someone had seen one, and before long five or six children were talking about dead rabbits. By the time the case got to the prosecutors, the children's stories had become so cross-fertilized that no charges could be brought.

Though prosecutors agree that intervention by parents is becoming a serious problem, defense allegations of "brainwashing" are less often made against parents than against the child therapists who have become a fixture of nearly every sexual abuse case. To listen to some defense lawyers, one would think the therapists were modern-day sorcerers who have the power to make children say that black is white. Most lawyers don't go quite that far, but many do suggest that some therapists at least begin with the preconception that children have been abused. "I think therapists, especially on the licensed marriage-and-family counselor level, are looking for child molestation and wanting to find it," a California attorney says.

Such expressions of concern strike a responsive chord among those who would rather not believe the stories being told by children, but the problem is more complex than that. It arises in large part because the therapist's task is not to get at the truth in a legal sense. That's the job of the police and prosecutors, who need information that can be admitted into evidence at a trial. Whether the questions that elicit that information are suggestive or coercive is as important to the police as how they are answered, but the therapists are most concerned with the therapeutic truth. "We're not interested in putting

with abusing eleven, the extra charge by itself is an injustice but probably not a major one — in for a penny, in for a pound. But what happens when the eleventh "victim" takes the witness stand to testify against the abuser? Because the story he tells isn't based on experience, he's an easy target for the defendant's lawyers, and when his story unravels during cross-examination, the jury can't help but wonder about the credibility of the ten other witnesses.

A corollary danger in such cases is that a child who has been abused may continue to add to his story until he is no longer useful as a witness. One California policeman recalled the case of a young girl who showed clear medical evidence of abuse, but whose story "just kept getting more and more fantastic, until she was talking about her teacher and her whole class standing out in the middle of the street naked. Our investigator said, 'Hey, wait a minute. I've been believing you up to now, but I think you're making this up.' At which point she admitted that maybe that part wasn't true, but that the part about the abuse was true. How in the hell do I put a kid like that on the witness stand?"

The greatest danger in macro cases, however, is that the child who exaggerates or lies — who introduces bizarre or otherwise improbable elements into his testimony that have not been mentioned by the other children — will cast serious doubt on the credibility of all the children, with the result that the entire case is dismissed as a fabrication on the part of the children.

In arguing that children have been "programmed" to testify against their clients, defense lawyers in sexual abuse cases often receive some unintended help from the victims' parents. If parents believe their child's story, they are understandably beside themselves. Though much of their anger is directed at their child's abuser, they probably reserve some of it for themselves, since they're the ones who hired the baby-sitter, or put their child in the day-care center, or unintentionally contributed in some other way to the abuse. It is not unusual for such parents to try to assuage their guilt by helping the police with their investigation. Because the child spends more time with his parents than with anyone else, there are many opportunities for the parents to go over the story again and again, to continue asking questions about how often the abuse occurred, what form it took, and who else was involved. Sometimes the parents' determination to "get" their child's abuser becomes a vendetta that consumes their lives.

The unfortunate result of parental involvement is often that the official investigation is muddled beyond repair. When another child at

while this was happening?" Susie's childish desire to please him by agreeing may prompt her to say yes when the answer is really no.

The problem of suggestibility is raised long before the case comes to trial, and it may be exacerbated by the special status that is accorded some victims of sexual abuse. The moment the suspicion arises that a child has been abused, he is likely to become the object of a great deal of attention and concern. He finds himself surrounded by policemen, social workers, and other solicitous adults who are sensitive to his every mood and who hang on his every word. Like most sexual abuse victims, he probably feels profoundly ashamed, even humiliated, but he also feels important, valued, and needed. Above all else he feels powerful, and within his family and among his classmates he may even briefly become a kind of celebrity.

There is a danger that, in order to hold on to the unaccustomed attention, some children may embroider their accounts of having been abused. As with children who lie outright, such embroidery is sometimes easy to recognize. When a four-year-old Arkansas boy said he had been abused in a rowboat on a lake during a nursery school outing, police thought the story sounded plausible. But when the child said the rowboat had sunk and that he and his abuser had swum ashore, they reminded the boy that he didn't know how to swim. In cases where there is a single victim and a single abuser, the problem of suggestibility is minimal. When there is a single set of assertions from a single victim, they can easily be cross-checked against one another. The danger reaches its peak in "macro" sexual abuse cases, where there are several possible abusers and many victims telling complicated stories about many different instances of abuse.

Even in cases where many children have been abused by many adults, it is unlikely that every available child has been abused by every possible abuser. Most pedophiles tend to target children who are withdrawn and passive and less likely to resist, and they also have their favorites. One danger in macro abuse cases is that a child who is among those not abused at a day-care center or in some other communal setting will claim that he was abused. Though the child's initial instinct may be to tell the truth, he finds himself surrounded by adults who continue to ask him if he is sure that nothing happened. Those children who were abused, moreover, seem to be accorded some special status. Under repeated questioning, the child's suggestibility and his wish to please his questioners may combine to produce a bandwagon effect in which he finally says, "Me too."

If the result is that a defendant who abused ten children is charged

Was it raining outside? Where was your dog while this was happening?" — he becomes hopelessly bogged down.

"I've had a couple of cases where a child would come in and go through this canned account of what happened," says a Minneapolis therapist. "But then you ask the child to slow down or something, and the kid gets all mixed up and has to go back to the very beginning, to make sure that the story gets straight. Anybody who has worked with sexually abused kids to any extent has a sense of when you can believe that this is a child's own account of what's happened and when this is something the child has been programmed to say."

To say that children rarely lie is not to say that they always tell the truth, only that most of them believe they're telling the truth. Children are more susceptible to confusion than adults, particularly when their questioner is consciously attempting to confuse them. But even when they're being questioned by a sympathetic therapist or prosecutor, some children will add improbable details to their stories. Children are highly suggestible, and most of them have learned that the way to get along in the world is to try to please everybody who's bigger than they are. That's one of the qualities that makes them vulnerable to being abused in the first place, but it means there is a danger that a child may supply the answers he thinks his questioner wants to hear.

Suggestibility becomes a particular problem when children testify a long time after the event. An eight-year-old who is recalling something that happened when he was four is much more amenable to suggestion than a child who is describing the events of the past week. Ironically, one of the special courtroom rules intended to make testifying easier on children, a rule that allows children to be asked the sort of leading questions that are forbidden for adult witnesses on direct examination, also makes it easier for the defense to create the impression that a child is being untruthful.

"What, if anything, did you do then?" is an example of a neutral question. Posed in a leading manner, the question becomes, "Did you run out of the house?" But when the question is really a statement of fact — "You ran out of the house, didn't you?" — it is clearly suggestive. A lawyer who says to an adult witness, "You ran out of the house, didn't you?" will surely be met with an objection from the other side. In the belief that children need to be helped along in their testimony, most courts allow both prosecution and defense to ask questions on direct examination that are leading. But the line between leading a witness and suggesting an answer is a fine one, and when the defense lawyer asks of Susie, "Isn't it true that your father was at work

probably seriously disturbed. Pathological liars are easy to spot, because they lie about everything.

If older children rarely lie about sexual abuse, it seems that younger children almost never do. It's not that they're incapable of lying — where is the child who hasn't made up a story about an invisible playmate or a talking pet? But most little children aren't malicious, and neither are the lies they tell. Their childish instinct is usually to trust everything and love everybody; it's simply not in their nature to make a malevolent, unprovoked accusation against an adult, especially one they know. Even those few children who might be so inclined are unable to lie convincingly about things with which they're unfamiliar. A teenage girl who makes a false accusation may have some firsthand knowledge of sex, and even if she doesn't she probably knows something about the mechanics involved. Younger children who don't have any firsthand knowledge cannot fool anyone for very long.

One idea that has been in vogue among defense lawyers is that all a child need do to acquire an encyclopedic knowledge of sodomy and intercourse is switch on the television when nobody's home and tune to the "porno channel." If such a channel exists, it is difficult to find. The closest thing to hard-core pornography on cable television is an occasional movie known as a "hard R," containing simulated sex. With the advent of videocassette recorders, adults can view the hardest-core pornographic films in their homes, and a few children may gain access to these in an unattended moment. But children who have seen graphic depictions of sexual intercourse can only describe sex from a visual perspective, and there is a vast difference between what sex looks like and what it feels like. A child who has glimpsed an erect penis on television cannot convincingly describe how it felt inside her mouth or her vagina, nor does a child who has merely watched an ejaculation know that semen tastes of salt.

Though false accusations in sexual abuse cases appear to be rare, most of those that are lodged come not from children but from adults, usually adults who have a vendetta of some sort against the person they're accusing. When young children lie, it is almost always because they have been coached by such an adult, often by a parent involved in a child-custody battle. As the divorce rate continues to rise, such fabrications appear to be rising along with it, but they are even easier to detect than lies told by teenagers. A child who has been taught to tell a story by rote can tell it in only one way. As soon as he is asked about extraneous details — "What color shirt did you say he was wearing?

The next day the jury comes back with a note saying they're hopelessly deadlocked. I said, 'Your Honor, I think if we get rid of this juror we'll get a verdict.' He wouldn't do it. After the jury was excused I talked to all the jurors, and I heard the same story about Joe from other people."

Most jurors are not child molesters, but many still have an instinctive need to feel that intelligent, successful people like themselves wouldn't abuse a child. They may empathize with the children involved, but they identify with the adults. "The whole trouble," says Ken Freeman, "is that we are so frightened for our children and so horrified that these crimes exist that we'd rather think they don't." An Arizona prosecutor agrees. "I don't understand what juries want," she says. "You don't have fingerprints, you don't have a videotape of the crime. What it really boils down to is, given the word of a child versus the word of an adult, they're going to believe the adult." Her frustration, shared by many of her colleagues, is highlighted by recent research at the University of Denver in which adult jurors at a mock trial were asked to evaluate the relative credibility of testimony by children and adults. Though they later had trouble explaining why, the jurors found all the children to be less credible than the adults.

The question of whether children lie about being sexually abused is central, and it is difficult to find a prosecutor or judge who does not recall at least one case in which he thought the child was lying. But it is also their nearly universal opinion that children very rarely lie about sexual abuse and that young children almost never lie, and such opinions are supported by some empirical evidence. When researchers at a Boston hospital reviewed more than a hundred sexual abuse cases from the first accusation to the final disposition, they found that only 4 percent of the allegations were ultimately proven to be untrue. When sexual abuse claims by three hundred Denver children were studied in comparable detail, fewer than 2 percent turned out to have been fabricated.

In both studies, nearly all the false allegations had come from older teenage girls, and most prosecutors agree that the greatest likelihood of fabrication exists when a girl of fourteen or fifteen claims to have been abused, particularly by a stepfather, a mother's boyfriend, a teacher, or some other unrelated adult with whom her relationship is already strained. The specter of the malicious teenager who points her finger for revenge is disturbing, but such fabrications are not only few in number, they are usually easy to detect. Most children are awkward liars to begin with, and a child who can sustain a false accusation over weeks of interviews with police and prosecutors is

abuse case, he said, "you look in your in-basket and go, 'Ick, what is this?' But if you're in private practice, there's a much more pristine approach. You wait until the check clears." Then Brunion offered his idea of a last-ditch defense. "Obviously, if you've got sexual inter-course, it's hard to say he didn't intend to gratify his lust, passion, etcetera," he said. "But if you have marginal-type acts like fondling, then you can put it into a context where it could be innocent. Changing the kid's wet pants can be a defense, if you've got nothing else."

Despite all the attention being paid by lawyers to the defense of those accused of child abuse, most child abusers never go to trial. In many cities it is not unusual for 90 or even 95 percent to plead guilty, and almost nowhere is the figure lower than 70 percent.[4] Assuming that a man or woman who is falsely accused of sexually abusing a child is more likely than not to fight the charges in court, such statistics say something about whether most children who claim to have been abused are telling the truth. In the aftermath of Jordan and McMartin, however, increasing numbers of defendants are choosing to take their chances with a jury, and many of those juries are becoming increas-ingly reluctant to convict.

Given the prevalence of child sexual abuse, a jury may contain at least one member who shares the defendant's sexual attraction to children, as happened in a sexual abuse case where the jurors were divided eleven to one in favor of conviction. "The jury is deliberating," the prosecutor said. "They're not coming back with a verdict. The case was pretty strong at trial, but still no verdict. So one day I get a phone call from the judge. He says, 'We have a note here that you need to consider.' I go to the courtroom. There is a note from the jury foreman, and the note says the following: 'Is it misconduct that one of the people on the jury says he feels that what the defendant did was no big deal because he regularly has sex with eleven- and twelve-year-old girls?'

"I look at that and I say, 'Oh, my God.' We have a hearing in chambers. The defense says that even if it's true it doesn't make any difference, because that doesn't necessarily mean the guy is a bad juror. When he said that, even the judge couldn't restrain himself from laughing. Then we called in the jury foreman. He says, 'Well, one day Joe was late to deliberations, and he said the reason he was late was that he had had some experience with a girl that day.' It turns out that in the neighborhood Joe lives in there are a lot of little girls who, if he gives them marijuana, will allow him to do anything he wants.

accused of child abuse is now such a common practice that lawyers' organizations are even offering seminars on the fine points of how to confuse children and bamboozle jurors.

At one California seminar, a lawyer began by declaring that "children are insidious liars, and they're practiced liars. They are the best. They can lie at the drop of a hat." In order to effectively discredit a child, the lawyer went on, "you want to know about the child's history. You want to know about people who don't like the child. You want to know what those people have to say about the child — subpoena the school records. Then insist upon your right of confrontation, insist that you must be able to cross-examine this child in an adversarial atmosphere. That's what a trial is all about. I find that children do not have real good memories, and to show that these children do not have real good memories, I ask them about specific occurrences in their life, such as their birthday, Valentine's Day, and so forth. I ask them where they were and what they did on that day, and I try to show that they really don't know any of these things. Give wings to the child's imagination, if it's a young child especially. Be prepared to show through your cross-examination that the child has a vivid imagination, that it's very suggestible. Be prepared to lead the child into a situation that could not possibly occur. What you want to project is the feeling that this particular child cannot be trusted to tell the truth."

Another lawyer at the same seminar offered his colleagues advice on how to deal with the jury. "Get them to realize the tremendous task you have," he said. "It is imperative to humanize the defendant. Don't be afraid to pat the defendant on the back. Prepare the defendant for their scrutiny, and have his family and friends nearby. Reeducate the jurors. Remember, we are dealing with a media blitz on this subject." In the event that the jury appeared to believe the child anyway, a third lawyer said, all was not lost. A possible defense is simply the assertion that the defendant was intoxicated when the abuse took place. Another is to argue that a good-faith mistake has been made about the victim's age, as in the time-honored plea, "Well, Judge, she said she was eighteen . . ." A third is the "out-of-character defense" — to insist that, no matter what the child says, the defendant is not the sort of person who would ever harm a child.

When the California Public Defenders Association held a similar gathering in Los Angeles, the featured speaker was Brad Brunion, the lawyer who had represented Virginia McMartin, and who began his talk with a little joke. When a public defender is assigned a sexual

of conducting a "witch hunt" aimed at destroying his client. Whichever course he chooses, the lawyer has a single, overriding goal — to show that the child, for reasons of his own or at the behest of some adult, has made up the allegations.

If such a contest seems like a gross mismatch, it usually is — an intelligent, well-educated trial lawyer with years of experience in questioning hostile witnesses pitted against a child who is easily confused about time, place, and the sequence of events, who tells different parts of the same story at different times, and who links things in his mind that may not be connected. "Didn't you tell the police this happened in the bedroom?" the defense attorney may ask. "Now you're saying it happened in the bathroom." Perhaps the door between the bedroom and the bathroom was open; perhaps the abuser took the child from the bedroom into the bathroom. In the child's mind the abuse occurred in the bedroom and the bathroom, but to the adults on the jury, who have learned to equate consistency with truthfulness, it begins to sound as though he is making the story up.

A defense attorney doesn't have to be brutal, or even particularly devious, to tie a child witness up in knots. Most of them are not brutal at all, since browbeating a child on the witness stand is not likely to win points with the jury. If the lawyer is smart, his questions are gentle and patient, even kindly. "Now, Susie," the lawyer may begin, "tell me. Have you ever told a lie? Do you have a special word you use for a lie? Have you ever told any little lies? A big lie? What's the difference between a big lie and a little lie? What's the biggest lie you ever told? Have you ever told a lie where your mother didn't find out? If your best friend said please don't tell your mother about something, would you lie for your best friend? Did you ever do this? Did you get caught?" The answers to such questions are preordained. Not only are all children capable of lying, all children do lie, since lying is a natural part of being surrounded by adults who dispense punishment for infractions of their rules. But once it has been established that the child is capable of lying, the first seeds of doubt have been planted in the jurors' minds.

As recently as a year or two ago, lawyers who would even consider representing a defendant in a sexual abuse case either advised their clients to plead guilty before trial or offered at best a half-hearted defense. In the aftermath of Jordan and McMartin, however, many lawyers have reached the conclusion that child sexual abuse cases are "defensible," by which they mean that children can be intimidated and confused into withholding information, giving incorrect answers, or seeming untruthful when in fact they are not. Defending those

York, woman who ran a day-care center in her home explained to the jury such things as the post-traumatic stress syndrome, and why many children wait for several days, or even weeks, before reporting that they have been abused. The jury found the woman guilty of two counts of child endangerment and convicted one of her employees of eleven counts of child rape. (The trial, which went on for more than four months, involved so much graphic testimony that the jurors asked the judge to exempt them from all future calls for jury duty. He did.)

Anyone can appear as an expert courtroom witness, as long as the judge in the case believes that the person's experience and training give sufficient weight to his opinions. But many judges refuse to permit expert testimony in child abuse cases on the grounds that there is no clearly defined field of expertise. Where, they ask, does it reside? With the police officer? The social worker? The psychologist? The family counselor? The sociologist? The professionals, who argue the same question among themselves, have yet to come up with an answer.

Another obstacle to the successful prosecution of child abusers is the ability of the defendant's lawyer to delay the trial for months, in some cases even for years, by filing a blizzard of motions seeking discovery of the prosecution's evidence, depositions of the victims, changes of venue, and whatever else the lawyer can think of. Such delaying tactics are a common feature of the criminal justice system, but in sexual abuse cases they exact a special cost. As the case drags on through continuance after continuance, the victim's family often becomes so frustrated and so concerned about the continuing impact of the ordeal on their child that it withdraws from the prosecution altogether. Even if the victim and his family stay the course, by the time the trial begins, chances are that the child will be called upon to testify about something that happened a year or two before. Because children's memories fade much faster than those of grown-ups, often the only choice is to dismiss the case.

If the case finally does come to trial, the defense's strategy changes from delay to attack. No matter what the charges against their client, most defense lawyers believe that the best defense is a good offense, and in sexual abuse cases the best offense consists of attacking the credibility of the prosecution's star witness, the child victim. As with Jordan and McMartin, the defendant's lawyer may declare that the child has been "brainwashed" by a policeman, a therapist, a social worker, or someone else associated with the prosecution. Or he may argue that the child's allegations are the result of the "hysteria" that surrounds the issue of child abuse. Or he may accuse the prosecutors

witnesses. Before children can testify in most states, however, they must convince the judge that they are competent witnesses, which means that they know the difference between the truth and a lie. The practice of testing a child's familiarity with the concept of truth dates back more than two centuries, to a ruling by a British jurist that whether or not young witnesses could give testimony depended on their awareness of "the danger and impiety of falsehood." From that decision has derived the modern-day competency hearing, a separate mini-trial that takes place before the regular one, and in which prosecutors, defense lawyers, and the judge take turns asking questions of the prospective witness.

If the judge decides that the child is capable of testifying truthfully, the trial proceeds. If not, the charges are dismissed. Most competency hearings begin with questions about the difference between truth and falsehood and the meaning of a sworn oath, but the divergent interests of the prosecution and the defense soon become clear. Because the prosecutors wish to show that the child is capable of testifying truthfully, they naturally tailor their questions with that goal in mind. The defense, on the other hand, tries to make the child out to be incompetent by asking questions like "Do you believe in Santa Claus?" or "What's the difference between right and wrong?" Not only are right and wrong difficult concepts even for adults, but most children do not have much experience in abstract thinking. "You ask a seven-year-old, 'Are you in school?' " one lawyer says. "And the child will say no. Well, you know darn well they're in school. You know they're in the second grade. What's wrong here? What's wrong is that the child is not in school at this moment. She's sitting right here in the courtroom."

Cases where the witnesses are very young present the greatest difficulty for prosecutors, but even with older witnesses there is a multitude of obstacles to be overcome. In helping juries assess guilt and innocence in ordinary criminal cases, prosecutors and defense lawyers have traditionally relied on disinterested experts to testify that a particular bullet was fired from a particular gun, or that a particular fingerprint was left by a particular individual. A major barrier in child abuse cases is the reluctance of many judges to allow the admission of expert testimony by psychologists and psychiatrists who can fill in the gaps in the jury's knowledge of child psychology and sexual abuse.

When such witnesses have been permitted, they have most often been helpful to the prosecution. A social worker who was permitted to take the stand as an expert witness at the trial of a Mount Vernon, New

child. Many of the prosecutors around the state just won't deal with it if the child's not going to make a good witness."

A California prosecutor who took a chance on a three-year-old incest victim, the youngest child ever to testify in that state, thought he had made the right move when the boy took the witness stand at his father's preliminary hearing and confidently told the judge how he had been abused by his father. But when the father's lawyer took over the questioning, the child denied that anything had happened. "He did pretty poorly," admitted the psychiatrist who had helped prepare the boy to testify, and who then had to explain to the court why a three-year-old might say one thing one minute and another the next. The boy's father was ultimately convicted, but only because of the judge's willingness to accept the psychiatrist's explanation.

Most distressing was the case of three-year-old Janine, whose parents had been divorced for about a year when the teachers at her day-care center first noticed something unusual about her behavior. Janine was spending alternate weeks with her divorced father and mother, and it was during her times with her father that she seemed to become a different child, tugging violently at her hair, using sexually explicit language, even regressing in her toilet training. When the teachers mentioned the behavior to her mother, the woman put it down to her daughter's distress over the divorce. The mother, a lawyer, simply found it inconceivable that her former husband, also a lawyer, was capable of abusing their daughter.

When Janine mumbled something about her daddy and her vagina, however, the teachers called the state child protection agency. At the urging of the agency, her mother took the girl to a child therapist, who concluded that the girl had been sexually abused by her father. A doctor's examination showed that the girl's hymen was broken and her vagina enlarged. But when her mother demanded that the district attorney bring charges against her former husband, the prosecutors replied that because Janine was too young to testify, they had nothing to take to trial. When the mother tried to terminate the joint-custody agreement that had been a condition of her divorce, the court refused, pointing out that the father had never been charged with a crime. Janine, now eight, still spends one night a week with her father and his new wife. "He still calls my daughter a liar," her mother says. "He says it didn't happen. It gets so confusing for her. I just keep telling her, 'You know it happened, because you were there.'"

When is a child old enough to testify? The question is ultimately up to the court, because there is no statutory age limit for courtroom

stick his finger in the vagina of every child that is brought to him. And if he can stick it in, he says, 'Vagina will admit finger — no other evidence of sexual abuse.' And if he can't stick it in, he says, 'Vagina would not admit finger — no evidence of sexual abuse.'

"Cases are being dismissed left and right because of his poor examinations. In this one case I had, his examination was totally inconsistent with what the child described as happening. The case was going to be rejected by the DA's office. I interviewed her, and she was so compelling in her description of what occurred that I couldn't believe the examination was accurate. So I went ahead and filed the case. Before we had a preliminary hearing, I decided to have the child reexamined by another doctor. This kid had gross signs of sexual abuse. She was only ten, but she had the vagina of a sexually active woman."

Even when conclusive medical evidence does exist, sexual abuse cases end up resting on the testimony of the children involved. When those children are too young to testify, there is likely to be no case at all. Though there are exceptions, it is a rule of thumb that most children under five are not capable of giving evidence in court. Even if they are, the chances are better than good that their testimony will work to the advantage of the defense rather than the prosecution. "The last time I had a four-year-old on the stand, it took me less than forty-five minutes to break her down," one of the defense lawyers in the Country Walk case was quoted as saying.[3] Many abusers have figured out what prosecutors already know, that it's open season on very young children; about half of all sexual abuse victims, including nearly all of those in preschool and day-care cases, are under five. Unless there is abundant and conclusive corroborating evidence, and unless the victim is unusually precocious, even the most dedicated prosecutor will rarely consider trying a case in which the principal witness is a very young child.

"So often, we'll have a parent who has a two-year-old who in some way or another has communicated something," says Ted Dewolf, who heads the child day-care licensing division of the Michigan Department of Social Services. "We'll talk with other parents and with other children to try to get some kind of corroborative information, but oftentimes it's just not there. If we're really concerned, if it appears as though something might have happened, we might bring in a psychologist or a therapist who might be a little more effective in interviewing that child, and there may be some conclusions from that. But in many cases the problem is simply the age of the

crimes, such as murder, also hinge on questions of intent. But in other kinds of cases there is often corroborating evidence that makes the defendant's intention clear, such as eyewitnesses who can tell what they saw and heard, or physical evidence like a bullet or a fingerprint. Because most child abusers operate in secret, in sexual abuse cases there are practically never any disinterested witnesses.

With other kinds of crimes, police working undercover can sometimes watch the criminal act take place. But the surveillance of a suspected child abuser raises a moral dilemma, as was discovered by a policeman investigating a physical therapist suspected of abusing crippled children in a small Northern California town. In hopes of garnering firsthand evidence, the officer watched through a hole in the man's office wall while he performed oral sex on a four-year-old cerebral palsy victim. Only after the therapist had finished did the officer emerge and place him under arrest. Though the suspect was convicted, the officer was fired for not having prevented the abuse from taking place.

In most sexual abuse cases, the only corroborating evidence likely to exist is medical. But medical evidence is not that common, and it is almost always open to interpretation. Oral sex may leave no symptoms at all unless the abuser has a venereal disease, and genital fondling is usually impossible to prove. Vaginal and anal intercourse sometimes result in scarred hymens and stretched sphincters as well, but even these are not conclusive. There may be other reasons for a scarred hymenal opening; according to one study, an enlarged vagina in young girls indicates sexual abuse in only three out of four cases.[1] Except for pregnancy, venereal diseases like gonorrhea or chlamydia are among the most reliable evidence that a child has been abused, since they are nearly impossible to acquire except through sexual contact. But even venereal disease adds up at best to circumstantial evidence, because it carries no name tag. It may be possible to prove that the child in question had sex with somebody, but not with whom.[2]

Like ballistics tests and fingerprints, medical evidence is only as good as the physician who assembles it. Findings taken by hurried, inexperienced, or indifferent doctors in busy clinics or hospital emergency rooms often turn out to be worthless in court. "I know this one doctor who does all the things I consider to be classic mistakes," says Ken Freeman, a veteran Los Angeles prosecutor. "Without understanding children, without understanding how to take a history, without even understanding how to examine children, he attempts to

photo lineups, and an archeological dig, the McMartin prosecutors had not found a shred of evidence to corroborate the children's stories.

But somehow it was all a bit anticlimactic, and even the question of whether Ray Buckey and his mother were guilty or innocent seemed almost immaterial. Guilty or not, it wasn't likely that anybody would ever again entrust the McMartins or the Buckeys with their children. What mattered far more than their guilt or innocence was whether it was even *possible* to prosecute relatively large numbers of defendants accused of abusing relatively large numbers of children.

While McMartin was receiving most of the attention, six new charges of felony sexual abuse were being filed in Los Angeles County every day. Prosecutors in Indianapolis had a hundred sexual abuse cases pending, triple the number two years before, and those in Wichita had more than a hundred. In Tucson there were three hundred cases waiting to go to court, in Seattle 350. Dane County, Wisconsin, was reporting ninety-four cases of incest in 1985, up from twelve the year before. Even tiny Hillsborough County, New Hampshire, was prosecuting two hundred sexual abuse cases a year. "Something has happened within the last two years," said Mike Fondi, a district judge in the Nevada capital of Carson City, population thirty-five thousand. "I can't believe the number of these cases that I get nowadays — not just incest, but child molestation and child abuse. I have more of those cases set for trial than any other kind of criminal case on my calendar."

Cases like McMartin and Jordan, the so-called macro cases, in which there were several defendants and many children, were filled with potential pitfalls. With so many witnesses to the same purported events, there was no way their stories were going to track perfectly. When defense attorneys, acting well within the bounds of courtroom procedure and rules of evidence, zeroed in on the imperfections, it was easy for them to raise serious questions about the children's credibility. The macro cases were few and far between, but in every state and city, growing numbers of children were claiming to have been sexually abused. In many states, especially those that placed a high premium on ensuring defendants' rights, many of the same problems that plagued the macro sexual abuse cases were making ordinary cases difficult to win.

Merely establishing that a child had been abused was not enough, since the prosecutor also had to prove who had done the abusing. Even then, it was usually necessary to show that the defendant intended to "arouse or gratify" his own lust or passion or that of the child. Other

Lawyers

A S IT HAD BEEN by the Jordan case for much of 1984, the topic of child sexual abuse in America was dominated during most of 1985 and 1986 by questions about what had happened at the McMartin preschool.

On Monday, July 13, 1987, nearly four years and six million dollars after Ray Buckey had first been arrested in Manhattan Beach in the fall of 1983, the McMartin trial finally got under way. It had taken three months to pick the jury of seven men and five women from a pool of several dozen potential jurors. Thirteen of the fourteen children the Buckeys were charged with having abused were scheduled to appear as witnesses; the children, all of them now between the ages of eight and twelve, would be testifying about things that had happened when they were three, four, and five. Some observers were predicting that the trial might last two years.

In her opening speech, Lael Rubin stated that following his second arrest in March of 1984, Ray Buckey had shared a jail cell with a convicted burglar who would testify that Ray had admitted sodomizing a two-and-a-half-year-old child and having sex with other children, taking photographs of some of them and threatening others to ensure their silence.

Dean Gits, Peggy McMartin Buckey's attorney, countered Rubin's disclosure with his own theory of the case. "These events never happened," Gits said. The McMartin preschool, far from having been the "hotbed of child molestation" portrayed by the prosecutors, had "functioned as a loving preschool for a period in excess of twenty years." Gits also pointed out that despite the searches of twenty-one homes, seven businesses, thirty-seven cars, three motorcycles, and a barn, despite interviews with more than six hundred people, forty-nine

material had knowingly been withheld, because he had simply assumed that Rubin or someone else had turned it over. Stevens also admitted that he hadn't thought the woman was unbalanced when the case began, and that she had probably "flipped out" over what she believed had happened to her child. It had been his view, Stevens said, that Johnson was "just another witness" for the prosecution, "and not as crucial as she seems to have become."

Though there were many other children and many other parents involved in the McMartin case, the defense was determined to make Judy Johnson a crucial witness, the fulcrum on which the forthcoming prosecution would depend. If Johnson took the stand and repeated the bizarre assertions she had made to the prosecutors in private, her testimony would likely sink the case. If she didn't, and if Gits and Davis questioned her about the memos, it would look as if she were covering something up. When Judy Johnson was found dead in her Manhattan Beach home, nobody quite knew what to think. But Judge Pounders ruled that the woman's death was not enough to derail the proceedings, and after a couple of suspense-filled weeks the coroner announced that she had died of natural causes, apparently from an alcohol-related liver failure. The mother who had started the McMartin case more than three years before appeared to have drunk herself to death.

It was in the midst of the hearing that Ray Buckey appeared in court to plead for bail. "I never in my life threatened a child, nor can I comprehend how anyone could," he told Judge Pounders, but Buckey insisted that he wanted a trial. "I do believe that this case should and must go to trial," he said. "The truth must be known and understood, the truth of my innocence and my mother's innocence and the truth of the wrong that has been done to the seven teachers and to the innocent families of the children. To say I don't fear for my future in the trial is a lie. But the one thing I don't fear, Your Honor, is the truth of my innocence and my mother's innocence. To put it simply, the truth will set me free."

Ray Buckey's request for bail was denied, and Judge Pounders ruled that the evidence against Ray and his mother was sufficiently compelling that both should stand trial. Many of the children's statements, Pounders said, appeared to be "spontaneous" and had "the ring of truth." He concluded: "The district attorney should proceed against these two defendants . . . these defendants are in a distinctly different situation than the other five." The defense's motion to dismiss the charges, the judge said, was denied.

By far the most explosive part of the tapes was Stevens's revelation that the prosecution had been concerned that Judy Johnson, the mother of the two-year-old boy who had started the Ray Buckey investigation, was of unsound mind. When Abby Mann, acting on "advice of counsel," turned the Stevens tapes over to the defense, Dan Davis and Dean Gits were delighted. That the prosecutors had had concerns about Johnson's sanity was clear, not just from Stevens's recollections but from a number of confidential memorandums subsequently discovered by the defense in Lael Rubin's files. The memorandums showed that the woman had accused a number of people besides Ray Buckey of having abused her son, among them her former husband, the employees of a Los Angeles health club, an AWOL Marine whose name she didn't know, and a member of the Los Angeles school board. She had told the prosecutors that Ray Buckey could fly, and that he and the other McMartin teachers had put staples in her son's ears and scissors in his eyes.

Lael Rubin and her new coprosecutor, Roger Gunson, agreed that Johnson had been a deeply troubled woman. But they pointed out that her mental problems hadn't become evident until after the case was nearly a year old, and that in any event her emotional instability had no bearing on whether her child had been sexually abused — the doctors at UCLA had confirmed that. The problem for the prosecutors was that they had never communicated their concerns about Johnson to the defendants' lawyers, as the rules of discovery required them to do. Judge Pounders had thrown out all of the defense's other arguments for a dismissal, but he agreed to take testimony on the question of whether Davis and Gits had been unfairly denied a vital prosecution document. Now a third proceeding, an "evidentiary hearing," would be sandwiched in between the preliminary hearing and what promised to be an equally lengthy trial.

When Glenn Stevens was called as a witness at the evidentiary hearing, he began by taking the Fifth Amendment. For a prosecutor to convey privileged information about the prosecution's strategy to the defense might be a crime, and it was also potential grounds for disbarment. Asked a pro forma question about whether he had been assigned to the McMartin case while he was a member of the district attorney's office, Stevens refused to answer. But when Stevens was granted immunity from prosecution and finally began to talk, his statements under oath were much softer than those in the tapes. It was true, he said, that the prosecution hadn't given the defense any of the memos that bore on Judy Johnson's sanity. But he couldn't say that the

against his client. Dean Gits, the lawyer representing Peggy McMartin Buckey, concurred in the motion for dismissal. Judge Bobb had retired to the sidelines, and the dismissal motion was heard by another judge, a man named William Pounders. Davis offered the court a number of grounds for throwing out what remained of the case, including the suggestion that Lael Rubin had been having an affair with another superior-court judge and might thus have influenced the collective judiciary against the McMartin defendants. Rubin denied that she had had such an affair, and when Davis was unable to come up with any proof, it simply confirmed the reputation he had among those who had been following the case: Ray Buckey's attorney would stop at nothing to see his client acquitted.

The most sensational of Davis's arguments involved prosecutor Glenn Stevens, who had been fired by Ira Reiner in January 1986 for having expressed his concerns about the case to the *Los Angeles Times*. After leaving the district attorney's office, Stevens had signed on, for an undisclosed fee, as a consultant to Abby Mann, a Hollywood movie writer who was trying to put together a television docudrama about the McMartin case. With his wife, Myra, Mann interviewed Stevens for more than thirty hours, and the tape-recorded interviews contained a good deal of inside information about the prosecution's preparation of the case. While working for the district attorney, Stevens had voted in favor of prosecuting Ray Buckey and his mother. Now, according to the tapes, he no longer believed that either one of them was guilty. What seemed to bother Stevens most was the fact that the massive police investigation hadn't turned up any solid corroboration of the children's stories. In the absence of corroboration, it seemed, he had stopped believing the children.

The McMartin parents were furious at Stevens's turnabout. "I put my child in his hands," one mother said. "He told us he believed us, and he has sold us out for thirty pieces of silver." In the interviews, Stevens painted Lael Rubin as blinded to reality by her ambition to follow in Jean Matusinka's footsteps and to become a judge, and he dismissed Kee MacFarlane as naive. "If you can criticize her for anything," he said, "it would be that she didn't really stop and take a look at exactly where we were and what was going on here, and really compare and contrast. Which is the same criticism you can heap on the DA's office." As for the docudrama, Stevens told the Manns, "You want this thing to generate a lot of controversy. That's when it becomes real sexy." If Ray Buckey and his mother were acquitted, Stevens said, "We'll be sitting on top of the world."

had been her decision in the first place. Ira Reiner kept repeating that he had inherited the McMartin case from his predecessor, and that once the preliminary hearing was under way, he had been powerless to stop it. What Reiner didn't seem to remember was that he could have dismissed the charges at any point during the hearing.

There were other explanations, but as what was left of the McMartin case ground its way through the criminal justice system, it was impossible not to see that many of the mistakes that had first been made in rustic Jordan, Minnesota, had been replicated in sophisticated Los Angeles County, and for many of the same reasons: the refusal of a tiny police department to ask for outside help, the use of social workers and child therapists to conduct crucial interviews with children, the resorting by some of those interviewers to leading or suggestive questions that would later give weight to charges of brainwashing, and the hasty and inadequate research done by a prosecution team always on the edge of being overwhelmed by its case.

Claiming that their reputations had been destroyed, the five former McMartin defendants filed a twenty-million-dollar lawsuit against the city of Manhattan Beach, the county of Los Angeles, Bob Philibosian, the Children's Institute, Kee MacFarlane, even against Wayne Satz, the local television reporter who had broken the McMartin story and whose coverage of the case had been the most aggressive of any local journalist. "All I want back is what I had stolen from me," Virginia McMartin told a news conference. "I want to be able to live my life the way I want."

As the McMartin case was collapsing under its own weight, the related sexual abuse investigations in the Manhattan Beach area were also falling apart. The sheriff's department task force that had been set up to look into the McMartin case had also interviewed scores of children from the half-dozen other local preschools that had fallen under suspicion. An eighteen-year-old playground aide at one of the schools had been indicted and tried, but when the jury could not agree on a verdict, prosecutors decided not to charge him again. By then the children at that school had been interviewed so many times and by so many different people that their stories were hopelessly confused. "I haven't got anybody I can put on the stand that hasn't contradicted themselves," one weary investigator said.

By the spring of 1986 the related investigations had officially been closed, but the McMartin case was still sputtering. Dan Davis, who was billing the county $116 an hour to continue his representation of Ray Buckey, asked the court to dismiss the 101 counts remaining

own judgment. He summoned the three McMartin prosecutors and several of his top assistants, and during one very long weekend they combed through the mountain of evidence produced by the preliminary hearing. When Reiner finally asked each of those present for their recommendations, Glenn Stevens said he thought that only the cases against Ray Buckey and his mother were strong enough to guarantee a conviction. Chris Johnston was even more cautious: only Ray Buckey should be tried, she said. Lael Rubin agreed that the cases against Ray Buckey and his mother were the most persuasive, but she thought she could convict Betty Raidor as well.

On January 17, 1986, in an announcement reminiscent of Kathleen Morris's press conference in Jordan, Reiner said that the charges against everyone except Ray and Peggy McMartin Buckey were being dismissed. The evidence against the Buckeys, Reiner said, was "very strong," even "compelling," but that against the five other defendants was weak. If Reiner's decision was a compromise, it was one that pleased nobody. Ray Buckey and his mother were furious, since they thought the charges against them should have been dropped along with the others. The other five defendants were equally furious — the hearing had cost them nearly two years of their lives and most of their savings, and now they were being denied the chance for a trial that might have cleared their names. Their five lawyers were equally angry. During the last weeks of the hearing they had begun to smell blood, and they had been looking forward, as one of them put it, to "kicking some derriere."

Angriest of all were the McMartin parents, including those parents who had declined to let their children testify. If the district attorney thought Ray and Peggy Buckey were guilty, then how could the others, who must at least have known what was going on at the school, be innocent? Ira Reiner, struggling to be as sensitive to their feelings as to his own reputation and to the public outcry his decision had provoked, tried his best to assuage them in private. "He made it very clear to us that he did not think these people were innocent," one parent said. "He said he just didn't have sufficient evidence to get a conviction, and that it hurt him greatly to have to let them go." But all the explanations in the world didn't help. "Ira Reiner is politically dead," one mother fumed, and she began organizing a drive to get the state attorney general to take over the case.

When asked later what had gone wrong, everyone had a different explanation. The worst mistake, Judge Bobb thought, had been joining the seven cases into one; she didn't seem to remember that it

prosecution." But just how badly wasn't clear until the *Los Angeles Times* reported that two of the three prosecutors in the case had decided that there wasn't enough evidence against four of the seven defendants to bring them to trial. The only defendants who deserved to be bound over, the two prosecutors were said to have concluded, were Ray Buckey, his mother, Peggy, and Betty Raidor. The article didn't identify the two prosecutors by name, but Lael Rubin wasn't one of them, which left only Glenn Stevens and Christine Johnson.

The prosecution had barely rested its case, and now two-thirds of the district attorney's team was jumping off the boat, or at least had one leg over the railing. Fortunately, the next move didn't belong to the prosecutors; it was up to Judge Bobb to decide whether they had demonstrated enough probable cause for her to order the defendants to stand trial. Before that could happen, the defense lawyers, who had read the *Times* article with great glee, invoked their right to present an "affirmative defense" — in effect, to put on a hearing of their own by calling witnesses to rebut the children's testimony. The affirmative defense, which lasted for nearly three months, was exhaustive but not persuasive. On January 9, 1986, Judge Bobb ordered all seven defendants to stand trial. The children's testimony, she said, had been "very credible."

Because the prosecution's case had been pared away to its bare bones, there weren't many counts remaining against most of the defendants. Ray Buckey faced the largest number, with eighty-two. But his mother, Peggy McMartin Buckey, was now only charged with twenty-four counts, and his sister, Peggy Ann, with eight. Betty Raidor faced ten counts, and Mary Ann Jackson and Babette Spitler four each. Virginia McMartin, who had celebrated her seventy-eighth birthday during the hearing, faced but a single count, the common charge of conspiracy.

Merely because Judge Bobb thought all the defendants ought to stand trial, it didn't mean the prosecutors had to try them all. Ira Reiner, the new district attorney, had inherited the case from Bob Philibosian, and during his first few months in office he had seen large parts of it dissolve. The district attorney's job, Reiner said, was to decide not whether there was enough evidence to bring defendants to trial — Judge Bobb had already done that — but whether there was enough to convict them. It was his moral and ethical obligation, Reiner said, not to force the McMartin defendants to undergo the additional expense and anguish of standing trial if he didn't think he could win a conviction.

Reiner wasn't willing to trust such a momentous decision to his

in court, Judge Bobb had no choice except to dismiss more than half of the charges against the seven defendants.

What had begun as the child abuse case of the century was rapidly dwindling, and the pieces that remained were much flimsier than anyone could have envisioned when the preliminary hearing began. None of the children who testified had been dissuaded from their insistence that they had been sexually abused at the school. As in the Jordan case, many of their accounts included the sort of anatomical and physiological details that it is difficult for young children to contrive. But the witnesses had been vague about times and places, and their testimony contained more than its share of discrepancies and contradictions.

Some of the contradictions were more serious than others. A nine-year-old boy who told of having been taken from the school to a private house where he was abused by strangers said at first that he had been driven to the house in a red convertible. Later he said it had been a green and white van. When the defense lawyers asked a seven-year-old whether some of his allegations were "stories" he had told so that the prosecutors "wouldn't be sad," he agreed that they were. But the most serious contradictions concerned who had done the abusing. One girl testified for the prosecution that Ray Buckey had photographed her and other children nude; on cross-examination she said that he had not. "When you say Ray did take pictures and he did not take pictures, are those both true?" Dan Davis asked. "Yes," the girl replied.

An eight-year-old girl who had named three of the McMartin teachers as those who had abused her said later she could not remember who her abusers were. Another girl identified the woman who had abused her as Peggy McMartin Buckey, then changed her mind. When a fourth witness was asked which of her teachers had abused her, she mentioned someone named "Miss Lo." Asked whether Miss Lo was in the courtroom, the girl nodded and pointed to one of the defendants. The woman she pointed to was Mary Ann Jackson. Miss Lo, it turned out, had been dead for several years.

The question raised by the children's testimony wasn't so much whether they were lying as whether they were testifying accurately. "With multiple defendants there is always a risk of implicating innocent people," said one prosecutor who was watching the case closely. "It's easy for those kids to remember that they were abused. Maybe they were even abused by four or five people. But there is a possibility — a danger, I think — of children starting to think that everybody they came in contact with when they were there was part of all this."

The contradictions, one defense lawyer said, were "killing the

only acquiesce to what we're saying but will go on to elaborate on it in great detail." But even MacFarlane didn't defend all the techniques she and her colleagues had used. "There are parts of tapes that certainly look like children were led into saying things," she admitted later. "I think we need to look a lot more closely at children's susceptibility and the way questions are asked. Where I think you get in trouble is when they say, 'Somebody touched me,' and you say, 'I know it was Mr. Ray. All the kids told me it was Mr. Ray, and you can tell me it was Mr. Ray. It was Mr. Ray, wasn't it?' That's a leading question, that's asking for a specific answer. Things that are in the therapeutic interest of children are not always in the legal interest, and that's where we've all got to get a lot better."

As the McMartin hearing went forward, it took on an increasingly fantastic tone. The ninth witness, a boy, said that children at the school had been beaten regularly with a ten-foot-long bullwhip and taken to the Episcopal church, where they were "slapped by a priest" if they refused to pray to "three or four gods." When the defense lawyers showed the boy some pictures and asked him to pick out his abusers, he selected photos of the Los Angeles city attorney and Chuck Norris, the movie actor. The embarrassed prosecutors said later that the boy had been mistaken in his recollections, but after he stepped down they decided not to call any of the other children who were likely to testify about satanic rituals or bizarre events.

The decision may have been wise from a strategic standpoint, but it cost the prosecution a number of its scheduled witnesses, and with the witness list diminishing rapidly, it was a loss they could ill afford. As the parents whose children hadn't yet testified watched the early witnesses squirming on the stand, they were beginning to have second thoughts about putting their own children through such an ordeal. Some of the parents told Lael Rubin that their children would not appear at all, that they were withdrawing from the case. The rest said theirs would testify only over the sort of closed-circuit television setup Judge Bobb had refused to approve.

The McMartin parents had been lobbying the California legislature to enact a statute authorizing televised testimony, but when the bill was finally passed, Judge Bobb again denied the prosecution's request. Only after she was reversed by another judge were the television cameras and monitors set up in her courtroom, but by that time only one child's parents were willing to allow him to testify. The boy was the fourteenth scheduled witness in the case, and now he would be the last. Now that twenty-seven of the forty-one scheduled witnesses would never appear

MacFarlane be charged with a crime for withholding information from the authorities, because she hadn't filed the child abuse reports required by the state on the children she'd interviewed. "I thought that law was for when you took a case to the police," MacFarlane said later. "I didn't think it was for when the police brought a case to you."

What could not have been foreseen when the McMartin investigation began was that the videotaped interviews, which had seemed like such a good idea at the time, would provide the strongest ammunition for the defense's claims of brainwashing by the prosecution. A few of the tapes were models of therapeutic technique, but others were seriously flawed by questions that were unnecessarily leading and suggestive. One tape showed an interviewer assuring a reticent child that many of the other McMartin children had already told her "yucky secrets," and that all of the McMartin teachers were "sick in the head." When another child was asked whether "Mr. Ray" had ever touched her, she vigorously shook her head. Only when the questioning persisted did the child agree that Ray Buckey had indeed touched her genitals. When a third child continued to insist that nobody at the McMartin school had abused her, the two interviewers told the girl that they themselves had been sexually abused as children, and that she would feel much better if she told someone about what had happened.

Some of the tapes reflected what seemed to be fundamental errors of procedure. MacFarlane and the other interviewers rarely began a session by asking directly, "Did anything happen to you?" Instead, the child would be given a McMartin class picture and asked to point to the children he knew. When a child was pointed out who had already been interviewed, the interviewer might say, "He told us what happened at the school," thereby establishing the premise that abuse had occurred. Whether the children were interviewed a short time after they claimed to have been abused or months and even years after the fact, virtually the same techniques had been used with all of them. In hopes of easing what the interviewers perceived as the children's embarrassment at talking about such a sensitive subject, they were allowed to respond to questions by using hand puppets. Rather than answer yes or no, a child would simply move the puppet's head up and down or sideways.

"If you really look at what brainwashing is, this isn't brainwashing," Kee MacFarlane said later. "I just don't believe that we have this incredible power to influence children, that children are incredibly more susceptible than we've ever considered, and that they will not

didn't lose a second. "You don't know what you mean by the word 'penis,' do you?" he shot back. "No," the girl admitted. "Did anyone ever tell you what a penis looks like?" he asked. She said that no one had. "I'm convinced this child didn't know what the sex organ was," Davis said later. "She used the word the adults told her to use." Kee MacFarlane had a different explanation. "She knows what a penis and a vagina are," she said. "It's just that she's at an age where she's horribly embarrassed by all of this. She just about died during the medical exam. I expected her to fold up on the stand. Those words didn't come from here, because we never used adult terminology with the kids. If they called it a google, we called it a google."

The prosecutors rejected the brainwashing allegations by pointing out, as had their counterparts in Jordan, that most of the children had accused only a few of the defendants. If the children had been brainwashed, the prosecutors said, then it hadn't been a very good job of brainwashing, or else why weren't all the children naming all seven defendants as their abusers? The defense lawyers were not persuaded, and according to them the head brainwasher was Kee MacFarlane herself. "She could get a six-month-old infant to say he's been abused," one of the defense lawyers said. In fact, MacFarlane had a certain childlike quality about her, and she was very good with children. She liked being around them, even those with problems, and they seemed to like her. "I think this is an ideal job," she said once. "They actually pay me to get down on the floor and play with kids all day."

The defense showed MacFarlane no mercy. When she took the witness stand to testify for the prosecution, one of the first things she was asked on cross-examination was whether she herself had been abused as a child. When she declined to answer on the ground that her childhood experiences were irrelevant to the issue at hand, Judge Bobb allowed her refusal to be interpreted as an acknowledgment that she had been abused. The first thing MacFarlane did after leaving the courtroom was to telephone her father and explain what had happened, before he heard about it on the evening news. He laughed and told her not to worry, but the attacks on MacFarlane continued.

When the defense pointed out that she was not a psychologist, MacFarlane replied that she had never claimed to be one. When rumors began circulating that she didn't even hold a degree in social work, the University of Maryland confirmed that MacFarlane was among its graduates. The most ludicrous attack of all came toward the end of the hearing, when one of the defense lawyers demanded that

Davis: Objection, leading.
Judge Bobb: Overruled.

And so it went, hour after hour, day after day, week after week. Judge Bobb seemed tentative in her handling of the defense lawyers, and occasionally rattled by them. "There's this incredible dynamic that goes on in court with seven lawyers versus one," one observer said. "When one of them makes an objection, the other six join in — they're on their feet jumping up and down, their hands are up, they're yelling. Just the psychological weight of that on the judge has to be a factor. She can shut them all up by sustaining what they want." But Bobb's patience with the defense was not endless. When Dan Davis objected that a child's answer to a question by Lael Rubin about the date of her birthday was hearsay, because the child had no firsthand knowledge of when she was born, the judge told Davis to shut up. "I'll just assume you have a continuing objection," she said acidly. Davis tried to keep quiet, but he couldn't. Bobb fined him five hundred dollars for contempt.

When Lael Rubin or one of the other prosecutors was finally able to finish, the seven defense lawyers would begin questioning the child in turn. The first witness, a seven-year-old boy, sat on the stand for a week while he was cross-examined on the minutiae of his allegations. The second witness, the ten-year-old, testified for sixteen days. "Children cannot survive extensive cross-examination, period," said one of Jean Matusinka's assistants. "And if you have multiple defendants, the problem of cross-examination is exacerbated. If you have seven attorneys, it's not seven times worse, it's two hundred and fifty times worse. It goes up exponentially." Outside the courtroom, Davis and the other defense lawyers conceded that their strategy of searching for discrepancies in the children's testimony through repeated questioning was regrettable, but they defended it as necessary to show how the children had been "programmed" by the prosecution.

Whatever the defense lawyers' rationale, no detail went unquestioned. A boy who said he had been sodomized by Ray Buckey with a pen was asked what color the pen was. Davis was also quick to point out that several of the children hadn't admitted to being abused until after they were interviewed by Kee MacFarlane and her social workers, and he thought it significant that some of the witnesses used terms, such as "oral sex" and "pubic hair," that were not part of an ordinary child's vocabulary. When the seventh witness, an eight-year-old girl, testified that Ray Buckey had "put his penis in my vagina," Davis

tell the mother, 'Go in the little yard and they'll be there.' He got the child dressed, peeked out the door, and said he had found the child in the classroom."

But most of the children who testified seemed overwhelmed, sometimes pausing for a full minute, or even two, before answering a question. For many children, however, the biggest trauma proved to be not the courtroom or even the defendants, but the defendants' seven lawyers. The McMartin defense team was not an overly distinguished group. Several had attended rather obscure law schools, some of them at night, but they made up for their lack of legal erudition with their tenacity and contentiousness. When they declared at the outset of the hearing that their clients were unequivocally innocent, it sounded like an echo from the Jordan case. Maybe some of the McMartin children had been sexually abused, the lawyers said, and maybe they hadn't. But it wasn't their clients who had done the abusing, and if the children were saying it was, then the children were lying. One of the lawyers' favorite tactics was objecting to nearly every question put to the children by Rubin and the other prosecutors; if there had been an award for the most objections raised, it would have gone to Ray Buckey's lawyer, Dan Davis. The following exchange was all too typical:

> *Rubin*: When you were a littler girl, did you go to the McMartin
> school?
> *Davis*: Objection, Your Honor. She's leading the witness.
> *Judge Bobb*: Objection overruled.
> *Rubin*: Can you tell us who your teachers were?
> *Davis*: Objection, vague.
> *Rubin*: Do you see Ray here in court today?
> *Witness*: Yes.
> *Rubin*: What is he wearing?
> *Davis*: Objection, calls for a conclusion.
> *Judge Bobb*: Overruled.
> *Witness*: A shirt.
> *Rubin*: Is the shirt a light color or a dark color?
> *Davis*: Objection, leading question.
> *Judge Bobb*: Overruled.
> *Rubin*: Do you see anybody else here in court who was at the school
> when you were there who was not a teacher?
> *Davis*: Objection, the "else" makes it vague.
> *Judge Bobb*: Overruled.
> *Rubin*: When you were at McMartin, did you ever have to play a
> game where you had to take your clothes off?

be able to testify. The oldest of the scheduled witnesses, a ten-year-old boy, was barely inside the statute, and even so he would be testifying about events that had taken place when he was four. In theory at least, the best witnesses would be the youngest children, those whose experiences were freshest in their minds. But because they were so young, the prosecutors were concerned that they would also be least able to withstand the rigors of testifying.

When Lael Rubin asked Judge Bobb to allow the children to testify over closed-circuit television, it was in hopes of sparing them the anguish of having to take the witness stand just a few feet away from where the seven defendants were seated. But when the state court of appeals ruled that televised testimony was unconstitutional because it had not been explicitly provided for under state law, Bobb denied the request and ordered the children to testify in person. The compromise she offered was to close her courtroom to spectators and reporters, who would watch the proceedings over closed-circuit TV from an adjacent courtroom. The children would still have to testify in front of some two dozen adults, including the defendants they said had threatened their lives and the lives of their parents. When the children were asked who they thought might be able to protect them, they all had the same answer. "We got ahold of Mr. T and asked him if he would come and talk to the children, to try to reassure them a little bit," said one of those involved in the case. "He said, 'Fine.' He also said, 'If they was my kids, you wouldn't need to have no trial.' " Mr. T did spend time with a few of the witnesses, but as they climbed the steps to the witness stand most of the children were still plainly frightened.

While staying within her role as an impartial fact finder, Bobb tried her best to allay the children's fears. "Good morning," she would tell each new witness brightly. "I am Judge Bobb. I'd like to introduce you to some of the people in the courtroom, and then I'm going to ask you to tell the truth, and the lawyers will start asking you some questions." For the next few minutes, Bobb would point out the court reporter, the clerk, and the bailiffs, and explain what each of them did.

A few of the young witnesses did rather well, such as the girl who said she had been deputized by Ray Buckey to act as a lookout for approaching parents. "I was outside swinging on the swing," the girl recalled. "Inside was Ray and some children. They had their clothes off. Ray was molesting and abusing the children. For little girls, he was sticking his penis in their vaginas and his fingers in their behind, and for little boys he put his penis in their butt. I'd run in and tell Ray the child's mother was coming. He'd put the children in the bathroom and

prosecution had to comply. Virginia McMartin and Peggy Ann Buckey waived their right to a hearing, choosing instead to stand trial on the strength of the grand jury indictment alone. But the prosecutors didn't agree. If they had to mount a preliminary hearing to accommodate the other five defendants, they said, then all seven defendants would have a preliminary hearing.

Aviva Bobb, the judge assigned to preside at the hearing, had never heard a child sexual abuse case. In fact, Bobb hadn't heard many felony cases of any kind in the three years she had been on the bench — drunk driving and other misdemeanors were more up her alley. Nor was Judge Bobb noted for her legal acumen; behind her back, lawyers called her "Judge Boob." In a rare interview, Bobb told the *Los Angeles Times* that she couldn't remember why she had wanted to become a lawyer, but that she liked being a judge and "deciding" things. The first thing for Judge Bobb to decide was what form the McMartin case should take. Should each of the seven defendants have a separate hearing, or should they be joined together into one giant hearing? Bobb's principal concern was which course would be easier on the children. As one prosecutor paraphrased her thinking, "Do you put the children through one big horrendous experience, or do you put them through seven slightly less horrendous experiences?" Bobb decided that one big horrendous experience was best, since it would theoretically reduce the number of times each child had to appear in court. The defense lawyers disagreed, but Lael Rubin had no objection. "We thought it was essential for pursuing the strongest case possible to have them all joined," she said.

Many preliminary hearings last for a day or less, and even in the most serious criminal case it is unusual for one to continue for more than a week. The McMartin hearing would run for twenty months, the longest judicial proceeding in California history and, at a cost of more than six million dollars, easily the most expensive. By the time it was over, forty-three thousand pages of transcribed testimony would fill more than five hundred volumes. Had the subject at hand been less grisly, the hearing would have been a fine satire of justice, worthy of Kafka or at least Gilbert and Sullivan. What it turned out to be was a monumental strategic error on the part of the prosecution.

There were a number of older children, some as old as fifteen and sixteen, who had once attended the McMartin school and who were now telling investigators essentially the same stories as the five-, six-, and seven-year-olds. But because the statute of limitations for sexual abuse cases in California is six years, none of the older children would

In hopes that the McMartin children might avoid the sort of repeated questioning that had marred the Jordan case, the Children's Institute was careful to preserve each of the initial interviews on videotape. Whenever someone wanted to know what a particular child had said about a particular defendant, all that was necessary was to watch the tape. But in their rush to draw up the expanded complaint, the prosecutors themselves hadn't had time to look at more than a few of the hundreds of tapes. Even then, what they saw was sketchy, because most of the tapes had been made early in the case, at a time when many of the children were still reluctant to talk. A few days before the expanded complaint was filed, MacFarlane offered to give Rubin her personal assessment of which children would make the best witnesses. When Rubin said that would be helpful, MacFarlane tried to remember which children had impressed her the most. She gave Rubin a list of names, but she wasn't sure it was the right list. After so many children, it was difficult to remember them all.

Some grand juries are little more than rubber stamps. Others can be more aggressive in seeking the truth than the prosecutors themselves. Most fall somewhere in between. But whatever their nature, grand juries are expensive, and many prosecutors save them for their most important cases, filing the less important ones in the form of a complaint. A few years ago, the California legislature, concerned that defendants who had been charged in a complaint were being denied an element of due process enjoyed by those indicted by a grand jury, passed a law mandating that anyone charged by complaint was entitled to a preliminary hearing before a judge. The hearing would be a pro forma proceeding at which the prosecution would present the bare bones of its case. The defendant, if he wished, could put on a brief affirmative defense. If the judge thought there was a reasonable suspicion that the defendant might be guilty, he would order a trial. If not, the case would be dismissed.

If the preliminary hearing seemed like a relatively inexpensive, efficient, and equitable means of ensuring greater justice, that was before the California Supreme Court decided that defendants who had been indicted by a grand jury were now being discriminated against. A preliminary hearing, the court said, gave a defendant some important rights that were not available to those charged in a grand jury indictment, such as the right to cross-examine witnesses and the right to a public hearing. Henceforth, everyone indicted by a grand jury would also be entitled to ask for a preliminary hearing. A "prelim" wouldn't be mandatory, but if a defendant wanted one, then the

With seven defendants, 115 counts, and a reservoir of 350 possible victims, the McMartin case was already enormous. But Philibosian, a hardrock conservative whose fast-draw approach to law enforcement was more popular among police officers than civil libertarians, didn't think it was big enough. Each of the counts in the grand jury indictment had been based on a specific allegation by a child who had testified behind closed doors, but there were still many uncharged counts that could be filed on the basis of subsequent statements by children who hadn't talked to the grand jury. When Philibosian said he wanted to add the rest of the charges, Lael Rubin agreed. "We as prosecutors," she said later, "have a duty to charge crimes that accurately reflect the magnitude of what has taken place."

In May 1984, the district attorney's office filed an expanded complaint that more than tripled the number of counts against the defendants, from 115 to 354, and more than doubled the number of child witnesses, from the original eighteen to forty-one. By then, considerable tension had developed between the new prosecution team and the old. "The McMartin prosecutors don't ask our advice, or welcome it for that matter," groused one member of the old team, who thought the expanded complaint was a serious error. "You can't charge too many counts," he said. "If you're talking about 150 or two hundred counts involving thirty or forty children, you have to be very careful. Little children have no time sense. It's very difficult for them to separate counts."

Philibosian, whose constituency was the downtown Los Angeles establishment, was then in the midst of a tough reelection battle against the city attorney, a liberal named Ira Reiner from the west side of town. Reiner was the favorite in the race, and there was more than a little muttering from Matusinka's staff about grandstanding in the face of a tough election. The expanded complaint did produce a whole new series of alarming headlines, but Philibosian lost the election anyway. Though it would not become apparent for months, the real problem the prosecutors faced was that they knew relatively little about the twenty-three new witnesses the expanded complaint had added to their case. Rubin and her team had met with a few of the children, but one of those present at the meetings thought they hadn't gone all that well. "They'd had no experience with child witnesses," the person said. "They'd never worked with kids. So we sat down together on the floor and I said, 'This is Lael, this is Glenn.' We had a little session where all I was really doing was facilitating the child's ability to talk to the DAs."

evidence and the children's testimony amounted to the prosecution's entire case.

Like the Jordan children, the McMartin children said they had been photographed while being abused, but the police who searched the McMartin defendants' houses never found a single photograph. Despite a ten-thousand-dollar reward posted by a group of McMartin parents and an appeal placed by a Los Angeles television station in the pedophile publication *Wonderland*, no photos of the McMartin children ever turned up. Nor was any of the McMartin defendants going to testify against another. When the lawyer for one of the defendants offered a guilty plea by his client to a reduced charge in return for her testimony against the others, Bob Philibosian, the district attorney, rejected the overture. All the defendants were culpable people, Philibosian said, and all should be tried and convicted. His decision to accept no pleas of guilty was one the McMartin prosecutors would come to regret.

Even without much in the way of corroborating evidence, Jean Matusinka thought she had a winnable case. It wasn't airtight, but the eighteen children who had appeared before the grand jury had made convincing witnesses, and the medical evidence seemed compelling. A few days after the indictments were returned, Matusinka was stunned when Philibosian told her he was reassigning the case. He tried to justify his decision on the grounds that Matusinka's child abuse unit already had a full caseload, but the lawyers on her staff didn't agree. "Philibosian's thinking was that any good prosecutor could handle any case," one of them said later. "That's probably true in any area other than child abuse. Anyone can handle a murder, for example. But to do child abuse cases, you need to know how to talk to parents and children."

The new lead prosecutor was Lael Rubin, an aggressive trial lawyer who thought well on her feet and was equally adept at handling the media. Among her most recent victories had been securing a guilty plea from Catherine Wilson, a Los Angeles woman known as the "kiddie porn queen." But as Rubin herself acknowledged, her experience in the area of child abuse was limited to a couple of incest cases early in her prosecutorial career. As her two principal assistants, Rubin chose two lawyers who had even less experience in the field than she. One, Glenn Stevens, was a young trial attorney known for his self-confidence and aggressiveness, which was perhaps why he was not particularly well liked by his colleagues. The third prosecutor, Christine Johnston, had a reputation as a careful researcher, if not as a particularly talented trial lawyer.

Even one member of the prosecution team admitted later that "some of them look like people I would really like, if it weren't for all the children I've talked to."

As it was being reported in excruciating detail across the country, the McMartin sexual abuse case was billed as the largest on record anywhere. Of the 400 children interviewed by MacFarlane and her colleagues at the Children's Institute, 350 eventually said they had been abused by somebody at the McMartin school, and because the school had been in operation for nearly twenty years, the potential scope of the case was much bigger than that. Men and women in their late teens and early twenties were calling the prosecutors to say that something had happened to them at the school many years before. "The numbers are just unbelievable," one of the prosecutors said. "I think we don't even know how large the number is."

She was talking about the number of victims, but she might have been referring to the number of suspects. Only Virginia McMartin and the six teachers had been formally charged, but the children who had looked at Kee MacFarlane's mug shots had picked out at least three dozen other people, some of them friends of the McMartins and the Buckeys, others prominent Manhattan Beach residents, still others with no apparent connection to the school or the community.

Most of the children said they had been abused inside the school itself, but one told of being abused in the storeroom of a Manhattan Beach grocery store where Ray Buckey once worked as a bag boy. Another recalled being forced to have sex inside a van while it was going through a local carwash. Shortly after he came under investigation, a doctor whose home had been pointed out by some of the children as one of the places they had been taken checked himself into a sanitarium for a long-term "alcohol cure." The police were never able to corroborate the children's stories of a "wild ride" to the doctor's home in a van with a half-dead baby bouncing around inside.

As the case expanded, Jean Matusinka and her staff, perhaps the most experienced prosecutors in the country at trying cases of child sexual abuse, managed somehow to stay abreast of its twists and turns. Matusinka herself had interviewed each of the eighteen children who testified before the grand jury that indicted the seven defendants. Those children had also been examined by Astrid Heger, a pediatrician who had joined Kee MacFarlane's task force. Heger quickly accumulated a number of color slides showing what she said were vaginal and anal scars that could only have been caused by the penetration of large foreign objects. But as had also been true in Jordan, the medical

children. If such an operation involves child pornography or the selling of children, as is frequently alleged, it may have greater financial, legal, and community resources at its disposal than those attempting to expose it."

MacFarlane acknowledged that "the proposition that a totally unknown number of preschools and other child-care institutions could be serving such purposes is formidable, but many of the cases could only have existed under these conspiratorial circumstances. I don't know if what we're dealing with can be called organized crime, or if there is an entity that uses schools as procurement places. But I do know that hundreds of children are alleging that they were pornographically photographed during their entire time at preschools, that they were taken far away to do so, sometimes so far away that they were taken on planes." Pressed for evidence, MacFarlane mentioned a rhyme she had heard recited by many of the McMartin children in describing the naked movie star game. "What you say is what you are," it went. "You're a naked movie star." She went on: "Some time later, I heard the exact same rhyme recited by a parent in another state where an arrest was made. I asked, 'Where did you hear that?' and the answer was, 'From my child.' " Though MacFarlane didn't say so, the out-of-state case in question was a Montessori school in Reno, where the children were also telling their therapists that, like the children in Memphis, they had been taken on short airplane trips to places they did not recognize. (The proprietor of the Montessori school has yet to come to trial.)

In March 1984, a Los Angeles County grand jury indicted Ray Buckey, his mother, grandmother, and sister, and three other women who had taught at the McMartin school. The seven defendants included virtually everyone who had worked there for the past several years, and when the charges were added up they totaled 115 separate counts. Many of those who saw the defendants' pictures in the newspapers or on television found it difficult to connect them with the prosecutors' descriptions of what had happened at the school. The most improbable of all was Virginia McMartin, who at her arraignment insisted on wearing the fuzzy teddy-bear pin that had become her trademark. With her gray hair and glasses, McMartin's daughter, Peggy McMartin Buckey, looked like everybody's favorite aunt. It would have been difficult to distinguish Ray Buckey and his twenty-eight-year-old sister, Peggy Ann, from the other young people who lived in Manhattan Beach. The last three defendants, Betty Raidor, Mary Ann Jackson, and Babette Spitler, appeared equally benign.

candle. At the time of the search, the handyman was facing sexual abuse charges in connection with a baby-sitting service he operated with another man and a woman from a motel in nearby Torrance. The McMartin children had recognized his picture in the newspaper as that of an abuser they knew only as the "Wolf Man," but the charges against the handyman were never substantiated. He was found dead of an apparent drug overdose on the eve of his trial.

Clandestine satanic ceremonies at an Episcopal church, especially a church that was one of the few liberal strongholds in a rather conservative community? Surely not possible, the police thought. They had second thoughts when the state closed a day-care center operated by the church after a half-dozen children there were found by doctors to have been sexually abused. In the months after the McMartin indictments were handed down, five other preschools not more than a few miles away also became the targets of sexual abuse investigations. One, the Manhattan Ranch School, was closed by the state after three McMartin children said they had been taken there and abused by strangers. When Los Angeles County sheriff's deputies began trying to unravel the connections, they found "substantial numbers" of children at each school who showed medical evidence of abuse. There wasn't any solid evidence of a multischool conspiracy, but neither was there any good explanation for the fact that children who didn't know one another were telling about having been taken in the same cars to the same houses, where they were abused by strangers. When stories began appearing in the Los Angeles newspapers about an apparently unrelated pedophile ring in Sacramento, 350 miles away, children from one of the South Bay schools said they recognized one of the Sacramento defendants from his picture. "I don't know what it is," said one of the consulting psychiatrists in the McMartin case, "but something is going on."

The day-care conspiracy theory first gained prominence in 1984, when Kee MacFarlane made a nationally televised appearance before a congressional subcommittee. She began her testimony by emphasizing that despite the mounting reports of abuse, most preschools and day-care centers were "healthy, responsible, and developmentally appropriate places for young children." What bothered her, she said, were similarities in the accounts given by children who had been abused at schools in several different cities. "I believe that we're dealing with an organized operation of child predators designed to prevent detection," MacFarlane said. "The preschool, in such a case, serves as a ruse for a larger, unthinkable network of crimes against

the children had been attending the school when Ray Buckey was arrested, but others hadn't gone there for several years. Some barely acknowledged that something might have happened to them at the school, and many kept insisting they had not been abused by anybody. But a few more children were talking every week, and they were telling a real horror story. Their teachers, they said, had tied them up and drugged them with various kinds of "medicine" — shots, little pink pills, and mysterious liquids that one child described as "making me feel like I was asleep even when I was awake." They had been raped and sodomized by Ray Buckey, and fondled and penetrated with pencils and other sharp foreign objects by some of the other teachers. Much of the abuse had taken the form of games. There had been the naked movie star game, the cowboy game, the doctor game, the alligator game, the tickle game, and the horsey game.

Among the most worrisome questions raised by the children's disclosures was why they had kept such secrets from their parents, in some cases for several years. The answer, according to the children, was that every so often one of the gerbils, turtles, or rabbits the school kept as pets had been killed in front of them, an example of what would happen to their parents if they ever "told." Some children told the interviewers that they had even been coached by their teachers about how to cope with the nightmares that resulted from the abuse. "They told us the monsters would come in the night and try to eat us," the children said, "and the way you make the monsters go away is, you sit up in bed and say, 'I promise I'll never tell anybody what happened to me.' And the monsters will go away."

The younger children's stories were chilling, but those told by a few of the older children, most of them boys who had been gone from the school for a few years, could only be called grotesque. The boys said they had been forced to drink rabbit's blood in an Episcopal church near their school, and they talked of having been abused by strangers wearing black robes and carrying black candles. Several told of visits to a local cemetery, where they were forced by Ray Buckey to help exhume bodies that Buckey then hacked up with knives. That story sounded slightly less improbable after the investigators found the children's descriptions of the cemetery's grounds and buildings to be accurate down to the placement of clocks and chairs.

The authorities' suspicions that there might be some satanic aspect to the McMartin case deepened after police who searched the house of an unemployed handyman identified by the children as one of their abusers found a pair of rabbit's ears, a black cloak, and a black

only asked about him." It wasn't until some of the children began to talk about having been abused in their classrooms that MacFarlane began to wonder whether the other teachers at the school had been aware of what was going on. "I got to thinking, it would have been pretty hard not to know this stuff was happening," MacFarlane said, "and I started saying things like, 'Well, where was Miss Peggy?' And they'd say, 'Oh, she was right there.' " MacFarlane assembled a small task force of friends and fellow social workers, including her roommate, to help with the interviews. The Manhattan Beach detectives weren't pleased, but if the children were talking to the social workers instead of to them, they had no choice except to relay their questions through MacFarlane and her group.

The role of go-between was not one the social workers relished. They might know something about children, but none of them had any training in how to question a witness or in the admissibility of criminal evidence. "The boundaries," MacFarlane admitted later, "got very blurred. The police brought me mug shots and photographs, and we showed those to the children. That's not something the institute had ever done before, and I don't think it was a good idea." MacFarlane was also troubled by some of the children's reactions to the photos. "I came to this real quick realization that kids are terrible at that kind of thing," she said. "They'll say, 'Oh, there's Uncle Bill,' and of course it isn't Uncle Bill. They were just picking out people who looked scary to them. I felt very uncomfortable with it. We never should have done it."

After months of playing therapist with one hand and policeman with the other, the social workers appealed to California attorney general John Van de Kamp to assign more investigators to the case. "We laid it on the line," MacFarlane said later. "We felt like we were way over our heads." But it was not until October 1984, more than sixteen months after Ray Buckey had first come under suspicion, that the Los Angeles County sheriff, Sherman Block, and Bob Philibosian, the district attorney, paid a visit to Chief Kuhlmeyer in Manhattan Beach. No one present that day will discuss what was said, or by whom, but a month later a special task force of twenty-five sheriff's deputies, headed by Lt. Dick Willey, entered the case from its temporary headquarters in an abandoned lifeguard station.

By then the trail was growing cold, but it had once been quite hot. As the children who had traipsed up the front steps of the Children's Institute began to number in the dozens, and then in the hundreds, the waiting time for interviews had grown to three months. Many of

their children's denials, their experience with the Manhattan Beach police was unsettling. Neither of the two detectives assigned to the Buckey investigation seemed particularly skilled at talking to children, especially children who said they had been sexually abused. Especially after the debacle of the police department's letter, Matusinka was reluctant to let the case stand or fall on the strength of the police investigation alone. In the course of her job, she had gotten to know practically everybody across the country who had anything to do with child abuse, including a woman at the National Center on Child Abuse and Neglect whose name was Kee MacFarlane.

MacFarlane had recently lost her job at NCCAN, a victim of the Reagan Administration's budget cutbacks in social services, and had moved to Los Angeles for what she hoped would be a pleasant sabbatical in the sunshine. She had some writing she wanted to finish, and she was thinking about studying for her doctorate in social work. She had also signed on as a consultant to the Children's Institute International, an agency that cared for abused and neglected children and which happened to be a favorite charity among the area's wealthy Republican women, including one who now lived in the White House. The institute's staff had begun to see increasing numbers of sexual abuse victims, and its directors were eager to develop the capability to treat such children. Kee MacFarlane had agreed to help design the program.

When Matusinka called MacFarlane to ask if she had time to talk to "a couple of kids from Manhattan Beach," MacFarlane reluctantly said yes. She hadn't intended to do any clinical work in California, and she hadn't applied for certification as a counselor there. But the Children's Institute itself was certified, and rather than say no, MacFarlane agreed to see the children. Despite everything else, she admitted later, she was curious to see just how big the Buckey case might turn out to be. The Manhattan Beach police might be able to keep outside law enforcement agencies from becoming involved in the McMartin case, but they couldn't very well tell the McMartin parents what to do with their children. When Jean Matusinka suggested that some of the McMartin parents call Kee MacFarlane, they did. "We don't like what the cops are doing with our kids," they told her. "Will you talk to them for us?"

At the beginning, the questions she asked the children were only about Ray Buckey. "In the first dozen or so interviews I never asked about any of the women," MacFarlane said later. "The prosecutors told me there was this guy they suspected, and could I find out? So I

you tell people not to tell anybody, they're not going to run right down to the school, that's pretty naive." The mass mailing, Chief Kuhlmeyer said later, "may not have been the best idea in the world. But we wanted to get the news out and we didn't have the resources to go down and knock at everybody's door."

Forty-eight hours after the letters were mailed, there weren't many people in Manhattan Beach who didn't know that Ray Buckey was suspected of molesting children, including Ray Buckey and his family. A warrant was issued for Buckey's arrest, and he was taken into custody. But when the police searched his house, they found nothing to corroborate the allegations. Because Jean Matusinka was reluctant to rest her entire case on the testimony of a two-year-old child, the charges against Buckey were dropped. The investigation, however, remained open. Most of the parents who received the letter from the police had asked their children whether "Mr. Ray" had done anything to them. A few said that he had, and while many said he had not, they seemed oddly reluctant to discuss the matter further.

In ones and twos, children who had answered yes or whose parents doubted their denials were taken to the Manhattan Beach police for further questioning, and very soon the police were in over their heads. One of Jean Matusinka's colleagues described them as unsophisticated officers who failed to recognize the potential scope of the case at the beginning, and who were too proud to ask for outside help when its enormity finally became clear. The Los Angeles County sheriff's department had thousands of deputies at its disposal, including several who were highly trained in working with sexually abused children, and the nine detectives of the LAPD's Sexually Exploited Child Unit were fifteen minutes away up the San Diego freeway. But neither the LAPD nor the sheriff's department could lift a finger without a formal request for assistance from Chief Kuhlmeyer, and when Matusinka and another prosecutor implored the chief to call for reinforcements, he replied that his department could handle it. "That's just not true," Chief Kuhlmeyer says. "That happened later on, and it didn't happen the way they're saying it. But we did not formally request outside help until the latter part of October [of 1984], and I've got to take the responsibility for that." The Manhattan Beach detectives did seek outside advice, however. "The good news is, they called us right at the beginning," one Los Angeles detective said. "They said, 'Look, we don't know anything about this.' We gave them all our best advice. The bad news is, they didn't take any of it."

For many McMartin parents, particularly those who didn't trust

the emergency room at UCLA; the doctors there informed her that her child had been sodomized. Johnson promptly withdrew her son from the McMartin school and returned to the Manhattan Beach police to file a complaint.

Manhattan Beach lies within Los Angeles County, but it is incorporated as an independent city, and criminal investigations there are the province of the small and rather relaxed Manhattan Beach police department, whose dozen or so detectives spend most of their time chasing narcotics violators and searching for stolen sports cars. Prosecuting those crimes, however, is the responsibility of the Los Angeles County district attorney's office — with more than six hundred lawyers on its staff, the largest legal office of any kind in the world. Prosecutors who draw a case within the Los Angeles city limits have the advantage of working with the Los Angeles police and its squadrons of crack investigators. But when a crime occurs in one of the many Los Angeles suburbs, it is usually the local police department that prepares the case for prosecution. The disparities among police agencies is particularly apparent in child sexual abuse cases. With detectives such as Bill Dworin among its members, the LAPD's Sexually Exploited Child Unit is widely considered the most experienced in the country. But most of the outlying police departments have few officers who can match the LAPD's expertise, and when Jean Matusinka heard about the Ray Buckey case, her first reaction was to ask herself why the McMartin school had to be in Manhattan Beach.

Matusinka, who headed the district attorney's child abuse unit, had been prosecuting child molesters for years, and she knew which police departments could make a case better and which could make it worse. But the Manhattan Beach police were on the case, and for better or for worse they were giving it their best effort. If Ray Buckey had abused one child at the McMartin school, the police reasoned, there might be other victims. But there were more than a hundred children enrolled at the school, and knocking on a hundred doors, or even making a hundred telephone calls, was more than the department's resources would allow. To Harry Kuhlmeyer, the chief of police, the most efficient solution seemed to be sending a letter to all the McMartin parents, advising them that Ray Buckey was under investigation and inviting them to report any suspicions that their own children had been abused. The letter asked the parents to keep the investigation confidential, but it didn't remain confidential for long. "If you're a parent," one recipient said later, "you get this thing and you go, 'My God, what's going on here?' When you think that because

year can be a long time, the McMartin school was about as close to an institution as it was possible to get.

Only in retrospect would many of the McMartin parents come to believe that they had overlooked some important clues. One was the rule that they were not to visit the school at all for the first six weeks their child was enrolled, and to visit later only after making an appointment well in advance. Parents who planned to pick their children up early in the day were required to give the teachers advance notice, and nap time was never to be interrupted. Similar rules apply at many preschools, but some of the McMartin parents also remembered that their children had sometimes come home wearing another child's clothing, or without the underwear they had worn that morning. "It just blew right past me," one father said. "All of us lead very busy lives." Another father, a lawyer, confessed to being puzzled about why his son cried when he was dropped off at the school each morning. "I said, 'You've got to be able to articulate it for me,' " the father said, "but he couldn't articulate it."

The first indications that something was amiss at the McMartin school trace back to the fall of 1983, around the same time that Officer Larry Norring was putting the handcuffs on Jim Rud up in Jordan. A few of the McMartin mothers had become vaguely uncomfortable with the way "Mr. Ray," one of the teachers at the school, behaved around their daughters. After talking among themselves, they got up the courage to have a word with Virginia McMartin's daughter, Peggy McMartin Buckey, who managed the school's day-to-day operations. "You know," one of them told her, "when we come to pick up the girls, they're crawling all over Ray. He's sitting there in his bathing suit, and they're hanging on his arms and legs, and it just doesn't seem appropriate."

"Mr. Ray" was Raymond Buckey, a twenty-six-year-old college dropout whose principal interests in life appeared to be lifting weights and gobbling health food. Buckey didn't have any particular qualifications for taking care of young children, but he did have excellent connections. Virginia McMartin was his grandmother, and Peggy Buckey was his mother. Not accustomed to having her son's motives questioned by those whose children she had seen fit to accept as students, Peggy brushed their concerns aside. A few weeks later, a two-year-old boy came home from the school with blood on his anus. His mother, a woman named Judy Johnson, went to the Manhattan Beach police, where officers encouraged her to have her son examined. When Johnson took the boy to a local hospital, she was redirected to

McMartin

J ORDAN, MINNESOTA, and Manhattan Beach, California, are about as unalike as two towns can be. Both are suburbs of bigger cities, but the seaside village of Manhattan Beach is what market researchers call an upper-quintile community. Manhattan Beach has its share of middle-class families, but most of them arrived before the California real-estate boom, which lifted the price of a two-bedroom bungalow well past a quarter-million dollars. Those who have moved in since the boom are largely aerospace engineers, lawyers, and other young professionals who can afford the cost of living there, but most of the new arrivals still need two incomes to gain a toehold. With so many working couples, the demand for day-care in Manhattan Beach is unusually brisk, and for those parents who could afford the tuition, Virginia McMartin's Pre-School seemed the most desirable of depositories for their children. Each day began with the children saluting the American flag. There were the requisite birthday parties and field trips, and the children often brought home some drawing or project they had made in class. Each December, their parents received a Christmas card with a group photo showing toddlers dressed in designer togs surrounded by their beaming teachers.

Those parents who bothered to look beneath the school's well-scrubbed surface found only further reassurance, in the form of glowing reports from state child-care inspectors that described the school as unusually well run, well staffed, and well equipped. But the ultimate in reassurance was Virginia McMartin herself, the school's seventy-seven-year-old founder and the matriarch of an established Manhattan Beach family. In the two decades since she had opened the school's doors, McMartin had received every award for civic service the city had to bestow. In a place where things change so fast that a

her into a closet in his bedroom, where he beat and raped her. It was then that she knew they would be married. It wasn't that she loved Frank Fuster, but she had no choice. "I was embarrassed, because I knew that nobody had ever seen my body," Ileana Fuster said. Ileana found out about her husband's sexual attraction to children only after he suggested that they begin taking in children to supplement his income.

As Ileana acknowledged her own part in the abuse, she also confirmed what the children had been saying. Her husband had indeed forced her to undress in front of the children, and ordered her to perform oral sex on them. Sometimes he wore a white sheet and a green mask, and when he did, he made her wear one too. The "demon slime" had been a combination of urine, Gatorade, and tranquilizers. Fuster had had sex with her in front of the children, and had even raped her in their presence with a crucifix and an electric drill. To frighten the children into silence, he had killed some blue parakeets in their kitchen. The "bluebirds" that had so puzzled the police hadn't been bluebirds at all, but "blue birds." The "pennies" she had put up his anus had been suppositories wrapped in copper-colored foil. As for what had happened to the videotapes, the masks, and the rest of Fuster's accoutrements, her husband had told her that somebody had removed them from their home the night before his arrest. Convicted of multiple accounts of child sexual abuse, Frank Fuster was sentenced to six consecutive life terms in prison.

an Eastern Airlines flight attendant and two Miami police officers, had never asked to see their license. "Everything seemed in order," the father of one of the children said later. "The house was very neat. They were very well-mannered people. They had it very organized, down to the health cards for us to fill out for our daughter before they would accept us." Only after the Fusters had been charged did some parents recall that one thing about the Country Walk Baby-Sitting Service had struck them as odd: there hadn't been any toys for the children to play with.

The investigators working on the Fuster case eventually concluded that more than a dozen children, all between the ages of three and six, had been sexually abused by the couple, and when eight of the alleged victims took the witness stand at the Fusters' trial, the stories they told began to sound familiar. The children said they had been forced to drink a liquid called "demon slime." They said the abuse had taken the form of games, such as the "ca-ca game" and the "pee-pee game," that involved excrement and urine. Frank and Ileana had worn scary-looking masks, and Frank had videotaped some of the games. Sometimes the couple had had sex with one another in the children's presence; the children had even seen Ileana put pennies up her husband's anus. Animals were killed, including some "bluebirds" that Frank Fuster stomped to death on the kitchen floor. Sometimes Frank had held a knife to the children's throats, threatening to kill them and their parents if they told anyone what really went on at the Country Walk Baby-Sitting Service.

Like the defense lawyers in the other ritualistic cases, the Fusters' attorneys argued from the start that the children were making the whole thing up — dead bluebirds on the kitchen floor and putting pennies up somebody's anus were the kind of fanciful ideas only a child could come up with. Ileana Fuster's lawyer went further, accusing the children's therapists of using "a more subtle form of coercion than the North Vietnamese did to our prisoners of war." As the children's bizarre testimony continued, the "Country Walk case" seemed headed for acquittal. Then came the break the prosecution had been hoping for. For reasons known only to her, Ileana Fuster pleaded guilty and agreed to testify against her husband.

With her deep-set eyes and long, braided hair, the young woman looked like a child herself as she took the witness stand to tell the strange story of her relationship with Frank Fuster. She had left her home in Honduras to join her mother in Miami, and she was barely sixteen when she met Fuster at a flea market. Six days later, he forced

even thousands of miles apart, children who had never met one another, were able to tell nearly identical lies — of why children in Sacramento, California, and West Point, New York, were talking about having taken part in mock marriage ceremonies.

If such reports were true, on the other hand, it meant that a certain number of abusers — how many no one could say — were not having sex with children for any of the usual reasons. The ritualistic abusers themselves might or might not have been abused as children. They might not even be sexually attracted to children. In contrast to the predilections of garden-variety child molesters, what appeared to excite these people most was terrifying and torturing the children they abused. Far from being child lovers, they were child haters.

The greatest obstacle to the successful prosecution of such cases was that none of the adults accused by the children had pleaded guilty. If only one defendant in a ritualistic case would admit his guilt and acknowledge the truth of the children's stories, it might be possible to get a handle on whatever was going on. Defendants in other child abuse cases were pleading guilty in great numbers, but all of those involved in the ritualistic cases still continued to insist that the stories of abuse and ritualism alike were lies, planted in the children's heads by the police, the prosecutors, and the therapists.

The first crack in the wall of silence appeared when a four-year-old Miami boy emerged from his family's bathroom and asked his mother to kiss his penis. Horrified, the woman asked him what he was talking about. "Ileana" had kissed his penis, the boy explained, and now he wanted his mother to do the same. Ileana was the eighteen-year-old wife of an interior designer and real-estate investor named Frank Fuster. In addition to their other businesses, the Fusters operated a child-care center from their home in the fashionable Miami neighborhood of Country Walk, and there the boy spent much of the day.

Ileana Fuster was a demure young woman, even shy, but her husband was a most unlikely baby-sitter. Frank Fuster, who had come to Miami from Cuba at the age of twelve, had killed another motorist in the middle of a bridge in an argument over which one of them had the right of way. A few years later, he had been convicted of sexually abusing a nine-year-old girl while driving her home from a children's birthday party. Since a convicted child abuser can hardly expect to obtain a day-care license, the Country Walk Baby-Sitting Service didn't have one, but it hadn't seemed to matter. The parents of the two dozen children for whom Ileana Fuster cared each day, among them

children, usually babies. Another similarity was that most of the children had talked about being sexually abused before they began talking about ritualism or dead babies — sometimes months before.

One theory was that the masks, the chanting, the potions, the dead animals, and all the rest might be nothing more than a ruse designed by child abusers to discredit their victims' stories. By the mid-1980s, any child who claimed to have been sexually abused was being taken very seriously indeed. But would a child who claimed to have been abused by someone wearing a devil's mask and holding a dead cat be taken quite as seriously? A second theory was that the rituals, particularly the animal sacrifices, were an attempt to frighten the children into silence. "It doesn't take an absolute genius to scare a child," one police officer said. "That's the simplest thing an adult can do. Saying, 'I'm the Devil, and I'm going to do this to you if you don't keep quiet,' that sort of thing. But I don't know." Or perhaps the masks were merely a way some abusers had of disguising their identities from their victims.

Some of the psychiatrists offered a more sophisticated explanation, drawn from the theory of the collective unconscious set forth by Carl Gustav Jung, the Swiss psychiatrist who founded the school of psychoanalysis that bears his name. According to Jung, there are fundamental myths about good and evil that are so common to human beings in every age and place that they cannot have been passed along from one generation to the next, but must have arisen spontaneously, from some sort of unconscious memory that is inherited by everyone. But if the tales of devil worship were the voice of the children's collective unconscious speaking, then why weren't all abused children talking about such things?

Was it possible that the children's unconscious minds were simply covering a terrifying core of real abuse with a protective overlay of devils and demons? Perhaps those who abused them somehow took on the black-masked personas of the devils of contemporary children's fiction, of characters like Darth Vader and Skeletor. Or perhaps it was an unconscious attempt to comprehend an inexplicable experience by placing it in a familiar context of good and evil. As for the dead animals and babies, perhaps the children equated being raped and tormented with death and murder. It was also possible, of course, that the children were simply making the stories up. But if what they were saying was make-believe, then why didn't their stories include such obvious impossibilities as dragons and flying saucers? And if they were lying, the question remained of how children in cities hundreds and

Though he was certain that the child had been sexually abused, the prosecutor in the case was not convinced that all of the accompanying stories were true. "They were as detailed as they were, I hesitate to use the word, unbelievable," he said, "because to at least some degree I believed them, although I had questions about some of it. I question how much of it was exaggeration or misunderstanding, and how much of it was fact. There's no doubt in my mind that she was a participant in satanic worship, but she also described at one point how her father put his hand around her hand holding a knife and how the two of them plunged the knife into the chest of an infant. There was some question in my mind about whether that was an actual sacrifice or possibly a simulated sacrifice, and that's what I said to the jury. I argued that this case wasn't about devil worship, that it was about child molestation, and that whether they believed or disbelieved the child about the satanic stuff, there should be no question that she was a victim of child molest." Unable to separate the two questions, the jury found itself hopelessly divided, and a mistrial was declared.

As cases involving the same allegations of ritualistic abuse popped up in Pennsylvania, New Jersey, Florida, Iowa, Michigan, and Texas, the police officers, prosecutors, and psychologists from around the country who had been assigned the task of unraveling them began talking and meeting informally, first among themselves and then with experts in child behavior. They were looking for an explanation that made sense, especially one that made sense to juries. Unless such an explanation was found, those adults who abused children sexually under bizarre circumstances would continue to go free, but there was a more compelling reason than that. The ritualistic cases were a tiny proportion of sexual abuse cases nationwide, but they were receiving a great deal of attention from the news media. The danger was that those who read and heard such preposterous-sounding accounts might begin to think that all children who claimed to have been sexually abused, whether by Satanists or not, were lying.

When the investigators and therapists compared notes, some common themes began to emerge. Among the most important was that many of the children involved in the ritualistic cases had physical symptoms of sexual abuse, which meant that even if they hadn't been abused by witches and devils, they had been abused by someone. The descriptions the children gave of the rituals and chants were also remarkably similar, and many reported being forced to drink some sort of liquid that made them feel strange. Almost all described the ceremonial killings of small animals, and several the murders of other

marriage ceremonies that were followed by pretend honeymoons. Some of them mentioned three young children, dressed in ragged clothes, who had been stabbed to death during one of the abusive rituals. Despite a medical diagnosis that some of the children in the case had been sexually abused, the judge dismissed the charges against all five defendants, saying he had found it impossible to separate those portions of the children's testimony that might be true from those that were not.

The prosecutor in the case protested the judge's dismissal, but to no avail. "I don't see where these kids would be able to come up with the consistent detail they come up with," he said, "if not from their own experience. Four of these children have described one specific incident where three other children were killed. If I worked night and day, I could not coach these kids into saying something like that. It's very difficult to place things in a child's mind when they haven't experienced something directly. Four of the children had physical findings consistent with kids who have been sexually abused — anal scarring in three of them, venereal warts on one of them, a notch in the hymen in one, which is highly significant in sexual cases. When it's all four kids from the same family, it's highly significant. We also had two kids in Texas who were saying the same thing, kids who had lived in the neighborhood at the time this occurred. Those kids hadn't seen anyone in the family for over two years. Their stories tracked very well. Some of the bizarre things that occurred, some of the threats, being taken to another house, the ritualistic activity, it was all consistent."

The Sacramento case never went to trial, but in other cases that did, prosecutors were discovering the difficulty of convincing juries to put aside whatever children had to say about black masses and dead babies and to concentrate on the question of whether they had been sexually abused. When a nine-year-old girl in a small town across the bay from San Francisco said she had been abused by her father and others under circumstances nearly identical to those described in Sacramento, the child therapist who examined the girl had no doubt she was telling the truth. "This happened in her father's home," the therapist said. "She was able to recite for me what she called their Egyptian names, to sing for me the chants and songs they sang. She described every conceivable sex act you can imagine. She described their playing with live snakes. She talked about how young women in their teens were sacrificed. Her description of how the guts pop out when you slit open a live abdomen does justice to a Vietnam war veteran."

evidence yet in any of these cases to really confront society. People aren't ready for it. There's so much disbelief just around molestation itself that when you add that to it, it becomes totally unbelievable, and juries won't convict."

In most cities where cases of ritualistic abuse have arisen, the police have taken such stories seriously, but most of the investigations have not made much progress. When prosecutors in the Mendocino case announced that they weren't going to trial, one of them explained that "all we really have is the testimony of very young kids who probably couldn't qualify as competent witnesses." Two of the Bakersfield children independently pointed out the same "evil church" where they said some of the ritualistic rites had taken place, but once the children were inside the church, they said they had made a mistake. When the police excavated the fields and dredged the lakes where the children said the bodies of the murdered children were, nothing was found — no bodies, no bones, no shreds of flesh. A search of one defendant's home turned up only some adult pornography; another defendant's home produced evidence of human blood on .the living room carpet, but nothing else. "I'm not naive," said an attorney for several of the Bakersfield defendants. "I think that probably some of these kids have been molested in some way. By whom and when, I don't know. But the satanic aspect of it, that's where they lose me."

The absence of physical evidence to back up the bizarre assertions was giving prosecutors nightmares, but not all of the ritualistic child abuse cases were being lost. In Des Moines, five members of a "witches' coven" were· convicted of hundreds of counts of sexually abusing teenage boys. In Richmond, Virginia, one person was convicted in a sexual abuse case where police recovered candles and other ritualistic paraphernalia. In El Paso, Texas, across the Rio Grande from Mexico, a young prosecutor named Deborah Kanof won a conviction of a thirty-five-year-old mother who had been charged with abusing eight children at the East Valley YWCA. Some of the victims in that case said they had been taken from the "Y" to a nearby house, where they were made to have sex with the teacher while men dressed in masks and werewolf costumes looked on. The woman got life in prison plus 311 years, the longest sentence for child sexual abuse in Texas history.

In other cases in other cities, the story had a different ending. Several children in Sacramento, California, were telling not only of slaughtered animals and adults who wore robes and masks, but of being forced by adults in the neighborhood to participate in mock

"death cult" that practiced ritual murder. He had once lived in Mendocino County and had known the woman who ran the fundamentalist preschool where children claimed to have been tied to crosses. One of Lake's neighbors recalled that he had tried to date her twelve-year-old daughter. When police found pictures of nude and partially nude girls inside his cinder-block chamber, Lake's ex-wife explained that her former husband had had a "fascination with virginity."

The secret of whatever Leonard Lake was about died with him. Not so with Richard Ramirez, the Los Angeles "Nightstalker," who was charged with having raped and murdered at least fourteen women in their beds, and of having kidnapped and sexually abused several young girls as well. At the scene of some of the slayings, Ramirez left a crudely drawn pentagram, the five-pointed "Devil's star"; one of the few women who survived an attack by Ramirez said he had worn a baseball cap with the letters *AC/DC* on the front. After his arrest, a high school classmate said Ramirez had been obsessed with Satanism ever since he heard *Highway to Hell*, an album by the rock band that calls itself AC/DC. His favorite song from the album, the classmate said, was called "Night Prowler." Anton LaVey recalled that Ramirez had once stopped him on a San Francisco street to say hello, and police said footprints found at the scene of some of the slayings matched those outside an East Los Angeles house used as a meeting place by a satanic cult. As he left the courtroom after being arraigned, Ramirez raised his fist to the judge and shouted, "Hail, Satan."

Leonard Lake and Richard Ramirez may have been committed Satanists, or merely pathological killers who used satanic doctrine to concoct a rationale for torture, rape, and murder. But some of those who have studied the Bakersfield and Memphis cases and others like them are at least open to the possibility of a connection between Satanism and the sexual abuse of children. "The only thing I know about it is that it exists," says a Denver pediatrician. "We've seen at least two families here where there was an enormous amount of acting out of Satanistic activities and where the children were also sexually abused. How widespread it is, I don't know. I think that whatever's going on has been going on underground, and that every now and then something bubbles up." A San Francisco child psychiatrist who treats sexually abused children agrees. "I've heard enough and seen enough," he says, "to think that it's something I don't want to be identified as knowing that much about. It does appear to be real and to exist. It appears to be pretty organized. Nobody's found enough physical

"under no circumstances would a Satanist sacrifice any animal or baby," and it forbids "rape, child molesting, or the sexual defilement of animals, or any other form of sexual activity which entails the participation of those who are unwilling or whose innocence or naïveté would allow them to be intimidated or misguided into doing something against their wishes." Like the Christian version, however, the *Satanic Bible* is open to a multitude of interpretations, and there is no reason to believe that all of LaVey's followers adhere to his prohibitions. In northern Arkansas, the number 666 and a five-pointed star, both universally recognized as satanic symbols, were found painted on rocks in a field where several cows had been slaughtered. In Santa Cruz, California, ninety miles south of San Francisco, the same symbols were left on the front door of a Greek Orthodox church where a priest was murdered.

Whenever authorities in this country have followed up rumors of satanic child abuse, they have come up empty-handed. In Oakland, California, not long ago, police got a tip that a local satanic sect was preparing to sacrifice a child. As they arrived at the appointed place, the officers heard screams coming from inside the building, but when they broke down the door they found a group of men and women who were about to kill a cat. Sheriff's deputies in Toledo, Ohio, bulldozed a suburban field after being told that a local satanic cult had buried the bodies of seventy-five children there. Various satanic artifacts were found, but no bodies. "There's a real problem in terms of investigating this thing," says a California police officer. "You can't get into it without being part of it. And you can't be part of it without doing things that you and I would consider unspeakable."

The only children's bodies recovered in California in recent memory were found in the summer of 1985, in shallow graves dug near a cabin in the Sierra Nevada mountains. The cabin belonged to thirty-nine-year-old Leonard Lake, who popped a cyanide capsule into his mouth after he was caught shoplifting in a south San Francisco hardware store. In the days that followed Lake's death, investigators literally unearthed the horror that had been his life — the mass graves he had filled with the bodies of two dozen friends, neighbors, and their children.

Near the cabin was a cinder-block "torture chamber," where Lake had sexually tormented a number of the women while video cameras captured it all on tape. The videotapes and the bodies were real, but the rest of the evidence was circumstantial. Lake, a self-styled survivalist, had told neighbors that he belonged to a San Francisco

nephew, and her son were charged with abusing, photographing, and torturing more than a dozen children they met through their baby-sitting service. Several of the children in that case said the trio had killed chickens, cats, and even a calf in their presence, and then used their blood and parts of their dismembered bodies in the abuse. As of the summer of 1987, the case had not yet gone to trial.

In one form or another, the ancient practice of devil worship has been around at least as long as Christianity. But modern Satanism can be traced to an occult revival in the last century led by a wealthy English magician and poet named Aleister Crowley, who is said to have been the inspiration for Somerset Maugham's novel *The Magician*. Crowley's hedonistic doctrine found its share of followers in America, some of whom erected a temple in his honor in the Palomar Mountains of California. Perhaps not entirely by coincidence, California is also the headquarters of the two modern-day satanic churches known to be active in this country. The oldest and largest, with a claimed membership of ten thousand, is the Church of Satan, founded in San Francisco two decades ago by Anton Szandor LaVey, a one-time circus performer who shaves his head, uses a tombstone for a coffee table, and claims to have performed the first satanic wedding ceremony in the United States while using a naked woman for an altar. The number-two satanic cult is the Temple of Set, also located in San Francisco and established a few years ago by an Army colonel who resigned as one of LaVey's top lieutenants in a dispute over the future direction of the Church of Satan.

It is not difficult to understand the attraction that Satanism, at least as interpreted by Anton LaVey, holds for those who cannot find comfort within the confines of ordinary religion. LaVey's doctrine is both hedonistic and libertarian, a self-centered and highly narcissistic creed that raises selfishness and revenge to the level of a sacrament while cloaking the whole mélange in intricate rituals and mystical symbols. Much of its appeal doubtless derives from the fact that Satanism and the occult have always been closely entwined with sexuality. A fundamental satanic tenet is the right of practitioners to abundant and guilt-free sex of nearly every description. In his *Satanic Bible*, LaVey accords his followers the freedom "to indulge your sexual desires with as many others as you feel are necessary to satisfy your particular needs." He also approves of the use of human sacrifice, but only "to dispose of a totally obnoxious and deserving individual."

Whatever else they are, are Satanists child abusers and child murderers too? Not, at least, on paper. The *Satanic Bible* declares that

Bluebird troop leader who also ran a licensed day-care center out of her ranch-style house. At her trial, McCuan testified that she had been sexually abused as a child. Following the longest criminal proceeding in Kern County history, the McCuans and their codefendants, Scott and Brenda Kniffen, were sentenced to a collective total of more than a thousand years in prison. A week after the sentences were handed down, the Kniffens were charged with having abused another nine-year-old girl while they were out on bail. Deborah McCuan's parents, charged in the same case with thirty-three counts of abuse of their grandchildren and the Kniffens' children, jumped bail and disappeared.

The current Bakersfield case seemed to be unrelated to the McCuans and the Kniffens, and it was also much more improbable. The children in this case were accusing *seventy-seven* adults of sexually abusing them. The abusers had worn robes and masks and chanted prayers to Satan. The rituals involved swords, knives, black candles, mysterious potions, dead animals, blood, urine, feces, and the sacrificial murders of at least twenty-seven other children. Some of the children were saying they had watched dead children being cooked and eaten and had been warned that they would meet the same fate unless they kept quiet. The local sheriff told reporters he was "absolutely convinced" that the children had witnessed the things they recounted, including the killing of babies. "It would be very easy to sweep all this under the rug and say, 'The kid made it up,' " said the sheriff's top deputy. "We don't take that attitude. We understand the initial human reaction of, I don't want to believe it, make it go away. But there are cases like this popping up all across the United States."

So there were. Another was in Mendocino County, California, north of San Francisco, where several children who attended a preschool run by fundamentalist Christians told police that they had been tied to crosses and made to chant, "Baby Jesus is dead," while being abused. That investigation began after a mother discovered her four-year-old daughter "acting out things in her sleep, stripping herself, putting her hands above her head like she were tied or handcuffed, spreading her legs on the bed, screaming in terror, begging someone not to hurt her." The nightmares, the mother said, "were like pornographic movies."

Mendocino County, a stunningly beautiful patch of green on the California coast that was once home to Charles Manson and the Reverend Jim Jones, has a long history of cult activity. But the same could not be said of Carson City, Nevada, where a woman, her

by her preschool teacher. Not sure what to make of the child's comment, the doctor reported it to the police. When child protection workers arrived, the child named three other children the teacher had also touched. Those children named other children, and those children named still others. "It was like dropping pebbles in a pond," one observer said. A fifty-four-year-old housewife and mother who worked part-time at the Georgian Hills Early Childhood Center, a church-run preschool in the heart of a conservative, solidly Baptist neighborhood, was charged with abusing nineteen children at the center, all of them under the age of five. Police later arrested the woman's law-student son and the pastor of the Georgian Hills Baptist Church, with which the day-care center was affiliated. When all of the indictments were added up, the number of victims totaled twenty-six, and doctors said many had physical symptoms consistent with having been sexually abused. By the summer of 1987, none of the defendants had yet gone to trial.

As was the case in most states, allegations of child sexual abuse in nurseries and preschools were not new to Tennessee. In the months before the Georgian Hills case surfaced, the state had closed a half-dozen other day-care centers because of suspected sexual abuse by staff members. But as the Georgian Hills children continued to talk, their stories ranged far beyond sexual abuse, and even their recollections of having been photographed nude were fast becoming standard. Some of the children told of having been taken to the Memphis airport, put aboard a small plane, and flown across the Mississippi River to a town in Arkansas, where they were abused by strangers. The strangers, they said, had worn masks and robes and carried black candles, and they had slaughtered gerbils and hamsters while the children watched. One of the strangers had even killed a child. Such stories might have been dismissed as childish fabrications, except for the fact that the same stories were being told by other children around the country, including more than a dozen children in Bakersfield, California, a hundred miles north of Los Angeles and two thousand miles from Memphis.

It was in Bakersfield, a fast-growing city at the southern end of California's Central Valley, that two married couples had been convicted the year before of having ritualistically abused their own and each other's children over a period of several years. The children in that case also told of having been taken by their parents to a motel and rented out to strangers by the hour. The ringleader in the earlier case appeared to have been one of the women, Deborah McCuan, a

the children clearly point the finger at several individuals," Grote said, and other parents said that at least four children had given graphic descriptions during videotaped interviews of having been sexually abused. Several, they said, were still suffering from nightmares. Rudy Giuliani, the United States attorney for the Southern District of New York, finally acknowledged that "there were indications that some children may have been abused at the West Point Child Development Center," and he recommended that West Point make "a program of therapy" available to the children.

There seemed to be a history of child abuse at West Point. In the fall of 1985, an employee of the Officers' Club was convicted of having sexually abused some boys on the Academy grounds. The man, a civilian, was on probation from a previous sexual abuse conviction. The year before, a senior commissioned officer at West Point, one of those Grote claimed was "implicated" in the day-care case, had been convicted of enticing two children to pose for pornographic pictures. When a West Point official said later that "the incident appeared alcohol-related," Walter Grote suggested that the official be assigned to "tour the country, reassuring mothers and fathers of children killed by drunk drivers that the consequences weren't so bad because they are 'alcohol-related.' "

The bitterness at West Point lingers on, but no child abuse investigation has created a bigger municipal scandal than the one that arose in New York City after three workers at a day-care center run by the Puerto Rican Association for Community Affairs were convicted of abusing twenty-one of the center's thirty children. Along with several hundred others, the center was funded and supervised by the city's Human Resources Administration. Investigators eventually uncovered thirty-nine cases in which children said they had been abused at six other city-funded centers, including one run by a Methodist church. In the wake of the scandal, Mayor Ed Koch sent letters to more than ten thousand city child-care workers in which he urged them to report any other instances of abuse. The head of the HRA was forced to resign after the Bronx district attorney accused the agency of obstructing his investigation by refusing to turn over records and tipping off some of the suspects.

Some parents whose children claimed to have been abused at the PRACA center vented their anger by throwing rocks at its windows. The anguish in the Bronx was replicated in Memphis, Tennessee, after a three-year-old girl who was being given a routine checkup by her family doctor mentioned that she had been touched in the same place

Hechinger, the respected education writer for *The New York Times*, has maintained that "these incidents can no longer be viewed as aberrations," and a few rough statistics do exist. The California Department of Social Services has between two and three hundred investigations of day-care centers under way at any one time, the majority of which involve sexual abuse. Given that there are six thousand licensed day-care centers in that state, the number under investigation is relatively small. Looked at another way, it is far too large.

There is practically no American city of any size in which at least one day-care center has not become the target of a sexual abuse investigation, and in some cities there have been many more than one. But there could be no more improbable setting for such charges than the U.S. Military Academy at West Point, New York. The West Point child abuse case surfaced in the summer of 1985, when Walter Grote, a doctor attached to the Point's medical staff, announced that·he was turning down a scheduled promotion to major. By all accounts, Grote had been an outstanding physician. His superiors used words like "excellent," "superb," and "extremely dedicated" to describe his performance, and his internal ratings were the highest possible. As Grote would explain later, he refused the promotion to protest what he considered an official cover-up of sexual abuse at a day-care center set up for the children of West Point's Army and civilian personnel.

According to Grote, the first indications of sexual abuse at West Point came when two boys who attended the center were seen by another doctor's wife engaging in anal sex behind her house. A few days later, another five-year-old boy at the same center attempted to have sex with a four-year-old girl while several other children looked on. In a letter to Secretary of the Army John Marsh, Jr., Grote maintained that "by the time I left West Point, I knew of approximately three dozen children who were ritualistically abused there," among them his own three-year-old daughter. Following Grote's refusal to accept the promotion, seventeen FBI agents were assigned to investigate the case, and they worked on it full-time for more than four months. By the time they were finished, the agents had conducted nearly a thousand interviews of parents, children, day-care workers, and others, enough to keep a federal grand jury busy for more than a year.

The grand jury failed to return indictments, and prosecutors said later that it had not been possible to identify any of the abusers from the testimony given by the children. The parents disagreed. "Many of

gate. Even those pedophiles who are not card-carrying members of NAMBLA or the Rene Guyon Society — and most are not — share the need for reinforcement and validation. In New Orleans a few years ago, a group of pedophiles actually formed their own Boy Scout troop and turned it into a sex-for-hire ring with customers across the country. The real purpose of Troop 137 was discovered only after one of the four leaders took pornographic photos of some of the scouts to a neighborhood Fotomat for developing. The scoutmaster, Richard Halverson, who worked during the day as a juvenile probation officer and was a foster father to two children, was sentenced to thirty years in prison. Three other men, including one who had been abused years before by his own scoutmaster, were also convicted.

When police searched Halverson's home, they found a letter from an Episcopal priest who ran Boy's Farm, a home for fatherless youths in Winchester, Tennessee. When police in Winchester searched the priest's house, they found a copy of an article in the Episcopal Church's national magazine praising Boy's Farm as "the farm that works." They also found pornographic photographs of several of the boys, including the priest's adopted son. The priest had been sending the pictures to his sponsors in return for tax-free contributions to the home's welfare fund. For larger contributions, meetings with the boys had been arranged.

Where a pedophile chooses to work depends on his preference in victims as much as on anything else. Abusers who are attracted to adolescent boys and girls are likely to become scoutmasters or coaches. For those whose attraction is to very young children, the day-care center is a nearly perfect milieu. One American child in ten is now cared for each day outside his home, whether in a day-care center, a nursery or Montessori school, or the home of a neighbor who looks after a few children each morning. There are no reliable statistics on the number of day-care centers where child sexual abuse has been reported or confirmed. Nobody even knows for sure how many day-care facilities there are, since so many of them are unlicensed. Executives of day-care trade associations try to minimize the problem by suggesting, without any basis in fact, that between 80 and 90 percent of all sexual abuse still takes place within the home.

While there is no reason to believe that the number of day-care centers where sexual abuse occurs is very large, there have been enough such cases that many insurance companies have canceled their coverage of day-care centers altogether, or raised premiums sufficiently to drive some centers out of business and others underground. Fred M.

two years — four in Louisiana, three in Rhode Island, two in Illinois, and others in Portland, San Diego, Boise, Milwaukee, Los Angeles, and San Francisco — and many more have been accused; even *L'Osservatore Romano*, the Vatican newspaper, was moved to issue a call for action against the "horror, worry, and humiliation" of child sexual abuse. "To attribute a whole series of episodes such as these to an occasional outburst of maniacs or of sick people," the newspaper said, "would be to exorcise a problem whose dimensions are growing." Among the most notable was the case of the Reverend Gilbert Gauthe, the pastor of Saint John's Parish in Henry, Louisiana, who admitted abusing at least thirty-seven young boys, some of them altar boys, over a five-year period. The forty-one-year-old Gauthe said the abuse had occurred in his rectory, on overnight camping trips, even in the confessional. On the eve of his trial, the priest pleaded guilty to most of the charges against him and drew a sentence of twenty years' hard labor. "God in His infinite mercy may find forgiveness for your crimes," said the judge, "but the imperative of justice cannot." In the first such settlement in its history, the Roman Catholic Church agreed to pay five million dollars to nine of the families whose sons were among Gauthe's victims.

Not only do teachers and priests have access to children, they are authoritarian figures and, often, the objects of an adolescent hero-worship that eases the road to seduction. While not every pedophile can become a teacher or a priest, there are plenty of other jobs available. The number of scout leaders convicted of abusing their charges rivals the number of clergymen, and judges seem to become particularly incensed at those who use such a beloved institution as a way to have sex with children. When a longtime scoutmaster from Norfolk, Virginia, admitted abusing twenty members of his troop, he was sentenced to 151 years in prison, and two troop leaders in St. Johns, Michigan, received life sentences. "If you're asking for mercy," the judge told the men, "you came to the wrong place." Scouting does not provide pedophiles with access to boys only. In 1984, several Los Angeles police officers, all of them men, were discovered having sex with the underage female Explorer Scouts who took part in a "ride-along" program their department sponsored. Like the Catholic Church, over the past few years the Boy Scouts of America has had to pay millions of dollars to the parents of scouts who were abused by their leaders.

Apart from the fact that they ensure access to a steady stream of children, youth organizations provide places for pedophiles to congre-

the case with the Connecticut minister who was also a Little League umpire and a scout leader on the side. John Donahue was a dedicated thespian, and no one suggested that his interest in the theater or in his school extended only to the young boys with whom he came in contact there. But pedophiles who lack Donahue's talent may take any job that permits them access to children. The number of Santa Clauses and clowns convicted of sexually abusing children is not small, but few pedophiles have displayed the imagination of the Dallas man caught posing as a woman, complete with wig, high heels, and makeup, in order to obtain jobs baby-sitting for the children he abused.

For much of the past decade, child protection workers have been struggling to convince the public that the greatest danger to children is not from the stranger who lurks outside the schoolyard, but from within their own homes and families. It may be true, however, that more children are abused outside their homes by grown-ups they know and trust than by members of their families. Twenty-three percent of the victims questioned by the *Los Angeles Times* said they had been abused by a parent or other close relative, while 33 percent said their abuser was an unrelated adult whom they knew. Even allowing for the fact that incest victims may be more reluctant than others to talk, it is possible that the greatest danger faced by children today is from unrelated adults they have been taught to obey.

One of the best ways of gaining access to children is to become a teacher. Some pedophiles are doubtless teachers first, eventually succumbing to a sexual attraction to children. But others are pedophiles first, only entering teaching as a way to be around children, and few American cities have been spared an accusation of child sexual abuse against such teachers. No city, however, has suffered so much recent anguish as Chicago, where at least nine educators, among them a former high school principal and a deputy school superintendent, have been accused or convicted of sexually abusing their pupils. One of the cases involved a veteran substitute teacher who was charged with abusing seven of his students, five girls and two boys, by prosecutors who said he used the school system "as a private hunting preserve." Two other Chicago teachers were charged with photographing their students and then selling the pictures to customers who included a former Catholic-school teacher, a retired public-school teacher, a lawyer for the Social Security Administration, and a nurse.

Another occupation attractive to pedophiles appears to be the priesthood. No faith is exempt, but more than a dozen Roman Catholic priests have been convicted of child sexual abuse over the past

Caretakers

F OR NEARLY two decades, parents in Minneapolis vied with one another to gain admission for their children to the prestigious Children's Theater Company and its affiliated school. Under the leadership of John Clark Donahue, the company's distinguished artistic director, the school had become a nationally acclaimed institution. One of the many magazine articles written over the years about Donahue and his methods lauded the man as a teacher given to "exploring feelings and emotions, not shying away from human relationships." Two years ago, the Twin Cities were stunned when Donahue pleaded guilty to having had sex with a number of his male students, including one he had abused during a performance, in an office overlooking the stage. Donahue later acknowledged having himself been abused as a child, and after he was sentenced to a year in prison, he wrote a letter to his students. "I was wrong to have engaged in any and all sexual activity with you," he said. "I was responsible for that activity, not you. I wish to sincerely apologize for my actions and assure you that you were correct in reporting me to the authorities." He promised the judge that when he was released from prison, he would help in the search for a solution to "this vast problem of child abuse."

There was nothing unique about John Clark Donahue. When the FBI studied the modi operandi of forty convicted pedophiles, it found that half had used their occupations as their principal way of meeting children. Many adults who work with children as part of their jobs or in their spare time do so only because they are committed to improving the welfare of children. But it cannot be a coincidence that pedophiles have turned up within the ranks of virtually every American youth organization, and in some cases several organizations at once, as was

kidnapping — one fewer than the year before. Even if that number is multiplied ten times, it is still barely half the number of children who die each year in accidental drownings.

Lost in all the emotion is the fact that the monumental effort to track down missing children has yet to recover a single child abducted by a stranger. Also lost is the potential effect of the hysteria on children who are not missing. "It's causing unnecessary fright in children, morbid fears," warns Dr. Benjamin Spock. "I don't see it doing any good, and I'm sure it's doing a lot of harm. It's wrong to scare children." His colleague, the psychologist Lee Salk, tells of children who are so terrified by all the warnings about malevolent strangers that they refuse to leave their homes. "We are terrifying our children to the point where they are going to be afraid to talk to strangers," Salk says. "How can they make friends?"

In 1985, when the *Denver Post* won a Pulitzer Prize for a series of articles that shed the first real light on the true dimensions of the missing-children problem, it should have signaled the beginning of a public awareness that the problem had been vastly overstated. By then, however, the issue had become institutionalized. The fingerprinting continued apace, and so did the televised announcements.

The pedophiles must have found the missing-children campaign amusing, for many of them were beginning to realize that they didn't even need to hang around video arcades and bus stations in order to have sex with children. What they were discovering was that by becoming temporary caretakers of one kind or another, it was possible to get parents, including many of the same parents who were so frightened by the specter of kidnapping, to deliver their children to them.

home." On the basis of Bobby's testimony, the judge dropped most of the sexual assault charges against Collins, but he instructed the jury that the issue of Bobby Smith's consent was irrelevant to the charge of kidnapping. If the jurors found that Collins had not had lawful custody of the boy, the judge said, they had no choice but to convict him. They did.

When they are examined closely, the numbers of missing children, which at first seem so alarming, turn out to be impossibly high. In many cases the statistics have been inflated or exaggerated by those who have an emotional or financial interest in sustaining the hysteria, but there has also been a good deal of genuine confusion that can be traced to faulty record keeping. Before 1982, when President Reagan signed the Missing Children's Assistance Act, there were no reliable statistics at all. Although the FBI created its computerized "missing persons file" in 1975, local police departments were not required to record the names of missing children with the FBI. Under the missing children's act, however, parents could insist that the names of their missing sons or daughters be entered into the federal computer, and many did. Since 1982, the FBI has received on the order of 330,000 such reports a year. But most of those reports are erased almost as fast as they come in, since more than 90 percent of the children reported to police as missing are actually runaways who are found, or who return home, within days.

In some cities, a mother who calls the police every time her toddler wanders a few yards from home raises the number of missing children by one. Even if the child is discovered ten minutes later sitting on a neighbor's lawn, he remains on record as a "missing child," and if he does the same thing a week later, the number of children who are missing goes up another notch. At any given time, there are only about thirty thousand missing children who have been gone for more than a few weeks. Of these, FBI agents say they believe that 95 percent are teenagers who have run away from home, in many cases to escape sexual abuse, or "throwaways" who have been kicked out by their parents.

Nearly all the rest are believed to have been taken by one parent from another in a custody dispute, which leaves room for a very small number who have actually been abducted by strangers. The National Child Safety Council, a thoroughly reputable body, knows of no more than a hundred children who have probably been kidnapped, and in 1985 the FBI had open investigations of only sixty-eight cases of missing children that met the strict federal criteria for possible

the parents' pictures on the milk cartons. But not all the missing
children had been taken by their parents. Like Adam Walsh, a handful
had actually been abducted. Among them was three-year-old Tara
Elizabeth Burke, taken from the backseat of her mother's car by Luis
(Tree Frog) Johnson and his eighteen-year-old lover, Alex Cabarga.
For most of the next year, Johnson, Cabarga, Tara Burke, and an
eleven-year-old Vietnamese boy named Mac Lin cruised the streets of
San Francisco's warehouse district in Johnson's cream-colored van. In
exchange for food, Mac Lin said later, the children had been forced to
have sex with the men and with each other.[13] But Tara Burke was an
exception, since most of the few other children known to have fallen
into the hands of pedophiles appeared to have done so voluntarily.

One was eleven-year-old Bobby Smith, whose picture had been
included in the "Adam Roll Call" and who was also among the seventy
or so children listed in the National Center's directory of abducted
children. Bobby's whereabouts were discovered after police in Provi-
dence, Rhode Island, tried to stop a car with a loud muffler. During
the chase that followed, the police discovered that the car was
registered to a man named David Collins. Collins wasn't driving his
car that day, but the registration bore his address. When the police
went to his apartment, they found Bobby Smith. Collins was charged
with kidnapping and sexual assault, but the testimony at his trial left
some questions unanswered.

Collins and Bobby had met at a Long Beach, California, video
arcade more than two years before, when Collins gave the boy a
handful of quarters. A friendship developed, followed by a sexual
relationship. According to Bobby's testimony in court, when Collins
took him for a ride up the California coast to Santa Barbara, he told the
man he didn't want to go back home. The pair kept driving north,
beginning a twenty-one-month journey that led them through the
Pacific Northwest, the Deep South, and finally to Providence. Collins
found a job and Bobby enrolled in school; neighbors said later that the
two had seemed like father and son. Bobby said he had not been forced
to pose for the nude photos that were found in the apartment. Nor, he
said, had he ever tried to escape, even after having seen his picture
smiling back at him from the television screen. He had been free to
come and go, even to call his parents if he had wanted to.

Asked why he hadn't, Bobby said he had been afraid — not afraid
of David Collins, but of being found by his parents. "I was getting
more and more scared," he said. "I was afraid that they were getting
more and more close to finding me, and that I would be put in a

child and set to trigger an alarm if he or she wandered too far. Even at $129.95, the manufacturer said that more than fifteen hundred had been sold. Much cheaper, at $6.95, were Kid-Kuffs, nylon straps that could be used to link a child's wrist to a parent's waist. A company official suggested that "when the children are grown, you can use it as a dog leash." Schools and shopping malls began fingerprinting elementary school children for free; many of the malls that sponsored the programs reported large increases in gross sales on the days the service was offered.

Dentists began implanting microdots containing children's names and addresses inside their teeth as an aid to identifying tiny bodies. A few pedophiles even got in on the act by setting up a Florida company called Child Search, Inc., to seek "possible solutions to the problem of lost and missing children." The forty-eight-year-old machinist who was the organization's president turned out to be a convicted child molester. So did its treasurer. A member of the board of directors had been convicted of kidnapping his own child from the home of his former wife. The company's state-issued license was finally revoked, but only after the president had been convicted again, this time of indecent exposure. It turned out that the backgrounds of the men had never been checked by the Florida agency that issued their license.

The intensity of the effort to locate missing children made it inevitable that some would eventually be found. Following the third showing of *Adam*, in April 1985, NBC broadcast the pictures and descriptions of fifty-four missing children. President Reagan himself introduced the "Adam Roll Call," asking his viewers to "please watch carefully. Maybe your eyes can help bring them home." Afterward the National Center for Missing and Exploited Children, a private agency funded by the U.S. Justice Department, received more than twenty-six hundred telephone calls from viewers who thought they had seen one of the children pictured.

Of the five children that were eventually located, none had been abducted by a stranger. Two teenage sisters listed as missing for the past seven years, and an eight-year-old girl missing for a year, were found living with divorced fathers who had taken the children from their ex-wives. The two other children identified through the broadcast were living with their divorced mother in Texas. A judge ordered them returned to their father, a Los Angeles physician who had previously been granted full custody by the courts.

Considering the number of missing children who were turning up living with one of their parents, it might have made more sense to put

and at least one network television documentary, repeated rumors of a shadowy ring of wealthy pedophiles who arranged to have young children snatched off the streets and sold into sexual bondage.

No missing child received more attention than six-year-old Adam Walsh, who disappeared from a Hollywood, Florida, shopping center in July 1981 and whose severed head was found two weeks later floating in a canal eighty miles from his home. The story of Adam's disappearance and death became the basis for the television movie *Adam*, which has so far been shown three times on network TV. Adam's father, John Walsh, quit his job as a hotel executive to become a full-time advocate for the cause of missing and murdered children. Walsh made headlines when he told a congressional subcommittee that one and a half million American children were reported missing every year. "We don't have a clue as to what happened to fifty thousand of them," Walsh said. "No town is safe and no child is safe from the sick, sadistic molesters and killers who roam our country at random. This country is littered with mutilated, raped, strangled little children."

Once the issue of missing children became a certified national problem, nearly everyone was eager to help resolve it. One idea that quickly gained currency was that the missing children might be found if only people knew who they were. If their pictures were posted in public places, the reasoning went, whoever was taking the children could not keep them for long. The logic behind the picture campaign was dubious at best, since children's appearances change so rapidly. But logic was obscured by the urgency to act, and major corporations began tripping over one another to help out.

More than sixty supermarket chains announced plans to post photo displays in fifty-five hundred stores, where they would be seen by eighty million Americans each week. The same pictures began turning up on milk cartons, grocery bags, utility bills, and bank statements, on the sides of moving vans, in the back seats of taxicabs, even on the plastic bags used by dry cleaners. More than ninety local television stations around the country began showing photographs of missing children as a regular part of their evening newscasts. So did the Cable News Network and CBS, which featured one child each night in a ten-second prime-time spot. The pictures were obtained for a fee from an Ohio production company whose president declared that as many as 150,000 children were being abducted by strangers each year.

For the tens of millions of children who were not yet missing, there was Kiddie Alert, a radio transmitter that could be attached to a

hundred Polaroid pictures of a dozen other girls. The police later called him a "serial" abuser, and one officer remarked that he must have had the cleanest house in town. A few of the girls in the photographs were identified by Colleen and Sandi from among their schoolmates, but the rest remained a mystery. Just as Walter Holbrook's preliminary hearing was about to begin, he pleaded guilty, explaining that he didn't want to be "an asshole" by forcing Colleen, Sandi, and the other girls to testify in open court. He was sentenced to twenty-six years in prison, and if he lives to serve his full sentence — no certain thing for a child molester in prison — he will be seventy when he gets out.

The most perplexing question was why Sandi, Colleen, and the other girls had gotten involved with Walter Holbrook in the first place. Afterward Sandi was ashamed, but she couldn't really say why she had done it. For the money, certainly, but there had to be more to it than the money, or even the marijuana and the sex. "They must have been getting some sort of emotional support and attention they weren't getting at home," one policeman suggested. "There was also a sense of adventure and excitement." What he seemed to be saying was that the girls had just been bored.

As the Holbrook case makes clear, it is hardly necessary for pedophiles to kidnap children in order to abuse them sexually. And yet, a 1985 survey by the magazine *Good Housekeeping* found that the number-one concern of American parents was kidnapping. On its face, what came to be known as the "missing children" story appeared to be one of the most wrenching of the decade. "This," intoned Phil Donahue during one of the many programs he devoted to the subject, "is as painful as life gets." It was also an issue tailor-made for the news media, which set out with determination to answer the many questions such stories provoked: How many American children were missing from their homes? Had these children been kidnapped? For what purpose, and by whom?

The reports became increasingly chilling. One wire service dispatch, carried by hundreds of newspapers in mid-1984, reported that "countless thousands" of American children had fallen victim to "an ugly underworld of abuse, terror, and death." *USA Today* warned that strangers were stealing twenty thousand children from their parents every year. Even *The New York Times*, not noted for overstatement, reported that thousands of children were "killed annually by repeat murderers who prey sexually on children, and by adults involved in child prostitution and pornography." A number of articles,

disease" made wearing clothes uncomfortable. The cheap etchings of
nude women that covered his walls also seemed out of place for such
a fastidious character. But the girls just shrugged it off — as one
policeman put it later, "they were fourteen going on forty-five." Before
long, Holbrook's real intentions began to emerge. When the girls' work
was done, Holbrook would call them into his bedroom to receive their
money. After they had been paid, he would ask one girl or the other
to rub his back with some of the vitamin E oil he kept on the
nightstand by his bed. The massages, he said, helped to ease the pain
of an old war wound. To Sandi and Colleen it didn't seem to matter;
if Holbrook wanted a massage, that was fine with them. Nor did they
appear to mind when, at Holbrook's suggestion, the massages pro-
gressed from his back to his front. "I can teach you things that will
make you a better girlfriend," he told the girls.

Eventually Holbrook mentioned a way the girls could make more
than the ten dollars he was paying them to clean his house. "He started
telling us about people who were going to come over, and how we were
going to have parties," Sandi said. "He said that we would be posing
for pictures. He told us they were going to be sent overseas, and that
there was no way they would be published in America." When
Holbrook began taking pictures, he kept reminding the girls to smile,
"so the pictures would look better and sell better." When the photo
session was over, he paid Colleen and Sandi each twenty-five dollars.
In the months that followed, there were more parties. To loosen things
up, Holbrook might provide some wine or a little marijuana. Some-
times he would hand Sandi the camera and ask her to photograph him
and Colleen. Once he paid the girls fifty dollars apiece.

When they asked where the photographs were going, Holbrook
vaguely mentioned a woman friend named Betty who sold pictures of
young girls through the mail. When their curiosity persisted, he
suggested that they write Betty a letter telling her which sexual acts they
were willing to perform and which they weren't. The two girls drew up
a two-column list, the first headed "Do Want to Do," the second
"Don't Want to Do." A few days later Holbrook showed the girls
Betty's reply, written in red ink. "Great," it said. "Love you, B." Once,
Holbrook asked Sandi and Colleen if they had any other friends who
were interested in cleaning house. He was particularly looking for
twelve-year-olds, Sandi recalled, "because they're flat-chested, and the
younger girls would sell better."

Colleen and Sandi were not Walter Holbrook's only housekeep-
ers. When police searched his townhouse, they found more than three

at him," a police officer says. "A pedophile will try to help him find it. And if he can't find it, the pedophile will buy him a new one." The busy or indifferent parents of such children are often relieved that their children have developed a close association with another adult, and it is also such parents who are least likely to interfere. Joseph Henry was amazed to find that the parents of his many victims "didn't ask questions when I spent hours and hours with their children and gave them gifts. On several occasions when they became aware of what I was doing, they just told me to stay away from their children. Charges were never pressed in many cases, because the parents did not want to cause any trouble."[12]

As was the case with the four young sisters from a Houston suburb who were abused for years by a group of neighborhood men, it is not uncommon for children to be attracted by the material benefits a relationship with a pedophile can offer. In return for sex, the men gave the sisters food, candy, clothing, and makeup, even a trip to the local amusement park. "It was like prostitution, but they didn't know it," a police officer said. "They thought this was the way life was, the way to get nice things." A Little League coach from Santa Clara, California, who lavished his fifty victims with gifts, trips to the movies, and pizza admitted that "the burden of repaying the debt, plus the fact that most children are taught to obey adults, was usually sufficient to ensure their cooperation."

Not all relationships between children and pedophiles are mercantile ones, nor are all children who become involved with pedophiles lonely or needy. None of the dozen or so girls who ran afoul of Walter Holbrook was particularly plain-looking. None was from a broken home, none was failing in school, none was bereft of friends. And Walter Holbrook was hardly the sort of person to help a child look for a lost bicycle, much less buy her a new one. As Sandi tells the story, it was during the summer between her freshman and sophomore years in high school that she first met Walter Holbrook. They were introduced by Colleen, one of her classmates, who had taken a part-time job cleaning the California townhouse that Holbrook shared with a traveling salesman. Holbrook was in the market for a second housekeeper, and he promised the two girls ten dollars apiece for a couple of hours' work. But he proved to be a demanding customer, ordering the girls around like the retired Marine sergeant he was.

At first, neither girl knew quite what to make of their employer. When they arrived with their cleaning paraphernalia, Holbrook greeted them dressed in a pair of undershorts, explaining that a "skin

income is not too high. Bowling alleys are good. I'm a very good bowler, the kind of person people watch. I've raced motorcycles and stock cars, flown airplanes and parachuted, all to meet kids. I've always met boys through the jobs I've had — running a karate school, driving an ice cream truck, selling motorcycles.

"One of the easiest ways to meet kids is through their parents. Now, I live with my mother, and I know kids' fathers and older brothers, so there's plenty of opportunity. I can introduce you to dozens of parents who think I'm Mr. Wonderful. I try to find kids who smoke dope. They're already keeping something from their parents. If you let a kid off a block from his home with a little reefer and a twenty-dollar bill in his pocket, he's not going to tell anybody what he just did. For me, the magic words are 'My folks are divorced.' [Most] of the boys I've had sex with came from single-parent families. The others had family troubles. A kid from a good, solid home wouldn't be with me in the first place.

"Usually the way I test kids is, I touch them on the knee. If they don't jump, I know I can go further. I take them out a time or two. Go-cart tracks and water slides are big. Invariably the kid says, 'When are you going to call me again?' First I build him up. I say, 'You're a really nice-looking kid, but the problem is, I'm gay.' The kid usually says, 'Well, it's OK. Don't worry about it.' I say, 'Well, one of these days I'm going to ask you to take your clothes off — don't get mad at me.' They just laugh. They don't think that will ever happen. It almost always does."

Phil's modus operandi says a lot about what sort of child becomes involved with a pedophile. Very young victims are not likely to have much in common with one another, since it's easy for a pedophile to use his status as an adult to convince a child who doesn't know any better that there's nothing wrong with having sex with him. For older children, entering into a sexual relationship with someone who is not a parent or relative is almost always a matter of conscious choice, and the children who make that choice appear to have some personality traits in common. As Phil suggests, the children most likely to become sexually involved with an unrelated adult are those with absent or indifferent parents, relatively unattractive children or those who think they're unattractive, children with negative self-images, poorer children, and children without many friends their own age.

Such children are prime candidates for the affection, attention, and understanding that are the pedophile's stock in trade. "If a seven-year-old loses his brand-new bike, his parents will probably yell

computer owners by calling a central telephone number. The computer industry estimates that there are something like 2,500 of these bulletin boards in operation at any one time, but since they are mostly run from garages and spare bedrooms, it is impossible to keep an accurate count.

Because pedophiles are compulsive record keepers, some of them are as attracted to computers as they are to children. Many pedophiles keep meticulous notes about each of the children they abuse, recording what was done to whom and where, the child's reaction, and so on. The records compiled by one Tennessee man included the average number of sex acts per child (64.68), the average duration of each relationship (2.2 years), the average age of each victim (10.89 years), even the approximate number of sperm cjaculated by each boy. [11] Such records help to satisfy the pedophile's compulsive need for reaffirmation, since by reliving each experience over and over he can continually reassure himself that he is loved by children. Before the advent of the home computer, pedophiles kept their records in notebooks or on index cards. In the hands of the police, however, written records also amount to a confession. In recent years, pedophiles have discovered that computers are not only a vastly superior system of record keeping, but that they can be programmed to destroy everything on command. For the pedophile who already owns a computer for some other purpose, plugging into a computerized bulletin board is a simple matter. An even more recent electronic advance is the "teenage party line," computer-controlled telephone services that charge callers one dollar a minute to take part in a free-for-all conversation with up to seven other people. Over the hubbub of eight voices speaking at once, introductions are made and home telephone numbers exchanged. Explicit sexual suggestions and four-letter-words are common. Though the party line operators admonish callers that they must be eighteen to participate, many sound much younger and some quite a bit older.

Computers make it easier for pedophiles to contact strange children, but there were plenty of children available before there were computers. To listen to pedophiles, one would think finding a child to seduce was the easiest thing in the world. Phil, a forty-one-year-old truck driver, had his first sexual experience with another boy at the age of fourteen. Since then, as he told Lynn Emmerman of the *Chicago Tribune,* he has abused about 130 boys. "Everybody has a niche, something they're good at," Phil said. "Unfortunately, I'm very good at picking up kids. It's incredibly easy. I like to go where the level of

one reason may be that there are so many underage prostitutes working the streets of America's cities. They can be found in New York City's Times Square and Chicago's Uptown, along Miami's Biscayne Boulevard and the Las Vegas Strip, in Boston's Combat Zone and San Francisco's Tenderloin, and not all of them are girls. Los Angeles police say there may be five thousand male prostitutes in that city under the age of fourteen. Some are homosexuals, but many have sex with men only because it is men who pay to have sex with young boys. "I don't consider myself gay," said one sixteen-year-old boy. "I really didn't like to have sex with other men, because it made me feel cheap. Most of the men who picked me up were stupid middle-class guys. I did it so I wouldn't starve to death. You do what you have to do."

Child prostitution is no longer just a big-city problem. Prostitutes as young as eleven were recently discovered working out of an Indiana truck stop, and Cedar Rapids, Iowa, now has one police officer assigned full-time to juvenile prostitution. According to the police chief of Wichita, Kansas, the recent arrests of a dozen child prostitutes there only "scratched the surface of a very significant problem in our community." Because the subject is a guaranteed shocker, over the past couple of years there have been a number of articles and television documentaries on child prostitution. But there is nothing very new about child prostitutes — back in 1944, the FBI reported that the number of young girls servicing the GI trade had risen by 70 percent since Pearl Harbor[10] — and the emphasis on this most visible manifestation of pedophilia obscures the fact that many pedophiles never have to pay for sex with children.

As David Sonenschein points out in *How to Have Sex with Kids*, "the important thing about meeting kids is that it happens best when you meet in places or in doing things that interest both of you. Like in video game arcades, kids can tell if you're just in there cruising for sex or are there because you like to play the games. The same with sports and sporting events. You can meet kids anywhere you go that you're interested in going. You can get to know kids through your job. Friends are a good source — once you get to know a kid, you can meet their friends. If you take kids anywhere after you meet them, unless you know them pretty well it may be best to stay in familiar areas so that if the kids want to leave, or have to, they can. This will help them be more at ease with you."

One of the newest ways of finding children is through computerized "bulletin boards," arrangements through which anyone with a personal computer hooked up to a telephone can contact other

for attention." But at least three of Henry's victims were acquired through a California prostitution ring run by a man named John Duncan who placed a classified advertisement in a pedophile publication called *Better Life.* As Henry recalled later, "Duncan wanted assurance I was not a cop, or any other such person trying to entrap him. He also wanted to hear about my experiences, past or present. I wrote and said I wasn't a police officer. I also told him about Barbara, the first girl I molested, and how I got interested in little girls. We began a long correspondence. Duncan began telling me about two girls he was molesting at the time, Tammy and Lisa, ages eight and nine. He also sent me their nude photos. I was desperate for friendship, someone who understood my obsession with children. My letters to Duncan ran as long as nine typed pages. I would sign them 'A fellow little girl lover.' I wrote Duncan telling him I planned to travel to California in the summer and would like to attend a child sex orgy, and I would be very glad to pay for this privilege. I wrote him, 'I want to assure you that I can keep my mouth shut.' "

When Henry arrived in California, "Duncan brought Tammy and Lisa over to my motel. That day I could not have the children alone to myself, because Duncan had arranged for another member of the ring to molest them. Several days later, Duncan and I molested Tammy and Lisa in my motel room. Then we went to a nearby park, where I pushed the girls on some swings. A few days later, after paying Duncan the hundred dollars that we agreed would be given to Yvonne's father, I had this eight-year-old to myself for about six hours. I wasn't sure I could go through with actually paying someone to have sex with their daughter. It was obvious Yvonne had been rented to several other men. The first thing she said to me that night was, 'What would you like me to do?' When I was unable to take Yvonne home that night because I didn't have a car, Yvonne's father phoned my motel room and said that since I was keeping her overnight, it would cost me another hundred dollars. The next day, when her father came to pick her up, the first thing he said was, 'Did you cooperate?' "

After returning to New York, Henry wrote John Duncan a note thanking him "for taking me out of hell and giving me a brief taste of Heaven." Joseph Henry, John Duncan, Yvonne's father, and six other men who had abused the children in the Duncan ring, several of whom were from out of state and one from England, all went to prison. Henry says he hears that Yvonne, now eighteen, "will never be normal." [9]

If such "baby pro" rings, as they are known, are relatively rare,

swapping them with other pedophiles. Such behavior may seem odd — what does an adult who has access to real children want with pornographic photos? But such photographs are much more than a child substitute. Homemade pornography not only feeds the pedophile's fantasies, it becomes a permanent record of the children he has known. The victims themselves may not stay young forever, but in the pedophile's album the eight-year-old remains forever eight. Not only do pictures of smiling children validate his behavior; such photographs also have a more practical application. In attempting to break down the resistance of a prospective victim, the pedophile can produce documentary evidence that children have sex with adults.

Because he takes such pains to compile his photographic record, and because that record acquires such enormous importance in his life, the pornographic photos the pedophile has made become his most treasured possession. If there is anything to be said in behalf of child pornography, it is that such pictures are better than a signed confession. The FBI's Ken Lanning calls pornography "the single most valuable piece of evidence you can have in any sexual abuse case. I would rather have child pornography than fifty-seven eyewitnesses. No child molester will go to court when you legally seize his pornography collection." For those who do choose to stand trial, the chances of an acquittal are slim. When a downstate Illinois dentist who served as the village school-board president and the local soccer coach was charged with sexually abusing a ten-year-old girl, his friends and neighbors leapt to his defense. Such was the dentist's reputation that he might never have been convicted had the police not discovered hundreds of pornographic photos of children hidden in a crawl space beneath his house.

Those pedophiles who don't have any other recourse obtain their victims from child prostitution rings. One such ring, located in the village of Waterville, Maine, provided children as young as four to a tightly knit group of friends and relatives for up to thirty dollars apiece. The Waterville victims were recruited from the neighborhood, but in some cases it is the parents who put their own children up for prostitution. A study of nine East Coast prostitutes between the ages of eight and twelve found that all had been living at home and attending school, and that their families were not only aware of what they were doing, but condoned and even encouraged it.[8]

Joseph Henry, currently serving a long sentence for child sexual abuse at California's Patton State Hospital, admits having sexually abused at least twenty-two girls during his fifty-plus years. Most of them he met on his own, children he describes as "lonely and longing

engaging in sexual activities or posing in an otherwise "lascivious" way, Hamilton's work is not illegal. But whatever its attraction for lovers of art and photography, its greatest appeal may well be to lovers of children.

Despite its own philosophical pretensions, *Wonderland* is really a flea market for the buying and selling of pictures of young children. Some of the advertisements it contains are placed by dealers, like the Redmond, Washington, firm that offers one photo collection of prepubescent girls titled *Still Too Young* and another called *La Petite Parisienne,* but most come from private individuals. "I want to buy VHS videotapes of preteens and teens doing anything nude," wrote one New Hampshire man, who promised "confidentiality assured." A Tennessee woman sought "photos of girls in swimsuits, panties, short sleepware [*sic*], or shorts — back, front, side views." For fifty dollars apiece, a woman in California offered videotapes of "beautiful teenage girls in all their NATURAL beauty." Some of his readers may, as Techter claims, be nothing more than individuals "whose collecting interests include preteen nudes." But some are clearly pedophiles, like the Pennsylvania man who mailed pornographic photos of children to a *Wonderland* advertiser who turned out to be an undercover policeman. Only after the man's arrest on pornography charges did police discover that he was wanted in another state on nineteen separate charges of child sexual abuse.

In recent months, several police officers around the country have begun corresponding with advertisers in *Wonderland* and similar publications, hoping to entice them into an exchange of child pornography that will result in a conviction. A few investigators, using pen names, have even placed their own carefully worded ads. One of Techter's readers complained in a recent letter that "there was a tri-state bust for [alleged] pornography distribution, and I and several of your followers were netted by an undercover cop out of Los Angeles named William Dworin, AKA Paul Davis. Anyone in contact with this man best beware! I was hit with a ten-man SWAT team that got everything I owned. My *very* expensive lawyer swears he'll get me off with probation — I hope."

Finding and prosecuting pedophiles through the exchange of child pornography is an effective tactic, since it is an unusual pedophile who does not also photograph his victims. Virtually all the child pornography produced in this country since the 1978 passage of federal antipornography statutes comes from practicing pedophiles who have graduated from making pictures for their own use to

More is known about how pedophiles meet one another. One way is by advertising, and one of their favorite advertising mediums is a curious brand of publication known as the "swinger magazine." Slickly lithographed on glossy paper and filled with advertisements mailed in by readers, such magazines are available in almost any adult bookstore. Most of the ads are placed by couples in search of other couples, but a surprising number are placed by men, women, and couples in search of other adults who enjoy having sex with children. To the uninitiated, the pedophiles' ads look like the others, but those in the know distinguish the child molesters from the wife swappers by looking for special code phrases. One commonly used phrase is "family fun" or some variation, such as "The family that plays together stays together."

Over the past couple of years the signals have become more subtle, but some pedophiles are still amazingly indiscreet. One young man, who described himself as "very sensual, very oral, college-educated, and divorced," advertised for "young ladies who are aware of the teachings of the Rene Guyon Society and approve of same." In response to a letter from a stranger seeking more information, the man readily acknowledged that he had been "involved in this type of thing for many, many years. My range of contacts in the past covers ages six to sixteen, both sexes."

Such indiscretion involves a much greater risk now that police officers in several cities have begun answering such ads and even placing some of their own. One of the police officers' favorite targets is *Wonderland*, the newsletter of a Chicago-based organization called the Lewis Carroll Collectors Guild.[7] David Techter, who presides over the Guild from his Lincoln Park apartment, describes it as "a voluntary association of persons who believe that nudist materials are constitutionally protected expression, and whose collecting interests include preteen nudes." Each issue of *Wonderland* is illustrated with suggestive, though not technically pornographic, drawings of very young children, and filled with a hodgepodge of Techter's philosophy and "reviews" of pornographic publications. Next to Vladimir Nabokov, whose satiric novel *Lolita* has become the pedophile's bible, the patron saint of Techter's followers is David Hamilton, a British-born photographer whose portraits of early-teenage girls are available in legitimate bookstores across the United States. The notion that Hamilton's work is art and not pornography is encouraged by the pairing of his photographs with text from some distinguished writers, among them the French surrealist Alain Robbe-Grillet. Since state and federal laws do not prohibit the sale of nude photographs of children who are not

North American Man/Boy Love Association, which made headlines a few years ago when seven of its members pleaded guilty to sexually abusing numerous children, including several members of the same Cub Scout pack. Among those convicted were a Manhattan neurologist, an Ohio politician, and a California physicist. NAMBLA is dedicated to fighting for the rights of children to have sex, but a recent issue of its monthly bulletin acknowledged that its chances of success were not good. "Man-boy love faces almost universal condemnation in America," the editors admitted. "Whether we are open about our feelings or try to blend in quietly, we are all threatened to some degree. We need not panic, but we should be prudent." The NAMBLA bulletin also publishes letters from its members and supporters, including a number who are behind bars. "I am still an inmate," one man wrote, "and appreciate receiving your Bulletin each month. I am here for consensual love with two brothers, eleven and fifteen. I too believe that boys shouldn't be exploited or abused. They should have freedom to choose whomever they want as friends, no matter what age brackets."

While organizations like NAMBLA and the Guyon Society present themselves as advocates for "children's rights," the right in which they're primarily interested is the right of their members to have sex with children. Such groups insist that the only thing that's wrong with sex with children is that society says it's wrong, and they point to a handful of studies suggesting that some children who began having sex at an early age were unharmed by the experience.[4] Any psychological damage, they say, occurs only after the child discovers that he has violated a social taboo.[5] When the government of the Netherlands recently suggested lowering the age of consent from sixteen to twelve, pedophile organizations in this country wondered why twelve-year-old Dutch children might be able to handle sex with adults when twelve-year-old American children weren't.

How many pedophiles are there? There isn't any real way of knowing, but it's likely that they are far outnumbered by their victims. Because their pursuit of children is so single-minded, most pedophiles have sex with many children during their lifetimes — not just with two or three, but with dozens and even scores. One group of thirty child sexual abusers studied by researchers at the Oregon State Hospital admitted having had sex with a combined total of 847 children, an average of nearly thirty victims apiece — a remarkable figure considering that most of the men had not yet reached the age of forty.[6]

one called *Maypie* and another named *Minor Problems*. According to Geoffrey Dickens, the member of Parliament who first disclosed the existence of PIE, its members included a former British ambassador to Canada and several members of the household staff at Buckingham Palace. Others identified later were an employee of the British Home Office, a scoutmaster, a public school teacher, and a vicar's son.

Largely because of its slogan — Sex by Year Eight or Else It's Too Late — the pedophile organization that has attracted the most attention in this country is the Rene Guyon Society. The group, which claims a membership of several thousand, is named after a French-born justice of the supreme court of Thailand who argued that much of what is wrong with contemporary civilization is traceable to its distorted view of sex. According to its own legend, the Guyon Society was founded in 1962 by seven couples who attended the same lecture on sexuality in the ballroom of a Los Angeles hotel. Whatever its true membership and origins, its only visible manifestations are a newsletter, a Beverly Hills post office box, and a self-appointed spokesman who gives his name as Tim O'Hara. "We were in the black civil rights movement originally," O'Hara says, "working with the ACLU and the NAACP. We were a bunch of high-principled activists, and we renamed ourselves the Guyon Society. We have no dues. It's not like the Elks Club. We advocate legalizing sex with children, but we do not practice it. We'd all be in jail, for one thing. No one can come into our society who has ever had sex with a child."

Though the Guyon Society has received a good deal of attention from the press, police suspect that its membership may not extend much beyond O'Hara himself. But there are a number of less well-known pedophile organizations that do boast a significant membership. One is the San Diego-based Childhood Sensuality Circle, founded by an eighty-four-year-old retired social worker, which seeks for children "the right to loving relationships." Joseph Henry, a convicted child molester who is a former member of the CSC, maintains that the group's "children's rights" stance is just a pose. "I can't stress enough," he says, "that that group and others, regardless of their publicly stated goals, are in practice little more than contact services for pedophiles. These groups serve as a reinforcement for pedophiles and a constant source for new friendships and, thus, a supply of new victims."[2] When the CSC's records were seized last year by the San Diego County sheriff's department, at least thirty of its members were found to have been arrested for child sexual abuse.[3]

Another pedophile organization in this country is NAMBLA, the

where "pictures of affirmative sex are condemned while photos of the Hiroshima cloud are printed in millions of children's schoolbooks." In private, as Sonenschein's pamphlet shows, the society takes a somewhat different tack.

The propensity of pedophiles to organize and proselytize illustrates one of the principal distinctions between those who abuse their own children sexually and those who abuse other people's children. Incestuous fathers are so secretive that it's difficult to imagine one of them composing an essay about how to have sex with a daughter or a son. Pedophiles, on the other hand, are "groupers" who actually seek one another out, to swap not only half-baked philosophies about having sex with children, but pictures of their victims and often the victims themselves. For those who devote their lives to the pursuit of sex with children, it's reassuring to consort with other outlaws. What pedophiles really seek from one another is validation, the knowledge that they're not alone.

The pedophile's grouping instinct also reflects his narcissism, because many have managed to convince themselves that they're at the forefront of a social and cultural revolution the rest of the world is blind to. They don't see themselves as child abusers at all, but as a politically oppressed minority of "child lovers" whose vocabulary doesn't include words like *sexual abuse*. To pedophiles it's "transgenerational sex," and they talk endlessly of their love for children and of children's affection for them. Because their devotion to children is so single-minded, they see themselves as vastly superior to other adults, particularly parents who don't have much time for their own children. Since it's usually the children of inattentive parents who become their victims, pedophiles insist that they're performing a service by filling the affection gap in children's lives. Though they may idealize children in the abstract and celebrate their "innocence" and "purity," the shallowness of the pedophiles' affection is betrayed by their private lingo, as in their description of a child who is new to having sex as "a kid with low mileage."

In recent years, a few bolder pedophiles in this country and abroad have set out to convince the rest of the world that sex with consenting children is fine. There was a considerable fuss in Great Britain a few years back when Parliament discovered the existence of something called the Paedophile Information Exchange, a small and selective group whose stated purpose was to "discuss strategies" for abolishing laws prohibiting consensual sex between adults and children. The Exchange even published two magazines for a brief time,

SIX
Pedophiles

I t is best when beginning sex with a kid to do it as part of a game. Sometimes a kid will make the first move, sometimes the adult. Sometimes the adult can create a situation where a kid can ask for sex or start sex if they want. Curiosity is a big factor; exploring somebody and having them explore you is another good way to start off. This can be a kind of show and tell. Just about everything that adults can do together an adult and a kid can do together. It's best to go slowly the first time — and it's more exciting that way too — but of course you have to be sensitive to size differences. Kids enjoy nonpenetrating sex the best. Most very young or small kids cannot and should not be penetrated by an adult. Having sex is having fun. If anyone is not able to relax, it won't be as enjoyable. Sex is play, not work. If you have sex with some that like it, they can tell those of their friends who may also be interested. Sometimes starting out sex is better if other kids are there doing it too. Group sex is a good way to experiment and experience all kinds of sex with all sorts of different partners. What better way to learn!

Thus begins a pamphlet entitled *How to Have Sex with Kids*. Though it had enjoyed a brisk underground circulation for several years, police were unaware of the pamphlet until 1983, when they found a copy in the apartment of a Houston jeweler convicted of sexually abusing a four-month-old boy. Further investigation revealed that the author, David Sonenschein, had "published" the document on copying machines in the offices of the Texas school district where he worked.[1] The police also discovered that Sonenschein was a member of the Texas-based Howard Nichols Society, an organization named after the fictional character who preyed on young girls in the television movie *Fallen Angel*. In public, the Nichols Society presents itself as a political-action organization, publicly disparaging a culture

guy did this to me, and my mom still loves him," she said. "Why can't she give me a little bit of that love? I figured maybe if I got him out of prison she'd love me. If I had known what I was getting into, as much as I wanted to satisfy my mother, I would never have gotten into this mess." Convicted of perjuring herself, the girl was sentenced to ninety days in jail.

The most celebrated recantation in a case of sexual abuse so far has been that of Amy, a twelve-year-old California girl who accused her stepfather, an Air Force surgeon, of having abused her sexually for several years. When Amy refused to take the witness stand against her abuser, the judge found her in contempt of court. After keeping Amy in solitary confinement for nine days at a juvenile detention center, the judge finally let her go, but on the condition that she have no contact with her stepfather. While children's-rights organizations railed against the judge for his heartlessness, Amy's mother told reporters how proud she was of her daughter's refusal to send her stepfather to jail. But the victim-witness coordinator for the local district attorney's office quoted Amy as having told her that she hated her stepfather and wanted him punished. Her mother, the girl said, had refused to let her come home if she testified against the man.

Open hostility, pressure to recant, divided loyalties that raise questions about the mother's ability to protect her child — all can have bearing upon the decision that must be made by child protection authorities of whether to take the incest victim from the home. The obvious solution to such a dilemma would seem to be to remove the abuser, not the victim. But when an incest mother chooses to side with her husband, nothing short of a court order can force him to leave. The result of such a step is that the child is left at home with a hostile mother, and even a court order does not guarantee that the mother will not allow her husband to return home surreptitiously.

Many victims solve the problem by running away, but in a significant number of cases the choice is to place the child in a foster home or children's shelter. More than a quarter of the victims in six thousand incest cases studied by David Finkelhor were placed in youth shelters or foster homes, a higher percentage of foster placements than for children who had been physically abused. Foster placement is supposed to be an emergency measure, reserved for cases where a child's physical safety is in jeopardy. But it is easy for children to get lost in the juvenile welfare system, and it is not unusual for the victims of incest to be shuffled from one temporary home to another for most of their childhoods.[4]

at her father, but part of her probably still loves him. What she wanted was for the incest to stop, not to become alienated from her family or to see her father in the penitentiary. As she comes face-to-face with the consequences of what she's done, the victim may begin to wish that she had kept quiet after all. It's too late for that, but she has another out. She can always tell the police that she lied.

The word *recantation* entered the popular American vocabulary in the summer of 1985, when a twenty-three-year-old New Hampshire housewife named Cathleen Crowell Webb said she had lied six years before when she accused a Chicago man named Gary Dotson of having raped her. She had made up the story, Webb said, because she feared she had become pregnant by her boyfriend. When Dotson appeared in a police lineup, she had picked him out at random. Because Webb's recantation contained a number of puzzling discrepancies, the judge who originally convicted Gary Dotson denied him a new trial. But by then public sentiment was so much in the young man's favor that Illinois governor Jim Thompson commuted his sentence to time served. For several weeks the Dotson case remained a staple of television interview programs and supermarket magazine covers, and it triggered a number of similar recantations by other adult victims of rape.

Though the fact was largely lost in the flurry of media attention, it is not unusual for adult rape victims to withdraw their initial allegations. While some recantations are no doubt the result of mistaken identity, rape crisis counselors believe that victims often change their stories because they fear testifying in public or retaliation from their attackers. Recantations by victims of child sexual abuse, particularly victims of incest, are more common still. When David Jones, a British child psychiatrist attached to Denver's Henry Kempe Center, surveyed three hundred sexual abuse cases, he discovered that one victim in eight eventually withdrew his or her accusations. Jones also found that such recantations were most likely to come about two weeks after the first allegation was made.

As prosecutors and judges become aware of the likelihood of recantations in incest cases, victims who change their stories are not always believed. A fourteen-year-old girl from Des Moines testified at her stepfather's trial that she had lied when she first said he abused her, explaining that she hated the man and wanted him out of the house. The judge refused to believe her, and the stepfather was convicted. The girl later withdrew her recantation, saying she had changed her story the first time at the behest of her mother. "I kept thinking that this

house and cooperating as best they can with the police, prosecutors, and social workers. But even an incest mother who is sympathetic toward her daughter may be unable to keep her conflicting loyalties from becoming apparent to the child. When the girl who watched the incest movie with her mother told a neighbor she was being abused by her father, the neighbor called police. Later that night, the girl's mother asked the child if her accusations were really true. "I said yeah," the girl recalled. "She believed me. Then she went straight to the jail to try and see my dad. It sort of made me upset. She keeps telling me that she's on my side, but sometimes I feel like that and sometimes I don't. She's been with him for years, and she just can't let go, I guess. She says she needs him. I know she cares a lot about me and my brother, but to think that she can't get along without him sort of makes me upset."

For some incest mothers, the impending loss of their husbands and the dissolution of their families may be more distressing than the disclosure of the incest. No matter what such a mother has suspected until then, to take the side of her daughter against her husband is to abandon her claim to the emotional and physical security their relationship provides. Unless he's willing to face the consequences, the husband usually makes it easy for his wife to take his side over that of their child. He denies the child's accusations, and the mother follows suit, agreeing that the child must be lying. If the mother's anger at her child seems genuine, part of it probably is anger at having been displaced by her daughter as the focus of her husband's affections. The rest is drawn from the damage to the narcissistic fantasy the mother has been weaving and embroidering for years, her pretense that she has a happy home and that she's been a good mother and wife.

If, despite the mother's protestations and those of her husband, the authorities continue to believe the child, her only hope of regaining what she stands to lose is to convince the child to change her story. "Look what you've done to our family," she says. "Everything was fine before you started telling these lies. Now all these strangers are poking around in our business. Your father is already in jail, and if he's convicted he'll have to go to prison. Then where will we get the money to live?" A mother whose loyalties are divided to any degree plays on the tremendous guilt and responsibility the child already feels, not just for having participated in the incest but for having reported it. If there are brothers and sisters who haven't been abused, they probably have grown to resent all the attention the victim has been receiving from their father, and now they join the chorus. The victim may be angry

or two occurrences, there isn't much for a mother to suspect. Even if she senses that something is amiss and asks her child what the trouble is, she may be told some vague story about problems at school and let it go at that. But in longer-term incest cases, even though neither the father nor the child is advertising the fact that they're having sex, the relationship is likely to be surrounded by a heavy air of secrecy and illicitness. In defense of such mothers, even when a direct question is asked of a longer-term incest victim, the child will often insist that nothing is wrong. One mother, concerned about the increasingly cuddly relationship between her husband and her fourteen-year-old daughter, made a special effort to tape a television movie about incest so that she and the girl could watch it together. "After it was over," the woman recalled, "I asked her, 'Has there ever been a time when Daddy has tried to be more than your father and your friend?' She said no." A few weeks later, the girl confided to a neighbor that she and her father had been having sex regularly for several years.

More than protecting themselves or their fathers, some children withhold the truth in the belief that they are sparing their mothers the anguish such a disclosure would entail. But children who lie for whatever reason often send subtle countervailing signals. "There were always hints I tried to give my mother," one incest victim recalled. "Once every two years, maybe, she'd ask me if my father had ever tried anything with me. And I'd always say no. But I'd be real quiet about it. I'd change the subject. If my daughter did that to me, I'd ask her why she was so quiet." It is a mistake to assume that the mother who has suspicions and fails to act condones what's going on. She may be horrified by what she half suspects, but the chances are good that she also feels immobilized, trapped in a web of circumstance not of her own making and powerless to act. If she's an ineffectual woman and easily intimidated, she may even fear her husband's physical retaliation.

In many cases, however, the child holds back the truth for fear of not being believed by the mother, and such fears are often well founded. The child sees how her father treats her mother and, more to the point, how the mother allows herself to be treated. Sooner or later she comes to realize that her mother's interests lie in maintaining the status quo. When incest victims finally decide to tell someone, it's no accident that most of them choose a teacher, a school counselor, a neighbor, a girlfriend — anybody but their mothers.

Once the incest is out in the open, many mothers summon the courage to provide their children with the protection and support that they have needed all along, ordering the abusive husbands from the

authorities, the girl said that her father, a forty-two-year-old electrician, had been abusing her sexually for years, but that she had only decided to arrange his killing because she feared he was about to turn his attention to her eight-year-old sister. Some juries have acquitted battered wives who admitted killing their abusive husbands, but no jury has yet been asked to decide whether incest might be grounds for a verdict of justifiable homicide.

Cases like those of Sarah Ann Rairdon and Cheryl Pierson raise the question, among others, of how a prolonged sexual relationship between a father and daughter can escape detection. To put it as frankly as possible, how can the mother of a child who is having sex with her husband *not* know what's going on? Some do. Some mothers actually conspire with their husbands in the abuse of their own children, like the Arizona woman who tried to obtain birth-control pills for her two daughters by explaining to a Planned Parenthood worker that the girls were "sleeping with their daddy." But most incestuous fathers aren't so open with their wives, and the mothers of their victims are far more likely to see or hear something — a word, a glance, a touch that seems practiced rather than casual — that only hints at the possibility of incest. Because the implications are too terrible to contemplate, such mothers may go to extraordinary lengths to deny the obvious.

Nahman Greenberg, a Chicago psychoanalyst, tells of one family in which the father, a highly paid director of computer services for a large corporation, had abused his eldest daughter since she was three. "They graduated to sexual intercourse by the age of eleven," Greenberg says, "and by the age of thirteen they had entered into a contract, the father and daughter, that she would be his primary sexual mate. The mother was allowed to have sex with him once a month. The contract was the daughter's idea. She liked this arrangement. She really was in love with her father. Quote, unquote, in love. The daughter describes a scene in which she and her father are nude, sitting in a room, watching TV. The mother walks in, and they don't have enough time to dress. So the mother turns around and walks out, apologizing for walking in. It's incredible — she walked in on this scene, and she just walked out. The girl didn't believe it. The mother does not acknowledge that she knew what was going on. Absolutely ignorant, had no knowledge of it. When you try to reconstruct it for her, to point out how she missed it, it's 'But I didn't see it.' "

Most "incest mothers" insist they had no notion of what was taking place beneath their own roofs, and when incest is limited to one

Tail County organized a search party. In the weeks that followed, the Rairdons' friends and neighbors printed thousands of flyers with Sarah Ann's picture and mailed them to police departments around the country. They raised a reward of six thousand dollars for her safe return, and Sarah Ann's picture began appearing with those of other missing children on grocery bags across the state. Her father, John Rairdon, a thirty-eight-year-old tire repairman, even went on television to appeal to his daughter's abductor. "Let her go," he pleaded. "Spare her from any more harm."

When Sarah Ann's badly decomposed body was discovered in a pasture, Otter Tail County mourned as one. It wasn't until three months later that John Rairdon confessed to police that he had murdered his daughter. They had been having sex for almost five years, he said, on at least sixty occasions that he could recall. There hadn't been any problem until the last couple of months, when she began resisting his advances. The day before Sarah Ann died, she successfully fought her father off for the first time. The next day he picked her up while she was walking home from school, drove her to an abandoned farmhouse, and tried to have sex with her again. Again she fought, and in a narcissistic rage, John Rairdon stabbed her in the stomach with an awl he used to repair tires. He watched while his daughter bled to death, then hid her body in a barn until he could bury it later in the field.

John Rairdon recanted his murder confession a few months later, saying he felt so guilty about having abused Sarah Ann that he had confessed to a murder he hadn't committed. "I knew I'd go to prison for the sexual abuse," Rairdon said at his preliminary hearing. "The officers knew me well and persuaded me I was guilty of murder. I just had to figure it out so the deputies would buy it. I was convinced that I had killed her. They told me I had to give them the details, and I thought I would have to make up a story good enough for them to believe." The jury was not persuaded. Convicted of his daughter's murder, John Rairdon was sentenced to life behind bars. Sarah Ann's stepmother, Marilyn Rairdon, was also convicted — not of having participated in the abuse, but of having knowingly allowed it to take place. She got two years' probation.

Sometimes it is the abusive parent who meets with a violent end. In March of last year, Cheryl Pierson, a seventeen-year-old Long Island cheerleader, pleaded guilty to manslaughter charges after she admitted promising a classmate $1,000 to kill her father, who was later shot to death in front of his house. In her confession to

remorse begins to fade, and the cycle of seduction, remorse, forgiveness, and seduction can repeat itself for years.

Some fathers may abuse a child once or twice and then, for reasons known only to themselves, stop forever. A few incestuous relationships go on until the father dies, or the daughter goes away to college or marries. A tiny number continue even after that. But no matter how old the child is when it begins, incest is most likely to come to an end during her early teenage years. When it does, it is nearly always the victim who wants out first. By the time the child becomes a teenager, she has almost certainly realized that her relationship with her father is not only illicit, but illegal. Everything about the incest is making her increasingly uncomfortable, but her discomfort may have less to do with her father than with boys her own age.

Now that she is thirteen or fourteen, her girlfriends are discovering boys, and as the incest victim listens to their adolescent natterings, she can no longer escape the fact that she's a species apart. Her friends are giggling about how they kissed a certain boy, while she's been having oral sex or intercourse with her father for years. As her resentment over her father's theft of her innocence grows, the incest victim's response is to tell him how she really feels about their relationship and to appeal to him to end it. If there are other children in the family, her father may simply let her go and turn, as Carl did, to one of her sisters. But if she is an only daughter, or if her siblings are not the right age, her father may do whatever he can to prevent the incest from ending.

He may seem sympathetic to her plight, and unless he's completely hardened to her, some of the sympathy may be genuine. But the narcissistic cravings that led him to his daughter in the first place continue to persist, and as the child's determination to break free continues to grow, her father tries to exert an increasing degree of control over her life. He regulates her friendships and associations, particularly those with boys, how much housework and homework she does, even what kinds of clothes she wears. He's trying to remind her of who's really in charge, but his controlling behavior only deepens his daughter's resistance, which in turn drives her father to new heights of anger and desperation. Usually the victim decides to fight back with one of the two weapons in her arsenal — either she runs away from home, or she blows the whistle on her father. But sometimes the incest ends in violence.

When thirteen-year-old Sarah Ann Rairdon disappeared during the four-mile walk from her rural Minnesota school to the house where she lived with her ten brothers and sisters, the people of Otter

of her relationship with her father, "I was the wife. I'd cook for him, I'd massage him, and then I would please him."

More often than might be suspected, the mother of an incest victim cooperates in such an exchange. If the mother herself was abused as a child, she may be so uncertain of her motherly role and her maternal authority that she tacitly allows her daughter to assume some of the burden. In the most extreme cases, the mother's authority is usurped until she is practically her child's child, almost without standing in her own home. Deep inside she may be angry and jealous over the alienation of her husband's affections and the loss of her wifely prerogatives, but her passivity and insecurity, and her ego's dependence on her continuing association with her husband, prevent her from stepping forward to reclaim her authority.

Role reversal may also contribute to the duration of father-daughter incest, both by making it easier for the father to rationalize his relationship with a daughter who is now behaving more like his wife and by making it more difficult for the daughter to stop the abuse. As she assumes her mother's responsibility for keeping the family intact, in a very proprietary sense it now becomes her family. To report the incest would be not only to discard the quasi-maternal status that she may have come to enjoy, but perhaps to send her father to jail and tear the family apart. The incest victim also gains power from the reversal of roles, and she may eventually recognize that she has acquired a tremendous hold over her father — a word from her and he goes directly to jail. What began as a one-sided exploitation now becomes a mutual one. As Rachel says, "I used it, but there was always a price to pay."

How does the incestuous father explain his behavior to himself? If, like Carl, he is without much apparent empathy of any kind, he can justify what he's doing with the most superficial of explanations. Perhaps he tells himself that he's showing his daughter how much he loves her, or that he's helping her to "learn about sex." For the fixated pedophile-father, the rationalization doesn't matter very much, because he really doesn't feel very bad. For regressive fathers, self-justification is a more complicated matter, because the father who turns to his daughter in a fit of narcissistic desperation is much more likely to detest himself. The conflict this ambivalence creates between his narcissistic ego and his "real" one may cause him to break down in tears and apologize, even to beg his daughter not to let him touch her again. Sensing the genuineness of his torment, his daughter may offer her forgiveness. But as soon as her father's ego feels empty again, his

have any doubts in the first place. If the girl is an adolescent when the
father's regressive tendencies are triggered, or if their relationship has
been particularly strained, his initial advance may be met by an
outright refusal and a threat to tell someone if it happens again. But if
most incest victims do not initially resist, it is simply because they have
no way of knowing that the incest is wrong. As Rachel pointed out, "I
never even thought of questioning my father. My father was right —
that's all there was to it."

Even to portray the incest victim as a reluctant participant is to
overlook the possibility that there are likely to be aspects of the
relationship she enjoys. As a by-product of the incest, she's receiving
a great deal of attention from the abusive parent. He may be slipping
into her bedroom three or four nights a week after her mother goes to
sleep, taking her on trips without the rest of the family, or doing
whatever else he needs to do to get her alone. To ensure her
compliance he gives her special presents and permissions, all the while
telling her he loves her more than her brothers and sisters, even more
than her mother.

For young girls who love their daddies, such attention can be
heady stuff, and while it is an exceedingly difficult idea for many
people to grasp, there is also the possibility that the child is enjoying
the sex. In Rhode Island not long ago, a Family Court Judge suggested
that many children "really enjoy" having sex with an adult. "I have
these cases all the time," the judge said, "and I never hear the girls com-
plain until they get hurt or something." The judge missed the point,
but even for young children sex can be highly pleasurable. Kinsey re-
ported orgasms in boys as young as five months, but Freud was the first
to recognize that small children, even infants, are capable of respond-
ing to sensuality. "No child," he wrote, "none, at least, who is men-
tally normal and still less one who is intellectually gifted — can avoid
being occupied with the problems of sex in the years before puberty."

The incest victim may have another motive for becoming an
accomplice in her own abuse. In the child's mind, once the incest has
begun she's won the competition with her mother for her father's
affections, and she often begins to take on aspects of her mother's
persona. Though it is by no means universal, in many incest cases the
victim actually exchanges roles with the parent of the same sex. This
sort of role reversal can happen when a mother who abuses her son
substitutes him physically and emotionally for his father. Most often it
is the daughter abused by her father who trades places with her mother,
becoming a "little mother" herself. Rachel puts it best when she says

or 70 percent of incest victims say their fathers had been drinking at the time the incest first occurred. In recent years, as marijuana, cocaine, and even heroin have become more widely available and also more affordable, reports of narcotics abuse by fathers who molest their children have also begun to climb.

In most cases where incest begins at an early age, the incestuous father is likely to be a pedophile in disguise, a man who knows soon after his children are born, perhaps even before they're born, that eventually he's going to have sex with them. Such fathers don't act impulsively. For them the abuse isn't triggered by a narcissistic crisis, and there is time to arrange things in ways that are conducive to what they have in mind. They may actually begin grooming the child from an early age, establishing a relationship in which the child becomes comfortable with being intimately touched and caressed. Perhaps the child's father helps her with bathing and dressing, or with combing or braiding her hair. Perhaps the two of them play wrestling or tickling games, or maybe he rubs her back. Eventually the backrubs give way to rubbing her breasts and then her vagina. Without understanding what's happened to her, the child is involved.

Because narcissistic families are not very communicative, it's easy for the abusive father to isolate the child emotionally from those she might turn to for help. He may drive a wedge between the child and her mother, either by disparaging the mother openly or simply by emphasizing her lack of authority. The picture he paints in the child's eyes is of someone who is without much influence inside the family or out, of someone who cannot be turned to for help. Once the victim has been insulated from her mother in this fashion, incest can continue unimpeded for years. Because fathers who have carefully laid the groundwork for incest are looking for a long-term relationship, not a one-night stand, it is not surprising that the use of force by incest abusers is not common. One Boston study found that fewer than one incest victim in ten suffered any serious physical injury, and that only a third had been subjected to any force at all. The use of violence most often accompanies sexual intercourse, but even then it is not very frequent. Over half the victims surveyed by the *Los Angeles Times* said they had had intercourse with adults while they were children, but only a fifth said they had been forced to do so.

The question of force really begs the issue anyway, because it's a rare child who's going to tell her daddy no. The father's natural authority is usually strong enough to assuage whatever initial doubts the child has about the propriety of what he proposes, and she may not

only thing that kept him from approaching his daughter's friends was his fear that they would "get a bad idea about me." More common, and in some ways more difficult to comprehend, is the father who never considers having sex with a child until fairly late in his marriage.

When a father makes a sexual advance toward his child, it is almost always triggered by some traumatic event, and the most common "trauma triggers" are those that affect the abuser's relationship with his wife. It might be her death, or her extended illness, or a divorce, anything that makes her unavailable to him. A number of incestuous fathers begin abusing their children only after they have separated from their wives. But such men are so dependent on their wives for ego nourishment that anything that puts emotional distance between the two can become a traumatic event. Perhaps she takes a job, begins working longer hours, becomes involved in volunteer work or something else that occupies her outside the home. For the first time in their married lives, part of the attention she used to pay her husband is directed somewhere else. Her decision may have had nothing to do with her husband, may have been purely a matter of economic necessity, but her husband's narcissistic ego doesn't make allowances for good intentions. In his mind he's been rejected and abandoned, and he turns for relief and gratification to one of his children.

The same sort of trauma can be precipitated by problems with the father's other main source of self-esteem, his job. The severest of all ego blows is being fired or laid off, and there is some evidence that the incidence of incest may be linked to the rate of unemployment. In one Chicago neighborhood over the past several years, reports of child sexual abuse have risen and fallen in nearly perfect unison with the level of unemployment. In many families where the father is out of work, the mother is forced to take a job, leaving her husband to shop, clean, and take care of the children. Not only do many men find such work demeaning and humiliating, it gives them more time at home with the children. But the loss of a job is not necessary by any means. Even an unkind word from the boss can send the genuine narcissist in search of alternative sources of admiration and approval.

As trouble with his wife or his job pushes his fragile world nearer to collapse, the abusive father's first response is often to begin drinking heavily. Alcohol helps quench his craving for gratification, and it is an effective means of boosting self-esteem. But alcohol is also a powerful disinhibitor, and anything that lowers his natural inhibitions makes it easier to abuse his child. It cannot be coincidence that as many as 60

scope, and it does not provide a basis for any solid conclusions about the frequency of mother-son incest.

Reports of father-daughter incest are much more common. The *Los Angeles Times* survey suggests that more than 750,000 adult women, about the population of Baltimore, are victims of father-daughter incest, and that there are another quarter-million girls now alive who will have sex with their natural fathers before they reach the age of eighteen. But sexual relationships between fathers and daughters merit attention for reasons beyond their numbers. Because abuser and victim share the same roof, father-daughter incest is likely to consist of many more occurrences than that involving an uncle or someone else who lives outside the home. Because of the peculiar dynamics that seem to exist within families where it takes place, father-daughter incest often compounds the damage it does by going on for several years. Finally, because most father-daughter incest occurs within the framework of the family, it inevitably has an impact on other family members who are not directly involved, particularly the victim's mother.

In what sort of family does father-daughter incest happen? Since incestuous fathers come from every social and economic stratum, there is no such thing as a typical "incest family." Indeed, because they often achieve a kind of surface stability that many normal families lack, families where incest is taking place may look to the rest of the world like models of matrimonial and filial devotion. Behind closed doors, however, they're likely to be families in name only, with very little cooperation or sense of community, and not much communication among their members. What appears from the outside to be marital bliss is really a narcissistic symbiosis, a pas de deux in which each partner's ego feeds so voraciously on the other's that neither has any interest in rocking the boat. Not only do the father and mother have an unspoken agreement to validate one another, they may share a narcissistic need to be seen as a model family, and very often they're successful. As Rachel pointed out, it was her family, which hardly qualifies as a model of anything when seen from the inside, that was chosen by local school officials as home for an Italian exchange student.

Nearly all incest families center around the abuser, but not all incest families are alike, and neither are all incestuous fathers. Some are essentially pedophiles who begin abusing their children soon after they're born and keep at it for years, often extending their reach to include children who are not their own. As Carl himself admits, the

likely, that children who receive such attention from their mothers and fathers will become sexually stimulated — it's a rare mother who hasn't noticed her boy baby develop a tiny erection when his penis is being washed. Nor is it unusual for mothers who breast-feed their sons or fathers who bounce their daughters on their laps to find that they are becoming sexually aroused themselves.

But when do intimacy and affection become sexual abuse? It's appropriate for a father to bathe his infant daughter, but the father who continues to help his nine-year-old daughter with her bath while insisting that he is just being "fatherly" is not being honest with his daughter or himself. The father who accidentally glimpses his adolescent daughter's breasts and is distressed to find himself aroused by the sight is responding normally, but the father who pretends to blunder into her bedroom by mistake in hopes of catching her half naked is behaving abusively.

Because children are naturally inclined to experiment sexually with one another, it has long been assumed that sex between siblings, particularly between brothers and sisters, was the most common form of incest. But that assumption is challenged by the *Los Angeles Times* survey, which found that only 2 percent of the female victims, and only 1 percent of the males, had ever had sex with a brother or sister. Three percent of the female victims, on the other hand, said they had had a sexual experience with their fathers while they were children, and 14 percent with an uncle. Though sibling incest is not always consensual, particularly in the case of an older brother and his much younger sister, the betrayal it entails is relatively small compared to that when the abuser is an uncle, grandparent, or someone else who assumes the stature of a parent in the child's eyes.[2] But it is sex between parents and their children that does the most harm of all. Parents are supposed to be beneficent caretakers, but it's impossible to be caretaker and lover at the same time. The parent who has sex with his or her child commits the ultimate betrayal, a betrayal by the one the child loves and trusts the most.

Though it represents a common theme in pornography, sex between mothers and sons has been viewed by many as what Rosemary Dinnage calls "the unexplained nub of incest: most seductive, most dangerous, most rarely acted out."[3] Is mother-son incest really all that rare? Since 7 percent of the men questioned in the Knoxville study mentioned in chapter 3 said they had been sexually abused by their natural mothers, it is more likely that such relationships simply go unreported. But the Knoxville study was neither random nor broad in

"That year I had twenty-six cases. Now we're running more than a thousand new cases a year, in a metropolitan area of a million people. That's of epidemic proportions, isn't it?"

Giaretto is correct, but even to call incest an epidemic is to understate the case. A quarter of the female sexual abuse victims and 10 percent of the male victims who were surveyed by the *Los Angeles Times* said they had had sex with a family member — a father, mother, uncle, aunt, grandparent, brother, sister, or cousin — while they were children. Applied to the general population, such figures suggest that there are nearly eight million Americans over the age of eighteen — more than the entire population of New Jersey — who are the victims of childhood incest. If children today are being abused by family members at the same rate as their parents and grandparents claim to have been, the number of current incest victims is equal to the populations of Dallas and Philadelphia put together.

Though incest is not a small problem, it is still the least talked-about form of child sexual abuse. One reason is that, unlike sexual abuse in a day-care center or some other communal setting, incest simply doesn't make news. The majority of incestuous parents plead guilty before they ever get to trial, and most incest trials are pretty much alike. But the real reason for the lack of public discussion is the notion, still widely held, that what goes on inside the home and within the family ought somehow to be exempt from public scrutiny. Two years ago, when the U.S. Justice Department criticized local police and prosecutors for their reluctance to assign a high priority to incest cases, it felt compelled to remind them that incest and child molestation "are not matters of personal belief, or how to deal with children or keep order in the house. They are crimes. They are prohibited."

Not only is incest the least discussed, it is also the least reported form of child abuse. The principal reason is simply that so many of its victims never tell anyone what has happened to them, but there are other reasons. Because it has been commonly thought that most incestuous parents abused only one of their children, even when there were several children to choose from, until quite recently a child protection worker wasn't likely to ask about the victim's sister or brother — or, for that matter, about her uncle or her grandfather.

Parents and others who assume a child-tending role cannot avoid being intimate with the children they care for. Bathing and diapering inevitably involve contact with children's genitals, and hugging, kissing, and petting are things most young children want and need from the grown-ups who care for them. It's not only possible, but

"Jean didn't have the slightest idea. I used to take a lot of risks at home, when she was there. I used to leave the doors unlocked. Sometimes she was in the next room. I felt I really wanted to get it over, get it out in the open. I didn't want to continue on, yet I couldn't stop myself. I couldn't go out and tell her, though. I remember one time Rachel and I had a talk. We were in the car, and she told me she wanted it to stop. I agreed with her, but I knew within myself I wasn't ready to let it go. I agreed with her just to make her feel good at the time. When it kept on, she said that she was going to tell her mother. I told her, 'Well, if that's what you want to do, go ahead and do it.' I didn't threaten her. I felt like I was going to lose them completely. I wanted them for myself. I wasn't ready to share them with anybody. I felt rejected by my own daughters, and I didn't know how to deal with it.

"The first time Jean found out about it, she didn't turn me in. We talked it over, and I promised her I would never do it again. She said, 'We're going to have to get you some kind of help, even if it's through books.' And that's what we tried. When they talked about it that night, I was pretty scared. I wasn't sure what to expect. I thought I would go to prison. I just said to myself, Well, I'm going to have to pay the consequences now. It was a relief that it came out. I spent a year in prison, at the county prison farm. I never talked to the other inmates about why I was there. They would ask, but I already had a story prepared. I told them I was in for assault and battery. When I got out, I had to look for another job. On the application, where it asks 'Have you ever been convicted?' I just told them no. It would be very hard to get a job otherwise. There's very few people that will give you a chance to work. It's my fault. I don't say it wasn't my fault. I don't feel good about it. I can't speak for them, but I know that I'll always love them. I know what I did was wrong. I wish a father would take a second look at himself before he starts this. If he gets any indication that he wants to, that's the time to get help. Don't wait until it's too late. I waited too long, and it got too easy."

<div align="center">* * *</div>

It was not very many years ago that incest was thought to be principally confined to what Tennyson called "the crowded couch in the warrens of the poor," to urban ghettos or isolated rural families in the hills of southern Kentucky.[1] "When I started in 1971, it was supposed to be one case of incest in every million people," says Henry Giaretto, a San Jose, California, psychologist who founded one of the nation's first treatment programs for incest victims and their families.

This is Rachel's father's story:

"It started when I was a kid. With my brother. I was abused by my own brother. It was when we were alone. He's about three or four years older. I didn't give it much thought for a long time. After I grew up a lot of the things I was doing were kind of crazy, but I never knew why. Crazy things, like driving sixty miles an hour through a red light, trying to kill myself. All those years I just put it inside and left it there for a long time. When I was a kid, I never told anybody. I felt like telling my mother, but I didn't. I was still angry because it happened. When I was abusing my daughters, I didn't think about what had happened to me in the past. What started me to molest them is when they used to sit in my lap when I was watching TV. Sometimes we would have a cover over us. That was when I used to fondle them. They were still pretty young. They used to sit a lot in my lap. My penis would get hard. I used to turn them toward me and feel their little bodies close to me. Rachel didn't develop until a lot later. I didn't always know I was going to be sexually attracted to them. I didn't know when they were babies. It kind of just hit me, for no reason at all. They used to sleep with me when they were babies, and I used to fondle them, their little vaginas. But I never really thought much about it. As time went by, I got more aggressive.

"At first I thought it was nothing bad. I felt it was a good relationship between me and my daughters. They didn't seem to find anything wrong with it. I didn't find anything wrong with it either, at first. Matter of fact, I thought it was the right thing to do. Why go look for it somewhere else when you got it right there at the house? As for them liking it, I can say that Rachel enjoyed it a couple of times, when she was about thirteen. She enjoyed it with me. I don't know if she had an orgasm or not. That I don't know. I never did have intercourse with any of them. That was off-limits. I wanted them to get married in white. I can satisfy myself without going through that. I used to look at their little friends, but I would never take the chance of trying to molest somebody else. Because I didn't want them to get a bad idea about me, like, Here's Rachel's father trying to do this with me. But yeah, I used to look at them — young girls, good shapes, nice-looking. As the years went by, there were times I'd feel guilty. There were a lot of times I did feel good about it, and there were a lot of times I didn't feel good about it. I used to get sick about it. It would go into the bathroom, and I would want to puke. I thought I saw Satan in the same mirror with me. Then I knew it was wrong, yet I could not stop myself.

never thought I'd be one of the women it happened to. Why me? Why did it happen to me? I was a good woman. I was an honest one. I raised his daughters clean. I kept the house up very, very well. Why touch my daughters? A lot of my friends, they were out there screwing around with other guys, friends that I knew. They were married and they were doing this. I had only one man in my life. There was nothing that he couldn't do to me.

"I didn't really have feelings in my sex life. I had already had five kids before I learned what it was to reach a climax. Sex to me was just being submissive to your husband, and that was it. I did it, and it was over with, and that's it. Once in a while he would put his arm around me and be kind to me. He was never violent with sex. I was always told you submit yourself to your husband, whatever he wants. He could have had it day and night. That's one part that bothers me a lot — that he could have had it anytime he wanted, and yet he molested the girls. I still can't understand that. I blamed myself for a long time. That I didn't pick it up. Maybe I didn't pick it up because my daughters always showed affection to their dad. They never showed the resentment or the hate they had for him, for what he'd done to them. They showed love and affection for him. He wouldn't let his daughters date. I thought it was an old-fashioned tradition, but he didn't want them near any other man. That any other man would get near his daughters, he couldn't handle that. We stayed together for the kids' sake, because they wanted Tanya and Lorene to have a dad. Rachel said she would deny it. She didn't want the law coming into it. I knew he'd get jail no matter what, and they didn't want that to happen to Tanya and Lorene, to lose their dad. So I told him, 'We're going to have to read some books.'

"I went to the library to do research on child abuse. But we didn't get anything out of it. I couldn't understand it. The words were too big. It was statistics, it wasn't real stories. He promised he wouldn't touch the girls ever again, and I believed him, one more time, trying to give him another chance in life. I think he was sincere. But after I found out about the molest, I put locks on their doors. I can see that sad face of his, trying to tell me he didn't do anything to Lorene. He said he had asked her, but he didn't touch her. To me it didn't matter. Then I didn't care if the law got involved in it or not. That's all I needed. My daughters come first. Carl was molested by his brother and by a stranger. What I can't understand is, he can remember the trauma — how could he traumatize somebody else? I thought I knew my husband pretty well."

kissing daddy. When we'd walk down the street, they'd grab daddy's hand. To me, that was the reality I wanted as a child. I always wanted that love and affection I never got. Even at that age, I was an adult. That was part of my survival. So I think that's why I was never a possessive mother. My younger sister was molested, but I wasn't. My father did touch Rachel, though, his own granddaughter. I hate my father for it, and yet I love my dad.

"They would have TV programs about how anybody can molest your children, it can be a member of the family. So I always protected my kids that way — telling them, 'I don't care if it's your daddy, don't let anybody touch any part of your body, you come and tell Momma right away.' Because of my dad. I still didn't trust men. It doesn't matter who it is. I thought, If my dad can do it, any man can. I always asked, because of the program I had seen. I guess because they loved me so much, they didn't tell me. That's the only thing I can think of. I think they were protecting me, really. They feared they would lose the family. I think they thought I wouldn't love them. When the time came, they looked at me, and they were real quiet. They sat at the end of the bed. I asked them what had happened. They didn't want to give any details, except that something had happened to them. I asked them, did he have sex with them? They said no, which he didn't with any of the kids. I told them, 'Dad's sick, Dad needs help, and I'm calling Dad in right now.' Carl already knew that Rachel was going to talk to me. She had told him it had to stop. He didn't run away. He stayed home. He waited for me to call him in the room.

"He didn't deny it. He said, 'Whatever they say.' He said he was sick. He couldn't explain it. He said, 'I can't tell you. I don't know why.' I was angry — how could he touch a part of my body? My children are my body, as far as I'm concerned. That was violating me. I cried and cried, until I couldn't cry anymore. That's when my love for Carl died. There's a part of me that will always love him. The real love that I had for him is there. The good love. But I think that I could kill him out of the hate that I have, if I didn't know how to control it. I fell apart. I literally was dying inside. It's like your world has ended. The person you trust more with your whole life has betrayed you. I trusted Carl totally. These were his daughters. I couldn't believe he could hurt them. My first thought was, Are my kids going to be OK? Because I've seen these programs about how kids turn into prostitutes and everything. None of them turned wild. My kids didn't wander the streets. Some kids destroy themselves. My kids did not become drug addicts. I knew I wasn't the only woman this ever happened to, but I

he'd be right there. And I heard his pants go on. All I could think was, God, please don't let this happen. Lorene broke down. She said he had asked her — that if she wanted to, they would. My mom was out of town. She called, and I said, 'I have to tell you something — Dad asked Lorene to do it.' She said, 'I'll be right there.' She was home in an hour. Everything happened at once. My dad left, and then we called the cops.

"For a long time, I thought it was my fault. When I was smaller, everyone used to say how pretty, how beautiful I was. Because I was so close to my dad, I'd always hug him and kiss him. I wore pajamas that were knee-high. I always thought that that had turned my dad on. For a long time afterward, I had so many problems. I had men teachers I couldn't even speak to. I didn't want to be touched. My boyfriend and I were becoming more involved. He stayed with me through the whole thing. But just because he was a guy, I didn't want to be around him. At first there would be certain things that he would want that I had a real hard time with, like getting on top, because it reminded me of my father. It was hard at first. But it was like, as long as I redid that act I was clean again. I've had a couple of nightmares where I'm terrified. But usually I say this little prayer that always gets me through it: 'Let the blood of the Lord Jesus Christ flow through me and redeem all the evil.' And then I fall asleep, and the dreams don't come back."

This is Rachel's mother's story:

"I met Carl at the age of thirteen, in junior high school. First boyfriend, and I fell in love. He enjoyed walking with me. We didn't have a car anyway. He was tall and thin, not too good-looking. He's more handsome now than he was then. I wasn't out for looks. He was very honest with me from the beginning. He always saw other girls, but he didn't lie to me about it. I remember him saying one time when we were younger, 'A man's not a man if he turns it down.' In fact, he'd take them to the shows, and I'd give him my baby-sitting money. I'd iron his clothes for him. He wasn't a violent person. One time he beat me up. One slap he gave me, and that was it. He knew that was something I wouldn't tolerate, because my father beat up my mother constantly. I would put up with women in our lives, but I would never put up with beating me up. The two qualities I liked the most were, he was good to me and he was honest. To me, honesty is very important in a man. I loved him. I was never a possessive person. I figured, he can have ten girlfriends, that's OK with me, as long as I'm one of them. My kids, from day one, were very affectionate with their dad. They used to sit on their dad's lap and give him hugs. They loved

do.' I didn't care, I just did it, took the money, and ran. I used it. I could say, 'Daddy, I need school clothes,' something like that. My dad was always willing to give. He provided whatever I needed. My other sisters, they never got what I did. But there was always a price to pay. I never felt like I was in competition with my mother. I never thought my mom and dad had a sex life. Seriously. Every time we'd go into their room, my dad had his pajamas on, and my mom had hers on.

"When I was twelve, we really lost contact a lot. I was at the age where I wanted to go to school dances. I wanted to have a boyfriend. Everybody else had one. I had someone who liked me, but I couldn't have a boyfriend. The only thing he didn't understand was when I talked to him about my boyfriend. I was never allowed to have boyfriends. We had an Italian student come live with us for the summer, a girl. And she was never left alone, I made sure of that, because by then I knew what was happening to me, and I sure as hell didn't want that to happen to her. At some point I just realized that this was not the way to go. I asked him kindly not to touch me anymore, that it was wrong, because I had started learning that in school. I asked him twice to stop. He would, but then he'd start again. I started hating him while it was happening, when I realized it wasn't daddy-love anymore. The first person I opened up to was my best friend. I just couldn't hold it in anymore. She couldn't believe it. I made her swear that she wouldn't say anything. I didn't know where to go. I went to Barbara, my oldest sister, and I cried, and I told her the truth. She said, 'You're not the only one.' My sisters, I didn't know about them. She said it happened to her, it happened to Renee, and we'd have to tell Mom. Barbara was like our second mom. So I went to Renee, and I said, 'We have to do it now.' She said OK. The thing that made us finally tell was Tanya and Lorene. We didn't want it to ever happen to them.

"We just held each other's hands, and we went to my mom's room. We told my mom, and my mom called my dad in. My dad said, 'I knew this would happen sooner or later.' He says now that when he found out I had said something, all he could think was, It's finally over. We had this discussion, and she asked us what we wanted her to do. At the time I didn't want my family to break up. So I told my mom that if she said anything I'd deny it. She said, 'All right,' and she made my dad swear to her that it would never happen again. A year or so later, my mom was out of town. Renee and Barbara were at work. I was tired, and I went to bed. I thought my dad had really changed. I heard the phone ring, and I woke up. I went to the hallway, and my dad said

Families

THIS IS RACHEL'S STORY. "I really can't remember much about my past, but from what my father told me it started very, very young. I wasn't even in kindergarten, less than five. It happened in the car. We were on our way to the store, me and my dad and my two sisters, and he just pulled us to the side of the road and asked us to play with him, you know, his privates. It became an everyday thing. I never even thought of questioning my father. My father was right — that's all there was to it. He fondled my chest, and he put his dick right between my legs. He never actually went in. He liked me to be in his bed. He liked me to massage his back, and stuff like that. My father would ask me to give him head and to play with him and pretend I was his wife. I'd cook for him, I'd massage him, and then I would please him. I just did it. For a long time it didn't make me feel like anything. It was something I was so used to that it just became an everyday thing. When Daddy said this was our little secret, I never even thought of questioning my father.

"We had a great relationship. He was everything I wanted in a father. He provided whatever I needed. He was always there to talk to. Mom always had something else to do — church meetings, school projects, something. Whatever my dad was doing, working on the lawn, fixing the car, he'd always pay attention to me. He never shut me up, never. He went to work every day, brought home his paycheck. He checked my grades constantly. I had to have a B average. He'd let me go with my girlfriends, and I always had girlfriends over. He was understanding about certain things. If my mother said I couldn't do something, Dad said I could. I'd always go to my dad first. I remember one time when I was going to the mall with my friends, and I needed a couple of dollars. And he said to me, 'Well, you know what you can

their children. They also feel degraded, not worthy of being treated well by anyone, and when someone does treat them well they feel guilty, because deep inside they're convinced they don't deserve such treatment.

As with male narcissists, their exaggerated underestimation of themselves leaves them almost completely dependent on the approval of others for their sense of self-esteem; much more so than for most other women, it is their relationships with men that they depend on for reflected status and power. Before they marry they often are promiscuous, in a continually unsuccessful effort to reconfirm what their narcissistic self believes is their desirability and attractiveness. They may distrust men and dislike them, but men are still the most important people in their lives. Such women often are overweight and unkempt, and they tend to speak with tentative, frightened voices, but the grandiose part of their personalities is likely to lead them to see themselves as physically appealing.

In many ways the narcissistic victim and the narcissistic victimizer are a near-perfect match, since the male's need to be admired and the female's need to be desired make them ideal mates. She tacitly agrees to supply the approval he so badly requires, while his gross dependence on her support of his fragile ego satisfies her desperate urge to be needed. It's not that such men consciously look for someone to marry so they can have children to abuse; though this undoubtedly happens, the equation is more likely to be made at an unconscious level. Such a man is naturally partial to a woman who he senses won't stand in his way on any count, who isn't going to ask many questions about how he lives his life, and it's easy for him to pick up on women who seem to have an unhealthy degree of dependence on men.

Neither does the narcissistic woman go about consciously seeking an abusive mate. But because her sense of self-esteem is derived indirectly from the men in her life, she finds the narcissistic male's attitude of surface superiority appealing. Not only does she not threaten his fragile ego, she nurtures it, because his ego is as important to her as it is to him. If it's their collective fiction that he's the smartest and handsomest guy in the world, then by extension she's the wife of the smartest and handsomest guy in the world. At the same time, her husband's narcissistic tendency to dismiss everyone around him as inferior confirms her own opinion that she's not worth much as a human being. Her husband may be manipulative and deceitful, and he may not afford her much respect, but if she was sexually abused as a child, these are things she's been comfortable with for years.

is. It's easy for mothers and other female caretakers to fondle and stimulate the children they care for, since it can be done under the guise of performing such motherly tasks as bathing and dressing. But no matter how many American women are abusing children sexually, no one suggests that the number of female abusers is ever likely to equal, or even approach, the number of sexually abusive men. If that's the case, what becomes of the rest of those women who were abused as children but who don't grow up to become abusers?

A remarkable number marry child abusers and become the mothers of sexually abused children. Researchers are unanimous in reporting that high percentages of the mothers of incest victims, 90 percent in one California study, were themselves the victims of sexual abuse. In many cases their mothers were also victims, and their mothers before them, which raises the possibility that child abuse may be passed from one generation to another like a hereditary disease. But the process by which such women find abusive men to marry puzzles many experts. "It might take us weeks to diagnose a man as an incestuous father," one therapist says, "but an 'incest mother' can go out and find herself an abusive husband in a matter of days. There's no way around it, because we've seen it happen over and over again. It's like they have letters painted on their foreheads that are invisible to everyone else."

One theory is that since people tend to marry others from the same social and economic backgrounds, sexually abused children have more access to one another while they are growing up. But this idea implies that sexual abuse is far more common among some social classes than others, and there is no evidence to support such an inference. Another possibility is that many girls who wish to escape from an incestuous relationship at home see early marriage as a quick exit and are thus more hasty than selective in their choice of partners. But the question is not why such women marry or when, but whom they marry. The answer may simply be that victims are attracted to victimizers.

While the female victim of sexual abuse may be every bit as narcissistic as her male counterpart, her narcissism takes a form that is not only much less grandiose, but much more negative and destructive. Like the male narcissist, such women live in constant fear of being found out for the frauds they think they really are. Many admit to a continuing fear that their children will be taken from them once they've been identified as "bad mothers." Such women say they feel isolated from everyone around them, particularly their husbands and

a serviceman killed in action, the seduction is presented to the boy as a special gift, a loving introduction to manhood, and there are many other movies and countless novels based on variations of the same scenario. Because of the resulting mythology, when sexually abusive relationships between women and young boys are reported to the authorities, action is not always taken. A Los Angeles man who discovered his fourteen-year-old son having sex with a thirty-five-year-old woman who lived down the street telephoned the police to demand that the woman be arrested. The officer who answered the telephone just laughed. "More power to him," the man was told. "He's just getting an early start in life."

Only after they become adults do some men acknowledge, even to themselves, that they were intimidated and frightened by a childhood sexual experience with an older woman. One of the few available estimates of the sexual abuse of boys is a retrospective survey conducted in Knoxville, Tennessee, and it illustrates the difficulty of getting men to talk about their childhood sexual experiences. When the Child and Family Service Agency of Knox County first ran an advertisement in the local newspaper asking to hear from men who had been sexually abused as children, it received just a few replies. But when the wording of the ad was changed from "sexual abuse" to "sexual experiences," more than a hundred men responded.

Many of the callers began by saying, "I wasn't really abused, but I thought you might like to know about this experience." Only 25 percent of the respondents said their abusers were men. All of the others had had sex with grown women while they were still children. Seven percent had been abused by their natural mothers, 15 percent by aunts, another 15 percent by their mothers' friends and neighbors, and the rest by their sisters, stepmothers, cousins, and teachers.

The average age of the victims at the time the abuse began was eleven — the youngest of them had been five, the oldest sixteen. In nearly every case, the women fondled the boys' genitals or exposed their breasts or genitals to them, but in more than three-quarters of the cases the women also performed oral sex on their victims. Sixty-two percent of the experiences involved intercourse. Thirty-six percent of the boys were abused by two women at the same time, and 23 percent said they were physically harmed in ways that ranged from slapping and spanking to ritualistic or sadistic behavior. In more than half the cases, the abusive relationships continued for more than a year.

One reason for the smaller incidence of reported sexual abuse by women may be that some of that abuse is never recognized for what it

begets abuse — suggests that nearly all child abusers were abused in some way as children. But the retrospective surveys that show the majority of victims to be girls and their abusers mostly men present an important question: If women who are abused as children acquire the same sorts of narcissistically disordered personalities as men who were abused, why aren't more women abusing children sexually? The answer may be that they are. The notion that sexual abuse by women is virtually nonexistent is common even among some professionals, and the idea of women having sex with children, particularly their own, does seem to violate some fundamental law of nature. Women are nurses, teachers, and mothers — caretakers, not tormentors. They heal, they don't hurt. It's as difficult to imagine the neighbor lady down the street abusing the little boy she sits for as it is to imagine a mother having sex with her own son. But neighbor ladies do have sex with the children they care for, and mothers do have sex with their sons, possibly in far larger numbers than most people suspect.

Of the male victims questioned by the *Los Angeles Times*, 17 percent said they had been abused by adult women while they were boys. That translates to more than two million American men who had similar experiences as children, and another million boys who will be abused by women before they reach adulthood. Surprising as such figures are, the real number of male victims may be close to, or even equal to, the number of girls. The main reason for the discrepancy is that, even later in life, men are much more reluctant than women to admit having been abused, because it goes against the grain of their masculinity to acknowledge having been taken advantage of by anybody. Boys who are sexually abused by men are often afraid they'll be labeled homosexual, but there's not much room for male victims of any kind in a society that celebrates *Rocky* and *Rambo*.[6] It's also possible, of course, that none of the male victims lied when they told the *Times* they had not been abused by women. But if that's the case, how to explain the large number of male abusers who say they were abused as children?

The sexual abuse of boys by women is particularly difficult to uncover, because many boys who have sex with grown women aren't sure whether or not they've been abused. They may secretly feel exploited and used, but their culture tells them they're lucky that they "got some" from an experienced female. The patient and tender older woman who initiates a young boy into the mysteries of love and sex is a perennial theme in fiction. In the film *Summer of '42*, the story of a fourteen-year-old boy who is seduced by the young, bereaved wife of

relatives or adults outside their families? The question here may be posed as follows: How can the child of parents who are neither abusive nor seductive, not distant and not smothering — in other words, the child of capable and effective parents — be derailed in his transition from narcissistic infant to well-ordered adult through abuse visited upon him by an outsider? The answer may be that the parents of a child who is seriously abused by someone outside his home are not, by definition, capable and effective parents.

It is difficult to imagine the child of parents who are the least bit sensitive to his emotions being abused by anyone for very long. Younger children who are molested by an uncle or a teacher may not know that what's happening to them is wrong, but most of them send their parents signals that something unusual is going on, and it is the narcissistic or otherwise ineffectual parent who is least likely to be tuned in to his child's frequency. For older children, the perpetuation of sexual abuse by someone outside the family depends most of all on secrecy, and the child who can be persuaded to keep such a secret from his parents has already received the message that he is not much trusted or loved by them. Either his parents have told the child in so many words that he cannot come to them for help, or they're so wrapped up in themselves that they're unavailable to him, or they're so demanding of perfection and intolerant of failure that the child fears being blamed for his own abuse. The pedophile, whose principal source of ego reinforcement is the affection and adoration of children, can be a rich source of the praise and understanding that such a child finds lacking at home.

The older child who consents to being abused by an unrelated adult raises a final question: If such abuse is not accompanied by either force or coercion, and if, as is most often the case, the pedophile is someone the child likes and admires, how do such experiences contribute to the proclivity such children display for becoming abusive adults themselves? When pedophiles insist, as many do, that they love children and treat them with respect, they may be echoing the expressions of love and respect they were denied when they were young, and on some level they may even believe what they say. But the attention and affection they shower upon their victims are manipulative and inherently empty, and consciously or unconsciously the victim knows it. The child who is spurned by distant or demanding parents and who seeks emotional solace from a child molester is both denied genuine affection and smothered by a bogus substitute, which may be the worst of all possible combinations.

The accumulative theory of child abuse — the idea that abuse

She's sixteen years old, she's responsible, she makes good grades, she's neat and tidy, and she comes from a nice suburban home. Her family is intact, she's a cheerleader, she's got all kinds of goals in mind. And she molests kids. She wasn't abused herself, though I was hoping she had been because that would be much easier to deal with. There's no sexual abuse, there's no physical abuse. In terms of emotional abuse, this child basically was her mom's best friend. She has not had a lot of control, in terms of what she's chosen to do or not do with her life. I guess you could say she's been smothered. With her, the source of her abusive behavior is just control, as opposed to a trauma in her life or some kind of stressful act."

Whether or not adults who were abused as children grow up to become child abusers probably depends in part on the intensity of their narcissism, which may in turn have to do with the nature and circumstances of their abuse — what form it took, how long it went on, and who the abuser was. Child abusers tend to be grossly narcissistic, enormously compulsive, and almost completely unempathic, but there are many lesser degrees of narcissism that leave individuals with some ability to empathize and to control their impulses. Moreover, powerful cultural and internal inhibitions must be overcome before having sex with a child, and it requires a very strong degree of narcissism to accomplish that task. And while narcissists do tend to be promiscuous and attracted to deviance, there are many sexual deviations to choose from besides sex with children. [5]

It is also true that a surprising number of childhood victims of sexual abuse become compulsive caretakers, who find work in nurseries or with youth groups or in some other capacity that brings them in contact with children, even as child therapists or child abuse counselors. This phenomenon of going to the other extreme, a process known as reaction-formation, is often their way of setting up an unconscious defense against their impulse to reenact their own abuse in the role of the abuser rather than the victim. But it is a fragile defense, one that Freud called "insecure and constantly threatened by the impulse which lurks in the unconscious." The danger that the defense will give way and allow the return of the repressed impulse to the conscious mind may explain why a number of youth leaders and child care workers who seem genuinely devoted to the welfare of children have also been found to be abusing them sexually.

Though it is admittedly rather rough-hewn, the narcissism theory may tell us something about the genesis of child sexual abuse by adults who were abused by their own parents. But what about those child abusers who were abused as children not by their parents, but by other

until after his arrest that John Gacy's narcissism achieved full flower. Without much ado he confessed to at least thirty-three murders, and the psychiatrists who examined him reported that he was behaving "like a star, the center of attention." His surface self-image, the psychiatrists said, was characterized by a "pervasive sense of power and brilliance, a sense that he is entitled to more than the average person." His lack of control under stress was "alarming," and so were his subsurface feelings of inadequacy and his lack of empathy. When Gacy talked about the murders, one psychiatrist said, it was "as though he were describing taking a drink of water."

Gacy was fully capable of behaving in what looked like a normal fashion, but underneath he lacked a conscience; one psychiatrist said he had a "Swiss-cheese superego." Gacy was a skilled manipulator of people who had the wives of the guards at the Cook County jail bring him his dinner each night. But whenever his grandiose sense of himself was threatened, Gacy erupted in a hostile, violent rage. "When he starts to express impulse and emotion, he has a minimum of control over himself," one psychiatrist reported. "When he has lost control, he explodes." In March 1980, John Wayne Gacy was convicted of the thirty-three murders to which he confessed. He awaits execution on Illinois's death row.

For the child who is physically, emotionally, or sexually brutal-ized, the pathway from victim to victimizer is clear. But to suggest that narcissism lies at the root of child abuse is not to say that all narcissists are child abusers, or that all abused children grow up to abuse children. The child who is emotionally "smothered" by his parents is just as likely to grow into a narcissistic adult as the child who is beaten or seduced.[4] When such children succeed, they're the smartest, prettiest, best-behaved children in the world; when they fail, their failure is ascribed to somebody else — a teacher, a coach, or whoever caught them up short. A child who can do no wrong is equally denied the opportunity to discover a realistic sense of himself. He receives so much attention, affection, and praise that the narcissistic cord is not only never cut, it is never even stretched, as if the training wheels were left on the bike forever. Such a child is likely to become a highly narcissistic adult, though not necessarily an abusive one.

Still, emotional smothering can be viewed as another form of child abuse, and it is possible for the narcissism of a child who was never seduced or brutalized to express itself as a desire for control through having sex with children. "I have a young woman now in treatment," says a Chicago therapist. "She's the perfect adolescent.

absent for some other reason, and it can also occur when a parent puts a great emotional distance between himself and his children. Not coincidentally, many adult narcissists describe their parents, particularly their fathers, as distant, demanding, even tyrannical. But the surest way of all to deny a child the time and space to discover his capacity for self-love and self-admiration is to abuse him physically, sexually, or emotionally.

Children who never make the transition from their infantile narcissism to a more realistic view of themselves enter adulthood still desperately dependent on the love and approval of those around them to reinforce their childish self-image.

John Wayne Gacy's father demanded perfection from his son and beat him with a razor strop whenever he failed to deliver it, which was often. "His father was after John all the time," Gacy's mother said at her son's trial. "He always called him stupid. My husband didn't show any love and affection for the children. He was cold-blooded." Gacy's sister agreed. "No one ever praised him," she said. "My dad never once said to my brother, 'Hey, John, you really did good for a change.' "

Despite his unpromising beginnings, John Gacy did well in life, mainly because his IQ placed him in the top 10 percent of the population. "He was a very smart, a brilliant person," his ex-wife said. "He had a memory like an elephant." Gacy became a prominent Chicago businessman and a successful building contractor, but his narcissism was never far beneath the surface. Though Gacy never went to college, he often pretended to have degrees in psychology and sociology. Even more improbably, sometimes he would pass himself off as a Cordon Bleu chef. Despite his Polish heritage, Gacy bragged about his connections with the Mob, confiding that his cousin was Tony (Big Tuna) Accardo, the Chicago Mafia boss. His friendships with big-name politicians were somewhat less imaginary. Among Gacy's proudest possessions was a photo of himself with First Lady Rosalynn Carter, taken during a Polish Constitution Day celebration in Chicago (the photo shows Gacy wearing a special security clearance pin issued by the Secret Service). "He said he was big with politicians and that if I ever got in trouble, just to let him know," said one of the many teenage boys Gacy hired to work part-time in his construction business. "He was a jolly type of guy, but he liked having things his own way. He liked the sense of power."

John Gacy also liked having sex with young boys, including some of his teenage employees, and strangling them afterward. But it was not

worthless, nearly all adults who have been caught having sex with children were badly mistreated by somebody when they were children. The answer, as simple as it is complex, appears to be that abuse begets abuse. But in order to understand why mistreated children grow up to mistreat children, it is necessary to see how the adult narcissistic personality develops.

Most babies are at the center of a universe populated by a mother and father who fulfill all their physical and emotional needs. When they cry out, their cries are answered immediately with food, or a change of diaper, or a hug. Denied nothing, they soon become accustomed to getting whatever they want whenever they want it. Eventually, however, most parents begin to put some distance between themselves and their children. This is clearly not the choice of the child, who would much rather remain the focus of attention. But as the child grows older, he probably begins to feel less privileged than he did as an infant or a toddler. Unless his parents continue to baby him, when he cries now there is sometimes no answer; sometimes it is late in coming, and sometimes it is the wrong answer altogether.

Not only is the child actually being denied some things, he is beginning to make mistakes and get into trouble. At first his narcissistic ego is gravely wounded — how dare his commands go disobeyed, his desires unfulfilled, his motives questioned? As the distancing process continues, however, the child eventually discovers that his parents aren't as crucial to his physical and emotional survival as he thought, that he can fulfill some of his own physical requirements and some of his emotional ones as well. When he was smaller, everything he did seemed to elicit praise. But when his mother and father fail to praise him now, it isn't the end of his world, because he's tapped into his own internal sources of approval as a means of bolstering his self-esteem.

The distancing process ideally continues through adolescence, until the narcissistic umbilical cord that links the child to his parents has been stretched to near the breaking point. Like any learning experience, however, such distancing must take place gradually, through a series of small disappointments and recoveries. Even though the child is no longer absolutely worshiped or adored, it's vital that he continue to feel loved and respected. Should his parents withdraw their emotional support too abruptly, his external sources of admiration and esteem would be completely cut off before he had taught himself to provide internal substitutes — as though the training wheels were taken off his bike before he was ready to ride it on his own. This sort of narcissistic trauma can result when a parent dies or is physically

example, and his remarkable ability to overcome the social and personal inhibitions that deter other people from having sex with children. Most narcissists practice self-denial in few aspects of their lives. All of their needs and wants, sexual and otherwise, are very strongly felt, and for them sex with children can easily become another compulsion. Whenever the narcissistic abuser feels rejected, which is often, his first impulse is to seek a quick fix from his most reliable source of ego gratification, his child victim of the moment.

Because he's less concerned about the possibility and the consequences of getting caught, and because he secretly believes that rules and laws are meant for others, the narcissist is much better equipped to overcome the taboos that prohibit others from having sex with children. Because he's so self-centered, such an individual can more easily surmount the internal inhibitions most people have about sex with children. Since his world revolves around the satisfaction of his own needs, he finds it nearly impossible to empathize with his victim. And because the piece of his psyche that allows him to put himself in his victim's place is missing, the narcissistic abuser doesn't even try. For him, the child is just an extension of his own ego.

The narcissist may be a failure as an empathic human being, but not all narcissists are failures in the world. Those who have the intellectual or emotional wherewithal to realize their grandiose fantasies may indeed become senators, or movie stars, or chief executives of giant corporations. "For all his inner suffering," writes Christopher Lasch, "the narcissist has many traits that make for success in bureaucratic institutions which put a premium on the manipulation of interpersonal relations, discourage the formation of deep personal attachments, and at the same time provide the narcissist with the approval he needs in order to validate his self-esteem."[3] But even the narcissist who holds a high political office or runs a giant company can never accept that those who support or work for him are truly loyal, and he lives in perpetual fear of being "found out" for the fraud he secretly believes he is. For such powerful and successful narcissistic personalities, the need for reassurance to fill the inner void is even greater.

Because not all child sexual abusers were sexually abused as children, to say that the majority of adults who abuse children sexually were sexually abused themselves does not fully explain the root cause of child sexual abuse. When physical and emotional abuse are added to the equation, however, a common theme begins to emerge. Whether they were sexually abused, or beaten, or merely made to feel

of any kind is the narcissist's drug, his way of giving himself the reward he has been denied by those around him and which he is certain he deserves. Eating and drinking are two sources of gratification, which may be why some narcissistic individuals tend toward obesity and alcoholism. But the physical pleasure from sex can be more intense than that from either food or drink, and many narcissists are consequently addicted to sex and to what it implies. The narcissist who is struggling to maintain his facade of superiority can never be loved enough. More than most people, he equates love with sex, to the point where sex becomes what Kohut calls an "incessant, self-reassuring performance." What the narcissist really seeks from intimate encounters is yet another piece of evidence that he is both desired and desirable, worthy and acceptable. More than wanting to make love, he wants to be loved — to be worshiped would be better still.

When the adults in his world are no longer willing to supply him with the uncritical love his ego craves, the narcissistic child abuser responds by turning for affection to children. With their naïveté and their natural capacity for affection, children are far more capable of idolatry than any of the adults the abuser knows. Anyone who secretly feels insignificant will try to recoup by seeking power over others, and children can be manipulated and dominated to a much greater degree than most grown-ups. No matter how impotent or insignificant the abuser feels in the world of adults, in the world of children he is a supreme authority figure, one who is indisputably in charge.

The grossly narcissistic nature of most child molesters may explain some of the distinctions between child abusers and rapists. Most rapists also seek power and control, but they do not ask love or even admiration of their victims. Their aim is to demean and humiliate, or at least to horrify and shock. If the rapist leaves his victim broken and bleeding, why not? For him the rape is the end of the relationship, not the beginning. Most child abusers, on the other hand, have sex with children they know, usually ones they know well, and often over a long period of time. While rapists may resort to physical violence, most child abusers do not, since it is difficult to solicit love and admiration from a child who has been beaten into submission. Far from wishing to see their victims suffer, most child abusers have a narcissistic need to believe that a child enjoys sex with them as much as they do with the child.

Beyond merely suggesting why some adults find children sexually appealing, the narcissistic theory of sexual abuse helps explain some other aspects of the child abuser's personality — his impulsiveness, for

read a certain book, is forced by his grandiose view of himself to say yes even when he has not — sometimes, as Kohut notes, with the indirectly beneficial result that he now has to rush and quickly read the book.[2] Even the seemingly modest and self-effacing person who persists in giving all credit to others for things he himself has accomplished is narcissistically attempting to win the gratitude and admiration of those others while refocusing the spotlight on himself.

Beneath the surface, the narcissist is so monumentally insecure, so profoundly unsure of himself, and so desperate for external reinforcement of his fragile self-image that he devotes his life to seeking the admiration of family, friends, colleagues, even casual acquaintances and strangers, anyone who will comply, and by whatever means necessary — hence the often-heard reaction among those who know someone accused of sexually abusing children, that "It can't be true. He's a nice guy." He may be a nice guy, but there's a method to his niceness. Whether he is being subtle or blatant, boastful or self-effacing, the narcissist is constantly maneuvering people and events to provide himself with the affection and attention he so badly needs. When they are not forthcoming, he often refuses to admit the obvious, and imposes his own interpretation on the behavior of others. The woman who chances to smile in his direction while passing on the street isn't just making a friendly gesture toward a stranger, she's making a pass.

In deference to the myth, narcissism is often misconstrued as simply an overweening vanity and sense of self-admiration. But the true narcissist is as familiar with self-hate as he is with self-love. No matter what he pretends to others or even to himself, deep inside he knows that his exalted self-image is a sham. Secretly he feels powerless, unworthy, and ashamed. When his grandiose view of himself is being nurtured by those around him, when he's being praised and rewarded and loved by his family and friends, the narcissist may feel magnanimous and "full," in concert with his false self-image, since the strength he draws from love and praise allows him to ignore his internal contradictions. But the slightest interruption in the flow of admiration intensifies the ever-present conflict between his grandiose view of himself and his realistic one. In an effort to relieve his private anguish, he may resort to acts of self-degradation and defilement, perhaps as an unconscious reminder to himself that he is not who he pretends to be.

Sexually abusing a child, particularly one's own child, is the most self-demeaning act of all, but there are also things about sex with children that help repair a wound to the narcissistic ego. Gratification

no one until he saw his own reflection in a pool of water and fell hopelessly in love with himself. So transfixed was he by his own image that, unable to leave the pond to eat or sleep, he withered and died. It was Freud, seeking to describe the kind of intense self-love character-istic of tiny infants, who coined the term narcissism. But it was Sandor Ferenczi who first recognized the existence of a personality disorder in adults that seemed to stem from an oversupply of infantile narcissism.

During the 1950s and 1960s, the concept of narcissism was refined and expanded by students and followers of Ferenczi, notably the late Heinz Kohut of the University of Chicago. As with most things, Kohut suggested, narcissism is a matter of degree. Everyone is narcissistic to some extent, since to be entirely without self-admiration would be no longer to exist. Moreover, the range within which varying degrees of narcissism can be viewed as a positive asset is fairly wide. It is only when an individual's self-image becomes grossly unrealistic that the borderline between a healthy personality and unhealthy one is traversed.

The extreme narcissist portrayed by modern psychiatry has aspects of the mythical figure in his character. His sense of his own superiority, and his certainty that everyone is as interested in him as he is in himself, can be suffocating. Outwardly, he retains a childish and unrealistically inflated view of his appearance, his abilities, and his intelligence, all of which are in his own eyes unique. The narcissist is forever mentioning the important people he knows, whether he knows them or not. He finds it hard to keep a secret, because telling secrets is a way of showing how important he is. He lies about both his real and imagined achievements, alternately taking credit that could not possibly be due him and disparaging the accomplishments of others. He indulges in grandiose and totally unrealistic fantasies — becoming a millionaire, becoming a movie star, becoming President — and whenever one of his schemes for gaining wealth or power collapses, he's got an even grander one just up his sleeve.

On paper, the extreme narcissist comes off as something of a cartoon character, an insufferable buffoon not unlike Ted Baxter, the preening anchorman on "The Mary Tyler Moore Show." But there are many quieter and less easily recognizable, though no less debili-tating, forms of narcissism. Kohut, who was the first to propose a systematic approach to the treatment of narcissistic disorders, describes the more typical narcissist as someone who will wander the streets of an unfamiliar city for hours rather than expose his lack of knowledge to strangers by asking directions. Or who, when asked whether he has

pictures but suggestive ones that only a true pedophile would find erotic. Many of the men developed erections, and when they were interviewed again, more than half admitted for the first time that they had abused children other than their own. Even so, the admissions did not always come easily. Judy Becker recalled one man who, insisting that "the test must be wrong," left the clinic in a huff. An hour later he telephoned to say he had just remembered abusing two unrelated children. "A hard thing to forget, I would think," Becker said.

By discounting the idea that all incestuous fathers, or even most of them, are necessarily regressive, the Able-Becker research adds an important dimension to the understanding of child sexual abuse. But an even more important dimension is still lacking. Labeling men as fixated, regressed, or crossover abusers may be a good way of describing their behavior, but it isn't much help in explaining why some men want to have sex with children while others do not. Freud suggested that human beings, in a cultural vacuum, are capable of being sexually attracted to just about anyone or anything, including children. Since no one lives in a cultural vacuum, Freud's theory of the polymorphous perverse can never be tested. The nature of sexual attraction remains so murky, in fact, that nobody really knows where any sexual preferences come from, even those that are considered normal. The consensus among those who have studied child abusers is that a sexual attraction to children is learned behavior and not inherited, but most researchers admit that they haven't a clue about what the learning mechanism is or how it works.

Despite the superficial differences among child abusers, is there some common experience or personality trait that links such individuals with one another? One thing many abusers have in common is that they themselves were sexually abused as children. Forty percent of the men in the Able-Becker study said they had been childhood victims of abuse, and other researchers have reported numbers as high as 80 percent. Such findings cannot be a coincidence, but to say that many child molesters were sexually abused as children still does not explain why a person grows up to treat children as he was treated when he was a child. Nor does it explain the behavior of all child molesters, since it leaves room for those who were not sexually abused as children. The closest anyone has come to a universal description of adults who are sexually attracted to children is that nearly all of them are narcissists. But what is narcissism, and how does it contribute to the sexual abuse of children?

The mythical Narcissus was a beautiful Greek youth who loved

malady or a disease, simply a sexual preference that is much more prevalent in this country than you would think."

Mike is dead-set against child abuse; it's just that he doesn't see himself as a child abuser. "If we're ever going to do something about child abuse," he says, "we're going to have to define it. Sex is going to have to be separated from child abuse. Forcing a child to have sex is the most reprehensible crime I can think of. But having sex with a willing, healthy girl is simply not an abnormal act. People just don't want to face the fact that a young girl becomes a sexual animal when she reaches the age of puberty. No amount of stupidity will ever convince a healthy thirteen- or fourteen-year-old girl who has just had an orgasm that she was a victim of abuse. I am not a pedophile according to the laws of science and nature. I guess it depends on which law you go by."

The clinical descriptions of regressed and fixated abusers appear to fit Jerry and Mike rather well, and they also apply to many others like them. But to classify every incestuous father as a regressed abuser would be incorrect, because a sizable minority of men who have sex with their own children are really fixated pedophiles. The existence of this third category of "crossover" abusers, fathers whose primary sexual attraction is toward children in general, has not been recognized until quite recently, and for good reason. Because of the notion that most incestuous fathers are regressive personalities whose abusive tendencies are only triggered by some trauma in their lives, such men are seen by many prosecutors and judges as a less serious threat to children. As such they stand a good chance of avoiding jail, and if they have also abused children besides their own, it's to their advantage to keep quiet about it.

The first researchers to break through this barrier of silence were Gene Able and Judith Becker of the New York State Psychiatric Institute.[1] Able and Becker assembled a group of 142 men who appeared at first to be typical incestuous fathers. All had admitted having sex with their own children and denied abusing any unrelated children, or even being sexually attracted to children in general. Before beginning their study, Able and Becker secured a promise from the police that none of the men would be charged with additional crimes if they admitted abusing other children in the course of treatment. Then they hooked the men up to a plethysmograph, a machine that can use a small collar filled with mercury to measure the erection of the penis — a sort of erotic lie detector.

The men were shown pictures of children, not pornographic

been with women his own age. But as his marriage deteriorated, Jerry found himself turning for companionship to his daughter Judy, who was also feeling abandoned by her mother. "Judy and I were close," he says. "We went to the store, we went to the shopping center, we went everywhere, holding hands. We made jokes, we talked a lot. She wanted attention, and I wanted attention. After a while I started getting turned on by her. She used to take showers and then walk from the bathroom into her room just wearing a little towel. To me that was very erotic. It started off with a lot of petting and so forth. She was in the house, we were very close, and Diane wasn't there. The first time she was very curious, very willing. When it got to where she was masturbating, me, she was about ten, probably, or eleven. When we got into oral sex, it went on for at least two or three years. We got together maybe three or four times a week."

According to Nicholas Groth, the second category of abuser, the "fixated" abuser, is a different personality altogether. His sexual interest in children develops early, even while he is still little more than a child himself, and it becomes the central focus of his life. As he grows older, the fixated child abuser remains so enamored of children that he may never feel any attraction for someone his own age. Because most fixated abusers are unlikely to marry and to have children of their own, their only recourse is to abuse other people's children. When they do, they act not on impulse but with a lifetime's worth of premeditation.

Mike is a college graduate, self-employed, intelligent, and artic-ulate. He is also an acknowledged pedophile whose victims so far number a dozen, all of them girls. His girlfriend of the moment is thirteen. Like most pedophiles, Mike becomes angry at the suggestion that his attraction to children is anything but a conscious choice. "I can relate to older women," he says. "I am not afraid of them. Having sex with women my own age is as simple as getting a beer out of the ice box. But I'm no more interested in having sex with one of them than with a buffalo." Mike was in his early twenties when he realized he was a pedophile, but the realization came gradually. "I dated girls my own age through high school," he says. "Then sometime during my college years I noticed that I had an attraction to girls much younger than I. It wasn't that noticeable for a college boy of twenty-one and a girl of fifteen to be seen together. But after I graduated from college, the girls stayed the same age and I got older. I became concerned enough about it to see a friend who was a psychiatrist. The only answer I got was that there is no answer, that it was not a treatable

Whatever the number of child abusers, many therapists continue to classify most of them into one of two very broad categories developed several years ago by Nicholas Groth, a psychologist who works primarily with inmates in the Connecticut state prison system. According to Groth, the first category, the "regressed" child abuser, is an adult male who has led a relatively ordinary life. Because he has teenage girlfriends while he's a teenager and adult women friends when he becomes an adult, the chances are good that he will marry and become a father. But at some point, usually during his thirties, his sexual interests suddenly expand to include children; because he's likely to be a heterosexual, it's also likely that the children to whom he's attracted are girls.

Most fathers who sexually abuse their own children fall into the regressed category by default, since to have fathered children in the first place they must have had some sexual attraction to an adult woman. What triggers the regression is usually a mystery to the abuser, who will frequently say something like, "I just don't understand why I did that. I've never been turned on by kids." When the incident is examined in retrospect, however, it usually becomes clear that the abuser was suffering from some unaccustomed stress at the moment he turned to his children for sex. In Jerry's case, it wasn't until his wife went back to school and left her husband to run the household that he started having sex with his daughter.

"Diane worked all day, and she went to school at night," Jerry recalled. "She was taking some very heavy classes, and she wouldn't settle for anything below an A. To do that, you have to keep your nose in the books. Because I was dealing with all the kids at home, it was me who took the responsibility for the kids doing well in school. I would tell her, 'I need your help, I want you to talk to the kids once in a while, I want you to see that they get some homework done. I want you to see that they take their baths.' She'd just say, 'Oh, don't worry about it.' And then something would happen, one of the kids would get in trouble or something, and she would still say, 'Don't worry about it.' I was very upset about that." Jerry found the changes in his life-style traumatic, and his sexual relationship with his wife was suffering as well. "We didn't have any kind of sex life," he says. "I don't call going to bed and her sitting there with a book and all of a sudden putting it down and wanting love something that's going to turn me on. I couldn't do that, so we just kind of shut off the sex. We were just one step away from getting divorced."

Until then, all of Jerry's physical and emotional relationships had

from abusers who were frightened of being found out. Instead, he gave the men an opportunity to disguise their answers through the use of a little-known polling technique, called the randomized response, that depends on the flip of a coin.

If someone flips a coin an infinite number of times, in exactly half the cases the coin will come up heads and in the other half it will come up tails. But flipping a coin even a few hundred times will produce results that are exceedingly close to a fifty-fifty split. Those who responded to the *Times* survey were told at one point that they were about to be asked a sensitive question, but that they would be able to answer in such a way that the poll taker would not know what their answer was. In fact, a set of two questions was posed to each respondent — the first an innocuous question, either about whether they were members of a labor union or whether they rented their homes, and the second a question about whether they had ever sexually abused a child. Then the respondents were asked to find a coin and flip it. If the coin came up heads, they should answer the innocuous question. If it came up tails, they should answer the second one.

Because the respondents didn't tell the poll takers how the coin toss turned out, the poll takers had no way of knowing which question was being answered. But it really didn't matter, because after 1,260 flips of the coin the chances were excellent that half the men had answered one of the two innocuous questions and the other half the question about child molesting. Depending on which of the two innocuous questions was asked as part of the coin-toss series, the other innocuous question had been inserted into the main body of that respondent's questionnaire. That told Lewis the average percentage of labor union members and home renters among his respondents, and it also made it possible for him to extrapolate the number of admitted child molesters in the survey.

The number he came up with was astonishing. About one man in ten, it seemed, acknowledged sexually abusing a child. Even when the standard margin of error was added, the conclusion was that between one man in five and one in fifteen was a child molester. A special margin of error had to be added to account for people who didn't understand the relatively complicated directions or who had simply lied. But even then, the absolute minimum figure — one abuser in every twenty-five American men — was four times higher than anyone had dared to speculate, and it brought a new order of magnitude to the question of how many child abusers there are.

Abusers

EXCEPT FOR THE FACT that they like to have sex with children, child abusers look and act pretty much like everybody else. Many of them are men and women with jobs and families, liked by their coworkers and neighbors and respected in their communities, the sort of people whose friends will say, "It can't be true. I know that guy. He's a nice guy." Researchers who have spent lifetimes searching for the profile of a typical child molester have concluded that there simply isn't any such thing. Child abusers can be rich or poor, smart or stupid, boorish or charming, failed or successful, black or white. Even some of the judges, prosecutors, police officers, and social workers whose job it is to put child molesters behind bars, and to protect their victims, have been convicted of molesting children.

How many child abusers are there? Nobody knows, mainly because those who abuse children sexually are far less inclined than their victims to talk about their experiences. The conventional wisdom among child protection workers, one founded on instinct rather than fact, has been that perhaps one adult male in every hundred abuses children sexually. If true, that would place the number of child molesters in America at a little over one million. But there is some new and persuasive evidence that even that remarkable number may be far too low. In addition to being the first to ask a random, nationwide sample of Americans whether they had been sexually abused as children, Bud Lewis of the *Los Angeles Times* was also the first to inquire into whether they had sexually abused any children. In conducting his 1985 survey, however, Lewis's poll takers didn't directly ask the 1,260 adult men they spoke to whether they were child molesters. To do so, Lewis thought, would surely produce denials

wanted a house in the suburbs. I wanted to do a lot of different things. My husband always said that I was frigid. That's a joke, but he really thought so. I had a lot of career ideas, and I was becoming very subordinated to my husband's ambitions.

"I had enough affairs that I remembered what it was like, that I didn't get out of practice. Every so often there's a real good man that comes along. Men seem to like me. I'm pretty selective with them, and the ones I like, I like a lot. They've always been older, more powerful. They tend to have white hair. I'm going to run out of older men soon. They don't last too long past seventy."

doctor, and he had treated me as a doctor, and I obviously had a lot of confidence in him. I found him very gentle. He sewed up my head when I fell off the swing and had to have a lot of stitches, that sort of thing. And he was a nice, handsome doctor. He looked like Douglas Fairbanks to me.

"Cathy had told me about being with him before, so I think I was pretty forewarned about what we were getting into. I think she was getting a real giggle out of it. She took me down to his room to show me, 'Look what Clay can do.' His wife was gone a lot. She had a boyfriend herself during those years. I didn't know exactly what their relationship was, but I knew that she went and stayed with him a lot. Clay never told me to keep it a secret. I think it was understood, just understood. It's the same kind of thing as little boys and little girls going out in the garage and playing doctor. I was pretty aware that you don't go home and tell your mother that either. He gave me a lot of nice presents. It wasn't part of the deal, but I was always rewarded by being his special little girl. I really loved him romantically, like a man and a woman. He was very exciting to be around. I got pleasure from it in a cuddly way, being held and petted. The payoff wasn't orgasms, it was something else. But I liked the sex part. I like a man's body, especially a nice, healthy man like him. Even when I was very little I liked that. There is something quite thrilling about the opposite sex, especially when you don't know what men look like or feel like or taste like.

"It went on with Clay until I was nine or ten. I truly don't remember feeling guilty about it, even when I was a teenager, getting out of high school and going into college and beginning to have normal relationships with boys. I never connected that with Clay.

"When I started seeing boys my own age, I didn't think of them the way I thought of Clay. I might as well have been a virgin. I had a steady boyfriend, petting in the backseat at the drive-in, all through high school. They were two different tracks, different experiences. I was everybody's favorite daughter-in-law type. And I wasn't promiscuous. I first had intercourse with somebody other than Clay between high school and college. It was somebody I worked with. It wasn't nearly as much fun. It was like the first time, but it wasn't any fun at all. It wasn't not nice, it was just nothing.

"I married a nice guy. The marriage was not passionate. I married him because he was a real good catch at the time. I don't think I ever regarded it as a marriage made in heaven, or even very romantic. It was a very convenient marriage for both of us. He was very boring. He

had my choice, I would have usurped my dad. Period. I would have. I didn't like it that my dad was sleeping with my mother."

It was not until his own children were grown that the repression finally gave way. "I would be out watering the yard, and I would see scenes. Me in the bathtub. Me with my mother and my aunt in that bedroom. Me and my mother at the lake. Things started falling into place. So I started going to therapy." When Hugh decided to confront his mother about what had happened, "she denied everything. She said, 'I guess if you've got to hate somebody, you might as well hate me.' She said, 'You're not going to be invited to my funeral. I don't want anybody there that doesn't love me. You cannot possibly love me and be saying these horrible things about me.' She's seventy-seven now, and I guess she sees everything falling apart as far as I'm concerned, and she wants me to save her ass. And I'm not going to do it anymore. I've done it. For many years, I carried a resentment and an anger. I waited for her apology. I waited for her admission of reality. Then my therapist said, 'How come you're so angry at your mother?' I let it go. She doesn't owe me anything. There's no debt owed anymore. I wish that it had never, ever got started in the first place, of course. Maybe I'd still be married. Maybe I wouldn't have become an alcoholic. I almost killed myself, you know. But she was my mother. And I loved her. And I forgive her. And I forgive myself for being sexual."

* * *

"I've never met a man like him," Karen says. "His name was Clay. He was a very close family friend. I can't remember when I didn't know him. His daughter Cathy, who was my age, was my best girlfriend. I remember the way that it all came about. I think I was seven when it started. The game was that we little girls would walk on his back like the Japanese women in the bathhouses, however that's done. It evolved very, very easily. It just wasn't difficult at all, either physically or emotionally. And I always loved being with him.

"The first time, it started with the walking on his back and ended up with us sitting in his lap. I can't really remember, but I think Cathy encouraged it. And he was quite ready for it. It was like grown-up intercourse. I didn't know very much about where babies come from at that age, but I don't think I thought it was shocking. I thought it was fascinating. It happened a lot after that. I don't imagine that it was more than once a week, but it was at least that. He would call, or I'd just go by his house. I don't remember being frightened. He was a

to help her take her pants off. I remember my mother coaching me to do things with Margaret, Margaret resisting, my mother telling me to go ahead, that Margaret doesn't really mean it when she says don't do that or slow down or stop, that the reason Margaret is unhappy and not having any sex is because she's always saying no. The next thing I remember happening is that the three of us were under the sheets, playing around."

The next summer, at the lake, when Hugh was thirteen, his mother walked into his bedroom late one night. "I remember it was stormy. We had electrical storms back there. She came in and asked me to come sleep with her because she was frightened. It was the only time she'd ever been frightened, but I went into the bed with her. What I remember is that when I woke up she was sucking on my toes and rubbing my legs and whimpering. And I'm turned on. I am turned on. And then I got on top of her, and I can remember touching and kissing and intercourse, and her crying afterwards and sobbing, saying how sorry she was and that she couldn't control herself, and that she missed my dad." The last incident Hugh remembers happened in a rowboat on the lake the summer before he entered college. "Mother was in the boat, and she said, 'Let's sunbathe, take off our suits.' We lay down in the bottom of the boat. I sat up every now and then, because it was my job to be sure that nobody discovered us."

They did not make love that day, though Hugh remembers wanting to. "I didn't like being seduced and not being able to complete it. There's still a lot of anger about it. Let's either do it or don't do it." During college, the sexual part of their relationship came to an end. "All through college I lived at home. We had a shower down in the basement. I'd go down there and take a shower rather than stand in the bathtub. And invariably my mother would find a reason to come down into the shower and see me naked. I started to complain about her invading my privacy. Her comment would be, 'Don't be ridiculous, you haven't got anything I haven't seen before.' I had a feeling that what she wanted to do was see me with an erection.

Hugh thinks he must have had "an awareness that the things we were doing we weren't supposed to be doing." But he also remembers thinking that "I had some power with this relationship, because it's mutual blackmail. She can blackmail me and I can blackmail her. I could get by with things that my dad couldn't get by with. And I still can to this day." Thirty-five years and hundreds of hours of therapy later, the anger still filters through his voice as he talks about his feelings for his mother. "I didn't like playing second fiddle. If I'd have

"When we would go to the lake every summer, my dad would stay home and only come up on the weekends. He wasn't usually around. I was kind of her counselor. I listened to her. I felt that it was my job to help with the kids at a very early age, to kind of help take care of the family. I became aware fairly young that I had to kind of take care of my mother. That also increased the bond, I supposed, between her and me. There was some feeling of jealousy and competition between my dad and me all the time, when I was a kid. We would compete in sports. I suppose part of it was Mother. Attention, affection, that kind of thing. I would have to keep a low profile. There were times when he would play with her buns and squeeze her breasts right in front of me and wink at me. The things I was knowing I had to keep to myself.

"She was aware that I had sexual desires, and I think it gave her some kind of enjoyment that I had those desires. She would embarrass me sometimes with her sexuality, if her dress got up too high on her legs, if her dress was unbuttoned too far. She would have me actually help her get dressed and undressed sometimes. She had good tits and she had a good body. She did. She was well built, and she was attractive, and she was sexy. She used to talk all the time about men's bodies, because my dad coached. She was always talking about this guy's body and that guy's body, and doesn't Uncle So-and-So have a beautiful physique. I have a recollection of seeing her suck a guy's cock who was a boarder at our house. I have a vague recollection of her with a doctor at the lake. Those things don't bother me that much. If it happened, it happened."

It was not until Hugh's mother drew her younger sister into their relationship that the boy began to grow uncomfortable. "I think they had been out in the kitchen. I don't know if they had had any wine or not. They weren't supposed to be drinking anything, according to the church, but they did. I had taken a bath. I had a towel around me. And my mother talked me into going into the bedroom with her and her sister, closing the door, putting a chair up underneath the door. Margaret, that's my aunt, took off her dress and her slip, sat down on the edge of the bed, and Mother said to help her off with her bra. And I did.

"We got into bed, and the idea was that Margaret got embarrassed and was uncomfortable around men. She wasn't married. And the idea was that we would show Margaret how to enjoy sex. So Mother and I showed her. Mother played with me, with my penis, and I got an erection. Then Margaret did the same thing. Then my mother told me

It was during an abortive journey to Cincinnati to rescue Darla's younger sister, who was enduring the same sort of abuse at the hands of her mother and stepfather, that the two girls finally became separated. "A trucker dropped us off at a truck stop someplace in Arizona. We were going to dine and dash — eat and run — because we didn't have much money. The waitress called the police because she figured we were runaways. They came in and picked us up." Unaccountably, the Arizona officers let Caroline go. On her own again, she returned to Los Angeles, not to Hollywood this time but to the San Fernando Valley, on the other side of the hills. Hollywood was where the "real prostitutes" hung out, and in her own mind Caroline still wasn't one of them.

It was in the Valley, on the corner of Ventura Boulevard one warm September evening, that Caroline solicited a middle-aged undercover policeman who she mistakenly thought was "too old to be a cop. I propositioned him, and he flipped his badge and says, 'You're under arrest.' I almost had a heart attack. He handcuffed me and off I went. He said, 'I have a daughter around your age. If I ever caught her out here, I'd kill her.' And I'm going, 'Oh, my God.' " Because there was a longstanding runaway warrant for her arrest, Caroline was remanded to a juvenile facility in Los Angeles, where she spent eight months in intensive psychotherapy. When the state finally let her out, Caroline went back home. But even though Franklin is living elsewhere, Caroline is uncomfortable with all the memories. She talks of going to live with her grandparents in Colorado, of finishing high school, of studying to become a computer programmer. And when she insists that selling sex "wasn't for me," that she "did it because I had to," she sounds as though she mostly believes it.

* * *

"It was a relationship Mother and I had that was special," Hugh says. "When she took a bath, she would call out to me to bring her a towel, sometimes wash her back, sometimes get in the tub with her. I have vague recollections of her washing my penis, me washing her breasts. I'm talking about up through like the fourth, fifth, and sixth grade. There was a lot of enjoyment. A lot of it was enjoyable, and it kind of cemented the relationship, I suppose. I know that it was a form of attention. It was not necessarily unpleasurable. My dad's not real talkative. Mother always used to complain about the fact that he didn't have feelings or emotions, and I did. And with coaching and teaching, he worked late, until seven or eight o'clock every night.

Besides the hundred dollars, the man gave the girls a motel room for the night, filling out the registration form and telling the desk clerk they were his granddaughters from out of town. The room would be their home for much of that summer, the rent paid each morning from the receipts of the night before. "I always figured prostitutes were sluts and tramps," Caroline said. "But after a while I sort of loosened up a little bit, and I started understanding the prostitute's viewpoint. They don't figure it's wrong, you know. You make love to your husband and he gives you money and buys you clothes. It's the same thing, in a way. I figured Franklin didn't give me anything, so at least I was getting something from it."

The girls developed a routine, taking one or two customers a night, three at the most. Though they always worked together, only one provided sex. "We'd let the man pick which one he wanted," Caroline said. "Whoever he didn't pick had the knife, in case he was a maniac." Most of the men were older, and they seemed to Caroline like regular people. "Me and Darla figured they were lonely, or that their wives were dead or something. We made up stories." They also established rules. They offered only oral sex, and only in the customer's car, at "this place way up in the hills where you can just park, where nobody thinks anything of it." Their price remained at one hundred dollars, substantially more than the regular Hollywood rate for street sex, because "the younger you are, the more you get. The tricks are looking for nine- and ten-year-olds now, and there's a lot of them out there too. I met this one little kid who had run away from home. He was eleven. I remember thinking, It's bad enough that I'm out here, let alone a little child."

Only once did they encounter any trouble, when a customer began to slap Darla after she refused to have intercourse with him. Caroline's knife was out in a flash. "I told him that if I ever saw him again I'd kill him. He said, 'Take my money, don't kill me.' We took his money, almost a thousand dollars. I held the knife to him while Darla took off his pants, and we got out of the car and took off. Then we set his pants on fire."

Caroline met another man who offered her a job making pornographic movies. "He wanted to see if I could play the little-girl virgin type," she said. "He said, 'Oh God, you'd be great for porno.' He said for every picture I'd get five hundred dollars." The money was tempting, but Caroline turned him down. "I figured I'd already lowered myself so far down that I wasn't going to lower myself any more."

not to come within a mile of his sister, Caroline's mother allowed him to return home.

Franklin began where he had left off. Since reporting the abuse hadn't solved her problem the first time, Caroline tried something different. She ran away, losing herself in the swarms of children who make the boulevards and back alleys of Hollywood their home, living with whoever would have her for a week or two and then hitting the streets again until someone else took pity on her. She moved in with some members of a motorcycle gang for whom she became a "house mouse," looking after their children and cleaning their shabby pad. It wasn't much of a life, but at least Caroline was safe until the gang members tired of her and tossed her out.

Her only real friend was Darla, a twelve-year-old runaway from Cincinnati who had made her way to Los Angeles by cadging rides from truckers. When they met on the corner of Hollywood Boulevard and Las Palmas Avenue, a favorite hangout for child prostitutes, "Darla was out there hustling. That was her only means of support. She didn't know what else to do. She showed me the burn marks on her stomach where her mom took lighted cigarettes and put them out, and told me stories about being raped by her stepfather." Her maternal instincts aroused, Caroline gathered the girl up and took her to the North Hollywood home where she had found a job keeping house for a young couple who had picked her up hitchhiking, "nice people who were helping me get back on my feet." But when the couple insisted that Darla leave because she wouldn't give up her Quaaludes, Caroline left with her.

Back on the street with no place to live and no money for food, Darla suggested that they turn a trick. When Caroline made a face, the younger girl assured her that it really wasn't that bad. Like most child prostitutes, the two girls didn't have a pimp or a madam behind them. When they went into business they did it on their own, the fifteen-year-old redhead and her twelve-year-old sidekick standing on Highland Avenue with their thumbs out, pretending they were hitchhiking and waiting for someone to stop. When someone finally did, he was old enough to be Caroline's grandfather. The man offered her a hundred dollars and Caroline agreed, but only if Darla could come along. He drove to a secluded spot in the Hollywood Hills, where Caroline performed oral sex while Darla acted as the lookout. "I just blocked it all out," Caroline said later. "It was a way to get money so Darla and I wouldn't be on the street. I thought he was an asshole. He shouldn't be coming out for young girls."

that if I were good enough I would be loved. I hate myself, and I hate other people for not loving me."

* * *

Caroline remembers clearly the night her brother Franklin, then twelve, first woke her from a sound sleep, remembers telling him to "stop playing around," pleading that she had to get up early to fix her younger brothers' school lunches. But Franklin did not stop, not then and not for years to come. Instead of telling her parents about what was happening, Caroline made excuses for her brother. "Before it happened, I loved him a lot," she says. "I figured he's mentally ill, he doesn't know what he's doing. I didn't want to send him to prison." When her two younger brothers, the ones she still calls "my angels," walked into her bedroom while Franklin was there, Caroline screamed at them to get out. She can still see the bewildered look on their faces. "In the morning we talked about it," she says. "I told them I didn't know what to do. But they were pretty young. I don't know if they really understood what I was saying."

Until then Caroline had been doing well in school, getting mostly A's and B's. But in the fourth grade she simply gave up, and her grades took a plunge. She sees it now as a cry for help, but it was so muffled that no one heard. Once, in a conversation with her father, she hinted at what was happening. "I said, 'Dad, if somebody did something to me, what would you do?' " When her father answered, "Kill him," she thought it best to let the matter drop. Only when Franklin began turning his attention to one of her younger brothers did Caroline, then fourteen, decide to act. "That just blew it," she says. "I raised them. When they first started to talk, they were calling me Mommy. I won't let anybody hurt my little brothers. They're my babies."

By then her parents were divorced, her mother remarried to a man Caroline neither liked nor trusted. When she finally decided to tell someone about Franklin, it was her junior high school counselor. The woman, she said, "almost had a heart attack. She called the police and everything. I was so scared." There was a hearing, and Franklin was committed to a psychiatric treatment center. It was after he went away that Caroline began "having bad dreams, losing all my emotions, hardening up so I wouldn't be hurt anymore." About the same time, she acquired her first real boyfriend. "I started trusting him, opening up, we talked. Then he wanted to take me into his bedroom, and I said, 'That's the end of that.' I never saw him again." After a few months Franklin was released. But despite a court order that he was

time that I became increasingly unhappy, a sadness that shaded everything I did and everywhere I went. I just couldn't seem to snap out of it. I think I understood that I should be seeing someone about this, but I felt too depressed to even bother. I don't remember any specific thoughts about killing myself, something I'd considered at least twice before, but I do remember thinking for days on end that if things didn't get better I would do it, that I couldn't bear feeling this terrible for years and years to come.

"Suffering through a long period of depression is hard to describe — it was like feeling trapped and helpless, unable to control my emotions, to be excited or happy about anything, sometimes unable even to get out of bed. Most of the time I could get dressed and go to work and do my job. But I cried all the time, frequently in the bathroom at work over nothing, more often at night, at home alone. The days I'd have to stay in bed were when I was so tired of crying and caring that I'd just go numb all over. I remember feeling that anyone could do anything to me and it wouldn't make any difference. This went on for nearly a year. I solved it once again by moving, this time two thousand miles away, to a new job in a new city where I didn't know anyone. At first the sheer craziness of all the things I had to do, from meeting people and learning my job to finding a home and a car, kept me so busy that I felt OK.

"About six months into my new job, the depression started again. I worked harder. I tried to do other things. It would abate for a while and then get worse again. Occasionally, because my job was so intense, it would go away completely for a while, only to creep back again. About twelve months into my new job I began to hate it, and to regret moving. That's when I started to apply to medical school — instead of dealing with the problem, I tried to escape once again. Six weeks after I began school, the crying jags and emotional upsets began again, nearly destroying my concentration and the friendships I was beginning to make.

"I chose to pursue a ridiculous relationship and became deeply depressed when it didn't work out. I studied myself into total exhaustion. I worried about everything. I couldn't sleep for days at a time. I tried to overcome the growing emptiness by making myself indispensable to my friends — cooking their meals, washing their clothes, typing their papers, a method of holding on to people I fell into frequently when I was depressed. Most of the men I've treated this way react similarly. They get used to it and then get angry if I stop. Then I don't feel appreciated, as though I will never be good enough,

I've never been sure why, but it would be eight years before I took the weight off. I think now my conflicting notions about sex probably contributed enormously. If I were unattractive I wouldn't have to worry about sex. And I didn't. I studied hard, became editor of the school paper, assistant director of the school show, author of the senior class play.

"I wanted to please everyone, my parents, my teachers, my friends. I gave myself as little time to think as possible — and no time to worry about boys. By the time I graduated I weighed a hundred and sixty pounds. I had to ask an older friend to take me to my senior prom because no one else had asked me. All during my adolescence and my twenties I never completely trusted men. I didn't like to be near people I didn't know, and I never talked to strangers. I remember one morning, fifteen years after that day in the barn, when some man grabbed my rear end as I was crossing Times Square, turning around and hitting him. I felt sad and angry all day long, and that night I had a nightmare about a barn. I was depressed for weeks afterward.

"At twenty-one, only a few months after I graduated from college, I started working at a high-pressure job at a very high-pressure organization. The depressions that had plagued me occasionally during high school and college started again. I 'cured' them by eating obsessively, or moving to a new apartment, or getting myself way too involved with work or in relationships with the wrong men. There were bright spots — a fairly long and stable time with a very kind older man when I was twenty-three — but when these ended the depressions got much worse. When I was twenty-four, in the space of two weeks my older man friend ended our relationship, my roommate moved out, and I switched jobs.

"I channeled all my efforts into losing weight, though I'd already lost about fifty pounds and really didn't need to lose any more. I became more than a little obsessed with food, dropping twenty pounds in six weeks, becoming so angry with myself that I'd cry if I ate more than a hard-boiled egg for dinner, exercising constantly. Fortunately my doctor caught on to what I was doing and helped, and my job turned out to be fun, and that helped. Things began to improve. I had about one and a half relatively unturbulent years, although they were marked by the fact that I dated no one during this time and spent an enormous amount of time shopping and living at my parents' house.

"Another slide into depression began about Christmas of the year I was twenty-five. I met a man on vacation, had a wild affair, came back to New York, and started sleeping with everyone. It was about this

elastic waistband on my shorts away from my body. I remember feeling afraid, but not really knowing why. Then he put his hand down my shorts and began rubbing between my legs. I remember being horribly embarrassed and upset and pulling away from him, saying something about not wanting to be tickled any more. I remember trying to find the door and trying to get away from the barn and being absolutely terrified that he would follow me. I have no memory of the rest of the day. Before I left to go home, I wanted to tell my friend's mother about what happened, but I was afraid that I would be blamed or that I would be punished for doing something so awful. My parents expected me to be perfect. So I didn't tell anyone.

"In the ninth grade, my best friend and I began spending Friday nights at her house or my house. We would stay up until three or four in the morning, talking about everything, eating Popsicles, watching reruns of 'Sea Hunt' and monster movies, listening to records and the radio, occasionally sneaking a beer or a Bloody Mary. We made dreadful Bloody Marys, but we didn't know the difference. We had adolescent crushes on everyone from boys at school to rock stars. Our high school was hosting an exchange student from Austria, blond, charming, and a good soccer player, very popular. On the night that winter vacation began, my friend's parents went away, and we decided to stay at her house, in the basement, which had twin beds, a TV, a stereo, and easy access to the kitchen.

"My friend's brother and the exchange student had gone to a party somewhere and came back about midnight, very drunk. The four of us ran around the house, having pillow fights and chasing each other. Down in the basement, where we went to 'talk,' the exchange student put his arm around me, and we began kissing. I remember feeling terrified and at the same time very aroused. Then he started to unzip my jeans. I felt instant panic — guilty and afraid, as though I were doing something disgusting and horrible. I felt awful. For months afterward I felt very ashamed, as though I'd done something that would ruin my life forever. I tried to convince myself that I hadn't been responsible — and that I hadn't liked it. But I hated myself for enjoying it even for a minute.

"I didn't think consciously of that day in the barn, but I'm sure that's what terrified me so much. I'm sure that my subconscious feelings about that day were what threw me into such a panic and made me later convince myself that I had almost been raped. That's how I felt, as if I had been violated in some way. It was just about that time that I began to gain a lot of weight. I began to eat compulsively.

Victims

N OT ALL SEXUALLY abused children grow up to become child abusers. Though Alison, Caroline, Hugh, and Karen were all abused as children, none of them has ever abused a child. But their lives as adults have been defined nonetheless by the anguish of their experiences as children, and the stories they tell compose a fairly comprehensive map of the psychological terrain of sexual abuse.

It was in the summer of her eleventh year that Alison was invited to visit the New England farm of her best school friend. Encouraged by the caretaker, a man in his early fifties who lived in a house up the road, she spent much of the time trying to train a chestnut foal that had been born a few weeks before. "The caretaker and his wife always seemed to enjoy having children around," Alison says. "I remember they had puzzles and games at their house, and I remember feeling very welcome there. The afternoon it happened must have been fairly hot, because I was wearing a sleeveless top and matching shorts and sneakers. It was dark inside the barn. We must have been standing on the lower level, because I remember looking up and seeing sunlight filtering through the dirty windows. There was lots of hay tied in bundles all around me, and I remember how nice it smelled.

"I remember standing in the barn, and I remember the caretaker grabbing me around the waist from behind, saying he was going to tickle me. I had grown up in a very reserved family, and I did not like to be touched by strangers. I did not want to be tickled, but I also remember thinking that children should behave. I was an eldest child and had always been told to set a good example. I was taught never to question what adults did or said. So when the 'tickling' started I didn't do anything. But soon the man was pulling my shirt up and pulling the

The irony, of course, is that in view of what the retrospective studies show about the probable extent of child sexual abuse, it is entirely possible that more of Freud's patients were telling the truth about their childhood experiences than he was ultimately prepared to believe. Especially in light of Ferenczi's discoveries, the principal question that arises is whether Freud was right the first time around, whether the seduction theory was essentially correct. If it was, then what are the implications for the validity of the oedipal theory with which it was replaced? Freud's daughter, Anna, has maintained that had her father clung to the seduction theory, "there would have been no psychoanalysis afterwards."[27] But what remains unclear is why, as Ferenczi appears to suggest, there cannot be a duality of theorems.

While Freud's original thinking has been questioned and modified over the years, hardly anyone in the mainstream of psychoanalysis argues with the importance of some kind of oedipal experience in children. Suppose that children who are not sexually abused do follow some variant of the oedipal path and that, for them, the desire for sex with the parent of the opposite gender is ultimately repressed. For those children who are abused, the repression of the oedipal desire and the consequent formation of the superego are simply interrupted by the intrusion of a real sexual experience that brings the unconscious forbidden fantasy to life. If this is so, it may explain why so many victims of child sexual abuse, and particularly victims of incest, enter adulthood so utterly lacking in self-esteem, and why so many sexually abused children grow up to become child abusers themselves.

selves after they became adults — admitting that they were child molesters.

Fantasies about having been sexually abused were one thing, Ferenczi thought, but fantasies about doing the abusing? As he thought it over, Ferenczi wondered whether the oedipus complex might be "the result of real acts on the part of adults, namely violent passions directed toward the child, who then develops a fixation, not from desire [as Freud maintained], but from fear."[25] It was in the final paper of his career that Ferenczi broke with his friend and mentor. "Even children of respected, high-minded, puritanical families," he declared, "fall victim to real rape much more frequently than one had dared to suspect . . . the obvious objection, that we are dealing with sexual fantasies of the child himself, that is, with hysterical lies, unfortunately is weakened by the multitude of confessions of this kind, on the part of patients in analysis, to assaults on children."[26]

When Ferenczi read his paper to the Twelfth Internationl Psycho-Analytic Congress in Wiesbaden in September 1932, it received a reception very much like the one accorded Freud in Vienna more than three decades before. This time, however, Freud himself was among the dissenters. Irretrievably committed by now to the oedipal theory and the body of psychoanalysis he had built up around it, and no doubt feeling betrayed by an old and trusted colleague as well, Freud tried to stop Ferenczi from reading his paper. Ferenczi's age and stature prevented such an affront, but when Ferenczi died a few months later, his ideas went with him.

Jeffrey Masson, a psychoanalyst and former secretary of the Freud Archives, attributes Freud's abandonment of the seduction theory to his desire to restore his credibility among his colleagues, a decision Masson calls "a personal failure of courage" and a "momentous about-face that would affect the lives of countless patients in psychotherapy from 1900 to the present." There is some evidence that he is not overstating the case. For much of this century, women who have sought psychotherapy to relieve the lingering agony of the sexual abuse they suffered as children have been told by Freudian-trained analysts that they were merely fantasizing about such experiences. When Judith Becker, who directs the sexual behavior clinic at the New York State Psychiatric Institute, studied four hundred women who were victims of childhood sexual abuse, she confessed to having been "amazed at some of the stories" they told about their therapists. "Either the therapist did not focus on the issue," Becker says, "or the women were made to feel responsible."

Freud also represents the child's first act of conscience. The outcome, Freud thought, was the formation of the "superego," that part of the psyche where the child's sense of self-esteem resides. Having done the right thing by not having done the wrong thing, the child is now entitled to feel proud of himself.

But what of the young girl unconsciously in love with her father who harbors murderous thoughts about her mother? For her castration is not a concern; Freud surmised that it was her disappointment at not having a penis that caused her to turn her affections toward her father in the first place. The girl's fear is that her mother, discovering in her daughter a rival for her husband's affections, will murder her. She is naturally frightened by this prospect, and the repression of her own oedipal impulse follows. But her fear of murderous revenge from her mother is seen as somehow less intense than that of the boy who fears castration, and for the young girl the repression is less complete and effective. Because there are a few chinks in her mental wall, she retains some sexual feelings for her father during childhood and even for the rest of her life, feelings that may play an important role in explaining the dynamics of father-daughter incest.[23]

At last, Freud thought, he had the riddle solved. The oedipal experience was not only the central event of childhood and the major determinant of the adult personality, it was also the "nuclear complex of every neurosis." Neurosis in adults wasn't caused by childhood sexual experiences after all, but by the unconscious desire for such experiences and the subsequent repression of that desire. Only when those repressed wishes had been summoned up from his patients' unconscious minds during psychoanalysis had they begun to "recollect" such scenes. Most of all, it wasn't that large numbers of children were actually having sex with their parents, merely that they unconsciously wished to do so.[24]

Since the seduction theory and the oedipal theory seemed mutually exclusive, it looked like the end of the seduction theory. It almost was, but not quite. In the early 1930s a brilliant Hungarian analyst named Sandor Ferenczi, one of Freud's closest colleagues and widely respected in his own right, began to wonder whether Freud hadn't been right the first time around. Like Freud, Ferenczi was seeing a number of patients who claimed to have been abused as children. Had he faithfully followed Freud's map of the psyche, he would have treated such claims as fantasy. But Ferenczi was also seeing something Freud hadn't seen. Several of his patients were admitting during analysis that they had had sex with children them-

had "met with an icy reception from the asses" — and this, Freud said, "after one has demonstrated to them a solution to a more-than-thousand-year-old problem, a source of the Nile! They can go to hell." Freud's colleagues apparently felt the same way about him. Around Vienna, he wrote, the word "has been given out to abandon me."

Less than two years passed before Freud began to doubt his own conclusions. In September 1897, when he wrote to Fliess about "the great secret of something that in the past few months has gradually dawned on me," the secret proved to be his growing conviction that most of the incidents of childhood abuse recounted by his patients had never actually occurred.[19] His error, Freud said, had been both in believing their stories of childhood seductions and in assuming he had thereby discovered the common root of their neuroses. Freud wasn't suggesting that no children were ever sexually abused. The explanation he gave to Fliess was his delayed recognition that it was highly unlikely that so *many* women had been abused, that "surely such widespread perversions against children are not very probable."[20]

Now that it was clear to Freud that many of the stories were only fantasies the patients had made up, he would have to look elsewhere for the causes of his patients' disorders, and for an explanation of why they had contrived such lies. The new theory that emerged would become the cornerstone of Freudian psychoanalysis. Freud called it the "oedipal theory," named after Oedipus, Sophocles' mythical King of Thebes, who unwittingly murders his father, Laius, and marries Laius's wife without realizing that she is really Jocasta, his mother. In the course of his own self-analysis, Freud had become aware of a vague sexual attraction toward his mother and an undefined anger toward his father. Now he wondered whether the patients who had "recalled" sexual experiences with their parents or other close relatives might not be expressing "wishful fantasies" that had begun taking shape while they were still tiny children.

As a natural consequence of such feelings, Freud thought, the child unconsciously fantasized about making love to its mother or father.[21] But the conundrum that inevitably arose in the tiny unconscious mind was how this could be accomplished without first doing away with the other parent. For the young boy, Freud thought, the fear was that his father might discover his murderous intentions and punish him with castration. So horrifying was the prospect that the boy quickly repressed all thought of mother-love, walling the idea off in the deepest part of his mind.[22] Though it is a reaction to the most primitive of fears, the repression of the oedipal impulse as conceived by

except that his patients did not make up a very good cross-section of nineteenth-century Viennese society. Then even more than now, psychoanalysis required a good deal of time and money, and those who availed themselves of Freud's services tended to be well-off and well educated. It was the backgrounds of his patients, in fact, that caused Freud so much astonishment at their recollections. There had been no suggestion in the medical literature of the time that sex with children was anywhere near as widespread as his patients were suggesting, especially among the privileged classes. But it wasn't just a few of Freud's patients who were recalling such abuse, it was every one of them.

So perplexed was Freud that he considered and reconsidered his findings. Were his patients lying? It didn't seem likely, since each of them had apparently repressed all memory of the abuse, dredging it up only after many hours of analysis had overcome what appeared to be their enormous resistance. Conscientious to a fault, Freud began to wonder whether he had inadvertently influenced his patients' recollections by unconsciously suggesting that he wanted them to remember such events. But that didn't seem likely either, in view of the shame and revulsion his patients had displayed while telling their stories.

Try as he might, Freud could see no alternative except to accept that what the women were telling him was the truth, and in 1896 he published his conclusion in a paper entitled *The Aetiology of Hysteria*. Elegantly written and faultlessly argued, it was and still is an extraordinary document. When Freud read the paper to a gathering of the Viennese Society for Psychiatry and Neurology, it marked his first major address to his fellow psychoanalysts, and what he proposed was nothing less than a revolutionary theory of mental illness: the idea that sexual experiences during childhood were the principal cause of neurotic behavior in adults. Freud called his idea the "seduction theory," and the implications were staggering. Since there was no apparent shortage of neurotic adults, the sexual abuse of children must be rampant.

The reaction to his address was immediate, though it was not what Freud had had in mind. The last thing the fledgling psychoanalytical community needed in its struggle for respectability was for one of its members — and a Jewish member at that, in a city that had just elected an anti-Semitic mayor — to announce his conclusion that the Vienna of Wittgenstein, Mahler, and Schoenberg was a city of child molesters. Five days after his speech, Freud wrote to Wilhelm Fliess, a Berlin surgeon who was then his closest friend, that his paper

marriage. "Nowadays," Aries writes, "the physical contacts described by Heroard would strike us as bordering on sexual perversion and nobody would dare to indulge in them publicly. This was not the case at the beginning of the seventeenth century."

Fueled by a moral and religious reformation, the growing predominance of manners, the Industrial Revolution, and the first child labor laws, such behavior began to give way to the notion that children ought to be shielded from the baser elements of life. But despite the gradual recognition that having sex with adults was probably not in children's best interests, a gap remained between word and deed. It was the children of the nineteenth century for whom the first fairy tales were written, but the Victorians have become notorious for preaching one thing and doing quite another where sex was concerned. In 1835, the Society for the Prevention of Juvenile Prostitution reckoned that four hundred Londoners depended for their livelihoods on the earnings of child prostitutes. London hospitals, it was said, had recorded twenty-seven hundred cases of venereal disease among children during the preceding eight years. One of the major accomplishments of England's Victorian-era child welfare brigades was to raise the legal age for prostitution from nine to thirteen.

Things were not much different on the Continent. Between 1858 and 1869, three-quarters of the French citizens charged with rape were accused of raping children, mainly girls, half of them younger than eleven. Alexandre Lacassagne, who held the chair of legal medicine at the University of Lyons, concluded in 1886 that as many as a third of the cases before the French criminal courts at any one time involved the sexual abuse of children.[18]

When the sexual abuse of children was rediscovered in Vienna a generation later, it was quite by accident. Sigmund Freud was just beginning to lay the foundations of what would become modern psychoanalysis, a field then regarded by most who had heard of it at all as a plaything of the idle rich at best and a brand of scientific witchcraft at worst. During the 1890s Freud treated a small group of women who complained of what he called "hysterical illness" — hypochondria, anxiety, hallucinations, and obsessive-compulsive behavior including unfounded fears and uncontrollable impulses, the sort of afflictions that today would be labeled neuroses. There is no detailed record of precisely what Freud's patients told him, but all acknowledged having been sexually abused as children, most by their fathers, a few by their brothers or some other close male relative.

Freud's research might have marked the first retrospective study,

Dunaway startles the audience by revealing that her sister is also her daughter, a phenomenon known to anthropologists as "role strain." In family-based societies especially, it is important that relationships be crystal-clear. Parents must be parents, children must be children, and siblings must be siblings. Incest scrambles these relationships, and the resulting confusion weakens not only the family structure but the fabric of the society as well.

The question of how often the incest taboo has been violated in different societies over the centuries is as murky as the taboo's origins. "We know a lot about what the rules are in other societies," one anthropologist says, "just like we thought we did in this society up until ten years ago. What we don't know is how often the rules are broken in other societies. That's where the big gap is. A lot of research really focuses on the regularities of cultural behavior rather than the deviance. We collect incest taboos, but it's very difficult to get at the question of how many people really broke them."

In many earlier societies, clear distinctions were drawn between sex with one's own children and sex with other peoples' children. While incest in fifteenth-century Venice was punished by long prison terms and even beheading, sex between adult men and unrelated girls was commonplace, so common that the average age at which girls married was fifteen.[16] The prohibition against sex with unrelated children does not appear to predate the idea of childhood itself, and the idea of childhood — which is to say, the recognition that children are not like adults — is a fairly recent one. Not until sometime in the seventeenth century were children recognized as requiring special protection from the rigors of the adult world. Philippe Aries, the cultural historian, points out that children portrayed in medieval and Renaissance paintings have the faces of grown men and women.[17]

Because children weren't accorded special status, there wasn't much concern about whether sex between adults and children was good or bad. Aries quotes from the memoirs of Heroard, physician to the French court in the early seventeenth century, in which he describes the rather raucous sex play engaged in by little Louis XIII and other members of the royal household, including Louis's mother. Little Louis, Heroard wrote, "made everybody kiss his cock. The Marquise [de Verneuil] often put her hand under his coat. He got his nanny to lay him on her bed where she played with him, putting her hand under his coat. The Queen, touching his cock, said: 'Son, I am holding your spout,' " When, at fourteen, Louis wed the Infanta of Spain, his mother watched while the couple consummated their

sections of Bangkok, and the "baby brothels" of Bombay are well known throughout the Indian subcontinent.

No modern society openly endorses sex between children and adults, but such has not always been the case. Egypt's nobility was once permitted to have sex with young family members, and sex was once allowed within the Hawaiian royal family as a means of ensuring that heirs to the throne would be of pure blood. There are a few accounts of more contemporary societies, most of them small and isolated tribes, where some form of sex with children is openly sanctioned. One is the Lepchas of Sikkim, high in the Himalayas, who are said to believe that early sex is necessary to promote the normal physiological development of a young girl.[13] Lepcha girls are betrothed at the age of eight to boys who are slightly older. If a girl does not soon begin her sex life with her intended spouse, an adult member of the village will volunteer to undertake the task. Anthropologists report that something similar occurs among the Chewa of Africa and the Ifuago of the Philippines. Sex between men and boys is also said to be encouraged in the Siwa Valley of North Africa and by some Australian aborigines.[14]

For the rest of the world, sex with children is nominally taboo — nominally, because the extent to which it apparently occurs raises the question of whether such a taboo really exists. The strongest taboo involves sex with one's own children; in that desire human beings appear to be quite alone, since no species of animal has yet been discovered in which adults display a genetic propensity to breed with their own young.[15] But whether the taboo is against having sex with children or, as some anthropologists maintain, merely against talking about having sex with children, its origins are obscure. It may be that, as Roland Summitt has suggested, sex with one's own offspring is such a convenient and appealing idea that the taboo arose as a practical defense against a natural experience with unfortunate biological consequences. It's possible for two close blood relatives to produce a perfectly healthy child, but such a child also has a much greater than average chance of inheriting some serious genetic flaw.

Another reason for the incest taboo might be economic. Claude Levi-Strauss, the French anthropologist, has suggested that the prohibition arose as a way of guaranteeing the exchange of women among families. If daughters bear their fathers' children instead of marrying and beginning families of their own, there will be no new families and the society will cease to flourish. A third reason could be cultural. At the end of the movie *Chinatown*, the character played by actress Faye

thousand British children fall victim to sexual abuse each year, not a small number in a nation of fifty million people.

Much less is known about child sexual abuse in the rest of the world. Though having sex with children is technically a crime in most European countries, child abuse there is not ordinarily considered a matter for law enforcement. All but the most egregious cases are treated as a public health problem best left to social service and child protection agencies to resolve. As a result statistics are sparse, and those that are available may reflect just a fraction of the real incidence. Fifteen thousand cases were reported in West Germany in 1985, and the Italian Association for the Prevention of Cruelty to Children says it knows of about the same number of reports in that country. Underreporting may be particularly high in Italy, however, where closely knit families resist intervention by neighbors or outsiders. In Holland, where the Ministry of Health has established special bureaus staffed by pediatricians and social workers to treat the victims of sexual abuse, an average of three thousand cases a year are recorded from among a total population of four million children.

Almost everywhere else in the world, the sexual abuse of children is low on the list of official priorities. Dick Willey, who heads the Los Angeles County Sheriff's Department task force on sexually abused children, recalls attending a conference in Europe where he was lectured by a woman from a drought-stricken African nation. "I can understand your concern over children that are being beaten and children that are being sexually abused," the woman said. "But I have ten thousand children a year dying of starvation." At another conference in Cairo, Willey said, "we got into a debate with some of the government people over there. They didn't even want to address the question of child sexual abuse. They didn't want to talk about it. We would start to get into the issue and it would be shifted over to something else. In many of these countries, children are a secondary or tertiary concern. They don't put the priority on children that we do here. There are a lot of caring people in every country who are doing what they can do, but they're placing their major emphasis on caring for children that have nowhere to live and nothing to eat, trying to keep them alive. It's the hierarchy of needs. Survival comes first."

In some very poor countries, sex with children, while not officially condoned, is unofficially tolerated. Under the regime of Ferdinand Marcos, the economy of Manila's Ermita district depended largely on the profits from child prostitution. The same is true in

become child abusers raises the possibility that child sexual abuse may be increasing of its own accord. When groups of men who admit abusing children are asked whether they themselves were sexually abused as children, the great majority say that they were. Not every sexually abused child grows up to become a child abuser — if that were the case, one American in every four or five would be having sex with children. But as the number of current victims increases, so does the population of future abusers, and because many abusers have more than one victim, the sexual abuse of children threatens to become an upward spiral.

Is the sexual abuse of children a uniquely American problem? It doesn't seem to be. In late 1983 the government of Canada set out to do what the government of this country has not yet done, by commissioning the Canadian Gallup organization to conduct face-to-face interviews with more than two thousand men and women on their sexual experiences as children. The survey, which filled thirteen hundred pages, found that more than one out of every two Canadian women, and more than one in three Canadian men, had been subjected to some kind of sexual abuse as a child.[11] It also found that Canadians of all ages reported about the same incidence of abuse, a strong indication that sexual abuse has been occurring there with about the same frequency for most of this century. Said the parliamentary committee that oversaw the project, "Sexual offenses are committed so frequently, and against so many persons, that there is an evident and urgent need to afford victims greater protection than that now being provided."

Except for the United States and Canada, only a handful of countries have carried out any serious research into the incidence of sexual abuse. Reports of child abuse in Great Britain have risen by some 70 percent over the past six years, but that country has been curiously late in recognizing child molestation as a substantial problem. Public attitudes in Britain began to change last year, when two researchers interviewed 2,019 English men and women over the age of fifteen. Twelve percent of the women and 10 percent of the men acknowledged having had sex with an adult while they were children.[12] Though lower than the figures produced by similar surveys in the United States, those numbers suggest that at least five million Britons now alive were sexually abused as children. "Two issues dominated British people's lives this year and last, world famine and child abuse," says Keith Bradbrook, an official of Britain's National Society for the Prevention of Cruelty to Children. Bradbrook estimates that some fifty

Lewis's numbers suggest that not all of the increase is attributable to an increased willingness to report, and there is some other support for such a conclusion. Diana Russell found that, except during the two world wars, when millions of American men were absent from the country, the incidence of incest increased from about 9 percent of girls "at risk" in 1916 to 28 percent in 1956.

Because of the loopholes in the retrospective studies, it's difficult to say with any certainty whether more children are being sexually abused now than before, but a number of demographic trends suggest that more children are at least running the risk of being abused. More than four American workers in ten are now women; more than half of the women with children under six, and half of those with children under three, work full time. For the first time in history, it seems, more American children have mothers who work than have ones who stay home. Many of those women are married, but many others are not. The number of single-parent families, nearly all of them headed by women, increased by more than 40 percent during the 1970s. The number of divorces in America is also rising steadily, and a fifth of all babies born in this country are born to unmarried women. By 1990, at least a third of all families with children will be headed by only one parent. More working, single, and divorced mothers means a greater demand for day-care centers, nurseries, and baby-sitters to look after preschoolers, and a greater demand for youth groups, sports teams, and other activities to fill the after-school hours of older children. Because some child abusers take jobs in day-care centers and other surroundings that provide them with access to children, more surrogate child-tenders may create more avenues for contact between abusers and potential victims.

There is another aspect to such demographics. As the divorce rate rises, so does the number of women who marry for a second time, and even a third. Fifteen years ago only a quarter of the marriages performed in this country were second marriages; today the figure is 34 percent. More second marriages mean more stepfathers, and step-daughters seem particularly vulnerable to sexual abuse. Diana Russell found that women who had a stepfather as a principal male figure in their childhoods were six times more likely to have been abused than those with a biological father.[10] As some researchers have begun to suspect, it may be the case that a growing number of stepfathers are really "smart pedophiles," men who marry divorced or single women with families as a way of getting close to children.

The recent recognition that many abused children grow up to

questioned reported at least one unwanted sexual experience with an adult while they were children — the highest number of victims uncovered by any survey thus far.[9] But Wyatt also asked the women whom they had told about being abused. "For those people who told nobody," she said, "I also asked, 'Why didn't you tell?' It's fascinating to see what those people said. 'I didn't tell because I thought I'd be blamed, or because no one would believe me, or that something about my behavior would be the issue, like "Why did you walk down that street?" or "What were you doing in that house?" more than "Who is this person and where can we find him?" ' " Even when a black child did tell, Wyatt found, her family was not likely to involve the police. "They tended to try to take care of the situation themselves," she said, "to go out and try to find the perpetrator. White families get involved in the system much more readily."

As Bud Lewis began breaking down the responses to the *Times* survey by age and geography, he discovered a couple of curious things. One was that there appeared to be some merit to the criticism of regional bias lodged against Diana Russell's findings. In most parts of the country, Lewis found, the number of victims closely matched the distribution of the population. But 21 percent of the victims lived in the five-state Pacific Region — California, Alaska, Hawaii, Oregon, and Washington — an area that has only 14 percent of the nation's population. Did a proportionally greater number of victims in the western United States mean that more children had been abused in the West than in the North, South, or East? It was certainly a possibility, but there was no way of knowing where the Pacific Region victims had actually grown up, because Lewis hadn't asked them.

Potentially more significant was Lewis's discovery that many of those who acknowledged having been abused were younger than those who said they hadn't been. Not that there weren't any old victims — one in three was over forty-five and one in ten over sixty-five, which meant there was nothing very new about sexual abuse in America. But the largest group of victims was between eighteen and twenty-nine. This might simply mean that older Americans were more reluctant to talk about their experiences. But it might also mean that more children have been sexually abused in the years since World War II.

Has the sexual abuse of children increased in recent years? Reports of sexually abused children are clearly on the rise, but some of that increase is doubtless a result of what statisticians call a "reporting phenomenon"; more reports don't necessarily mean more victims in an absolute sense, only that more victims are coming forward. But

survey also provided a clue to just how well hidden sexual abuse has been over the years, since a third of the victims said they had never told anyone about their experiences, not even their husbands or wives. Even when they had told someone, in most cases nothing had been done; only 3 percent of the cases were ever reported to the police.

Apart from providing by far the clearest picture yet of the magnitude of child sexual abuse in America, the *Times* survey helped answer an equally important question: Who are the victims of child sexual abuse? In some ways the victims didn't seem much different from the nonvictims. They were slightly better educated, more of them were employed, and those that were working held somewhat better jobs. Most of the victims lived in the suburbs, were slightly less religious and somewhat more liberal politically. It was just below the surface, however, that the important differences began to emerge. Though a number of the victims had grown up in families headed by women, they hadn't been as close to their mothers as the nonvictims had. The victims had come from smaller families and had been more isolated as children. They described their families as significantly less happy than those of the nonvictims, and their adult lives also seemed more disjointed. More of them were separated or divorced, and more had also remarried. Least surprising of all, their adult sexual relationships had been much less satisfactory.

For decades the sexual abuse of children has been popularly perceived as a "lower-class phenomenon," which is a polite way of saying that it is mostly a problem among the poor, especially blacks and other minorities. Researchers have tried to change this perception by pointing out that child sexual abuse must really be a mainstream crime, since there are more white, middle-class sexual abuse victims flowing through the courts and child protective agencies than any other kind. The retrospective studies do suggest that white, middle-class children are most often abused, but there are also more white, middle-class children living in this country than any other kind. To emphasize abuse among the middle class is to risk overlooking abuse among minorities; the *Times* survey found that the incidence of sexual abuse among blacks and whites is almost exactly the same, about 21 percent for men and women combined.

Why do so few black victims show up within the criminal justice system? One answer is provided by Gail Wyatt, a professor of medical psychology at UCLA who spent two years interviewing a random sample of 248 adult women in Los Angeles County, half of them black and the other half white. In all, 59 percent of the women Wyatt

Lewis looked over the current literature, but when he asked some of the scholars for suggestions about how to proceed, the responses were not encouraging. "They thought that I would screw it up," he said. Bud Lewis, who probably knew more about telephone polling than all the sociologists in the country put together, went ahead. Over a period of eight days in July 1985 telephones began ringing across the country, in Cape Cod cottages and Midwestern farmhouses, in Manhattan apartment buildings and Southern California condominiums. By the time Lewis's poll takers were done, they had questioned 2,627 men and women, from every state in the nation.[6]

Because of the cleverness with which the survey had been designed, nearly all the people who answered their phones were willing to talk. "I had a couple of innocuous questions at the beginning," Lewis said, "and then I told them what the survey was going to be about and asked whether it was going to give them any difficulty to talk about it." Only three people in every hundred said it would; the rest plowed bravely through the next ninety-seven questions. What Lewis most wanted to find was the number of sexual abuse victims among them, but his approach was indirect. "I moved into general attitudes about child sexual abuse that anybody would answer," he said, "and then I got into questions like how prevalent they thought it was. And then I asked them, 'If you were a victim, would you tell about it?' And of course, most people said they would. And then I just said, 'Well, were you?' And they sort of hooked themselves, because they said they'd tell."

Twenty-two percent of those questioned, 27 percent of the women and 16 percent of the men, said they had been sexually abused as children.[7] If those percentages were applied to the current population, it meant that nearly thirty-eight million adults had been sexually abused as children, several hundred thousand more than voted for Walter Mondale in 1984.[8] Lewis's poll takers didn't question any children, but if the experiences of American children were the same as those of their parents and grandparents, more than eight million girls and five million boys then alive will be sexually abused before they reach their eighteenth birthdays.

Many of the abuses uncovered by the *Times* survey were of the most serious kind, and they cast doubt on a number of myths about the sexual abuse of children — that intercourse between adults and children is relatively rare, that most sexual abuse is accompanied by the use of physical force, that boys are almost never the victims of abuse, and that most abusers are people the child doesn't know. The

children under ten the penalties are even more severe. But Russell's survey helped to refine the question by making a distinction between victims who were younger than thirteen and those who were older. What she found was that 28 percent of the women who said they had been seriously abused had been abused before reaching the age of fourteen, 12 percent by someone in their families.

Like Kinsey and Finkelhor before her, Russell had an advantage over most people who ask the public questions — she didn't have to worry very much about being lied to. People might tell a poll taker they're going to vote Democratic when they're really going to vote Republican, but it's hard to think of a reason for anyone to say she was sexually abused as a child when she really wasn't. Much more likely was the possibility that some of the women in Russell's survey had lied when they said they hadn't been sexually abused as children, which meant there was a good chance Russell's figures were too low.

When Russell published her findings at the end of 1983, it was in a relatively obscure journal, and almost nobody noticed outside the small community of child advocates who read such publications, the same people who for years had been trying to tell the public that the sexual abuse of children was a far larger problem than anyone knew.[5] But Russell's figures were so far beyond those reported by Kinsey and Finkelhor that even some of the experts didn't trust them completely. Random sample or not, some of Russell's colleagues suggested that any survey conducted in San Francisco was bound to be unrepresentative of the rest of the country. Even if 38 percent of San Francisco women had been sexually abused as children, one ought not to assume the same was true for the women of Oshkosh or Cedar Rapids. When Russell pointed out that many of the women she interviewed had moved to San Francisco from somewhere else, her critics replied that perhaps women who moved to San Francisco were not the same as women who didn't.

As the debate over the validity of Russell's findings continued, Bud Lewis was watching from the sidelines. Lewis was the director of the *Los Angeles Times* poll, and his careful and scholarly approach to questions of public opinion had made the poll one of the most respected anywhere. Like most big-city newspapers, the *Times* had been devoting a lot of space to the subject of child sexual abuse, and some of the editors who worked there were beginning to ask the same question as their readers: Could this really be happening to so many American children? What was badly needed, Lewis thought, was a random national survey, one that included men as well as women.

The instinctive answer is that any sexual contact between an adult and a child is abusive, and yet the same degree of seriousness cannot be attached to intercourse as to fondling. Because of the disturbing impact they can have on young children, experiences such as exhibitionism, in which the victim's body is never actually touched, must also be included.

Russell divided the experiences reported by the women in her survey into three categories: very serious abuse, which she defined as vaginal, oral, and anal intercourse, cunnilingus, and analingus; serious abuse (genital fondling, simulated intercourse, penetration of the anus or vagina with a finger); and least serious abuse (fondling buttocks, thighs, legs, or other body parts, clothed breasts or genitals, and kissing). Nearly two-thirds of the incidents recalled by women who said they had had sex with parents or other relatives, and four-fifths of those recalled by women who said they had been abused by non-relatives, qualified as either very serious or serious. When exhibitionism and other "noncontact" experiences were added in, the number of women in the survey who reported some sort of sexual abuse as children rose to 54 percent.

Any discussion of child sexual abuse must also include the question of what a child is, and the answer is not as obvious as it appears. A century ago, sex between children and adults was illegal in most states only if the child was younger than eleven. Today the generally accepted age at which a child becomes an adult is eighteen, which also happens to be the age of consent in most places, although not in all. In South Dakota and Virginia the age of consent is fifteen, and in Colorado, Hawaii, and Georgia it's fourteen. Not only are some statutes inconsistent in their definition of a child, they reflect an inability to decide what child abuse is. When a forty-year-old Tennessee dairy farmer had sex with the thirteen-year-old girl who lived on the next farm, prosecutors prepared to charge the man with statutory rape. But Tennessee law prohibits having sex with a thirteen-year-old girl only if she's not your wife; the farmer married the girl and remained a free man.

A sexual relationship between a grown man and a thirteen-year-old girl, while illegal in most states, cannot be looked at in quite the same way as one between a grown man and a six-year-old, and most state laws make allowances for age differences among the victims of sexual abuse. In California, any sexual activity with a boy or girl between the ages of fourteen and seventeen is statutory rape. If the child is under fourteen, the offense is child molestation, and for

half of this century, sex between adults and children in America was fairly commonplace. Nearly a quarter of the four thousand women who answered Kinsey's questions said they had either had sex with adult men while they were children or had been approached by men seeking sex.

Even more remarkable was the degree to which that part of Kinsey's report was almost completely ignored, not just by the public but by his fellow researchers. In 1955, when S. K. Weinberg published what was then considered a landmark study of incest, he estimated that its victims totaled only one English-speaking child in every million.[3] One of the first contemporary researchers to follow in Kinsey's footsteps was David Finkelhor, a sociologist from the University of New Hampshire who handed out written questionnaires asking eight hundred students at six New England colleges whether they had been abused as children.[4] Finkelhor's numbers were a little lower than Kinsey's — 19 percent of the women students and 9 percent of the men said they had had some sort of sex with an adult while they were children — and the problem with Finkelhor's findings, as had been the case with Kinsey's, was that the people he questioned had not been randomly selected. The women who talked with Kinsey's interviewers had volunteered to be questioned about their sex lives, which by itself meant that they weren't representative of the general population. Finkelhor's subjects were not only volunteers, they were also college students, which set them doubly apart from the average American man or woman.

The first truly random sexual abuse survey wasn't begun until 1979, when Diana Russell, a British-born sociologist with a Harvard Ph.D., set out to interview more than nine hundred randomly chosen San Francisco women about their childhood sexual experiences. It was then the largest and most complex survey of its type ever undertaken, and Russell spent the next five years assembling and analyzing the results. What she found was that 38 percent of those questioned — nearly four women in every ten — had been sexually abused by an adult relative, acquaintance, or stranger before reaching the age of eighteen.

Sexual abuse is a term more of art than of science. It can cover a multitude of sins, from exhibitionism and fondling to sexual inter-course, by a multitude of abusers, from parents and teachers to baby-sitters and strangers. It can happen once or it can go on for years. It can be violent or not violent. Russell's survey raised the question, not as facile as it sounds, of what, precisely, constitutes sexual abuse.

Numbers

THE STORY THAT appeared on the front page of the *Los Angeles Times* for Sunday, August 25, 1985, was thoroughly unequivocal: "At least 22% of Americans," it began, "have been victims of child sexual abuse, although one-third of them told no one at the time and lived with their secret well into adulthood." As the article went on to show, the *Times* had done something no one had ever attempted. Using the techniques of an ordinary public opinion poll, it had conducted a random survey in which thousands of Americans were asked not whom they planned to vote for or what they thought about arms control, but whether they had been sexually abused as children. In trying to get a handle on the true extent of child sexual abuse in America, the *Times* had taken a retrospective approach. If, as the child advocates maintained, many of the children who were being sexually abused were not talking, and if, as the doubters made clear, many of those who were talking were not being believed, then why not ask adults about their sexual experiences as children?

It wasn't exactly a new idea. One of the first to try such a backward-looking survey had been Alfred Kinsey, the zoology professor from Indiana University who became this country's pioneer researcher in the field of human sexuality. When it was finally published, in 1948, Kinsey's *Sexual Behavior in the Human Female* was a national best-seller for weeks.[1] Although viewed by those who hadn't read it as something of a risqué document, the Kinsey survey was 842 pages of the most dispassionate and clinical language imaginable, reinforced with charts, graphs, and tables.[2] By illuminating what Americans really did inside their bedrooms, as opposed to what they pretended to do, Kinsey had made a giant stride toward the demystification of sex in America. Among his most important findings was that, during the first

whether an accusation of abuse is true, the report in question is either labeled "unfounded" or purged from the state's central registry altogether.[3] During an average month in 1985, nearly five thousand Los Angeles children who were suspected of being physically or sexually abused were never visited by a child protection worker at all.

The social workers, police officers, and prosecutors assigned to handle such cases also point out that the reports of child sexual abuse are the most difficult to prove. Many children who have been starved or beaten will carry with them some visible evidence of mistreatment, but in cases of sexual abuse there may well be no evidence at all. If a child is too young or too frightened to talk, or if there is no physical or medical evidence to support his allegations, the only choice is to mark the case "unfounded."

Because so many children who are sexually abused never tell anybody about it in the first place, all the numbers being tossed about were misleading anyway. But with all the doubt and confusion that had sprung up around the issue, such nuances were largely lost. If 1984 had been the year of the sexually abused child, then 1985 was fast becoming the year of the child abuse backlash, an understandable reaction to an issue that had assumed in some minds the proportions of a hysteria. There were, after all, something like sixty-three million children in America, and while a problem that afflicted a few thousand children every year was to be dealt with expeditiously, it didn't necessarily demand any more urgency than suicide or drug abuse or a dozen equally compelling problems. To many of those who had initially been alarmed by what they heard and read, child sexual abuse was beginning to look like a rather modest social problem. But that was before anybody knew that thirty-eight million American men and women had been sexually abused as children.

Center on Child Abuse and Neglect, the chief federal agency charged with promoting the protection of children. Among those who seized upon his research were Paul and Shirley Eberle, the authors of *The Politics of Child Abuse,*[2] who toured the country to argue that child protection advocates were conducting a "child abuse witch hunt" and "profiteering on the ruin of innocent people."

Like the Eberles, most of those who cited the Besharov paper as evidence that children were lying about sexual abuse hadn't read it very carefully. For one thing, Besharov's statistics included all types of child abuse reports, not just sexual abuse but physical abuse and neglect. For another, most child abuse reports come not from children but from adults. Some of the overreporting, Besharov said, doubtless resulted from mistaken expressions of concern by well-intentioned adults. He also acknowledged that "few of these 'unfounded' reports are made maliciously; rather, most involve confusion over what types of situations should be reported. Approximately half involve situations of poor child care which, though of legitimate concern, are not sufficiently serious to be considered 'child maltreatment.' "

Also largely overlooked in the debate Besharov's article generated was the fact that *unfounded* did not mean untrue, but only that the allegations in question could not be proved one way or the other. Besharov noted that while they have gotten better in recent years, state-run child-protection bureaucracies have not increased their capacity to investigate suspected child abuse by anything resembling the exponential increase in the number of reports. Because of highly publicized child abuse hotlines and relatively new laws requiring a wide range of professionals to report any instance of suspected child abuse, many more reports are being funneled to such agencies than they can effectively investigate. California's child protection system has long been pointed to as a model for other states, and it is better than most, but the California Department of Social Services admits that it investigates fewer than half of the fifty thousand child abuse reports it receives each year.

Most states now have laws requiring that child abuse reports be investigated, and some determination made, within what is proving to be an impossibly short period of time. In many states an investigation must be begun within twenty-four hours of the receipt of a report, but in practice such deadlines are often ignored. In order to keep the case alive, harried child protection workers routinely certify that they have met the deadline for beginning an inquiry, even when they cannot find the victim's home. If they cannot determine within a week or ten days

or starvation of affection, the disease or the cure?" Sensing the wind's shifting direction, twenty-six accused child molesters in the Bakersfield, California, jail went on a hunger strike, demanding that prosecutors allow them to take lie-detector tests to establish their innocence. The strike followed a protest outside the jail by a new organization called VOCAL, short for Victims of Child Abuse Laws, whose 120 chapters around the country were composed of men and women claiming to have been unjustly accused of abusing children. Leslie Wimberly, the head of VOCAL's California chapter, spoke for many when she said, "The consensus that a child does not lie is wrong and behind the times."

It wasn't that anybody, aside from the child molesters, was in favor of adults having sex with children, or even that anybody thought that child sexual abuse didn't exist. Rather, the concern seemed to focus on the question of how many children were being sexually abused, of just how large the problem really was. To judge from the current increase in child abuse reports, it seemed quite large. A decade ago, only about twelve thousand American children were reported each year as having been sexually abused. By 1985 the number had passed 150,000, and no state or region seemed to be exempt. Reports in Georgia were up by 102 percent, in Iowa by 40 percent, in North Carolina by 43 percent, in Rhode Island by 51 percent. Even largely rural Maine was reporting a single-year increase of 300 percent.

Startling as they were, such numbers were almost certainly too low. Not all states kept child abuse statistics, and those that did tallied them in different ways. Some states counted the number of families where abuse had been reported, not the number of victims in each family. Some states only counted the number of children who were abused, not the number of times they were abused or the number of adults who abused them. Some states didn't even distinguish between physical and sexual abuse, or between abuse and neglect, and most didn't count abuse by neighbors or day-care workers or other non-relatives.

Those who wished to dismiss the problem of child sexual abuse as *de minimus* suggested that many of the reports were simply untrue, a notion that can be traced to an article by Douglas J. Besharov that appeared in the summer of 1985 in the *Harvard Journal of Law and Public Policy*.[1] Besharov's assertion that 65 percent of the child abuse reports made in this country proved to be "unfounded" received a surprising degree of publicity, in part because he spoke with considerable authority — Besharov was a former director of the National

ladies who had earned extra money baby-sitting began to look for other sources of income.

Had children gone mad? Possibly, some thought, recalling the Salem witch trials. What seemed more likely, though, was that ambitious prosecutors, overzealous police officers, and the news media were putting ideas into children's heads. The news media, perhaps the most sensitive to criticism of all public institutions, soon began trying to make up for its perceived excess. "A lot of the graphic horror stories in the press are themselves little more than child porn," wrote Michael Kinsley, *The New Republic*'s respected editor. "And when they're not being salacious, the media are being mawkish, which sells almost as well." On "60 Minutes," Mike Wallace reported the story of Erin Tobin, a University of Texas coed accused of sexually abusing the three-year-old twins for whom she occasionally baby-sat; her arrest had been highly publicized before a grand jury decided there was insufficient evidence to bring her to trial.

"Are we in the media responsible for all the attention," Wallace asked, "all of the lurid details of this kind of thing coming out now?" An equally concerned voice belonged to Phil Donahue, whose producers assembled a panel of people, among them Bob and Lois Bentz, who claimed to have been unjustly accused of sexually abusing children. "What is child abuse?" Donahue demanded. "And should children be able to accuse you? And is that information enough to convict you? And who's watching the prosecutors? We are scared to death of child abusers in this country, and it appears that on more than one occasion we have perhaps gone too far and railroaded innocent people." Leo Buscaglia, the University of Southern California psychologist who wrote best-selling books urging people to love one another, was also moved to wonder whether "the cure isn't worse than the disease." As deplorable as child abuse was, he wrote, "it would be more harmful to eliminate all physical contact between adults and children. Children need to be cuddled and hugged for health reasons and for the security that is conveyed by a gentle hand, a reassuring touch."

The growing public concern was perhaps best expressed by a member of the Jewish Big Brothers Association of Los Angeles, who wrote to a local newspaper that "in the current climate of accusation, the concept of innocent until proven guilty is forgotten. When that happens, we've committed a crime even worse than child sexual molestation. If this hysteria continues unabated, a generation from now someone is going to ask the question: What is worse, molestation

To most of those who didn't live there, the Jordan sex case was a string of newspaper headlines or a series of disconnected images fluttering across a television screen — handcuffed parents being led away in ones and twos followed by thirty-second interviews with somber investigators, angry defense lawyers, grim-faced defendants, and a self-righteous-sounding prosecutor. Incomprehensible to begin with, the case was also unrivaled in its complexity, and many of the details and nuances had long since gotten lost. As Kathleen Morris's prosecution fell apart piece by piece, Jordan became "that little town up in Minnesota where all the children lied." When the case finally disintegrated in full public view, it was perhaps inevitable that "Jordan" would become a paradigm of sorts, a one-word metaphor for the combination of anger, repulsion, and incredulity that the subject of child sexual abuse evoked in most of those who thought about it.

Many people were thinking about it, for by the end of 1984, it was becoming difficult to pick up a newspaper or turn on a television set without reading or hearing of someone else who had been convicted of sexually abusing a child, including a surprising number of prominent and respected men and women: school principals and military officers, police officers and doctors, nursery school owners and university professors, professional athletes and television stars, socialites and rock musicians, even clergymen. More than the names and numbers, though, it was the suddenness of it all that didn't make sense. Not many Americans were under the impression that their society didn't have its share of troubles, but now they were being asked to believe that they faced yet another enormous and urgent problem, one that had been there all along, hidden from their view.

It was asking a lot, and not only because the uncounted thousands of children claiming to have been sexually abused were telling Americans something unpleasant about themselves. Children also seemed to have acquired the power to point a finger and send an adult to jail, and some of those who were not frightened for their children were becoming frightened of their children. Parents were thinking twice before letting a child awakened by a nightmare crawl into their bed, for fear of what the child might say at school the next day about having "slept with Mommy and Daddy." Preschool teachers who had once rewarded good behavior with a hug and a kiss were telling children instead to "give yourself a pat on the back." Fathers playing tag with their children at the neighborhood pool pretended not to hear when children they didn't know asked to join the game. Neighbor

lawyer to represent her before the commission, she chose Steve Doyle, her ex-husband. Doyle had also been one of the defense attorneys in the case, but by then nobody in Scott County was very much surprised by anything Kathleen Morris did. Among the first to testify at the Morris hearing was Officer Larry Norring, who had worked full time on the case since arresting Jim Rud more than two years before. If Norring hadn't been a child abuse expert when the case began, he was one by now. Norring thought most of the cases had been solid ones, "excellent cases" that should have been taken to court.

Several of the investigators who had worked on the murder angle followed Norring, and despite the FBI's conclusions, they still weren't certain that no murders had taken place. "Something terrible happened to those children," said a Jordan police detective named Norm Pint. "You could see the fear and distress in their faces when they talked about it. But whenever we got into locations of where the bodies were buried, it was like the clouds rolled in. It was never clear what happened to the bodies." Earl Fleck, a policeman from neighboring Shakopee, even suggested an explanation. "I wonder," he said, "if the children weren't speaking to us metaphorically, in a sense reporting to us their own deaths. I think the children were crying out to us in reporting the death of their own inner soul, their own spiritual life, and they were screaming to us in a sense and saying, 'I'm dying here, this is killing us.' "

After hearing two weeks of testimony and examining five thousand pages of documents, the commission faulted Morris for keeping the murder investigation a secret from the defense and for misleading the judge about where the witnesses at the Bentz trial had been housed. But it reserved its strongest criticism for her decision to drop the remaining charges in the case. "Those defendants who were guilty went free," the report said, "and those who were innocent were left without the opportunity to clear their names. Those children who were victims became victims once again, abandoned by the system and by the system's representative, Kathleen Morris." Merely dropping the charges did not constitute malfeasance, however, and there was not sufficient cause to recommend that Morris be removed from office. Governor Perpich, who had agreed to abide by the commission's findings, made it official: Kathleen Morris would remain as prosecutor until the voters of Scott County had a chance to speak. In November 1986, the voters made their feelings clear. By nearly a two-to-one margin, Morris was defeated for reelection by a challenger fresh out of law school.

their children, had been interviewed. Standard electronic and physical surveillance techniques were not used. Search warrants were rarely obtained. "The tragedy of Scott County," the report said, "goes beyond the inability to successfully prosecute individuals who may have committed child sexual abuse. Equally tragic is the possibility that some were unjustly accused and forced to endure long separations from their families." Attorney General Humphrey suggested that Kathleen Morris might want to resign.

She didn't, but her methods, like those of the police and the therapists, were being questioned in other quarters. When they were asked for their opinions of what had gone wrong, most of those familiar with the full scope of the case included the name of Kathleen Morris somewhere in their answers. "It's hard for me to explain why Kathleen did a lot of the things she did," said one. "Kathleen's tough to figure," said another. "It just got away from Kathleen," said a third. Among the questions was why Morris had charged two dozen people before she had obtained a single verdict, rather than trying to win a conviction in her best case and using it as a foundation to charge and prosecute the others. "You go for your best stuff first," one Minneapolis lawyer said. "You don't charge the world and try to beat the world. Nobody's that good."

Morris replied hotly that she had acted to protect the children from further abuse. Only by charging their parents as soon as an allegation had been made, she said, could she ask a judge to remove the children from their homes. It sounded like a reasonable explanation, exept that in Minnesota, as in most states, children can be taken from abusive or neglectful parents who have not been charged with any crime. Another question being asked was how the twenty-four defendants had been chosen from among the forty-five adult suspects listed in police records, particularly since some of those not charged had been accused earlier, and of more serious abuses, than some of those who were charged. Morris stood her ground. "I'm supposed to be the villain," she replied. "Let me be the villain. They have to have somebody to blame. There's a lot of wrong happening in the world. Wrong is what's happening to kids. It's not fair for the kids, so why should it be fair for me? I've got a whole bunch of kids I've got to worry about. They don't want to believe what's going on? Let them blame me."

As the questions continued to resound, Minnesota governor Rudy Perpich appointed a commission of inquiry to pass judgment on Morris's handling of the case. When Morris decided she needed a

recantation was what he hoped to gain. His provisional sentence of six years had been predicated on his telling the truth, and now the plea bargain agreement was out the window. By claiming he had lied, Rud was looking at maximum hard time, forty years in the Minnesota Correctional Facility at St. Cloud. The state and federal agents didn't have any answers, and when a polygraph examination failed to determine whether Rud was really lying, they just put him and his unfathomable motives aside. "He's got so many stories," one said, "who knows what he's saying anymore?"

The agents had better things to do, poring over the thousands of pages of interview reports assembled by police and therapists during the first investigation and painfully cross-indexing each accusation by every child by date, time, place, and corroborating witness, then interviewing the children yet again to sort out the inconsistencies. "We're starting over," one of the federal agents said. "We have our own methods for conducting an investigation. I'm not saying that their way was wrong or our way is right, but I can tell you that our way is successful."

The cross-checking produced some interesting insights. "Some of the kids are liars," another agent said. "Some are telling the truth. We just don't know which is which." The more the agents learned, the more they were convinced that at least some of the adults were guilty. "It isn't just James Rud who's involved in this," a senior investigator said, but a third agent warned that it would be foolish to equate all the former defendants. Three or four, he said, appeared to be genuine psychopaths. The rest, including most of the women, were followers. "Maybe they didn't do anything, but they knew what was happening," the agent said. "They went along with what their husbands wanted. They were very passive, dependent people who had had hard lives. They were victims like their children." Despite their conclusions, the agents were not optimistic about their chances of bringing new charges. "We'd have to find something new," one agent said. "I'm very realistic about what we have to deal with. These kids have suffered some credibility problems."

Two months later, the Jordan case was closed forever. In a twenty-nine-page report titled "Scott County Investigations," the attorney general's office explained that there was "insufficient evidence to justify the filing of any new sex abuse charges." All of the obstacles that couldn't be overcome, the report went on, stemmed from the mishandling of the original investigation, and the list of errors was long. Some of the defendants had been arrested before they, or even

stories — always with the standard disclaimer that no one had yet been found guilty — that portrayed the case as among the most sordid crimes in recent memory. Now, in a flash, the whole thing had simply evaporated. Within the criminal justice community, particularly among those who had been involved in some aspect of the investigation, the anger at Kathleen Morris was intense. Certainly mistakes had been made, the investigators agreed, but they were mostly mistakes of procedure and preparation, not mistakes of fact. The investigators also pointed out that most of the children who had fouled things up by talking about murderers had been considered loose cannons from the beginning. There were still a number of younger children who had said nothing about any murder and who were prepared to testify against half of the erstwhile defendants. Perhaps the case could not be resurrected in its entirety, but a large part of it seemed salvageable. The only question was, Who would do the salvaging? Two days after the charges were dropped, Hubert H. Humphrey III, the Minnesota attorney general and son of the late senator, announced that his office, in conjunction with the Bureau of Criminal Apprehension and the FBI, was taking over the Jordan case.

Then, another explosion. Jim Rud, promised leniency in return for the truth, was now telling investigators that the statement he had given them three months before, the one that corroborated many of the children's accounts, was a tapestry of lies. Rud wasn't professing his own innocence; he still admitted having abused sixteen of the children in the case. What he was saying now was that he knew nothing about any abuse by the Bentzes or any of the other adults. "I worked on my own," he told Lynn Emmerman of the *Chicago Tribune* from his cell at the Scott County jail. When he began talking to the police, Rud said, he didn't plan to lie. But his lawyer had routinely been sending him copies of the police reports provided by the prosecution, reports that summarized the investigators' interviews with the children, and he had used them as a basis for his fabrications. "Put yourself in my shoes for a minute," Rud said. "Think of forty years behind bars. You'd probably do anything to get out of that." Even to falsely accuse his own parents? "I love my parents dearly," he said. "They know I lied. I have lots of guilt."

Rud's recantation was a blow, but he had only implicated just over half of the twenty-four defendants in his statement, and he was not the only one who had said he was present at the gatherings and parties. Most of the children had said so too, and they had said it months before he did. But the biggest mystery surrounding Rud's

twenty-one remaining defendants. As a group their credibility was shot, and without their testimony, half of Morris's remaining cases went up in smoke, since how could any jury possibly believe that children who had lied about a murder were telling the truth about having been sexually abused? "Those children," one of the defense lawyers said later, "would have been destroyed on the witness stand." The six other children who had told about the murder were sticking to their stories, but now the FBI had entered the investigation on the grounds that the murdered child might have been brought to Minnesota from another state.

Most of the FBI agents assigned to the Jordan case had been extensively trained in sexual abuse investigations, and they brought with them a professionalism and an air of efficiency and authority that the children were not used to. Most important, the federal agents had no investment in the outcome of the case. "We'd say, How do you know this happened? When? Where? What were the other people doing?" one of the agents said. "Let's say a kid saw someone dump a body at a certain location on the river. We'd take the kid out there, and he'd positively identify the location. We'd ask him when it happened, and he'd give us a certain date. We'd check the conditions on the river that day and find out the river was flooded, that it was impossible to dump a body there." Faced with such intensive scrutiny, it wasn't long before the other children began to recant. One boy had insisted that the body of the murdered child had been carried across a particular bridge. When the FBI discovered that the bridge had been washed away by a flood the year before, the boy broke down and cried. He had lied about the murder, he said, because he thought that the lie would keep him from being returned to his parents. A second boy, the one who said the murdered child had been the drummer in a rock and roll band, admitted that he had gotten the idea of ritualistic torture from a television program he had seen. He had lied about the murder because he wanted to please the investigators, whom he had come to think of as his friends and who seemed always to want something more from him. The four other children who had been counted by the police as among the seven who claimed a murder had occurred told the FBI they had never said any such thing. What they had meant, they said, was that some of the children who were abused had also been hurt.

In Jordan and around the country, the reaction to the dropping of the charges was one of utter astonishment. For months, out-of-state reporters had been visiting the town, talking to those on both sides of the case and to the townspeople caught in the middle, and then filing

by the grown-ups. It was there, however, that the children's accounts began to diverge. One child said the boy had worn a red and blue shirt and pink, yellow, and red pants. Another said he wore a jacket with zippers on the front, "like Michael Jackson." A third child described the victim as dressed in a light-blue shirt and cutoff jeans. A fourth said he had worn a black shirt and black pants. Nor could the children agree on whether the boy had been shot, stabbed, or drowned, or whether his body had been buried in the woods or thrown in the Minnesota River. A couple of the children even said there had been more than one murder.

While the Bentz trial was getting under way, the investigators had been out looking for bodies, but the murder investigation was running into one brick wall after another. It didn't take the investigators long to conclude that some of the children's accounts were fanciful on their face — the assertion, for instance, from the same eleven-year-old who admitted having lied at the Bentz trial, that the murdered child had been the drummer in a band hired to perform at one of the parties. But some of the other accounts seemed to ring true, and the police continued to puzzle over how so many children who had seen one another only briefly or not at all over the past several months could have provided essentially the same physical description of the murdered child. When one young witness described for a therapist how the boy had gone into convulsions, the therapist thought it was "a piece of medical detail that I felt uncomfortable with a child knowing."

It was during a child custody hearing in family court that one of the seven children who had talked about the murders, a nine-year-old girl, finally admitted that she had lied — not about having been abused, she told the judge, but about having watched a child die. There hadn't been any strange boy, and there hadn't been any murder. The girl's recantation — which she would later recant again, after it was too late to matter — left Kathleen Morris with no other choice. Just as the second couple was about to go to trial, Morris called a press conference to announce that all of the charges against the twenty-one remaining defendants in the sexual abuse case — the original two dozen minus Jim Rud and Bob and Lois Bentz — were being dropped.

Morris left the reason for the dismissals vague, saying only that to pursue the remaining sexual abuse cases would jeopardize another, unspecified investigation of "great magnitude." But to those who knew what was going on behind the scenes, the reason was crystal-clear. The seven children who had made the murder allegations were the key witnesses, and in some cases the only witnesses, against ten of the

father to submit to anal intercourse, turned toward the judge with tears in his eyes and asked for an assurance that "he won't do that no more." The twelve jurors deliberated for twenty-two hours before acquitting the Bentzes on all counts. The trial had been an ordeal for everyone, not just for the defendants and the jurors but also for the witnesses, some of whom cried and vomited after leaving the stand. But the trial and its outcome were equally devastating for the children waiting to testify in the cases yet to come. For months they had been reassured by Kathleen Morris and her staff that all that mattered was that they tell the truth. If they did, they would be believed, their parents would "get help," they could go home again, and everything would work out.

Now things weren't working out, either for the children or for the prosecutors. While the Bentzes were appearing on "Nightline" and the "Phil Donahue Show" to express their relief at having been acquitted and their outrage at having been put on trial in the first place, Morris and her assistants were preparing to go back into court. The second trial in the case was scheduled to begin in less than a week, this one of a Scott County deputy sheriff and his wife, charged with sexually abusing their two daughters and two other children. This time, however, there would be no star witness, and Kathleen Morris had another problem as well. The prosecutors were under a court order to provide their investigative files to the defendants' lawyers, but there were 126 pages of police reports they had not yet turned over. The defense lawyers knew about the reports, but they had no idea what the files contained. When Don Nichols, the second couple's lawyer, asked the court to order that he be given the documents, he was acting on a hunch. "If somebody doesn't want to give me something," he told Eileen Ogintz, "I always like to know what it is." As soon as Nichols got his hands on the files, the reason for the prosecutors' reluctance became clear.

Early in July, a few of the children had begun suggesting to police that the assaults by their parents had extended beyond sexual abuse into some nether region they could not, or would not, name. Finally one of the boys came out with it. At one of the parties, he said, a child had been murdered. As was by then their habit, the investigators summoned most of the other children in the case to ask what they knew about a murder. The idea seemed so improbable as to be beyond serious consideration, but six of the children agreed that a murder had taken place. The victim, they said, had been a young black boy with curly hair who had shown up at one of the parties unaccompanied by an adult. Before he was killed, the boy had been tortured with a knife

had forced him to have anal intercourse. The boy repeated his accusation from the witness stand, then proceeded to chip away at his own credibility on cross-examination. Was he a believable witness? asked Earl Gray. Not really, the boy replied. Did he exaggerate things a lot? Well, yes, he did. Did he hate Bob Bentz for having abused him? No, he liked Bob Bentz. Was it true, as he had told the police, that Lois Bentz had made him put his finger in her anus? No, it wasn't true. Was that a big lie or a little lie? A big lie, the boy replied.

The boy was followed by an eleven-year-old girl who said she had been forced to perform fellatio both on Bob Bentz and on the Bentzes' dog. Asked during cross-examination whether she had ever lied about anything, the girl replied, "Of course. Kids aren't perfect. Everyone doesn't always tell the truth." Then another girl, a ten-year-old, admitted under cross-examination that the six young witnesses in the case had discussed their testimony over dinner the night before at the Howard Johnson motel where Kathleen Morris had put them up during the trial. For Morris, who had previously assured the judge that the witnesses were being kept apart to prevent the comingling of their stories, it was disaster number three.

Those who attended the trial were as puzzled by Kathleen Morris's strategy as by the performance of some of her witnesses. Her own interrogation of the children was limited mainly to questions that could be answered yes or no, and which left very little room for the sort of elaboration that juries find most convincing. Earl Gray and his defense team were more vigorous, sometimes even engaging in shouting matches with some of the children, but Morris remained seated during much of Gray's cross-examination, rising only occasionally to object that the children were being badgered. Then, when Gray called a Minneapolis psychologist to testify in the Bentzes behalf, Morris did not object to his credentials as an expert, a standard prosecution move. Nor did she cross-examine the psychologist on his pronouncement that the children had been subjected by the therapists and the police to the same brainwashing techniques perfected by the Chinese Communists. When Bob and Lois Bentz took the stand to deny the allegations against them, Morris didn't cross-examine them either.

Not that the disasters were unmitigated. Several of the children, including the Bentzes' six-year-old son, testified in what many observers thought was a convincing fashion that they had been abused by Bob Bentz, Lois Bentz, or both. A particularly dramatic moment occurred when the six-year-old, having told of being forced by his

were even promised that they would not have to testify at all. "They looked hard for somebody to roll over," one of the defense lawyers said. "I'm usually offered one deal. I've never been offered so many deals. They weren't prepared to take these cases to trial. They weren't ready to go."

In the end, the only defendant to accept Morris's offer was Jim Rud, the first person charged in the case and the one who had the most to lose. With a previous conviction for child sexual abuse in Virginia, where he had been stationed when he was in the Army, and another in nearby Dakota County, Minnesota, Rud was in danger of becoming a three-time loser. If he were convicted a third time in Minnesota, then the only state that had strict sentencing guidelines for child sexual abusers, Rud would be seventy-five by the time he emerged from the state penitentiary. Under the terms of the plea bargain, however, he would have to serve only six years. The Minnesota legal community, watching the Jordan case with fascination, was stunned — not that Rud had taken the deal, but that it had been offered in the first place. "For Kathleen Morris to offer Rud the deal she did," another prosecutor said later, "she had to be very desperate."

In return for leniency Jim Rud promised to tell all, and on August 14 he started talking. He kept at it for most of the next four days, until he had delivered a 113-page, single-spaced statement implicating eighteen of the twenty-three other defendants in the case, including his own parents. Yes, Rud said, he had been there when it happened. He had attended the sex parties and some of the other gatherings, had taken part in the abusive games described by the children, had seen adults and children having sex with one another. Everything the children said was true.

When the Bentz trial opened two weeks later, the first witness to take the stand was the prosecution's star, Jim Rud, the man who was supposed to wrap the whole case into one neat package. The Bentzes, looking tense, were seated with Earl Gray and his co-counsel at the defense table a few feet away. But when Morris asked Rud to point out Bob Bentz for the record, he couldn't. Morris tried gamely to continue, but as Rud babbled on, his testimony wandered far afield. Too far, the Bentzes' lawyers thought, and they quickly objected. When the judge ruled that the prosecution had improperly allowed Rud to testify about crimes with which the Bentzes had not been charged, Rud disappeared from the courtroom, but his testimony was only disaster number one. Disaster number two was the second witness, an eleven-year-old boy who had told the police that Bob Bentz

objects of their childhood, and even their parents, were on their way
to becoming professional witnesses, and they were growing weary of
the constant questioning. The prosecutors defended the incessant
re-interviewing by pointing to the scope and complexity of the case. In
an ordinary sexual abuse case, they said, where there was a single
victim and a single victimizer, one or two interviews might be enough.
But in a case like this one, with so many victims and so many suspects
and so many separate instances and allegations, how else were they to
sort it out?

As July faded into August the prosecutors were forced to face the
uncomfortable fact that, while the investigation was far from complete,
they were due in court in less than a month. The first trial, that of a
couple named Bob and Lois Bentz, who were accused of abusing their
three sons and three unrelated children, was scheduled to begin on
August 27. Though lawyers for several of the defendants had asked for
extra time to prepare for trial, the Bentzes' lawyers were not among
them. "I wanted to be first," Earl Gray, the couple's lead counsel, told
Eileen Ogintz of the *Chicago Tribune*. "I was scared of having
somebody else be first." Had he asked for a continuance everything
might have turned out differently, but Gray sensed that Kathleen
Morris was not ready to go to trial, and his instinct proved to be right.
Morris, whose case rested on the testimony of the children and some
ambiguous medical evidence, had been hoping against hope that at
least one of the defendants would "roll over" by pleading guilty and
agreeing to testify against the others. A guilty plea would solve much
of Morris's problem, not just by reducing her caseload and encouraging
other defendants to enter similar pleas, but by giving her the thing she
needed most of all — an adult witness who could take the stand and
say, "I was there when it happened."

The prosecutors had already discussed plea bargains with several
defendants, in some cases on the same day that they were arrested. At
first the discussions were of the kind that take place as a matter of
course in any conspiracy case — an offer to allow a defendant to plead
guilty to reduced charges in return for testifying against the other
suspects. But as the Bentz trial neared, it became clear that nobody was
eager to accept Morris's offer, and the pressure to make a deal with
someone — anyone — became intense. The prosecutors had insisted
at the beginning that anyone who pleaded guilty and agreed to testify
would have to serve at least some token time in jail. But as time grew
short, some of the defendants were being told that the prosecutors
would recommend probation in return for a plea of guilty, and a few

defendant, she said, had confronted her in the grocery store and warned her to "stop your damn lying."

A small-town criminal justice system can overload in short order, and the management of the Jordan case was rapidly becoming more than seven police and sheriff's investigators, several prosecutors, a half-dozen therapists, and an equal number of social workers could handle. The case records were beginning to reflect the overload. Many of the police reports and some of the criminal complaints were being so hastily assembled that children's names were misspelled and their birthdates and even their sexes listed incorrectly. Only a handful of the interviews had been recorded on tape, which meant that most of the interview reports were paraphrased rather than verbatim, something that would eventually make it impossible to know precisely which questions had been asked of which children, and also precisely which answers they had given.

Not only were the investigators overwhelmed, they were mostly untrained in the intricacies of interviewing small children about sexual abuse. Only one, Pat Shannon of the Minnesota Bureau of Criminal Apprehension, could qualify as an expert, but Shannon hadn't entered the case until it was already nine months old. One of the others had attended a week-long seminar on the subject of child sexual abuse, and two had taken a four-hour course in "family relations." The rest had no training at all. Larry Norring had been taken off patrol duty to work on the case, and another investigator had a background as a crime-scene technician. Though they were not really part of the law enforcement team, the therapists were acting as surrogate investigators themselves. Any revelations made by the children during therapy were passed on to the police, and the police in turn fed the children questions through the therapists. The law enforcement types, one therapist said later, had been "well-motivated people," but she shuddered at the interview techniques of "guys who were writing speeding tickets one day and questioning kids the next."

Whatever their other failings, they were methodical to a fault. Whenever a new allegation arose, the investigator who heard it first would not only ask each of the other children about it, he would pass it on to his fellow investigators, who would raise it in all of their own interviews. The result was that the children in the case were being called upon to repeat their stories over and over, many of them as often as fifteen or twenty times, not counting the interviews they gave to prosecutors, therapists, and social workers. The children, living in foster homes and missing their brothers, sisters, pets, the familiar

search warrant with an arrest warrant," the official said, "particularly when you're looking for pictures." Inexplicably, the homes of most of the other defendants in the case were never searched at all.

The only potential corroborating evidence available to the prosecutors was medical, and some of that was compelling. When a professor of pediatrics from the University of Minnesota examined one of the older girls in the case he found she had suffered such severe physical damage that she could not control her bladder or bowels. At least ten of the other children examined by three different doctors showed evidence of some kind of sexual abuse, and four others showed signs of possible abuse. But the medical findings were by no means clear-cut. Many of the examinations had been performed by a family practitioner, and they had been rather rudimentary. According to the reports the doctor submitted, his technique consisted mainly of using his fingers to see whether the children's sphincters, vaginas, and hymens had been enlarged, a common method where sexual abuse is suspected, but one that many physicians dismiss as inaccurate in the extreme. For one thing, the human finger is something less than a precision measuring device. For another, hymens can be stretched and sphincters and vaginas enlarged for reasons that have nothing to do with sexual abuse. To confuse matters further, some of the medical findings contradicted statements by the children. One young girl who claimed that two of the male defendants had penetrated her rectally "lots of times" had a rectum that appeared to be normal. An older girl who said two defendants had had vaginal intercourse with her had a hymen that was "substantially intact."

As the Fourth of July came and went, the village of Jordan had divided itself into three camps. The first was made up of the defendants and their relatives, neighbors, and friends, all of whom protested that the case was at best a publicity grab by Kathleen Morris, and at worst a vendetta and a witch-hunt. In the second camp were the investigators, the prosecutors, and their relatives, neighbors, and friends, all of them convinced that what Morris was uncovering leaf by twig was the most heinous case of child sexual abuse in the history of Minnesota or any other state. Some Jordanites joined one camp or the other right away; in the best Minnesota tradition, most chose to wait and see. But the tension around town was not only palpable, it was visible and audible — coffee-shop arguments, street-corner debates, even face-to-face confrontations between the accusers and the accused. One eleven-year-old victim complained to police that one of the female defendants had been "giving me the finger around town"; another

noted that the children had been discriminating in their allegations, that no child had accused every defendant and that most had accused only a few. "If they were just trying to make up things and say everybody's a terrible monster," one therapist said, "it doesn't make sense to me that they would really differentiate who did what."

Such distinctions were important, for as the Jordan investigation continued through the summer of 1984 the question of the children's veracity was becoming paramount. The police had been able to come up with next to nothing in the way of physical evidence to corroborate the children's stories, and what little they had found was inconclusive. When two children said their anuses had been penetrated with miniature bowling pins and candles at one defendant's house, the house was searched. A miniature bowling pin and some candles were recovered, and a laboratory analysis found that both were coated with an unidentified "organic material" that could have been feces. The tests gave no indication, however, of who had used the items or for what. But for the failure to search Jim Rud's trailer the night he was arrested, there might have been much more. Many of the children had told of being photographed naked by Rud and some of the other defendants, and a few mentioned having seen Rud's scrapbooks of nude photos of children. Had such pictures been found, the case against Rud and any of the other defendants portrayed in the pictures would have been airtight. But when Larry Norring searched Rud's trailer nine days after his arrest, there weren't any photos or scrapbooks to be found.

According to the official report he typed up later, when Norring arrived at the trailer he saw "a stack of approximately 12 VCR cassette tapes, a large box containing pornographic magazines in the living area and two green garbage bags of pornographic material in the bedroom area." There were also "numerous items of children's clothing," including some underwear. But then Jim Rud's parents, both of whom would be charged in the case less than two weeks later, showed up and stopped the search. So "abusive and threatening" was the couple, Norring reported, that he "vacated the premises to avoid an altercation." As he was leaving, he saw the Ruds carrying "unknown items of personal property in boxes and bags" from the trailer. When Norring returned at nine o'clock the next morning the tapes, the pornography, and most of the children's clothing were no longer there. Much later, a senior Minnesota law enforcement official brought in to review Kathleen Morris's handling of the prosecution admitted that search warrants weren't issued as they should have been. "Usually you get a

place, the defendants' lawyers said, was plainly impossible. The only thing more inconceivable, the authorities replied, was that the children had made it all up. Privately, not all the lawyers were quick to insist that all the other defendants were equally innocent, or that the whole case was nothing but a children's conspiracy of lies. Some children, most of them agreed, had clearly been abused, but by whom was another question.

The defense hoped to show that many of the children's recollections of times and places didn't coincide with the events they described, and the statements taken by the police and therapists did contain a number of inconsistencies. One five-year-old girl, when asked where she was abused, first said it had happened, "upstairs, by the TV." Reminded that the TV was downstairs, the girl corrected herself. When a four-year-old who told investigators she had been abused by one of the defendants two days before was informed that the man had been in jail for weeks, she agreed it must have happened earlier. To the defense lawyers, most of whom were more accustomed to cross-examining adult witnesses about the details of traffic accidents and barroom brawls, such contradictions were the stuff of which acquittals were made. Seeking a convincing explanation for the children's allegations, the lawyers settled on the idea that the children had been brainwashed by the therapists. But the half-dozen psychologists working on the case, who by now were seeing most of the purported victims at least once a week, were less concerned about the discrepancies. "Five-year-olds change their stories," one said. "When you discover the cookie on the floor and he's the only one in the room, you'll get five different stories on something as innocent as that. Now imagine your son being severely sexually abused over a long period of time, and you can imagine why they are telling different stories at different times."

The therapists pointed out that although nearly all the children were being kept in separate foster homes and hadn't seen each other for months, many had told essentially similar stories, and they were also impressed with the physiological details the children supplied. "They tell you what sex is like," said one therapist. "They say, 'He put lotion on his penis before he put it in my butt.' When a three-year-old tells you that, there's nothing for me to conclude other than the kid is relating something that really happened to them." Most of the questions asked during the interviews had been designed not to put words into the children's mouths, but were open-ended: "Did someone have you do something?" or "Who touched you?" The therapists also

jail" or even killed if they did not submit. Some of the children talked freely to the police. Others talked only to the half-dozen child therapists who had been brought in from Minneapolis to help them deal with the aftereffects of the abuse. A few, mostly very young children, were reluctant to talk at all, and a few older ones could not seem to stop talking. As winter gave way to spring, the pages of police reports numbered in the thousands, and still the questioning went on: Who else hurt you? Do you know any other children who were hurt? Is there anything else you haven't told us?

From the day it surfaced, the Jordan case enjoyed the full attention of Kathleen Morris, then thirty-nine, the local prosecuting attorney who had become known for an aggressiveness that bordered on flamboyance and a penchant for working seven-day weeks. Morris, whose waist-length hair and lack of makeup contrasted sharply with her tailored business suits, had already won a reputation beyond the borders of Scott County, the state's second smallest. As a young assistant prosecutor, Morris had made her first headlines when, while prosecuting a narcotics case, she told a reporter that she favored legalizing marijuana. The offhand remark caused a furor, but within a year Morris had been elected chief prosecutor. When she won six convictions in the first child sexual abuse case in Scott County history, she emerged a self-styled champion of children's rights, crisscrossing the state to make speeches about child abuse and to criticize her fellow prosecutors for steering clear of such difficult cases. It wasn't uncommon to hear people say that someday Kathleen Morris was going to be Minnesota's first female attorney general, or maybe its first female governor, but not everybody felt that way. "People either love me or hate me," Morris was fond of saying. "I guess I'd rather they love me, but I'm not going to worry about it if they don't."

By the spring of 1984 the "Jordan sex case" was beginning to attract some national attention, and most of the news reports reflected one of two points of view. According to the prosecutors and the police, what had happened in Jordan was beyond imagination — two dozen men and women, most of them married, most of them parents, many of them solid citizens, had forged a twisted conspiracy of sex and torture with their own children as its victims. According to the defendants and their lawyers, what had actually happened was just as incomprehensible — two dozen men and women, friends, neighbors, and churchgoers, were faced with the loss of their savings, their homes, their jobs, and their reputations because their children had lied. For a black fantasy such as the children described to have taken

charged with the sexual abuse of several other children. So would a deputy sheriff, a truck driver, a printing-equipment operator, an auto-body painter, a waitress at the local truck stop, an employee of the county assessor's office, an eight-year veteran of the Jordan police department, and both of Jim Rud's parents. A few of the defendants in the case were strangers, a few others related by birth or marriage. Most had become acquainted in the ways that people get to know one another in any small town, as neighbors, parishioners, customers, and friends of friends. On the surface the defendants didn't seem much different from anybody else, but the tales their children were telling were growing more horrifying by the day.

One boy, seeking to pinpoint one of the many occasions on which, he said, he had been abused by his parents, remembered that "we had pizza that night, because Mom and Dad went shopping." A girl recalled being abused by a neighbor lady who had just finished fixing her hair into a ponytail. Another boy said he had been abused by his parents in his own living room while watching "Wonder Woman" on TV. A girl said her grandmother had abused her with a pair of scissors before giving her macaroni and cheese for lunch. But not all of the abuse had been so matter-of-fact. There had also been "parties" that sometimes included ten or fifteen adults and as many children, parties where everyone played hide-and-seek or baseball or some other game, the sort of get-togethers one might expect to find on a summer evening in a small Midwestern town — except that, the children said, the outcome of the games had been their parents' way of determining which adults would have sex with which children.

When they talked about the sex, the children described nearly every permutation imaginable — mothers and fathers with sons and daughters, aunts and uncles with nieces and nephews, grandparents with grandchildren, children with one another and even with their pets. At one party, they said, the abusive games were followed by a hot dog supper. At another, everyone had strawberry ice cream afterward. Though they were copied down in the stilted dialect that is the universal trademark of police reports, the children's stories managed to retain some of their innocent language. One boy said his parents had put their mouths on his "freddie." Another talked of being forced to put his penis in his mother's "chinese." A young girl spoke of having been penetrated in both her "front butt" and her "back butt." Some of the children said they were given drugs and liquor, mostly beer and wine but sometimes peppermint schnapps, to encourage their compliance. Others said they had been threatened with being hurt or "sent to

them. Those who said it had were taken to talk with the police, who by now were struggling to cope with what would have been a major child-abuse case in a city many times the size of Jordan.

When the children were asked whether they knew of any others who had been abused, nearly every child supplied at least one new name. When they were asked who had abused them, many named several adults, often including their own parents. As it unfolded, the tale being told by the children of Jordan was a most improbable one — nobody in Minnesota law enforcement could remember anything remotely like it — and it was being told in a most improbable setting, a Minneapolis suburb distinguished only by the consummate ordinariness of small-town America. With its spired churches, main-street cafés, and simple, sturdy houses, it was possible from a distance to mistake the village of Jordan for a painting on a calendar, or perhaps for Garrison Keillor's mythical hamlet, Lake Wobegon. Seen from up close, Jordan was less picturesque, a little threadbare in places and beginning to sag, but most of those who lived there were the kind of phlegmatic, reliable folk that Keillor has in mind when he says no true Minnesotan accepts an offer of anything until it has been made at least three times.

At the beginning the investigation focused on the Valley Green trailer park, the first stop for those arriving in town and the last for those on their way to somewhere else, but before long it had expanded to include some of the middle-class families who lived in the large, pleasant houses that were, both literally and figuratively, on the other side of the tracks. By then it wasn't only the children who were talking. One morning a woman walked into the police department to report that Rud had been photographing her five-year-old twin daughters in the nude, and that he had probably abused them sexually as well. When she and her children visited Rud's trailer, the woman said, he often took one girl or the other into a back bedroom for a few minutes at a time. As she was leaving, the woman named three other children Rud had molested, not at his trailer but at the house of Judy Kath, one of the two original complainants in the case, who also happened to be Jim Rud's former fiancée.

Less than a month after Judy Kath and Chris Brown had taken their daughters to see Officer Norring, both women were under arrest themselves, Brown charged with abusing Judy Kath's daughter and one of her own, Kath with promoting a minor, her own daughter, to "engage in obscene works." Brown's current boyfriend, her ex-husband, her sister, and her brother-in-law would eventually be

Questions

I T WAS SOMETIME on the afternoon of September 26, 1983, that Judy Kath and Christine Brown, their ten-year-old daughters in tow, marched into the Jordan, Minnesota, police department. The two girls, their mothers said, wanted to talk to someone about James John Rud, a twenty-seven-year-old trash collector who lived by himself in a shabby mobile home at the Valley Green Trailer Park. Jordan's five-man department had no one on its staff who could qualify as an expert in child sexual abuse, certainly not patrolman Larry Norring. But when the girls announced that Rud had been abusing them sexually, Norring did not take their allegations lightly. Later that evening, while Rud was riding his motorcycle on one of the narrow county roads outside of town, Norring pulled him over and placed him under arrest. Had the matter ended there, with a suspect behind bars, it might have been worth a single headline in the Minneapolis papers. But the matter did not end there, and before it was finally over, it would occasion many headlines.

Norring's superiors took the girls' allegations as seriously as he had, and in the days and weeks that followed, the police interviewed a number of other children. Some of them were playmates of the two girls, others the sons and daughters of Rud's neighbors at the trailer park or of women he had befriended at meetings of Alcoholics Anonymous. To the surprise of no one more than the police, many of the children told essentially the same story. As residents of small American towns will attest, very little happens in such places that does not quickly become common knowledge, and no sooner had the investigation begun than dozens of worried parents, particularly those whose children had known Jim Rud or any of his victims, were asking their own sons and daughters whether anything had happened to

1

BY SILENCE
BETRAYED

The large gaps in my knowledge of psychiatry and the law will be immediately apparent to members of those professions, but few journalists ever become experts in the subjects they write about. The reporter's task is to gather information from those who do have expertise, to sift it and synthesize it and then present it in a clear and balanced way. If I have managed to do that here, it is only because I received so much help and encouragement from so many people.

Above all, I must express my gratitude to Jim Squires, Dick Ciccone, and Doug Kneeland of the *Chicago Tribune*, who were among the first editors in the country to recognize the importance of writing at length about sexually abused children, and who provided me with the time and resources to pursue the subject as fully as I did. I am also grateful to Lynn Emmerman and Eileen Ogintz, my *Tribune* colleagues, who did most of the reporting on the Jordan, Minnesota, case.

Every effort has been made to ensure that the many trials and other legal proceedings mentioned in this book were reported accurately. All dispositions were up to date as of the summer of 1987, when the manuscript went to press, although some verdicts may have subsequently been reversed on appeal.

In the course of my research I spent many hours talking to men and women who were sexually abused as children or who have abused children sexually. All spoke to me in the hope that telling their stories might make a difference to the lives of uncounted others who share their grief and pain. They also spoke in confidence, and I have honored their requests that their real names not be used and that other identifying details about them, their families, and their lives be changed without affecting the substance of their stories.

Those to whom I can express my appreciation by name for having given so freely of their expertise include Jon Conte, Ken Freeman, Roland Summitt, Nahman Greenberg, and Bud Lewis, all of whom were kind enough to read the manuscript or portions of it, and to recommend important changes and clarifications. Their suggestions improved it enormously, as did the thoughtful editing of Bill Phillips, Doug Kneeland, and Prudence Crewdson. Thanks also to Henry Giaretto, Judith Becker, David Corwin, Ken Lanning, Bill Dworin, Paul Abramson, Anne Cohn, Bruce Selcraig, Steve Wolf, Lucy Berliner, Norm Coleman, Toby Tyler, Seth Goldstein, Mike Fondi, Terry O'Brien, Rob Freeman-Longo, Roger Smith, Michael Ryan, David Jones, Donald Bross, Donna Rosenberg, David Finkelhor, Diana Russell, Gail Wyatt, and others too numerous to mention.

All errors, of course, remain my own.

not even the senator herself, was prepared for the national impact her speech would have. "I never realized it would be such a sensation," she said later. "I had been so involved in the subject that I thought it was commonly talked about. Victims must speak out."

That spring, when I left Chicago to take up a new assignment as the *Tribune*'s Los Angeles correspondent, I arrived on the West Coast a few weeks after the first indictments had been handed down in the Virginia McMartin's Pre-School case. Not just one or two children, the McMartin prosecutors were saying, but dozens of them, possibly hundreds, had been sadistically and ritually abused for a decade by a cabal of teachers at the school. The children represented an insignificant fraction of the six million toddlers who are cared for each day by someone outside their homes, but many parents who read and heard about the case were beginning to wonder about the nurseries, day-care centers, and preschools where they deposited their own children each morning. Before long, most of the state agencies that regulated day-care centers learned what the child-abuse hotline people had known for months: Americans were becoming worried about their children.

I spent most of the next year writing about the sexual abuse of children for the *Tribune*, and it was a wrenching experience. Before the year was over, I had become convinced that sexual abuse is one of the most pressing problems faced by this society, all the more urgent because there are so few apparent solutions. Even more disquieting, however, were the responses I received from those who politely inquired what I was writing about. A surprising number, including some people I thought I knew well, would cautiously acknowledge that "something like that happened to me when I was a kid," and go on to tell about having been molested by a father or an uncle or a teacher. Most of the others, including some whom I knew to be sensitive and humane individuals, had somehow become convinced that children who claim to be sexually abused are lying. Because it hadn't happened to them, it seemed, they simply couldn't imagine its happening to anyone.

To those who were abused as children, I hope this book will offer at least the faint reassurance that they are far from alone. To those who disbelieve the children, I hope it will offer some reasons to reconsider their disbelief. This book is not intended as a scholarly study, though for those who are interested in knowing more I have cited much of the currently available research. It is, rather, an overview of what is known about the sexual abuse of children in America. If I offer no ultimate solutions, it is because I know of none.

PREFACE

N JANUARY 1984, ABC-TV broad-
cast a made-for-television movie called
Something About Amelia. It was unlike
anything seen on television before, the story of a white, middle-class,
teenage girl who has a sexual relationship with her father. Deftly acted
and dramatically understated, *Amelia* contained a message that child-
protection workers had been trying to convey for years — that the
sexual abuse of children in America is not uncommon, and not bound
by class or culture. Nearly half of those who watched television that
night were watching *Amelia*, and when it was over, child-abuse
telephone hotlines across the country began to ring. The callers
numbered not in the hundreds or the thousands, but in the tens of
thousands. They included children who said they were being sexually
abused, children who thought their friends were being abused,
teachers who thought their students were being abused, mothers who
thought their daughters and sons were being abused, grown women
and not a few men who said they had been abused as children — even
a handful of child abusers who wanted help.

Over the next few days, the hotline operated by the state of Illinois
received thousands of those calls. I was then day metropolitan editor of
the *Chicago Tribune*, and it was the story we printed about the reaction
to *Amelia* that caused me to really think for the first time about child
abuse and child abusers. I had known there were child molesters, of
course; as a child I had been warned not to take candy from
strangers — but no strangers ever offered me candy, and like most
Americans, I had always assumed they were a rare species.

A couple of months later, in the hope of learning more, I flew to
Washington, D.C., for the Third National Conference on the Sexual
Victimization of Children. The opening address was delivered by
Paula Hawkins of Florida, a formidable advocate for the rights of
children during her six years in the United States Senate.[1] Putting
aside much of her prepared text, Hawkins announced that she had
been sexually abused by an elderly neighbor at the age of six. No one,

CONTENTS

For Anders

First edition

LIBRARY OF CONGRESS CATALOGING-IN-PUBLICATION DATA

Crewdson, John, 1945–
 By silence betrayed.

 Includes index.
 1. Child molesting — United States. 2. Sexually
abused children — United States. I. Title.
HQ72.U53C74 1988 362.7'044 87-22555
ISBN 0-316-16094-6

FG

Published simultaneously in Canada
by Little, Brown & Company (Canada) Limited

PRINTED IN THE UNITED STATES OF AMERICA

BY SILENCE BETRAYED

Sexual Abuse of Children in America

John Crewdson

LITTLE, BROWN and COMPANY
Boston Toronto

Also by John Crewdson

The Tarnished Door: The New
Immigrants and the Transformation
of America

BY SILENCE
BETRAYED